Reading Portland

The City in Prose

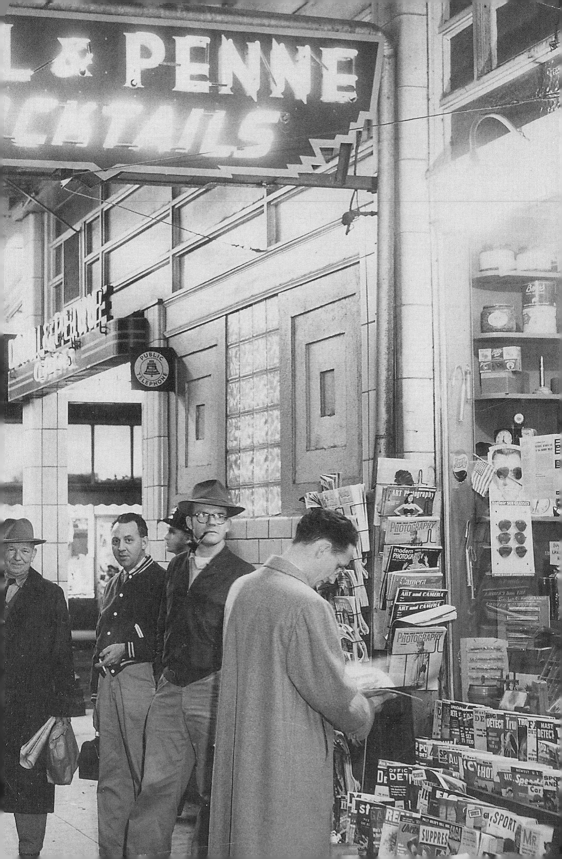

Reading Portland

The City in Prose

John Trombold & Peter Donahue
editors

Oregon Historical Society Press, Portland
in association with
University of Washington Press, Seattle & London

Oregon Historical Society Press
1200 SW Park Avenue, Portland, Oregon 97205, USA
www.ohs.org

in association with
University of Washington Press
P.O. Box 50096, Seattle, Washington 98145, USA
www.washington.edu/uwpress

The paper used in this publication is acid-free. It meets the minimum requirements of American National Standard for Information Sciences — Permanence of Paper for Printed Library Materials, ANSI Z39.48—1984.

Cover Design: Ashley Saleeba

All photographs, unless otherwise noted, are from the collections of the Oregon Historical Society Reference Library, Portland. For a full list of figures, see page 569.

Library of Congress Cataloging-in-Publication Data
Reading Portland: the city in prose / edited by John Trombold and Peter Donahue.
 p. cm.
 Includes bibliographical references.
 ISBN-13 978-0-295-98677-7 (acid-free paper)
 ISBN-10 0-295-98677-8 (acid-free paper)
1. Portland (Or.)—Literary collections. 2. American prose literature—Oregon—Portland.
3. Portland (Or.)—Fiction. 4. Portland (Or.) I. Trombold, John. II. Donahue, Peter.
 PS572.P6R43 2006
 810.8'03279549—dc22
 2006033090

For Susan Donahue and
Charles Trombold

Contents

Modern Portland: The Rose City

Portland Proper: Neighborhoods, Activists, Nature, and Beer

Contemporary Portland: Scenes and Reflections

The Pull of the Rivers: *A Preface*
by Peter Donahue

> *I said, How many rivers have you got in Portland Town?*
> — from "Portland Town," by Woody Guthrie

I first visited Portland in the summer of 1980, shortly after Mount St. Helens blew. Even though winds had blown much of the ash eastward, it still coated the ground and formed small drifts along curbs and in building recesses throughout the city. A progressive-minded, Spanish-speaking friend of mine from New Jersey had signed on with VISTA, the domestic equivalent of the Peace Corps, which had assigned him to help Mexican migrant workers in the strawberry fields in the mid Willamette Valley. My stated purpose in taking the train north from San Francisco, where I was living that summer, was to visit my friend. In truth, visiting my old pal was simply a pretext for a long-anticipated excursion to Portland.

I had few preconceptions of the city. All I knew was that it lay situated on the Columbia River, the majestic waterway that cut through the Cascades in its headlong run to the Pacific. I was familiar with enough folk music to know the Woody Guthrie songs—such as "Roll On, Columbia," the official Washington State folk song—which fed my romance of the Great Northwest. By right of its being on "that King Columbia river," Portland Town, to my mind, at least, stood as the undisputed capital of the region.

It was with no small measure of dismay, therefore, that I came to learn the actual geographical layout of the city in relation to its rivers—"the city on the Columbia," as William Least Heat Moon points out in his selection in *Reading Portland*, is Vancouver." I'll own up here to the sad fact that, before arriving in Portland in 1980, I did not know where the Willamette River was. I had heard of it, as in the Willamette River Valley, but I had no idea of its relation to Portland. To me, Portland had always been a one-river town, that one river being the Columbia—the one Lewis and Clark had ventured down, the one Woody Guthrie sang about. End of story. So, after arriving at Union Station and finding a $65-a-week hotel room, I went in search of the mighty Columbia. I asked someone on the street how to get to the river, and he pointed me in the right direction. At last, I thought, the Columbia River, one of the great natural wonders of the world, the Mississippi of the West, and started humming "Roll On, Columbia."

What a shock it was to my twenty-year-old naiveté when I discovered that Portland sits on the Willamette. I was confounded. Where was the Columbia? Too embarrassed to ask, I bought a map, found a dim tavern near Burnside in which to drown my humiliation, and studied the city's geography.

Once over my disappointment, I set about walking as much of the city as I could over the ensuing week. I spent a good deal of time hiking through Forest Park, climbing the hills toward Council Crest Park, rutting around Old Town and Chinatown, strolling the South Park blocks through the Portland State University campus, and crisscrossing the many bridges that span the Willamette River, with which I'd made my peace. Regrettably, I didn't explore North Portland much, an area I would only come to know as I came to feel more at home in the city.

It wasn't until my first week in Portland had come to an end that I finally set eyes on the Columbia. Heading north to Seattle on the train, we crossed a narrow iron bridge that allowed me to see just how wide and mighty the Columbia is, especially compared to the more winnowy Willamette. The Portland of my Northwest romance, however, had already suffered in my estimation for not having its downtown smack dab on the Columbia, and my allegiance shifted to Seattle—Did I mentioned my youthful naiveté?—as the rightful capital of the Great Northwest.

Still, my memories of my week in Portland remained strong. My single fondest memory was of the Benson Bubblers. Installed throughout the city's central district by timber baron-philanthropist Simon Benson in 1912, the four-font fountains burble eternally, offering pedestrians a sense of calm, watery opulence. Their verdigris stands, brass bowls, and stainless steel fonts have a delicate neoclassical style that bespeaks the city's refinement. The water rises about an inch or two, softly, like an artesian spring—nature and civilization beautifully wedded. I also had serene memories of the Willamette, which one can leisurely walk beside and stroll across. There is something about rivers that draws us to them. They pull on us in a manner that writer Mike Tidwell describes as the "ancient riparian dance between people and water."

The Willamette and the Columbia make Portland the region's crossroad. According to the City of Portland Auditor's Office, the intersecting deep-blue lines of the city's official flag represent the rivers, its yellow-and-white stripes the city's agricultural and commercial ties, and its evergreen background the surrounding Oregon forests. At the center of the flag lies a star—technically, a hypocycloid—which represents the city at the confluence of the two rivers. Designed by Douglas Lynch, former president of the Portland Art Commission, the flag was adopted by the city in 1970 and modified in 2002. Frankly, it's the only city flag I know, the only one that ever caught my attention.

In the fall of 1946, Reed College and the Portland Library Association hosted the first Writers' Conference on the Northwest, a collective effort to explore the question of regional identity. The presenters included novelists, journalists, editors, literary critics, historians, and a sociologist. They were mostly white and mostly male. Every presenter's writing career was tied, to some

extent, to the Northwest. In the course of the conference, the presenters discussed a range of issues, from the Northwest's rugged geography to its frontier history, from its natural resources to its cultural achievements. Yet, few of the presenters commented directly on Portland. They seemed to take for granted that, as the region's oldest, most established urban center, the city was the natural site from which to conduct a rigorous examination of the region as a whole.

At the opening session of the conference, Reed College President Peter H. Odegard argued that just as Americans had an economic and cultural dependence on Europe, the Northwest had a dependence on the East. He did not call for economic or cultural independence—a Northwest "autarchy." Rather, he recognized that the Pacific Northwest—the one of European descent, at least—was made up of New Englanders and New Yorkers, southerners and midwesterners.

Lancaster Pollard, superintendent of the Oregon Historical Society, reminded the audience that Portland was the region's undisputed capital, a city that was founded on and grew from pre-established traditions. Portland had continued "Old South and New England traditions," he said, which gave the city "an air of sedate and assured stability and has resulted in [its] liberal conservatism." Such liberal conservatism was apparent at the turn of the twentieth century through such polar yet compatible figures as C.E.S. Wood, anarchist poet and founding member of the Portland Public Library, and Harvey W. Scott, conservative editor of the *Oregonian*, and at the turn of the twenty-first century through Portland's popular conservative talk-radio and its populist, left-leaning polity. This putative paradox continues today, it can be argued, because Portland has for so long embraced its own regional (and international) hybridity, which itself has been transformed as Portland has changed with each new population group that makes its mark on the city. The depth and range of the selections in *Reading Portland* exemplify and highlight that hybridity.

Pollard, who made it his life's mission to promote and chronicle Northwest literature, pointed out another important trait of the region's literature. "There was a continuous literature," he said, "of deliberately devised craftsmanship in poetry, fiction and essay from the beginning of American penetration [into the Northwest]. It was 'frontier' only in its subject, in its descriptions of a new land or of pioneer life, not in any psychological coarseness or unlettered rudeness, for it was usually not inferior as writing to most that was published elsewhere in the United States at the time." He cited Jesse Applegate, Abigail Scott Duniway, and Joaquin Miller—each of whom is included in *Reading Portland*—among the region's many lettered writers.

While the city of Seattle, a relative latecomer to the region's settlement, persisted in its "frontier psychology," forestalling its cultural rise to prominence, Portland established itself from its earliest days as a literary center.

Pollard recognized the contributions of such writers as Frances Fuller Victor, John Reed, and James Stevens in carrying on the region's "better than merely competent" writings into the twentieth century. We can add to his list the many writers, from Ursula K. Le Guin to Chuck Palahniuk, who have given the city such a prominent literary profile into the twenty-first century.

The keynote speaker at the Writers' Conference on the Northwest in 1946 was Carl Van Doren, a midwesterner who had established himself as an East Coast intellectual. Van Doren had a keen appreciation for the Northwest. He talked about what he called the "process of intersectional naturalization," by which migrants take something of their native region with them to their adopted region. He made the important distinction between being a native citizen and a natural citizen of a place. A migrant to a region might have more affinity for and understanding of her adopted region than the native citizen who does not feel at home and longs to escape it. If all great literature tends to be regionally inflected, as many critics acknowledge, it stands to reason that it derives from readers' recognition of an author's natural citizenship of a particular place. Consider Edith Wharton (Northeast), William Faulkner (South), Willa Cather (Midwest), Cormac McCarthy (Southwest), and David Guterson (Northwest). Yet, Van Doren warned his audience of the dangers of over-emphasizing regional self-consciousness, particularly in literature. Great works are not created by writers striving to be regional, he reminded his audience, but by those whose work is intrinsically informed by it.

In 1927, nineteen years before the Writers Conference on the Northwest, James Stevens (one of the conference presenters) and H.L. Davis wrote "Status Rerum," the notoriously vehement protest against the state of Northwest literature. They subtitled the piece "A Manifesto Upon the Present Condition of Northwestern Literature, Containing Several Near-Libelous Utterances, Upon Persons in the Public Eye." "Something is wrong with Northwestern literature," they began. Every other region in the country had produced "a body of writing of which it can be proud," but the Northwest "has produced a vast quantity of bilge, so vast, indeed, that the few books which are entitled to respect are totally lost in the general and seemingly interminable avalanche of tripe." It was a sanctimonious screed, lacking both perspective and critical acumen, yet at the time it was written and throughout most of the twentieth century it accurately reflected the general view of Northwest literature. Since World War II, however, this view has been steadily refuted by literary anthologies such as Stewart Holbrook's two-volume *Promised Land: A Collection of Northwest Writing* (1945, 1974), Ellis Lucia's *This Land Around Us: A Treasure of Pacific Northwest Writing* (1969), Michael Strelow's *An Anthology of Northwest Writing: 1900-1950* (1979), and Bruce Barcott's *Northwest Passages: A Literary Anthology of the Pacific Northwest from Coyote Tales to Roadside Attractions* (1994). The Stevens-Davis evaluation of Northwest writing has also been discredited by the growing body of critical studies, such as

Nicholas O'Connell's *On Sacred Ground: The Spirit of Place in Pacific Northwest Literature* (2003) and reprint series such as those at Oregon State University Press and Washington State University Press. Today, the wealth of Northwest literature that needs to be recognized, read, and studied is a given, freeing scholars and editors to focus on individual authors and specific areas.

One of those areas is urban literature. The notion of regionalism, especially in respect to literature, most often evokes images of a rural outback, a swath of the map unmarked by crisscrossing roads and highways, a section of country sporadically dotted by townships and characterized by unspoken codes of conduct and deep-rooted colloquialisms. But every region is defined by its rural, urban, and increasingly suburban (and exurban) elements. Every region has cities. In 1938, in a talk to the City Club of Portland, Lewis Mumford urged the city's leaders, planners, and citizens to wake up and recognize themselves as urbanites. To think regionally, he suggested, one must keep the region's cities foremost in mind. With Portland's beautiful natural surroundings and abundant natural resources, Mumford declared, "you have here a basis for civilization on its highest scale." From the literary perspective, as represented through the selections in *Reading Portland*, we like to think Mumford's implied challenge has been met.

Acknowledgments

Compiling *Reading Portland* meant conversing with a village. At the inception of this book, essential advice and suggestions came to us from Brian Booth, Carl Abbott, Kim Stafford, and David Milholland. Once begun, the project seemed to pass us from writer to writer. Portland poet Lisa Steinman offered high praise for Mathew Stadler's fine essay "The Regime of the Picturesque," which led to discovery of that essayist in North Portland. (It seems that writers, like rivers, continents, and regions, can be "discovered.") Stadler provided other suggestions for inclusion in the collection. Soon more suggestions came to us from Walt Curtis. During this period, Charles Trombold was born and proceeded to make the anthology devoted to his place of birth a competitor for time and attention.

River City authority Kimbark MacColl then reviewed the *Reading Portland* table of contents and remarked: "There certainly is a lot of water here!" Ann Fulton and Katrine Barber provided crucial historical perspective on resources for understanding Indian history in the Portland area. Sandy Polishuk, Debra Shein, Xander Patterson, Robert Van Dyk, Sue Danielson, and David Oates made valuable comments. Arthur MacArthur, Debbie Snyder, Susan Hartwell, Victoria Campbell, and Alice and David Davies provided helpful assistance. Laura Dedon and Tyler Smoker provided timely aid. Although this anthology is focused neither on poetry nor on urban studies, the writings of poet Peter Sears, on the one hand, and urbanist Steve Reed Johnson, on the other, influenced our understanding of the city. Editing of the introduction by Susan Donahue and the timely reinforcement of editorial wisdom by Courtney Davies was invaluable. While all of these commentators were essential to the compiling, organization, and assessment of these Portland writings, any and all errors here remain ours, not those of our advisors.

We are also deeply indebted to John Wilson Room librarian Jim Carmin at the Multnomah County Library; Caroline Mann, head of Public Services at the University of Portland Library; Oregon Historical Society reference archivist Shawna Gandy; Susan Seyl, Oregon Historical Society public services librarian; Jane Carr, reference librarian at Lake Oswego Public Library; interlibrary loan librarian Jenny Bornstein at Lewis & Clark College; and Reference and Digital Learning Librarian Carol McCulley at Linfield College.

Andrew O'Keefe researched extensively in the Oregon Historical Society photographic archives and provided elusive biographical detail on authors. His interest in the development of the book never flagged. The anthology would not have been possible without Marvin and Abby Dawson's countless volunteer hours at the Oregon Historical Society. We are also grateful for the support of the staff at Birmingham Southern College, University of Portland, and Linfield College. Anonymous reviewers of the Oregon Historical Society Press Editorial Advisory Board challenged the assumptions of this collection and made useful suggestions. We appreciate work done by Oregon Historical Society Press

interns Kirstie Richman and Chris Stillwell. We would like to extend our gratitude to the University of Washington Press, co-publisher of this volume. We are delighted to recognize the assistance and guidance of Eliza Jones, production editor, and Marianne Keddington-Lang, director of the Oregon Historical Society Press, throughout the planning and development of this anthology, which would not have been possible without their excellent direction. We also thank Dean Shapiro and Lucy Berkley at the Oregon Historical Society for their help in processing the photographs in the book. Finally, for over two years Brent Davies enjoyed hearing these stories and kindly and patiently entertained lengthy and unexpected narratives about her hometown at all hours and under quite varied domestic circumstances. And she has known the names of all of Portland's bridges since third grade.

Reading Portland: *An Introduction*
by John Trombold

The city of Portland and the surrounding metropolitan area—which includes parts of six counties in Oregon and Washington—is located a hundred miles inland from the Pacific Ocean at the confluence of two definitive Oregon rivers, the Willamette and the Columbia. Perhaps expressive of the convergence of these two great rivers, descriptions of Portland trace multiple junctions and divergences.

Consider the many names, histories, and cultural references given to what is now Council Crest Park, a lovely city park in Portland's West Hills. Nineteenth-century Portland publisher George Himes declared that "no city in the world has a point so near from which so much can be seen."* The prospect from atop Portland's highest spot, with its expansive vista of glaciated, volcanic peaks, suggests infinite expanses that could support any lofty tale. Portland's Parks and Recreation Department explains that Council Crest was originally named Talbot's Mountain for its pioneer settlers, that it was later known as Glass Hill, and still later as Fairmont, the name of the current boulevard surrounding the park.

Attributed to legend is the idea that Council Crest is named for councils of Native Americans who met at this spot. Himes and an inscription located in the inner circle at the park itself attribute the name to thirty ministers who were delegates to the 1898 meeting of the National Council of Congregational Churches. Himes suggests that the ministers chose the name Council Crest in homage to what they might have believed were the Indian councils held there during a romantic prehistoric past. In *Oregon Geographic Names,* Lewis L. McArthur mourns the mythologizing of Council Crest and worries that the "thousands of people who visit this spot every year will accept this modern myth as gospel, and another piece of Portland history will be lost."**

While Council Crest once provided a place for ministers to take in an Olympian perspective, it was later the location for an amusement park, torn down in 1941. And there are other events and details: Near an observation tower in the park, presently a water tower, someone once stole a statue of a mother and child, which, sculptor Frederic Littman once pointed out, some people mistakenly thought represented a pioneer. Police rediscovered the statue in a Portland backyard during a narcotics raid. One tourist Website touts the park as a fine place for acoustic experiments in calling out into the open air and then hearing an echo. Another recommends the Crest as a great spot for kissing.

In all, Council Crest figures as a site for sacred legend, history, amusement, petty theft, and even ambiguity. Yet, what writers attribute to place can reveal

*Oregon Historical Society Research Library, scrapbook no. 36, p. 172.
**Lewis A. McArthur and Lewis L. McArthur, *Oregon Geographic Names,* 7th ed. (Portland: Oregon Historical Society Press, 2003), 239.

as much of interest to readers as the accepted historical truth, especially when clear patterns in these attributions appear over time. History must share Council Crest with narrative, whether engraved in parks or described in a novel.

The selections of *Reading Portland* intermingle and evoke characterizations of Portland. This anthology of historiography, journalism, oral history, essays, creative nonfiction, memoirs, historical and contemporary fiction—in Westerns, detective stories, mysteries, and science fiction—is a marvelous composition. Taken together, these prose writings are notable for their insight, eloquence, and intelligence. In contributing to a broad understanding of place, they entertain, quarrel, insist, condemn, ridicule, confess, report, affirm, celebrate, and narrate.

The stories in *Reading Portland* illustrate how a national American narrative of progress shaped an understanding of the landscape that became a city through colonization. It is the American claims—based on Captain Robert Gray's 1792 entrance into the Columbia, Lewis and Clark's 1805-1806 expedition, and American colonization south of the river—that usually receive priority in our understanding of this period. *Reading Portland* considers a parallel experience—the British claims on territory based on the undeniable success of Fort Vancouver, the extended narrative of Lt. William Broughton's explorations up the Columbia, and David Douglas's quest for Pacific Northwest flora and fauna at the behest of the Horticultural Society of London.

These chronicled endeavors—naturalistic, ethnographic, and commercial— were partly inspired by international competition for trade and the search for knowledge of new geographies. American naturalist John Kirk Townsend and British botanist Thomas Nuttall laid claim to local knowledge through their writing and observations, as when Townsend, in his disturbing account, attempts to remove a deceased Indian from Sauvie Island for the purposes of science. The Hudson's Bay Company factor, Dr. John McLoughlin, founded Oregon City in 1842, just south of what is today Portland proper, in an ongoing rivalry with American Methodists for land on which to locate a mill. The next year, Americans circulated a petition complaining about being subject to British authority in the Willamette Valley. Hall Jackson Kelley, who historian Frances Fuller Victor called the "prophet of Oregon," reflected American concerns about British influence when he wrote in 1831 that the Society for the Settlement of Oregon "view[s] with alarm the progress, which the subjects of that nation [England] have made, in the colonization of the Oregon Territory. Already, have they, flourishing towns, strong fortifications, and cultivated farms." For the British, spies Henry James Warre and Mervin Vavasour corresponded about Oregon City while observing it from a strategic perspective in 1847, when political control of the region jointly governed by Britain and the U.S. could still ignite military confrontation. In estimating how Oregon City could be defended once the British occupied it, Warre and Vavasour reported that McLoughlin's mills "might be . . . made defensible, being built of square timber."

Once they had come by ship from the Pacific, by wagon over the Rockies and the Cascades, and by raft down the Columbia, Portland settlers encountered less in the way of grand international rivalry—the subject of newspaper columns and political orations—than the more basic problems of survival and perseverance. Relations with the Chinook, Molalla, Calapuya, Kathlamet, and Multnomah peoples who lived in villages along the rivers took a variety of turns, both peaceful and threatening, and colonists recorded their experiences along with information such as population size, customs, and inclinations toward trade and labor. Matter-of-fact references to negotiating with Indians the purchase price for horses and dogs for food are a part of the early journals and diaries of those traveling the Columbia and Willamette rivers. Early narratives also prefigure the dramatic historical consequences of American colonization, as their capacity to describe a new geographical periphery became the foundation for American claims to what would become Portland.

The Lewis and Clark Expedition was a preliminary step in the very concrete endeavor of advancing Thomas Jefferson's dream of an empire stretching to the Pacific Ocean. The journals provided the first expression in writing of the president's intention to assimilate western American Indians in an imperial enterprise.* That dream was realized retrospectively as Oregon City's cultural triumph. In his popular western saga, *Empire Builders*, Robert Ormond Case exalts U.S. Marshall Joseph L. Meek, the executioner of five Cayuse found guilty in 1850 of killing Marcus and Narcissa Whitman and twelve other would-be settlers. Underscoring both the triumph of territorial law in Oregon's capitol and Meek's reported knowledge of Indians, Case tells the story of how those who had explored and settled the frontier made that legal framework possible through their own heroic experience. Writing nearly a hundred years after the executions, Case portrays Meek as a stock character whose traits are patterned after previous narratives. These antecedent stories celebrate figures who act on knowledge derived from accumulated and sustained colonial effort previously recorded in the ethnographic narratives of early explorers and fur trappers such as Edward Bell, clerk on the HMS *Chatham*, Lewis and Clark, Pierre-Jean de Smet, Henry Alexander, and Gustavus Hines and the narratives of settlement and colonization of such visionaries as Daniel Lee and Jackson Hall Kelley.

This same sense of civilizing mission is evident in the epic vision of Abigail Scott Duniway's *Captain Gray's Company*, which describes prairie schooners crossing the plains as if they were ocean-going vessels. Eva Emery Dye's romantic epic, *The Conquest*, lionizes Lewis and Clark and conceives of their imperial mission as historical literary romance. The two captains, she wrote, were agents of "progressive modern nations . . . pitted in this race for Empire." The resounding conclusion of Dye's novel joins the theme of the race for empire with the

*See William Lang, L. and Carl Abbott, *Two Centuries of Lewis & Clark: Reflections On the Voyage of Discovery* (Portland: Oregon Historical Society, 2004).

founding of a great city on the Columbia and the Willamette: "Where rolls the Columbia and where the snow-peaks of Hood, Adams, Jefferson, Rainier, and St. Helens look down, a metropolis has arisen in the very Multnomah where Clark took his last soundings." Dye's "Wolf Meetings" describes a historic moment of civic decision for Oregon Territory settlers when they cast their votes in Champoeg for regional independence or affiliation with either the U.S. or Britain.

Both Duniway and Dye understood the Oregon story as a heroic epic, emphasizing pioneer women's dedication to a civilizing mission. Their themes harmonize with Milo Milton Quaife's 1923 introduction to Alexander Ross's *Adventures of the First Settlers on the Oregon or Columbia River*. The toils of those adventurers, he writes, "were not less great than those of the heroes of Homer's tale, while the distances traversed by the ancient Trojans, and the variety of climes and peoples encountered, pale to insignificance in comparison with those which figure in the tale of their modern prototypes." Enthusiasm for the tale of the colonization of Oregon and the founding of a city gained momentum from the idea of Manifest Destiny in the American West—Dye referred to it as Magnificent Destiny—and reinforced the idea that American settlement in this new land was providential.

Long before white settlement, Sauvie Island was an important center for the Multnomah people. Called "Wappatoo Island" or "Wappato Island" by Lewis and Clark, "Wapto Island" by Franchère, "Wyeth Island" and "Willamette Island" by others, its many names suggest its central geographical importance as well as the plurality of narrative claims made on it. Sadly, there is no extant published account of how Native peoples viewed the first explorers and settlers who arrived at the confluence of the Columbia and Willamette over two hundred years ago. The most eloquent testimony to Native civilization in this locale is a four-and-a-half-foot-tall sculpture that was the centerpiece of the Portland Art Museum's 2005 exhibition *People of the River*. Carved of basalt stone between the years 1000 and 1700, this anthropomorphic figure is a powerful reminder of how settled the area was long before Portland's "settlers" arrived. Between 1775 and 1862, Pacific Northwest Native populations, estimated at between 188,000 and a million people before contact, were decimated by smallpox, measles, malaria, whooping cough, typhus, typhoid, and influenza—diseases introduced by Europeans. As anthropologist Kenneth Ames concludes, "The cumulative effect was, for all of the Western Hemisphere as well as the Northwest Coast, the greatest demographic catastrophe in human history."[*]

Some colonists regarded the spread of devastating disease as an ally of Euramerican civilization. Nathaniel J. Wyeth, the founder of trading posts at Fort Hall and Fort William on Sauvie Island, where two thousand people once lived, wrote in 1835:

[*]See Kenneth M. Ames and Herbert D.G. Maschner, *Peoples of the Northwest Coast: Their Archaeology and Prehistory* (London: Thames & Hudson, 1999).

Pre-contact statue from the Columbia River, in the collections of the Portland Art Museum

This Wappato Island which I have selected for our establishment is about 15 miles long and about average of three wide. On one side runs the Columbia on the other the Multnomah [Willamette]. It consists of woodlands and prairie and on it there is considerable deer and those who could spare time to hunt might live well but a mortality has carried off to a man its inhabitants and there is nothing to attest that they ever existed except their decaying houses, their graves and their unburied bones of which there are heaps. So you see as the righteous people of New England say providence has made room for me and without doing them more injury than I should if I had made room for myself by killing them off.

One might dismiss such attitudes as rare or consider them alien to those who labored in the missions and in the clearings destined to become cities (especially since Wyeth failed in his colonizing mission, abandoned his fort, and sold out to John McLoughlin at Fort Vancouver), but it is significant that a writer as popular as Washington Irving praised Wyeth's entrepreneurial efforts on the island in *The Adventures of Captain Bonneville.*

In this tradition of colonialism, ethnocentrism, and displacement, the seemingly innocuous naming of Council Crest appears as part of a pattern of cultural appropriation whereby religious leaders sanctioned the claiming of place. Whether or not Council Crest was ever used for Indian councils, we can be reasonably certain that ministers could conceive that the councils took place and that their own meeting at the same prominent viewpoint expressed their imagined relation to an adopted and assimilated Native legacy.

When C.E.S. Wood sought to salvage some respectability from the chosen name of Portland by Pettygrove and Lovejoy and W.A. Goulder remarked on how his was not the first discovery of Oregon City, they overlooked the important point made by Mary Alpin in Fred Lockley's "Hudson Bay Days," when she describes her childhood in the very same locale: "In those days what we now

call Oregon City was called *Cuhute*, though the white people called it Wallamet Falls." Native names seemingly escaped Wood's and Goulder's notice, not to mention Pettygrove's and Lovejoy's. In contrast, Stewart Holbrook argued that Portland should be named "Multnomah."

Whether place-names displace or reimagine and appropriate a Native presence, though, these names are reminders of a legacy of colonization. This legacy is the heritage of all residents of Portland, reflected in the general recognition that the city is both better than and lesser than the metropole of the eastern seaboard. What most Portland residents proclaim is their avid love for the city—the *better than*. As Richard Neuberger announces in his essay "My Hometown Is Good Enough For Me," "I live right where I was born and raised. I intend to keep on doing so. What's more, I commend it to all my fellow citizens who can't wait to shake the hometown dust from their oxfords and sandals."

To help navigate these texts and their varying definitions of Portland in different historical periods, Peter Donahue and I organized the selections of *Reading Portland* into five parts. "Before Portland," which is available on an educational CD through the Oregon Historical Society, presents narratives about contacts among explorers, settlers, and indigenous peoples—writings that describe the landscape long before the city existed, except in the imaginations of adventurers, explorers, missionaries, and chroniclers. In this section of the earliest writings about Portland, ironically available only in digital form, readers' feet will not find pavement—or even a wooden sidewalk. "Early Portland" charts the development of the city, while "Modern Portland" captures the city during World War I and the Great Depression. "Portland Proper" considers the city during World War II and into the later twentieth century. Finally, "Contemporary Portland" presents writings that capture the entire horizon of the metropolis, its homes and neighborhoods, its streets and parks.

In these pages, journalist John Reed describes his youth in his Portland memoir "Thirty Years," and novelist Alan Cheuse portrays the romantic first meeting of Reed and Louise Bryant on the streets of Portland in his historical novel *The Bohemians*. We can appreciate the relative merits of a fictional and nonfictional treatment of Portland and be surprised by the magical rotation that allows two authors who also serve in the same volume as fictional characters. In "Two Judges," the journalist Louise Bryant, not the fictional character, reports on the virtues and vices of two Portland judges, a local topic that people in cities larger than Portland pondered while reading the 1916 piece in the nationally circulated newspaper, the *Masses*. Through reading Bryant, Reed, and Cheuse—journalism, personal narrative, and historical fiction—we can understand each as a different part of a social web of Portland texts.

As if to illustrate the interplay of nonfictional exploration narrative and fictional adventure stories, Kim Stafford's autobiographical essay, "The Separate Hearth," describes his childhood explorative play as an imaginary member of the Lewis and Clark Expedition *and* as the Charcoal Wagon Boy, who is intro-

duced earlier in the anthology as the protagonist in Theresa Truchot's juvenile historical fiction. Poet C.E.S. Wood, who inaugurated the tradition of the Portland Rose Parade with an essay published in 1908, figures, too, in James Stevens's novel *Big Jim Turner* in a discussion among Portland millworkers. These triangulating Portland stories reveal the city as an evolving subject, described differently as writers tell and retell stories, and contribute to elaborate patterns that collectively define a sense of place. This kind of writerly description with an awareness of antecedents is itself a local tradition. As pioneer W.A. Goulder recalls in his 1909 *Reminiscences*, a memoir of his arrival in Oregon City over a half-century earlier:

> The shades of evening, which falls early on a rainy day in this latitude, found us crossing the foaming and surging waters of the Willamette at a point near the centre of the young settlement called "Oregon City," and just below "Tum Water," or falls, which we now saw for the first time. The falls and the picturesque scenery surrounding them, had already long been the theme of poets and tourists. . . .

Goulder gives readers an ironic description of his own elevated status, marching in Portland's pioneer parades at the beginning of the twentieth century. He wryly observes that his is far from being the first published description of the scene he sees. His pioneering discovery of place, like Stafford's childhood exploration of the woods, is already partly scripted and thus part of a history of writing. Nicolas Biddle's 1814 redaction of the Lewis and Clark journals as an adventure story and Eva Emery Dye's enlargement of that received story as a heroic set-piece nearly a century later had set the stage and established a tradition.

Awareness that, in some ways, one's story is already told informs the more metropolitan writings in *Reading Portland*. The city's celebrated saloons and brothels, parks and gardens, bridges and rail traffic, even its architecture have set Portland apart as a subject for writers who have sensed that it repeatedly dramatizes its own sense of purpose, as if it were a central protagonist of the national story or perhaps an epic in pursuit of its own ideals. The 1905 Lewis and Clark Exposition, the subject of one anonymous writer's essay, showcased Portland's image of itself as a city issuing triumphantly from the region, motivated by a mission to industrialize, not merely settle, a wilderness. That the celebration of the centennial of the Lewis and Clark Expedition should then serve the city's promotional needs urges an understanding of Portland as another kind of subject in another kind of American story.

Springing from a wider western experience, stories about the Pacific Northwest have for a long time meditated on the region's natural beauty and rural character. It has seemed natural to find metaphors for the city in the surrounding landscape—in the context of the grandeur of the mountains to the east and as the gateway to the Pacific Ocean to the west. One irony of the 1905 Exposition—built on and around Guild Lake, now filled in and a thriving industrial

area—was its emphatic statement about the permanence of the city, the ultimate subservience of nature to human achievement. This is a theme suitable for a settled country that is rather different from what the pioneers viewed, with or without the foretaste provided by accounts of explorers, fur trappers, and early pioneers. Portland could be seen as a "focusing point of all streams of production and achievement from a region singularly blessed in natural resources and in inhabitants," as the anonymous writer described the city during her visit to the Exposition fairgrounds.

In writers' imaginations, Portland has even assumed the proportions of imperial Rome, but also in a metaphor much more familiar to contemporary readers—as a cultivated rose thriving in a historic garden. As C.E.S. Wood wrote in "Portland's Feast of Roses":

> If Portland seems to me to have burst the bud like a rose touched by the summer sun, how must it seem to those still living who remember the Rose City in 1847, a forest of firs out of the shadows of which stole a few frame shacks along the edge of the Willamette; a bakery on the north side of Morrison Street, which street was named for J.L. Morrison, who had a little store at the foot of it. Pettygrove's store, at the foot of Washington Street, a log cabin at the foot of Burnside (on Captain Couch's donation land claim), Job McNamee's log house at Front and Alder, Terwilliger's blacksmith shop on Main Street, between First and Second; the salmon fishery at the foot of Salmon Street, and on the corner of Taylor and Front the most superb structure in Portland, Waymire's double log cabin.

Rhapsodic about the city's blossoming from humble beginnings, Wood is less enthusiastic about the familiar story of the naming of Portland by Asa Lovejoy and Francis Pettygrove, in which the two city fathers flipped a coin to choose between the names of Portland and Boston. Wood salvages what regional identity he can from their admittedly East Coast-centric choice: "Port Land, where the seaport and the great continent meet; the highest point to which great ocean vessels can come to meet the land; and this it is which will make the Rose City the queen city of the Northwest."

Wood is not unusual in his enthusiasm. In 1878, the Englishman Wallis Nash regretted, after visiting Portland, that the region was no longer a British colony. Yet, early Portland also suffered under the withering commentary of detractors. Rudyard Kipling's remarks about Portland in the same period were less than sanguine: "Portland . . . is a city of fifty thousand, possessing the electric light of course, equally, of course, devoid of pavements, and a port of entry about a hundred miles from the sea at which steamers can load. It is a poor city that cannot say it has no equal on the Pacific coast. . . ." An ambassador for a higher level of civilization, Kipling complained that "Portland is so busy it can't attend to its own sewage or paving." Few would have been more offended by this

remark than Portland promoter Harvey Scott, the first editor and publisher of the *Oregonian* and author of the monumental *History of Portland* (1890). He was an entrepreneur, journalist, and city historian with a steadfast faith in Portland's destiny. For Scott, the question of significance was not whether Portland should be regarded in its promise as a center of civilization but rather which part of its character might best explain the city's actual triumph.

Whether they praised Portland's virtues or underscored its shortcomings, the city's chroniclers reminded readers that the city possesses a comparatively long history worthy of attention. Portland was incorporated in 1851, eight years before Oregon became a state. The greater metropolitan area now encompasses both the territorial center of commerce in Oregon City—the oldest incorporated city on the West Coast and once the capitol of the Oregon Territory—and Fort Vancouver, north of the Columbia River, once a center of the British fur trade. In time, Portland became an important railroad terminus and, for many, the city at the end of the line rather than the frontier settlement at the end of the Oregon Trail. Rival river settlements—Vancouver, St. Helen's, Linnton, St. John's, Lake Oswego, West Linn, Milwaukie, Sellwood, Oregon City—each with its own boat landing, sought predominance on the Willamette and the Columbia. The area became known as River City, its very name connoting a certain balance between the forces of nature and urbanization, between salmon and steamships. Portland's bridges span natural obstacles, and its beautiful gardens signify the coordination of nature and civilization.

Portland's people also seem to coordinate between nature and an urban environment. In Kevin Canty's *Winslow in Love*, the writer-protagonist sits in a Portland bar and muses over lines from Ezra Pound's "In the Station at the Metro," a poem derived from the experience of modern Paris. The comparison produces a contrast, as Winslow wonders at the flow of people, like schools of fish (anadromous, of course) turning in unison while "schooling to their separate ends." Like any large city, Portland seems to permit both collusion and nearly anonymous individuality, and yet it singularly promises some mutual accommodation in a salmonid vision of an urban life.

Urbane Portlanders take in an industrialized scene, as Robin Cody, David Duncan, and Louis Masson illustrate through their literary navigations. Cody's canoe trip on the Columbia in *Voyage of a Summer Sun* and Duncan's journey up the less-than-pristine Johnson Creek (called "Grant Creek" in *The River Why*) dramatize a cultural struggle between the gain and loss of nature. Masson's tugboat plies a working Willamette. In "Hometown," Tom McAllister and David B. Marshall, with a remarkable knowledge of historic populations of native birds, reveal through their memories what has disappeared. In *The Astonishing Elephant*, Shana Anderson comments indirectly on our notion of the natural in the urban space—in this case, the zoo. The same physical boundaries between freedom and captivity are flaunted by three skateboarding teenagers in Peter Rock's novel *The Bewildered*, when they so freely speed by the zoo's enclosed animals. Conscious of the constraints on nature and the limits of the urban, David Oates,

in "Boots on the Ground," relates his walk tracing Portland's Urban Growth Boundary and ponders international politics. Oates associates the boundaries of Portland and its countryside with global boundaries, as if in walking the city's periphery he was measuring its global latitude and longitude. In these converging perspectives, each writer offers a unique measure of the city.

Contemporary writings in *Reading Portland* pursue a certain frank rawness. Mikal Gilmore reveals the apocryphal story of his brother's struggle to emerge from a field of blackberries in southeast Portland, which certainly provides no haven from the similarly unredeemed social world that produced his murderous sibling. In "After Celilo," Ed Edmo finds a new point of reference on the Burnside Bridge, which contrasts with the mythic Bridge of the Gods and invokes a distant past also dramatized in Frederic Homer Balch's *Bridge of the Gods*. In "Buckskin," it is Liz Woody's car that ironically transports her literary spirit. William Least Heat Moon's "Robot River" does not mistake the Willamette River—with the Superfund site of Portland Harbor—for simple wilderness.

In a selection from his book on *Greater Portland*, urban historian Carl Abbott declares Beverly Cleary's Portland to be alive and well but also gently challenges Cleary's portrayal of homogeneous white neighborhoods by describing Portland's eastside ethnic diversity and casting Portland neighborhoods as politically progressive. Squarely downtown, though, is the story of Aaron and Jeannette Meier and their department store, Meier & Frank, which highlights the rise of an industrious Jewish family. Kathryn Hall Bogle testifies about Portland's segregation era, which is also recounted in Elizabeth McLagan's broader history of the Portland African American community. In "Where Jump Was a Noun," Bob Dietsche recalls the city's historic place in the national web of rail and shipping transportation, which employed many African Americans, and a city privileged to possess "Black Broadway" along Williams Avenue in north Portland.

Common historical moments sometimes link parallel explorations of place. John Okada's *No-No Boy* portrays the interwoven politics of identity and refusal in postwar Portland, and Lawson Inada takes readers to a Portland Rose Parade seen through the eyes of young girls faced with impending Japanese relocation during World War II. Marie Rose Wong elaborates the history of Portland's Chinese and notes the prominence of the Chinatown Gateway, that symbolic bridge between Portland and China at Fourth and Burnside. Daniel Chacón's "Aztlán, Oregon" portrays the consequences of frustration for a Chicano protagonist who searches for an imagined Chicano heartland that Portland cannot accommodate. And few representations of Portland racism are more sobering than Elinor Langer's *A Hundred Little Hitlers*, which recounts the activities of white supremacist skinhead punks in the city.

Susan Orlean's "Figures at the Mall" etches the reverence for figure skater Tonya Harding by the community of Clackamas and her infamous grasping for glory at a local mall. Walt Curtis's *Mala Noche* provides a self-critical perspective on a white protagonist's amorous fascination with Chicanos. Martha Gies's

"Obdulia at the Rose Garden" brings to light the nighttime laboring of those who keep performance stages cleaned and set during the day. Jan Morris's "The Other Portland" takes stock of social difference when she describes her stroll to Old Town and Chinatown, crossing into a rough corner before retreating for "a restorative coffee in a more soothing side of town." James Stevens depicts Wobbly sentiments and workingmen's lives in a Portland mill in "Little Pretty and the Seven Bulls," a chapter from *Big Jim Turner*. In "Brown at the Edges with a Chewy White Center," Mathew Stadler describes the city changing, as "the nominally urban downtown is home to a narrow elite, while the multitude that makes up the life and future of the city has been shunted to the periphery." Sandy Polishuk's retrospective *Sticking to the Union* chronicles class struggle, and Michael Munk's "Portland's 'Silk Stocking Mob'" marks a related moment when Portland experienced what was perhaps a more explicit form of class warfare—the 1934 longshoremen's strike. In a less overtly political spirit, Augusta Clawson's wartime diary describes her work building Liberty ships on Swan Island, where she constructed a new identify as Wanda the Welder.

Murder and mystery have long been features of the city landscape. April Henry's *Buried Diamonds*, Jewel Lansing's *Deadly Games in City Hall*, Ed Goldberg's *Dead Air*, Richard Hugo's *Murder and the Good Life*, and Phillip Margolin's *Ties That Bind* consider Portland as a mysterious but ultimately knowable city, one that offers both seemingly arbitrary criminal events and the ultimate explanations that a case's resolution provides. Dedicated nighttime stories, these novels usher Portland into a morning-after, though there are a number of gentle reminders—from Stewart Holbrook's essay "Three Sirens" to selections from Chuck Palahniuk's *Fugitives and Refugees* or Phil Stanford's *Portland Confidential*—that Portland's legacy involves as much seediness as rosiness, despite strong efforts to create a righteous city, such as those described in Malcolm Clark's classic *The War on the Webfoot Saloon*.

Other writings find concrete realities through a rigorous focus on the local—micro-histories such as Xander Patterson's "Terrasquirma and the Engines of Social Change in 1970s Portland," a chronicle of Portland's recycling commune; Kenneth Stern's *Loud Hawk*, a legal adventure of an attorney in an AIM household; and memoirs such as Laurence Pratt's *I Remember Portland*, which takes readers through the city's neighborhoods. Novels such as Nancy Noon Kendall's *The Wise in Heart*, Alan Hart's *Dr. Mallory*, Albert Drake's *One Summer*, Don Carpenter's *The Class of '49*, Katherine Dunn's *Truck*, and Beverly Whitmore's *The Effects of Light*, like the creative nonfiction of Douglas Coupland's *Generation X* and Donald Miller's *Blue Like Jazz*, evince a highly localized metropolitan sensibility.

How is this sensibility distinct from that of other American cities? In her 1942 address to the Portland Art Museum, Barbara Hartwell spoke of the local concerns of Portland's "society," with its inflexible set of social "standards, a remarkable 'touch' with Europe and the Eastern coast, and an equally remarkable dimness about the several thousand miles that lay between the Pacific and

the Atlantic." A need for national inclusion and a provincial insistence on cultural difference shapes her inclusive list of contradictory local characteristics. As in many Portland stories, we find in Hartwell's account both an eagerness to bond the Northwest to the East (and to Europe) and a desire to challenge those cultural affiliations.

Hartwell invokes an ideal of Portland cultural independence embodied in socialite Nanny Wood—the wife of C.E.S. Wood—whom Hartwell finds "in every way sufficient to herself and to her friends in Portland." Portland is sufficient to itself, but the city challenges the navigation of its many representations. In a selection from *River-Horse: The Logbook of a Boat Across America*, Least Heat Moon and his crew visit "that Beulahland of bibliolatry called Powell's City of Books," where "my sailors lost their bearings . . . and did not heave into view until four hours later." *Reading Portland* celebrates that bibliolatry, the Portland world of texts that can make readers feel a shared search for place and an occasional shared loss of bearings. At moments, the city can be seen through the lens of many possible futures that make solid geography and architecture seem temporal and fluid. Portland author Ursula Le Guin's *Lathe of Heaven* is set entirely within one city, but a city pluralized by a series of possibilities dreamed into reality by George Orr, a protagonist whose dreams create a multitude of Portlands. Psychically transformed by Orr's unconscious, prophetic power to change the known world, the Portland of Le Guin's novel is seemingly imbued with Thomas Jefferson's vision and Eva Emery Dye's sense of drama and destiny for the great metropolis. Restoring historical perspective on the city are selections from novels such as Joel Redon's *The Road to Zena*, Janet Stevenson's *Departure*, Ernest Haycox's *The Long Storm*, and the nonfiction of Evelyn McDaniel Gibb, *Two Wheels North: Bicycling the West Coast in 1909*.

This interplay of the real and the fictional, the political and the literary imagination, renders the particularity of place for Portlanders as does beautiful Council Crest Park, Himes's "point so near from which so much can be seen." The city summit, which in its fanciful misnomer signifies for us both a beautiful vista and the expansive vision of those who enjoy it, invokes how these writings about Portland reflect on place while place reflects on its writers. As if they were errant urban historians seated on Council Crest, these writers about a place—and sometimes also of it—show us the patterns of an emergent urban landscape and also the patterns of their own making.

Reading Portland

The City in Prose

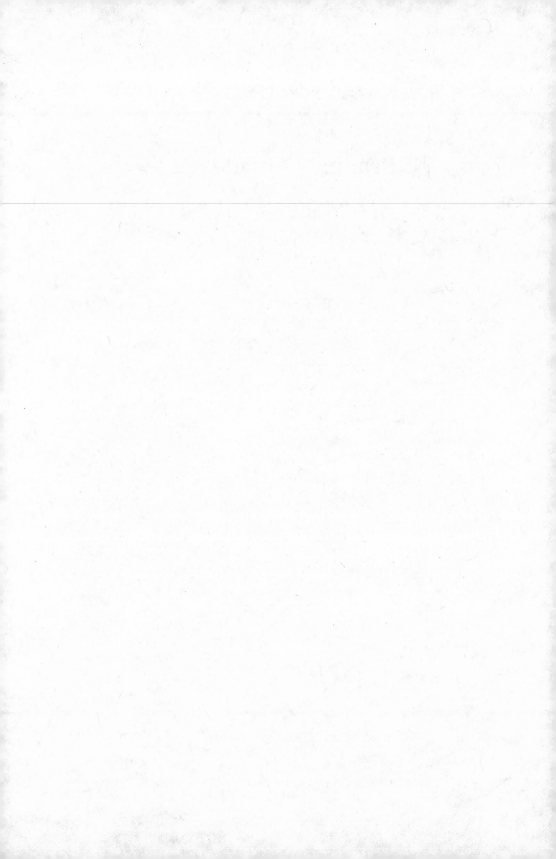

EARLY PORTLAND

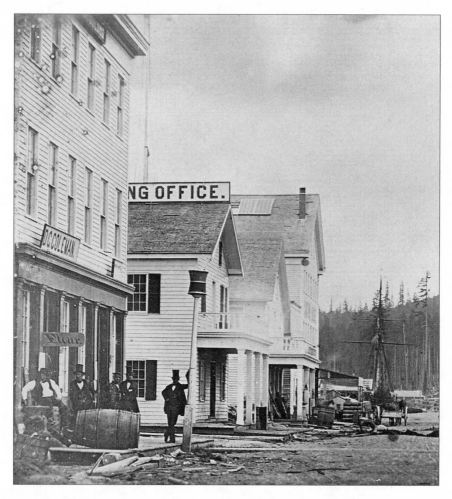

Muddy Streets and Destiny

MATTHEW DEADY

Matthew Paul Deady (1824–1893), a founder of the Portland Library Association and the Portland Law School, was a regent of Stanford University and president of the University of Oregon's Board of Regents. Deady was born in Talbot County, Maryland, and moved with his family to Ohio in 1837, where he studied law and blacksmithing and was admitted to the Ohio bar. In 1849, he taught school for a few months in Lafayette, Oregon, and established a law practice there in 1850. He was elected to three sessions in the Oregon legislature and in 1853 became a judge in the Oregon Supreme Court's southwest district, based in the Umpqua Valley. In 1857, he presided over the Oregon Constitutional Convention. He was appointed U.S. district judge for the District of Oregon by President James Buchanan in 1859, a position he held until the end of his career. This essay appeared in Overland Monthly *in July 1868.*

Portland-on-Wallamet

The apparent tendency of modern civilization is to repress and prevent the growth of individual extremes and produce only the mere average man. The city is the great promoter and centre of this civilization, as the castle and its surroundings was of that of the feudal ages. In the fourteenth century the town ranked below the manor, and the burghers counted it an honor and a security to enjoy the favor and protection of the lord of the soil.

Now all this is reversed. The country is subordinate to the town. The latter is the ever widening arena in which our material and sensuous people seek and find the best market for their abilities and the readiest gratification of their tastes and ambition.

But the rage for civic life as yet only exists in a modified form in some parts of the Republic. There are still some favored portions of this very progressive country, where the plow and the reaping hook maintain their ancient ascendancy in the popular use and estimation.

Among the fir-clad hills and broad rich valleys of Oregon, the bucolic instinct still lingers. Of the 100,000 people who constitute the permanent population of Oregon, fully four-fifths of them dwell not in town or village, but upon farms. Yet the commercial metropolis of Oregon—PORTLAND-ON-WALLAMET—is the second town in importance on the Pacific coast. Next to San Francisco, the capital and commerce of the Pacific slope will centre in this solid and reliable Oregon town.

Geographically speaking, Portland is situated in north latitude, forty-five degrees, thirty minutes, and west longitude, one hundred and twenty-two degrees, twenty-seven minutes, and thirty seconds, on the west bank of the Wallamet river and near the northern end of the great valley of the same name. From the sea, the town is approached by the Columbia river. This

magnificent stream drains a greater and more varied extent of country than any water course upon the continent. Vessels drawing sixteen feet of water can go in and out the Columbia in ordinary weather and tide with safety; and when these are favorable they may sink four feet deeper without danger. After crossing the bar you sail or steam up this broad stream, past Irving's classic Astoria, in nearly a due west direction about fifty miles, then twining shortly but not sharply to the south, you hold the latter course for about forty miles. These ninety miles are counted "as the crow flies," on an air line, but by the thread of the river the distance is reckoned one hundred and eight miles. At this point the Columbia bends (speaking or rather looking up stream) a little north of west, making quite an elbow. On the outer and west side of this elbow enters the Wallamet river, flowing generally from the south. Up this deep, quiet stream you glide twelve miles, when you step ashore at Portland and make yourself at home at any one of a dozen hotels that promise at least all they perform. There is also a daily line of stages and steamboats leaving Portland for the south—the former going up the Wallamet river from sixty to one hundred and fifty miles, owing to the season of the year, and the latter running to the Sacramento valley, and thence connecting by railway and steamboats with San Francisco. In the months of May, June and July, the healthy traveler may enjoy a delightful ride upon these stages—clearing the ground at the rate of one hundred miles in twenty-four hours.

At this time work is going on upon two lines of railway extending from Portland up the Wallamet valley, one on either side of the Wallamet river. How many struggles and failures these experimental enterprises are doomed to undergo before they are accomplished, no one can predict; but as the world now goes, their accomplishment is only a question of time. From the conformation of the country these roads must merge into one at about one hundred and twenty miles south of Portland. Then, whether they will deflect to the left and go through the Cascade mountains to the east of Eugene, and on in the direction of Goose lake and the Humboldt to the Central Pacific, or continue due south to the southern border of Oregon, through the Umpqua and Rogue river valleys, with a view of meeting a railway from Sacramento, is a question now under discussion, somewhat prematurely. A railway up the valley of the Columbia, to connect Portland with the Central Pacific at Salt Lake, is also a favorite project with many Portlanders, and one that persons now living are likely to see realized.

From this hasty glance at the lines of travel—actual and possible—that terminate in Portland, it is apparent that its facilities for commerce and communication with the world must always give it great importance in the business affairs of the coast.

In 1843—three years before the treaty with Great Britain, by which the latter withdrew all claim to Oregon Territory south of the forty-ninth parallel, and before the American people by the election of President Polk declared

for the whole of Oregon—"Fifty-four forty or fight"—the site of Portland was, in the language of the country, "taken up" by a settler named Overton. Nothing much is remembered of Overton. It is understood that he was from Tennessee. He left the country soon after, and among the early settlers there is a tradition that he was hung in Texas, whether justly or not is not known. Probably on this account Portlanders do not generally trace their genealogy farther back than to Messrs. Lovejoy and Pettygrove, who succeeded Overton in the possession of the land in the fall of 1843 or spring of 1844. At this time the site was covered with a dense forest of fir timber. In 1844, a log dwelling was erected by the proprietors, near the corner of Washington and Front streets. In the summer of 1845 a portion of the land was surveyed into blocks and lots. A block contained eight lots of fifty feet front, and one hundred feet in depth. In the following winter Pettygrove erected the first store house—long called the old "shingle store," because its walls were covered with shingles on the outside instead of sawn boards. The lot on which the building stood is now the southwest corner of Washington and Front streets. It could have been bought at that time for less than $100; to-day it will command two hundred times that sum, or $400 a front foot. The lot is now covered by a three-story brick building, the corner room of which (twenty-five by seventy feet) rents for $250 a month in gold. During this summer (1848) the embryo city was christened Portland. At the same time it narrowly escaped being overburdened with the ambitious name of *Boston*.

It happened in this way: Mr. Lovejoy being a native of Massachusetts of course desired to call the place after the capital of his state. On the other hand, Mr. Pettygrove being a Maine man preferred Portland. The dispute was finally settled by an appeal to the simple modern substitute for the ancient wager of battle, a game of heads or tails. Mr. P. tossed a copper cent, which he carried as a *souvenir* of other days, and as good fortune would have it, Portland won.

In 1846, some lots were disposed of to settlers, and a wharf and slaughterhouse constructed on the bank of the river.

From this time forth the new town was an existing fact, though it was not until the year 1851 that Oregon's ancient capital—Oregon city—situated at the great falls of the Wallamet, gave in, and acknowledged that the commercial sceptre had departed from her people. In the mean time Portland was described by strangers and tourists as "a place twelve miles below Oregon city." . . .

This is a moderate estimate of the country which lies at the back of Portland. It will be seen at a glance that the trade and commerce of such a valley must in time build up and sustain quite a city. Yet it is not in the highway of the world, no more than Boston or Philadelphia. It will never be the centre of fashion, speculation or thought. Do what it will, it will be comparatively a provincial place, and noted for peculiarities in manners, opinions and busi-

ness; but it will be worth more dollars per head than either London or New York, and its good citizens will sleep sounder and live longer than the San Franciscans. In population it may not, in this century, if ever, exceed 50,000, and its strongest sons will often be drawn away to the Metropolis of the Pacific, where they are sure to win the prizes in commerce, the arts and professions. Yet for all that and more, if any young person who reads this is casting about for a place where a fair stock of sense, industry and good habits will, within certain limits, pay certainly and well in any honest calling, let him or her take passage at once for PORTLAND-ON-WALLAMET.

HARVEY W. SCOTT

Considered Oregon's first great newspaperman, Harvey W. Scott (1838–1910) migrated from Illinois to Oregon in 1852. After fighting in the Yakima War, Scott attended Pacific University, graduating in 1863. He worked as a miner, was a librarian in Portland, and read for the law. He wrote for the Oregonian *and was named editor in 1866. Scott eventually became co-owner of the* Oregonian *and remained with the paper until his death, shaping its conservative editorial position and establishing its influence in Oregon politics and public opinion. Scott was briefly the president of the Oregon Historical Society, and, in recognition of his lifelong advocacy of the Northwest, Portland's Mt. Scott was named in his honor. He was the brother of suffragist and journalist Abigail Scott Duniway. Much of Scott's writings was edited and published in book form after his death, including the six-volume* History of Oregon Country. *This excerpt from* History of Portland *recognizes "the circles of cities" in the Oregon Territory that preceded Portland and details Portland's emergence as the region's preeminent city.*

Position and Advantages of Portland

Although of a different order, the history of the modern city should be no less interesting than that of an ancient metropolis like Jerusalem or Athens. It treats no less of human endeavor, and no less segregates and epitomizes human life. If that in which men busy themselves, and that which they produce is anywhere, or at any time, calculated to attract attention and demand investigation and analysis, why not here in Oregon, on the banks of the Willamette, as well as five to ten thousand miles away, in Spain or in Turkey?

Unlike the ancient or medieval city, it does not embrace within its walls—in fact, boasting no walls—the whole life and history of a people. The Roman Empire without Rome would be like Hamlet without Hamlet. But America without New York City would still be America, lacking only some million and a half of people. In our modern life the process of civil and social organi-

zation has gone so far that the center of supreme interest is in the whole confederation, in the whole national life, or broadly, in the people themselves, and not restricted to any one locality, individual or race. It would, therefore, be impossible to discover in any one American city a civil or political principle apart from that of the surrounding country. . . .

Settlement and Early Times

It is to be borne in mind that there was in Oregon an ancient circle of cities whose rise and growth belong to a day earlier than that of Portland. By reference to the chapter upon the earliest times and the provisional government, one will see that Astoria, down near the Ocean, had already been flourishing, amid its gigantic spruce trees and sea breezes, for more than thirty years, and for a part of the time figured as the sole American city on the Pacific Coast. It had furthermore so far attracted the attention as to have become the subject of one of Irving's historical romances, and was reckoned along with Mexico and Cuzco as one of the great cities of Western exploit and renown.

Vancouver, the most distant seat of the great English fur monopoly, whose proprietors sat in Parliament in London, and had Princes on the list of their business progenitors and patrons, had been in existence twenty years, and the chief factor who sat in its office and looked up and down the broad Columbia for the coming and going of his bateaux and the motley fleet of Indian canoes and pirogues, had grown white-headed in this long expanse of historic time before Portland had its first cabin.

Oregon City, five years later (1829), was selected as a site for a city by Dr. McLoughlin, and he was accustomed to send up thither little squads of Canadians with axes and picks to slash brush and cut trees and to dig among the boulders and gravel, somewhat after the manner of the modern pre-emptor or homesteader, to show that the place was his, even though he were not upon it the whole time. In 1840 a number of Methodist Missionaries looked upon this site by the Falls, and concluded, being Americans, that they had as much right to the place as any one, and accordingly began building a city. A year of this occupancy did as much for the growth of the place as had the preceding eleven of a British rule. Indeed McLoughlin was so benevolent as to permit the Americans to use his squared timbers for their own edifices. Oregon City grew to her supremacy long before the first nail was driven in a Portland roof. If any one of these three early emporiums of the primitive times had possessed the position to be the principal places that they once aspired to become, they had abundant opportunity for realizing their hopes.

On the Willamette and the Columbia, numberless other points strove to become the place. It was well enough understood that on this strip of water must somewhere be located the metropolis of the Northwest, and every new

Harvey Scott reading the Oregonian *near Seaside in 1905*

settler so fortunate as to own a piece of land on either side of the river hoped to make it the center of the capital. Opposite Oregon City, Robert Moore, from Pennsylvania, found indications of iron in the soil, and here laid off Linn City in 1843, and persisted in living upon his site, although he was well laughed at by one of our naval officers for his extravagant hopes. His city later on became known by the less ambitious but more attractive name of Robin's Nest. Below Moore's, Hugh Burns, an Irishman, laid off Multnomah City and started the place by setting up a blacksmith shop. Some years later (1847), Lot Whitcomb, of Illinois, a man of rare enterprise, united with Seth Luelling and later with Captain Joseph Kellogg, to make Milwaukie the New York of the Pacific Coast. Below the present site of Portland, on the right bank of the Willamette, was St. Johns, founded by John Johns, whose brick store is still a conspicuous mark on the green slope of this beautiful little spot. At the head of Sauvies' Island was Linnton, a most ambitious point, established as early as 1844 by M.M. McCarver, with the assistance of Peter Burnett, both of whom were brainy and stalwart men, famous in early history. The former

is said to have declared that his city would beat anything on the coast if they could only get nails enough there. Near the mouth of the Willamette Slough was Milton, founded in 1846 by Captain Nathaniel Crosby. On the Oregon shore opposite the lower end of Sauvies' Island where the lower mouth of the Willamette unites with the Columbia was set St. Helens on a natural site of great beauty. It was established about 1845-46 by Captain Knighton and others. The geographical position of all these embryo cities was equal to that of Portland, and the latter had but little advantage over any of them in priority of date of establishment, or in thrift and ability upon which to begin. All these points were energetic and were possessed of unbounded ambition to be first in empire. During those early years before 1850 the whole lower Willamette was in a state of agitation and excitement, striving to find some point, or node, of crystallization for the coming grandeur of population and wealth. This had been going on some years before Portland was thought of, and she seems to have been selected by nature as the outcome of the struggle for survival. . . .

From the foregoing, the reader may infer that the primitive days were very rude and the early population very intemperate. These incidents, however, are given only as illustrating a certain phase of life to be seen at the time. Situated between the very strict and upright community at Oregon City, and the very decorous and perfunctory English society at Vancouver, the renegades of the two, who did not carry their dignity or national preference to a high pitch, used to slip off and together grow hilarious somewhere between the lines. But the men who made Portland maintained a high character even though sometimes under a plain garb of frontiersmen's buckskin clothing. . . .

This history of Portland is the product of research and labor extended in all directions that promised results; it is probably as complete as any that is likely to be prepared, and yet not so complete by any means as it would be, were it practicable to gather, to sift and to compare all facts of interest that are yet retained in the memory of living persons or set down in documents remaining in private hands. Unfortunately, the mass of these materials is beyond the reach of those who undertake to prepare a work like this, and writers or editor must be content with such records and recollections as can be gathered by diligence, though knowing that more has been missed than obtained.

The retrospect of the history of Portland shows steady growth, consciousness of destiny, development of character and assimilation thereto of the forces gathered and gathering here. It shows a society knit together by long intercourse and by community of interest, developing characteristics that give Portland an individuality recognizable by all who come in contact with her, establishing the homogeneity of her people, and advancing them to the

conditions of well regulated and orderly municipal life. Portland has the experience and conservatism of the past blended with the activity of the present and the inspiration of the future. From her past she has a basis of solid strength; from her present, the hope and purpose of enterprising spirit. The two united give the prophecy of her history.

This prophecy is founded in conditions that make it impressive and give assurance of certain fulfillment. So much has been done and gained that the future is no longer problematic. Destiny is so far advanced that prophecy cannot miss its mark. Portland, no mean city already, is destined to be a great one. Who can guess with how curious an interest this account of beginnings of the city of Portland; this record of the city of Portland of to-day, will be read in the great city of Portland, forty or one hundred years from to-day! Individual life is short and in the main unimportant, but the collective life of men is long and important, and its development through secular periods, largely under the stimulating variety of city life, makes the soul of history, whose record gives dignity to the career of the human race.

JANET STEVENSON

Writer and civic leader Janet Stevenson (1913–) has lived in Oregon since 1975. She graduated from Bryn Mawr College in 1933 and earned an M.F.A. from Yale University in 1937. She taught English and drama at the University of Southern California and at Portland State University. In her writing, Stevenson has focused on Pacific Northwest history and the history of segregation and the struggle for civil rights. Her plays include Time Out of Mind, Weep No More, *and* Counter-Attack *(with Philip Stevenson). She published one political biography and several books for young readers. Her novels include* Weep No More *(1957),* The Ardent Years *(1960), and* Sisters and Brothers *(1966). This excerpt is from her novel* Departure *(1985), the story of Amanda Bright, who finds herself in Fort Vancouver in 1851 while her husband is at sea.*

The Third Month

Midmonth there was a day more like late spring than early winter. There had been a respite from rain, and the sun shone briefly, but brightly, every day. Janet and the papoose sat on a log that served as a doorstep, warming themselves. Mrs. Holloway was examining the little orchard she had planted in the summer, snipping off premature buds that might be blasted in the next frost.

Amanda was knitting a pair of wool stockings. She had dried out her boots and greased them. Her feet felt warm for the first time in a month, and

she was hoping to finish the stockings in time to insulate them against the next onslaught of chilblains. Tassy came running up the trail from the river with unusual animation in her face.

"A ship with sails comes up the river," she said.

"Is it my husband's?"

Tassy said no. And it brought no letters. The men at the wharf were saying that the ship was of the English. But it was stopping here. It was rare for a ship flying the Union Jack to stop short of the residence of the Hudson Bay's factor in Oregon City. Tassy seemed to expect Amanda to take particular interest in this phenomenon. "A ship with sails take you to your people," she said.

Amanda shook her head. A ship with sails would take her the first leg of her journey if she could pay for her passage, but she couldn't. Not having listened to what Jonathan said on that subject, she did not even know what it would cost. Well, at least the new arrival offered her a chance to inquire.

She put her knitting into the pocket of her apron, pulled her shawl from the peg, and set out for the wharf.

The vessel was a brig, out of Bristol. There was no officer visible on the quarterdeck. The bosun was supervising the unloading of what looked like bolts of yard goods. Mr. Leary, the dry goods merchant, was standing under the portico of the City Hotel, in conversation with a gentleman who might be either the master of the vessel or its mate.

Amanda was reluctant to interrupt them with a question she wanted to sound casual, so she settled herself on a stump that served in place of a bench and occupied herself with the heel of her stocking.

She had hardly got it turned when Mr. Leary was at her elbow, asking her pardon for the liberty and introducing the gentleman as Captain Cartwright.

"He seed you knitting, Mrs. Bright, and allowed as how he hoped to get hisself some stockings while he's here. We do sometimes have a few pairs to sell—take them from ladies to even their accounts—but at present we're out."

"And I made bold to hope you might see your way to supplying my need, ma'am."

There was a twang in the man's voice that reminded Amanda of Davy and prejudiced her in his favor. But she had to explain that she was only just learning to knit and not quick enough to finish a pair of stockings in anything less than a week.

Captain Cartwright looked dashed. He was not going to linger that long in Portland. "I'm anxious to be across that damned bar before the next set of storms comes down."

Amanda asked where he was bound. To San Francisco, he said, then down the coast of Mexico to Panama, Peru, and thence around the Horn. "Homebound for Bristol out of Boston."

Keeping her eyes on her needles, Amanda asked if the captain happened to know the fare for a passage, say, to Panama. Or all the way around the Horn and up to Boston?

Captain Cartwright named a figure that might as well have been astronomical, since she was penniless. Still, it was not as bad as she had feared. She thanked him and said again that she was sorry not to be able to oblige him.

"If you are thinking of a voyage to Boston," the captain said, "I wonder, would you be interested in working out your passage?"

Working! She saw herself standing on deck with the sextant; sitting at the desk, computing and charting; commanding; . . . But of course that was not what he had in mind.

The captain was explaining that his wardrobe was in a shocking state after three years at sea—linens needed washing, jackets and unmentionables needed mending. He could use some warm mittens as well as socks. And it so happened there was an empty stateroom on the brig. He did not ordinarily take passengers, but Amanda was welcome. She could share the officers' mess. Perhaps she might turn her hand to improving the fare.

He waited for her answer like a suitor who has made a proposal of marriage. She felt the tensing pull of temptation. But only for a moment. It snapped when she saw the solution she had been waiting for, the answer to prayers she had not consciously prayed.

She declined politely. The captain doffed his hat and hoped he had not given offense. She said he had not and forced herself to walk away at a dignified pace, all the time wanting to fly up the muddy street to the cabin. To pour out her plan to her companions. To engage them in it.

There were four men to every woman in Portland—not counting transients who came by ship or on horseback, from the sea or the interior valleys. Fewer than half of them were married or had a woman to "do" for them. Washing, mending, knitting, sewing, baking—there were any number of services women could perform.

For money! Not for credit at the store. Nor in exchange for fish or game or potatoes or wheat. For money—bank notes, silver, or gold. Men had money even in this place. They spent it on other needs. Why not on their personal comfort?

It was not easy to persuade Tassy or Mrs. Holloway that taking money in return for woman's work was respectable. Tassy had no objection to barter, but exchange through the medium of precious metal seemed to make her uneasy, as if it involved the breaking of some taboo. Mrs. Holloway said that her way was to give of whatever she had to whomsoever was in need of it and to accept gratefully whatsoever was given to her, without calculating reciprocal values.

"But I can see how it might be different in your circumstances," she added.

Amanda was stung to defensiveness. Men had no scruples about taking money for their labor. For example, the Reverend Holloway: "He went to the mines to earn money. And without leaving you enough for your needs. You can't depend on friends' charity for shoes or blankets or candlewick, to say nothing of pans and a shovel and hatchet to replace the ones he took with him."

Mrs. Holloway did not let herself be provoked into argument. All she would say—with wounded dignity—was that Amanda could count on her help at any time it was needed. Then she had a sudden inspiration.

"Maybe I could put by for a harmonium!" It had like to broke her husband's heart when they had to throw away that little pump organ they had carried across the plains. It was the last of all the possessions they had abandoned on one particularly bitter grade when oxen and wagon threatened to give out. "I can't think what would make him prouder than to come back and find the Lord has shown us the way to make it up!"

And with such a goal, Mrs. Holloway could recruit other women. There were only five families in the Holloways' congregation. It was not as large as the Methodists' or the Catholics' or even the Congregationalists', but five resourceful women were not to be sneezed at. And six growing girls besides, all of them able to knit.

"The thing would be to get wool enough."

Tassy knew where she could barter for raw wool.

"It's a deal of work to wash and card it," Mrs. Holloway said, "and we'll need to make a quantity of soap." But with enough hands to share the labor, nothing was impossible. And with plenty of soap, it might even be possible to undertake real heavy washings.

So the enterprise was launched.

The Fourth Month

On the first day of the new year they celebrated.

Christmas had not been festive. A few days before the twenty-fifth, Mrs. Holloway consulted Amanda on the propriety of accepting an invitation from the Methodists, who had a church building, to include the Holloways' congregation in their services.

Amanda convinced her that none of the differences in dogma were as weighty as what Christians had in common on the anniversary of the birth of Him through whom they all hoped for salvation. The other members of the congregation agreed, and there was much anticipation. Hymns of the season were hummed while the women worked at their spinning or at their baking or even at the washtubs.

About midday on the twenty-fourth, Mrs. Holloway began to bleed. She was diffident about explaining her sudden weakness, but within an hour Amanda understood and went for the midwife. It was a miscarriage, not the first Mrs. Holloway had suffered. (For the first time Amanda noticed how little flesh the woman carried on her heavy frame.) There was no ergot in the settlement, and nothing in the midwife's bundle of remedies seemed to slow the flow of blood. But when Tassy understood the nature of the trouble, she paid a visit to the Indian encampment at the north end of the town and returned with remedies: one dried root and several species of berries. A strong, bitter infusion was prepared, and little by little the hemorrhage was stanched.

By Christmas morning the crisis was past, but there could be no thought of leaving the cabin. Outside a heavy ground fog closed the visible world to a circle a few yards in diameter, within which even the frailest feathers of weed and grass showed frosty white against the gray. Overhead one could make out the vague forms of spruces rising out of nothingness and disappearing into nothingness, a ring of darkness like the walls of a dungeon. But inside the cabin the fire was bright, and there was plenty to eat. The women of the congregation had seen to that. Amanda read from the New Testament and sang as many carols as she could remember. Mrs. Holloway lay quiet and listened, weeping a little now and then, not from pain nor even from sorrow at her loss, but only because it was "so good . . . having the love of friends."

New Year's Day was different.

Tassy and Amanda had cut cedar branches to make garlands and gone into the forest for holly berries. Tassy had snared a rabbit. And Mrs. Holloway was well enough to have a try at making a New England Indian pudding, using wheat grits in place of cornmeal. It had not turned out quite to suit her, but they ate it with appetite.

After the meal there was a surprise for Amanda. "By rights we should save it for Twelfth Night," Mrs. Holloway said, "but Tassy and I are no better than children at waiting."

From under her mattress she brought a flat package. Amanda unwrapped it to find yards and yards of green merino. Enough for a dress and a shawl.

"For your voyage."

The two women had taken money from their earnings to buy the goods from Mr. Leary's store. "We knew it might be some time before you'll need it, but if we'd waited, it might have been gone. There was another shade of green—more to the blue—that I fancied because it had more the look of the sea about it. But that had already been spoken for."

Too moved to speak her thanks, Amanda fingered the fine wool and remembered the ship that had brought it here, the captain's proposal, how it had changed their lives.

After the dishes were washed and dried, Mrs. Holloway asked Tassy to tell them one of the legends of her people. "She knows enough of them to make a book."

Tassy obliged with the story of the war between the snow-covered mountains on the far side of the great river.

Very long ago, a beautiful, white-robed woman mountain came to live in the valley between the two men mountains. Both of them fell in love with her and began to quarrel over which should possess her. They became so angry that they took off their white coats, painted their bodies with fire, and began to hurl great rocks at each other. The whole earth trembled as the mountains spat fire and belched great clouds of smoke that hid the sun.

At last they tired and stopped to rest. The air cleared, and they could see what they had done. The land had been burned clean of all its fruits. The game had been driven away. Even the fish were gone. This was because the fighting mountains had torn a great hole in the earth, and the waters of the lake had rushed out, taking all the fish with them, leaving a stone bridge over the tunnel they carved.

All the people who had not been killed by the fire and the falling rocks were hiding in caves. They were starving and sick, and they called to Kemush, the Creator, for help.

He came to earth, and the mountains were made ashamed. As punishment, Kemush ordered them to wear their ugly black war coats for fifty seasons. After that he would decide which of them would possess the beautiful woman mountain. And to remind them that a woman's beauty is not lasting, he put an ugly, toothless old woman as guard on the stone bridge that led from one mountain to the other. If they broke their promise to be at peace, he warned, the stone bridge would fall and new afflictions would come upon the land.

For many years the mountains were at peace. They put on their coats of white buckskin again. But one day they looked upon the woman mountain and forgot their promise. They quarreled. The stone bridge fell. Many people were drowned by the wave of its falling. And neither of the man mountains was given the beautiful woman mountain to possess.

"How did she feel?" Amanda asked, when it was apparent that the tale had ended. "Did she want to marry either of them?"

Tassy did not know. The story did not say.

Mrs. Holloway was reminded of questions she had long wanted to ask about marriage customs among the Indians and how they differed from Christian practice. Tassy's answers provoked more questions. What emerged, bit by bit, was a way of life in which women had no more right of choice than slaves. Marriage was a sentence to hard labor, in return for which they received only the barest sustenance, and, when times were hard, not even that.

Mrs. Holloway's tongue clucked. She hoped Tassy was thankful to have been saved from such a future by her marriage to Mr. Whitt. But Tassy did not seem thankful. Amanda had the impression that she not only accepted but preferred a system that was patently—savagely!—unjust. Was there something about it, not yet explained, that made the bargain more bearable?

She tried some questions of her own: How was work divided within the tribe? What was expected of women, besides the bearing of children?

Tassy reeled off a list of tasks, beginning with the gathering of wild foods and medicinal herbs; the preserving and preparing of these as well as of the fish and game provided by the hunters; and other labors—all of them menial, most of them requiring great strength and endurance, some downright dangerous.

"Women do what men do not like because women cannot do what men can," Tassy finished with what Amanda took to be irony.

"And what is it men do that's too difficult for women?"

"Fight enemies. Take slaves. Build canoes. Build lodges."

Amanda was growing contentious. She was not convinced that women could do none of these things, given a motive and an opportunity. But what mattered more was that men's work seemed to be respected and rewarded, while women's work was not. "Why is hunting more honorable than gathering, for instance?"

Tassy did not find the concepts "reward" and "honor" meaningful in this context. Her view of life—the life of the group—was molded by the imperative of survival. All must contribute as they were able, or the people would die.

"Women are able to bring forth the next generation," Amanda said. "What's more important than that?"

Mrs. Holloway intervened to defuse the impending controversy. In her opinion, the heart of the matter was that woman's nature—Indian or white or what you would—was different from man's. Nurture came natural to a woman and was its own reward.

"That's what a woman is. Her nature is to give, without thought of recompense. By giving she is replenished, filled and fulfilled. It is different with a man."

Amanda could hear her mother's voice. Or was it her grandmother's? The old lies, handed on from mother to daughter, down the generations. And they *were* lies—no matter who spoke them or how often. Men and women were not different in this: either could use the other in the search for wholeness and peace, but neither was fulfilled by such usage.

Tassy and Mrs. Holloway were nodding to each other, finding common ground across the vast gulf between their worlds. Ground from which Amanda was excluded. What had she done—or not done—to deserve this? Was it because they had borne children and she had not? But she had been

childless an hour ago and admitted to the sisterhood. There was the green merino wool to prove it.

Men and women were different. And she was different from both—like Eve after she had eaten the forbidden fruit. If she could not learn to hold her tongue, she too would be driven from the Garden. Without Adam. Alone in a strange land.

She thought again of Louisa. Louisa would not believe the old lies, the old laws. She and the other privileged women who inhabited the world Horrie described—they had all tasted the forbidden fruit. One day, when she had finished her voyaging, she would ask admission to that world, to a Garden from which she could not be expelled.

The Fifth Month

By the middle of February Amanda had put by the sum Captain Cartwright named for a passage to Panama. It was not enough to see her across the isthmus and north by sea to Boston, but she was confident she could manage that before the end of summer, and her confidence started her dreaming again. . . .

Perhaps if she took passage as far as San Francisco, she would have a greater choice of options. Perhaps the fare between that place and Panama—on one of those half-empty emigrant ships—would be less than the captain had thought. There might even be a ship that carried the master's wife aboard, willing to accept a lesser payment or even none at all. If such a suppliant had come to her when she was the only woman aboard, how gladly she would have welcomed a companion.

While she dreamed, she worked. Worked hard and for long hours. Most of what fell to her share was washing—great loads of heavy cottons and linens that took boiling and bleaching and could only by dried on bright days when the wind was brisk. Her hands were chapped and cracked despite nightly applications of mutton fat. Her shoulders ached from the angle at which she leaned over the washtub. But her forearms had grown stronger and tired less easily now, and she was learning some tricks that lightened the labor.

The green wool dress was cut out and basted together. Mrs. Holloway had provided the shears and helped with the cutting. Tassy turned out to be a fine needlewoman. She and Amanda worked at the seaming whenever the weather decreed a respite from the washboard.

They sat together this morning, listening to the light rain—so fragile after the downpours of winter—and working their way toward each other along the bottom hem. There was the sound of a wagon passing outside, heading up the plank road that led to the valley.

Tassy stopped sewing to listen, and smiled—something she did so sel-

dom that it made what followed memorable. She had intended to follow the plank road into the valley, she said, as soon as it was spring. The plains were a good place to look for a male protector. "Valley white men plant wheat. Do not go on ships."

It was Amanda's understanding that plenty of white settlers from the valley had joined the rush south when news of the gold strike came. But she did not want to disturb Tassy's rare communicative mood by arguing the point. "Have you decided not to go?" she asked.

Tassy nodded. "I stay with her. But not if he comes."

Amanda was not sure whether "he" was the Reverend Holloway or John Whitt. She was filled with curiosity, but cautious. "Is Mr. Whitt a good —" She revised the sentence before it was finished, "father to your baby?"

Tassy nodded.

"Did you marry him willingly? Or was there someone else you would rather have had as a husband?"

"I was bought by him. For horses."

"Your father sold you?" Amanda was horrified.

"Not my father. The chief of the village where the stone bridge of the gods fell into the river." Tassy and her brother had been captured returning to their home after a season at the mission school. Enslaved—but only for a short time. The boy was sold to another Indian tribe; Tassy, to Whitt. She had planned to escape at the first opportunity and return to her people. But then there was a child.

"How long ago was that?"

Five years. The first child did not live, but for quite a while Tassy was not strong enough to walk very far. Then there was another child, this one.

They sewed in silence until their needles met. The hem was finished. When Mrs. Holloway came back, there would be one more fitting. Then, if there were no adjustments to be made, the bodice and skirt would be joined to the belt.

"You will be happy to return to your people?" Tassy asked.

"Of course. Overjoyed." But the words did not ring quite true. She would be overjoyed to see her loved ones—parents, brothers, all the wide circle of relations and comrades of her school days. But after the rejoicing, or even before it, the future widened like a starless night.

What would her life be in Salem? She would not starve or be sold into slavery. She would not need a male protector who planted wheat and did not go to sea. She would not be deprived—except of a reason for living. There would be tasks for her to perform, needs to fill: the care of her parents as they grew older . . . of other people's children. Or she might find work that would earn her a moiety of independence—some occupation more to her liking than laundering. But even if she were able to find her way to the world Horace had described, Louisa's world—and it seemed possible only in

daydreams—she would find no work that would challenge and stretch her, nothing that would fill her heart and mind.

She dreamed that night of a woman dressed in a green merino dress. Seated in a chair whose back was turned to the dreamer. A chair with a high carved back and horse-hair upholstery . . . Such a chair belonged in a parlor, not out of doors . . . on the roof of a house with a widow's walk The wind was blowing, but not one of the woman's hairs was moved by it. Amanda sensed that if anyone were to touch her, she would topple forward and fall.

A few days later, the mail schooner brought a letter for her. It was from her mother, who was full of loving concern for her health and comfort but "glad all the same that you made so prudent a decision. We look forward to hearing that you have embarked on your homeward journey, but let it not be till all prospects are favorable." Nothing to indicate that they knew her real situation, nothing to indicate that they questioned her account of things. A conventional maternal letter from a conventional woman to the daughter she had bade good-bye less than two years ago. Still, it warmed her.

As Amanda slipped it back into its envelope, she saw a small, separate page. On it was a postscript, in her mother's hand, that appeared hastily, almost carelessly, written: "Your Aunt Agatha asks a favor. That you write of your cousin's death to a friend—a Miss Brown, of Cambridge. Your aunt does not know the lady but understands her to be the daughter of the Unitarian minister of that place. She asks also that you keep this in confidence."

Amanda sat up after the rest had gone to sleep to write a letter to be carried on the mail schooner's trip downriver. It was odd after all the other letters—some written out, some only dreamed—to find herself hard put to find words for Louisa. Words that would reach a real woman whom she did not know, whose outlines she had filled in with the lineaments of a sister she had created out of her need.

In the end, she wrote only the simplest account of "our mutual loss." She wanted to write more, to confide enough of her own situation so that Louisa might understand how closely it resembled hers. Each of them had lost the love around which she had arranged her life's plan. Each must make a new plan. They could offer each other much comfort, much support. But all she could say at this time was that she hoped Louisa would write to her in care of her parents in Salem, that one day—perhaps before the year was over—they would surely meet.

As she was melting the wax to seal the envelope, she decided to copy out Mr. Emerson's poem and include it.

ROBERT ORMOND CASE

A resident of Portland for most of his life, Robert Ormond Case (1895–1964) was born in Dallas, Texas. He graduated from Tualatin Academy in Forest Grove and attended the University of Oregon before enlisting in the U.S. Army in 1917. He wrote and edited for the Oregonian *from 1921 to 1925 and was the author of over a dozen Western novels and hundreds of serialized novels for popular magazines such as* Collier's, *the* Saturday Evening Post, *and* Country Gentlemen. *In 1944, Case was awarded a Peabody award for "Song of Columbia," a radio script. This provocative excerpt from the historical fiction* Empire Builders *invites a consideration of the relationship between racism against indigenous peoples and the practices of colonialism. Here, Case celebrates U.S. Marshall Joseph L. Meek for his handling of the five Cayuse—Clokomas, Kiamasumkin, Isiaasheluckas, Tomahas, and Tiloukaikt—who were accused of murdering Marcus and Narcissa Whitman and twelve others at Waiiletpu in 1847.*

1850—Interlude

In Oregon City, in May of 1850, occurred one of the spectacular events of the crowded decade. It was the trial of the five Cayuse warriors responsible for the Whitman massacre more than two years before.

The Cayuses had learned what it meant to make war on the whites. It had been a savage lesson. They had lost many of their fighting men, had been driven from their hunting and grazing grounds, and were close to starvation; and the peace treaty required them to deliver the five warriors over to the white men.

The three-day trial began at Oregon City on May 22. Hundreds of settlers were there, many of them impatient with all this formality. These Cayuse murderers were obviously guilty; why not hang them and have done with it? Hundreds of Indians came to watch the white man's formal death ceremonies, and they, in turn, were watched narrowly by the settlers. All combined to set a grim, colorful stage.

The true drama occurred behind the scenes: the manner in which the five unrepentant Cayuses reacted to the thing which these affable, inscrutable, conquering white men called—justice.

Once to Every Warrior

The Whitman massacre occurred on November 20, 1847. Not until the spring of 1850, at the close of the Cayuse war, were the five Indian leaders in that brutal crime brought to trial at Oregon City, seat of the Oregon territorial government.

The five prisoners were delivered to Oregon City by the military and there

turned over to Joseph L. Meek, the United States marshal. Meek had a place ready for them—a small frame building on the brink of the falls, connected to the bank by a narrow causeway. Escape or rescue was next to impossible from such a spot.

Meek had waited a long time for this event. He had, in fact, dreamed about it. He was a resplendent figure in white buckskin, with his badge of office glittering on his breast and a pistol and knife at his belt. The five Cayuses were bronzed and erect. They carried themselves haughtily in the presence of their enemies, prepared to meet death as warriors should.

The most important of the five was young Tomahas, known as "The Murderer." Tomahas had personally killed Dr. Whitman with his war ax, first striking the doctor from behind, then again and again as the kindly missionary lay helpless at his feet. The four others, as minor chiefs, had directed the general slaughter that had followed.

Meek knew all five renegades, and they knew him, but no sign of recognition passed between them during the formalities of transfer, or while Meek was escorting them to their quarters. The enormous crowd remained on the bank except for an alert, self-assured man named Pritchett, who followed Meek and his prisoners out on the causeway.

After the five warriors were in their cell Meek turned to look inquiringly at Pritchett. Pritchett wasn't a settler. He was secretary of the territory, a political appointee of President Polk.

"What d'ye want, Pritchett? I've got to talk to these boys—tell 'em how we do business and all that."

"Oh, you talk their language?" Pritchett spoke with a touch of condescension. "Of course! I'd forgotten your wife is a Nez Percé."

"Oh, shore. I've been to plenty of their powwows."

"Good! Then you can do some interpreting for me. You know I'm defending them at the trial."

"Yeah?" Joe eyed him sourly. "Making a little political hay, are you, Pritchett? Get the court interpreter, then. Talk to Judge Pratt."

"That won't be necessary, I'm sure. After all, I'm secretary of the territory, Meek."

"And this is Federal business, my friend! Don't throw your weight around here! Go on ashore. See Judge Pratt. Get along, now!"

Pritchett went ashore, greatly annoyed. The five prisoners hadn't understood what was said, but their black eyes glittered with amusement. They knew Joe Meek to be a happy warrior. It was now plain that he had much authority among these lesser whites.

Joe explained the procedure to them in their own tongue. They were prisoners, but they would be well fed, well cared for, until the trial. The trial, Joe explained, was a very formal and important council, held before all the people. One white man, a great orator, would describe the crimes the prisoners

Joseph Lafayette Meek (1810–1875)

had committed—and another white man, also a great orator, would assert loudly and with an appearance of great earnestness that they were innocent. Then twelve white men, selected for the purpose, would weigh everything that had been said and decide whether they were guilty or innocent.

Joe spoke gravely, in the formal phrases used by the Cayuses in their council of chiefs.

"And now—is it understood? Tomahas, have you questions to ask?"

"We are greatly puzzled, Joe Meek," Tomahas replied. 'We have killed your medicine man, Whitman. His blood is on our hands. Why do you give us food to eat and this good lodge in which to sleep?"

This was somewhat obscure to Joe himself, but he explained patiently: "Because you are innocent until the twelve white men say you are guilty in the great council I have spoken of."

"But *we* say we are guilty. We do not deny it. Why, then, must they hold a great council to decide it?"

Joe Meek shook his head. "You have your customs, Tomahas. We have ours. This is the white man's custom. Are there more questions?"

The five Indians whispered together in a corner. Joe Meek watched them with grim and understanding amusement. He knew the Indian viewpoint thoroughly. They had come here fortified against whatever tortures the white men might inflict upon them. Now, having been treated with kindness, they were bewildered—and completely suspicious.

Finally Tomahas spoke again.

"We will wait and see, Joe Meek. . . . Tell us this, however. Your squaw is a Nez Percé. The Nez Percés are brothers to the Cayuses. Therefore, you are our brother?"

"No. I am *blood* brother to the whites. You have killed my people."

"But you will speak truth to us always?"

"Yes, you may rely upon me. I will speak only truth."

Tomahas inclined his head. "Very well. We are alone among our enemies. We will rely upon you."

Their bewilderment became tinged with contempt while waiting for the trial. Their two defense attorneys—Clairborne and Pritchett—called upon them with the court interpreter, but they refused to talk unless Joe Meek stood by. They called their attorneys "big voices"—indicating their disdain— and were insulted by the suggestion that they plead not guilty.

"What do these big voices mean?" Tomahas demanded. "Are they making sport with us? Shall we say we are *not* guilty when the twelve men in the great council will know we are lying?"

"It is the white man's custom, Tomahas."

"But there will be those in the council who *saw* my war ax kill the medicine man, Whitman! . . . Very well, Joe Meek. If you say it is so, it is so."

When the trial began the primitive courtroom was crowded. It was a beautiful day—May 22, 1850—and the windows were left open for the benefit of hundreds of spectators massed outside. The five prisoners sat on a bench, facing Judge Pratt. The jury was at the judge's right, the prosecution and defense attorneys at his left. The witnesses—many of them survivors of the Whitman massacre—sat on long benches that flanked the wall.

The star witness was a sixteen-year-old girl named Catherine Segar. Catherine, or "Cathy," had been fourteen at the time of the massacre, but she had witnessed it all, and each detail was etched indelibly on her mind. She told how Tomahas had killed Dr. Whitman. She described Mrs. Whitman's death, and the manner in which her two older brothers were killed before her eyes. She described with terrible clarity how unarmed white men were shot as they ran toward shelter and wounded men were beaten with war clubs as they lay weltering in their own blood. She told of the little children, the ones with the measles, burning with fever, lying on the ground through the long night in the bitter wind, crying for water. Her baby sister had died the second day. Two other little girls—half-breeds—had died the third day from fever, thirst, and starvation.

Joe Meek translated all this, his ordinarily good-natured face twisted into bitter lines. Tomahas was more and more scornful of the white man's customs.

"Do they listen to the words of half-grown squaws?"

"*This* little squaw was there, Tomahas."

"And these twelve men—they are not warriors. I have been watching them. They looked at us fiercely only once. It was when the little squaw told about the little ones who died on the third day!"

Joe Meek nodded. "They do not like to hear that little children lay on the frozen ground in the dark night, calling for water."

"What are little girls? They will never be warriors. And one of them was a Shoshone!"

"That is correct, Tomahas," Joe Meek said. "Yes, one of them was a Shoshone."

The argument began on the second day. The prosecutor's summation was brief. He pointed out quietly that the Cayuse tribe itself had designated these five as the murderers. Witnesses had identified them—actual witnesses of the massacre. The facts spoke for themselves.

The defense had a field day. Clairborne opened with an impassioned plea on a point of law—that Oregon hadn't even been a territory at the time of the massacre. Therefore, this court had no jurisdiction. Then Pritchett took the floor. He had political ambitions, and this was the largest crowd ever assembled in the valley. He ranted and roared, striking the table with his clenched fist.

"I say to you, gentlemen, that these five defendants are guilty of no crime by any yardstick of justice! In their view the massacre was an act of war— the first blow struck in defense of their hunting grounds. We have already defeated and humbled the Cayuse tribe. Why should we take further revenge on the bodies of these unfortunate savages?"

The eyes of the five renegades glittered with amusement when this argument was explained to them. Kindness had no place in the Cayuse code. Pity was a synonym for weakness. When they had returned to their quarters that night Tomahas put his contempt into words.

"There are two kinds of white men. Some are mighty warriors. They followed us over our own trails and fought us on our own ground. When we charged they did not retreat; they killed many of us and our horses—and laughed. *Such* men we respect."

"And the others, Tomahas?" Joe prompted.

"These others are squaws. They do no fighting. They have seen no blood. They are soft. Yet *they* are the ones who make the big talk in your council!"

"Like this big voice, Pritchett? . . . Yes, I have noticed that, Tomahas. In war we fight without mercy. In the councils of peace, after the victory is won, we are always soft."

"We are warriors, Joe Meek! Let warriors judge us! We are ready to die!"

Joe Meek chuckled, though his eyes held no mirth. "Be patient, my friend. If the twelve men say you are guilty, you will die."

"At the hands of warriors?"

"Yes. A warrior will be your executioner." The case went to the jury on the third day. In a little over an hour they returned with their verdict—guilty And still, to the annoyance of the prisoners, the big talk went on. Joe explained what it was about: the big voice, Pritchett, was asking for a *new* council. He was talking about appealing to the greatest council of all, beyond the mountains at a place called Washington.

But all these motions were overruled and the prisoners were sentenced. They were impressed by this ceremony. They stood erect, facing the judge. Joe Meek stood with them, and the room grew very quiet while the judge spoke. Nine days hence, on June 2, they would be hanged by the neck until dead.

The judge asked them if they understood the sentence. They replied through Joe Meek that they did. Did they have anything to say? With the eyes of hundreds upon them they stood haughty and silent.

But when they were safe in their cell—safe from the curious eyes of the soft ones—Tomahas turned on Joe fiercely.

"There must be no hanging, Joe Meek! Let them use knives! Let them use rifles! . . . We have relied upon you. You have given us your word!"

"When did I say you would *not* be hung, Tomahas?"

"You said a warrior would be our executioner!"

"That is correct. And he will hang you."

"But hanging is for thieves who crawl in the night! It is for cowards who cheat and lie! It is for the coyotes at heart! *We* are warriors!"

"Cowards killed Whitman when he carried no weapon," Joe said sternly. "Crawling snakes killed his squaw. Coyotes at heart let little ones die in the lonely night calling for water."

Tomahas gestured his disgust. "That is war. Are you soft too, Joe Meek? Let us talk to our executioner. He will understand!"

"You have already talked to him. He understands—and you understand him." Joe Meek smiled a little. "*I* am the executioner, Tomahas."

The scaffold was built in the open so the public could view the spectacle. Day by day the prisoners could hear the sound of hammers and saws above the roaring of the falls. Various ladies' societies sent delegations to Joe Meek. They asked him how he could bear to take the lives of his fellow men. Wouldn't it be a load on his conscience?

Joe explained cheerfully that the jury had found the prisoners guilty, the judge had sentenced them, and it was the duty of the United States marshal to carry out the sentence. Joe Meek wasn't squeamish about doing his duty!

The night before the day of execution, as Joe stepped ashore from the causeway, Pritchett took form in the shadow. Nobody was near by, but Pritchett spoke cautiously.

"Listen, Joe. I'm acting governor of the territory now that General Lane had to leave for the south. These Indians can be useful to you and me. I think I'll grant them a stay of execution."

Joe eyed him fixedly. "Yeah?"

"Yes. That will give us time to take them back to Washington on appeal. You have some axes to grind back there, haven't you? Of course! And it'll attract the attention of the whole country. . . . Now look—I'll give you an order tomorrow. As soon as the crowd's gathered you read the order—"

"Hold on!" Joe interrupted. "The deal's off!"

"This is official, Meek! You can't disregard—"

"Listen to *me*, Pritchett. Don't you know *anything* about Indians? Let these boys get away after promising to hang them, and what happens? Inside of thirty days we're jumped by every tribe around us. They'd figure we'd *all* gone soft!"

"Nevertheless, it's your duty—"

"It's my duty to hang these varmints—and hang they shorely will! . . . Scat, now! Get away from me! Doggone, do I have to hire a rat terrier to keep you out of my way?"

The next day—and it was a beautiful summer day—the place of execution was crowded long before the appointed hour. Many blanketed Indians were there, stolid and impassive. Many settlers, equally impassive, quietly took up their positions among them. Some of these frontiersmen had fought in the Cayuse war. Some had lost brothers and sons in the campaign. Some, like Joe Meek, had helped bury the bones that prowling wolves had left among the ruins of Whitman's mission.

These were not soft men; and Joe Meek, surveying the scene with a cheerful, experienced eye, knew there would be no trouble from the Indians.

The five prisoners walked erectly into public view, their bronzed, hollow cheeks impassive. Not once during the nine days had they renewed their pleas for a more honorable death. But as they drew near the scaffold between solid walls of spectators Tomahas spoke bitterly.

"There are so *many* soft ones! Must they gather like crows to see five warriors die?"

"It will be over quickly," Joe returned. "Make your hearts strong."

"You have a knife, Joe Meek."

"No, you must hang."

"How can we face our friends in Spirit-Land with no wounds on our bodies and with the marks of a *rope* around our necks?"

In spite of his spiritual armor, Joe was a little touched. "It is only shame, Tomahas? You are not afraid?"

Tomahas gave him a glance of bleak surprise. "Who fears death?"

"Very well," Joe said. "There is no shame here. I will tell you why—after we climb up to the hanging place."

The scaffold, reared above the crowd, had a grim and awesome appearance. Rough steps led up from the rear. In front of the high platform five ropes were suspended from an overhead beam. The trap door was hinged at the back and at its front was supported by a single rope lashed to one of the upright posts. When Joe cut this rope the five would fall together.

The preliminaries at the foot of the scaffold were soon over, and Joe and his prisoners mounted to the platform. The five took their places stoically, and Joe adjusted the ropes. They watched him, waiting. He had promised them death without shame. He came at last to Tomahas, and the young chief whispered, his lips scarcely moving:

"The knife, Joe Meek?"

"No, you must hang," Joe replied. "But listen closely. . . . If you kill your enemy's brother, or his son, or his daughter, does not your enemy say in his heart: 'I will have blood for blood?'"

The five muttered agreement. "That is true."

"Very well. When I buried the bones of the little ones who died with Whitman I said in my heart, '*I* will see these warriors hung.' It was the blood oath. . . . tell your friends *that* in Spirit-Land—and they will understand. Who can escape the blood oath?"

"But it must *be* the blood oath," Tomahas pointed out. "It must be your own flesh. Did *you* have a brother, a son, or a daughter among those who died with Whitman?"

"Yes, Tomahas. The little Shoshone who died the third night was my daughter. Her mother was my first squaw." Joe finished adjusting the noose and stepped back. "Now, is it understood? Are you ready?"

There was a pause, then Tomahas spoke for the five. "We understand. We are ready, Joe Meek."

Joe cut the rope and the five fell. The scaffold creaked. A sigh came from the assembled hundreds like a gust of wind in timber. Joe descended to the ground with a firm step and strode off through the crowd without a backward glance. His duty was done; the burying of the five bodies was a chore for lesser men.

ALFRED POWERS

A graduate of the University of Oregon, Alfred Powers (1888–1984) was a scholar of Oregon history, the popular author of adventure novels set in Oregon, and an influential teacher at Portland State University. In addition to his endur- ing contributions to Oregon historical scholarship with such volumes as History of Oregon Literature *(1935) and* A Century of Coos and Curry: History of Southwest Oregon *(with Emil Petersen, 1952),* Powers was admired by young readers for such enticing books as *Marooned in Crater Lake: Stories of the Skyline Trail, the Umpqua Trail and the Old Oregon Trail *(1930) and* True Adventures on Westward Trails *(1954). In this excerpt from* Long Way to Frisco: A Folk Adventure Novel of California and Oregon in 1852 *(1951), Powers demonstrates his flare for blending folksy humor with detailed historical narrative.*

From *Long Way to Frisco*

I was sixteen years old. Big Tim was twenty. Yet I then began and later con- tinued to order him around as if I were his ordained overseer. I have since thought it is not healthy for one human being to be able, as fancy moves him, to tell another one to come and go, to fetch and carry—even less healthy for the teller than the told.

Except for developing a bossy trait in me and too obedient a trait in him- self, Big Tim was a happy addition to our crew. His erstwhile confederates never showed up, and we never asked him about them. By leaving him as factotum with the hogs, we were able to double up the buying in the field. Levi went out on buying expeditions by himself, and Joe Meek and I went forth together.

At this rapid rate it wasn't long before the Oregon City *Spectator* could report:

> The San Francisco hog buyers, Levi Hunt, Esq., and Cornelius Rogers, Esq., expect this week to complete their purchases of 1400 head in the Willamette Valley. Friday will be a busy day at Clackamas Island, where the animals are yarded, when the final deliveries are made. Joe Meek, ex- Territorial marshal and a familiar figure in Oregon City, has been promi- nent here again. He has been assisting the two Californians.
>
> Messrs. Hunt and Rogers have charted the *Chinook Wind,* just now being finished at the Multnomah Shipyard in Portland. Her maiden voy- age will be to transport the 1400 head of hogs to San Francisco.
>
> Next week, Messrs. Hunt and Rogers, assisted by Mr. Meek and Big Tim Beebe, will drive the hogs from Oregon City to Portland. They expect no difficulties and no inconvenience to the inhabitants during the short

journey of 14 miles. The west side route through Oswego will be used. The *Chinook Wind*, a large ship, is unable safely to attempt running the Narrows upriver to Oregon City in this season of low water.

The people of Oregon have enjoyed having the gentlemen, Hunt and Rogers, in their midst. In addition to leaving $14,000 in gold among the husbandmen of the Willamette Valley, and substantially additional amounts for feed, the amiable qualities of the two men have made them many friends.

A few citizens residing in the vicinity of Clackamas Island, the big water-surrounded hog lot, have objected to the sounds and odors of the animals, the *Spectator* having received three indignant letters which have not been given space in our columns. The merchants of the town, realizing the advantages to farmers and tradesmen, have given no support to these complaints.

The *Spectator* wishes a fortunate sea trip for the hog cargo. It is understood the enterprise will be profitable to Messrs. Hunt and Rogers. The hogs are all consigned to Otto Kraxburger at San Francisco, one of the largest meat dealers on the Pacific Coast. The *Spectator* hopes the special flavor of Oregon bacon and hams will stimulate a lively demand for Oregon hogs. We believe a market of this nature to be quite as important as having improved breeds in the way constantly urged by Mr. Ben Cannon in addresses at meetings and in more letters to the public than the *Spectator* has had space to print.

After this piece appeared in the paper, people began to come down to the mainland opposite our island and tell us how to drive the hogs to Portland. Most of this advice didn't overlook the matter of buying something from the adviser or hiring him to help.

We saw no reason why we shouldn't drive them in the ordinary way. We hired from the corral man eight horses and riders at fifteen dollars apiece, four for each side of the marching hogs. And we hired a man at five dollars to walk on one side of the column. Big Tim would walk on the other. Joe Meek would ride ahead. I would ride at the end. Levi would be a file closer, riding wherever there was trouble.

We put the animals across the river in the Oregon City ferry, which also at each trip towed our own scow loaded up with fifty. We started at four in the morning and had them all over by ten o'clock. The country was pretty well settled between Oregon City and Portland. During the first mile, we went along at a good pace and without mishap.

"All those fellers with their schemes," said Levi. "It's jest a matter of drivin' 'em like cattle, like sheep."

But we began to meet vehicles. Buggies and wagons and drays parted the marching column. A yoke of oxen hitched to a covered wagon were changed

from plodders to animated creatures which took the wagon on a wild goose chase, a sunbonneted mother and three butternut children yelling as they went and the hogs darting out of the way. City horses, with offended nostrils, reared and bolted. The hogs darted between the wheels and among the legs of the teams.

The swine, from being a compact and orderly mass the width of the road, and a quarter of a mile long, became a scattering, unwieldy column shedding individual hogs and groups of hogs every which way.

Scores of them broke through the fences of the roadside dwellers, over-turning hives of bees; sending chickens jumping and flying and cackling, and shedding feathers; harvesting a clover patch in short order. Big Tim and the other man on foot and the eleven of us on horseback herded them franti-cally, but while we were getting one bunch back into the road another bunch would tear loose into forbidden precincts.

They invaded yards and hencoops and sheds and stables and gardens and crops—to uproot, to trample, to overrun, to frighten, to excite all dogs along the way and infuriate all inhabitants. Our passage was like a pestilence.

We were threatened with the law and tongue-lashed, and handed indig-nation in a dozen forms. A gun was brandished by a woman whose clothes-line collapsed into the dust and whose fresh wash became a carpet for the hogs to run over. A man mounted a fast horse, went to Oregon City, and brought back the sheriff.

"Who's in charge here?" he demanded.

"One of them," answered Big Tim, pointing to Levi and to me.

He rode up to me. "Stop the drive. Get them back to Oregon City."

"I'll discuss it with my partner," I said.

"You'll get them back to Oregon City," he said, "and you'll do it at once."

"I'll have to see my partner," I repeated.

"Now, look here," said the sheriff, "do you want me to arrest you? Any more contempt and that's what'll happen."

"Sheriff, we've got to see how to turn them. It's not easy, with them so much out of control."

"Well, get them turned around before they ruin the whole country. And if they wreck things any more on the way back to Oregon City, you'll pay for it. Understand, you'll pay damages."

We finally got the hogs back to Clackamas Island—but what to do then?

THERESA TRUCHOT

Theresa Truchot (1891–1980) was a teacher, singer, and historical researcher who moved to Lake Oswego with her husband, William Bryan Truchot, in 1929. During World War II, Truchot assembled a scrapbook of correspondence with Lake Oswego residents and produced—as writer, editor, and distributor—a newsletter, The Oswego Honk, *for soldiers overseas. Truchot studied writing with Alfred Powers and collected local stories of Lake Oswego's early days, when its ironworks fueled aspirations for the town. Her 1976 collection,* In Their Own Words, *includes the recollections of early Lake Oswego residents. In this selection from her novel for young readers,* Charcoal Wagon Boy *(1952)—which is based on stories told to her by longtime Lake Oswego resident Charles Dickinson—twelve-year-old Eben Sutton meets a new boy in town.*

Smuggler Catchers

Eben had hunted over the country north of Sucker Lake ever since he could shoot his father's Kentucky rifle. So now when he came to the hilltop where he had seen a light the night before, he recognized the faint trail leading into the hazel thicket. Hidden from the road by the brush was a small natural opening in the forest. There Eben found the ashes of a small fire. He saw trampled grass and broken brush.

I'm a-going to watch this place, he told himself. *They'll be back.*

Next day he was busy with his plans as he plodded along beside the oxen over the muddy road that wound through the timber to Oswego. Past the Franklin place they trudged, then skirted restless Tryon Creek.

How can I ever stay awake to watch that hide-out unless I'm looking after the charcoal pit? Father always takes the night watch when he's home.

He put on the lock chain to brake the wagon on a slippery grade. It surprised him when the oxen stopped abruptly at the foot of the hill. Coming around the bend was his old Indian friend on the shaggy pony.

"Hello, Two Crows."

"*Klahowya six.*"

Eben told the Indian about the riders in the night. "Who do you think they are?" he asked.

His friend gazed at the shadowy forest. "Two Crows tell you. White man dig holes for iron. Let evil spirits out of ground. Evil spirits ride at night. Two Crows know. Two Crows see evil spirits. Evil spirits live on island."

"The island in Sucker Lake—I mean Waluga Lake?" Eben quickly changed to the Indian name.

The old man nodded. "No good come from white man's iron. No good." He kicked his pony and passed around the wagon without another word.

The island that the Indian referred to was a lonely spot. Thick undergrowth circled its stony top. No farms, no homes occupied that region, for the shore was almost solid rock. Farther west were the farms of the Prossers, the Bryants, and old Caleb Barnes.

I wonder, thought Eben as he goaded the slow-moving oxen, *just who the evil spirits are that Two Crows has seen on the island. They would have a good hiding place.*

He wanted to see Bert Lively and tell him his experience. At the smelter he asked Yancy about Bert.

"Hain't been in with his charcoal yet. This good June weather's a-keeping a lot of farmers busy at home."

"Say, Yancy," Eben burst out, "did you ever hear if they caught those smugglers up at Oregon City?"

"Smugglers?" Yancy roared with laughter. "Never heard tell of them. What with minding this yard twelve hours a day, I don't pay no heed to such as smugglers."

"What's this about smugglers?" asked a strange voice. Eben swung around to see a tall, bearded man in city clothes. Eben admired the cut of his dark coat, the pink-flowered shirt, shiny boots, and tall hat.

Yancy was still laughing. "Eben here, was asking me if they'd caught them. And me? I never even heard of the varmints."

There was something in the quick gaze the stranger shot his way that made Eben uneasy. He turned the oxen at once toward the charcoal shed. By now the stranger also was laughing. But as Eben glanced over his shoulder at the men, he met another sharp look.

Wondering about the man, Eben drove into the shed. Unhooking the lead team, he led them around to the back of the wagon. He fastened them to the first drawboard. As they pulled it away smoothly, the black load fell to the ground.

"Hello, Smudgeface." There stood the redhead who had run away with the turtles long ago, so long ago that Eben had lost his anger.

"Oh, it's you again. Where've you been all this time?"

"I had to stay in Portland because there wasn't any school out here."

"Whatever became of those turtles?"

"Some folks sent them to a Dr. Chapman in Portland. He knows all about turtles and things. Say, what's your name?"

"Eben Sutton." He hooked the oxen to the second drawboard.

"Where do you live?"

"On my father's donation land claim."

"What's that?"

"Oh, land, a square mile of it he got from the government in 1852 and earned by living on it."

"I'm from Connecticut," announced the redhead.

As the oxen pulled away the second board, Eben forked the rest of the load to the ground.

"Yep," the other went on, "we came round the Horn in a sailing vessel. Took us seven months from New York. We were in the biggest storm you ever saw—waves this high." He pointed to the top of the shed.

"My mother came across the plains in a covered wagon," said Eben, not to be outdone, "and father crossed the Isthmus of Panama when General Grant was bringing soldiers over it. Grant was only a lieutenant then, though. Part of my father's trip was on a railroad, some on donkeyback right through the jungle, some by boat."

"In Connecticut there are heaps of railroads. There aren't any in Oregon."

"Oh, but there's a-going to be two of them. One will be East Side, the other, West Side."

"Do you get paid for doing this?" the redhead asked as Eben hooked his lead team once more in place.

"Of course not. This is my father's charcoal wagon."

"I'm water boy at the furnace. I get twenty-five cents a day to fill their two water crocks. I'm going to buy me a silver watch and chain like my father's. He's top-filler at the furnace."

"I might get a watch myself, some day," said Eben recklessly.

"You just said you didn't get paid."

"Oh, I aim to get the reward for catching the smugglers."

The instant the boastful words were uttered, Eben wished he had never said them, for the blue eyes of the other fairly bulged with interest.

"Smugglers!" he scoffed. "There's no such thing around here."

"There is too."

"What do they smuggle?"

"I don't rightly know."

"Well, if there's a reward, I just think I'll be catching them myself."

As the redhead turned to leave the shed, Eben, standing beside his oxen, could see the reward slipping through his fingers.

"Smugglers!" the town boy rolled the word on his tongue. "Sure there'd be smugglers with all the ships from China and such putting into Portland."

"Say, what's your name?" blurted Eben.

"Silas Smuggler-Catcher O'Connor," returned the redhead mockingly and vanished. Eben had such an empty feeling in his stomach that he forgot to look for Bert Lively. He headed the oxen homeward.

Someone else wanted that reward as much as he did—*Silas Smuggler-Catcher O'Connor.*

ERNEST HAYCOX

Born in Portland, Ernest Haycox (1899–1950) moved often until his parents divorced and he began to live on his own. He worked in a variety of jobs and moved briefly to San Francisco before returning to Portland and graduating from Lincoln High School. Lying about his age, he enlisted in the Oregon National Guard in 1915 and went to Mexico before being sent to guard mines in eastern Washington and pursuing members of the IWW. In 1917, he was a platoon leader in France. He went to Reed College in 1919 and attended the University of Oregon, where in 1921 he won the Edson Marshall Prize for undergraduate writing. Haycox is the author of novels and short stories, many of which were adapted for radio and film. His prolific writings—some of which were serialized in Overland Monthly, *the* Saturday Evening Post, *and* Collier's—*were praised by critics and writers such as Bernard DeVoto and Ernest Hemingway. Haycox was particularly attentive to setting in his work. In* Long Storm, *a novel set in Portland during the Civil War, the city is divided between the "secesh" and those loyal to the Union.*

From *The Long Storm*

They came to the edge of the crowd. Old Colonel Delaney was speaking, a lawyer, a loyal Union man, a cool and tough character who knew when to be a firebrand.

"They are among us—perhaps even here now listening—these men of the maelstrom, who took their milk at the breast of the harlot Sedition. She is their true mother, malign and heartless and owning no scruples to the laws of God or man. Yes, and they are her true sons, come among us to spread the seeds of treachery whose flowers are more poisonous than mountain ash. Have you read the *Times* this morning? The editor of that paper—that sheet, that rag, that foul and bloody banner of indecency—is one of the breed. What did he say? He said that the Union Party was a corruption composed of black Republicans and backsliding Democrats—that the only true faith was the Democratic Party—that rump of a thing deserted by all loyal Democrats and now composed only of ragtag and bobtail, openly urging the destruction of this Union, openly advocating that this State withdraw and become a part of an Independent, slave-loving Pacific Republic. I say—"

The rising tumult of the audience stopped him; he stood good-humoredly patient while men cheered and their voices lifted shrill heated calls. The tar barrel's light laid a tawny, smoke-shot glow over the scene and its flickering created the illusion that men were swaying and gently capering to its tempo. Behind the Colonel stood a band which now broke into the "Battle Hymn of the Republic." The voice of the crowd thickened to a solid and continuous shouting.

Lily looked on, her eyes quick to see and her manner turned eager. The

Colonel's words had brought up some of her own loyalty; now and then she lifted on her toes and put a hand to Musick's shoulder for support, and once when a near-by man blocked her view, she gave him a push with her arm.

The band quit and the Colonel's strong tenor voice renewed the attack. "Those men are traitors to this Union, openly and continuously and adversely. I say they were born traitors and their characters are such they could be nothing else but traitors. I say that when the election day of June seventh comes, we shall destroy their standing forever in this state, destroy them politically, and, if they persist in their machinations, then by God of Heaven, we shall destroy them physically—"

His remark touched off another demonstration. But a voice stronger than even the Colonel's began to be heard through the crying of the crowd and, lifting his glance, Musick saw Floyd Ringrose on top of the board awning of the building across from the Pioneer. Ringrose had gone into that building, ascended to a second-story room and had climbed through a window to the awning. Thus twelve feet above the crowd, he pointed his finger like a gun at the Colonel.

"Yield" he cried. "You have said too much."

The crowd grew quieter. The Colonel, facing Ringrose, said: "Have I smoked out a Copperhead?"

"Listen to me, you windy mouthpiece," said Ringrose. "I am a citizen of this Union. I was born in the South and I am a Democrat. I am a free man and my politics are my own. I say to you that your words are the words of a liar when you brand Southerners as you do."

"What are you then? " challenged the Colonel. "If you are a Union man, you've got no sore corn to be stepped on. Or are you a Copperhead?"

"Whatever I may be, sir," said Ringrose, "you are a jackass."

"The braying I hear does not come from my direction," stated the Colonel.

Ringrose looked at the crowd and made his appeal to it. "Men like that man," he said, pointing to the Colonel, "are dangerous. They inflame, they destroy. What is a Copperhead? Why, apparently any man who does not believe exactly as this fanatical bigot believes. I have affection for my country and so do we all. But you do not make Christians by fire or sword. You may take the South and rape it and gut it and lay it waste, but you cannot change its opinion. The South was a part of our country. It would still be a part of our country if reason had been used upon it, if men had been big enough to admit that other men may honestly hold to their own opinions. Upon this continent two kinds of beliefs can live side by side. But upon this continent you cannot have a prostrate South and a triumphant North. It will not work. What have we got for our war but tears and tragedy? Nothing more! No answer and no solution—nothing but Northern and Southern men fallen

and rotting like cornstalks. Is that the answer? Never! The South may die but it will not surrender its ancient beliefs. It will not surrender its respect. It will fight to the last man, and the Northern armies will wilt away of bullet and disease in the Southern swamps and some day there will be nothing left of either North or South but skeletons upon the earth, and the buzzards will wheel over an empty and desolate scene, and they alone will profit from the insane machinations of men like this man who, pouring his bile and fury upon our quivering sensibilities, at last destroys our fortunes, our homes, our lives." He paused for breath; he paused in a heavy silence, and then in a softer tone he drove in his point. "Is it total destruction of everything you want? Or do you want to let the South go in peace, so that we may all survive? I say—"

Shoved on by an offended loyalty he could not control, Musick abruptly pushed his way through the still audience. This man was eloquent and he made vice seem pretty; this man was a pure Copperhead spreading his wares. Musick came up to a two-by-two post supporting the awning upon which Ringrose stood. He struck the post with a shoulder and felt it give. By then he was enormously angered; the feeling got into him and went bounding through him until he could stand no resistance. He backed off and struck the post again and carried it away by his attack. He jumped aside as the end of the awning collapsed. Ringrose slid down the sagging boards, feet foremost, hit the ground, rolled, and sprang up. He made a complete turn about; when he saw Musick he halted and drew himself straight. The fall had jarred him. He was pale and his hair fell across his forehead in a yellow swirl. "By God," he said, "do you let me alone, or do I have to kill you?"

"You," said Musick, "are a Copperhead straight out."

"I warn you, sir," said Ringrose, "let me alone. I shall speak. I am free to speak."

"You're free to speak. But I do not want to hear you and I am free to shut you up."

"Take care," said Ringrose. An oldness, a wildness came to him; his face was scratched by long lines and his skin seemed of a sudden the same color as his hair. He threw back his head and he made a gesture with one hand toward his waistband. He had the edge of his coat shoved aside when Musick hit him across the arm and drove the arm from its downward swing. He waited a moment, and saw that Ringrose meant to try again; then he smashed him left-handed on the neck and tipped him into the crowd.

Musick said, "I won't hear that talk. You're for the Union or you're against it. One thing or the other." He waited and he watched Ringrose, and he had a hope that Ringrose would come at him again. He wanted this fight; the urge came out of nowhere and was something he could not help.

Ringrose looked at the crowd; he studied the surrounding faces carefully, and straightened to watch Musick again. He was debating the fight and half

inclined to renew it. The wish burned in his eyes and created that bright odd-
ness which Musick had before observed in them; but in the end he turned
on his heels and pushed his rough way through the crowd and disappeared
in the darkness of Alder.

Colonel Delaney called: "You have cooled our friend, Adam. Now let me
finish my pleading." He was good-natured about it and the crowd was good-
natured; and in fact the Colonel, resuming the speech, had difficulty whip-
ping up a proper state of emotion. Musick, returning to Lily, observed this
and smiled at it. Oregonians were a different lot than Ringrose knew about.
They were a steady and fairly mild people, they liked their politics rough but
they could be amused later at their own intemperance. It was a rare thing to
get them up to intense pitch; they much preferred easier ways.

"I'm glad you brought me," Lily said.

"I'm a plain fool," he said cheerfully. "Is it too cold for ice cream?"

"It would be nice." She took his arm and walked with him along the back
edge of the crowd. They went half a block up Morrison, entered Coffin's Ice
Cream Saloon, and sat down at a table; she was both pleased with him and
concerned with him.

"I knew you intended to hit him," she said. "It was on your face. You're
satisfied now. If you had whiskers, like a tiger, you'd be licking them."

"A man gets old and stale from too much thinking. Good thing sometimes
to use his muscles and forget about his mind."

"He'll have to leave town. They'll tar and feather him. Who is he?"

"Ringrose. A newcomer. Portland's got a way of taking the swash out of
men like that. Lappeus will cart him off to jail tomorrow and Risley will fine
him twenty-five dollars for breaking peace. Afterwards he'll walk the street
and nobody will give him a thought. We are a peculiar people."

The ice cream had the flavor of lemon in it and was very cold. Other
young couples came in, and spoke. Perry Judd, mate of the *Claire*, sat near
by with Phoebe McCornack, both of them so engrossed that they saw nobody
else. As he sat there, not much interested in talking, Musick tried to describe
Lily to himself, but had no great luck. She was pretty, but prettiness was an
ordinary word. Perhaps she was beautiful. He had considerable reluctance
in admitting that, for beauty was something the poets talked of in vague and
often straining terms which meant nothing.

She was at present paying him for bringing her here, showing him an
attention which women used on men, young or old, whenever it suited them;
it was a little coin which they always found at hand. He watched her lips,
which had seemed to him on occasion to be full of want. How hard did desire
press her and with what grace did she surround it? When she looked up to a
man, one day, and accepted him would that man see only a shallow bright-
ness of desire, or would he see a glow that tied him to her forever? He looked
down at his dish of cream. He ate it and continued to think about her.

"Adam," she said, "you didn't answer me. What am I?"

"Webley Barnes's daughter. A girl in a brown coat. No, not a girl. A woman."

"What's a woman?"

"Other half of a man. But a man has a level and so has a woman and neither knows if they'll match up right. They never know until it's too late."

"Want me to think you're wise, don't you?"

He enjoyed the light malice in her talk. He paid for the ice cream and they moved up Morrison into the street's darkness. Here and there lighted house windows made yellow squares against the night, and somebody near by played a piano stiffly and badly. In the damp air lay suspended the heavy odor of the firs crowding this town. At Seventh, Musick swung north. Lily seemed to be content with this, and paced with him. The mass of houses was dark and the town was dark; and blackness was a pressure upon Portland. Far up on the edge of town she checked him, saying, "It's late," and turned him back. He was happy at this moment and could not tell why. He walked down Montgomery to Sixth, and along Sixth, and presently passed the Thorpe house. He had given no thought to it but he felt a change in the girl beside him so that he unexpectedly knew she hated Edith Thorpe. The revelation astonished him. How much hatred was there like this, deep and still and hidden in the people he daily saw?

They walked on homeward with the ease gone. He opened the gate and stepped aside. She went through it to the porch and reached the door and turned to him; coming nearer her he caught the tenseness of her attitude, as though she had come to a crisis and had stiffened herself to meet it. She had no explanation to give him, yet she blocked the door and compelled him to halt and puzzle out what was in her mind.

He bent to catch a better view of her face and when he saw the heaviness of her lips he thought he knew what she was telling him; and a pair of shears seemed to cut a restraining cord and he put his arms around her waist and drew her in to him. He was not yet sure and he felt a great dread of making a mistake with this girl. For a moment he watched her and saw no anger and felt no resistance; then he lowered his head and kissed her.

It was what she had wanted. She felt the luxury of it as well as he; and for him it was a need that he could neither check nor satisfy. A fine sweat broke out upon him. He knew the pressure of his arms and his mouth was too great for her, yet her own arms were tight around him, holding him as he held her. As long as it was this way, he felt he had his rights to her—the rights of any man in a woman who willingly met him; but in a little while there was no more force in her and she lay passive, waiting for him to be done. He no longer had her. He stepped immediately away; his knees were unsteady and there was a vibration all through him.

She was calmer than he was. Her voice revealed it. "You wanted to know," she said. "Now you ought to know."

"It was good. That's all I know."

"Oh, Adam," she murmured, and added: "I wasn't saying I was in love." She tried to read the little shifts of expression on his face, but got nothing from them; and her manner settled and she shook her head. "I thought I had been so clear," she said, and entered the house.

He remained on the porch for five or ten minutes, needing the cool night's air; then he went inside and crossed to the kitchen. She had found herself a cup and had poured herself coffee from the still-warm coffeepot on the back of the stove; she sat with her arms on the table, once more a girl who looked regretfully at something beyond her reach. He got another cup and took a chair opposite her. She wasn't what she had been before. He could not mark the exact change, but the change had nevertheless happened.

"And I wasn't trying to take you away from Edith," she said.

He finished his coffee and rose; he washed the cup and set it away and left the kitchen. He heard her call his name and he turned back to the doorway. "I'm sorry," she said. "I shouldn't have permitted it."

He climbed to his room, loose and confused; he sat on a chair and put his feet on the bed. Was she hating him now? Maybe he had left the print of brutality on her mouth. He wasn't certain of himself. Maybe the impulses which drove a man so hard were dirt-common, nothing better; maybe she wished for something else and hadn't found it. Well, the kiss should have told her all she needed to know about him. She held the information now.

He removed his feet from the bed and laid his hands on his knees. They had looked at each other for more than a year with a safe distance between them. In a moment's time he had crossed the distance. There was no back-tracking from it. He couldn't again look at her without a feeling of ownership, and inevitably in his mind would be the question—when would he next possess her? It would be in her eyes when she looked at him, the knowledge of what she had given, and her intimate thoughts as to when she would once more give. A man could not walk into a woman, turn about and walk out; from here onward when he looked at her, across the table or across the length of a room, there would be a knowingness between them. Was it only male and female stalking each other? Or was there in all this the first sound of the angels singing? He stared at his hands.

MALCOLM CLARK JR.

A third-generation Oregonian, Malcolm Clark Jr. (1917–1989) graduated from Grant High School and attended the University of Washington. He married Portland City Auditor Barbara Clark and for over twenty years worked as the office manager of his father's law practice in Portland. Much of Clark's inspiration came from his maternal grandmother, pioneer Emma Freeborn Clarke, and he pursued Oregon history with brilliance and passion. Best known for Eden Seekers: The Settlement Of Oregon, 1818–1862 *(1981), Clark also edited* Pharisee Among Philistines: The Diary of Judge Matthew P. Deady, 1871–1892 *(1969). This essay, published in 1969, captures a dramatic moment in Portland social history when the leaders of the temperance movement clashed with the law and the owner of the Webfoot Saloon in 1871.*

The War on the Webfoot Saloon

APPEAL TO MANUFACTURERS AND DEALERS IN INTOXICATING DRINKS. *Knowing, as you do, the fearful effects of intoxicating drinks, we, the women of Portland, after earnest prayer and deliberation, have decided to appeal to you to desist from this ruinous traffic, that our husbands, brothers, and especially our sons, be no longer exposed to this terrible temptation, and that we may no longer see them led into those paths which go down to sin, and bring both soul and body to destruction. We appeal to the better instincts of your hearts; in the name of desolated homes, blasted hopes, ruined lives and widowed hearts; for the honor of our community; for our prosperity; for our happiness; for our good name as a town; in the name of God, who will judge you as well as ourselves; for the sake of your souls, which are to be saved or lost. We beg, we implore you to cleanse yourselves from this heinous sin, and place yourselves in the ranks of those who are striving to elevate and ennoble themselves and their fellow-men; and to this we ask you to pledge yourselves.*

—WOMEN'S TEMPERANCE PRAYER LEAGUE, *Portland, Oregon*

Frances Fuller Victor did not march in the ranks of the Great Crusade since, as she said, she had fought out her own crusade in private, long before, and the scars had not yet been effaced. But her heart was in the Cause and each new day of the campaign found her a visitor at Camp, sometimes as honored counsellor, sometimes as a kindly nurse who gave aid to the injured or succor to the weary, and when the War was over she wrote out its history in a little book so that there would ever be a record of those stirring deeds and grand heroics. If the unfeeling world has forgot, it was through no fault of hers.

In order to understand what occurred, it is necessary to keep in mind that in the seventies drunkenness was, on the male side, epidemic. The "eye-opener" set the day in motion, and thereafter citizens of every class "op'd

their eyes" at regular intervals until they found they could no longer open them at all. Gentlemen of consequence on occasion nestled down in some convenient gutter and a jurist of more than local renown, by applying himself early and often, won the soubriquet, "the Whiskey Judge."

Conditions such as these prevailed throughout the nation and not least of all in Portland, where there was a licensed liquor outlet for every forty persons in the community, men, women and children taken together (though some of the latter were tee-totalers), establishments ranging in tone and appointments from the urbane Charley Knowles' Oro Fino down to the redoubtable Miss Celia Levy's Oriflamme. The saloons that lined Yamhill Street's "Court of Death"—the rookery wherein nested the city s more bedraggled birds-of-passage—were deadfalls without exception; poisonous dens from whence little gusts of viciousness puffed into the streets, pushing before them cargoed demi-reps.

There were reactions, of course. The liquor fraternity was roundly denounced from the pulpits, in language Apocalyptic. Newspapers stood forth, almost without exception, for regulation and restraint (the very nearly universal intemperance of editors notwithstanding). Abstinence pledges were circulated, and signed, and soon forgot. These efforts, and others urged by the female lecturers who were touring about in increasing numbers delivering inflammatory addresses, failed to accomplish any lasting results. But early in 1874 matters took a new turn.

The idea was born early that year in Ohio and transported West, after the feminine fashion, by word of mouth and with such commendable rapidity that by the middle of February the ladies of Portland were astir, bursting with vague plans and inchoate ambitions and already heating up their energies at the fire of righteous zeal. These early days were filled with much aimless goings-about, with badly-attended meetings held at haphazard intervals, but by the first of March the movement was taking definable form. On the sixth of that month, in her weekly sheet, *The New Northwest*, Abigail Scott Duniway published an editorial titled "PRAYING DOWN SALOONS" which opened coyly, "This exciting topic, just now *the* theme of the newspapers, it behooves us to have an editorial word on it."

In point of fact, the Portland dailies had taken no more than passing notice of the temperance agitation. But no matter. Mrs. Duniway was safely air-borne and soaring off on a flight of speculation:

> To begin with, then, we are rejoiced to see something started which will bring the women to the knowledge they can deviate from long-established customs without bringing down the heavens upon their heads. *Thousands and tens of thousands of them will blockade sidewalks, interfere with municipal ordinances, sing and pray in the most public places to be seen of men*, and by this means be awakened to a realizing sense of their political duties.

Once launched, the Great Crusade scudded away before a gale of windy oratory. On March 10 the Reverend Mr. Medbury, seconded by five brother parsons—Atkinson, Izer, Eaton, Lindsley and Eliot—called a meeting at the First Baptist Church. Fifty ladies attended and were harangued, agitated and up-lifted until the ministerial team had talked itself hoarse. Meetings were held on succeeding days, each one larger and more fevered than the one preceding. Ladies were encouraged to "exchange experiences," that is, to recite, without paltering over details, the drunken depravities of sons and husbands. Heated by these pious flames, the new movement quickly raised a formidable head of steam. On the sixteenth the Women's Temperance Prayer League was formally organized. Headquarters were set up in the Taylor Street Methodist Church and plans were made to hold afternoon and evening meetings daily from that moment forward. On March 18 the League issued a public appeal to saloon-keepers, urging them to shut up shop. The same day an abstinence pledge was drawn up and put into circulation. By the twentieth more than eleven hundred signatures had been obtained. "The women," Mrs. Victor wrote enthusiastically, "seem everywhere to be lifted up out of themselves, their little vanities and sectarianisms, and to be moved with a very powerful influence."

As stirring and inspiriting as were these events, they were no more than preliminaries to the meeting of March 23. On that day, after prayerful consideration and a certain amount of sharp debate, it was determined that the war must be carried into the camp of the enemy; that prayers and hymn-singing must be conducted in the saloons themselves. A few of the more conservative ladies withdrew in protest, but the remainder of the membership closed up the files. And so it was that the next afternoon a little band of twelve issued bravely forth from Taylor Street to do battle with Demon Rum.

It happens not infrequently in war that decisive battles are fought at points remote from the main current of the conflict. So it was to be in the Great Temperance Crusade. While the twelve wended their way to Thomas Shartle's, on First near Taylor, then back to the church, then out once more to a rum-shop dubbed the Evening Call, drawing in their wake a crowd of impressive proportions, other Leaguers were hanging about the city in search of additional signatures for the Pledge. It was such a pair of outriders who trotted down Morrison Street to the corner of First, where they paused uncertainly before the swinging doors of Walter Moffett's Webfoot Saloon.

It was, as such places went, reasonably respectable. And Moffett himself was a man of solid reputation. He had followed the sea in his youth and acquired shipping interests, some of which he still retained. His wife was a Terwilliger. He was by way of being a man of property, for he owned not only the Webfoot, but also the Tom Thumb, on Front near Alder; and he was accounted honest, for it was said that his bartenders were instructed to give the customer full measure. But there were secrets he had hitherto nursed in

his breast. He had an intense dislike for female do-gooders, he regarded the Temperance movement as hypocritical humbuggery, and he was possessed of an explosive temper equipped with a very short fuse.

Here is what occurred, as Frances Fuller Victor afterwards told it:

> As is well known, Mr. Moffett's place is upon a corner, with a door upon either side, so that one can pass into one on Morrison Street and out the other on First Street, almost at a stride. The two ladies, trembling, but full of holy zeal, paused at the entrance on Morrison Street, and stepped into the saloon whose proprietor was as unknown to them as the proprietors of other saloons. As they entered, Mr. Moffett, on the alert, (for the saloon-keepers on this Coast had not been reading the news without preparing for a contest), entered by the Front Street door, which brought him face to face with his visitors. Without giving them time to announce their errand, he seized each rudely by an arm, and thrust them into the street, exclaiming, "Get out of this! I keep a respectable house and don't want any d—d w—s here."
>
> Shocking as such a reception must have been to any woman, many long and earnest prayers had not given these women a preparation for these things. . . . Mrs. Reid, one of the two thus insulted, turned and looked up over the door to ascertain what sort of place, kept by what sort of man, this might be; and the name, struck her with horror.
>
> "Walter Moffett!" she exclaimed. "Can this be Walter Moffett? Why, Walter Moffett, I used to know you; and I prayed with your wife for your safety when you were at sea years ago!"
>
> "I don't want any of your d—d prayers; I want you to get out of this and stay out; that's all I want of you. I don't keep a wh—e house."

From which they gathered he wished them to depart, and so they did.

First blood for Walter Moffett.

This shocking reverse was reported that evening at the Taylor Street Church, and the account raised a wild storm of outrage and indignation. The Crusade, until now uncertainly and imperfectly assembled, was riveted by burning determination into a tireless and efficient war machine, with the destruction of the Webfoot Saloon as its first objective. Other establishments would be invaded, other barkeeps assaulted by song and prayer, but upon Walter Moffett would be visited the full fury of the petticoat revolution. And like Grant at Cold Harbor, the Leaguers prepared to fight it out along that line if it took all summer.

At the outset the ladies contented themselves with an occasional reconnaissance in force. An harassing action here, a flank attack there, probing the defenses. Almost daily the Crusaders visited the Webfoot, demanded

entrance, were refused and moved meekly off. But throughout the city tension was mounting. Even Moffett himself was not fatuous enough to believe that he was going to escape so easily, and he might be seen, now and again, peering nervously out at his swinging doors. On the thirty-first of March the ladies suddenly changed tactics. Having applied for admission and been turned away, they ranged themselves in a line in front of the saloon and began to pray and sing. A large crowd collected almost immediately. Moffett shortly appeared, wearing his spectacles and an expression of mock dignity, and carrying a Bible from which he proceeded to read passages "selected with express reference to the occasion, being such detached portions of the Holy Writ which, when taken disconnectedly, are the most offensive and improper." The ladies sang louder. Moffett shouted. In thus wise the duel continued until four o'clock, when the Leaguers withdrew. During a short lull in the proceedings one of them, tears in her eyes, asked Moffett why he persisted in acting so. He replied stoutly that he was an educated man; that he attended to his own business and urged others to do the same; that his tormentors were hypocrites; and that he stood as fair in the books Up There as any one.

The lady who had inquired had not done so out of idle curiosity, and that night the question was much discussed in the meeting at the church. There were a few who felt that the Webfoot's proprietor was an incorrigible and should henceforth be ignored. But the majority took the position that he should be granted no special dispensation, and there were even those who argued that his excitable and erratic behaviour was caused by an uneasy conscience, and was thus a sign that he was not damned beyond Salvation.

Armoured by the irrefutable logic of this, the Leaguers stood to their guns. April 1 found them once more at the corner of Morrison and First. There they were set upon by a number of low fellows who beat gongs in their faces and threw firecrackers under their feet. The Crusaders were unimpressed. But the mob of onlookers grew ugly and the police, fearing violence, persuaded the ladies to disperse.

For the next few days the action moved elsewhere, though there was a brief encounter on the fifth, and the Webfoot's proprietor and patrons enjoyed comparative peace. But at ten-thirty on the morning of April 7 the Leaguers appeared in force, some fifteen strong. No more had they arrived than hundreds of curiosity seekers rushed up from all directions, so that in less than three minutes more than a thousand persons had assembled. The crowd was so large that it completely jammed the sidewalks and overflowed into the streets. Moffett set up a frenzied piping on his whistle and shortly the ponderous figure of Police Chief Lappeus could be seen breasting the press. When the Chief was close enough to hear, the Webfoot's proprietor called out in a loud voice that he was a tax-payer, that he was entitled to the full protection of the law, that he had paid $100 for a license that very

morning and had a right to operate his business, that the Crusaders were harassing him and he demanded they be dispersed.

As it happened, Lappeus himself had once tried his hand at The Trade, having been one of the original owners of the Oro Fino; but in the present matter he kept his sympathies, if he had any, to himself. He approached the ladies and with grave dignity asked them to withdraw. They flatly refused. He warned them that their continued presence might lead to violence, even bloodshed. They replied loftily that it was God's Cause in which they were engaged and that their consciences were clear. Whereupon he told them, with sad reluctance, that their obstinate course left him no alternative but arrest. So everybody trooped down First Street to the jail, the Chief in the lead and the crowd bringing up the rear.

When word of the incident got out—which it very quickly did—the fathers, husbands, brothers and assorted male relatives of the arrested Leaguers descended on the municipal building in clouds ("In an excited state of mind," said the *Oregonian* reporter), to offer bail. The ladies, who had spent the intervening time rendering such hymns as *Fight the Good Fight* and *Blessed Are Thy Courts Above*, steadfastly declined. And so they were carted off to the lock-up where they spent two or three refreshing hours in song and prayer while the authorities scurried about collecting the officers of the court in order that trial might be held. The cause was heard by Judge Denny and the complaint dismissed after defendants' counsel, C.W. Parrish, argued that the Crusaders were not disturbing the peace, but merely exercising freedom of worship.

The Leaguers did not visit the Webfoot again until April 14, and on that occasion for but half an hour, but there were rumours that the ladies were making big medicine. And reports were afoot that Moffett was not idle; that he had purchased larger gongs and a wheezy hand organ and had signed on three new recruits, two small boys and a fragrant character known as Tripe Fritz. By this time the Great Crusade had truly become "*the* theme of the newspapers," and was the principal topic of public discussion as well. There was a general feeling that a great battle was in the works, that the Crusaders would undertake one grand, final effort to sack the citadel which had till now defied them. And on the afternoon of the sixteenth of April, they did.

Fifteen Leaguers arrived in front of the Webfoot a little after two. Moffett was prepared for them. Even before devotions were begun the defenders set up a hideous din that brought spectators on the gallop. Each of the two small boys pounded a large Chinese gong, Tripe Fritz ground at the organ, and Moffett himself shrilled away on the whistle. This hideous clamour continued for an hour, the Crusaders meanwhile calmly saying prayers and singing songs which not even those closest to them could hear. Fritz grew arm-weary. The two boys, despite the encouraging shouts of their commander, were perceptibly weakening. Moffett's face had acquired a purplish cast. It

was then that J.F. Good, one of the barkeeps at the saloon, decided on a *ruse de guerre*. Near the corner stood a hydrant, attached to which was a large hose used to fill the street sprinkler wagons. Good turned on the hydrant and deluged the sidewalk. The crowd moved back out of range. The ladies did not budge. Then Good played the hose on the building, so that the water ran down the plank awning and cascaded off. The Leaguers were drenched, soaked to the skin through their multiple petticoats, but they did not flinch. By that time the small boys had given out entire, and so Good put the hose aside and took up one gong. Fritz hammered the other. A hobbledehoy who frequented the place turned the handle of the organ. And Moffett blew on the whistle—when he could find breath enough. The ladies were still fresh and imperturbable.

Two hours more. Someone had brought out chairs and the Crusaders were sitting in a long line at the edge of the sidewalk, each back primly erect, each mouth moving with unceasing fervour. In a fury of frustration one of the beaters thrust his gong close against the face of a Mrs. Stitzel, who sat near the head of the line. Mrs. Stitzel was attempting to wrest the gong away when Moffett came rushing up, jerked it from her, and at the same time drew a pistol which he brandished about in a menacing fashion. Cooler heads prevailed upon him to put the gun back in his pocket.

The tide of battle ebbed and flowed. It was now nearly five o'clock. Good, who had been making frequent trips into the interior of the saloon in search of liquid strength and consolation, was thoroughly drunk. He began to swear bitterly at the Leaguers. A bystander, one William Grooms, stepped up and smote Good mightily between the eyes, knocking him flat. Within seconds the fighting was general, though the Crusaders seemed to take no notice of it. Moffett's little army, finding itself hopelessly outnumbered—the crowd had grown to well over a thousand—backed hastily into the Webfoot. As many men as could pushed in behind. Guns and knives were drawn, chairs were thrown about, glass was smashed. Just then the police, who until that moment had found pressing business elsewhere, swept down on the scene and restored order.

Outside, the ladies were still singing away. They had neither moved nor missed a note.

Moffett had lost the organ and one gong in the riot and was forced to make do with the remaining gong and a few tin cans. His aides labored hard, but they were obviously disheartened. The Crusaders, meanwhile, wore quiet smiles of triumph. It was nearly six o'clock before they raised the siege.

Next morning at ten they were back; twenty-one of them, this time, each carrying a camp stool. "Every appearance indicated," said the awed *Oregonian* reporter, "that [they] intended to spend the day on the sidewalk." As on previous occasions an enormous crowd gathered within minutes. The sidewalks were quickly jammed. In the street, wagons, omnibuses, private

carriages, horses and men swirled and eddied in dusty confusion, and the balcony of the Occidental Hotel, which overlooked the scene, creaked under the weight of the spectators who lined it. But the partisans of the Webfoot were strangely quiet. No gongs were clanged, no whistle blown. Instead the proprietor hustled off to bring the police.

All twenty-one of the ladies were arrested, but since the complaint was based upon the events of the preceding day only six were actually brought to trial: the Mesdames Shindler, Sparrow, Ritter, Swafford, Fletcher and Stitzel. This time there was no mention of praying and singing, it being simply charged that "the defendants . . . did willfully and unlawfully conduct themselves in a disorderly and violent manner . . . by making a loud noise and creating a disturbance . . ."[8] Which was not in strict accordance with the facts but might, by a little judicious twisting, be made to seem so. After extensive legal maneuvering Judge Denny ruled that the complaint was proper as to form and content, and on the morning of April 20 a jury of six was empanelled (a saloon-keeper and five other businessmen), and the prisoners were brought before the Bar. City Attorney Mulkey and Mr. E.A. Cronin represented the City. Ex-Governor Gibbs and Mr. Parrish defended.

The court was packed to capacity and beyond, for the crowd spilled down the stairs and into the street below, where it depended upon rumours and misinformation for excitement. In the court room itself a heavy percentage of the onlookers were women, grim and indomitable, all of them following the proceedings with a savage intensity that bore down upon judge and jury like a leaden weight.

Mr. Mulkey opened with the remark that the defendants, being women, were not accountable beings, a bit of bile which caused heartburnings in more than one feminist breast. Governor Gibbs, when his time came, sharply cross-examined Walter Moffett about the two gongs and the hand organ—a line of question that discomfited supporters of The Trade. What with objections and irrelevancies, and a considerable amount of pettifogging, the trial dragged out for two days. It was not until very late in the afternoon of the twenty-first that the jury retired to consider the evidence. An hour passed. The crowd grew restive. The room was stuffy and the air had a used taste. Here a seat was vacated, there another. At six-thirty began a general exodus. But it was half an hour more before the six good men and true felt the court was sufficiently empty that they might with safety emerge to announce they had found five of the defendants guilty as charged. The sixth had proved an alibi.

Because of the lateness of the hour, sentencing was set over until the following morning. At the time appointed the condemned five stood in a brave little row before the Bench while Judge Denny gave each of them a choice between paying a five dollar fine or spending a day in jail. Lawyer Gibbs hurried up to announce that a number of citizens had come forward with offers to pay the fines. The ladies refused. Mrs. Sparrow, as spokeswoman,

read a four-hundred word protest which ended: "The jury had kindly recommended us to mercy; we ask no mercy—we demand JUSTICE." After which the Judge handed down the sentences.

The remainder of the day they spent locked up in the third floor jail, holding court for the throng of well-wishers who poured in endless procession through the corridors, drinking the hot soup brought them by thoughtful friends, singing and praying at intervals, and enjoying themselves hugely.

At last the visiting hours ended. The fair prisoners, apparently believing they were to be held overnight, settled themselves comfortably down. But then, wrote Frances Fuller Victor:

> . . . about half-past eight o'clock, . . . having been furnished with night clothes, etc., and having said good-night as they believed for the last time, they were just about preparing for slumber, some of them with their shoes unlaced and others partly undressed when Chief of Police Lappeus appeared and in peremptory tones ordered them to leave the jail.
>
> On being remonstrated with for giving this order after allowing their friends to go away, and being assured of their willingness to remain . . . the officer insisted, saying:
>
> "I'm the boss here; you leave!"
>
> Thus turned out, the ladies groped their way downstairs, but finding that quite a crowd of men were collected at the corner of the block, were afraid to go upon the streets, and returned to their prison. After a little deliberation, one of their number proposed that they make another effort to get away, and even went so far as to claim the protection of a stranger who chanced to be near the jail . . .

And so, with a single escort, the little flotilla of five sailed up to the Taylor Street Church, where its unexpected appearance set off a demonstration that was, according to one damp-eyed observer, the most touching witnessed since the boys came home from the War Between the States.

The arrest and imprisonment of some of their members, far from dampening the spirits of the Crusaders, spurred them to more feverish activity. Platoons of Leaguers marched sternly up this street and down that. Ladies singly and in pairs, and wearing mysterious smiles, rushed about on obscure errands. Moffett was bedevilled without remission while he, as a retaliatory measure, took to following his tormentors about, muttering imprecations and offering unsolicited advice. Meanwhile the League was supporting a weekly sheet, the *Temperance Star,* and had endorsed a slate of Temperance candidates in the forthcoming election. (One gentleman to whom support was given frankly admitted he indulged, but was apparently considered acceptable because he was nearly always sober.) The reverend gentry who were riding herd on the skirted whirlwind were shining with elation. Saloon-

keepers and other politicians were openly worried. Then, on the very morning of the canvass, there was distributed over the signature of the League a little broadside sweetly titled, *The Voter's Book of Remembrance.*

This extraordinary document was probably the work of A.C. Edmunds—preacher, laborer, journalist and sometimes agitator. But whoever prepared it possessed a very large vocabulary of exceedingly short words. The burden of the *Book* was that members of the liquor trade went hand-in-hand with practitioners of another—and older—profession, and that any citizen low enough to vote against the Temperance candidates was a supporter of Sin, an unAmerican scoundrel, and an arch-foe of Home and Mother.

The town exploded. What had previously made the League impervious to attack was the high moral tone which its members assumed. The *Voter's Book*, however, was rich with clinical descriptions framed in language exceedingly blunt. The Crusaders' bright mantle of respectability was torn from them in a trice. The politicians howled. The newspapers thundered. The clergymen retreated with unseemly haste, disclaiming responsibility. Large numbers of ladies tucked up their skirts and hurriedly sought places of safety. And the Temperance candidates were thumped.

It was the beginning of the end. The little corporal's guard of stalwarts which remained true to the standard was soon broken up by jealousies and wrangling. The *New Northwest* tossed rocks at the preachers; the *Temperance Star* shied stones at the *New Northwest*. On July 17, under the title, "CRUSADERS, WHAT THINK YOU?" Mrs. Duniway published a remarkable about-face which began:

> Haven't you discovered at last, to your sorrow, that the boy preachers who, in their silly zeal, have commanded you to be content to work as outlaws [have misled you.]

And which ended:

> We have all along rejoiced in your work, not because we believe the saloons of Portland would tremble under it . . . [but] because we saw that your failure . . . would open your eyes to the power of the ballot.

After which parting blast she climbed aboard her suffragette hobby-horse and galloped noisily off in search of new dragons, preferably male. The Great Crusade was over.

But there remains a casualty to report. As the months passed, Walter Moffett grew wan and weak. His eye lost its lustre, his step its spring. After a time he sold out his establishments and returned to the shipping game. It did no good. His health continued to decline. At length he sailed off to the South Seas in search of peace and healing breezes, but he died along the way.

The cause of his passing was unknown, though there were those among his friends who muttered darkly that he had been struck down before his time by an excess of Temperance.

The body was returned to Portland for burial. In the obituaries, the newspapers made no mention of the late unpleasantness, perhaps because it was already almost forgotten. For the League appeared as dead as Walter Moffett (it was, in fact, resurrected as the WCTU), and saloons were safe from invasions of unseemly sanctity. When gentlemen gathered together to bend an elbow and wet a lip they agreed, with quiet grins, that the Cup That Cheers had come to stay, and Prohibition was a pipe dream.

There was not one among them clear-eyed enough to discern, some forty years away, far off on the veriest margin of Time's horizon, a cloud no bigger than the Little Woman's hand.

STEWART HOLBROOK

Born in Vermont, Stewart Holbrook (1893–1964) was a World War I veteran who found his way to the Pacific Northwest through work in the logging camps of British Columbia. A cub reporter in Canada before the war, Holbrook arrived in Portland in 1923 to become the associate editor of Lumber News. *Through his articles in the* Oregonian *and other periodicals, the more than thirty books he wrote and edited—including* Far Corner: A Personal View of the Pacific Northwest *(1952) and* Promised Land: A Collection of Northwest Writing *(1945)—and the many lectures he gave throughout the country, Holbrook became one of the most popular and prolific chroniclers of Pacific Northwest life and history. His social and political concerns are often reflected in what he regarded as his "lowbrow" writings, including his accounts of working people, the unemployed, the down-and-out, the outcast, and the eccentric. This portrait of three Portlanders was first published in 1948 in H.L. Mencken's* American Mercury.

The Three Sirens of Portland

None of the three was particularly fair to look upon, yet they came to be called the Three Sirens and doubtless earned the title at their respective places of business in the Oregon city of Portland. Customers and police knew them as Liverpool Liz, Mary Cook and Nancy Boggs; and on occasion they were called by other names, though they seemed not to mind.

Of the trio Liz, who was born Elizabeth Smith in Liverpool, England, about 1850, was the best business woman. Nancy Boggs, an American, was the toughest. Mary Cook was unique in that she did her own bouncing—this in a day when bouncing was no genteel matter.

The time was from the late 1870s until a little after 1900. Portland was already old, as age goes in the Far West, but it was easily the liveliest port on the Northwest coast. Grain came here in a flood from the inland counties for shipment to the world. Eighteen big sawmills along the waterfront whined and clattered night and day. Windjammers were always in the harbor waiting to pick up cargo, while their crews cavorted on shore. Loggers arrived in droves to have their dental work done. It was a rich claim for any progressive business woman to work. The Three Sirens were progressive and they were hard workers.

Where Mary Cook was born or even where she died is regrettably not known. But she was, certainly, an able and hardy character, a behemoth of a girl weighing more than two hundred pounds and standing, in her red morocco slippers, a full six feet. She had a consuming urge to be dainty, and veterans of the time and place tell me she was indeed graceful, except perhaps when she was throwing around the crockery and bar glasses.

Mary's establishment was named the Ivy Green, and though a few disgruntled customers said a prefix, namely "Poison," should be added, it was no worse than any combination saloon-brothel, and perhaps considerably better. The Ivy Green catered to sailors and lumberjacks, but it was not exclusive, and most any male with a few dollars was tolerated.

Mary was an excellent greeter. She liked to stand just inside the swinging doors, and smoke big, black cigars while she welcomed the boys. As a blower of smoke-rings she had no equal, male or female, and if you held out a forefinger toward her, she would blow three neat rings around it, for good luck. If urged, Mary put on her Scotchman-smoking act. She'd blow a single ring, let it drift some three or four feet away, then go after it with her mouth wide open, and swallow it. This amused the customers no end and Mary never tired of it.

Although Mary was good-natured, even jolly, she was a stickler for keeping what she said was good order in the Ivy Green. I should like to have been in her establishment on that gorgeous evening in 1896 when Mary took in hand a celebrated local character by name of John P. Sullivan. This fellow was a part-time logger and a part-time fighter who claimed to be a nephew of the great Boston Strong Boy. He came into Mary's one night and took on a few. When the bar was well filled he announced himself. "I can," he said, "lick any son of a bitch in the place."

Nobody said anything. Mary herself had just blown a neat ring, but now she let it drift. All was quiet for a moment. John P. Sullivan glared at the crowd. "I can," he repeated in a loud voice, "lick any son of a bitch in the place."

Now Mary Cook spoke. "Does that apply to women too?" The voice was soprano, rather musical, but anybody short of a drunk could have detected an edge to it.

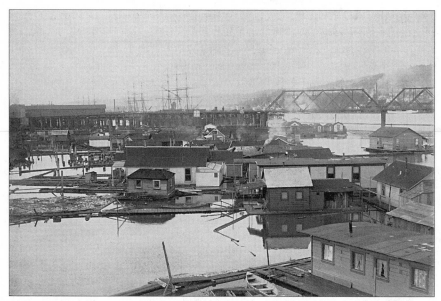

Scows at the Portland Harbor on the Willamette

"I am talking about anybody—man, woman or devil," said John P. Sullivan, large as life.

Veterans among the barflies watched with anticipation approaching agony as Mary threw away her half-smoked cheroot. She dusted her hands a bit, then ambled toward the great John P. Sullivan like a monstrous female moose. A friend of mine, the late Edward (Spider) Johnson, was among those present. "This Sullivan," he told me, "claimed to have wrestled with a shorthorn bull and to have broken the animal's neck. But the poor man—he did not know what was coming now."

John P. stood his ground as Mary approached, planning no doubt to slap the woman's face should she be so foolish as to attack him.

Walking up close to the big fighting-man, Mary put her face near his. "Listen," she said, and her voice was like unto jasper, "listen, you mug, have I gotta make an example of you?"

John P. Sullivan started to say something, what no one ever will know, for at that instant the cyclone that was Mary Cook struck him. She grabbed him by his two prominent ears and twirled him around like a top. Next, she applied one heavy hand to Sullivan's coat collar, the other to the seat of his pants. She picked him up bodily from the floor. She turned and heaved, and John P. flew almost the length of the room, hitting the floor just short of the swinging doors.

"Not so good," Mary remarked with a deep sigh. With four long strides she was standing over the fallen man. Again she applied the Ivy Green hold, only this time she picked him up and held him aloft, as if offering a supplication. "Open the doors, some of you dingbats," she commanded. Wide swung the doors, and then with a truly mighty heave Mary sent John P. Sullivan skidding along the sidewalk, a thing composed of two-inch Douglas fir and abristle with long splinters caused by the calked boots of hundreds of loggers. I have heard that no less than three hundred pieces of wood were extracted from the rear and flanks of John P. Sullivan, who never again made unseemly remarks in the Ivy Green.

"I hated to do it," Mary moaned, in reference to the incident, "I hated to do it, but I just gotta keep my refectory a decent place for gentlemen."

Liverpool Liz was no amazon, but she was husky enough for her height, which was about five feet two inches. She was well known for the necklace she wore upon almost all occasions. It was a rugged hunk of jewelry, so large and heavy that nobody ever thought of it as a bauble; and at the end of the enormous golden links hung a cluster of great diamonds. Her limey accent was rich and heavy, and she was a favorite with seamen, the majority of whom in that era were British.

Liz called her place the Senate saloon. The street level part was actually a saloon. Upstairs she kept her stable of female entertainers, whose number varied according to conditions in the harbor and in the logging woods. At the back of the bar were a couple of steps that led up to a small platform. In the ceiling was a hole. When drinks were wanted upstairs, the order would be shouted down, and one of the barkeeps would mix the order and hand the drinks up through the aperture. Why Liz, who was progressive in other respects, never installed a dumbwaiter is beyond knowing. Bartenders disliked the system and complained, but it was never changed.

There was, however, a modern bell system at the bar which Liz found useful on occasion. Say that a customer came in, feeling happy, and saw there were only four or five men at the bar. He'd tell the barkeep to set 'em up for everybody. "Yes sir," the barkeep would reply, meanwhile pressing a button that rang a buzzer upstairs. Within a few seconds anywhere from six to a dozen girls, often with escorts, would troop down the back stairs and into the barroom, laughing, shouting for drinks, including champagne, which Liz kept especially for the gag. The poor sucker who had originally figured that "drinks for everybody" would run to not more than a dollar, thus found himself paying anywhere from five to twenty-five dollars. Liz said that it helped pay the rent.

Yet Liverpool Liz was a pretty decent sort and probably more honest than her customers had a right to expect. She never, it is said, permitted a drunk to be rolled in her place, upstairs or down. She had an enormous safe—with an oil painting of Niagara Falls on the outside door—in which she kept the

cash and valuables of her customers. This wasn't a racket. The logger or sea-man who was overburdened with money and who hoped to make it last for a week or two, turned over such surplus as he wished to Liz. She put it in a manila envelope, sealed it and wrote the man's name on the cover. It was then put into the safe. Even if her place did get most of it in the end, the customer was grateful. He had not been rolled, and the system, moreover, did tend to make his stake last longer. Hundreds of loggers and seamen went away to tout the honesty of Liverpool Liz, and to return to her place when opportunity offered.

Although the record is far from clear, talk has it that Liz was married two or three times. If so, none of them could have lasted, for she appears to have run her place pretty much with a lone hand. One of her noted bouncers was a character called Tattoo Kelly. He had blue and red eagles tattooed all over his body and had once been an inmate of a sideshow. He had also been a sailor, an English sailor; and had done a little fighting. He got enough of the latter in the Senate saloon to keep him in trim; but eventually he murdered a man and was sent to the penitentiary.

If Liz had been content with her Senate she might have died a wealthy old harlot. But when the bicycle craze came along somebody talked her into buying a piece of suburban property and making it into a bicycle track, which she called Evergreen park. Right in the middle of her property she set up a saloon. This was probably an error of judgment, for parents of young cyclists did not approve of saloons in conjunction with playgrounds. Then the bicycle craze passed, and Liz was left holding property into which she had put much of her savings.

Finally, the Senate, on which her small fortune was founded, began to know days and nights when scarcely a seaman showed up for entertainment. The winged ships were passing, and the steam vessels carried fewer men into Portland.

And so at last the Senate closed its doors, and Liz herself died not long after, of pneumonia. She was given decent Christian burial in Portland's Lone Fir cemetery, in a grave not far from that of Jim Turk, who had made a busi-ness of shanghaiing men, and who had often coordinated his activities with those of Liverpool Liz and Nancy Boggs.

It was said of Nancy Boggs that she invented the whiskey-scow. This is prob-ably a debatable subject, in which I am not especially interested, but it is a fact that in 1880 Miss Boggs was the owner and proprietor of a floating hell-hole that was anchored in the Willamette River, which is Portland's harbor. At that time there were two cities, Portland and East Portland, with the river between them, each seeking to outdo the other. The lovely and alert Miss Boggs, learning that there was some doubt as to who should administer the law in the harbor, sought to make capital of the situation.

Dredging up sufficient cash to purchase an old sawdust scow, she had erected on its deck a two-story house. The lower section provided for the devotees of Bacchus and Terpsichore, the upper was devoted wholly to Venus. She painted it bright green and stationed it in the middle of the river. In the meantime she had stocked it with the best she could find of what came in bottles and corsets.

Miss Boggs' floating palace of sin was a success from the night it opened. On both east and west shores she stationed boatmen-pimps charged with seducing, then rowing customers to the middle of the stream, where Nancy and her girls took care of the rest. Now and then, some drunk would fall into the water, on occasion to drown; but on the whole the thing worked out very well. If the East Portland cops, in a moment of virtue, set out to raid the place, Miss Boggs, always forewarned, simply upped anchor and moved the scow nearer the Portland shore and thus into the jurisdiction of that city. It also worked in reverse order.

Then, in 1882, came one of those great moral waves that sweep over American cities every decade or so. Egged on by reformers, the police of both Portland and East Portland made a combined raid on the scow. Do not for a moment believe Miss Boggs was not ready. She herself in person met the combined police forces with hose in hand, and out of the hose issued terrific blasts of steam straight from the scow's heating plant. Cursing and screaming like all the Harpies alive, Nancy poured live steam over the bluecoats, who got out of there quickly.

Returning to their respective stations, the policemen applied grease to their burns while their superiors considered what to do. Eventually they got an idea. Along in the dark of the next morning, some unnamed policeman in a rowboat very quietly cut the manila ropes midway between the deck and anchor, and Miss Boggs' scow started on a wild trip downstream. The river was high, just then, and filled with eddies and whirlpools. Miss Boggs was aroused to find her houseboat spinning slowly in mid-river, heading straight out toward the Pacific ocean.

A woman of decision and quick action, Miss Boggs first attempted to wake the one man on board. But he was still heavy in his cups. So, bidding her frightened girls be calm, Nancy lowered away a small rowboat, got into it, and rowed as for dear life to the shore at Albina, an East Portland suburb. There, with great speed, she awoke a stern-wheeler captain and talked him into immediate action. He roused his crew and, with Nancy aboard, they set out to get lines to the heaving scow. Then, with Nancy standing staunch and bold as a figurehead at the head of her scow, it was towed back upstream and anchored at its accustomed and proper place in the middle of Portland harbor. I doubt that it was gone long enough to have lost a dollar in trade.

Miss Boggs continued in business until conditions warranted a move to

dry land, and even there she did very well, it is said, but with less gusto than in her scow days.

The Burnside Street bridge across the Willamette bears a marker telling how the Messrs. Lewis & Clark, explorers, reached that point in their voyage up the Willamette. I think a small footnote could well grace the plaque. It would relate that here was anchored for several years what was doubtless the first whisky scow in all the Far West, operated for the refreshment of travelers and the benefit of Miss Nancy Boggs, able mariner and a notable grower of fine roses in the city whose slogan is: "For you a rose in Portland grows."

RUDYARD KIPLING

The life of Rudyard Kipling (1865–1936) corresponded with the British Empire at its height. Born in Bombay, India, he was poet laureate of England in 1895 and was awarded the Nobel Prize for Literature in 1907 and the Gold Medal of the Royal Society of Literature in 1926. Both Kipling and Mark Twain visited Portland just before the turn of the twentieth century; but unlike Twain, who stayed in the Portland Hotel and offered only mild recommendations that Portland macadamize its streets and build a new train depot, Kipling wrote a scathing commentary on the growing city's infrastructure and its mercantile crassness. As the literary voice of the late Victorian Age and the author of newspaper articles and poetry, novels, and short stories, Kipling's authority was inestimable, and his standards for a civilized society would have been sobering. His observations in From Sea to Sea: Letters of Travel *(1906) contradict local newspapers' boasts about the grandeur of the city of 50,000 people by dwelling on the lack of proper sewage and paving, not to mention a shooting that took place just before his visit.*

From *From Sea to Sea*

The descent brought us far into Oregon and a timber and wheat country. We drove through wheat and pine in alternate slices, but pine chiefly, till we reached Portland, which is a city of fifty thousand, possessing the electric light of course, equally, of course, devoid of pavements, and a port of entry about a hundred miles from the sea at which big steamers can load. It is a poor city that cannot say it has no equal on the Pacific coast. Portland shouts this to the pines which run down from a thousand-foot ridge clear up to the city. You may sit in a bedizened bar-room furnished with telephone and clicker, and in half an hour be in the woods.

Portland produces lumber and jig-saw fittings for houses, and beer and buggies, and bricks and biscuit; and, in case you should miss the fact, there

are glorified views of the town hung up in public places with the value of the products set down in dollars. All this is excellent and exactly suitable to the opening of a new country; but when a man tells you it is civilisation, you object. The first thing that the civilised man learns to do is to keep the dollars in the background, because they are only the oil of the machine that makes life go smoothly.

Portland is so busy that it can't attend to its own sewage or paving, and the four-storey brick blocks front cobble-stones and plank sidewalks and other things much worse. I saw a foundation being dug out. The sewage of perhaps twenty years ago had thoroughly soaked into the soil, and there was a familiar and Oriental look about the compost that flew up with each shovel-load. Yet the local papers, as was just and proper, swore there was no place like Portland, Oregon, U.S.A., chronicled the performances of Oregonians, "claimed" prominent citizens elsewhere as Oregonians, and fought tooth and nail for dock, rail, and wharfage projects. And you could find men who had thrown in their lives with the city, who were bound up in it, and worked their life out for what they conceived to be its material prosperity. Pity it is to record that in this strenuous, labouring town there had been a week before, a shooting-case. One well-known man had shot another on the street, and was now pleading self-defence because the other man had, or the murderer thought he had, a pistol about him. Not content with shooting him dead, he squibbed off his revolver into him as he lay. I read the pleadings, and they made me ill. So far as I could judge, if the dead man's body had been found with a pistol on it, the shooter would have gone free. Apart from the mere murder, cowardly enough in itself, there was a refinement of cowardice in the plea. Here in this civilised city the surviving brute was afraid he would be shot—fancied he saw the other man make a motion to his hip-pocket, and so on. Eventually the jury disagreed. And the degrading thing was that the trial was reported by men who evidently understood all about the pistol, was tried before a jury who were versed in the etiquette of the hip-pocket, and was discussed on the streets by men equally initiate.

But let us return to more cheerful things. The insurance-agent introduced us as friends to a real-estate man, who promptly bade us go up the Columbia River for a day while he made inquiries about fishing. There was no overwhelming formality. The old man was addressed as "California," I answered indifferently to "England" or "Johnny Bull," and the real-estate man was "Portland." This was a lofty and spacious form of address.

So California and I took a steamboat, and upon a sumptuous blue and gold morning steered up the Willamette River, on which Portland stands, into the great Columbia—the river that brings the salmon that goes into the tin that is emptied into the dish when the extra guest arrives in India. California introduced me to the boat and the scenery, showed me the "texas," the difference between a "tow-head " and a "sawyer," and the precise nature of a

"slue." All I remember is a delightful feeling that Mark Twain's Huckleberry Finn and Mississippi Pilot were quite true, and that I could almost recognise the very reaches down which Huck and Jim had drifted. We were on the border line between Oregon State and Washington Territory, but that didn't matter. The Columbia was the Mississippi so far as I was concerned. We ran along the sides of wooded islands whose banks were caving in with perpetual smashes, and we skipped from one side to another of the mile-wide stream in search of a channel, exactly like a Mississippi steamer, and when we wanted to pick up or set down a passenger we chose a soft and safe place on the shore and ran our very snub nose against it. California spoke to each new passenger as he came aboard and told me the man's birthplace. A long-haired tender of kine crashed out of the underwood, waved his hat, and was taken aboard forthwith. "South Carolina," said California, almost without looking at him. "When he talks you will hear a softer dialect than mine." And it befell as he said: whereat I marvelled, and California chuckled. Every island in the river carried fields of rich wheat, orchards, and a white, wooden house; or else, if the pines grew very thickly, a sawmill, the tremulous whine of whose saws flickered across the water like the drone of a tired bee. From remarks he let fall I gathered that California owned timber ships and dealt in lumber, had ranches too, a partner, and everything handsome about him; in addition to a chequered career of some thirty-five years. But he looked almost as disreputable a loafer as I.

"Say, young feller, we're going to see scenery now. You shout and sing," said California, when the bland wooded islands gave place to bolder out-lines, and the steamer ran herself into a hornet's nest of black-fanged rocks not a foot below the boiling broken water. We were trying to get up a slue, or back channel, by a short cut, and the stern-wheel never spun twice in the same direction. Then we hit a floating log with a jar that ran through our system, and then, white-bellied, open-gilled, spun by a dead salmon—a lordly twenty-pound Chinook salmon who had perished in his pride. "You'll see the salmon-wheels 'fore long," said a man who lived "way back on the Wash-oogle," and whose hat was spangled with trout-flies. "Those Chinook salmon never rise to the fly. The canneries take them by the wheel." At the next bend we sighted a wheel—an infernal arrangement of wire-gauze compartments worked by the current and moved out from a barge in shore to scoop up the salmon as he races up the river. California swore long and fluently at the sight, and the more fluently when he was told of the weight of a good night's catch—some thousands of pounds. Think of the black and bloody murder of it! But you out yonder insist in buying tinned salmon, and the canneries cannot live by letting down lines.

About this time California was struck with madness. I found him dancing on the fore-deck shouting, "Isn't she a daisy? Isn't she a darling?" He had

found a waterfall—a blown thread of white vapour that broke from the crest of a hill—a waterfall eight hundred and fifty feet high whose voice was even louder than the voice of the river.

JOAQUIN MILLER

Born in Indiana, Cincinnatus Hiner Miller (1839–1913) trekked westward on the Oregon Trail with his family in 1852 and settled in the Willamette Valley. He pursued a career of adventuring in Northern California and the Oregon and Washington territories, including prospecting for gold and spending time with Native Americans. After a scrap with the law, Miller adopted the pseudonym Joaquin, possibly after the Mexican outlaw/folk-hero Joaquin Murietta. In his twenties, he married Oregon poet Theresa Dyer (pen name Minnie Myrtle) and began writing for newspapers and submitting poems and stories to such magazines as The Overland Monthly. *After a contentious divorce, Miller moved to San Francisco to make his literary fame among the likes of Bret Harte and Mark Twain. His reputation as a Western writer was sealed through his volume of poems* Songs of the Sierras *(1871). Called the "Poet of the Sierras" and the "Byron of Oregon," Miller was one of the most popular myth-makers of the American West, and his poetry, fiction, and nonfiction were characterized by an action-filled romanticizing of western landscapes and their inhabitants. This excerpt is from his autobiographical* Memorie and Rime *(1884).*

The New and the Old

The careless and happy Indians who used to ride in a long bright line up and down the land and past the door, laughing at our little fence as they leaped their ponies over the few rails that cost us so much labor, now ride only on the ghostly clouds. There is not one left now in all the land.

The vast level valley before us at the base of this long and lonely ridge of flowers and fruit and sunny water, is a waving wheatfield now, and houses, little palaces of peace and refinement, even of splendor, dot the land as thick as stars in heaven at night under the strangely perfect skies. And the thousand square miles of hyacinth blossoms that made blue like the skies this whole valley for months together, have given place to a shield of gold on our mother's breast.

And so the world goes on. The wheels of progress have rolled over the graves of the pioneers and they are level as the fields of golden grain. And it is well. Even the marble tombs of the strange and strong new people—paving their way with gold where we came long ago with toil and peril—even these will be levelled, as our graves are levelled, and give place to others.

The world is round. Let us look forward. Yet what is there that is lovely, what is there to love in this new tide of people pouring in upon us with their airs and their arrogance? They despise us and our primitive ways. Yet their hard examples give us little encouragement to abandon our ways and accept theirs.

Nothing ever happened so disastrous to the Pacific States as the building of the Pacific Railroad. It became at once a sort of syphon, which let in a stream of weak and worthless people, and gave the brave young States here all the vanities and vices of the East, with none of the virtues.

The isolation of this country, the valor, the virtues, and the unusual wealth of the people—all these gave it an elevation and splendor that no land in so short a time ever attained. Even the literature began to have a flavor and individuality all its own. But all this became neutralized, passed away and perished, when men came and went so easily to and from the Pacific States.

Monopolists came and laid hands on the lands, the mines, the cattle—indeed, all things; and made, or attempted to make the men, gray and grizzled old pioneers, hewers of wood and drawers of water.

Even our seaport, which ought to be a great commercial city, is sick and gloomy and sad. She looks like a ship at half-mast.

It is not the immigration of Chinamen; for the Chinaman is not in any sense of the word an immigrant. He does not come to stay. I think it would be much better for the country if he did. If the Chinese could be treated so that their better class would come, and bring money, and remain, instead of having their laborers only come, to get hold of a few dollars and then return, I think the Chinese question would be satisfactorily solved.

But the real trouble began in gambling. When the railroad brought Wall Street it brought that which was tenfold more fatal than any plague ever brought us from an infected port. This spirit of speculation led honest men from their work in the mines to the cities. Nine men out of ten of them perished—either financially, morally, or physically. Perhaps the tenth man—the coarsest, the grossest, and hardest—held out, got hold of millions, and became a king.

But Oregon proper is a sort of nut—a nut with a sweet, rich kernel, but also with a bitter bark and rind—through which you have to gnaw in order to reach the kernel. Portland is the bark or rind. The rich heart of the richest young State in the Union lies nearly two hundred miles in the interior. Portland sits at the sea-door—the very gates of the State—taking toll of him that comes and him that goes. The Orient has met the Occident here in this westmost town. One of these new men, a speculator in town lots and land, who was clad in a slouch hat and enormous mud-boots reaching almost to the knees, approached me in Portland. He carried an umbrella thrust up under his arm, while his two fore-fingers hooked and wrestled resolutely

together as he stood before me. He chewed tobacco violently, and now and then fired a brown stream far up and down the new pine sidewalk.

"Can't you put this city into poetry? Yes, you kin. What's poetry good for, if it can't rize the price of land? Jist tell 'em we never had a shake. Yes, an' tell 'em that the old men never die; but jist git kivered with moss and blow away. An' tell 'em—yes, tell 'em that the timber grows so tall that it takes a man an' two small boys to see to the top of a tree! Yes, an' tell 'em that we have to tie poles to the cows' horns, to let the wrinkles run out on. Yes, biggest country, richest country an' dogondest healthiest country this side of Jericho! Yes, it is."

Drip! drip! drip! The rain put a stop to the man's speech. But he shall not be forgotten, for I had sketched him, from his prodigious boots to the very tobacco-stained beard, long before he gave his last testimony of the health and wealth of his chosen home.

Drip! drip! drip! Slop! slop! slop! incessantly and all the time, for an uninterrupted half a year, here in this mossy, mouldy town of Portland. Rain! rain! rain! until the trees grow out of the cracks and roofs of the houses, and until, tradition says, Mother Nature comes to the aid of the inhabitants and makes them web-footed, like the water-fowl. And even then, and in the face of all this, this man stood up before me with the water fairly bending his umbrella from the weight of the rain—the rain running down his nose, his head, his hair—and there he smilingly bowed and protested that it did not really rain much in Portland; but that down about the mouth of the Columbia, at Astoria, it did "sometimes rain a-right smart."

No, I don't like the new money-getting strangers. But the pioneers here were giants. Look at a piece of their gold! These men fashioned their own coin, as no other part of this Republic ever did. They coined it out of pure gold, without alloy, and stamped on its face the figure of a beaver and sheaves of wheat, the signs of industry and plenty. Its device of toil and harvest heralded it. Its intrinsic worth and solid value placed it above the need of any other indorsement. The wars, the trials, and the achievements of these men mark a shining bit of history. There is nothing nobler in the annals of the bravest and oldest States in the Union than the achievements of this State of Oregon.

JOEL REDON

Born in Portland, Joel Redon (1961–1995) attended high school in Lake Oswego and studied writing at New York University. Redon's family ties to Oregon stretch back several generations, and his series of novels explores that rich and complicated history. His novels include Bloodstream *(1989), an autobiographical novel about a young gay man with AIDS returning to his family in Oregon, and* If Not on Earth, Then in Heaven *(1991), an account of his grandparents' courtship. In this excerpt from* The Road to Zena *(1992), the story of the author's great-great aunt's illness and failed love affair in turn-of-the-century Portland, Redon describes the character Mae as she arrives at the Portland train station in 1901, seeking a job as a schoolteacher in the rough-and-tumble city.*

From *The Road to Zena*

When Mae arrived in Portland, on a bright, sunshiny morning in September 1901, flowers were still blooming in several small parks in the downtown area. The grass was freshly clipped and everyone was well dressed, all in a hurry to go somewhere. She was no exception. When the train stopped at Union Station that morning, amid a great cloud of steam and an angry clanging of bells, she stepped onto the ground of a modern exciting world, where progress and education most surely mattered, and where animals and dirt farmers were nowhere to be seen. She breathed deeply, as if for the first time in her short life.

A brakeman in a blue uniform and a brown straw hat had placed a small stepladder before the vestibule doorway and extended his hand to help her down. He even offered to help her with her trunk, but she refused. "I'll get a cab," she said, "and the driver will carry it." People of every description, including swarms of children, clambered down the steps behind her. Just then a young boy started to run and bumped into her. She fell, knocking off her hat with its eighteen-inch-wide floppy brim. Then her hair, puffed up and held with hairpins, came loose. Her white gloves were impossibly soiled. The conductor himself rescued her and tried to assist her in getting a cab. "I know how to handle children," she told him, "that's my job. They tend to be hasty. They mean no harm."

As she stood outside the station, she smelled the odors of the roundhouse where the trains were kept for repairs, the sawmills and factories, as well as the coal smoke from the train. She was certain that she could even smell sawdust. She looked up to the West Hills above the city, dark with trees, and she knew that despite the noise and the commotion, she was glad she'd come, and that she was eager to get on with her mission. How could I describe this all to Viv? she wondered. But then she knew that he must have been to Portland before, and that he would know her excitement.

As she waited patiently for the hansom cab, she looked out at the Willamette River, and saw the tall masts and spars of square-rigged sailing ships. Lumber schooners with as many as five masts stood tied at the docks. She could smell the produce, tar, and oakum, even the lumber, as she continued to wait, her long skirt soiled from when she'd tripped. Finally, when the cab came, she was so happy that she gave the driver a large tip when he took her to the Martha Washington Hotel for Women, a long, elegant white mansion, where she would stay during her exams and while she taught through the winter and spring.

After settling in at the hotel, she stopped to buy a postal card at a newsstand. She scribbled out a message to Vivian and addressed it to OAC in Corvallis. She couldn't help being excited for him, as he started his first year of college. Even she had never gone to college which, when she became a teacher, wasn't necessary. "Let me know everything," she wrote, "I think I'm as anxious as you are." She'd signed it: "from your loving girl, Mae."

As she made her way to the offices of the Portland School Board, she looked at the pretty gray bricks on the street that had all been laid out in a slanting direction, so that they dovetailed together nicely. But the streets were too bumpy for her to walk on with her high-buttoned, thin-soled shoes. Afraid of falling again, she kept to the sidewalks as much as possible, though other women were more adventuresome than she. All around her, as she drew closer to the offices, came shouts from the drivers, and the clang of the iron-shod horses and mules. There was the sound of the huge freight wagons, and the smell of manure everywhere. Streetcars ran along Third and Fifth Streets and up Washington and Morrison, bumper to bumper, grinding and roaring, creating sprays of brilliant sparks; the sound of the clanging gong, which the motormen rang, was deafening. At nearly every corner, a motorman would have to descend from his trolley, and with a rope, shift the wheel back onto its track.

When at last she arrived at the offices of the school board, she saw that a crowd of young women had already gathered for the teaching exams. Her spirits deflated as she took her seat with the others. After being outside in the great din, she was relieved that it was so quiet in the room when the test began; the only sound was the scratching that could be heard of pencil lead. She felt peaceful and sure of herself as she answered the questions.

Two hours passed before the exams were all completed. Isabelle, the girl next to her, talked to Mae as the girls waited to be informed when to return for their test results.

"I'm so disappointed," she told Mae. "Last year, all I could get were jobs outside of Portland, in those small schoolhouses that have wood stoves. I declined every position they offered me. If we didn't have money in the family, I should truly give up."

Mae felt panicky. "You mean we're not assured of positions in public schools here in the city?"

"You saw all the girls. You'll be lucky if you don't have to go out somewhere and stay with your students' families."

When they left, Isabelle gave Mae her address and told her to come by some afternoon to visit. Mae promised she would.

Outside, on the way back to her hotel—where she would soon spend all that she'd earned and saved over the past year—she was disgusted by the sight of so many drunkards. It wasn't enough that they looked and smelled so bad, they were aggressive, too. She smelled whiskey and beer in many of the doorways. Sailors, as well as lumberjacks and sawmill hands, staggered on the sidewalks. She glared at them when they tried to speak to her. Seedy-looking men streamed from every other shop entrance, which proved to be a saloon or a beer hall. As she passed the corner saloons with their swinging doors, she could hear loud voices raised and the slap of cards on green felt-topped tables. The City of Roses, she thought, scornfully, as she watched women leaving these saloons through the women's entrances. Even children were carrying home pails of beer. The sights disgusted her. "Oh, Viv," she would write later that evening, "I think Portland's main product is alcohol. You can't begin to believe it."

After dinner in the oak dining hall, with all the other young women, she went out again, ignoring the stern looks and warnings of the others. While she walked, she thought of Vivian; she wanted to try to chase from her mind any of the disillusionment that was creeping up on her. Perhaps she'd flunked the tests.

Thinking so deeply, she didn't even notice when she found herself in what was obviously the "red-light" district, on Fourth Street near Chinatown. North of Oak Street, on Fourth, she came to a row of two-story buildings. A woman sat in the window, her name, "Mercy," on a sign above her. Horrified, Mae began to walk quickly, past "the cribs" as they were called. These bordellos were so numerous that they seemed to dominate the business district: prostitution, an equal rival to the saloons. Even the women, standing near the saloons in skirts that were above their knees, frightened her. Where did Carry Nation find her unending strength? She decided to head away and go to Chinatown, across Burnside, where she would find a clean, bright restaurant and have a cup of tea. In her purse she carried the violet stationery she'd recently purchased for her letters to Vivian.

The pale glow of the street lamps grew brighter and more intense as the street noises grew louder. A drunken sailor called to her from across the street. "Eh, missy," he shouted, "what are ya' doin' here? Buying mittens?" She thought of answering him, but knew better. Wasted pearls, she said to herself as she hurried on, her breath coming in sharp gasps.

When she reached Chinatown she discovered it was inhabited mostly by men who kept to themselves. They wore their hair in a long braid in back of their heads with black ribbons at the end. Mae, who'd never seen this before, thought they were stylish. As she passed by their shops, she pretended that she was in a foreign land—Singapore or Shanghai. The sound of Cantonese, which she heard from the shops, sounded so melodic that she often stopped to listen. In Chinatown she wasn't the least bit afraid. She was delicate, but she was headstrong, and she'd faced enough unruly children to be free of the normal fear that most women might feel. The strings of exotic vegetables and the freshly slaughtered ducks hanging in the shops intrigued her, but she was, on the whole, put off by the meat, which seemed to be in advanced stages of decay. Dressed in their dark blue skirts that hung down below their trousers which looked like pajamas, the men were less offensive somehow than the Americans on the other side of Burnside Street. She liked the handsome young men about the open shops, certain that they would make dedicated students, so courteous and dignified. "Coolies," the Chinese working men who carried things, were polite, too, she found. They kept to themselves and hardly seemed to notice her at all, unless she bumped into one of them, and then they made quick apologetic signs.

She accidentally entered a "Joss House," a Chinese temple, with its altar and colorful tapestries inscribed with large black characters, and the heavy smell of incense. The Chinese people all stared at her, too surprised, she felt, to even speak. When finally she came to a restaurant and entered it, she saw everyone's head turn. Now it had happened again. Just as in the red-light district, she was in the wrong place. Laughing to herself, she left; her fear returned only when she had to cross the red-light district once more. There would be several weeks of waiting before she would hear her test results and be given a position. She only hoped that exploring the city would provide her with enough to do, and that her money would hold out until she received her first paycheck. She also hoped that Vivian would write to her soon and ease her curiosity.

That night, in bed, she felt the loneliness of the distance that had grown between herself and Dae. How long it seemed since they'd slept in the same bed, worn the same clothes. She thought of Zena, too, and the beauty of its hills and streams. I have gone very far, she thought, in her tiny room with its bath and indoor plumbing. I will make a great teacher, she decided, anxious to be assigned to a group of children, and I will inspire them so that their lives can become great.

Late into the night she pictured herself against the great backdrop of Portland, helping young people, teaching those who could not read to recite long passages from the Bible or the Gettysburg Address. At dawn she was fast asleep and she did not stir when the bell rang for breakfast.

E. KIMBARK MACCOLL

E. Kimbark MacColl (1925–) wrote three histories of Portland portraying its civic life and the interconnections of its economic growth, politics, and businesses: The Shaping of a City: Business and Politics in Portland, Oregon, 1885–1915 *(1976),* The Growth of a City: Power and Politics in Portland, Oregon, 1915 –1950 *(1979), and (with Harry Stein)* Merchants, Money, and Power: The Portland Establishment, 1843–1913 *(1988). A graduate of Princeton University, MacColl first came to Portland in 1953 to be an intern at Reed College under the auspices of a Ford Foundation grant. MacColl was director of admissions at Reed College until 1959, when he became head of Catlin Gable School, a position he held until 1967. In this excerpt from* The Shaping of a City, *MacColl gives an overview of Portland's early growth, business vicissitudes, and political pangs.*

A Wide Angle View

From the time of its incorporation in 1851, Portland was a cumulative growth city. Although the founding fathers did lay out an initial grid of 200 foot square blocks, thus setting the pattern for future downtown development, much of the growth was by chance rather than by design. As with the majority of Western American cities, Portland grew by means of the gradual accretion of individual entrepreneurs and by the rapid and often disorderly accumulations of speculators.

By the mid-1870's Portland had achieved an enviable reputation as a handsome city, but mostly because of its unique natural setting. Recalling his first day in Portland during July of 1874, railroad magnate Henry Villard was later to write:

> "I had heard much praise . . . of Portland, but its attractiveness went beyond my anticipations. [From Marquam Hill] The grand panorama I saw spread out before me from that height with the three snow-clad giants of Mt. Hood, Mt. St. Helens, and Mt. Adams clearly visible in their mighty splendor, seemed to me one of the finest sights I had ever enjoyed. The city . . . appeared to contain . . . an unusual number of large and solid business buildings and handsome private residences. There was also a great deal of activity in the streets and on the river, indicating thriving business; altogether, Portland was surpassed in few respects by any other city in the United States that I knew."

Historian John Fiske likened Portland to a New England town and its residents comparable to "New England folks." One visitor after another commented about the quality and comfort of the homes. The public facilities, however, left much to be desired. The *Oregonian* in 1889 bemoaned the

unsanitary conditions in the sewers and gutters, "the most filthy city in the Northern States." The city's extensive "home-made" wooden sidewalks provoked the *West Shore* to report: "The new sidewalks put down this year are a disgrace to a Russian village."

In 1891, Portland was observed by *Oregonian* editor Harvey Scott to be a "well balanced, civic and social organism" with few of the problems faced by the large Eastern cities: minimum geographic social segregation, no dirty industry, little permanent unemployment, and few unassimilated immigrants except for the Chinese colony. As a visitor from New Orleans had written in 1888: "The muddy current of common immigration flowing across the Atlantic from Europe drops its silt on the Atlantic slope and in the valley of the Mississippi. This raw, un-American material is too heavy with poverty and ignorance to reach Oregon." Practically no slum type dwellings existed outside of the North End—the "White Chapel" district—that was viewed primarily as a transient area where vice and gambling, although illegal, were accepted as normal activities as long as they were not too openly disreputable.

On the West side of the river the city was compact except for the wealthier neighborhoods developing in the hills and on the fringes of downtown. Even after the merger of 1891, when the built-up areas on the East side were consolidated with old Portland on the West side, the city of 62,000 encompassed only 26 square miles, (about 32 percent of its 1976 size) with a low population density of 2100 per square mile. Writing in 1893, the Rev. H.K. Hines commented that Portland was "so new, and yet so old."

> "Approaching it by the river but little can be seen of it but a long, low range of docks and wharves by the side of which are lying scores of steamers, or before them are anchored many ships of the sea. The impression is disappointing. The steep hills to the west seem almost to impend over the city, which appears to rest on a narrow shelf of land at their base, but a little elevated above the tide. As one steps ashore and rises into the streets, and looks up and down and out, between the long rows of stores and hotels, rising for six or ten stories, of massive form and splendid architecture, and sees the ceaseless stream of comers and goers, the flashing by of hundreds of electric cars, and listens to the ceaseless roar of business, the illusion of the first impression vanishes, and he awakens to find himself in the heart of a great commercial emporium."

Portland prided itself on its unique character, molded in part by this thriving commercial life. It was a city of broad based wealth (one national study claimed it to be the third richest in the world in proportion to population), a development due largely to the character and background of its pioneers. The influence of the small town in New England, Pennsylvania, New Jersey,

New York, and Ohio; the particular personal traits of the German-Jewish, Scottish and English immigrants; the conservative financial practices which eschewed credit for cash; the pursuit of sound investment instead of risky speculation; a commitment to public education; a concern for cultural matters; a dislike of ostentation; all blended together to give Portland a special quality of affluence, tempered by civility and good taste.

What was not unique about Portland was the fact that it was a corrupt city, corrupted in part by the very success and power of its wealthiest pioneer families and some of their newly arrived associates. Below the veneer of respectability was a system of dirty politics in which the "plutocrats" would not deign to soil their hands, at least directly. Vice, gambling and liquor were profitable enterprises, especially to those members of Portland's establishment who owned the property but who did not feel any personal responsibility for its use. As the late New York Rabbi Stephen Wise was to comment in his *Challenging Years,* reflecting back on his early rabbinate in Portland:

> "I came into closer touch with the things out of which grew lawless power of civic corruption. It was the union of gambling and liquor interests plus organized prostitution, which, in collusion with city officials and above all with the police department, poisoned and corroded the life of the city. The hold of these forces upon the city's life was fully known to the acquiescent and rather cynical population, which seemed to take it for granted that organized vice was entitled to no small part in managing the city and its affairs."

The major corruption afflicting both Portland and Oregon stemmed from the inability or unwillingness of the business-political leadership to distinguish between two antagonistic interests—the public and the private. The granting of undue privileges to any person, group, or corporation was a corrupt practice, warned the renowned United States Prosecutor Francis Heney in 1905 when he told some of Portland's eminent lawyers and business leaders: "You men corrupt all you touch." Heney cited the activities of the vice interests and the railroads as the major sources of corruption. The system was the demon. It could corrupt any individual, no matter how sincere, distinguished, or personally honest. One could become corrupted by association, by pressure, or by indifference to the ethical distinction between means and ends in human behavior. The protection of private interests and access to power and influence were strong motives. Henry Reed, an acute observer of the Portland scene for over 50 years, spoke to the same issue raised by Heney when he said: "Business in this world is not done according to the Golden Rule . . . Businessmen . . . (in general) . . . adopt that course which offers them the greatest profits or the greatest satisfaction."

To most citizens, the purpose of city government, apart from the custom-

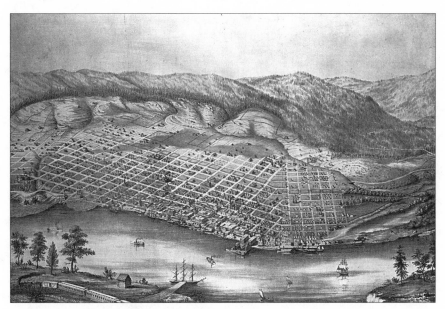

A bird's-eye view of Portland in 1870, by N.F. Castleman

ary attempts to preserve a modicum of law, order, and health, was to serve economic development. This was a legitimate tradition in keeping with the American credo. It was only natural, therefore, that those men who achieved material success through the free enterprise system would receive public acclaim and be given community—especially political—leadership roles.

In the 30 year period under review, most of the public decisions reached by the Portland City council were in reality compromises between competing private economic interests. Although the city was over 80 percent Republican in registration, few of the decisions were determined on the basis of party affiliation alone; most were arrived at by personal agreement among friends regardless of party. Portland, as with the rest of Oregon, had long experienced a tradition of personalized politics. The decisions reached were based more on the personal relationships involved than on the intrinsic merits of the issues.

The introduction of the statewide direct primary in 1904 and the preferential voting system of the new city charter in 1913 tended to diminish the strength of party discipline. The Initiative, which together with the Referendum had been approved in 1902, was instrumental in the passage in 1908 of a law that required all candidates for the state legislature to commit themselves formally in advance of the general election as to whether or not they would be bound to support the U.S. Senate candidate receiving the

largest number of votes in that election. This change in traditional political procedure weakened party loyalty even further. Thus, the power of the local political machines was greatly diminished by 1915. How else can one explain the election of Democrats Harry Lane as Mayor (1905–1909), and as U.S. Senator (1913); George Chamberlain as Governor (1903–1909), and as U.S. Senator (1909), and Oswald West as Governor (1911–1915)? All three played important roles in Portland's political life while they held office. They were rare public leaders who clearly saw the distinction between public and private interests. They were products as well as initiators of the reform reaction associated with the Progressive Era.

Lane, West, and Chamberlain were genuine public servants—leaders who told the people the truth as they saw it. The city councils and legislatures, on the other hand, were composed of middle to upper middle class citizens with narrow geographic and economic concerns. They could be expected to follow the paths of least resistance, normally taking their cues from special interests. The nature and composition of the city council did change over the 30 year period. The direct influence and participation of the city's elite in political life diminished, but until 1913 the votes were assured by pressure, favor and sometimes bribery. The reforms of the Progressive Era were primarily technical in nature. Although they did clean up the city council chambers they produced no fundamental changes in the business-political power relationship.

With the exception of Mayor Harry Lane, none of Portland's leaders during the period 1885–1915 foresaw the long-term consequences of many of the political and business decisions that led subsequently to much of today's urban disorder and physical blight. As with most of America's urban development, Portland's growth was—and still is—dominated by the concept of the sanctity of private land ownership. Private property, including that held by corporations, has been considered a civil liberty, not a public or social resource. The prevailing maxim of American city growth has been "life, liberty and the pursuit of the dollar," or, as the late international city planner Constantine Doxiades put it, "human greed."

Early in this century, J. P. Morgan associate George F. Baer, President of the Reading Railroad, made the classic remark about how "God, in his infinite wisdom," had "given the control of property interests of the country" to "Christian men" who proceeded to manage them. In 1910, *Oregonian* Editor Harvey Scott, an active investor in his own right, wrote on a parallel theme when he editorialized: "Every city should leave to private enterprise the active industries, on which development depends" otherwise the city will "advance to a socialistic system." Also in 1910, railroad lawyer and Oregon historian Joseph Gaston accurately expressed the prevailing attitude of Portland's business leadership when he wrote: "The growth of a city does not depend so much upon its machinery of government or even upon the

men who fill the public offices as upon those who foster the trade relations and promote commercial activity." In retrospect, the then widely accepted truth of Gaston's statement has been borne out by historical events. Sixty-five years ago, few questioned the notion that growth and progress were synonymous.

Lewis Mumford was given scant attention when he spoke to the Portland City Club in 1938. He admonished Oregonians for having been asleep in failing to protect their natural resources. "The Columbia land that needed to be controlled most vigorously has already been grabbed up. Certain persons are licking their chops and counting their gold," he declared, pointing to landowners who were busy making eyes at industrial leaders. Only in recent times has enlightened business leadership begun to see that a system of unrestricted economic growth might not result in progress; that it might contain the seeds of its own destruction.

STEPHEN DOUGLAS PUTER

The leader of the infamous Oregon land fraud ring, Steven Douglas Puter (1857–?) confessed while in prison for his misdeeds, for which he received a presidential pardon in 1907. Horace Stevens (1858–?), who collaborated on Puter's wry, nonfictional account of the scheme, Looters of the Public Domain *(1909), was careful in his preface to spare the city of Portland any guilt by association with the fraud. "Portland," he wrote, "more beautiful than Palmyra of old, with a moral refinement and culture that shines with lustrous brilliancy in the galaxy of Northwestern cities, and famed as the most healthy municipality of the world in civic and climatic conditions, had no important share in these land frauds, after all the aspersions that have been heaped upon her fair name." Yet, this excerpt from* Looters, *about an incident that occurred during President Theodore Roosevelt's whistle stop in the city in the spring of 1903, shows that Portland held room for the shenanigans of former land commissioners.*

History of the Picture that Elected Hermann to Congress

One of the most brazen efforts to gain cheap notoriety ever recorded is portrayed in the illustration, revealing President Roosevelt in the act of delivering a rear-platform speech, with Binger Hermann, the disgraced former Land Commissioner, standing complacently by his side, as if ordained to assist in courting the plaudits of the multitude.

Those unfamiliar with the relations existing between the two at the time would very naturally assume that the Ex-Commmissioner of the General

Theodore Roosevelt with Binger Hermann

Land Office was the favored companion of the President upon this auspicious occasion, and that the Chief Executive found an affinity-like pleasure in his presence. As a matter of fact, he was simply a skeleton at the feast, and had appeared unbidden upon the scene at a moment when the photographer for a local newspaper was about to snap his camera.

During President Roosevelt's tour of the West in the Spring of 1903, his itinerary included a visit to Portland, Oregon, and by some unexplained hocus-pocus, Hermann, who resides at Roseburg, in the southern part of the State, and was a candidate upon the Republican ticket for representative from the First Congressional District of Oregon, had smuggled himself on board the Presidential train, and with an exhibition of that rare quality of pure and unadulterated audacity that has invariably been the Ex-Land Commissioner's principal stock in trade, had ensconced himself in the private car

of Mr. Roosevelt, who, but a short time previously, had unceremoniously ousted Hermann from office on account of his crooked transactions.

As the train moved into the depot at Portland, a vast concourse of citizens had assembled to pay its respects to the distinguished visitor, and, in response to the popular demand, the President appeared upon the rear platform and proceeded to deliver one of his characteristic addresses. At this juncture, H.M. Smith, a member of the art department of the *Evening Telegram*, set his camera in position, with a view of taking an interesting scene. The arrangements of the photographer were not lost to the eagle eyes of Mr. Hermann, who discerned in the situation a golden opportunity for retrieving his rapidly fading political fortunes.

With an acumen worthy of a better cause, Hermann timed his arrival coincident with the photographer's operations, and the two men are shown as if on terms of the utmost intimacy.

Not content with the veneering of fame thus obtained, Hermann had enlarged copies of the picture circulated broadcast throughout his Congressional District, with the result that he was triumphantly elected, as President Roosevelt has always been such a popular idol in the Oregon country that Hermann's constituents were under the impression they were doing the Chief Executive a personal favor by sending the deposed Land Commissioner to a seat in the legislative halls of the nation; general publicity to the reasons for his removal from office not having been given at this time.

Hermann's connection with the incident mentioned, is on a par with his conduct at the time he first appeared before the Federal Grand Jury of Oregon that returned indictments against him afterward. He had been called to give testimony in his own behalf in one of the several cases under consideration against himself, and as Hermann entered the Grand Jury room, he threw his right arm familiarly over the shoulders of Special Assistant Heney, who preceded him, as if the latter were his bosom companion, and in this manner stalked majestically into the presence of the inquisitorial body, much to Heney's unconcealed disgust. In fact, the most plausible explanation as to why the Ex-Land Commissioner refrained from maintaining a continuous loving embrace of the Government prosecutor throughout the entire proceedings exists in the belief that the rear portion of Heney's neck was becoming too warm for further comfort.

ANONYMOUS

This anonymous account appeared in 1905 in the magazine Independent. *In a socially progressive muckraking spirit and a tone of condescension, the magazine editor offered this note as an introduction: "Those who have wondered what was behind the uniform politeness and unreadable face of a Japanese servant will be interested in the very frank confession of one, whose preconceived ideal of America as a land of opportunity and equality has been disproved by his experiences here. We have not made any alterations in the manuscript, for his occasional use of Japanese idioms and of bookish English makes his narrative all the more personal and naïve. He requests us to withhold his name, but possibly some of his employers will recognize themselves as seen in a Japanese mirror."*

The Life Story of a Japanese Servant

The desire to see America was burning at my boyish heart. The land of freedom and civilization of which I heard so much from missionaries and the wonderful story of America I heard of those of my race who returned from here made my longing ungovernable. Meantime I have been reading a popular novel among the boys, "The Adventurous Life of Tsurukichi Tanaka, Japanese Robinson Crusoe." How he acquired new knowledge from America and how he is honored and favored by the capitalists in Japan. How willingly he has endured the hardships in order to achieve the success. The story made a strong impression on my mind. Finally I made up my mind to come to this country to receive an American education.

I was an orphan and the first great trouble was who will help me the expense? I have some property my father left for me. But a minor has not legally inherited, hence no power to dispossess them. There must be at least 200 yen for the fare and equipment. While 200 yen has only exchange value to $100 of American gold, the sum is really a considerable amount for a boy. Two hundred yen will be a sufficient capital to start a small grocery store in the country town or to start a prospective fish market in the city. Of course, my uncle shook his head and would not allow me to go to America. After a great deal of difficulty and delay I have prevailed over his objection. My heart swelled joy when I got a passport, Government permission to leave the country, after waiting thirty days investigated if really I am a student and who are the guardians to pay money in case of necessity. A few days later I found myself on board the *Empress of Japan*, of the Canadian Pacific Line. The moment steamer commence to leave Yokohama I wished to jump back to shore, but was too late and I was too old and ashamed to cry.

After the thirteen days' weary voyage we reached Victoria, B.C. When I have landed there I have disappointed as there not any wonderful sight to be seen not much different that of foreign settlement in Yokohama. My

destination was Portland, Ore., where my cousin is studying. Before I took a boat in Puget Sound to Tacoma, Wash., we have to be examined by the immigration officer. To my surprise these officers looked to me like a plain citizen—no extravagant dignity, no authoritative air. I felt so envious, I said to myself, "Ah! Indeed this is the characteristic of democracy, equality of personal right so well shown." I respect the officers more on this account. They asked me several questions. I answered with my broken English I have learned at Yokohama Commercial School. Finally they said: "So you are a student? How much money have you at hand?" I showed them $50. The law requires $30. The officers gave me a piece of stamped paper—certificate—to permit me go into the United States. I left Victoria 8 P.M. and arrived Tacoma, Wash., 6 A.M. Again I have surprised with the muddy streets and the dirty wharf. I thought the wharf of Yokohama is hundred times better. Next morning I left for Portland, Ore.

Great disappointment and regret I have experienced when I was told that I, the boy of 17 years old, smaller in stature indeed than an ordinary 14 years old American boy, imperfect in English knowledge, I can be any use here, but become a domestic servant, as the field for Japanese very narrow and limited. Thus reluctantly I have submitted to be a recruit of the army of domestic servants of which I ever dreamed up to this time. The place where I got to work in the first time was a boarding house. My duties were to peel potatoes, wash the dishes, a few laundry work, and also I was expected to do whatever mistress, waitress and cook has told me.

When I first entered the kitchen wearing a white apron what an uncomfortable and mortifying feeling I experienced. I thought I shall never be able to proceed the work. I felt as if I am pressed down on my shoulder with loaded tons of weight. My heart palpitates. I did not know what I am and what to say. I stood by the door of kitchen motionless like a stone, with a dumbfounded silence. The cook gave me a scornful look and said nothing. Perhaps at her first glance she perceived me entirely unfit to be her help. A kindly looking waitress, slender, alert Swedish girl, sympathetically put the question to me if I am first time to work. She said, "Oh! well, you will get learn and soon be used to it!" as if she has fully understand the situation. Indeed, this ordinary remarks were such a encouragement. She and cook soon opened the conference how to rescue me. In a moment I was to the mercy of Diana of the kitchen like Arethusa. Whistling up the courage I started to work. The work being entirely new and also such an unaccustomed one, I felt exceedingly unpleasant and hard. Sonorous voice from the cook of my slowness in peeling potatoes often vibrated into my tympanum. The waitress occasionally called out for the butter plates and saucers at the top of her displeasing voice. Frequently the words "Hurry up!" were added. I always noticed her lips at the motion rather than hands. The proprietor, an old lady, painstakingly taught me to work how. Almost always commencing

the phrase "I show you" and ending "Did you understand?" The words were so prominently sounded; finally made me tired of it and latter grew hated to hear of it. Taking the advantage of my green hand Diana of kitchen often unloaded hers to me. Thus I have been working almost all the time from 5:30 A.M. to 9 P.M. When I got through the day's work I was tired.

Things went on, however, fairly well for the first six days, forgetting my state and trying to adapt my own into the environment. But when Sunday come all my subsided emotions sprung up, recollecting how pleasantly I used spend the holidays. This memory of past pleasure vast contrast of the present one made me feel ache. What would the boys in Japan say if they found me out. I am thus employed in the kitchen receiving the orders from the maid-servant whom I have once looked down and thought never to be equal while I was dining at my uncle's house. I feel the home-sick. I was so lonesome and so sorry that I came to America. Ignoring the kind advice of my friends, rejecting the offer of help from my uncle at home, quickened by my youthful sentiment to be the independent, and believing the work alone to be the noble, I came to this country to educate myself worthy to my father's name. How beautiful idea it was while it existed in imagination, but how hard it is when it came to practice. There was no honor, no responsibility, no sense of duty, but the pliancy of servitude was the cardinal requirement. There is no personal liberty while your manhood is completely ignored.

Subduing my vanity, overcoming from the humiliation and swallowing down all the complaints, weariness and discouragement, I went on one week until Sunday. In spite of my determination to face into the world, manly defending my own in what I have within, together with my energy and ability, I could not resist the offspring from my broken-hearted emotions. Carrying the heavy and sad heart was simply dragged by the day's routine work. The old lady inquired me if I am not sick. I replied, "No." Thank enough for a first time she gave me a chance to rest from one o'clock to four afternoon. Sooner I retired into my room, locked the door, throwing the apron away. I cast myself down on the bed and sobbed to my heart contention. Thus let out all my suppressed emotion of grief from the morning. You might laugh at me, yet none the less it was a true state of my mind at that moment. After this free outburst of my passion I felt better. I was keenly felt the environment was altogether not congenial. I noticed myself I am inclining considerably sensitive.

After I stay there about ten days I asked the old lady that I should be discharged. She wanted me to state the reason. My real objection was that the work was indeed too hard and unpleasant for me to bear and also there were no time even to read a book. But I thought it rather impolite to say so and partly my strange pride hated to confess my weakness, fearing the reflection as a lazy boy. Really I could not think how smoothly I should tell

my reasons. So I kept silent rather with a stupefied look. She suggested me if the work were not too hard. It was just the point, but how foolish I was; I did positively denied. "Then why can you not stay here?" she went on. I said, childishly, "I have nothing to complain; simply I wants to go back to New York. My passion wants to." Then she smiled and said, "Poor boy; you better think over; I shall speak to you to-morrow." Next day she told me how she shall be sorry to lose me just when I have began to be handy to her after the hard task to taught me work how. Tactfully she persuaded me to stay. At the end of second week I asked my wages, but she refused on the ground that if she does I might leave her. Day by day my sorrow and regret grew stronger. My heavy heart made me feel so hard to work. At that moment I felt as if I am in the prison assigned to the hard labor. My coveted desire was to be freed from the yoke of this old lady. Believing the impossibility to obtain her sanction, early in the next morning while everybody still in the bed, I hide my satchel under the bush in the back yard. When mistress went on market afternoon, while everybody is busy, I have jumped out from the window and climbed up the fence to next door and slip away. Leaving the note and wages behind me, I hurried back to Japanese Christian Home.

Since then I have tried a few other places with a better success at each trial and in course of time I have quite accustomed to it and gradually become indifferent as the humiliation melted down. Though I never felt proud of this vocation, in several cases I have commenced to manifest the interest of my avocation as a professor of Dust and Ashes. The place where I worked nearly three years was an ideal position for a servant as could be had. The master was a manager of a local wholesale concern. He was a man of sunny side of age, cultured and careful, conservative gentleman, being a graduate of Princeton. His wife, Mrs. B., was young and pretty, dignified yet not boasted. She was wonderfully industrial lady. She attends woman's club, church and social functions. Yet never neglect her home duty. Sometimes I found her before the sewing machine. She was such a devoted wife whenever she went out shopping, to club, or afternoon tea, or what not, she was always at home before her husband come back from the office. Often she went out a block or two to meet him and then both come home together side by side. Their home life was indeed an ideal one. Their differences were easily made out. It was very seldom the master alone goes out the evening, except in business. Occasionally they went to the theater and concert. Every Sunday both went together to the morning service and afternoon they drived to the cemetery, where the mistress's beloved mother resting eternally.

She was such a sympathetic young lady whenever I was busy, being near examination. She arranged for me not to have any company and very often they have dined out. Indeed, I adored her as much as Henry Esmond did to Lady Castlemond. She was, however, not angel or goddess. Sometimes she showed the weakness of human nature. One day while I was wiping

the mirror of the hall stand the mirror slipped down and broken to pieces. Fortunately she was around and witnessed the whole process. It was indeed a pure accident. It is bad enough to break the mirror even in Japan, as we write figuratively the broken mirror, meaning the divorce. In old mythological way we regard the mirror as a woman's heart. I felt very bad with the mingling emotion of guilt and remorse. She repeated nearly rest of the day how it is a bad luck and were I only been careful so on. Made me exceedingly uncomfortable.

I was exceedingly hate to leave her place, but I got through High School and there was no colleges around. Hence I was compelled to bid farewell to my adored and respected mistress, who was kind enough to take me as her *protégé* and treated me an equal. It seems to me no language are too extravagant to compliment her in order to express my gratitude toward her.

ANONYMOUS

In 1905, the Lewis and Clark Centennial Exposition and Oriental Fair, which sought to dramatize Portland's providential success as a city, drew over a million and a half visitors over the four and a half months it was open. This article on the Exposition appeared in the Independent *with this editorial introduction: "The following article is by a lady whom we especially commissioned to write for us her impressions of the Lewis and Clark Exposition. She modestly prefers not to have her name appear."*

The Portland Exposition

It is a common remark even with Portland people themselves that, of course compared with the gigantic shows of the past twelve years, this Lewis and Clark Centennial is small and not much is here to hold the interest of a supercilious generation which has already visited Chicago, Paris and St. Louis. But it is hard to conceive the soul so unimaginative or supercilious that by the time it has approached Portland it will fail to see the Exposition grounds as the focusing point of all the streams of production and achievement from a region singularly blessed in natural resources and in inhabitants. Those who stay away may choose to explain their absence by condescending reference to a "little Exposition," but from those whose spirits have been attuned to closer harmony with it by every day's journey westward one rarely hears the disdainful "Oh! I saw all that in St. Louis."

Seen in its true light the Exposition is big, and big just as its originators meant it to be, for to the eye which sees its full import *it is the West,* and never once, from Denver to San Francisco, from Vancouver to Los Angeles, do you get away from the atmosphere of the Lewis and Clark Centennial.

Portland has somehow solved the problem of disposing of its crowd more comfortably than a part of the railroad companies. Perhaps it is younger and more susceptible to thrills of compassion; perhaps with such a climate and location it could not make its guests uncomfortable if it would. Certain it is that *comfort* is one of the ever present features distinguishing it among expositions. Fancy the peace which enfolds the feminine spirit as one realizes that she can tramp all day among the exhibits untroubled by the habitual Exposition consciousness that she is "a sight." Even the larger masculine mind cannot be above a certain satisfaction in the possibility of coming through a day, and evening, too, with unwilted collar. Also, if my own experience may be trusted as typical, the body no less than the mind gains from exploring such Exposition grounds as never were before—park and lake and river outspread along the foothills of a great mountain range, with four snowy peaks in the distance, huge guards who change their uniforms hourly through all gradations of rose and silver and dazzling white. The penny-in-the-slot weighing machine is one form of dissipation whose allurements I am never able to withstand so long as a penny is forthcoming from my own purse or that of a friend. Conscientious patronage of the entire Lewis and Clark collection, from the "Trail's" entrance to the Fairbanks exhibit in the Machinery Building (where you are weighed "without money and without price"), not omitting the youth upon the Bridge of Nations who guesses your weight and takes pay according to his accuracy, showed that in my few days' stay in Portland I had added to my original delicate proportions more than as many pounds as there had been days.

There is, of course, an occasional sightseer, some schoolma'am (I have been one myself, but I also know the vacation art), or delegate from a woman's club, who comes to improve her mind and reduce her weight, and I doubt not she succeeds in both. We saw one of her in the Forestry Building, with note book in hand. She was industriously taking down all the data supplied by the young men in charge of the miniature Columbia River, which, faithfully reproducing all the machinery of the salmon industry, occupies a conspicuous central position, as it should, in this wonderful temple to the sylvan deities of Oregon and Washington. She will go home with every detail and date of ante and post mortem salmon existence, from yellow egg to salad on your luncheon table, on tap for her (let us hope) information-thirsty neighborhood, and she will know the exact amount of lumber contained in each huge tree trunk that rises from floor to lofty roof; but she will miss, I think, something of the ingenuous joy of the young woman who said: "Oh! weren't the tiny fish too cunning as they swam in an animated phalanx with heads all pointed up stream?"

Our party did not refuse enlightenment, either, in the captivating Baby Incubator, altho, to be sure, it was the doctor who received the most of that. The doctor's wife and I possibly took a more lively (and intelligent) interest

in the tying of the pink and blue butterfly bows which impart to the bag of waterproof cloth in which the mites are incased an infinitely more festal appearance than is ever produced by the ruffles and hemstitching of the mother-tended baby. At any rate we ran off in the middle of a valuable discussion upon temperatures and nourishment at another woman's announcement of "the cutest little brown-eyed one in that next room." But we learned enough to be quite convinced of the good fortune of the incubator baby.

It is among the peculiar advantages of the Portland Fair, however, that one may absorb an unusual amount of really valuable information without going in search of it. I suppose that others have made as interesting displays in forestry and irrigation; I confess that I never looked to see. But here, in the heart of a region whose very life they are, they assumed for me an importance far exceeding Oriental embroidery and Italian mosaic. The Fisheries Exhibit is relatively small, but hundreds who never went near more imposing displays crowd around the tanks showing the baby life of the salmon, which they are now eating fresh for the first time. In the excellent Government Exhibit one now takes time to read the letters bearing many a great American's autograph and making frequent mention of Lewis and Clark; and I felt a new interest in Filipino cooking utensils when I had just fallen in with an old college friend, fresh from Government service among the Igorrotes, who pointed out those from whose like he had more than once been served. Then, too, you take time in Portland to do so many of the silly things which bring joy to the soul, especially the soul old and dignified enough to know better. When "hitting the trail" of course you would spend an evening in Kiralfy's gorgeous "Venice," and another among Jabour's trained animals; you would also probably "bite" on some of the fake shows; but if the "Trail" were as long as the "Pike" you might hurry on and miss the delight of being swindled out of successive dimes by such engaging gentlemen as preside over the side attractions, in "Fair Japan," for example.

There is, of course, the Forestry Building, the happiest bit of originality Portland has to offer. One would not regret having come far to see only this marvelous "log cabin," 205 feet long by 108 feet wide, its roof resting upon a colonnade of fifty-two tree trunks, all clothed still in the rough bark of their forest life, 50 feet high and in diameter equaling the height of a tall man, while as many more trees, just as thick and half as high, support the rustic galleries which skirt the structure on side and end. To one who has inhaled the woodsy fragrance of the place, and measured his insignificant stature beside its monster pillars, the effort to convey an idea of it to others seems so futile that he is forced from customary forms of description, from literary terms to numerical; for here, at least, figures must prove more eloquent than adjectives, even adjectives in the superlative degree. Permit me, therefore, to filch a single item from the estimates of one who has described the building in detail:

"One of the logs contains enough lumber with which to build a one-story cottage 40 x 40 feet in size, with a fence around it, and board walks leading up to it. And there would still be enough wood left to kindle the fire in the grate for many months."

It was in this place, most perfect type of the wondrous West, this spot where the strength of its ancient forests and the vigor of its new-born cities have met in enduring hand-clasp, that Joaquin Miller stood on a Saturday in mid-July and received the many who came to greet him as poet of the Pacific and acknowledge that he had been a true seer when he wrote of their region years ago:

"Dared I but say a prophecy,
 As sang the holy men of old,
Of rock-built cities yet to be
 Along these shining shores of gold
Crawling athirst into the sea,
 What wondrous marvels might be told!

Here learned and famous from afar
 To pay their noble court shall come,
And shall not seek or see in vain,
 But look on all with wonder dumb!"

He had not in mind, I fancy, either a generation ago or on that day of his reception by enthusiastic Oregonians, alone or even largely the great progress of the far Western States in things material. It is no small indication of the spirit of the region—its fearlessness and independence of judgment—that it has dared to face the bugbear of all previous American expositions and seems to have proved it after all a monster of only imaginary deadliness. Perhaps most significant of any feature connected with Sunday opening at Portland is the fact that it has not come about in response to the clamor of the worldly-minded and of a secular press, but that the committee which has worked for it and now directs it has for chairman and secretary ministers of the Gospel, and its entire membership drawn from the clergy of Portland or members of the laity eminent for adherence to high moral and religious standards. Certain restrictions have been imposed and carefully maintained; the gates remain closed until noon, thus removing temptation from the path of those whose feet might not steadfastly tread the way to the morning services of the churches; the "Trail" is closed all day, and no machinery is in operation. All other exhibits may be visited as on week days, and open-air entertainment is provided in concerts by a number of excellent bands (those from neighboring military posts and the young Indians from Sherman Insti-

The Government Building at the Lewis and Clark Exposition in 1905

tute lending a satisfying Western flavor), which play at different buildings throughout afternoon and evening.

The scheme of the Sunday opening, however, goes much beyond the mere provision of decent and pleasant recreation for a visiting crowd, which, if shut out from here, might seek it through devices less innocent. The major part of the committee's effort, so far as Sunday is concerned, has been directed to the afternoon service in the Auditorium, and there is apparently much reason for gratification with the result of their efforts, both in what they have been able to provide and in the public response in interest and attendance. The program consists of a simple religious service, wholly undenominational, save that one Sunday will be given over exclusively to the direction of the Roman Catholic Church, but simplicity is made impressive by the excellence of the speakers and the music. Comment upon the committee's success in respect of the former would be superfluous when their roll runs: Robert McIntyre, Emil G. Hirsch, James W. Lee, Merle St. C. Wright, Charles M. Sheldon, Josiah Strong, Newell Dwight Hillis and Washington Gladden.

One Sunday afternoon of each month is to be given to the rendition of one of the great oratorios, "The Messiah," if I remember aright, the chorus for these being drawn from Portland and its environs, and the director being a Portland musician. The music for the weekly service is also supplied by local talent, and if all of it ranks with the Lakme Quartet, which it was our good fortune to hear, its quality is far from amateurish. The exquisite voices of these young women and their admirable training in quartet work are well worth crossing a continent to hear.

It has seemed worth while to speak at this length of Sunday opening at the Lewis and Clark Exposition, because it is an experiment which will be watched with interest as a precedent for coming world's fairs. Perhaps its completest vindication is the entire absence of protest from either press or people of Oregon, with the possible exception of holders of "Trail" concessions, whose complaint is not of the opening, but of its restrictions.

Another of the unique features of this Exposition is the manifest realization of a group of Western States of their kinship, their common origin and common destiny. There is rivalry, to be sure, but of that good-natured sort which, tho it may poke a bit of fun, is proud to see, and to let others see, its brothers' success. Thus Portland, since to her belongs the honor of the Fair, is very generous in calling the visitor's attention to the beauty of Washington's and California's State buildings, and has admitted to her scheme of illuminations, shining afar across Guild's Lake, the familiar watchword of the "Tacoma Booster," "Watch Tacoma Grow." And Idaho combines tribute to her neighbor with appreciation of her own merits in the sentiment wrought in her native grains upon the door over against the flaming Washingtonian beacon:

> "While you watch your neighbors grow
> Keep your eye on Idaho."

To Idaho, I think, belongs the palm for the most remarkable product exhibited by any State. I would not rank above it the huge grizzly made from California fruit nor the picture of the Exposition grounds done in human hair by a daughter of Oregon. It is a square of gayly embroidered canvas bearing this simple legend, "Made by a Gentleman." Modest in all but his choice of colors was this retiring soul, and the unexpectedness of it makes his offering the more fraught with tender interest. One might have been prepared for it from Rhode Island, or even Pennsylvania, but not here in the haunts of the "cow puncher" and the "broncho buster," and the picture of the gentle creature, sitting apart from his ruder kind, decorating the Christmas sofa cushion and laundry bag of many a lady friend, will long cling in my imagination.

Of the eleven States represented by buildings and exhibits creditable and

in some instances remarkable Illinois has undoubtedly sounded the note which will vibrate in most hearts and be longest remembered. She makes no display of imposing architecture nor of giant fruits and abundant harvests; it is only a plain and ugly little house, with an interior adorned by scant and unpretentious furniture. But crowds flock to see the counterpart of the Springfield home of Abraham Lincoln and linger long in the square rooms, whose walls are eloquent with Illinois history. The collection of pictures, made by Mrs. Jessie Palmer Weber, is designed to cover the story of Illinois from earliest times to the present day, and most interesting and pregnant with surprise as well is the array of Illinois Governors, for Louis XIV leads the procession, and George III of England stands before La Salle, while Patrick Henry's face reminds that Illinois was once a county of Virginia. But it is the Lincoln relics which hold the crowd, often with moistened eyes: the marriage certificate with the name of Nancy Hanks, the request to Stanton for a few flags for Tad, the brief note to Grant concerning Lee's surrender, the pictures of Ford's Theater, of Booth and the other conspirators, the mud-scraper on the back porch.

Of all the sights that thrill, of all that gives distinction to Portland's Exposition, none can claim precedence of the figure of the Indian girl, with her papoose strapped to her back, leaning forward to look far out across the lake to the sea. The artist has idealized her doubtless, this Shoshone captive, wife—with a one-third interest—of a Canadian voyageur; but since qualities of mind and heart are hardly expressed in bronze, who would not wish that youth and grace should be the outward form of that courage which risked her own life to save the papers and scientific instruments of the explorers, that unselfishness which defrauded her own child to share with them her last loaf? The unveiling of this first statue of an Indian woman, designed by an American woman (Miss Alice Cooper, of Denver), was fitly made an event of importance by the managers of the Exposition and the women of the West.

JAMES STEVENS

Born in Iowa, James Stevens (1891–1972) came to the Northwest at an early age. He attended (and was expelled from) school in Idaho and, after serving in World War I, worked in the Oregon woods and lumber mills. He also began writing. Stevens's first book, Paul Bunyan *(1925), launched his career as the chronicler of the northwoods logger and drew comparisons with such writers as Carl Sandburg, Sherwood Anderson, and Ring Lardner. With friend and fellow author H.L. Davis, Stevens wrote "Status Rerum: A Manifesto upon the Present Condition of Northwestern Literature" (1927), which with its "Near-Libelous Utterances" about Northwest literati began a heated debate over the quality of Northwest literature. In 1948, he published* Big Jim Turner, *an autobiographical, working-class novel. Stevens, who lived in Seattle and worked in public relations for a West Coast lumber association, has been criticized for promoting the industry through a mythologizing of the logger, but this excerpt from* Big Jim Turner *reveals his interest in the pro-labor perspective through his depiction of the labor strife in Portland.*

Little Pretty and the Seven Bulls

The sad October days had come to the timber coast and its lumber rivers. This was a morning of gray drizzle and no wind. I toiled through it comfortably enough on the green-chain of the Copenhagen sawmill, shielded by a shed roof. Most days there was no harder work to be found in Portland, a city of hard work that stood amid valleys of hard work. Seven of us were strung along two sides of a waist-high platform a dozen feet wide and a hundred long, on which conveyor chains crawled with fresh, green lumber from the old sawmill. There were four stations on one side, three on the other, with a row of two-wheeled trucks along each station. Every truck was for a particular size and grade of green lumber. A chainman's job was to watch the crawl of lumber for grade marks and sizes, then pull off and load the items that belonged in his station. No work could have been simpler. So I liked it, for it left me free to muse and dream. No work was heavier. This bothered me none. Soon I'd be twenty. I was a bull. We were seven. You had to be a bull to hold 'er down anywhere on the Copenhagen green-chain.

The weather drizzled gently on through the morning—"Oregon mist," the old Portland Webfooters called it. I liked it fine. It was a prime morning. They were small logs today, out there in the river booms; and small logs riding up the slip, the jack-ladder, in grip of creeping bullchain to log deck and bandsaw headrig. This meant a smaller cut than common for the day, and easy going for the men with weak heads and strong backs who took care of the cut on green-chain and timber chute. So I jogged along with my share of the slugs of rough-green; sorting and hauling; bunching pieces and swing-

Workers on a cigar raft in the Columbia River

ing each bunch into a slide through my mulehide mittens and over thighs aproned with belting leather, to its proper truck.

Like that, over and over; taking it as it came with no rush or worry; musing on why and how I had returned to my native shore; dreaming of the books.

I was free. A free man still.

The quitting whistle blew through the gentle gray weather; the cool, soft air, the sweet rain; so fine and good for the life of hard work with trees and lumber in the Oregon outdoors.

We headed with our lunch buckets for the fire room of the mill's power plant. Sawdust was the fuel, fed in from towering bins the size of railroad water tanks. It was clean heat, a good-smelling place. I liked the noon hour here, not only because of the pleasure of stuffing a hungry gut, but for the company, the talk, the arguments, the stories; all serving to pull me out of myself and back into the world of men. An hour of it was enough. But it was a good change.

One of the chainmen, one English-born and with the name of Cecil Hurst, was openly a member of the Industrial Workers of the World. Today

he brought along a new copy of the weekly paper, *Direct Action*. Cecil passed it around. Each bull gave it a polite look, a wise nod or two, then passed the paper to the next man. I was about to do the same when the face of a girl in a picture on the front page reached out and fairly took hold of my eyes. It was a little picture above a poem. The poem was called "Rebel Girl." It was by Elizabeth Clover.

I looked in her face and read her true name again and again, and between my looks her printed poem—

REBEL GIRL
 By Elizabeth Clover

I am a rebel for reason:
I would hear young mothers singing
As only the secure and hopeful sing.
I would see their cupboards full
Of everything,
And the young fathers bringing
More, more, more.

I am a rebel from hearing
The bitter cry of the children
And the young mothers' crying;
From seeing the young fathers,
The strong, the good young men,
Seeing them despair
Over their dying.

The lines lost me from the present. The paper was taken from my hand and voices sounded, but for me the barrier I'd built against the old life was broken and I was far through it, backwashed.

My memory saw her stand and sing, a pale, scrawny kid in faded dress and wrinkled stockings in Aunt Sue's front room, a kid escaped from that trap of a homestead place in the sagebrush hills—singing "Arise, ye prisoners of starvation," to the pleasure of Wiley Hurd, to the disgust of Aunt Sue and to my wonder. As plain as life I could see the back of her head again as it had been on the snowy day Uncle Gabe drove us on a bobsled through the hills; Bess up on the spring seat, me standing behind her, seeing her ears, neck, and silks of hair so close; with my first faint scent and sight of girl touching on woman. Then the day, the moment of holding her to me in Mother Morgan's place. What I'd kept of that was a note in mind, "Poetry is made of moments." Sweetness and wonder, delight and glory. Then the sight of her paleness, and the feel of her thinness in my arms and to my hands. Sorrow, sorrow to my heart, hold me close to thee, as the tears start. Tears from the

depths of. Deep as love, deep as first love and wild with all regret, Oh, God damn, damn, damn. Back now where I started from. Ocean, mountains, forests, foreign land—all a barrier blown away as the mists are blown.

It was a blast. It knocked the wits out of me. I caught myself saying aloud, "I love her. I love her." Then—

"V'at the hal you talkin', Big Yim? You mean you love Emma Goldman?"

I swung the heel of my hand up against the side of my head and batted out the haze. The chainmen, and four or five others too, were gaping at me. It was Shot Gunderson, the boss of the green-chain, who had spoken.

"No, Shot," I said, trying to sound offhand-like. "Not Emma. The girl who wrote the poem there—Elizabeth Clover. We were kids together in Idaho, and I've known her since."

"Oh," Shot grunted. He peered at the Wobbly paper again. "Bay Yeesus," he said. "Vell, v'at you know! V'y, the little pretty! Look at her har, noo! Big Yim's girl—v'y, the little pretty!"

All hands shoved around and craned over to look again. The big pictures and headlines on the front page were of Emma Goldman, and of Mother Morgan and Joe Hill, with a story on how they were all coming to Portland to fight for free speech in a week of meetings at Millwrights Hall. The Wobblies, anarchists and Socialists were joining for the fight. Another part of the page had a headline that read, "COL. CHARLES ERSKINE SCOTT WOOD LENDS SUPPORT." I knew of him as an old Indian fighter and a famous Socialist poet. What he said in the story was—

"We have free speech in Portland, and free speech is here to stay."

Bess Clover's picture was a little one, with her poem, down in the left lower corner of the page. But it said she was to take part in the free-speech meetings. And so for me there was no more peace.

The talk roared on around me. I half heard what was said. It appeared that the fight to come had been boiled up mainly by the local I.W.W. on one side and the also rowdy Jehovah's Pilots on the other. During my four months in Portland I had taken great pains to keep clear of both camps, even in my mind. But I'd heard that the old American Protective Association, once powerful in Portland through the organizing of hate against the Roman Catholics, was thriving here again by doing the same against the labor rebels. First, the A.P.A. leaders had raised a great uproar to stop the well-known anarchist and free-love woman, Miss Emma Goldman, from giving lectures in Portland. Now Miss Goldman was coming, with the famous old-time labor agitator of the West, Mother Morgan, and the Wobbly organizer, Joe Hill, to back her. It appeared that Bess was an I.W.W. too. She was to appear as a singer of Joe Hill's rebel songs. It burned in me that Joe was a man like Russ Hicks and that Bess would be drawn to him, and was with him. It burned, I say, it was a live coal eating in me. The talk went on with me half hearing. But I was well-posted. The Grand Army of the Republic and the Spanish War Veterans

had been the first to threaten the meetings. Then Pastor Joanna of Jehovah's
Pilots had made a special trip up from Grays Harbor and raised the loudest
outcry of all against free speech for Emma Goldman, Mother Morgan and
Joe Hill. At the present point she had put the A.P.A. and the G.A.R. deep in
the shade. Pastor Joanna had plainly preached that blood would flow in the
streets around Millwrights Hall if Emma Goldman tried to lecture there.

"V'er the hal is this har Millwrights Hall?" Shot Gunderson wanted to
know. "Vat street is goin' to run vit' blood?"

"It's the old Knights of Labor hall on Front," a mill man said. "It's across
the street from the river dock where we take the sawdust scows and tie them
up for use by the Eastway power plant."

Shot Gunderson nodded that he knew the place. He stared at me while
he nodded, his Swede eyes lighting into a wild blue glitter. His face split in
a fearsome grin.

"Bay Yeesus," breathed Shot. "Them Yehovah's Pilots think they goin' stop
Little Pretty from her free speech, hey? Vell, ve see about that—the Seven
Bulls see about it, you bat you! Plenty room for a gude fight, yesiree—and
sawdust to bury the bodies, bay the holy ol' mackinaw! Coom on, you Yeho-
vah's Pilots! Moor lumber!"

The mill whistle had blown, and we stood up to go back to work. I was
busy for a minute, talking Cecil Hurst into giving me his copy of *Direct
Action*. Then, heading out into the soft rain, I began to remember some of
the bughouse stories on Shot Gunderson that were circulated up and down
the Columbia River. They worried me all the afternoon. There were no more
dreams. I was no longer a free man.

Shot Gunderson was the smallest of the Seven Bulls of the Copenhagen saw-
mill. A wiry runt of forty years, with straw hair, pale eyes and a peaked chin,
Shot owned more muscle power and whizzbang per pound than any man
and a half I'd ever known. For ten years he had bossed this green-chain, and
for twice ten years he had boiled his innards in *aqua vit'* weekly from Satur-
day night until midnight Sunday. In all the time he'd never needed to take
a day off for drunkenness, sickness, broken bones, love or death. He com-
monly consumed at least a quart of tomatoes with each meal. The sawdust
savages of the Columbia River mills wondered little at Shot's consumption
of firewater, but they did marvel at how he downed the canned tomatoes.
When a savage was at a table and wanted a helping of this dish, he was apt
to say, "Please pass the Gundersons." The saying spread.

Every new "squarehead Swede" story that came along was hung on Shot
Gunderson. Years back some bard had set going a string of tales about Shot
and his crew, calling them the Seven Bulls. The name caught on with the
sawdust savages of the Columbia River mills. In the stories they passed
along, the Seven Bulls were ever the same—in their way like the eternal

Seven Axmen of Paul Bunyan's logging camp. But Andy Jonken and Mike Hrbacek were the only two who had worked with Shot long enough to be considered as home guards. The others would change, come and go, but Shot would hire none who was not a young bull of a man; large, powerful and full of steam. He himself was always the runt of his crew; standing five feet, seven inches, and weighing no more than a hundred and seventy-five pounds. But no man could beat him at handling lumber.

Andy and Mike were each heavier and taller than me, and I was now nudging past six feet, two inches, and two hundred and ten pounds in socks. The other three go-abouts who were now in the Seven Bulls—Turk Manique, Mart MacHagg and Sailor Cecil Hurst—were my size and more. By October we'd all become a really solid crew that had known no change for three months. Now we knew just how and when to gang up on the rushes of lumber that would pile down on the crawling chains for a single station. Shot Gunderson would go a whole shift very often without calling an order.

It was just the place, just the job I needed, to keep on in my way of lone freedom after return to my native shore. There was a warm comradeship of work around the green-chain, without much time or want for talking. Of course every place of work has its reader and argufier, and the one here was Cecil Hurst. He had read the philosophers, and what he'd read seemed to be sort of mired in his mind—he just couldn't run it out straight in his talk. But the Sailor did give me names and make me curious enough to look through the ponderous and heavy jaws of the books of Buckle, Kant, Spinoza, Marx, Spencer and Huxley in the Free Public Library. Sample plowings in the works of the philosophers only made the reading and study of Walt Whitman seem easier to me. The *Leaves* and the Lang *Odyssey* were the only book gifts of Uncle Dan'l that I'd kept. I had found good for my soul in Walt Whitman at every turn. Now nearly all his poems were printed on my mind and heart. So I could read them and say them by the hour on the work of the sawmill green-chain. Walt Whitman made Big Jim Turner feel so welcome I never wearied of reciting—

> *The youngest mechanic is closest to me, he knows me well,*
> *The woodman that takes his axe and jug with him shall take me with him*
> *all day,*
> *The farm boy ploughing in the field feels good at the sound of my voice,*
> *In vessels that sail my words sail, I go with fishermen and seamen and love*
> *them.*

He told me to let my soul stand cool and composed before a million universes. He said to me there is no trade or employment but the young man following it may become a hero.

Among all the poets, storytellers and philosophers I'd read, Walt Whit-

man was the one who walked, worked, sat, stood with me as living face and voice, living arm on my shoulders, living hand clasping my hand. Truly his poems were a man to me. I gazed into the face of his poems and said, "Father," sometimes with tears.

No sadness, though, in the poems or the work. Good days, good days still. Looking out under the eave of the shed's roof and over the truckloads of green lumber and the piles on the cargo dock, I saw a broad river. Yonder flowed the Willamette, sister of the Salmon and the Snake, soon to join them in the Columbia, the Old Whale. From this place I had seen ocean ships of all the maritime nations pass.

Coastwise schooners, stern-wheelers, tugs, ferries, fishing boats, sailing craft, sawdust barges, rowboats, log rafts, boys' rafts, liners, whalers and battleships passed my place of labor.

On many days freighters were moored at the dock yonder to load lumber. Black sides, red trim, white superstructure, brown or yellow booms, emblems of many colors on smokestacks, various flags astern.

There was a green ribbon of island nigh the far bank. The bank lifted in a bluff that would brush the blue sky, or the fleecy sky, or the wet, gray sky, with evergreens.

Eventides and Sundays there was the Free Public Library, the rooms walled with books, long tables, chairs, welcome, kind people.

Ellen Crady was so lovely, golden and fragile I could fear that a strong look of mine might hurt her. But she was at ease with me and kept me at ease. I'd grown into the habit of looking up tough references with her; some of them real, some invented. Looking, we'd speak of other things. Ellen liked to tell me of young men who had caught aspiration in the deeps of poverty and ignorance to write books of poetry or tales. She talked me into a study of the novel, *Martin Eden*, although I'd come to believe that Jack London was one who had sold his talent for gold and then used Socialism as a hidey-hole for his shame.

"Look for the good," said Ellen. "There is good in all things."

I said, "You might be right," a remark I'd come to use as a standard reply to moralizing. "You know, Ellen, you may be right," I said. "I'll take a prowl through *Martin Eden*, lookin' for good."

Mrs. Mary Wink was Ellen's boss, chubby, black-eyed, always full of business, sharp but kind to Ellen and the other library girls, and the same to me. I met her in the way of going up to her on my first visit to the Free Public Library and speaking to her about Lily Hurd, who had worked in the Portland library years back, when she was Lily Yardley. Mrs. Wink had loved Lily. I told her what I knew she would like to hear; most of all on how I had first met Lily when she was Knox librarian. I told that I'd been a ragged, diseased boy who was being egged into a life of crime by a drunkard uncle. I had

started to drink rye whisky myself, and was on the point of rustling cattle, I told Mrs. Wink, when Lily Yardley the same as took me by the hand and led me into reading *Oliver Twist* and other novels by Charles Dickens.

"It was to improve my morals," I said, "and it did."

Well, it was like drawing four aces in poker when I had the notion of kind of spreading it on with that story. Mrs. Wink was almost rabid on Charles Dickens.

"Indeed," she said, her black eyes shining, "and it was I, young man, who led Lily as a young girl into appreciation of Charles Dickens; so I am going to claim a mite of credit for your juvenile regeneration!"

Mrs. Wink fairly sang the fine words. I'd gone right on playing up to her for four months, and she was as good as any woman alive could have been to me, except for being strict with Ellen when I was around. I didn't really mind the strictness. Ellen was engaged to a college man. But he wouldn't graduate for a year; and so in her kind of fragile, saintly way she would get, well, cousinly with me; and I expected she would with other poets.

A free place of free books in a free land, the Portland Free Public Library had grown in my sight as an American glory. There I lived with books. The Library was Poor Poets' Home for me. I walked with books read to its doors, and I walked with books unread from its doors to my place. Thereby I was a rich young man.

My place was a basement room that was just about big enough for me to turn around in without stepping on my own feet. It was furnished for what was called light housekeeping. The room was really a hole in the ground, with two little street-level windows that looked down from under a ceiling of beaded boards with well-smoked gray paint on them.

Above the outside door dampness had seeped through the concrete wall to make a blot on the painted surface. The blot had taken on the shape of a fat face with a mighty mustache and three chins. At first I called it my bust of Pallas just above my chamber door. Then it struck me that the blot looked more like an image of the face of President William Howard Taft than anything else. I was always having such notions. The like was needed to make the cheap room a tolerable habitation.

Now, at October's end, this basement room had been my home for four months. The rent for it furnished was an even seven dollars a month. On the average, light and gas put another dollar and a half a month on the rent. My natural big appetite and the hard work made the grub come high. Breakfast was commonly ham, eggs, hot cakes, or maybe oven biscuits, with hot beans for extra hunger, and three or four bakery doughnuts and a quart of coffee to top off. I'd pack a plain lunch of a loaf of bread cut into slices fit for man-sized sandwiches of meat, cheese, fried egg and jelly. No pie or cake for me at a lunch, as I was careful for my digestion and would eat plenty of canned

tomatoes; not as many as Shot Gunderson did, but plenty. Evenings I'd whack off a shave, pull on my blue serge, a real nice suit that had cost me seventeen dollars and some cents, stick a readymade bow tie in the neck of a fresh shirt, give my button shoes a polish, then go eat a steak or pork chops in style at a restaurant; never less than a quarter meal, sometimes a splurge for thirty-five cents. Then and then only in any day I would indulge myself to a hunk of cake or a quarter of pie, as this would go with the meal. I would not take a chaw after the evening meal but only a cigarette. Then, as genteel as anybody, I'd hustle for the Free Public Library. Some nights, of course, I'd hole up in my basement home to read or to work on poetry notions. I resisted evil.

We got four bits a day above common wages on the Copenhagen green-chain. The big pay was why Shot Gunderson could be so choosy in his hiring. I made twenty-seven and a half cents an hour, two dollars and seventy-five cents each ten-hour day, sixteen dollars and fifty cents every sixty-hour week, and seventy-one dollars and fifty cents any twenty-six-day month. It was good money, however you looked at it. Old Einar Skjalgsson's system was to pay high for good men, and then treat 'em right. He'd grown rich at it and all his hands were his friends to boot.

I've set all this down here to give simple facts on how poetry can be studied and written out here in the West by a young man with no schooling, if he is strong, willing and sincere. Simple facts on a simple thing. Many were doing it in ways more or less like my way. A hobo circus worker, a boy sailor, an immigrant logging-camp blacksmith, a milk-wagon teamster—many and many young men at the same time were forgetting the poverty of their lives and their lack of schooling; and were finding their ways to pure art, to the eternal peaks of poetry, through the Free Public Library of America.

In my basement room I wrote poems for Bess Clover. One was a sonnet—

Again, again light fails in swamp of thought
 That life is murk for me; the toil and fears
 The bondboy knew, his hunger and his tears—
From these my shapes of beauty must be wrought.
Hope beds with others as each day is caught
 In net of night to feed the bestial years.
 Sleep scorns me then, and sullen fancy leers,
Yet Poesy I praise; O love long sought!
 O bearer of my only wanted fire
 And light! Come lie with me; so that my dreams
 May fertile prove, and grow in this desire
 My life's pure light; glow-warmth to thread the seams
Of dismal workdays closed in grime and mire.
 No sun I seek, only meek candle gleams.

Rough work; and nobody could tell the spike knots, checks, conk and wane better than I could in a glance at any line. But I was bound to keep at it. I hoped to write a pure yet fiery sonnet by the age of thirty. If I didn't I'd yet keep on. My last lick in life, I vowed, would be a try at a sonnet. Did I drown, like Martin Eden, that horse's rosette, my last struggle would be to write a sonnet line on water. That's what I bragged to Ellen Crady.

With that sonnet in the rough and kindred rhymes, I fared forth for Bess on the night of battle.

Men and women were coming along the old street and turning regularly under the canopy and lights of the wide entrance and stairway to Millwrights Hall. I had no more than arrived and inquired if Miss Clover had come yet (which she hadn't) than a parade appeared. It marched on the planks of an open dock of the river front, across the street from the hall. Twenty or so men were stringing along like labor pickets. Each wore the kind of pilot's cap that marked a member of Pastor Joanna's new sect. Each man packed a big sign, home-painted. The signs read like this—

> GOD HATES FREE LOVE . . .
> AMERICANS HATE ANARCHISTS . . .
> SHAME, SHAME, EMMA GOLDMAN . . .
> PROTECT PORTLAND'S PURITY . . .
> STAND BY THE FLAG . . .

Somewhere up the street yonder, in the rainy shadows and post lights, Shot Gunderson, Cecil Hurst, Andy Jonken, Mike Hrbacek, Turk Manique and Mart MacHagg would be waiting for me. We had all met down here the afternoon and night before (Sunday, with no one around) and practiced out the plan that Shot had rigged up for the Seven Bulls to follow in the fight for Little Pretty. Then it had looked to be the damnedest foolishness, with us all simply begging to be beaten up by a mob, then ending in jail. But now the prospect was not so bad. Many had joined Charles Erskine Scott against the "enemies of American free speech," and the mighty newspaper, the *Oregonian,* was standing for free speech, too. But what had really made the A.P.A. and the G.A.R. back up was the Jehovah's Pilots.

Pastor Joanna got her picture in the papers, robes and all, along with a new threat to fetch an army of Christian loggers up from Grays Harbor "to take care of the Anarchists and Free Lovers, the Devil's Own." The *Oregonian* thundered a warning against sham saints and said it would be a mistake to make a martyr of Emma Goldman. The proud Protestants and Old Soldiers were keeping quiet. Now, it appeared that the Jehovah's Pilots were all that the Seven Bulls would have to worry about in the protection of Little Pretty.

I hustled on to join them. Then—

"Jim!" I heard. "Jim Turner!"

I plowed to a stop and wheeled about. Bess Clover ran from ahead of a bunch of people who had come into the hall's entrance behind me. I fairly lunged toward her, and she stopped in the fringe of the canopy lamps. I saw her face, her hands reaching, light between us, and fine slanting lines of rain in the light—and then the shape of a man swung around her and shouldered in between us, and that voice like steel pounding steel drove at me.

"Get back to your Christers, Big Jim!"

It was Joe Hill, all right, Joe Hill with his gun under his coat and his right hand ready to flash for it. The eyes that could look at you like the eyes from a picture of Jesus Christ were deathly in their glittering stare. I saw murder in them and in every line of his frozen face. I saw it and realized it in seconds; in a split of a second. And with it I remembered the face of Rough Rider Al Bliss, the crooked long scratch, the blood spreading. And with it I felt the natural cocking of my left fist for the snap of the hook that I could throw as fast as Joe Hill or anybody else might pull and shoot a gun. There was no time to think. I did not think. These things were in me, images of instinct, light-fast.

But I flinched, and this was in me too, without thought, I flinched backward, from Joe Hill and then from Bess Clover, as she caught at Joe Hill's right arm in both hands and gripped it to her.

I saw her face again. It was stricken, her eyes accused me.

"Yellow fink Christer," Joe Hill chopped out the words. "Scissor-bill fink and stool! I know and Bess knows and Black Dan Barton knows you for a grayback bastard dehorn, a traitor to your fellow workers! What you did in Montana you will always do. Now get back to your gang over there in a three-count or I'll gun you!"

Preacher boy in Montana—and they believed I was at it here—even Bess believed it. I tried to ask, "You don't, do you?" but there was a lock on my throat.

Then the voice of Shot Gunderson sawed down the street—

"Hey, you bulls! Look noo! Big Yim and Little Pretty!"

Hobnails hammered on the cobblestones.

What I might have done I'll never know, had I been given the three seconds, Joe Hill's three-count. Surely I'd have hooked him, as I later imagined it over and over in my mind. But with the roars of the Seven Bulls the people who were with Bess and Joe grabbed them and hauled them for the stairway hall and I was driven to join Shot Gunderson and my other mates in their charge on the parade of Jehovah's Pilots.

What had just happened was as slag inside me. I swung around like a machine and ran over for the dock with the bulls, then lined out as we had practiced the battle plan last night. I was wildly alive, yet numb, frozen.

Shot Gunderson, with a war cry so blood-curdling it would have done credit to an old-time Modoc, charged. His charge was over the river dock planking for the straggle-parade of Jehovah's Pilots and their banners as it turned at one end of the dock. He charged low-crouched and leaping, like a cougar, or as he would lunge after a large timber on the green-chain of the Copenhagen sawmill. Right as he had planned it, Shot Gunderson hooked the head parader of the Jehovah's Pilots, hoisted him, swung him, heaved him, let him sail; all with the neck-and-butt grips of the bum's rush. Then Shot swung and charged for Number Two, yowling—

"Moor lumber! She's rollin' from the old sawmill!"

It was a nightmare in my sight and in my mind. You couldn't believe the like was going on even when you were in the thick of it. And I was frozen, all slagged inside from taking what I'd taken from Joe Hill. I piled into my place with Cecil Hurst, but there were not just the two of us—the Old Nick was hooked to me, also; grinning through the rainy lights, snorting in the wind, "Now you pay me, Big Jim Turner!" Oh, the mess, the mire!

The wild, crazy play went on, to make another big story of Shot Gunderson and the Seven Bulls for the river sawmills, then to grow in another shape as lore of the fighting Wobblies of the West.

Actually it was no more than a roughhouse. On from Shot Gunderson the first Jehovah's Pilot was caught before he spread-eagled by Mart MacHagg, who hooked and slung him on to Turk Manique. Then he was rushed and lofted away to Andy Jonken, who green-chained him down the line to Mike Hrbacek. Then it was up to Cecil and me to unload the man.

We stood nigh the end of the dock which was used as a well mooring for the sawdust barges that were collected for power-plant fuel here. About ten feet down in the shadows bulged the top of a load of sawdust from a Copenhagen sawmill barge. Shot Gunderson had used his influence to make sure it was here tonight. It was our target.

Cecil and I were used to teaming up to pull timbers off the green-chain. He was such a Wobbly it was simply fun for him to hook that first Pilot as the man came flying at us from Mike Hrbacek's paws, and to swing him high with me and let him fly on over the dockside. The poor fool of a Pilot let out the most pitiful howl and wildest plea as he sailed; being sure and certain that he was on his way to the black water of the deep river; never dreaming he was aimed for a pile of soft sawdust. Cecil was laughing his head off by the time the second Pilot came at us, whooping and flopping. In any other circumstance I'd have died a-laughing, too, but not now, not with the Old Nick here.

We swung and heaved the second man over, with him praying lickety-split in groans of despair.

Up the dock Shot Gunderson kept unloosing his Modoc yells, cougar screams, with green-chain calls in between—

"V'at's wrong in the old sawmill? Ve vant moor lumber har! Coom on vit' the lumber! T'ree cheers foor Little Pretty, bay Yeesus!"

All inside of a couple of minutes Shot Gunderson's lumber-slugging paws closed on the duds and flesh of one Jehovah's Pilot after another. Some fought free of his hooks. Others bunched on him to try to beat him down and take him apart. All of the signs were flat on the dock planks, I could see, up there in rain-glimmered rays from the lights at the entrance of the hall across the street. Shot had been beaten seven ways with the banner standards. Out of the melee he would plunge regularly, hooking and swinging and rushing a Pilot, while he let out a cougar squawl. Then—

"Fire, fire! The old sawmill's burnin' down! The roof's fallin' in! Ay don' give a gude damn! Moor lumber! Keep lumber comin' har!"

In the couple of minutes or so we heaved a dozen of the Jehovah's Pilots overside. Then the police came charging two ways along the street. The paraders who were not already running lit out now. But the Seven Bulls stayed, all for Shot Gunderson.

He stood in the thick of broken and fallen banners, legs spraddled over one that read, "PROTECT PORTLAND'S PURITY." He hauled a pint of *aqua vit'* from his hip pocket, broke it open, reared back and drank the bottle dry, then threw it toward the howls that came as from the deep, dark river.

The police were nigh on us. I stood by with the others, feeling a fool, low, lost, and not caring a hoot. Peering through the wet light I saw a blob of people under the canopy of the hall entrance. Surely one of the faces was Bess Clover's. She had seen, she must know now that I hadn't been here against her or to keep Emma Goldman from giving her lecture.

"Whuf!" said Shot Gunderson. "Nothin' like a gude little snort after gude vork." He faced the squad of police. "Vell, men," he said, "now ve got to yail and have fine sleep. Don' vorry. Old Einar is primed to bail us out in time for vork tomorrow. The old Copenhagen sawmill got to keep sawin' lumber, you bat you!"

And so for the second time in my life I went off to jail, while the Portland Fire Department rescued the Jehovah's Pilots from the sawdust barge, and Emma Goldman went on in freedom to deliver her lecture of the evening on "The Social Significance of the Modern Drama"—and all of it for the sweet sake of Little Pretty.

STEVEN LOWENSTEIN

A Portland civic activist, attorney Steve Lowenstein (1938–1990) worked as exec-utive assistant for Portland City Commissioner Mike Lindberg for six years. A graduate of Oberlin College and Yale Law School, he worked in Ethiopia and Chile for the Ford Foundation before coming to Portland in 1970, where he became active in efforts to create low-income housing. During the Vietnam war, Lowenstein represented the People's Army Jamboree when it risked conflict with the American Legion convention in Portland. He directed Oregon Legal Services for twelve years and started the Oregon Legal Foundation. Lowenstein was the author of Lawyers, Legal Education, and Development: An Examination of the Process of Reform in Chile *(1970) and two volumes of materials for the legal study of penal codes in Ethiopia and Switzerland. This selection from* The Jews of Oregon, 1850–1950 *(1987) chronicles the making of the Meier & Frank department store.*

The Story of Aaron and Jeanette Meier

Aaron Meier was born in Ellerstadt, Bavaria, on May 22, 1831. His father died when Aaron was still a boy, and he worked in the brickyard of an uncle to help his family while attending school. In 1855, at the age of twenty-four, he decided to join his two brothers, Julius and Emanuel, in Downieville, Cal-ifornia, where they operated a general merchandise store. Aaron worked in the store as well as peddling goods deep into Oregon territory for two years before deciding to strike out on his own. Taking a steamer to Portland, he opened a dry goods and clothing store in 1857 with partners N. Simon and Nathan Meerholtz at 137 Front Avenue. Barely thirty-five by fifty feet in size, the store was stocked with several hundred dollars worth of merchandise. By 1857, Portland's population had grown to about thirteen hundred, and the city already had forty-two stores selling dry goods and groceries.

Aaron returned to Ellerstadt in 1863 to visit his mother, leaving his shop in the hands of a partner. While in Germany he married Jeanette Hirsch, twelve years his junior, whose father, Moses, was a grain buyer and well-known to the Meiers. Aaron also acquired fourteen thousand dollars, which was his share of the family estate..Returning to Portland with his new wife, Meier stopped in New York and spent much of his inheritance on merchan-dise. But the first of several setbacks awaited him in Portland, where he learned that his partner had bankrupted the store the previous year and that a number of merchants in Eastern Oregon had reneged on payments for merchandise he had brought west for them. Meier virtually had to begin over again.

He reopened for business across the street at 136 Front Avenue in larger quarters that measured fifty by one hundred feet. He hand built shelves with rough boards and constructed counters from packing boxes covered with

calico. Aaron and Jeanette lived in an apartment nearby, and she brought hot lunch to him each day. Their first child, Fannie, was born in 1865, the year following their return from Germany. Before their second child, Abe, was born, Aaron had purchased a lot at Third and Columbia and built a two-story house for $350. There Abe, Julius and Hattie were born, though Hattie died in infancy.

These were very hard years for Aaron and Jeanette. Funds and credit were difficult to come by. As Jeanette recalled in 1920:

> Everything seemed to be going wrong. We needed money, oh, so bad, we needed money. Mr. Meier kept saying over and over that if we had a few thousand dollars our troubles would be over. At the bank our credit was strained almost to the breaking point. My husband went to friend after friend, but none could help, at least none did. Finally we went to a Mr. D. P. Thompson, almost a stranger, and Mr. Thompson said, "Yes, I will see you through," and he did. He let Aaron have all the money he needed, and it was the turning point in our business affairs.

As the store began to prosper, more help was needed, and, as did so many Jewish merchants of the day, they brought relatives over from the old country. In this case, they brought the Hirsches—Jeanette's half-brothers, cousins and nephews from the marriage of her father, Moses, to his second wife. As Harold Hirsch, Jeanette's great-nephew, recalled in the 1970s, the less fortunate members of the family were brought over "partly because of family feelings of sympathy and love and partly because they could get darn cheap, trustworthy labor that way." In fact, the work ethic was so strong that when Harold's father, Max Hirsch, asked to take a few days vacation to accompany friends to Wilhoit Springs, the sharp response was "What do you want a vacation for? You just came!" This was seven years after he had begun working for the store.

(Max finally left as Meier & Frank's superintendent in 1907, and with Harry Weis purchased the Willamette Tent and Awning Company from Oregon pioneer Henry Wemme, whose last will and testament would play a key, cameo role in helping to make Aaron and Jeanette's youngest son, Julius, governor of Oregon. The firm, which became known as Hirsch-Weis, later anglicized its name to White Stag. Initially they made canvas for ships and tents, horse covers and waterbags for Alaskan gold prospectors. Harold Hirsch started the company's formal sportswear lines during the Depression and built the company into a major manufacturing concern. In 1966, Warnaco, a large Connecticut clothing manufacturer, accumulated sufficient stock to incorporate White Stag as a Warnaco unit, and in 1987 it closed all White Stag operations in Portland.)

In 1870, on a buying trip to San Francisco, Aaron Meier met Emil Frank

and invited him to Portland to work as a clerk in his store. In 1873, Emil Frank became Aaron's partner. That same year, a major fire destroyed much of downtown Portland, including the Meier store. Once again, Meier had to start over, this time returning to the other side of Front Avenue, where his first store had been located. The new store was the first Meier & Frank and covered an entire block.

Emil's brother, Sigmund Frank, followed him from San Francisco in 1873 and immediately made a strong impression on Aaron and Jeanette. Sigmund had been trained in music in Germany and had taught piano and violin in New York to earn funds to come west. Only twenty-three years old in 1873, he was full of ideas and energy. The Meier and Frank dynasty became firmly established with the celebrated marriage of Sigmund to Aaron and Jeanette's oldest child, Fannie, on December 8, 1885.

The children of this marriage, along with Meier's sons Abe and Julius and their children, would play key roles in building Meier & Frank into a preeminent commercial enterprise until they fell into bitter rivalries after Jeanette's death that ended in the sale of the store. Sigmund replaced his brother, Emil, as the principal partner in Meier & Frank in 1887. The following year Emil went into business with Louis Blumauer, the first Jewish child born in Oregon, forming Blumauer and Frank, a large wholesale drug company which was later sold to McKesson Robins.

Through much of Aaron's life, and particularly after his death at the age of fifty-eight in 1889, Jeanette, who would live for another thirty-six years, was a powerful force at Meier & Frank. A short, stout German matriarch, Jeanette held court at first in the back of the store and later, when she would be called "Tante Jeanette" and "Grandma Meier," in the upstairs sitting room of her home. The many direct and more distant relatives who held positions in the store were "told" how the store was to be managed; when arguments broke out, Jeanette was the final and absolute arbiter. Harold Hirsch remembers Sunday night family gatherings as a young child:

> Not only were they social meetings, but they were business meetings. I can recall sitting at the children's table and listening while my great-aunt, Jeanette Hirsch Meier, got up at the head table and told each of these men exactly what they were going to do and how they were going to do it. When there were arguments, "Tante Jeanette," as we called her, would "bang their heads together." It is interesting that, practically from the year she died, the family began to fall apart and individuals to go their own way.

Jeanette Meier went to the store every day and is said to have paid minute attention to the smallest detail. She determined, for instance, that the feather dusters so common at the turn of the century would no longer be used, since they "only moved the dust around;" a dust cloth would take their place.

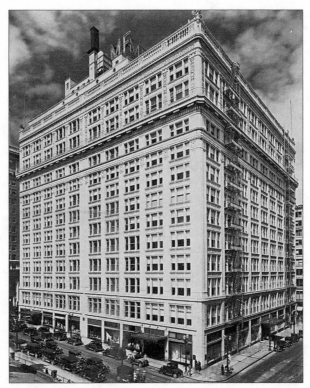

The Meier & Frank building in 1932

Sigmund Frank was formally the chief officer of Meier & Frank from Aaron's death until his own in 1910, and he did provide solid management. But while Aaron and Jeanette's oldest son, Abe, took over as figurehead president until 1930, it was Jeanette who by force of personality and constant surveillance guided Meier & Frank from a country store to the largest department store in the Northwest. . . .

In 1925, when Jeanette Meier died, her will had expressed the "earnest wish and prayer" that her heirs carry on in harmony "the great enterprise initiated by my husband . . . the Meier & Frank store." But her wish was not to be fulfilled. In 1964, when Lloyd Frank's children's trusts terminated, Aaron lost control of a majority of Meier & Frank stock and the dam broke. Years of family resentment and frustration at Aaron's willful management exploded, and Lloyd's widow and daughters joined forces with Julius Meier's widow and children. Led by Jack Meier, Julius' son, they controlled more than half of the shares of common stock outstanding and, therefore, the board of directors. They removed Aaron as president and Gerry, his son,

who was vice-president and Salem store manager, from membership on the board.

As a result, Aaron, Gerry and their immediate family, who controlled just over 20 percent of the stock, decided to sell it at fifty dollars per share to Edward William Carter of the Broadway-Hale chain, thereby gaining, in addition to ten million dollars, the power of a major national chain to wield in their family dispute. Jack's group desired a tax-free merger with May Department Stores, but they were blocked by the requirement that two-thirds of the shares approve such a transaction; Aaron's block, together with the 20 percent of the shares that had been sold to the public in 1937, prevented the merger.

In response, Jack's forces sold rights to purchase their shares for fifty-six dollars apiece to the May Company, the offer good until December 1, 1966. The local family feud was now a national battle; both sides vied for additional shares, which skyrocketed during the battle from twenty to over sixty dollars a share before the fight was over.

Portland was fascinated with the conflict. Long stories appeared daily in both the *Oregonian* and the *Oregon Journal,* and even New York and its financial community followed the saga in the *New York Times*. Finally, the deadlock was broken: as the December, 1966, option deadline approached, Carter and Broadway-Hale stores sold their shares to May Company for sixty-three dollars each. The store that Aaron Meier had struggled to begin more than a hundred years earlier, that Jeanette had forcefully guided to prominence, and to which so many family members and others had contributed, was now part of an impersonal national chain. It was a fate that many other family-owned department stores would meet as nationwide conglomerates paid huge sums for local stores after World War II.

MODERN PORTLAND

The Rose City

CHARLES ERSKINE SCOTT WOOD

C.E.S. Wood (1852–1944) is one of the most interesting and colorful figures in Portland history. A graduate of West Point Military Academy, he fought in the Nez Perce and Bannock-Paiute war and earned a Ph.D. and a law degree from Columbia University. He was an attorney in Portland for more than three decades and was a founding member of the Portland Public Library and the Portland Art Museum. Wood was a self-proclaimed anarchist and anti-imperialist and a celebrated author who contributed regularly to The Masses, The Public, *and* Pacific Monthly. *His most popular titles include* Poet in the Desert *(1915), based on his experiences in eastern Oregon, and* Heavenly Discourse *(1927), a conversation between God and Mark Twain. This article, published in* Pacific Monthly *in 1908, is a tribute to early twentieth-century Portland and an anticipation of the city's first Rose Festival.*

Portland's Feast of Roses

Shall China have her Feast of Lanterns and Japan her Feast of Cherry Blossoms and all Europe its Feast of Fools (a festival no place really need be without), and shall not Portland have her Feast of Roses? She calls herself the Rose City, but she is three thousand years behind the times. Ancient Rhodes, by her very name, was the Rose City. The rose was her emblem, and upon her coins was beautifully minted a half-opened rose. Imperial flower, badge of contending York and Lancaster, and so far as history can run and with every nation, the Queen of Flowers. He whom we know as Anacreon, "Boast of the Ionians," sang:

> Roses (Love's delight) let's join
> To the red cheek'd God of Wine.
> Roses crown us while we laugh
> And the juice of Autumn quaff.
> Roses of all flowers the king,
> Roses, the fresh pride of spring. . . .

Portland! It might have had a better name and got in a better way than by Pettygrove and Lovejoy tossing a copper coin to see whether it should be called Portland or Boston. As if there were no other names; no new names for the new country and the new city and the new life. But we are not a people of the imagination; not a people of poetry and art, but an unimaginative, plodding, utilitarian and commercial people. And yet the name has a special significance after all. Port Land, where the seaport and the great continent meet; the highest point to which great ocean vessels can come to meet the land; and this it is which will make the Rose City the queen city of

the Northwest, if not of the Pacific Coast, and for this she is wise to choose
for her emblem the queen of flowers. Portland sits where the waters of the
Willamette and the great Columbia meet. The drops of water which pass her
gates, come from the snowy peaks of the Rockies in British Columbia by the
resistless Columbia, one of the great rivers of the world; and from the crest of
the Rocky Mountains near the Yellowstone National Park by the Snake River,
whose springs are but a few minutes' walk from the sources of the Missouri;
and from the snow peaks of the Cascade range by the Willamette River, flow-
ing north to swell the Columbia. The water drops in these rivers not only
can bear traffic; but as they flow, so in inevitable economy must all the trade
of this great inland empire roll down hill to the door of Portland. The great
economic struggle to which the Rose City must gird herself is whether this
inconceivable volume of traffic shall find the sea at her harbor, or roll further
on to find it on Puget Sound. The only gap in the entire Cascade range of
mountains at tide level is that magnificent rending of the mountains through
which flows the Columbia. I am informed by *Reminiscences of an Old Eng-
lish Civil Engineer*, just printed by Robert Maitland Brereton, C.E., that the
natural drainage area, tributary by the law of gravity to Portland by way of
the Columbia River, whether by water, or by rail following water grade, is
225,000 square miles, 195,000 of which are in the United States, as against
60,000 square miles tributary by watershed to San Francisco.

The whole problem lies in a forty-foot channel over the Columbia River
bar and a thirty-foot channel to Portland, both of which all engineers unite
in declaring easily practicable, merely a question of money, and not a pro-
hibitory sum of money either.

Blessed by the gods, Portland sits like a young queen awaiting tribute.
The whole world lies at her feet. Golden seas of grain are at her back which
last year furnished nearly sixty million bushels of wheat and over twenty
million bushels additional, barley and oats; and the country not yet touched.
Orchards which produce apples, cherries and pears unrivaled in the world.
Forests and mines, and the latest discoveries in Eastern Oregon indicate gas
and petroleum. She sits truly crowned with roses. Her summers are Eden
and her winters are only the fresh warm weeping of the skies; no storms; no
freezing; no bitter winds. Health waits upon her, and she is foremost in the
world in that blessing without which all else is naught.

The whole population of Oregon a little over thirty years ago was less
than one hundred thousand people. Today it is something over six hundred
thousand, of whom about two hundred thousand are in and around Port-
land, and there is a population in that great area naturally tributary to Port-
land of about a million, though it is easily capable of sustaining in comfort
and happiness more than fifteen million people.

These are some of the thoughts which lead her lovers to place upon Port-
land's brow the queenly wreath of roses.

The first First Rose Festival parade

I am reluctant to boast of age myself, and certainly I am no pioneer. When I took station at Fort Vancouver in 1875, Portland was but a straggling town of frame buildings. I remember hearing Mr. Lloyd Brooke boasting to a friend, an army officer who before the war had been stationed at Vancouver with Grant, that Portland had twelve thousand inhabitants exclusive of Chinese, and regretting that the friend had not put some money into Portland real estate years before. But the Portland of those days was practically only three or four streets back from the river. The business district was on Front and First Streets from Pine to Yamhill. Second Street was Chinatown, and the residences were on Third, Fourth and Fifth. Captain J.C. Ainsworth lived where now is the Ainsworth building, and Mr. C.H. Lewis, Dr. R.B. Wilson, Dr. R. Glisan, the Burnsides and Saviers and Captain Flanders lived on Fourth Street north of Stark, and during the high water of June, 1876, visits in this quarter were conducted by means of skiffs,—Venetian days. The only river-crossing was the Stark Street ferry, and a muddy road ran across the Peninsula through farms and fir timber to the Vancouver ferry on the Columbia. Among the hotels were The Cosmopolitan, at First and Stark Streets, and The Occidental, at Ash Street, both two-story frame buildings,

and on First Street, near Morrison, was Thompson's "Two-Bit House," to which the prospector, the trapper, the immigrant and the flat-broke were charmed by the witchery of poetry:

> *Thompson's Two Bit House,*
> *No deception there.*
> *Hi-you, muck-a-muck,*
> *And here's your bill of fare.*

Then followed the bait for the day, such as: "Eggs with coffee and biscuit, 25 cents. Chops and potatoes, 25 cents," etc., ending with another flight of the poetic imagination in homely English and unfettered spelling:

> *Now is the time to take the wrinkles*
> *Out of your belly after the hard winter.*

Certainly none but a serpent could have resisted this.

Communication with the outer world was by stage from Roseburg over the Siskiyous to Redding and Sacramento, and by the weekly wooden steamers *Ajax* and *Oriflamme* to San Francisco. On steamer days Portland's business hours did not end till the sailing of the steamer late at night. Her coming was heralded from down the river by the boom of her cannon, and she found the whole town at the dock to greet her: merchants for their mail and invoices, expressmen and hackmen for jobs, many to meet friends and others just for the excitement of the thing.

If Portland seems to me to have burst the bud like a rose touched by the summer sun, how must it seem to those still living who remember the Rose City as, in 1847, a forest of firs out of the shadows of which stole a few frame shacks along the edge of the Willamette; a bakery on the north side of Morrison Street, which street was named for J.L. Morrison, who had a little store at the foot of it. Pettygrove's store, at the foot of Washington Street, a log cabin at the foot of Burnside (on Captain Couch's donation land claim), Job McNamee's log house at Front and Alder, Terwilliger's blacksmith shop on Main Street, between First and Second; the salmon fishery at the foot of Salmon Street, and on the corner of Taylor and Front the most superb structure in Portland, Waymire's double log cabin. On the bank of the river was his sawmill, a whip-saw operated by two men, one in the sawpit and one on the log. Humble beginning for the city which today manufactures more lumber than any city in the world: chief city of a state which holds one-sixth of the timber of the United States, more than three hundred billion feet, with twenty-three billion feet additional from that part of Washington tributary to the Columbia. Metropolis of a territory two hundred and twenty-five thousand square miles in extent. If only Tallantyre and Waymire,

the two whip-saw lumber mill men of Portland sixty years ago, could stand as I have stood on the heights above the city on a sparkling autumn morning and mark the straight columns of steam rising all along the river like great altar-fires, blending with the pearly clouds and reflected in the river so that earth and sky mingled in one vaporous mystery, what a dream it would seem. To the silence of these heights rises the constant drone of the great band-saws which are slicing up five hundred and fifty million feet of lumber a year. Perhaps to these pioneer sawyers it would seem even more a dream if they were brought face to face with one of these great mills with its acres of stored lumber, its wilderness of electric lights at night, the scream of its saws, and the rumble of its chains and rollers; its giant log-ways, the Titanic power which snatches from the river, as a monster seizing its prey, logs five feet, even six feet and more in diameter, and rolls, shifts and adjusts them to its maw as if they were straws.

Like our great counterparts the Romans, we are, as I have said, a commercial and a utilitarian, not a poetic or artistic people. Our genius, too, is for construction; construction in institutions as well as in stone and mortar. Our art finds its place in skyscrapers and bridges. The dreamer has no place with us, though all which truly lives forever has begun as a dream. Three hundred billion feet of timber in Oregon are impossible figures to count on the fingers, but they are easily grasped by arithmetic. It is no trouble to divide them by Portland's own cut of lumber (which is only a part of the total cut), five hundred and fifty million feet a year, and to guess at the day when the Oregon forests shall not be. The City of Roses carved from that forest will have to take its visitors even now far to show them so much as a few acres of an unbroken forest, and it is so everywhere. The dollar rules, and except for the Government reservations there has been no thought of preserving a specimen of what mysterious Nature was a thousand years in building into infinite beauty with infinite patience. When I see a dead giant rising from the river and placed dripping and naked before the saw, stripped of its armor of rugged bark to which the lichens and mosses clung lovingly till the last, I am foolish enough to think of the past ages and the future, and to believe that it is not necessary all should be wiped off clean, and when I hear the shriek of the log at the first bite of the saw I am Greek enough to think of Daphne and the dryads and the hamadryads, and I like to think of the shadowy aisles of an untouched Oregon forest, where the sky is blotted out by the dark and over-arching roof of green and into the sky, smooth and clear and round, for one hundred, two hundred feet, rise the great solemn columns of this cathedral. I smell the balsam and feel the soft carpet of needles and of moss and look into those bluish depths where the giant trunks become almost ghostly and, behind that veil, it seems to me still lingers the Great Spirit of Creation. There brooding Silence shuts out the world and in these temples there is perfect rest. It seems to me that this great beauty and solemnity is perhaps as

valuable as the shriek and clamor of the mill. It is a pity to have all this majesty of antiquity wholly destroyed. Man cannot restore it. It cannot be rebuilt by Nature herself in less than a thousand years, nor indeed ever, for it never is renewed the same. Nor do the Government reservations preserve this to us; they, too, are wholly utilitarian and their plan contemplates the gradual sale and destruction of these Titans. There is no spot where the primeval forest is assured from the attack of that worst of all microbes, the dollar.

But Portland in her Feast of Roses is to throw commerce and the dollar to the winds. For one week at least she invites you to joy and beauty. To open your eyes and see the world you live in. King Rex—which sounds tautological to say the least, but perhaps it is spelling Wrecks as Thompson spelled wrinkles—is to lead the festal procession, and with him it will be as with Browning's patriot:

> It was roses, roses all the way
> And myrtle mixed in my path like mad.
> The house-roofs seemed to heave and sway,
> The church spires flamed the flags they had.

And no veering of the fickle populace with King Rex on the scaffold at the end of his journey.

The city will be gay. It is a good thing, for tomorrow we die. The wise and inscrutable Celestial will hang out his great diaphanous lanterns with splendid red letters and invite you to his Orient-smelling shop, or serve you chop-suey, delicious tea, almonds and ginger and kumquhats in syrup on the balcony of his restaurant. The ships which carry wheat and flour and canned salmon to feed the world will flutter their many-colored buntings and perhaps the battleships—those wastrels of the Nation in which the people persist in taking delight—will sit upon the bosom of the Willamette like sacred swans. *Themmes* had his Spenser and the Willamette, its Sam Simpson. Get his beautiful *Willamette* and read it, if you read poetry. No one does. The Willamette is one of her jewels which Portland will show you. Her very own. She shares it not with other states or even other nations, as she must the Columbia. The Willamette, more gentle than the mighty Columbia, sings sweetly to its banks of green as it comes from the Southland.

Today (the end of April) the maples, hazels, alders and willows make a bright, bright new green with their young leaves, so that the river is all emerald and sapphire. The wild currant bushes make spots of coral pink along the bank and the hills are gay with dogwood blossoms scattered like stars. Sylvan, crystal and beautiful, like a bride pacing down an avenue of blossoms, the Willamette comes to Oregon City and there, wild and disheveled, plunges over, scattering for our uses in its plunge one and a half times the power given by the Mississippi at the Falls of St. Anthony; and then, as if

subdued, our beautiful river flows more broadly to Portland, decorated with verdant islands and guarded by hills of bluish green which cast their reflections into the water, giving it where it mingles with the sky, the liquid and changeful beauty of the peacock's breast.

Portland will decorate her streets for her Feast of Roses, but if you would truly see the beauty she has to offer, go upon her hills. The city lies in an amphitheatre surrounded by hills seven hundred and a thousand feet high, soft with green of many hues. From these hills the city itself takes its place as only a bright and scattered spot in the landscape; its spires and towers rising above the common level; its smoke and steam wreathing about it; its houses half-concealed in trees and shrubbery, and the river lying like a silver ribbon through this house-clustered area which lies like a dotted rug upon the scene. Blue to the south is the valley of the Willamette; blue to the north the valley of the Columbia; blue to the east the great Cascade range, toward which roll the lesser hills, paling as they go and bright with villas and villages. Set into this blue, like pearls upon a sapphire girdle, glow the great snow mountains: Jefferson to the south; Hood full in front, sometimes it seems just across the river; St. Helens, also, full before us like a pearly bubble of the world, and above the horizon the peaks of Rainier on the Sound and Adams away up in the Yakima country. This is a picture never the same, nor ever was from Time's beginning, nor ever will be, and not the same hour by hour. I have watched Mt. Hood and, all in a single hour in the evening, have seen it pearly white afloat in blue; then delicate rose upon amethyst; then, when all the earth had fallen into deep purple shadow, above it, against a rosy sky, flamed the great snow-peak, glorious in the rays of the sun, which it alone of all the earth still caught in full effulgence. At such a moment the great mountain seems to glow with an internal fire, as if it were a molten mass of metal sending out light: straw color, orange, cherry red; and then in a moment it is gone. The shadows have climbed quickly to the summit and the cold mountain becomes a sentinel of the night. And cool caressing night comes with gentle step and healing finger tips, the earth vanishes and fairy land appears. Far as the eye can reach the lights of the city glitter like a lower heaven, and on clear nights it is as if the sky had fallen or the world was one vast starry and sparkling space. To these hills the birds resort in the evening, making a carnival of song till slumber hushes them. Here are leafy thickets of hazel, wild currant, plumy spirea, the orange-blossom syringa and wild rose. Groups of dogwood trees, white in the spring and red in the fall. Wide-spreading maples and young firs with aromatic smell. But the giants are all gone. In the middle distance, down the Willamette River, is a small white block with a black line of smokestack. It is one of the boasts of Portland, the Portland Flouring Mills, which grinds for that wise people we are pleased to call the heathen, three-quarters of a million barrels of flour a year, and is the head of a system which grinds nearly two million barrels. But among

these hills, with the plaintive warble of a thrush sounding from a grove and the great snow-peaks looming into the sky, the mill seems only a very small white speck on the face of Nature.

LOUISE BRYANT

A graduate of the University of Oregon, Louise Bryant (1885–1936) had a penchant for radical politics with a feminist bent. When she lived in Portland, she wrote and served as an editor for the local society magazine Spectator *and became acquainted with the city's leftist writers, artists, and activists. At one gathering, she met John Reed, whose writings she had become familiar with through* The Masses. *In 1916, Bryant left her dentist husband to move with Reed to New York City's Greenwich Village, the heart of the country's Bohemian culture, and later that year the two married. The following year, they traveled to Russia to report on the revolution there. In 1918, Bryant published* Six Red Months in Russia: An Observer's Account of Russia Before and During the Proletarian Dictatorship *and, the following year, returned to Portland to lecture on the topic. Four years later, after Reed's death, she published* Mirrors of Moscow *(1923) and continued to build her reputation as a serious international journalist. In this piece for* The Masses *(1916), Bryant profiles two Portland judges and their positions on unemployment, homelessness, and child illegitimacy.*

Two Judges

Something almost like a miracle has happened in Portland, Oregon. It happened to two judges. When it happened, one of them ceased to be a judge. And the other—but here is the story.

John S. Stevenson was a poor, lonely, and ambitious youth. He always had to work hard for everything he ever got. When he was a reporter he studied law at night. By unceasing perseverance at the age of forty, he became a Municipal Judge. That was two years ago. It was a real achievement for him. He felt some satisfaction with life. When he took the bench he had no sympathy for the man who failed.

Judge Stevenson is an absolutely honest man. The limit sentences he imposed and his harsh attitude toward the shivering unfortunates who stood before him in those first days were an honest expression of his own attitude about life. His own struggle had left him hard. He had worked. He had achieved. Why couldn't they?

About a year ago something happened to Judge Stevenson's soul. It was during the winter and there was the usual problem of the unemployed. It

happened to be worse that winter than ever before. Men slept, by the hundreds, most of them without blankets, in the breezy tabernacle that was built for Gypsy Smith's revival meetings. Those who could not get in roamed the streets. Every morning the police court overflowed with "vags." They didn't even have room in the jails for them.

One morning Judge Stevenson said, "I am not going to send any more men to the rock pile because they can't get jobs when there are no jobs."

A few days ago he resigned.

When the papers interviewed him on his unusual action, he said that the police court is a failure, that men were never reformed by being sent to jail. He said: "Crime is a relative proposition. Environment, opportunity and temptation converge together in making a man a criminal; not alone is it human weakness. Under the same conditions and circumstances, I would probably have done the same things as the men I sentence." He said that he was sick of the whole thing and that he had had his share in the misery of it. And so he retired into private life.

William N. Gatens, the other judge, was also a poor boy and an orphan. He earned his own living from the time he was twelve. Physically he is very frail. His vigorous activities cost him a mighty effort.

When he was head of the Juvenile Court he said publicly it was a failure: but nevertheless it may be remarked that little boys and girls never came before him trembling, and they always shook hands with him as equals when they left. He never said very much to the children, but he said a good deal to the people who brought them there. Things they never wanted to repeat. He was removed from the Juvenile Court because of the honest statements he made concerning it.

During his last two years as judge of the District Court, he has handed down some of the most remarkable decisions that were ever made. He is not afraid of anything and is unshakeable in his knowledge of the law.

It was he who, when Emma Goldman was on trial for distributing birth control literature and a smart young assistant attorney was flourishing the "obscene" sheet, said, "Ignorance and prudery are the millstones about the neck of progress. Everyone knows that we are shocked by things publicly stated that we know privately ourselves," and he dismissed the case.

It is Judge Gatens who has worked untiringly for years to pass a law to legitimize illegitimate children. He has worked for equal suffrage and every other liberal cause that has come up in the state. He will give you a divorce in his court if you don't love the person you are legally tied to.

He has made people in Oregon think. He looks pretty tired sometimes, but he always stays on the job.

Now I wonder what the readers of *The Masses* think about the different way these two men acted when they discovered the truth about their jobs.

You honor the judge who resigned, as you must honor every sincere and noble action. But the man who stayed—didn't he do something better still? What do you think?

EVELYN MCDANIEL GIBB

The stories of Evelyn Gibb (1924–) have appeared in many magazines and in the Chicken Soup For the Soul *book series. She lives in Sedro Woolley, Washington. In* Two Wheels North: Bicycling the West Coast in 1909 *(2000), Gibb recounts the story of two young men during the first decade of the twentieth century who bicycle and work their way from California to Seattle. In this excerpt, the men pedal their way in Portland, straight into "the hubbub of an honest-to-Sam city."*

From *Two Wheels North*

We coasted lickety-split down the graveled, winding grade, the cool air freshening us, along with our spirits. More and more lights pricked on, though the west sky still blazed reds and oranges.

"Bigger than I thought," Ray yelled back, an excitement in his voice. "And there's our Willamette River, all grown up. Runs right—through—town." A rock stumbled his talk, as he took a hand from the bars to sweep it north, where in the distance another river flowed hugely east to west. "And there, the absolute—ly, true Co—lumbia River."

A mighty swath of water it was too, the broad path of it catching the low light along its massive passage to the sea. "Lewis and Clark and their boys must have had themselves a fine sail down that old river," I hollered, while it struck me they could have felt the same inside tingles at their first sight of this country as Ray and I did now, a hundred years later.

Soon we would be in Portland. I realized suddenly that the tiredness which had ached my every bone on the other side of the hill had stayed there—on the other side of the hill; I felt brand new. "Look there." I waved east where Mt. Hood rose in a snowy cone that sunset had turned to strawberry cream. Less than ten minutes later we pedaled along a paved street smack in the hubbub of an honest-to-Sam city.

Already we had met three automobiles and passed several more. Drays, express wagons, one-horse deliveries, buggies added to the muddle even at this hour on Monday. Pedestrians, mostly men in dark suits and bowlers, walked with important steps in front of us, behind us, off and on the street, swarming the sidewalks thick as flies on a flop. To each side, cheek-by-jowl buildings towered eight to ten stories, and were fancily decorated with arched entries and heavy doors that held thick, figured glass, and facades ringed

round with fierce-looking lions or sturdy ladies wearing spiked crowns.

"Watch out, Vic! You near ran down that fellow and his trash cart."

We bounced over electric car tracks, and threaded through the wagons and walkers, my pulse at full gallop. I wanted to holler and shout, be part of the noise. Ahead, a streetcar clanged and started up. Horses whinnied and snorted as they clopped along on the macadam. Everywhere, the clatter of wheel rims. Off a ways a horn oog-aahed. Not since I was in San Francisco when I was ten had I seen and heard a city, and I was too young then to feel the throb and beat of thousands of folks living close.

"Find a park where we can roll up?" Ray yelled.

"Down this street looks like the courthouse." We signaled our arms for a left turn.

The government buildings' grounds were wide-reaching, with bushes and trees enough we could disappear from scrutiny. And the Post Office was bound to be nearby. Later, as we lay rolled up under a rhododendron the size of a wood shed, our blankets back to back, my every muscle had its own story about how long our day had been. Even the street noise wouldn't steal my sleep this night. "Cyclometer says eight hundred and ten," I said, my eyes shutting down.

Ray muttered, "Tomorrow, have to find Burnside Street. See that longest bar in the world," and grunted.

Tomorrow came quick enough. A dinging streetcar bell brought me awake. My blanket felt clammy from the fog that veiled the whole world and dripped from the trees like rain. Ray was packed and chewing jerky as he sat on the grass watching a Metropolitan electric car unload then load flocks of people, the action looking staged behind a gray scrim. Conductors at either end of the car, at the tiller and the back door, stood smartly erect in their double-breasted dark uniforms and squared-off caps. The people scrambling on and off looked only in a hurry.

Once packed, I grabbed some jerky, and puzzled if the odd wonder in me was born of the leavings from a last night's dream, or if Ray really had suggested we go see that longest bar. If he had, was it just sleep talk? Either way, I decided not to ask him.

Locking our wheels in front of the courthouse seemed as safe a place as we might find. Free of the bikes, we could see the city. A sling of our rucksacks on our backs and we were off. Fog seemed even denser, but a man at the foot of the courthouse steps told us it was sure to lift by noon. At the Post Office we headed for the General Delivery window where I had a fine letter from little Hazel, and one from Papa and Mama. A note from Finley said town folks liked what we wrote and to keep sending our letters. Ray's mother wrote how she and his sister missed him and asking when did he think he could come home. She sent a money order for five dollars, which he cashed right there in the Post Office.

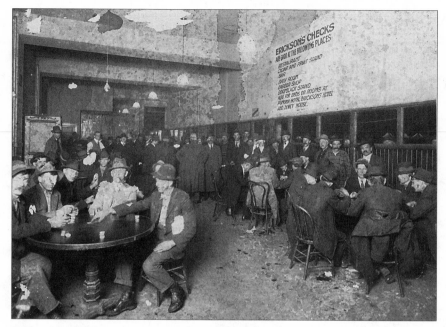

Erickson's Saloon

"Now we shouldn't have to work again before Seattle," he said.

"But your mama wants you to get home on that money. We sure won't spend it 'less we have to."

Electric car after car took us from one end of the great city to the other. I couldn't remember when the fog disappeared, but the sun was a warm one all afternoon. We got off at the police headquarters because the conductor said prisoners from the basement jail were let out in the daytime to work in the shops up and down the street. In a small grocery we bought some bread and cheese, then shuffled about in a big market with marble-countered stalls, but we never saw anyone who looked like a let-out criminal.

It was some after the sun sank that the conductor called, "Burnside." On the instant Ray and I both reached up to pull the cord. From where we got off it wasn't far to the building with the small oval sign: Erickson's Saloon.

"There's still light. You want to go back? Clean the bikes?" I watched him closely. Yes I wanted to see that bar; what I wasn't sure I wanted was to see Ray in a saloon. "Plenty of time to bike-clean in Washington where the bars aren't as long, Vic." Ray definitely had not been sleep-talking last night. I grinned. But this friend of mine best get all his parts going the same direction if he's thinking to one day march down that narrow churchy aisle with a band around his collar, was my feel for it.

Erickson's was as much arena as saloon. More men filled the place than I'd ever seen in a single room. Crowded around tables, standing at the back and side walls along what must have been the bar, milling, talking in groups as they entered behind us, laughing and slapping each other on the back. The air was blue smoke that drifted in lazy clouds about the lamps dangling on long cords from the high ceiling. Every man wore either a pipe or cigar in his mouth, taking it out only to talk or drink. From somewhere down at the end of the room waves of laughter and banjo music pulsed through the vast assembly of hatted, smoking, card-playing drinkers and talkers.

"You boys meeting someone?" A short man in a wrinkled gray suit crowded close.

"Just here to look," I yelled over the din.

"There's a store of lookin' to be done, lads." The fellow had Ray and me by the elbows. "This way," he hollered in a friendly way and guided us between several groups to a round table where a white-bearded fellow leaned back in his chair and stared into his glass. "Sit down, m'lads," said our chummy fellow. "You need a drink. It's a fearsome wait at the bar. I'll just mosey around, tell Charlie we got newcomers needs good treatment."

"No cause you should trouble for us," Ray said. I said, "We'll buy our own, and thanks." I slipped off my pack, set it on the table and dug out the money.

"We're a city likes to show folks a good time. Now you boys look around. I'll be back with a couple of Oregon beers and wait for you."

"All right." I slapped two nickels in his hand. "We'll just look about. Meet you back here."

Off from the main room were other rooms, one with private booths behind large wooden panels. Men carrying drinks moved from place to place. A large sign on the wall listed a number of locations in the building that honored Erickson's checks, whatever they might be. A barbershop, the back room, a bootblack stand. Ray talked near my ear. "A man could live right here and never need to leave."

To judge from the mob that crowded three and four deep down the length of one long wall and curved into another, and then another, the bar was for sure a far-going one. We edged closer. Then, through the jostling mob, we saw the bar: a thick slab of handsome dark wood polished like a mirror.

"Better muscle in if you want a drink," a tall fellow shouted next to us. His fedora pulled low over one eye gave him the look of a dandy, but his angular, stubbled face looked down at us openly. "We have a drink waiting at a table," Ray told him. "We're mostly interested in seeing that bar. The longest in the world?"

"That's right. When the town was under water during the big flood in '89, the boys tell they couldn't be parted from that bar. Just took it up so's it'd float, and had their drinks as usual. I think I believe it, though beer

spins some fine yarns." The fellow had a deep laugh that rumbled through his spare frame. "Name's Amos. You men from around here?" He held out a hand, and we shook.

"Come down to the end here where we can talk and you can appreciate the beauty of the wood in this bar." He gestured to where several stools stood empty.

"On our way to Seattle to see the fair," Ray offered, as we slid our hands over the bar's velvet-smooth surface.

"Fine fair. Friend of mine just got back. Says it's as good as ours was in aught five, lots of it almost the same, he said. For ten cents you can get a ride on Lake Washington. Grandest body of fresh water west of the Great Lakes, they like to call it. My friend says that may even be true."

Amos motioned us to sit on the stools, taking some care to flip out his coat tails before perching between us. His were not the clothes of a laboring man. "I want to tell you boys the gondola rides on our little lake here at Council Crest were about as pretty as any you'll find. Ladies liked them too. Especially in the evening." Amos was a man maybe thirty-five, with a worldly kind of sadness about him.

"So, on your way to Seattle. You come up on the S.P.? Hoboing? There's no more Southern Pacific across the Columbia, you know. Northern Pacific takes you on to Seattle."

Amos told the big-bellied barkeep we didn't need drinks, then was properly appreciative we had biked our way up from California. He asked about the roads and what kind of weather we ran into. Ray and I took turns telling about our trip. Two men who had been talking nearby now stood behind us and listened. Ray livened to his stories, eagerly waiting for me to finish mine, even finishing for me if I hunted for the words. A third fellow, and another, stood around us and asked questions too. Before I was through telling about the Greek road gang, Ray was starting his story of the rattlesnake. With our map laid out on the bar he showed the gathering exactly where it happened.

Finally, I said we should go back to our table. "A fellow up there kindly offered to get us a drink. Said he'd wait for us."

"Short fellow? Near the main entrance?" Amos asked. "Told you he'd tell Charlie to give you an Oregon beer 'cause you're from out of town?" The men nodded and laughed, enjoying whatever was the big joke.

"That's Mort, all right. Erickson's greeter, unofficial, that is," said one fellow. The men watched us knowingly, saying, "Good old Mort," "Never takes a day off, that one," "Always looking for young hot bloods."

"Did you give him any money?" Amos asked gravely. "Make him any promises?"

"Couple of nickels," I said. "No promises," Ray added.

"Kiss those nickels goodbye," bellowed a big fellow in overalls.

"Vic, Ray." Amos was earnest. "These folks and I have been in Portland awhile. I'm in business down the street and glad for the new mayor because of the trade. But Harvey here." Amos took hold of the arm of a middle-aged man standing near. "Harvey wrote a good many pieces in the *Oregon Journal* to keep Lane in office. But good old Portland voted for Joe Simon. Soon as Simon took office the unsavories came to power with him. Mort now, he works for the "Mansion of Sin," old Madame Fanshaw's place. You know what I'm talking about, boys?"

"We do." It was Ray got his tongue to going while I still chewed on mine.

"Well, Mort is out looking for business for his ladies. But if he thinks he won't be able to interest a man in his pretty women, then he's likely to steal. And Mort's just one. There are others, plenty of them right in this saloon. My advice, you boys don't even go back to that front table for your beer, or your nickels, and consider yourselves fortunate. You might just leave right here through the side door." The others nodded, saying, "Good advice, lads," "Best be on your way," "Catch that old ferry across the river."

"Thanks," Ray said. "But Vic here left his sack on the table up front. We're grateful for the warning though." He turned to lead the way back through the thicket of drinking men whose talk was louder now, gustier than when we came in. "See that fair good and proper, lads" one of the men hollered after us. "Good luck," another yelled. We waved to them over the hats of the crowd.

Scrambling our way through the revelers was slow work. My head was in a spin: nickels, rucksack. I couldn't even remember what we'd put in Ray's sack and what we stuffed in mine. Nearer the front entrance, the new arrivals, eager to get back to the bar, were even harder to buck.

Ahead, Ray inched around a clump of roisterers, and I was finally clear of a bunch of fellows putting on their greatcoats. I made my way to Ray now standing at our table. No Mort. No white-bearded man. On the table were two empty glasses and a full ashtray. No rucksack.

Ray held out his hand. In his palm sat our witless billiken. "Left us the imp," he groaned.

BARBARA BARTLETT HARTWELL

Barbara Bartlett Hartwell (1892–1973) taught Sunday school at Ascension Chapel and Trinity Church, where she was a veritable community pillar. Born in Portland, she attended St. Helens Hall (now Oregon Episcopal School) and trained in library science at Columbia University. She married Mortimer Hartwell and raised four children. Hartwell was devoted to Oregon historical subjects and was active in the Colonial Dames of America and the Oregon Historical Society. She published two historical works: Fifty Years: A History of the Colonial Dames of America in the State of Oregon, 1923–1973 *(1973) with Mrs. Burt Brown Barker, and* Sprigs of Rosemary *(1975). She was well known for her oratory, and this address to the Portland Art Museum in 1942 is a fine example.*

The Wood Household

There were in the Portland of my girlhood a number of houses which possessed individual atmospheres. Their interiors and exteriors, the feel of their carpets beneath my feet, the smell of their dining rooms, the taste of their food, the personality of their cooks, the books, manner and subtle emanations of their owners have remained with me as vividly as the smell and color of Portland's streets in the days of hot, fat, pink Caroline Testout roses down parking strip after parking strip.

In that period of cable cars groaning up the trestle over Goose Hollow while you looked quakingly at the earth far beneath; of swimming at Bundy's; the Portland Academy where Alta Smith monotonously took all the prizes in all the subjects; picnics at Oregon City amidst poison oak, refreshed by lemon pie and sarsaparilla; when rain pattered exquisitely on the tin roofs of Victorian balconies that jutted out from numberless arched Victorian windows; when the "Rose Parade" was an intimate thing; when everyone knew everyone else and his horse and Miss Becky Biddle was pointed out by the bystanders as that "beautiful blond—the one in Alice blue and Merry Widow hat"; when the Corbetts' coachman George drove their carriage trimmed with lupin; when the sight of Miss Carrie Flanders on horseback sitting perfectly on her side-saddle made you feel Hyde Park didn't have ALL the cards or Central Park either; when . . . but I can't go on enumerating those sights and sounds that are gone forever; there must be a final "when," with its dependent clauses, that somehow sums up the whole period and gives in a sentence the essential difference between Portland then and now. When, in short, Portland was a town in size—leisurely, wooden sidewalked, spacious gardened, concentrated—with neighbor's yard touching neighbor's yard; with a clear cut "society," a rigid set of standards, a remarkable "touch" with Europe and the Eastern coast, and an equally remarkable dimness about the several thousand miles that lay between the Pacific and Atlantic; a town

with an atmosphere of New England simplicity combined with dignified opulence.

Standing out against this background were the seven houses that gave the atmosphere of which I speak, an atmosphere as different from that of San Francisco, Seattle, Spokane, as great-grandmother's potpourri jar from the best concentrated Coty "Quelques Fleurs"; the H.W. Corbetts', the Ladds', the Henry Failings', the Lewis's, the Tuckers', the Ayers',—and lastly the Woods', where the Portland Heights car, containing everyone you knew by sight, whined its way over the quivering wooden inadequacy called the Ford Bridge. Seven houses, each as different as the colors of the spectrum, but blending into each other as colors do, for Portland was charmingly intimate in those days—wasn't Mrs. Wood reported to have called Mrs. Ayer "Daisy" in someone's hearing? This story was never really verified. However, I saw with my own eyes a note on her desk beginning "My dear Daisy," but imagination boggles over anyone calling Mrs. Wood "Nanny" or Mrs. Beck "Sarah." It is a surprise to me that I know what their first names were, and only shows the amazing detail with which my mother, incomparable raconteur, regaled me with stories of an older Portland than mine, when Miss Nanny Moale Smith of Baltimore married Mr. C.E.S. Wood, lieutenant in the United States army, and came out to be ever afterward the only original Mrs. Wood. I remember calling up the house in my crude girlhood—after she had collected some daughters-in-law—and asking to speak to Mrs. C.E.S. Wood. Her own voice withered me in four words. "Mrs. Wood is sufficient," she said with extreme dryness.

And, indeed, she and it were in every way sufficient to herself and her friends and to Portland. She was of that rare race of charmers who live forever; and the Wood household, with all its inhabitants from master and mistress through its distracting five children, had a QUALITY. I do not remember the current cliché word "glamour" being used then—the dictionary says "enchantment" is included within the definition. The Woods were fascinating, and to be in their house was to me an enchantment—a glamour shed itself over everything they did.

The other six houses expressed hospitality, dignity, sumptuousness, stateliness, wealth, gracious intellectuality; the Woods' was of a different world. It was Bohemia without shabbiness; it was unconventional, but shot through with conventionality like changeable silk. Just as you expected the Woods to be married in city halls or temples to Minerva, they were married in churches. But then, the sting of being married in churches was removed by the poultice of "contracts," which the protagonists signed under the Jovian guidance of Mr. Wood, while Portland Society (and those at the weddings were Portland Society) shuddered pleasurably over such a combination of the Altar and the Grove. The "contracts" were for the purpose of dissolving at will the bond just tied, and as the married pair were invariably immensely

in love, with all the warmth of personal passion and mutual family benedictions, the signing of them was an excuse for champagne and jest.

The Wood house was of the world as I have said—the world of Art, Music, Literature, and also the world of "who's who" and Society Bluebooks and the I.W.W. Except that it has never been the custom of those in the Bluebook to possess it, any more than Burke's Peerage would be the bedside solace of Lord Salisbury, such a volume at the Woods' would have found itself jostling "The Masses"—or the other way about, depending upon your viewpoint. In its rooms, dark with brocade, where rareties in glass, porcelain and metal gleamed through a kind of rich smelling gloom; where footfalls were hushed on dim handicraft from Persia; where books were smooth to the cheek in hand-tooled leather, and where there was such a plethora of precious things that the bathrooms startled unacquainted bathers with plunging horses from the Parthenon threatening them in the shower, one might meet almost anything or anybody—distinguished generals; Indian chiefs; Mr. Childe Hassam collecting his colors for an onslaught into Eastern Oregon; Phimister Proctor resting between beasts; editors; men of letters; radicals; and those among that Portland society of mansard roof whose dazzlement over such exotic persons as artists and Indians exceeded their native shyness at meeting them.

The food was fit for kings—the less stodgy royalties at least—kings with catholic tastes in oil and garlic, familiar with truffles and galentines; hams stuffed with honey; canvasbacks (shot by young Erskine, that hero of romance) lying in a bed of cress, served with wild rice and spiced huckleberry. The dining room was darkness visible, made more sombre by Spanish leather chairs. On the faint gold walls the oil paintings were mere dark brown mysteries in gilt frames highlighted by the white belly of a fish, where, if one went near enough, one discerned a dead duck, a bunch of grapes, a half a pear. About the room hung an aroma of wine and spice—the darkness only added to the spell. Even a child knew that when candles were lighted, and the company sat down about the table, toying with Lucullan items, the wit crackled and flashed as in no other dining room, led by that prince of hosts and story-tellers. The slices fell from the haunch of venison (shot by Erskine, the eldest son of the house, who was my idea of the ultimate in young manhood) and the anecdotes kept up with the slices, while Mrs. Wood, in an aura of charm, sat indifferently pecking at some milk toast. The ortolans and larks' tongues meant less than nothing to Mrs. Wood, who was given to headaches and dietetic denials.

Dear Mrs. Wood! How I wish I could make you live as you lived for me and the Portland of my day! Your enchanting face with its irregular features; the sallow complexion; the deep dark eyes; the poise of the head wrapped around and around with those masses of unbelievable hair that, released from pins, fell about your knees; your voice, which I can "do" perfectly and yet can't put on paper; your complete charm a combination of the utterly

natural and the woman of the world. I see you and hear you as if I had just shut the door on Ford street. She talked with everyone, male and female, with camaraderie. She was interested in everything. She could be trundled to the opera in an applebox on wheels, keep up the liveliest interchange with the vegetable man, bandy witticisms with an ambassador, be amused and amuseable, startle men callers by whisking them into the basement to help her track a rat that had been disturbing the peace; send unsuspecting men friends on mysterious errands; scramble about the rocks at Ecola in the most remarkable conglomeration of garments; and always there hung about her an impalpable but imperishable dignity. She was and will remain our only "grande dame." She was completely at home in any circle and always captured it; darkies of course adored her. They recognized at once the "quality." She had unfailing manners—she made a party.

At the end of her life, before she was an invalid, but an old woman, I remember I had an out-of-town guest either very august and dull or very crude and brilliant (I quite forget which) but I do remember that I could struggle with neither extreme. Whom to get to relieve the situation? Mrs. Wood, of course. So we thankfully drove sixteen miles to fetch her and return her. In an age of motors she never had one. She used the Portland Heights street car for her carriage to the immense enlightenment and enlivenment of the general public. It was a privilege to be delayed in the trolley before Mrs. Wood's house, while Mrs. Wood called a few last Baltimorean commands to the maid, and prepared to carry one of her unusual bundles down the steps. But having no motor was an indirect boon to duller people who owned cars. It was a delight to fetch and carry for Mrs. Wood—one fought for the honor.

She never read books, though she carried fat volumes about with a placemark in the first fifty pages. She was immeasurably more interesting than a thousand people who are erudite. She knew life, society, humanity; she was inescapably the center of attraction wherever she found herself; and age could not wither her nor custom stale.

I felt about Mrs. Wood as the heroine of "A London Life" did about old Mrs. Berrington; and my idea of a perfect evening was Mrs. Wood and me alone—or perhaps one other person as audience to us—in front of the fire, starting the ball by looking at the old photograph book, whose introductory picture was Mrs. Wood at the age of eighteen, under a parasol, gazing up archly into the faces of a clustered group of West Point cadets of the class of '74! And the handsomest face among them was Mr. Charles Erskine Scott Wood.

The glamour of the Wood house was far more than its extraordinary mistress. Mr. Wood was even more an extraordinary man. He should have lived in New York or Paris or San Francisco. Thank heaven he did not. He painted charmingly; he wrote poetry of color, depth, great delicacy and passion; he

was a brilliant lawyer, a friend of humanity, the dearest of fathers, the kindest of hosts. He was responsible for the lambent glow of originality and daring that illumined a fairly heavy and respectable quarter of a century in a town suffering from an almost too decided New England flavor. This period was before the days when business men "painted." They bought paintings but they created nothing beyond railroads and banks.

Certainly no one else on earth, as we knew it, could defend the I.W.W. in hand-tucked shirts. No other man in the world would send, or thought of sending, his eldest son to live with Nez Perce Indians and later to Harvard. He was immensely handsome with an Olympian beard and was always being compared with Jove. In an age of circumspection and avoidance of anything "animal" in conversation or art, he hurled startling Saxonisms into frightened ears. He enjoyed sending subscriptions to "The Masses" to hide-bound conservatives, he revelled in ridicule of the Church, and he was throttled by hospitality at Mount Angel. He was generous at his own table, and liked nothing better than a party for charity at which signs like "Gamble for God's Sake" shocked and tickled the eyes of a generation brought up to regard the Deity as more than an epithet or the point of a joke. His library was filled with magnificent "unexpurgated" books, first editions, translations. At fifteen one had a guilty sense that Mr. Wood's library was "wicked." Whenever I was in there I blushed if "discovered," as they say on the stage; and I did enough extremely surreptitious reading to be unstartled by Hemingway or Dos Passos in later life.

But with all Mrs. Wood's charm and Mr. Wood's versatile brilliance, the final touch to the house, that made it unique, were the children; at a time when people—fascinating, brilliant, social people who went everywhere and did everything—had children. Whether any Wood child was, as an individual, as remarkable as Mr. and Mrs. Wood I can't say; en bande they were irresistible. They were as colorful as a painting by Van Gogh. They were utterly uninhibited before anyone ever heard the word; their personalities were allowed to ramble richly at will, however they impeded the personalities of others. They sang their prayers to the street songs of the Spanish war. "Now I lay me down to sleep; I pray the Lord my soul to keep—ta-ra-boom-de-ay." They were either so good looking or so bewitching that you forgot to notice whether they were or not. They moved in the glow of the spotlight; keeping wildcats in their backyard; going off on solitary camping trips at ages so tender it was a step from pram to the tepee; holding up traffic by riding in front of horsecars. They consorted with people with names, Roosevelts and Morgans and Crowninshields; they belonged to clubs that were mentioned in novels. The East was, so to speak, their washpot, and Europe held no terrors for them. To a shy thirteen-year-old girl looking over the wall from St. Helen's Hall, which guarded the "Word" under Mr. Wood's very beard, these princes and princesses were too heady to be spoken to; they were to me a

remote cyclorama of romance seen through theatrical gauze and illuminated colored lights.

To go to Nan Wood's wedding at Trinity, and watch the sun suddenly shine through stained glass onto her silver train . . . ah, Beverly of Graustark . . . oh, Flavia of Zenda!! Here you were in the flesh! To sit at the Woman's Exchange on Fifth street and see Lisa Wood lunching with a beau, and holding up a coffee cup on a level with her eyes to see if they matched, (I only saw this in dumb show and don't know what ardent compliment brought forth the by-play) to SEE was a thrill; and to imagine DOING it some day! Could I possibly hold anything to my eyes, just plain watery blue eyes, and have someone look at me like that? And in the dazzling publicity of the Woman's Exchange, filled with Failings and Fashion?

As for the Wood young men, they were to me gods, who came out of the great world of Harvard and Cornell; whose lives were spent in flannels, dropping witticisms, pursuing damsels, ignoring the heartbroken, indulging in cataclysmic practical jokes, holding hands with heroines of romance like Margaret Walter (oh, those braids!), dancing with rhythmic perfection, singing songs to mandolins—"and every afternoon at four, I calls upon my mani-cure, and takes her for a walk." Max on horseback accompanying Margaret Montgomery, who wore the first white doeskin riding breeches in Portland; Erskine walking lissomely through the garden with a book in his hand, a sort of Byron and Robert Chambers hero in one; Berwick clowning until one wanted to DIE, just laughing like that; it was such agony! I stared at them dumbly at big weddings, from street corners, in the precious darkness of their own house—a thin white blond child to whom their mother, for inex-plicable reasons, was being kind.

The casualness with which these children "took" this very house was part of their fascination. Max, who looked like a Spaniard and had so much charm that it HIT you like an electric volt, was unmoved, like his mother, by pâté and truffles, though for different reasons. He liked boiled rice, lamb chops and chocolate cake, and such was his charm that no matter how inconve-nient or how many other people wanted something else, he got rice, lamb chops and chocolate cake. He visited us in Lewiston before his marriage and Mamma's Norwegian cook, who never spoke, if possible, and before she gave birth to a word swallowed in a visible, sliding, Adam's apple sort of way, made chocolate cake for six weeks. We all became very weary of its very color, and finally Mamma was firm. "Hilda, you MUST make a different sort of cake; ANY kind but NOT chocolate!" That night chocolate appeared, and before Mamma's wrath Hilda merely swallowed and said stonily, "Mr. Wood like this kind best."

When these royalties began to marry, romance for me reached its highest peak. I met Becky Biddle downtown at Meier and Frank's, selecting a dance frock shortly before her wedding. She was a creature from a fairy tale, gold,

and ivory, and blue! And when I learned that my hero and heroine were going off ON A CAMPING TRIP ON THEIR HONEYMOON, nothing except the last chapter of "The Virginian" had ever given me such a tremendous thrill.

The house on Ford street is gone now—there is no Ford street, no quivering wooden bridge, no street cars packed with familiar faces. The tangled garden where Mrs. Wood scolded the gardener to his infinite delight, and where the boys dug what they thought were truffles and ate them, being followed almost immediately by near extinction, has died of neglect and starvation. No Phoenix rose from its ashes, no family will ever take the place of that radiant and radiating circle that scandalized, delighted, entertained, bewildered Portland from the eighties to the Great War. They lived through Portland at its best when it had distinction and charm. And they were the center of it—the most distinguished and most charming.

JOHN REED

Journalist, poet, labor activist, and adventurer, John Reed (1887–1920) came from a wealthy Portland family that supported Theodore Roosevelt's progressive campaigns against corporate monopolies and corruption. Reed attended Harvard University, immersed himself in New York's Bohemian circles, and became one of his generation's leading foreign correspondents. In 1920, he established himself as the voice of the Russian Revolution in America through his firsthand account in Ten Days That Shook the World. *Reed also reported on the Mexican revolution and World War I, contributing regularly to* The Metropolitan, New Review, The Masses, *and* The New Communist. *He married journalist and author Louise Bryant in 1917 and, during the course of his career, befriended many prominent artists, writers, and political figures. In this article, published posthumously in* The New Republic *(1936), Reed reflects on his childhood in the city.*

Almost Thirty

I am twenty-nine years old, and I know that this is the end of a part of my life, the end of youth. Sometimes it seems to me the end of the world's youth too; certainly the Great War has done something to us all. But it is also the beginning of a new phase of life, and the world we live in is so full of swift change and color and meaning that I can hardly keep from imagining the splendid and terrible possibilities of the time to come. The last 10 years I've gone up and down the earth drinking in experience, fighting and loving, seeing and hearing and testing things. I've traveled all over Europe, and to the borders of the East, and down in Mexico, having adventures; seeing men killed and broken, victorious and laughing, men with visions and men with

a sense of humor. I've watched civilization change and broaden and sweeten in my lifetime; and I've watched it wither and crumble in the red blast of war. And war I have seen, too, in the trenches, with the armies. I'm not quite sick of seeing yet, but soon I will be—I know that. My future life will not be what it has been. And so I want to stop a minute, and look back, and get my bearings.

A great deal of my boyhood was illness and physical weakness, and I was never really well until my sixteenth year. The beginning of my remembered life was a turmoil of imaginings—formless perceptions of beauty, which broke forth in voluminous verses, sensations of fear, of tenderness of pain. Then came a period of intense emotion, in which I endowed certain girls with the attributes of Guinevere, and had a vision of Galahad and the Sangraal in the sky over the football field; a furious energy drove me to all kinds of bodily and mental exercise, without any particular direction—except that I felt sure I was going to be a great poet and novelist. After that I was increasingly active and restless, more ambitious of place and power, less exalted, scattering myself in a hundred different directions; life became a beloved moving picture, thought about only in brilliant flashes, conceived as emotion and sensation. And now, almost 30, some of that old superabundant vitality is gone, and with it the all-sufficient joy of mere living. A good many of my beliefs have got twisted by the Great War. I am weakened by a serious operation. Some things I think I have settled, but in other ways I am back where I started—a turmoil of imaginings.

I must find myself again. Some men seem to get their direction early, to grow naturally and with little change to the thing they are to be. I have no idea what I shall be or do one month from now. Whenever I have tried to become some one thing, I have failed; it is only by drifting with the wind that I have found myself, and plunged joyously into a new role. I have discovered that I am only happy when I'm working hard at something I like. I never stuck long at anything I didn't like, and now I couldn't if I wanted to; on the other hand, there are very few things I don't get some fun out of, if only the novelty of experience. I love people, except the well-fed smug, and am interested in all new things and all the beautiful old things they do. I love beauty and chance and change, but less now in the external world and more in my mind. I suppose I'll always be a Romanticist.

From the very beginning my excitable imagination fed on fantasy. I still remember my grandfather's house, where I was born—a lordly gray mansion modeled on a French chateau, with its immense park, its formal gardens, lawns, stables, greenhouses and glass grape-arbor, the tame deer among the trees. All that remains to me of my grandfather is his majestic height, his long slim fingers and the polished courtesy of his manners. He had come around the Horn in a sailing ship when the West Coast was the wild frontier, made his pile and lived with Russian lavishness. Portland was less than 30

John Reed in about 1916

years old, a little town carved out of the Oregon forests, with streets deep in mud and the wilderness coming down close around it. Through this my grandfather drove his blooded horses to his smart carriages, imported from the East—and from Europe—with liveried coachmen and footmen on the box. The lawn terrace below the house was surrounded on three sides by great fir trees, up whose sides ran gas-pipes grown over with bark; on summer evenings canvas was laid on the turf, and people danced, illuminated by flaming jets which seemed to spout from the trees. There was something fantastic in all that.

Then we were poor, living in a little house down in the town, with a crowd of gay young people around my gay young father and mother. My head was full of fairy stories and tales of giants, witches and dragons, and I invented a monster called Hormuz, who lived in the woods behind the town and devoured little children—with which I terrified the small boys and girls of the neighborhood and incidentally myself. Almost all the servants in those days were Chinese, who stayed for years, at last getting to be almost members of the family. They brought ghosts and superstitions into the house, and the tang of bloody feuds among themselves, idols and foods and drinks, strange customs and ceremonies; half-affectionate, half-contemptuous, wholly independent, and withal outlandish, they have left me a memory of pig-tails and gongs and fluttering red paper. And there

was my uncle, a romantic figure who played at coffee-planting in Central America, mixed in revolutions, and sometimes blew in, tanned and bearded and speaking "spigotty" like a *mestizo*. Once the tale ran that he had helped to lead a revolution that captured Guatemala for a few brief days, and was made Secretary of State; the first thing he did was to appropriate the funds of the National Treasury to give a grand state ball, and then he declared war on the German Empire—because he had flunked his German course in college. Later he went out to the Philippines as a volunteer in the Spanish War—and the tale of how he was made King of Guam is still told with shouts of mirth by the veterans of the Second Oregon.

My mother, who has always encouraged me in the things I wanted to do, taught me to read. I don't know when that was, but I remember the orgy of books I plunged into. History was my passion, kings strutting about and the armored ranks of men-at-arms clashing forward in close ranks against a hail of cloth-yard shafts; but I was equally enamored of Mark Twain, and Bill Nye, and Blackmore's *Lorna Doone,* and Webster's Unabridged Dictionary, and *The Arabian Nights,* and the *Tales of the Round Table.* What I didn't understand, my imagination interpreted. At the age of nine I began to write a Comic History of the United States—after Bill Nye—and I think it was then I made up my mind to be a writer.

About that time we moved to an apartment hotel, and I went to school. Those first few years of school stimulated my ambition to learn; but since then the curricula of schools and colleges have meant little to me. I've always been an indifferent student, to say the least, except when some subject like elementary chemistry, or English poetry, or composition caught my imagination—or the personality of some great teacher, like Professor Copeland of Harvard. Why should I have been interested in the stupid education of our time? We take young soaring imaginations, consumed with curiosity about the life they see all around, and feed them with dead technique; the flawless purity of Washington, Lincoln's humdrum chivalry, our dull and virtuous history and England's honest glory; Addison's graceful style as an essayist, Goldsmith celebrating the rural clergy of the eighteenth century, Dr. Johnson at his most vapid, and George Eliot's *Silas Marner;* Macaulay, and the sonorous oratings of Edmund Burke; and in Latin, Caesar's Gallic guide-book, and Cicero's mouthings about Roman politics. And the teachers! Men and women—usually women—whose chief qualification is that they can plough steadily through a dull round of dates, acts, half-truths and rules for style, without questioning, without interpreting and without seeing how ridiculously unlike the world their teachings are. I have forgotten most of it, forced on me before I was ready; what I do know came mostly from books I had the curiosity to read outside school hours. And many fine things I have had to force myself to explore again, because school once spoiled them for me.

But in going to school I first entered the world of my fellows, and the

social experience meant more and more to me until it almost crowded out the study side altogether. I can still see the school playground full of running and shouting and clamoring boys, and feel as I felt then when they stopped here and there to look at me, a new boy, with curious and insolent eyes, I was small though, and not very well, and at the beginning I didn't mix much with them. . . . But after school was out there were great doings, which were too exciting to keep out of. The town was divided into districts, ruled over by gangs of boys in a constant state of fierce warfare. I belonged to the Fourteenth Street gang, whose chief was a tall, curly-headed Irish boy who lived across the street—he is now a policeman. My best friend could make sounds like a bugle, and he was trumpeter. Standing in the middle of the street he would blow, and in a minute boys would come swarming to him, tearing up lawns and making mudballs as they came. Then we'd go running and shouting up the hill to give battle to the Montgomery Street gang, or beat off their attack. . . . And there were the wooded hills behind the town, where Indians and bears and outlaws might be lurking to be trailed by our scouts and Robin Hoods.

Both my mother's parents and my father came from upper New York State, and when I was 10 years old my mother and my brother and I went East to visit them. We spent a summer month at Plymouth, Massachusetts, visited New York (I still remember the awful summer heat, the vermin in our boarding houses and the steam-engines on the Elevated), and were in Washington when the *Maine* blew up and the first volunteers left for the Spanish War.

Then I was back in Portland, in a new house, settling into the life of school and play. We had a theatre in our attic, where we acted over our plays, and we built scenic railways in the yard, and log cabins in the woods back of town. I had a number of highly colored schemes for getting adventure and wealth at the same time. For instance, I once began to dig a tunnel from our house to school, about a mile away; we were going to steal two sheep and hide them in the tunnel, and these two sheep were going to have children, and so on, until a large flock had gathered—then we'd sell them. My brother and I had a pony, and we went on camping trips back in the woods, and sailing and swimming and camping up the Willamette River. I began to write poetry, too, and read voraciously everything I could get hold of, from Edwin Arnold's *Light of Asia* and Marie Corelli, to Scott and Stevenson and Sir Thomas Malory.

But with all this I wasn't entirely happy. I was often ill. Outside of a few friends, I wasn't a success with the boys. I hadn't strength or fight enough to be good at athletics—except swimming, which I have always loved; and I was a good deal of a physical coward. I would sneak out over the back fence to avoid boys who were "laying" for me, or who I thought were "laying" for me. Sometimes I fought, when I couldn't help myself, and sometimes even won; but I preferred to be called a coward than fight. I hated pain. My imagi-

nation conjured up horrible things that would happen to me, and I simply ran away. One time, when I was on the editorial board of the school paper, a boy I was afraid of warned me not to publish a joking paragraph I had written about him—and I didn't. . . . My way to school lay through a sort of slum district, called Goose Hollow, peopled with brutal Irish boys, many of whom grew up to be prizefighters and baseball stars. I was literally frightened out of my sense when I went through Goose Hollow. Once a Goose Hollowite made me promise to give him a nickel if he didn't hit me, and walked up to my house with me while I got it for him. . . . The strange thing was that when I was cornered, and fought, even a licking wasn't a hundredth as bad as I thought it would be; but I never learned anything from that—the next time I ran away just the same, and suffered the most ghastly pangs of fear.

I wasn't much good at the things other boys were, and their codes of honor and conduct didn't hold me. They felt it, too, and had a sort of good-natured contempt for me. I was neither one thing nor the other, neither altogether coward nor brave, neither manly nor sissified, neither ashamed nor unashamed. I think that is why my impression of my boyhood is an unhappy one, and why I have so few close friends in Portland, and why I don't want ever again to live there.

It must have disappointed my father that I was like that, though he never said much about it. He was a great fighter, one of the first of the little bank of political insurgents who were afterwards, as the Progressive Party, to give expression to the new social conscience of the American middle class. His terrible slashing wit, his fine scorn of stupidity and cowardice and littleness, made him many enemies, who never dared attack him to his face, but fought him secretly, and were glad when he died. As United States Marshal under Roosevelt, it was he who, with Francis J. Heney and Lincoln Steffens, smashed the Oregon Land Fraud Ring; which was a brave thing to do in Oregon then. I remember him and Heney in the Marshal's office guying William J. Bums, the detective on the case, for his Hawkshaw make-up and his ridiculous melodramatics. In 1910 a man came around to browbeat my father into contributing to the Republican campaign fund, and he kicked the collector down the courthouse stairs—and was removed from the marshalship by President Taft. Afterward he ran for Congress, but lost out by a slim margin, mainly because he came East to see me graduate from college instead of stumping the state.

When I was 16, I went East to a New Jersey boarding school, and then to Harvard College, and afterward to Europe for a year's travel; and my brother followed me through college. We never knew until later how much our mother and father denied themselves that we might go, and how he poured out his life that we might live like rich men's sons. He and mother always gave us more than we asked, in freedom and understanding as well as material things. And on the day my brother graduated from college, he broke

under the terrible effort, and died a few weeks later. It has always seemed to me bitter irony that he couldn't have lived to see my little success. He was always more like a wise, kind friend than a father.

ALAN CHEUSE

Born and raised in New Jersey, Alan Cheuse (1940–) earned a B.A. and a Ph.D. in comparative literature from Rutgers University. His short story collections and novels include Candace and Other Stories *(1980),* The Grandmother's Club *(1988),* Talking Horse *(1990), and* Lost and Old Rivers *(1998). His nonfiction titles include* Fall Out of Heaven: An Autobiographical Journey Across Russia *(1987) and* Listening to the Page: Adventures in Reading and Writing *(2001). Cheuse teaches creative writing at George Mason University in Alexandria, Virginia, and is a book reviewer for NPR's "All Things Considered." In this excerpt from* The Bohemians: The Story of John Reed and His Friends Who Shook the World *(1982), Cheuse gives a fictionalized account of a return visit Reed makes to his hometown of Portland, where he meets Louise Bryant for the first time.*

From *The Bohemians*

This all began with a head cold, the most common thing in Portland of a wet winter afternoon. Having once again traveled westward by train with all good intentions of cheering Mother, I found myself in bed for several days, and she hovered about my couch, as though I were back in my old Stout Street room suffering from my ailing kidney.

Mother, however, could not cheer me much. Her pained letters, the notations about her finances that Harry had posted, lay as heavily on my mind now that I was here as they had since my return from abroad. The cash I had sent on ahead, nearly the entire proceeds of the payments from the *Metropolitan* for the Eastern European series, had been already paid to creditors who had waited out of a sense of loyalty to what the family used to be, some of them for as long as a year. More bills had piled up in the meantime. Her health was not marvelous. By means of some intricate figuring that had, he claimed, something to do with the war, the landlord had seen fit to raise her rent. And she paid out more for little services, deliveries, and taxi fares now that she wasn't well enough to do for herself all the things she used to do.

Harry helped a lot, of course. But because he was as yet not sure what he cared most about, he was in and out of jobs, never staying long enough at one to build up savings enough to carry both him and mother through his next stretch of unemployment. Since he was a Reed, he did this with grace

and, if there was an audience, good humor. But during my first full day in bed—after waiting of course for Mother to leave the room to attend to some business she had at the stove—he lamented the *plans* he had had, and while he wasn't complaining, he was wondering if I truly saw how much he was giving of his time and his life to the care of our Mom.

"Look, Hare," I said, "don't you think I'm aware of what you do for Mother? I cover the battlefront, you cover the home front."

Acheu!

I sneezed: punctuation from the gods. I hadn't lied. I admired Harry for the devotion he had showed to Mother through all the rainy days he'd spent here since his own commencement from Harvard. I could not imagine myself living in Portland, but I suspected that if Harry's willingness to return home hadn't freed me from the day-to-day responsibilities for Mother's care, I might possibly have turned my path back toward the West Coast, might have embarked on a career in San Francisco and paid more frequent visits. But Jack, came a truthful voice that had lived with me often since my trip through the Balkans, you'd stay on the scene for a month or two and then ship out down the coast like Uncle Ray and watch the natives revolute themselves in Bolivia. Or returning one day from covering a tea party where someone lectured about Original Sin, you'd see a sign in a shop window, a sail in the harbor, catch a cup of coffee, buff up an editor with visions of a story, and find yourself on a freighter under a sun dipping into the sea all the way to China.

Acheu!

"If the war keeps up," Harry said, drawing me out of my feverish reveries of alternative presents, "I'll be called up to fight and there'll be no one here to care for her." He paced from one side of the bed to the other, glancing down at last and saying: "It's important for us to try and set up some kind of constant for her. I have a line on some stocks that might do her well. Of course we all know how you feel about capitalistic ventures such as that."

"Cabalistic is more like it, Hare. You never know from one day to the next what kind of magician is manipulating the market. I'm not against capitalism in principle, only in practice. If all the Moms in the world stopped paying out their hard-earned cash for pieces of paper that are traded around until no one knows how much they'll be worth from one day to the next, maybe all the certificate barons would have to practice their chicanery on one another. Then they'd see how they like to get stung. The thing to do is for all of us to pick up and leave all those money magicians high and dry. Why, they'd look around and see that America had gone out from under them, like the tide pulling back at the call of the moon. They'd either have to change their ways or stay out of the wet with the rest of us." My head jerked back as though it were a puppet's in a showman's handglove. "*Ach—*"

"Watch where you sneeze now!" Hare backed away from my bedside.

"—*cheu!* Christ! You've got lovely weather here. I haven't felt so bad since I don't know when. I twice passed through the Valley of the Shadow of Death when I was in the Balkans and drank and ate with the sickliest folks you could imagine until the Czar's boys threw me and Mike Robinson back over the border into Poland. They wanted to bury me several times, sometimes out of concern about my future health, sometimes out of wishful thinking. But I didn't get sick once over there."

"Aw, Jack," Hare said, "You're a lucky man. But we're talking seriously here about a serious subject. How much cash can you spare if I come up with an investment that could give Mom something to grow on during the next five years?"

I patted my dear brother on the arm. "You're talking like one of the Rockefellers. You ought to come to Manhattan and talk like that and you'll make enough for Mom to live a hundred years on! 'Something to grow on!' You're the best investment she ever made! While—I'm her—ahem—her dividend that never really paid off. The cash I sent you from New York was my last penny. I've got enough with me now to keep me for a week and feed me on the train trip back. I know what you're thinking. I've traveled up and down the country, been to Mexico, ridden with the revolutionaries, sailed to Europe more times than you've been to New York City, and put out dozens of articles not to mention two books, and you're wondering why I don't have any more ready cash than a working stiff after he's hit the bars on payday? Because that's all I am, Hare, just another working stiff. I go from assignment to assignment, keep my apartment in New York on the good graces of roommates whose welcome I have long outlived, and don't know how I'm going to be eating come tomorrow. I won't know until I return to New York and pick up some new assignments. And then, chances are, it will be about a beauty contest for turtles instead of an interview with the secretary of state! That's what I have to do just to keep my head above water!"

Harry looked as though he was brother to the boy who assassinated the archduke at Sarajevo.

"So you don't think you can contribute anything toward this? It's an apartment building, five flats, a place for all of us to live as well, me, Mother. You'd have a room when you came to visit, I don't know how I'm going to raise my part of it. I've got a friend who thinks he might go in on it with me. An old friend of Papa's downtown will help us out with the loan . . ."

If Harry was looking at the assassin of his lifetime, I was looking up at the little boy who always got left behind. He had grown thinner since my last visit. The broad healthy face, the husky cheeks that were Papa's legacy to his boys had turned wan and waxy. The time he had passed here in attendance on Mother had taken more than a few years' worth of fire from his eyes, and I blinked out of fear that this was how I would look if sickly or dying.

"I might try wiring the editor of the *Metropolitan* for an advance against

an article I could make up real quick. But I'm ashamed to say that would be a pitiful amount."

"It wouldn't be pitiful if you went out of your way to do that. It would be a mighty nice thing, Jack, because every little bit will help. You've always been a good brother, and I've always admired you, Jack—"

I pushed him as hard as I could in the direction of the door.

"Get your mournful puss out of here and buy some apartment buildings!"

I lay abed in solitude, musing upon mother's sad condition, Harry's loyalty, the state of my life. Books I'd never written took shape in my mind and then diffused into the foggy drizzle outside the bedroom window. I had walked over acres of corpses, bodies thick as grass, survived the threat of plague, crossed the border into Russia, been arrested, walked out again. Little could touch me now except mother's plight.

I slept awhile. Upon awakening, I accepted an invitation Carl Walters extended over the telephone. Walters, an old friend, told me that there was going to be a fine group of people over the next evening and that I could turn down the invitation at the risk of finding myself replaced by a sea otter. Colonel Wood and some others I'd like to see would be there. I told him that my head was stuffed but my shirt wasn't and that I'd be happy to attend. If my cold was going to keep me here another day I might as well give the disease to some fellow writers and artists.

Mother took great pleasure in nursing me through the day. By the morning, I felt well enough to get some exercise. I dressed and went out into the fog. The walk downhill went briskly, and with my stuffed head protected by my hat, the venture did not seem so bad at all. Noisome fumes drifted along the roadway as I reached the thick of the traffic. Since I had last seen it, Portland had become not just one of your thriving Western cities but a place like Hartford or Newark, a location with the mark of true progress stamped on it and its inhabitants.

I glanced at father's watch as I strode along. My fingers closed on the ring that had been burning a hole in my pocket ever since I had retrieved it from the nail on Mabel's apartment door. That trinket had traveled with me across the Atlantic and overland into the Valley of the Shadow of Death—the bloody Balkans and the Russian front where flies died with more dignity than soldiers—and out again. It gave shape to my private sorrows even while my eyes, ears, nose were subjected to the greatest public horrors our age had yet known. Mabel's vision of Evil seemed laughable alongside stacks of corpses piled higher than men are tall, and my own fate appeared as ephemeral as smoke rising from the battlefield. Yet the pain remained, and each time I had contemplated flinging the golden trinket into the ocean or the bloody mud I had paused and considered how much worse my grief might be without it.

Portrait of Louise Bryant, painted by John H. Trullinger in 1913

"Hello," was all she said when I emerged from the pawn shop.

"Do I know you?" I asked, licking the lightest tinge of salt from my lips.

"Possibly."

Her scarlet hair glistened, uncovered as it was to the falling rain. The daring glint I spied in her grey-green glance showed me at once that she was the kind of woman who purposely went out without her hat. Did she like the feel of the rain? Or did she merely want others to notice the way the freshly fallen water illuminated her long, bright mane of frilly, lush hair? But couldn't it be both? Trim in a smooth cloth coat she stood, daring me with her stance as well as her eyes.

"It wasn't in Bucharest, was it? I've just come back from Bucharest."

"I know," she said. "But it wasn't Bucharest."

"You know I've been there? Was it Paris then?"

"Nope."

"You say 'Nope' like a cowboy. Are you a cowboy? Or a cowboy's best girl?"

"A cowboy's best daughter. Will you guess again?"

"What? Oh, the place, the place, sorry. Well . . . was it Paris?"

"You've asked me that already and I said no."

"Was it Cleveland?"

She laughed, a curling wave of sound that made me shiver.

"You're getting closer."

"Sandusky?"

She laughed again.

"Nope."

"MacDougal Street?"

"Where's that?"

"Aha, you are a cowboy's daughter if you don't know MacDougal Street. I'll try cities farther west." And then I sneezed.

"Perhaps we ought to get out of the rain while we play."

"Not back in there," I said as she stepped back into the entranceway to the pawnshop. "I just had a very bad experience in there."

"Sell your typewriter, Mister Reed?"

"Worse than that. Call me 'Jack.' And will you please tell me who you are and where we've met?" I motioned for her to follow me along the street. The rain had not let up, but I paid little attention to it now, except where it glistened on her hair.

"We've never actually met," she said, "but we came close to meeting one night at the I.W.W. hall when Emma Goldman came to speak."

"Aha! Go on."

We walked in a southerly direction at a leisurely pace, past the court buildings, a little park, and up toward the hills where small frame houses had spread since my childhood. After a block or two, the pavement stopped. Horses and a few wagons, an auto here and there, traveled the muddy roadway.

"I'm suddenly quite embarrassed by this."

"What? By what?"

"Meeting you this way."

"Don't be silly. I'm having fun." I sneezed a monstrous sneeze and she grabbed my arm, as if I might slip into the muck of the roadway. "I have a cold. I guess you'd want to call it a bad cold."

She touched her fingertips to my forehead.

"What's your diagnosis, nurse?"

"Hot and wet."

"I've been worse. Right here in Portland I've been sicker than I've ever been anywhere else in the world. Except maybe for one time in Mexico."

"When you were riding with 'La Tropa.'"

"You read that, huh? and you know I've been to the Eastern front. I guess I'm the one who should be embarrassed now. You're my *audience*."

"You couldn't ask for a better one." She shook her glossy mane. "You'll catch pneumonia if we keep you standing here."

"Well, I wasn't going to give up on you until I found out where we'd met. I am an intrepid reporter."

"Shall we walk back toward the center of town? You really need to get out of the rain."

"If you'll tell me the awful circumstances of our encounter. Was I so drunk that I've obliterated it from my memory? That's the only time your intrepid reporter seems to miss the important details."

"I was the intrepid reporter then," she recounted, calling me back to an evening on a previous visit when Hare and I listened to Emma's speech in the labor hall while a group of students, boys and girls giggling and applauding together, huddled up front near the podium. "I covered her talk for a little socialist newspaper we publish on the campus at Eugene."

"I thought you might be a little socialist."

She tore her arm away from mine and gazed sullenly at the gray and dripping sky.

"Well, wait a minute. I didn't mean to hurt your feelings. It just surprised me."

"Can't a woman be a socialist? What about Emma? Or don't you count her as a woman?" A few passersby looked at us now, thinking, I supposed, how only lovers could find it within them to rush about in the wet on such a misery-making afternoon as this.

"Please, listen, I didn't mean to insult your sex. I was marveling at it, in fact! Emma is middle-aged and weighs more than my brother. I had never met a girl as *pretty* as you who was a radical besides." I tried to take her arm but she brushed my hand aside. "You believe me, don't you? This is so crazy! Dear pretty stranger, we're arguing like good friends, and I don't even know your *name*."

She laughed and looked for all the world like a child at play.

"Louise Trullinger."

"Hello, Louise Trullinger," I offered my hand.

She placed her hand on my arm, and we started walking briskly back toward town.

"So Emma was your hero? Your heroine, I mean."

"Yes."

"But you knew who I was, too?"

"A few of us read everything you wrote in the magazines. I bought your books, too."

"That's lovely. Are you studying politics at the university?"

"You think—?" She burst into laughter again, glancing around at me, laughing in my face.

"What do you do here in Portland?"

She laughed again, that thrilling, rippling, chilling sound. She laughed more than any other woman I had met. She laughed as often as other females cried.

"I write. For my own pleasure. I paint a little, too. And I help out with the socialist meetings now and then. I keep a studio in town."

"That sounds swell. But how do you support yourself? Writing takes so much time. And you have to pay for a studio."

"The oldest profession," she said, her eyes fairly sparkling in accompaniment.

My heart sank like a stone in the muddy roadway.

"I don't believe it." So young, so beautiful, so intelligent. The other prostitutes I'd met had possessed one or two of these qualities but not all of them together. And they had been always somewhat bedraggled, depressed, downtrodden. "You couldn't be a street-walker and a socialist. The two things are antithetical!"

I sneezed violently, feeling her catch at my arm.

"But couldn't I be a *married woman* and a prostitute? Aren't *those* professions one and the same?"

"Trullinger . . . Trullinger. What was your name before it was Trullinger?"

"Eve. And then I changed it to Mary. A virginal touch, don't you think? Most people called me by my father's name which was Bryant. You may call me Eve Temptress Mary Mother-of-God Louise Bryant Trullinger. Or just plain Lou."

I picked my heart out of the roadway, rinsed it in rain-water, and handed it over to Lou.

I basked awhile in the heat that flowed in waves from the big pot-bellied stove in the center of the room. Two floors above a busy side street near the center of town, the large one-room studio, with its kitchen area and toilet behind a screen in the southwest corner, might have overlooked a warehouse loading ramp in Little Italy in New York City. Covers from back issues of *Blast* decorated the walls, along with a few *Metropolitans* that announced my articles, drawings from socialist newspapers around the country, strands of beads, homemade drawings, old embroidered pillow cases, fresh typescript on which verses lay in irregular stanzas that I skimmed while behind the scarlet screen the scarlet-haired woman fixed me something to drink.

> *Yellow sail on the horizon*
> *A wave curls*
> *Tide draws you close*

Several covers of *Burdick's Pattern Monthly* framed under glass.
Someone's attempt to do Multnomah Falls in the mode of the French light painters.
A pencil sketch of a long-limbed dark-haired woman whose face and breasts pointed toward a sun not visible.

> *Do you know, stranger, whose soldiers*
> *guard this wall?*
> *His love for the treasure within is*
> *legend in this province.*
> *Twelve rows of Saracens stand between*
> *his jewel-box and the avaricious few*
> *who dare to envy it.*
> *A hundred vicisius Hareem guards block*
> *entrance to the chamber of his love . . .*

"Sounds like something I once wrote."
Dishes clattered behind the screen.
"What? I can't hear you."
"Nothing. I'm just studying your decor."

> *North-west current,*
> *Flowing toward my beach,*
> *Heat of Nippon.*

"Here you are," she said, coming around from behind the screen. She had changed her long cloth coat for a long blue silk robe. In her hands, she bore a tray with steaming white mugs. "You may sit down, sir."
I settled myself on the broad, soft sofa behind which stood another screen. She sat cross-legged on cushions on the other side of a low stone table. Light from three large windows behind her glazed the air on either side of her pale, compelling face: the sheen of hair and silk, the freckled thighs she showed at the hem of her robe nourished my glance. I wiped my raw, moist nose, smiled, and reached for a mug.
"Looks delicious."
She raised her own cup.
"To your health."
"To my rotten health."
Light fell gracefully on her rounded ankle. When her robe rose slightly at the tug of her upraised arm, I caught a glimpse of freckled thigh. "What is

this luscious potion, Madame Witch?"

"Tea, milk, honey, and the gum of a sacred tree of the old Northwest. How did you find me out in my witchery? I usually like to let my victims suffer awhile."

"And am I but a cipher in a long parade of bewitched males whom you've taken out of the rain?"

"You're the second one who has ever entered these secret halls."

My heart leapt! My mouth went dry. Muscles in my calves rippled with a life of their own.

"Is that true?"

She laughed a shocking laugh.

"Oh, yes! But look what happened to the last one before you!"

"What's that?"

She twisted slightly on her cushiony throne and yanked a dull-white oblong object from behind the table leg.

"Yoicks!"

"Yorick, you mean." She held up a grinning skull. "Alas, he didn't measure up to my usual standard and I had to . . . well, look rather gravely on his love for me."

"Where the hell did you get that?"

"I have another confession to make, mister Reed."

"I told you to call me 'Jack.' Now 'fess up."

"My husband gave it to me."

"Is he a gravedigger?" I sipped at my potion.

"No, he's a dentist."

Now I laughed, nearly spilling tea across my trousers.

"So it's *dentistry* that finances this den of iniquity."

"*Den*tistry of iniquity, yes. But don't you think he's lovely?" She ran her palm across the skull's forehead. "I call him 'Taft,' after our beloved former president. But sometimes I call him 'Daft' and other times I call him 'Drafty.' The wind whistles through his open spaces!"

"And what do we call what we're doing? '*Den*tryst-ing'?"

"Very punny, mister Reed. Your editor must delete those puns from your articles. I don't recall such low play with words anywhere among them."

"Very *dent*eresting, your point of view. But why did he give you that? *Memento mori?*"

"Is that Japanese? I have a love for the Japanese—"

"It's Latin. Which I have hated ever since college, though I once cared enough to translate Horace. Did your husband give it to you to remind you of death?"

"Not death. Teeth. Dentists don't think of death! Only of uppers and low-ers, molars and bicuspids. And roots, there's more talk of roots than you'd imagine. And nerves. *Les nerfs, monsieurs, sont terribles.* Actually, I took it

from his office thinking that I might stick a candle in it and serve a Hallow-een dinner. But I've never had the strength or the nerve, *les nerfs, monsieurs,* to cut it open. Talk about nerve. You can really lose it when you're married to a dentist, unless you put your mind to saving it."

"It seems as though you've done a good job of that." I sipped more of the brew. The skull stared inertly at the rain. My new friend sighed and skimmed her tongue lightly across the rim of her mug. "Trullinger is a good person," she said. "I like him a lot. I even love him sometimes. Most of his friends think he's mad to put up with me. He tries so hard. He's changed a good deal for the better since we married." She let the skull fall into her lap where it rested, jaws down, in an enviable location. "He's seen the value in giving me freedom. It's better for his own nerves that way. He's even written poetry in the last few months."

"Aha! Then you didn't write that awful poem on the wall. He spelled 'vicious' v-i-c-i-s-i-u-s." My mug was nearly empty, and I lay my head back against the pillows. I hadn't sneezed since we'd come indoors. I was feeling first-rate.

"You're the one who's vicious. Spell it however you like!" She frowned, creating a picture I did not care to gaze on for too long. It showed the lines at the corners of her eyes and made her long face appear older than it was. (On the walk to the studio we had exchanged our birth dates and it turned out that she and I were almost exactly the same age.)

"Sorry. I'm sure he must be a good sport to let you have your fun. Does he get his fun as well?"

Her smile returned, a puzzled smile but at least it replaced the gloomy pucker around her eyes.

"I can't really say. He could see other women if he liked. But I don't think he wants to. That poem reveals a great deal about how he feels about me."

"But it talks about a 'Hareem.' Perhaps he keeps a lot of other women."

"We'd be even then."

"Do you keep a lot of men?"

She showed me a new face, not a frowning visage but a sly, squint-eyed mask.

"I have my secrets."

"Never admit, never accuse. That's my motto."

"Wonderful. Who taught you that?"

"I learned it myself the hard way."

Now her guarded look faded.

"Please tell me how."

I sneezed furiously, spraying spittle across my trousers.

Lou leaped nimbly to her feet, snatching my mug from my grasp; the skull rolled into a corner and lay at rest once again.

"You'll need another of these."

"I didn't spill it all."

Our eyes met as if in the exotic setting of her liberal husband's awful poem.

"But enough."

"Enough."

Lou swirled behind the curtain to replenish my drink. I lay back on the sofa, running amuck in my mind. Lou reappeared from behind the curtain, holding aloft another mug of the steaming tea.

"Drink."

I sipped, let the hot brew lave my tongue and slip warmly down my throat. My head cleared suddenly, the way a winter sun peeps out from behind dense clouds and warms you well before it slips back into the gloom.

"Did you add rum to this? It's really helping."

She nodded teasingly, retrieving the skull and holding it up before her face.

"We aim to please," she said through the gaping jaw. "Now tell us your sad story and we shall judge it. If it seems appropriate, we shall even offer a prophecy. Why, when we found you standing in the foyer of a pawn shop, were you weeping into your hands?"

"You saw me?"

"You're a bit embarrassed? I thought you were the kind of person who never gets embarrassed."

"That's true. Damn it, you know me better than you know yourself!"

"You wouldn't know that." She placed the skull on the table and stared defiantly across the space between us. "You know next to nothing at all about me."

"I think I know quite a bit by your name, Louise Mary Mother-of-Eve Bryant Trullinger. You're not any relation of William Cullen Bryant, are you?"

"You think you're being cute. But as a matter of fact, I might be. I used to say 'To a Waterfowl' over and over to myself while walking about the desert. *Whither, 'midst falling dew,/While glow the heavens with the last steps of day,/Far, through their rosy depths dost thou pursue/Thy solitary way?* Would you like to hear the rest? *Vainly the fowler's eye/might mark thy distant flight—*"

"Not my favorite poet. Was he on your father's side or your mother's?"

"He never took sides. A fair man, lousy poet."

"Stupid of me to ask. What did your father do for a living?"

"My real father did only one thing that mattered. He abandoned us when I was quite small. We were living in San Francisco. Mother took us to Nevada and married Bryant there. He was a railroad man, built rights-of-way across the desert. My real father died in the San Francisco quake. I always remember that day because I was playing down by the telegraph station when the news came clacking in. The earth had swallowed up my Papa whole. At

first I was glad. But I had horrible dreams for years afterward. Mother never blinked an eye. I hated her from then on."

"The aftershock."

"What?"

"The aftershock. You still feel the aftershock of the San Francisco earthquake."

A strange look came into her eyes.

"Thou'rt gone," she chanted, using the skull as a megaphone, *"the abyss of heaven/Hath swallowed up thy form—"*

"Appropriate! Your father and the waterfowl!"

"—yet, on my heart/Deeply hath sunk the lesson thou hast given./And shall not soon depart." She paused, as though out of breath from running.

"Might as well finish it," I marveled at her pluck as she plunged back into the poem, like a swimmer into a broad, swiftly moving stream.

"He, who, from zone to zone,/Guides through the boundless sky thy certain flight,/In the long way that I must trace alone,/Will lead my steps aright." She took a breath and, once more, lay the skull aside. "Not my favorite poet, but we must honor our ancestor, mustn't we?"

"You learned about ancestor worship from the Japanese fellow who wrote those cute short poems, I'll bet. They're nice, for free lines. Is he?"

The lady actually blushed, yanking nervously at the drawstring of her robe. "No wonder the French wanted to shoot you as a spy!"

"Doesn't the dentist want to shoot the Japanese for pinning his poetry on your walls?"

"Trullinger is a nice, understanding soul. I told you, he wants to be a free soul. And so do I. We help each other in our struggles. As you can see, he even writes poetry, and you know how the average bourgeois detests the stuff. They'd make a law against it if they could."

"Now if you want a dangerous poetry that speaks to life, I'll quote you Byron."

"Quote away!"

Her eyes blazed as she deposited herself lithely alongside me.

"Eighth canto of *Don Juan,* stanzas fifty and fifty-one. The battle sequence. Waterloo."

"You must have a good memory."

The delicious fog of her scent enveloped me.

"God save the king!—"

"Did Byron say that?"

"Wait! *—and kings/for if he don't, I doubt men will longer—"*

The sofa shook as she laughed.

"I think I hear a little bird who sings/The people by and by will be the stronger !" She recited along with me.

"You know the lines!"

"Of course, I do," Lou said. "I live that poem!"

"You love it, you mean."

"I *live* it."

She forthrightly rearranged herself so that nothing more than the length of a butterfly's wing kept us apart. Then the width. She trembled, as a bird about to sing sometimes trembles. Our lips touched, held: we spoke in tongues.

"You have now been awarded the Jack Reed Memorial Head Cold," I teased her when I broke free. "It has been a pleasure to bestow it upon you."

She touched a finger to my lips.

She slipped off her robe. The pale-white bodice that sheathed her showed pearly in the glow of the stove.

Beyond the window the rain had stopped. Twilight yielded to evening.

"'*That day they read no further,*'" she said, propped up on an elbow and looking quite puckish.

"You know your Dante and your Byron. But if your logic were correct, after reading the Byron we'd rise up from our couch and make revolution, instead of lying down 'and making—"

"We *will* make a revolution, Jack. One thing at a time. Today you've got a cold, and you barely have time to embrace me before you have to get dressed for dinner."

"How'd you guess that? I have a dinner invitation. Or did. But I'm going to take you out instead. If you tell me where *the* place to eat is these days, we're on our way."

"You can't turn down your invitation at this hour, can you? Not for an old pickup on the street like me."

"Of course, I can. I will. If you're just a pickup, it's pickups for me from now on."

"Well spoken, parfit knight. But let's get dressed for dinner or our hosts will wonder where we are—"

Lou planted a kiss on my forehead and leaped nimbly from the bed.

"How did you . . . ?"

"You goose. I'm invited there myself. They think we'd make a match!"

On our way to dinner, Lou admitted the truth. She had been walking along, turned at the sound of a loud sneeze. She recognized me and followed me for several blocks and decided to speak to me only when she saw me weeping in the alcove of the pawn shop.

"Are you ever going to tell me what that's all about?"

I told her about Mabel and the ring, and how I dared myself to get rid of it.

"If you gave me a ring I'd never return it."

"If I gave you a ring, and you gave it back, I wouldn't pawn it. I'd give you one you couldn't give back."

"Through my nose?"

My head suddenly felt clearer than it had in days.

"You've cured me!"

"The rum does it every time."

"It wasn't the rum."

Her voice dropped suddenly, like a sail when the wind fades.

"I know, my darling Jack."

"My lovey."

"Sweetest sweetness."

"Daring lover."

"Hairy lover."

"Honey lover."

Dinner was a marvelous charade. Lou and I staggered our arrivals and played the night out as though we had just been introduced. Trullinger was not present at the meal. Our hosts clearly wanted to see how we would react to each other.

It was difficult explaining my absence to Mother the next morning. But she was pleased that my cold had subsided. The intensity of my affections for Lou escaped her until the next day when I introduced one lady to the other. She sighed, smiled, kissed Lou, and blessed me. Harry was pleased to receive my token contribution (the proceeds from the ring) toward his project. He lent us his car for an excursion to Astoria. While waves roared in on us, we talked about the past.

ALAN HART

Alan Hart (1890–1962) grew up as Alberta Lucille Hart in Albany, Oregon. After attending Albany College (now Lewis & Clark College) and graduating with a medical degree from the University of Oregon, he began his medical practice and transitioned from female to male. When Hart had difficulty retaining work because of the questions of sexual identity that hounded him, he continued his medical education, married Inez Stark (to whom he remained married to the end of his life), and turned to writing. In 1935, he published Doctor Mallory, *his first of four medical novels, which include* The Undaunted *(1936),* In the Lives of Men *(1937), and* Doctor Finlay Sees It Through *(1942), all set in the Pacific Northwest. Reviewers recognized the novels for their "careful, interesting, and authentic picture of human values in the medical profession." Hart had a distinguished medical career and made valuable contributions to the treatment of tuberculosis and the field of radiology (including publishing a book on the subject,* These Mysterious Rays, *in 1945).* Doctor Mallory *is the life-story of a gifted, ambitious doctor who tries to make a difference in a remote Oregon town. This excerpt from the novel shows the young medical student fulfilling his "clinicals" in one of the rougher sections of "Pacific City" (Portland).*

From *Doctor Mallory*

"Hell's bells! What a night!"

Robert Mallory ran his fingers through his tumbled shock of thick, straight, brown hair and in unusual weariness stretched his arms full length above his wide, square shoulders.

"What'd you expect in a dump like this? You can't always have easy cases."

"Chuck" Brantner held out a packet of cigarettes. Mallory reached eagerly to help himself. The flaring match showed two tired young faces.

Side by side the men leaned against the porch railing, facing the east where a faint radiance was just beginning to border the upper rim of the valley. Mallory looked up presently at the taller, slimmer figure beside him.

"I don't expect to have easy cases always, Chuck. But a mess like this one to-night doesn't make me any keener about obstetrics. That girl had five minutes' fun, three months' vomiting, and then this! In a Rescue Home, of all places. Shrieking, blood, uproar, all of us fogging around like mad all night!" His eyes turned toward the vaguely outlined shrubbery on the lawn below them.

Brantner exhaled a cloud of smoke with a sigh so deep that it was almost a grunt.

"It could've been a God damn sight worse, though. She might've died. And I haven't lost a mother out here all year."

"That would have spoiled your record," said Mallory dryly. "And you're so proud of it. What gets me is that I'm in for this job next year—eight months of it."

"Well, you're a damn sight better prepared for it than most Junior medics. Let me tell you that," retorted Brantner. "You've been out here with me on every case I've had and I let you do more than Stockton ever let me when I was his assistant. I counted up a while ago. We've done forty-one deliveries in the Home since October and there are two more due before I graduate. And so far not one of them lost! That's what tickles me. Some record for my Senior year, eh boy? And a damn good nest-egg for you to start with, even though you don't appreciate it."

"Yes, if you feel that way about it." Mallory flicked off the ash and looked at the glowing end of his cigarette. "But I still think the whole thing is a God-forsaken, hellacious, damned job for everybody concerned, and especially for that washed-out rag of a girl in there! I'm not crazy over the prospect of this work next year."

"Oh hell, you'll get used to it." Brantner tossed away his stub. "Guess I'll have a look at our patient and then take a snooze. We can't get a car into town until six o'clock anyhow."

Except for the double windows to the right of the entrance, the Anne Morrison Memorial Rescue Home was in darkness. Before it stretched the soft, smooth sward that extended outward fifty feet to the highway. Mallory walked softly down the steps and on to the lawn; the thick cushion of grass was pleasant underfoot. He looked back at the building, saw a shadow move briskly across the lighted windows of the maternity room, and smiled; even Miss Jackson's silhouette on the window-blind managed somehow to seem angular and severe.

In spite of the fact that their patient had not died, Mallory was still depressed. True that they had been forced to send into the city for help and that, while they waited for the arrival of the professor of obstetrics, Brantner's self-confidence had cracked, but that wretched sixteen-year-old who had been down to the gates of death was alive. And her baby had lived too. A squalling lump of unwanted, red humanity. What was ahead of them, or—for that matter—of any of the twenty-five girls upstairs whose time had not yet come? Through the open casements of the upper floor Mallory thought he could hear the faint sounds they made in their sleep.

He shook himself and retraced his steps toward the building. Life seemed such a mess when he was out here at the Rescue Home. Two years ago, he remembered, he hadn't known such places existed.

Brantner was just coming out of the maternity.

"She's in pretty good shape, Bob, considering what she's been through. Her pulse is better and she's not flowing so much. I'm going to lie down awhile. There's still an hour and a half before the first car."

The two young men walked back along the corridor, through a door marked "Doctor," into a small room furnished with a smooth leather couch, three chairs of the Mission variety, and one ancient tattered upholstered armchair. On the wall was an old-fashioned telephone with a crank, beyond it the door into a washroom through which Brantner promptly disappeared.

Mallory flung himself into the decrepit armchair and pulled out a brown briar pipe. His shirt hung open at the neck and his sleeves were rolled high over thick muscular forearms.

"Yes, I think she's going to pull through," said Brantner, standing in the doorway wiping his hands. "I admit I thought it was all up with her for a while. Even Robinson, you noticed, looked down his nose when he first saw her. Nobody can sneeze at eclampsia. This is going to look good on the records." A smile broke over the thin hawk face. "Twenty-two convulsions, and alive and O.K. Besides, it was good for you to be in on a case like this, Bob. You might've gone for a long time before you saw another like it."

Mallory scratched a match loudly.

"Oh, shut up, Chuck! You make me sick! All you ever think about is that damned record of yours. And you talk as though you'd arranged the whole thing for my benefit. Bah! You were scared as bad as I was, and you know it. How's your underwear this morning?"

"None of your damn business!" Brantner threw himself down on the couch. "Gimme a cigarette, will you? You'll admit, I suppose, that I never let on in there that I had the wind up. Out here a fellow has to remember to keep up a front. The girls don't know we're not full fledged doctors yet, and if they knew we were scared the nurses would go to pieces too. They can't realize like we do that it's perfectly safe, with the profs. on call for emergencies."

From the depths of the aged armchair in which he rested on the small of his back Mallory looked ironically at Brantner.

"You don't say so, Chuck! Now ain't that something? Everything perfectly safe! Well, well! But it's that kid in there, that girl, that I can't get out of my head."

"Aw, pipe down, Bob. The girl was just obeying the laws of biology. What she did and what happened to her were perfectly natural." Slowly Brantner's face lost its look of interest; his words began to blur and run together; his lips sagged apart.

"I didn't say it wasn't natural," whispered Mallory as he bent forward, picked the smouldering cigarette out of Brantner's mouth, threw it on the floor and set his foot on it. Then he tiptoed across the floor, threw open the back window, and leaned out. He had been too close to death that night to relax as Brantner had done.

The air was cool and sweet on his warm skin, the morning stillness grateful to his ears that all night had been ringing with the tense sounds of travail.

Across the garden he could see a grove of trees stark against the lightening sky. The world outside was beautiful; only inside were there pain and harshness and injustice. People, that was the trouble; people, with their worn-out notions of right and wrong. Building Rescue Homes in a fine glow of philanthropy so that the shame of girls might be ostentatiously covered with the cloak of blatant charity.

Robert Mallory might have said truthfully, like the cinema star of a later day, "I'm no angel," but in him there was a desire for something better. Now it flickered down and now it flamed high, but it never died out. With the secrecy of the young male about things spiritual, he concealed it from his fellows, partly from shyness and partly from an impulse to conformity. But this morning that fire burned brightly. He hated the injustice that made this Rescue Home necessary, that had brought into it a sixteen-year-old girl, that would brand her baby illegitimate. A baby illegitimate! Why not rivers and floods and winds and mountains, too?

It was not fair. Often the boy Mallory had resented with his fists whatever had seemed to him unfair whether it had been expedient to do so or not. The man Mallory felt the same impulse. Many emotions flooded over him as he stood by the window. Inarticulate, hazy emotions, but stirring, for all that. Somehow he meant to do something about all this injustice. He would stand for life against death, for light against darkness, for the weak against the brutal. He had helped to win that night; he would win in the nights to come. He would beat back death from his patients. Some one must always stand between life and death, keeping back the dark invader so that life could develop and find the good and the beautiful. He would be that some one. He would help make progress possible. He would be a defender of the gates of life behind which evolution might go on unhindered.

Mallory straightened himself. He was tired and his back ached. He was even vaguely aware that he was hungry. But he was too vibrant with aspiration, too full of wonder at the promise of his calling, too sure of his own election to the company of the defenders of life to think of sleeping or eating. Leaving the window open so that the early morning breeze might sweep across Brantner's thin, tired face, he stole quietly out of the room.

In the maternity he found Miss Jackson working over the new-born and engrossed in her task. Mallory went to lean on the foot of the mother's bed. Lying on her back without a movement except the slow heaving of her chest as she breathed, the girl was so thin and pale that he was almost ashamed of his own thick-chested robustness. Her mouth was a little open, her sallow face held not one fleck of color. Mallory counted her respirations, then went to the side of the bed and laid his square-tipped fingers gently on her wrist. Pulse almost normal. She was better, not a doubt of it, much better. She turned her head a trifle and her bluish lips puffed out with every labored expiration.

To Mallory she still seemed half dead. And she was too young to be there. When children got caught in belts and flywheels, somebody stopped the machinery and got them out, but no one did that sort of thing for these girls. And yet it was the same sort of situation. They were caught by a biological urge that was too strong for them to control; they were little girls, most of them, but they had to pay the price. Little girls, women's penalties!

Miss Jackson's brisk voice startled him. "Come and look at the baby, Dr. Mallory. Isn't he fine? Seven pounds, twelve ounces."

The nurse beamed upon the infant as though part of the credit for his excellent condition belonged by right to her.

Gravely Mallory looked down at the red wrinkled face with its closed eyes and barely parted lips; he slid his hand inside the blanket. The baby closed a fist on one thick finger. Liking for the firm softness of a baby's flesh flashed out in the man's quick smile.

"He's certainly a fine boy." The nurse repeated her pronouncement.

"Yes, he's a good-looking youngster." Mallory's voice was deep, quiet. "But what's going to become of him, Miss Jackson? What chance will he have in the world? I may be all wrong but I was just thinking that there's seven pounds, twelve ounces too much of him. It might've been better for him and his mother too if he'd been born dead."

"Why, Dr. Mallory, how can you talk that way? I'm surprised at you. We very seldom lose a baby in the Home. I'd have been broken-hearted if we hadn't pulled this case through. I'm sure we'll be able to find a good home for such a nice looking baby. Don't forget that he's in God's care. He'll have his chance."

"I hope so," answered Mallory. "I hope so. Because nobody else is going to give a damn about him, I'm afraid."

In his way of speaking there was doubtfulness as to the dependability of Providence in these matters, but in his eyes was the look of the tolerant adult who hesitates to spoil a child's faith in Santa Claus. If Miss Jackson really felt that way about it, it was better not to disturb her.

From the door Mallory looked back again. The bare whiteness of the room was repellent; life ought to begin in peace and beauty, not in a barren place like this. But of course Brantner's record for never losing a mother and the Home's record for seldom losing a baby were more important than what happened to either.

Save the mother. What for? To go back home and be whispered about and pointed at on the streets? Save the baby. What for? Only God knew. For one blinding instant Mallory saw the chamber of existence with walls pierced by many archways but by only two that led anywhere—birth and death. Through these there was one-way traffic. About this girl and her infant there was just one thing certain: having both been born, they must both die. There was no escape from that finality. True, he had helped to

defeat death that night, had held the gates of life against him, had beat back the black destroyer. But it was not for long. Like fire, life is a triumphant, beautiful thing; but it is finally extinguished. Why? Mallory asked himself. Extinguished here only to spring up again somewhere else, and repeat the performance?

For his ignorance Mallory shrugged his shoulders and stole softly back into the doctors' room.

SANDY POLISHUK

An activist and oral historian with a special interest in radical women, Sandy Polishuk (1940–) is a former textile artist, radio producer, and librarian who has lived in Oregon since 1963. She teaches oral history at Portland State University, is the author of Sticking to the Union: An Oral History of the Life and Times of Julia Ruuttila *(2003), and is a producer of the video* Good Work Sister! Women Shipyard Workers of World War II. *Her essays have appeared in literary and scholarly journals, including* Oral History Review. *In this excerpt from* Sticking to the Union, *Julia Ruuttila—Northwest labor activist, feminist, and peace advocate—recalls her struggles on Portland's waterfront and in its mills during the longshoremen and woodworkers' strikes of the 1930s. Polishuk's commentary is in italics.*

From *Sticking to the Union*

So a couple of years later, it occurred to me, what am I sitting around here for still working my feet off in restaurants when I could be tallying lumber myself. So I went down to the mill office and applied for a job as a tally-woman, and they told me, "Oh no, women can't do that kind of work. What makes you think you can tally lumber?"

I said, "Just give me a chance, I'll prove it."

"Nothing doing. We don't hire women tallymen. We're not going to have any women working in this sawmill."

Some of the people that worked in that mill lived in Linnton on the hill-side. They were the better-paid workers. The lowest of the low workers lived down in these dreadful little shacks. They were duplexes made of No. 4 common, with knotholes so big you could look through into the next apart-ment and see your neighbors quarreling over which bills to pay, or even reach through with a stick and snag a piece of bread off their table. They had no hot water and they had a toilet in a sort of a clothes closet and a kitchen sink. They were three-room affairs.

That's where I met the Japanese. Although they lived in some of these

same places, they were so clean and they had little flower gardens and even flower boxes on their roofs of their little shacks. So I insisted we move from where we were living up near the tram into the mill, and move down with the Japanese. Some of them were quite well educated. The ones that joined the union—after we started organizing the union—were the best union members that we had.

All the big mills were in Portland. They've since all moved down into southern Oregon because the timber has been cut off in this end of the state. There was one in downtown Portland, Eastern-Western, and there were two at Linnton: Clark & Wilson and West Oregon. And there were a couple out in St. Johns: Inman-Poulsen and Portland, and another one, Jones, out in southwest on the river.

My husband worked at West Oregon in Linnton. When they first started to organize the union, a man approached him and Butch said, "Ah, hell with it." He said, "Trade unions aren't any good." You know, that's what the Wobblies thought in those days, they thought they were formed so that one craft, y'know, would always scab on another. And that usually had held true.

I didn't have the slightest interest in the AFL efforts to organize the mills either. I thought they were a scabby craft outfit because I was brought up in the IWW and that's what they thought of craft unions. But then, in 1934 the Longshoremen went on strike in Portland.

Although the International Longshoremen's Association was founded in 1892, it had virtually disappeared from the region. But in 1933, fueled by the passage of the NIRA, longshoremen began flocking into the union. In 1934 they went on strike for union recognition up and down the Pacific Coast.

Longshoremen's working conditions were nearly unbearable. The longshoremen wanted a closed shop and control of the hiring hall. This latter demand made a lot of sense, given the infamous shape-up, where foremen chose the lucky few who more than likely had slipped them a bottle of liquor or other bribe. The men would show up at six in the morning for work that started at eight on the chance of getting picked. Sometimes they would be told to show up at three or four in the morning only to wait for a ship that didn't come in. And if it didn't come, they were not paid. When they did get work, they could be forced to work round the clock until the job was done, to utter exhaustion. And since 1929, there was less work and income for nearly everyone.

Even before they went on strike, the Longshoremen were preparing for a long battle. They expected the strike to be lengthy and they knew they couldn't do it alone. In Portland, they went to the unemployed council and to college students to explain the coming strike and to ask them not to scab. They went to neighborhood grocers, small farmers, and the churches across town to educate them so they would be ready with donations when the time came. They also opened a commis-

sary with food, donated by farmers and grocers, and supplies they'd bought with money donated by other unions.

The Longshoremen emerged victorious, in July 1934, after striking for nearly three months. The Pacific Coast waterfront would never be the same again. Once they won, the Longshoremen helped the other unions. They would no longer unload a truck if the driver couldn't show his union card (the Teamsters grew nearly tenfold as a result) and they wouldn't eat in a restaurant unless it had a union waitress. So all the unions benefited because, as longshoreman Louis "Frank" Young said, "We wouldn't touch nothing that wasn't union."

Butch had no use for the strike because Longshoremen were AFL at that time, and he was still an IWW. But then came the day in the 1934 dock strike when four men were shot over at Pier Park in Portland by the police. The police chief had put armed policemen on gondolas on the railroad tracks that led into Terminal 4. That's where they had all of their scabs concentrated. They were trying to take hot cargo in to be loaded on the ships and they had a lot of college students from Oregon State that were acting as scabs. That's where they got their goddamn scabs.

And there was a huge mass of longshoremen because the railroad men said they would not move the trains—they belonged to the railroad unions—they would not move the trains into Terminal 4 if there were people on the tracks. So a great many longshoremen rushed out there, and sat on the tracks. And they were all up and down the right-of-way and the police fired, and four men were shot. None of them were killed, though in the same strike in Seattle and San Pedro [Los Angeles] and San Francisco, men were killed. I think two hundred men were shot in San Francisco, but only two were killed.

The wife of an Italian millworker got the motes out of my eyes. The day after the shooting, she came to me and said she and her daughter and husband were going to go over to St. Johns and see what was going on up there. By the way, the foreign-born people at West Oregon were the only ones that took any interest at that time in the longshore strike. They knew a great deal more than the rest of us about what it was really all about.

What I saw over there changed the entire course of my life.

This longshoreman's son said he'd take us down the trail onto the railroad camp so we could get a real good look at what was going on down there. Before he took us there he took us up to the place where the four longshoremen had been shot. There was still blood there. Some of it had sunk in and the railroad ties were red. Longshoremen had a large wreath of red roses there in their honor and they had it roped off.

And we saw the trees in the park that were pockmarked, literally pockmarked, with bullet holes. Some of the men, to get away from the shooting, had run up to the fence around the park, and it wasn't very far from the play area where a great many children had been at play, and they thought

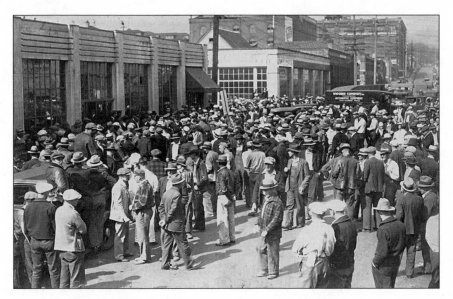

Striking longshoremen on May 11, 1934

that was firecrackers, and they got off the swings and teeter-totters and all ran down that way. Why they weren't all killed I've never been able to figure out. For years, you could go out there and dig lead out of the bark of those trees.

We went up on this bluff where the strikers were set up. You could look down from there into Terminal 4. They had the scabs headquartered on a ship that was tied up there. The terminal was like an armed camp. They had barbed wire fence around it; they had sandbag huts inside the fence with gun emplacements; they had machine guns down at the gate into the terminal; they had an armored truck running around in there. The strikers had their soup kitchen up there on the bluff and they had fires going with mulligan stew cooking. They had their arsenal of weapons. What do you think their arsenal consisted of? Slingshots and a couple of boxes full of pebbles. Slingshots against machine guns.

And while I was standing there with my three Italian friends looking down into the armed camp, and it *was* an armed camp, a whole bunch of deputized thugs, is what they were, swarmed out of this one sandbag hut and ordered us off the tracks. This Italian millworker said, "You don't have any authority here. This is railroad property. You can't order us off." So they knocked this striker's son down on the ground—he was quite slender—and began kicking him in the stomach. We tried to stop them and they pulled their guns, and I really expected to be shot. I was so frightened that I

couldn't move. I hung on to this Italian woman or I would have fallen down. She stood like a rock.

Just then a longshoreman came from behind one of those little yellow railroad huts. He was a big tall man about six feet tall and had his hand in his pocket bulged out like this. I realized afterwards it was his hand and not a gun. You see these things in the movies and you think what a bunch of baloney. He said, "If you're looking for trouble, you're going to get it. Now get back down where you came from and move right now." And they slithered off the track and back down the bank, through the barbed wire fence, into their stupid huts, and we were left alive.

As we walked along, Mrs. Tenderelli kept saying: "You with your machine of writing could do much."

I typed a petition on my beat-up, thirdhand Underwood, demanding the removal of that police chief—his name was Colonel B. K. Lawson—for the shooting of unarmed men near a park where children were at play. Many people signed the petition and that triggered off quite a wave among various groups throughout Portland, and "Bloody Shirt Joe" [the sobriquet they hung on Mayor Joseph K. Carson after this incident] had to fire him. It was the first conscious, planned, political action of my life.

By the time I got home, I was convinced that the longshoremen were on the right track and, whatever kind of a union they belonged to, there was nothing wrong with it. So I told Butch, "We've been quite wrong about this strike and about the AFL longshoremen. This isn't the ordinary craft union. This is industrial war. It's the real thing and we belong in it."

The 1934 strike of the longshoremen was sort of a mainspring for everyone else that wanted to organize in the industrial type of unions. There always had been crafts around this area, you know, but there was nothing much for the industrial workers or nothing that amounted to anything.

This man had tried to get Butch to sign up in the federal union of the lumber and sawmill workers that had a federal charter under the Carpenters and Joiners. They were trying to organize the mill and had about ten people signed up, that was all. There were three hundred fifty people worked at West Oregon and seven hundred at the other mill out there. I said, "You gotta get in and join the Carpenters and Joiners and help to organize the workers at this mill and I'll help you."

Well, it was a more or less industrial type of union, but it was one without any democracy because you paid your dues and you paid your per capita tax to the Carpenters and Joiners, you could send delegates to their conventions and conferences, but you didn't have any vote. They call it a federal union, federal charter. . . .

One of the hospitals in this end of town threw out a woman who had just had a baby right after the baby was born because they didn't have money

to pay on the bill in advance. So, we made a layette for that woman—I shouldn't say *we* because I can't sew—and someone went to her house and nursed her until she was on her feet. And we took food to her. We did a great deal of that type of thing in the Woodworkers' auxiliary.

Then we got the idea that we should have someone come and speak to our auxiliary meetings on birth control because it was no time to be bringing any more children into the world when we couldn't even feed the ones that we had. I think I must have gone to see Dr. [Marie] Equi to find out who we could get—that's probably the first time I met her. She was a wonderful person and she gave me the name of Dr. Lena Kenin. So I went to see her and she agreed to come and speak at a meeting on different methods of birth control, something that most of our members knew absolutely nothing about. It was the largest meeting that we ever had. We advertised it in all areas where the workers lived. It was just absolutely jammed.

Well, she advocated the use of diaphragms to be used with some kind of cream; however, they had to be fitted. So she volunteered her services. I think she agreed to fit diaphragms to a large number of women, maybe twenty. But we realized to get all of our people covered and to get those diaphragms bought, we were going to have to get other doctors interested. So we sent a committee up to the medical school.

What a fight that was! The head of the medical school was a Catholic. Well, we had a sit-down up there. That's right! So they finally agreed to fit the diaphragms. We had a tussle with the welfare to make them buy the diaphragms, but we won that one too. How many years ago that was. Portland was very backward in those days.

Father Jackson was the priest in North Portland. I began going to Mass at that church because a great many of the woodworkers, especially the ones born in the old country, were Catholics, and I went to their funerals and weddings.

The first time I talked to Father Jackson seriously about problems was after the lockout started. A great many of the students went to Catholic high schools in another part of the city and they had no carfare to get to school. So I went to see Father Jackson about what could be done, and he said, "Why didn't their parents come and talk to me?"

I said, "They're embarrassed that they have no money, but you are the priest of this parish and it's up to you to arrange something. This is a poor parish, but there are parishes in Portland that aren't poor."

He said, "You're right. I'm glad you told me."

He raised the money for the carfare. So after that we used to talk a good deal about the different problems connected with the people. He became a very good friend of mine.

You know if you're out of work that long there comes a time when some of your members will go back in to work and that had happened in several

of our mills. But it didn't happen at any of the mills where we had a lot of people that belonged to the women's auxiliary, because we used to send committees to their plant meetings and at the proper place in the meeting the committee would get up and say, "The women are behind you. Stick it out!" We didn't lose a single mill in which we had a large membership, not one! Because the women thoroughly understood what it was all about, that we for a short time had been in control, more or less, of our own lives and destiny.

We didn't want to give up this union that had real guts and democracy. We not only had better wages, but we cut down the overtime without pay. We had gotten our self-respect and independence, so they weren't about to give that up even if they didn't understand all this theory and the history of the struggle of the masses.

When you are involved in a huge mass struggle like that, you have so many immediate problems to take care of. You try and get people to do things they've never done before, such as marching on the courthouse, so you don't have time to get up and say, "Well now, the reason that we're involved in this is really because we need a different social and economic system." You talk about the immediate thing.

Well, a few loggers' wives were already radicalized because they were married to men who had been in the IWW and perhaps several others got radicalized, like one woman who'd been a teacher and was a reader. But a great many of the women could only read what they called the big words, you know, the newspaper headlines, the big words. And an awful lot of *men* couldn't read and write. We could tell, because we used to hand out copies of the *Timber Worker* and the guys would hold it upside down. I mean, that's pitiful. It's hard to radicalize people if they can't read. In fact, we set up classes to teach some of the men how to read.

We wanted to get everybody registered to vote, because there were a few people in office we wanted to get rid of, like Major General Charles H. Martin, who was governor of Oregon during some of these troubles.

Now there were other things that we did to help win the lockout. I remember one desperation point when some of our own members in the auxiliary began to say, "Maybe we better think this over and quit trying to beef up our men because I think we're gonna lose this and we better go back." I think we'd been out about six months then.

So I talked to some of the women that were on the executive board of our auxiliary and we decided that the best thing to do was to take the little bit of money we had left in our treasury out and to have a huge party for all of our members, and the union members too, to get their courage up. So the women that could cook, we had them bake cakes in washtubs. We took copies of the old AFL charter and cut them up in small pieces and passed those pieces around for souvenirs. We had gallons of coffee and we

sang union songs like "Solidarity." That seemed to greatly revive everyone's courage.

Another time when things were very low, we got two movie houses out in the working-class end of town to give us a free movie. We always tried to think of things like that that we could do when people's spirits were flagging.

Of course, the neighborhood I lived in was occupied almost entirely by millworkers. We were all in the same boat. Practically all of the children went to school there. The PTA had always looked down on us and none of us were welcome at PTA meetings, but we decided to have a meeting in the school and explain, invite all the teachers and the PTA ladies to come and tell them that they had to join us.

We had several demands. We wanted to get free bus passes purchased by the PTA or by the school board so that our sons and daughters who were high school age could get to high school. And we thought they should help us get shoes. We had gone to the Sunshine Division—I've never had any use for them ever since—and they gave one boy a pair of shoes. The soles fell off before he got home!!

So we organized this big meeting and, much to my surprise, most of the teachers came to it and the PTA ladies came. They all signed a resolution that we had about what the lockout was all about and that the children shouldn't be punished over this and join us in our demands. Our demands were kind of meek and mild, but we got a good deal of publicity that way. So gradually the support widened out. By this time, a great many of us had got a pretty good education in doing the best we could to get help.

We also used to go out on the picket lines. I remember going on the picket line at West Oregon and you could see all of our seventeen scabs working in there, working on the green chain. They were poor workers and I remember one of them ran the jitney off the dock because he didn't know how to operate it. We used to stand on the railroad tracks beyond the sidetrack and we used to scream, "Scab," and other words at our seventeen scabs.

There was another factor in winning this lockout and getting our members back to work. That was the National Labor Relations Board hearings that were held on our charges of unfair labor practice. Now at that time the NLRB, which was set up under the Roosevelt administration, was a very fair outfit. I well remember the hearing that was held in the case of West Oregon. I went there so I could write it up for the union newspaper.

The hero of the lockout was a Japanese woman. There were a lot of Japanese workers there. Well, maybe not a lot, but sixty or seventy. And several of them had wives. One of these women, Mary Itoyama, got up and testified that one of the top foremen at the mill had come to the house where she lived with her husband, who worked on the green chain at West Oregon, and said if he didn't go through the picket line and go to work they would both be deported.

The company had their representative at the hearing and this man got up and denied that he'd ever done such a thing. She got very angry. She stood up and she shook her finger at him and said, "He's a no-good, no-truth man." She couldn't think of the word "liar." I'll never forget that woman. "No-good, no-truth man," that's what she said.

We won that one. It was really terrific.

MICHAEL MUNK

Born in Prague, Czechoslovakia, Michael Munk (1934–) graduated from Reed College, received an M.A. from the University of Oregon, and earned a Ph.D. from New York University. He taught political science at the State University of New York at Stony Brook and Roosevelt University and retired from teaching at Rutgers University. He is an Honorary Trustee of the Oregon Cultural Heritage Commission and has taught at Clatsop Community College. With Melvin Herman, Munk wrote Decision Making in Poverty Programs *(1968). He has published in the* Oregon Historical Quarterly—*receiving in 1997 the Joel Palmer Prize for best article—and for two years wrote a column, "Our Radical Past," for the* Portland Alliance. *His forthcoming book is* The Red Guide to Portland. *In this essay, "Portland's 'Silk Stocking Mob': The Citizens' Emergency League in the 1934 Maritime Strike," Munk chronicles a moment when class warfare threatened to erupt in Portland.*

Portland's "Silk Stocking Mob"

In the West Coast maritime strike of 1934, a landmark in labor history known as the Big Strike, longshoremen and supporting maritime workers shut down every port from Bellingham to San Pedro. According to one historian, it "was the most devastating work stoppage in Oregon's history." For 82 days, maritime commerce was halted, lumber and grain exports ceased, and an estimated 50,000 workers in the state lost jobs, including 12,000 to 15,000 in the Portland area. Workers emerged victorious despite strikebreakers, police and National Guard intervention, and accusations that they were communists. After a bitter summer struggle that captured the nation's attention, they won a coastwide contract and gained control over waterfront hiring. Most significant, the maritime workers demonstrated the power of labor solidarity that was soon to launch the Congress of Industrial Organizations (CIO).

The strikers' determination to hold out against desperate efforts to open ports frequently led to violence amid intense media coverage. The violence was almost always associated with employers' attempts to run strikebreak-

ers through picket lines with police protection—a strategy that had proved successful in breaking previous longshore strikes. Although workers have acknowledged that physical persuasion was sometimes the only way to discourage strikebreakers, employers have been less forthcoming about their use of violence.

When the strike began to affect commerce beyond the waterfront, business leaders in major ports organized what they called "citizens committees" that instigated violence. Perhaps because they claimed to champion law and order against the "revolutionary" violence of the strikers, respected business leaders, as well as their decision to use any means necessary to break the strike—including vigilante violence—have not undergone much scrutiny.

This is the story of how that decision was made on June 8, 1934, and carried out in Portland, as recorded primarily in the files of the Portland Chamber of Commerce. Despite the chamber's effort to keep its backing of the Citizens Emergency Committee secret, the Oregon Federation of Labor was to coin another name for the CEC and its leaders. "They were a mob," the unions charged, "a silk stocking mob."

The chamber's files only rarely reveal the charged atmosphere of the summer of 1934. Because the significant Minneapolis Teamsters and Toledo Auto-Lite strikes broke out the same year, 1934 might have been the closest the United States has ever come to class warfare. That specter was dramatically presented to the chamber's board of directors by its Washington, D.C., representative and executive vice-president, William Daniel Boone Dodson, on the eve of the June 8 decision. "If twenty or twenty-five million workers were united in one organization headed by one ambitious leader," Dodson wrote, "he would have greater power than any president could win through ordinary elections and could defeat or elect all major offices." Citing "political students" in Washington as his authority, he warned the chamber that "such a development could be effective in placing in the hands of one class of American citizens the greatest power that has ever yet been bestowed or permitted in any class or type by a democratic form of government."

In any case, the militancy of the maritime workers was matched by the employers' angry determination to retain their previously unchallenged power over who could work on the waterfront. One person who heard the employers' end of a telephone argument with strikers was impressed by the "bitterness of feelings between employers and strike leaders" and reported that the dispute was "marked by strong language on the employers' end at least."

The maritime strike that so angered Portland's silk stockings was a consequence of workers' long-standing and pervasive grievances. More than two months earlier, in April 1934, an undercover agent from the Portland police department's Red Squad, spying on a union meeting, found a "packed hall

jammed with longshoremen . . . who were raring to strike." After lengthy negotiations with waterfront employers failed, West Coast dockhands had finally walked off the job on May 9. By striking, the 1,000 members of Portland Local 38-78 of the American Federation of Labor International Longshoremens Association (ILA) ignored a warning from E.C. Davis, president of the Waterfront Employers Association. Davis evoked Karl Marx's celebrated "reserve army" when he threatened that he "would have very little trouble hiring men to work the struck ships . . . from the ranks of the many unemployed workers in the Portland area."

Recognizing a potential threat to the success of the strike, the Oregon Unemployed Councils, organized primarily by the Communist party, and the Oregon Workers Alliance worked hard at persuading that army of potential strikebreakers not to scab. Four delegates from the Unemployed Councils declared at an ILA meeting that they "had 30,000 men to help the strikers." A police spy reported that "they would place five men deep the length of the waterfront and that there would be no scabbing."

Several accounts agree that the absence of scabbing was a major reason the silk stockings failed to break the strike. The Portland longshore leader Matt Meehan declared, "All during the strike, there wasn't one of these unemployed groups, not one man, that scabbed." One writer concludes, "Everyone that I've talked to has said [that the Unemployed Councils] were fundamental to the success of the strike." Another study found that in other West Coast ports "most of the strikebreakers were drawn from the ranks of college students, the unemployed and Negroes." But in Portland, students from the University of Oregon, the University of Washington, Reed College, and the Monmouth Normal School met to pledge, "We will fight all scab-herders, and we will prevent students from strike-breaking."

Both sides understood that the initial response of the armed forces of legitimate authority—the Portland Police Bureau—was critical to the outcome of the strike. Pickets were encouraged on the first day, when 1,000 of them prevented about 150 men, mainly gang bosses on the employers' regular payroll, from leaving the hiring hall. The police limited themselves to escorting the scabs home. Employers saw police inability or unwillingness to protect the strikebreakers as an ominous sign and demanded that the city provide more aggressive police intervention on their behalf. Arthur Farmer, the chamber's manager of maritime commerce, warned that if police protection was "not as effective as it could or should be . . . shipping here will remain at a standstill until and unless protection is given the strike breakers."

Several days later, Farmer expressed increased concern to his boss, Dodson, who directed the chamber's staff from the office of Senator Charles McNary, a Republican. Farmer described how the strikers had "rendered useless" the buses lined up to take scabs to the docks, how strikebreakers

were "manhandled," and how cars "belonging to strike breakers and company employees were overturned and damaged." Through all this violence, he complained, the police stood by, offering "no fight to the strikers and no assistance to the strikebreakers." Less than a week into the strike, Farmer upgraded the crisis from a longshoremen's strike to "a siege on Portland industry."

May 15 saw another defeat for the employers, who had docked the steamer *Admiral Evans* on the Willamette waterfront downtown as a dormitory for strikebreakers and their guards. As many as 100 longshoremen boarded the *Evans* and, after a pitched battle, forced the strikebreakers off the ship, injuring at least five. The victorious strikers then cut the moorings, and the *Evans* drifted downstream to lodge against the Broadway Bridge.

When Farmer wired his report on that incident to Dodson, his first concern continued to be that the "regular policemen standing by offered no fight." Referring to a joint request by Mayor Joseph Carson and the county sheriff Martin Pratt to Governor Julius Meier for National Guard troops, he noted that they "stated [that the] situation could not be handled by the existing complement of officers. Steamship companies refuse to send strike breakers to work under present conditions." Citing closed mills, perishables rotting on the docks, and industries shutting down for lack of raw materials, Farmer recommended "zoning off a section of the city and putting it under military control." If the Oregon National Guard could not enforce martial law, he wrote, "very strenuous efforts will be made to get federal troops on the job."

Farmer's proposal of military intervention was more than a trial balloon. A Portland *News-Telegram* headline reported the Carson-Pratt plea under the headline "Martial Law Expected in City Monday." But the governor surprised Portland's business and political leaders by rejecting their demand, which led waterfront employers to discover an ominous new political threat. In the absence of military intervention, the steamship operators, waterfront employers, and the Portland Stevedoring Company issued a joint statement declaring, "The strike has developed . . . alarming, almost revolutionary proportions."

The local chamber manager, Walter May, complained to Dodson:

> The strikers are making jokes of the police, throwing them in the river occasionally and seeing many of the men to the hospital while there was no real show of strength on the part of the police. The Governor is not ready to call our state troops and rioting is continuing.

Farmer too offered to cite "innumerable cases of violence where police were swept aside or where police refused to interfere."

These events persuaded Portland's business leaders that they faced a genuine—if not revolutionary—crisis. In the face of the strikers' determination to stop strikebreakers, employers were shocked to find that they could no longer rely on political leaders to help them break picket lines or even protect sleeping strikebreakers. But they were not in agreement on how to respond. Some, like the printing company owner Homer Lessard, accused the chamber president and *Oregon Journal* publisher, P.L. Jackson, of "lack[ing] the guts to put the blame on Governor Meier. Is he afraid by calling out the militia he might lose a few accounts for the Meier and Frank and you, a few subs for the *Journal?*"

May was probably referring to such views when he reported to Dodson, "The chamber board has been in a difficult position. Mr. Jackson does not intend to have a 'hot pot' left in the Chamber lap. On the other hand, . . . several members of our board are quite militant in the matter and want the Chamber to do something."

Farmer was convinced that the strike was directed by radicals like Harry Bridges (whom he erroneously identified as "an Austrian reputed to be 'red'") following the model of "the Red Strike in China." Although perhaps not worldwide, as Farmer imagined, there was indeed support for the strike from the Portland Central Labor Council (CLC), and especially from other maritime unions and local radicals. The Waterfront Employers Association, in a half-page *Oregonian* ad, tried to separate the conservative CLC and ILA leadership from radicals and leftists among the strike leaders. It urged "conservative labor to run the Reds out of the [labor] councils."

Reporting to Dodson on May 29, May reiterated that "from the first day it was apparent that our police protection was inadequate, disorganized and unwilling to fight the rioters. The local union officials are not, in my opinion, in control because the 'red' or radical group has taken it out of their hands and all actions of the officials have to be confirmed by the men." And he was especially disturbed that an "intelligence officer from the US Army in San Francisco has come to our office and advised that troops won't be called out." The officer raised the political specter haunting May when he told him, "Portland is the worst hot spot in which to release troops at this time because if there is a revolution in the making such action would precipitate it."

May also summarized the mood of chamber members in the early weeks of the strike and noted that board members would have to decide "whether . . . to call on a special deputized force to combat the riots in order to move cargo." . .

"Director Mecklem," the minutes record, "further suggested that in the absence of that procedure an alternative would be to enroll a volunteer group of citizens to act in a capacity of a vigilante committee." Heeding Dodson's

warning about the bloodshed the vigilantes would cause, Mecklem urged his colleagues to agree to his proposal for a citizens committee by telling them that he "did not think the Board of Directors would accept the responsibility of setting up a vigilante group to combat the strikers." . . .

At the June 8 meeting, the chamber board of directors unanimously accepted Mecklem's proposal and charged the Citizens Emergency Committee with breaking the strike, by other than peaceful means if necessary. The board authorized the militant Mecklem and Cabell to head the group and to demand more aggressive intervention by city, county, and state authorities, and it named additional members to serve as a nucleus. . . .

The CEC's first priority was to get authorization from the city to use private money to hire up to 5,000 of the special police that it estimated would be needed to challenge the strikers' control of the waterfront. Mayor Carson quickly acceded to an initial hiring of 200 specials, although several city commissioners resisted. In addition to wages, the CEC was to provide additional support and equipment, including 500 special police badges at a dollar each.. . . .

The chamber also distributed its own official strike bulletins. One of these, dated July 3, appeared to respond to the ILA leader Charles Peabody's public claim that "Portlanders have the right to know who is subscribing to the special fund" to hire the specials. Although it did not reveal the chamber's role, the bulletin explained that "a large group of Portland businessmen constituted themselves into a voluntary committee known as the CEC." After listing several cases of alleged violence by strikers against strikebreakers, the chamber declared, "These incidents show that outside the jurisdiction of the Labor Temple there [has] been operating in defiance of law and order a group who by their violence place an indelible stigma on legitimate labor organizations. Their intolerable offences are innumerable." The chamber declared that after all "reasonable efforts" to end the violence had failed, the CEC had subscribed an initial fund of $100,000. That amount had been

> turned over to the Chief of Police to be used for such expenses as he might incur in augmenting and equipping the Portland Police Department that said Department might be capable of protecting life and property threatened or attacked by the unlawful elements which attach themselves to the water front strike.

In fact, by July 3 the business leaders had already decided that hiring specials and improving their public relations would not ensure their victory over the strikers. The time had arrived to establish a new organization, the Citizens Emergency League (CEL).

If the CEC was a front for the Portland Chamber of Commerce, then the CEL can best be described as a front for the CEC. At their June 8 meeting, the chamber directors had decided to hide their link to the CEC, even though its initial activities—paying for the specials and attacking the strikers in the press—were not actually illegal. Not surprisingly, the directors also wanted to maintain their distance from the armed vigilantes who were described on the CEL application form as "able-bodied, patriotic American Citizens . . . to be used in cases of extreme emergency to maintain law and order; and for the protection of lives and property.". . . .

In response to the threat of a coastwide general strike, Aird raised his recruiting quota to 10,000 minutemen and soon reported that applications were "pouring in to protect the lives and property of Portland citizens in times of stress." Application forms described the CEL as a voluntary association of citizens, "joined together to more effectively discharge our recognized duty as citizens; and to offer our services to a recognized Governmental authority to be used in cases of extreme emergency to maintain law and order; and for the protection of lives and property."

The CEC emphasized its military image. Not only were applicants asked to detail their prior wartime experience and the firearms they owned, but they were also asked, "Have you had any experience with gas bombs?" According to a young Richard Neuberger, the CEL was "a law-and-order group indexed by blocks and districts and neighborhoods [through which] stout-hearted citizens with military experience could be depended upon to defend the American Way of Life."

CEL members wore service disks inscribed "CEL—for Law and Order" on one side and "Minute Men, Lexington, Mass., 1776—Portland, Ore., 1934" on the other. The chamber assistant manager, Lynn Sabin, noted that they were stamped with the member's number and—together with red, white, and blue armbands bearing the letters C-E-L—were "to be worn by members in case of being called out as law enforcement officers.". . . .

It was not until Portland's own "Bloody Wednesday" on July 11 that Carson and the silk stockings revealed how they intended to escalate their effort to break the strike. For two months, the solidarity and militancy of the strikers had repulsed every step to open the port, and desperation now appeared to overcome their opponents. On July 10, the CEL had demanded that "the State Police take charge of all public thoroughfares," and it announced that Terminal 4 in the St. Johns neighborhood would be opened for shipping by any means necessary. Called "Fort Carson" by the strikers, the municipal terminal was the well-fenced and relatively remote site where strikebreakers and the CEC-funded specials were housed and fed. Toby Christiansen, a strike veteran, recalled: "Some scabs stayed in the terminal the whole time. Some were sneaking in and out to cash their checks. A few made it past our pickets but

their checks didn't." But not all enlisted for the duration; the *Oregon Journal* reported that two specials "gave up their stars and fled Terminal 4."

As specials stood guard around the terminal on July 11, the CEL mobilized and deployed companies in the neighborhood; residents complained about the armed outsiders patrolling local streets. Then Mayor Carson made his move: he put heavily armed specials under the personal command of the police chief on a flatcar at the head of a Union Pacific freight train and tried to ram it through the longshoremen's picket lines.

As the defiant pickets gathered to stop the train, the specials on the flat-car fired several volleys into their ranks, wounding four: Elmus (Buster) Beatty, Peter Steffensen, Bert Yates, and William Huntington. But the strikers reformed their lines, greased the railway tracks, and at a heavy cost repulsed Bloody Shirt Carson's attempt to open Terminal 4.

Bloody Wednesday apparently convinced Carson and the silk stockings that communists were responsible for the failure, setting off a genuine red scare. The next day, the Communist party leader Dirk DeJonge was arrested for distributing leaflets that called for a protest meeting for which he had no license. CEL vigilantes were accused of joining with the police Red Squad in raids on radical unions and political organizations, resulting in about 100 arrests. Homeless men were arrested and sent out of town on trains amid rumors that reds were on their way to Portland from all over the West Coast. Frightened by panicky newspaper reports of an impending general strike, Portland police raided the Marine Workers Industrial Union (MWIU) office July 17 and arrested eight men and one woman, several of whom, including Manly Mitchell and Howard McPeak, were charged with violating Oregon's criminal syndicalism law by advocating a general strike. The next day, while the police were invading the Workers Bookstore and the Communist party and Young Communist League headquarters and arresting 40 more people (including the bookstore manager John Weber and DeJonge—again!), the silk-stocking guns fired once more.

On July 18 the CEC specials at Terminal 4 shot at President Roosevelt's personal emissary, Senator Robert Wagner, and his inspection party, who were sent to ensure that the strike would not spoil the president's scheduled visit to Portland on August 4. Wagner, whom Dodson had disparaged as prolabor, was not hit, but cars in his party were riddled with bullet holes.

At this point, Governor Meier finally recognized the specter that had been haunting Portland's business leaders. He wired President Roosevelt, then on a navy cruiser in the Pacific headed for Portland, telling him, "We are now in a state of armed hostilities," without noting that the only guns being fired were hired by the employers. Playing on fears of the red threat, Meier went on to tell the president, "The situation is complicated by Communist interference," and he pleaded for federal troops immediately "to pre-

vent insurrection which, if not checked, will develop into civil war." When Roosevelt declined, Meier finally called out the National Guard the day after the Wagner shooting, but he confined most troops to suburban Clackamas County. Carson's raids on radicals also continued, with the International Labor Defense office and the MWIU (again) as the targets.

Thus it was the desperate resort to violence and political suppression by the silk stocking mob that brought the Big Strike to a crisis. Strike supporters charged the CEL with inspiring and participating in yet another police raid on July 27. A public meeting called to protest the shootings and arrests was broken up, and four speakers—the Communist leader Dirk DeJonge, Edward Denny, the Young Communist League leader Donald Cluster, and the future Lincoln Brigade vet Earl Steward—were arrested and charged with violating Oregon's criminal syndicalism law. At their trial, the defendants argued that "every state's witness—both the police officers and the private citizens—are members of the CEL—armed vigilantes organized by the Chamber of Commerce." Among the witnesses against DeJonge were the Red Squad members Captain Walter Odale and Merriel R. Bacon, a police spy who had infiltrated the Oregon Communist party.

Actual victory for the strikers came in October, when arbitrators awarded the longshoremen virtually all of their demands. Ever since, the success of the Big Strike of 1934 has been credited with sparking an upsurge of labor militancy throughout the Northwest and the nation. In 1937, West Coast longshoremen (except the Tacoma local, which remained in the ILA-AFL until 1957) joined the CIO as today's International Longshore and Warehouse Union.

LAURENCE PRATT

Reared in Portland, Laurence Pratt (1888–1985) attended Lincoln High School and graduated from Reed College and the University of Washington. For four years, he worked for the Crown Willamette Paper Company in Camas, Washington, generating the source material for A Saga of a Paper Mill *(1935), his first book of poems. He was professor of English at Pacific University in the 1920s and taught English for twenty-one years at Portland's Jefferson High School and for three years at Oswego High School. He was also one of Oregon's most prolific poets, publishing in numerous magazine, newspapers, and anthologies. His books include* Harp of Water *(1939),* Rooms in Caliban's Cave *(1942),* April Out of Stone *(1946),* Black Fire, White Fire *(1953)* New American Legends *(1958), and* Black Mandolin *(1973). His nonfiction works include* Portland, My City: A New Portland Book Years 1915 to 1917 *(1967), and* An Oregon Boyhood by Dowrick *(1969). In these excerpts*

from I Remember Portland, 1899-1915: A Vivid Look at Sturdy Days as Told to Lawrence Pratt *(1965), Pratt remembers the city's Chinatown and "Red Light District" during the first decade of the twentieth century.*

Chinatown

Smells, sights, and sounds along Second Avenue were of a different world. Beginning at the south side of Oak Street, across from the Police Station, were intriguing objects. There in little shops with doors and windows open to the street, wares were displayed to both eye and nose. The meats didn't smell exactly decayed, but they had a very strong and disagreeable odor. I might say stench. They looked as strange as they smelled. Strings of vegetables hung from the ceiling—perhaps garlic and similar pungent growths.

In every shop and crowding the sidewalks outside were men of China. I don't remember definitely any women, but believe a few elderly Chinese women went by occasionally. The men were there by thousands, old, middle-aged, and young. Nearly all dressed alike. They wore dark blue loose-fitting trousers of soft, thin material resembling pajamas, with long shirts of the same material hanging down outside the trousers, and shuffled by in ornate slippers. Every Chinaman had a long queue of black hair with black ribbons woven or braided into it and tied in little bows at the end.

I remember especially the clusters of young chaps, handsome, slim fellows of seventeen or eighteen years, chattering away in their strange tongue, their soft, dark eyes shining from their happy yellow faces. Their queues hung far below their waists. Many of them held the end of the queue in one hand thrust into a pocket, so the queue formed a loop hanging below the waist line. I understood the queue was most important to each Chinese as a sign of his loyalty to the ruling Manchu dynasty. We had some idiotic young rowdies then as we do now; and occasionally a few American youths would catch a young Chinese lad and cut his queue off, a cause of extreme grief to him.

The Orientals I have just described may have been the wealthier ones. They seemed to have nothing to do but stand about and chatter. There were also those working in the shops, and another set who appeared up and down the street carrying burdens. These were perhaps the most picturesque of all. Each had a long pole across his shoulders, with a large basket hanging from either end, crammed with goods. Sometimes these were covered by woven straw lids. More often they were open and filled with vegetables. They appeared to be very heavy, and the bearer swung along in a kind of rhythmical glide, his knees slightly bent.

Chinatown extended southward on both sides of Second Avenue a quarter mile. Other parts of it were farther north and west, on Fourth Avenue, or Fifth. On special occasions, such as Chinese New Years, the rest of Portland

was welcome to visit the area. I went along with other visitors and followed through stores and "Joss Houses." These were their temples. There would be a large room with altars and tapestries. Incense made the air sweet and heavy. One might chance upon a priest chanting through a service. Again, there would be a parade, colorful and strange. All vehicles then were horse-drawn. But there might be a weird dragon one hundred feet long, walking on scores of feet. It would wind from one side of the street to the other. Ahead of or behind it went an orchestra of Chinese flutes and gongs. The notes were high, sometimes almost shrieking and having a wailing quality. The small gongs were struck several times, then came the loud crash of the big one. And everywhere was the odor of gunpowder as thousands of firecrackers exploded. On one occasion I stayed with the celebration until three in the morning.

Another kind of Chinese parade I would see when there was a funeral in the district. There were the same wailing clarinets or other reed instruments, and the percussions. The procession of carriages would be many blocks long. Most important was the hearse with the coffin and the throwing out of paper strips. These were about two inches by four or five and were punched full of holes. Thousands of them were thrown into the air as the procession went along. The purpose, I was told, was to hinder and delay any demons who might try to snatch the soul of the deceased before the body was safely entombed. By some characteristic of the universal laws, a demon on such a chase was required to crawl through every hole in every paper thus thrown into the air before he could proceed in his pursuit of the deceased one's soul. Thus the interment could take place in plenty of time to save the individual. . . .

Bicycle

It was a great day for me when my brother bought a bicycle for me to use, to speed up delivery. I was becoming more valuable in the shop, so it was desirable to save time spent outside, taking proofs for customers to check, delivering jobs, and doing a variety of errands, all on foot. We put a wire basket on the handlebars, and I was now a more respectable deliveryman. It worked well, though I remember that on one occasion the basket broke or tilted so a whole job of printing was scattered on the street. I parked my bicycle at the curb, and darted about among horses and carts, retrieving most of the quota. Some had to be reprinted at a loss.

This was the era of the bicycle. A boy was as eager for a "wheel," the current name for a bicycle, as a teenager is now for a car. There were paths built especially for bicycles alongside many roadways. The roads were usually unpaved, and deep in summer dust and winter mud. In each Oregon town there was likely to be a circular or oval path for bicycling and for bicycle rac-

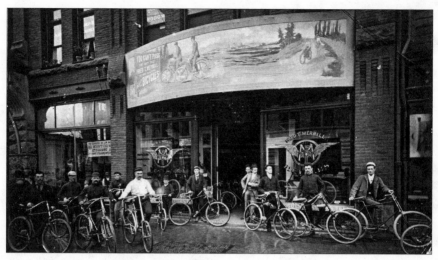

The Fred T. Merrill Bicycle Shop in Portland

ing on festive occasions. From Portland a bicycle path was built beside the road north to St. Johns, and another one to Vancouver.

Because I was shy, I didn't make acquaintances. However, I became rather companionable with a Jewish boy named Ben who lived in the Marquam Rooming House on Sixth Avenue at Alder. The structure was on the west side of the avenue, three stories high, half a block long, and a potential firetrap. Ben and I would sometimes ride our "wheels" around together, often on quiet Oak Street near the print shop, after supper in summer. We learned several tricks and stunts, getting a thrill out of our cleverness. We would ride on one pedal with both legs on one side of the bicycle. We would sit on the handlebars and ride backward. A much harder stunt was to sit on the seat looking forward but riding backward. Or we would get the bicycle going at good speed then climb up with feet on the seat and hands still on the handlebars. We might even, for a brief time, stand clear up on the seat, as the bicycle went forward by momentum while we maintained a precarious balance.

For a period of time, I was sent home to Forest Grove, twenty-six miles west, on Saturdays for weekends. I would ride my "wheel" down Sixth Avenue to the Union Depot and check it into the baggage car of the Southern Pacific train. At Forest Grove I would retrieve it, and have it to ride there on Sunday with boys I used to go to school with. Then I would have to put it on the Monday morning train to Portland. On two occasions the baggage man didn't put it on the Forest Grove train on Saturday evening. I had to do without it there on Sunday. Worst of all, he then put it on the Monday morning train to Forest Grove, so I had to do my deliveries on foot all week until

I went back to Forest Grove the next weekend. It didn't please my brother at all.

Bicycles were big business then. There were many tandems for two riders. There were bicycles for three or even five riders in a row. The outstanding Portland dealer was Fred T. Merrill, with a large store on Sixth Avenue about Alder. In years that followed, when automobiles came into existence, he sold Ford cars, and had a big business. By 1905 there were said to be forty automobiles in Portland. The permitted speed was eight or ten miles an hour in town, with fifteen miles allowed farther out. Later Merrill established a large hotel or rooming house east of Portland, called the Twelve Mile House. Rightly or wrongly it had a dubious reputation. Today Zimmerman's super-market is at about that spot.

The trick riding and pleasure riding my bicycle endured sometimes caused it to need repairs. Fortunately, Rydman's repair shop was at hand. But when I broke a pedal or a chain, or needed a new tire, everyone was unhappy except the repair man. Ross had a bicycle for his own use. In my bookkeeping of the shop's accounts I had to enter all bicycle expenses. To avoid writing "Laurence's bicycle" I used, at Ross's suggestion, the term PDQ which, as everyone knows, stands for "pretty damn quick." The brief term I had for Ross's "wheel" was "Ikey."

JAMES BEARD

Born of pioneer parents and raised in a small, family-operated Portland hotel, James Beard (1903–1985) was one of America's greatest chefs, influencing genera-tions of chefs, food experts, and cookbook authors. His family spent its summers at Gearhart on the Oregon coast, and he attended Reed College briefly before moving away from Oregon. By his early thirties, living in New York, he had discovered the culinary arts. Over the next several decades, he ran a cooking school (with a branch in Seaside, Oregon), hosted a television cooking show, contributed to culinary and lifestyle magazines, and wrote a score of cookbooks. In Delights and Prejudices: A Memoir with Recipes (1965), which Julia Child called "a timeless celebration of the good life," Beard takes his readers on a culinary tour from the Northwest and New York to Europe and South America. In these excerpts, Beard remembers how he grew up "as precocious and nasty a child as ever inhabited Portland."

From *Delights and Prejudices*

The first to hear of the sale of the hotel was Let. He came to my mother and said, "Missy, do you have all your money?"

"Let," my mother replied, "I have every damned cent, but that's for your ears only. Why?"

Let explained that he was tired of hotel work and would prefer not to work without her. If she had been paid in full by the new owners, he would help Mother in her own house; if not, he would stay on at the hotel, upholding its standards, until she did have her money. So Let was able to depart from the Gladstone along with Mother, leaving Poy and Gin and several others to take over the kitchen.

To my father my mother had announced, "I'm selling. I've built and furnished a house in Hawthorne Park near the Summerses. I want a child. After that's achieved you have a home in my house but it's not your house. Live your life and I'll look after mine. Lucille will be under my supervision."

So at forty-two Mother produced me—a new venture. She was in business again. When I first brightened the Beard household, in 1903, I was golden-haired, fair and plump (there has always been enough meat on the bones for two). I have often said that Mother brought me up in the same way she ran her hotel—more manager than mother. She gave instructions on how I was to be fed, what I was to wear, what I was to see and do, and somebody else—at first a nurse, then a Chinese amah, whom I adored—carried out her plans. Later in life, she guided my taste in the theater and music, and for this I will be eternally grateful, for I heard and saw all the "greats" of their day, and my love of the theater and music endures.

I grew up in the helter-skelter of her life. For periods I saw her constantly, and at other times she disappeared for a long stretch into one of her projects. I was alone frequently, but I was enterprising, and I read a good deal, far beyond my years. And perhaps I spent too much time in the company of Elizabeth Beard's guests, for I listened to a lot of adult talk, adopted snobbish ideas and expressed myself freely on almost any subject. I could toss a remark into mixed company that unnerved the entire gathering, which, I have always imagined, secretly delighted my mother. I soon became as precocious and nasty a child as ever inhabited Portland. Even my mother's closest friends ran and locked their children away when I appeared. At home everyone spoiled me, and I was a special favorite of Let's.

He came frequently to the house, but he refused to live there. He knew better. Mother, much to her annoyance, never quite knew where he lived, although she knew where to leave messages that would bring him running. All through Chinatown I am certain we were observed continually and Let was given full reports of our comings and goings. He gave himself away several times. When he was angry with Mother he would punish her by staying away and by just not being found. The two still had their battles—and continued to produce food wonderful beyond belief. And with my appearance, they developed new pride in the mastery of their art. Both wanted to instill in me a love for food, and together with the cook of Mrs. Summers, the wife of my godfather, General Summers, they offered me the most varied gastronomic experiences any child ever had.

Very early in life I came to adore the smell of good things baking. In the morning there were the light rolls made by Let. My father's roll was always baked in a one-pound baking-powder can and blossomed over the top. I remembered it years later when I first came to know *brioche mousseline,* also baked in its own cylindrical tin. Let's rolls were superb hot or toasted. For dinner, the dough was shaped into Parker House rolls, and sometimes it was rolled into cinnamon buns or cinnamon bread, with pecans, hazelnuts, raisins, butter and brown sugar. These cinnamon delights were sought after by all our friends.

Our daily bread varied. Let made a bread which was best eaten fresh. Mother made a more stalwart bread—I am certain she rid herself of much personal anguish in the kneading—which used hard wheat flour and no sweetening. Mother maintained that it should be eaten when slightly stale, and I discovered that its flavor did improve after it had rested and firmed. At times, however, it seemed impossible for me to resist it hot from the oven and gloriously yeasty. It sliced to perfection, and when paper-thin and spread with good fresh butter, for tea or for breakfast, or for picnics or train rides, few things have tasted better. I especially liked sandwiches of this bread made with thin slices of onion, salt and plenty of butter, and served with cooled broiled chicken. And sandwiches of thin-sliced chicken or turkey between buttered slices of this bread were unequaled by any combination, including three-deckers, ever dreamed of.

Mother's bread also made wonderful cinnamon toast: slices of bread toasted, then spread well with butter, brown sugar and cinnamon and placed under a hot broiler until the coating melted. Eaten with cups of rich and creamy hot chocolate on a winter's afternoon or evening, this was an unforgettable feast.

The making of bread then was more of a struggle than it is today. Sponge used to be set with potato water and yeast and then left to rise overnight. The next morning it was beaten down, kneaded, formed into loaves, left to rise again and then baked. With our modern electric mixers, dough hooks and improved methods, baking need not be a daylong chore. However, finding the right flour is sometimes a problem. I am a great devotee of hard wheat flour and I send to the far corners to try new flours. I am convinced that the average all-purpose flour we find in the shops will not make the same bread as the heavier, rougher flour which I knew as a child and which many of the French and Italian bakers in and around New York use. For light rolls and for brioche the usual all-purpose flour seems to suffice and, in fact, to be extremely good. Don't let the lack of heavy flour discourage you from making bread, which can be one of the most satisfactory accomplishments in the kitchen. If I were you, I would first try sour-dough bread. Begin with a

sourdough starter and perfect your technique until you can turn out beautiful loaves. This will be a bread of which you may well be proud.

We didn't always eat plain homemade bread in our house. It was often varied with rye, whole wheat and graham bread. And, of course, the quick breads, so popular in America, were part of my mother's baking repertory. She made light biscuits with heavy cream, cut, dipped in butter and baked, which were like floating bits of cloud. They disappeared as fast as they could be brought to table and were often served on Sunday morning with wonderfully flavored comb honey that seemed a perfect match. The honey might be of a clover flavor one week, a buckwheat the next and perhaps a superb wild huckleberry the next, which Mother found somewhere and contracted for each year. . . .

Of course, Mother's delight in food was not confined to the oven. She derived an intense pleasure from eating perfectly ripened fruit fresh from the tree and tender vegetables right from the garden. It was a peaceful bower she had fashioned for herself—this restless woman—around the Hawthorne Park house. There were flowers, rosebushes and shade trees. The fruit trees numbered three Gravenstein apples, a Lambert cherry, a Royal Anne cherry and three May Duke cherries. There was also a greengage plum and later an English walnut. These bore magnificent fruit and supplied both the Hawthorne Park house and the house at the beach for the entire summer. Such cherries the Lambert produced—huge, purple, luxuriant!

There was a tidy garden patch at the back of the house where Mother grew chives, shallots, onions, radishes, some herbs and always a few hills of potatoes. She would insist on having these potatoes dug very early. She felt if you were going to eat new potatoes, you ate them small, cooked them little and gave them plenty of butter. Therefore, we ate potatoes the size of small marbles, and they had a flavor superior to all other potatoes. Recently at the farmers' market in Lausanne, I found enough of these tiny potatoes to feast on with sentimental delight. Some restaurants ruin them by overcooking them in fat until they are hard and leathery. To be at their best, they should be cooked in their skins, which intensifies the flavor. Sometimes we ate them with their jackets and sometimes without. Occasionally Mother combined them with the tenderest of new peas from the garden, cooked for just a few minutes in a little water with lettuce leaves and butter. What a combination of flavors!

Just as we had people like Mrs. Harris to bring us butter and eggs, there were others on the lookout for Mother's favorite fruits and vegetables. These scouts would call her the minute a shipment arrived, and she would be on the way to collect it with great dispatch. Thus we had the first artichokes of the season to arrive in Portland, and we had them in quantity while they lasted. The same was true of California strawberries, raspberries, aspara-

gus, beans and many other items. Mother was not a season rusher, but she wanted the first good fruits and vegetables that appeared. She maintained that little fruit which traveled from California had the quality of the well-matured local fruit in season, but she kept trying the imports anyway. She generally rejected them in disgust.

In those days there were a great many Italian truck gardeners who had large plots in town and who, in addition, were hucksters. With horse and wagon they sold in different neighborhoods on different days. We had two such men coming to us two or three times a week. Aside from their own produce, they brought vegetables and fruits from other parts of the country. Later, of course, they became motorized and had much more of a selection to offer. The one, Joseph Galluzzo, finally moved into the public market, where he had only his own produce to sell and no longer had to endure the hardships of driving through town. The other, Delfinio Antrozzo, came to us for many years and gradually became a part of the family life.

He was not long in falling under the wily spell of Mother and would bring her choice tidbits, bottles of homemade wine and sometimes Italian dishes made by his wife. He and Mother would spend endless amounts of time discussing the quality of his merchandise and the ways of cooking vegetables. When either Joe or Delfinio offered vegetables or fruits new to Mother or suggested new ways of preparing familiar things, she always experimented. If she liked the result, she would keep working to perfect the flavor.

Thus it was that I learned as a child to enjoy many vegetables considered outlandish by most other people—cardoons, broccoli, eggplant, zucchini, mustard greens, baby turnips, fava beans, varieties of shell and snap beans, and every type of melon one could dream of. Delfinio grew beautiful leeks, and we had them often in several different guises, including a wonderful leek vinaigrette. Also from Delfinio we learned the delicacy of Savoy cabbage with its tender, curly leaves. This vegetable became the basis of several fine dishes, including an extremely good stuffed cabbage, made with not the leaves but the whole cabbage, scooped out, filled with a savory mixture, wrapped carefully and baked in broth a very short time—not only incredibly good in flavor but very attractive to look upon when it was brought to the table. . . .

Portland had a great public market which was originally built along Yamhill Street for about five blocks, on both sides of the street part of the way and on one side the rest. Farmers and producers took stands, which they rented from the city at nominal sums, and filled them with seasonal display, beginning in the spring with the earliest asparagus and berries and continuing through into the winter with celery bleached to an ivory whiteness by the Foltz family, all the winter root vegetables, late cauliflower, apples and pears, nuts and wild mushrooms—in effect, the round of the earth's gifts to the palate. In addition, there were poultry, pork and pork products, dairy

products, eggs, honeys and some prepared foods. Certain people were the sole vendors of some items. One woman always had fine lemon cucumbers, for instance, and she was inundated with orders when they were in season. Another woman specialized in the heaviest cream imaginable, and this was as much in demand as anything on the market, requiring orders two or three days in advance. The cream was as close to great French cream as one could find, and the flavor was superb with fruits or in sauces, or whipped as a topping for puddings and soufflés. Some people had better corn than others, and one could buy tiny ears of Golden Bantam picked in the morning to be eaten at night.

Apples were a round of delight in themselves, from the early Gravensteins through the Baldwins, the Rambeaux, the Kings, the Spitzenburgs, the Northern Spies, the Winesaps, the Fall Bananas, the Winter Bananas, and the Newtown Pippins. Each apple had its distinctive flavor, texture and color. Each was right for a certain use. The Gravensteins, for example, made perfect pies, baked apples, applesauce and salads, as did the Spitzenburgs, later in the season. My mother loved the scrubby russet look of the Rambeaux, the pungence of the Spitzenburgs and the delicacy of the Baldwin and the Belleflower. All of these had their places in the seasonal schedule and were purchased by the box.

Tomatoes provided a kaleidoscopic array. There were the familiar large and small red ones, huge yellow and whitish ones, and the plum, cherry and pear tomatoes in all colors from pale white-yellow to a pinky red and a deep red.

One could even find morels in the market. I remember the first time I saw them. I was quite shocked by their strange appearance. To me they resembled dried-up brains (they still do) and I couldn't imagine what they were. I had eaten them at home but had never seen them before in the raw state. But how good they were, made into an omelet, added to the sauce for a chicken or served with veal. In fact, when I first had them I thought they were the most delicious morsels I had ever tasted. Later in life I discovered they were as precious as truffles, but I couldn't have enjoyed them any more than I did when I knew them as strange wild mushrooms.

It was an education in food to know the public market as I did, first as a child when I was largely a spectator and then as a young man when I was a customer. From its international roster of producers—Chinese, Japanese, Italian, German, Swiss, English and a few of Czech and other nationalities— I learned the various national vegetables and seasonal specialties. I had my first white raspberries from this market and my first tiny husk tomatoes, also known as ground cherries. The latter come late in the fall and make a superb preserve which is incomparable in flavor and texture. They exist in France in a larger version. I have seen them in various parts of the Northwest and West but never in the East, until the last few years.

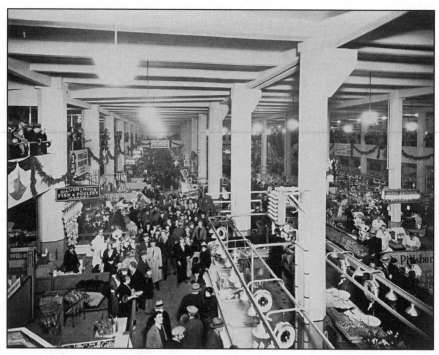

Inside the Portland Market building

I particularly remember one very early visit to the market in the company of my nursemaid. We had just been to the doctor's and on the way back stopped to buy a few things for my mother. When they were wrapped and handed to the maid, she said quietly, "Please charge them to Mrs. Beard." The clerk blanched and said, "For God's sake, give me that package. If I sent that to her, she'd kill me."

Despite this account, Mother was not the terror of the Portland market. She was uncompromising in her standards, true, but she could joke with the toughest guy in the market or with the most supercilious shop owner. She would offer advice to farmers on the growing of vegetables, and they, in turn, would counsel her on the cooking of them. It was usually a friendly exchange, but sometimes when Mother was bored by a longwinded purveyor, she would suddenly stride off, muttering a ribald remark under her breath. On the whole, she was the *fournisseurs'* ideal customer. She had her favorite clerks in every store, and they loved her.

Mother was not one who felt that she should limit her patronage to one shop. She distributed her custom and she was constantly on the search for different products, and always the best. One place she patronized—called La Grande Creamery, which is a pretty grand name for anything—was a

fascinating shop. It did a great deal of business with restaurants and hotels and had served Mother for years. What a treasure house it became to me! It dealt in fine poultry and game birds and cheese and eggs. Every week when we bought chickens for our regular Sunday breakfast, I would come away with one or two pounds of gizzards and hearts for myself. I had developed a passion for these. I couldn't abide, and cannot till this day, the livers—not even one liver! I can eat anything else in the world, but this texture repulses me for some reason; and once or twice when it would have been embarrassing not to eat them, I have swallowed them practically whole! But the heart and gizzard I preferred to any other part of the chicken; and when my father came to the beach for a weekend he would bring me my quota. I am still fond of them and prepare them in a variety of ways—sautéed, braised with heavy cream, done with barley in a casserole, grilled with crumbs; and the gizzards are delicious when made into an hors d'oeuvre similar to beef salad.

Cheese came into my life through La Grande Creamery also. They had fine Cheddar of varying ages, Switzerland cheese, Roquefort, excellent Brie and Camembert from the Rouge et Noir people in California, and occasionally good French Camembert and Brie—these and something called "cream brick cheese," which reminds me of a Port-Salut or, if it is very ripe, of a great Pont-l'Évêque.

At home we ate some beautifully aged Cheddar and often had it on toast, hot and bubbling, as a supper or luncheon dish. With a curl or two of bacon on it, what a superb snack it was! I developed a taste for Emmentha—we had no Gruyère in those days in Portland. Each time I went into La Grande Creamery I managed to get a generous slice of it as a premium and marched along the street nibbling it with the greatest relish.

Sometimes unusual types of cheese would arrive at La Grande Creamery, and we were sent bits to sample, for after all, we were pretty good customers, in or out of the hotel business. I am grateful to have learned young that cheese has an important place in a menu. It isn't something to serve with apple pie, and it isn't something to cut into nasty little cubes and serve with crackers. Early in life I learned to see the beauty of great slabs or rounds of cheese on the table, and I still respond to the sight of a well-stocked cheese tray properly presented. Cheese must have warmth and time to soften. Too many households and too many restaurants ruin every bit of their cheese by keeping it under constant refrigeration. Cheese that is served cold and hard is not fit for consumption.

Another exciting marketing experience for me was the butcher shops. Unlike the run-of-the-mill butcher who catered to a small patronage, these were lively wholesale and retail markets. There was sawdust on the floors, and great cooling boxes, as wonderful to me as an art gallery, held a fascinating array of carcasses waiting to be cut up. It was a special treat when I could

get into the boxes to look around and emerge munching on sausage or ham or some such delight.

Mother would pick a piece of beef, have most of the ribs and part of the short loin hung for her, and then take away one huge roast and several steaks at the same time. She would also buy plate or brisket for *pot-au-feu,* and she would have the butcher corn certain cuts for her to be used as corned beef. . . .

Then there were marvelous excursions to Chinatown for visiting and buying. We ate Chinese food at home whenever Let wanted to cook for us—Mother never mastered the dishes—but we often lunched or dined with Chinese friends in one of their restaurants. At New Year's we would be invited into scores of homes, when the finest of hangings and *objets d'art* would be on display. I missed some of the great dinners on these occasions, but I did taste the delicacies from time to time, for there would always be presents of sweet-meats and bits of pastry for the younger group when we went to call, and on shopping days, when we stopped by to see friends, there was invariably an offering of tea and a delicious morsel.

We often marketed for jars of preserved ginger, preserved and candied kumquats, canned and fresh lichee nuts and some of the fine Chinese pickles for use in sweet-and-sour sauces and to accompany cold meats. Also, we bought fresh bean sprouts and water chestnuts in season, and when the mandarin oranges arrived by boat from China, this was an event which called for a shopping trip of its own. The oranges were exquisite and delicate in flavor, possessing a quality seldom equaled by any others I have eaten—pure, heavenly sweetness.

I had always loved lichees in syrup, and when I finally tasted a fresh one, I knew why. This is the most exotically flavored fresh fruit in the world and probably the most luscious fruit ever known. Why it has never been more popular is something I cannot understand. It is fragile, yes, and comparatively difficult to come by. In New York we have been blessed of late by having them on the market for a fortnight or so each year. During that all-too-brief period I cannot have enough of them, so remarkably satisfying do I find them.

Whether it was in Chinatown or the public market, my Mother adored shopping. She had a standing order for such things as sausage meat, cured sausages, a liver *pâté* that one woman made each fall, ground cherries, certain beans and tomatoes, radishes, corn and cauliflower, and her own particular choices of Foltz's celery. I sometimes think she enjoyed shopping for these things more than preparing or eating them. Her virtuosity in selecting food few women I have known could match. Years later in Paris, when I went marketing with Madame Gafner, whose small restaurant I frequented, I was reminded of my mother's touch in picking a succulent fish, the perfect cheese, or the tenderest asparagus. I was lucky to have such a tutor.

NANCY NOON KENDALL

The author of two Oregon novels, Nancy Noon Kendall (1900–1994) was born in Portland at the corner of 12th and Market Streets. She attended Portland Academy and graduated from Annie Wright Seminary in Tacoma, Washington. She attended the University of Oregon in Eugene, where she worked on the Oregon Monthly *and the* Emerald, *and lived in Vancouver, Washington, in the 1930s. Her first novel was* The New House *(1934).* The Wise in Heart *(1947) was originally named* The Park. *Kendall summarized the story this way: "It is about Portland and has for a setting the old Park blocks, and is a study of a group of children who were too heartily guided by their Victorian parents and therefore all turned out unhappily." The central adult figure in this domestic drama is Mama Dean.*

From *The Wise in Heart*

It was a big boy who condemned Laura. He was on the window seat, valiantly disregarding velvet upholstery as he ground away at a shingle with a scroll saw. "You never want to put a doll in the doll buggy until some other kid wants to put the cat in it," he continued. "You just love being a pig, that's all."

"You shut up, Flip Carmody!" Laura squealed. Her pale face flushed lavender. Laura never flushed true crimson. Later, in maturity, she was to recognize that unpleasant mauve shade which spread across her features with the slightest change of mood and to loathe it. "I hate boys who think they're so smart." She jiggled the doll cab importantly to show her good intentions. "And you better clean up that sawdust you're spilling around. If you don't, I'll tell my mamma. Just because your mamma brought you over here to our house to have tea with us is no reason for you to make our nice nursery into a pigsty."

"I didn't want to come over here today, and you know it. I never want to come near your old house!" The big boy shouted so loudly that the cat leaped from Cathy's arms and scuttled away to hide beneath the bookcase. "But we always have to come because your ma says to mine, 'The little dears can have their nursery tea while we have ours, like we always do,' in her big sugarpie voice, and everyone jumps to obey her. Even my mom! So here we are, shut up to fight like a lot of tomcats all afternoon. If anyone but your ma planned such fool stunts, no one would pay any attention, but here we are, and a fine day spoiled for us all!"

Why was it that all the children—yes, and all the mammas, too—had to be tied to the mighty apron strings of Mamma Dean? Flip wondered. Who had appointed her queen of the tribe? No one had, Flip decided; she had just climbed up on the throne and nobody had ever been able to shove her off. He wished he knew how to give the first push that would make the throne

totter. Flip sighed. He knew that part of the trouble, so far as he and his family were concerned, was that they were related to the Deans—remotely related, but related. What Flip couldn't understand was why people had to swallow relations, even when those relations were dreadful people who had nothing whatever in common with one, really. Nor could he understand why his parents, with all the town to choose from, had to build their home right next door to Mamma Dean's.

Ah, but that was just the point. Mamma Dean again! Mamma Dean had chosen the location for the two homes. Mamma Dean was determined to arrange the destinies of all things, great or small, which came within her ken. She had appointed herself captain of a small group of individuals who, having been tied together for several generations by business connections as well as, in the case of the Carmodys, by blood, had decided for various reasons—economic and otherwise—upon a collective pilgrimage to the West. This migration had been from New England to Oregon, and although it took place long after the oxcart era, Mamma Dean played her part as valiantly as any member of one of those early emigrant trains. And upon reaching their destination, she had stood, like Balboa on his peak in Darien, and surveyed the city that had been chosen for their future home.

The children must have the best environment. The future of the children must be first in mind before one single step toward the actual building could be taken. Mamma investigated all sections of the city and, after due consideration, decided upon the Park. Everybody of importance lived near the Park. Therefore the Deans, the Carmodys, and the Fanshaws bought property and erected homes facing the Park.

Cut into blocks, the Park bisected the city, running through its heart from the north to the south. In the industrial section the space had been utilized for the location of administration bulldogs. North, near the depot and river docks, little Chinese and Japanese children played under trees that were powdered with factory dust. South, beyond the hills that jutted into the city like the outline of a sleeping dragon, the Park was the possession of Italian, Russian, and Jewish families, who spent all their leisure time enjoying green grass and cool shade. The squares of the Park that ran closely against the base of the wooded hills were restricted. Here were the homes of the affluent. Each massive pile of masonry represented some dream which had reached culmination in the form of a home.

It was here, close to the base of the sheltering hills, that Mamma Dean had established her tribe. Here the children were being reared in a vale of rarefied peace and intense decency. There were no walls surrounding the Park, but Mamma Dean had created ramparts out of her own solid opinions.

The house, which Mamma planned and was unmistakably her mansion, although Papa had paid for it, was a massive lump of cream-colored wood. It did not belong to any true form of architecture, although it followed the

jigsaw period of Chester Arthur. There was a flavor of Grecian art in the tall ornamental pillars that graced its front. And there were bay windows wherever a window could bay forth. Stained-glass panes in the hall windows and in the front door lent a warm blob of color, but in spite of this inviting touch, the front veranda was narrow and unfriendly. Yard after yard of wooden lace draped the eaves. All casements were embellished, and here and there a carved wooden face appeared. A curve of driveway swept in from the street and led to an imposing porte-cochere at the side of the house. The porte-cochere touched pillars in chummy fashion with the porte-cochere of the next dwelling—the "twin" house, where Natalie Carmody and her family lived.

Mamma Dean always spoke of the other mammas as "the girls," because once they had all been schoolmates in New England. Moreover, she and Natalie Carmody were second cousins and really closer than sisters. Besides, at the time the new homes were built things in pairs had been *so good*! Statues and clocks and vases and umbrella stands and books all came in pairs, so why not twin houses?

Concealed in Mamma Dean's heart was another reason for erecting twin houses. She was dubious concerning Natalie Carmody's taste in architecture. Given her head, Natalie might produce heaven only knew what in the line of a home. Yes, heaven only knew what! Given her head and a second's breathing space away from mamma's guidance, Natalie often did odd things. And Mamma had no wish to spend her days living next door to some quaint conceit that looked like a witch's cottage. Natalie had mentioned a longing for thatched roofs, weather vanes, leaded windowpanes, and a walled garden. Such a cottage belonged in an illustration for a fairy tale, but it had no right alongside the Dean edifice in the Park. Mamma frowned on Natalie's conception of an Anne Hathaway house, and the twin mansions became the visible evidence of her conception of the proper background for the rearing of the children.

The two houses were identical inside as well as outside, with enormous high-ceilinged rooms and vast halls carved down their middles. Front parlors, back parlors, libraries, and dining rooms—all were the same.

In the Dean house the front parlor contained the "marbles," which Mamma had herself chosen on her one European tour. She had bought them in Rome, and each night they were dusted and covered with a trifle of yellow gauze to insure prolonged whiteness of the Carrara. Marbles, in Mamma's opinion, required great care. In the library were the "bronzes," also imported on the same grand tour. All the statues were ugly and all wore raiment, for Mamma believed nudity in art was not to be tolerated. Particularly in a home where there were children!

The dining room in the Dean mansion was awesomely repellent to everyone except Mamma. She admired her own choice of golden-oak carved

furniture, and considered the "still life" on the walls particularly attractive. Just why she cherished an affection for pictures of very dead speckled fish arranged on very green leaves, and two dead hares hanging limply from a bough, is a mystery.

Swinging doors led from the dining room to the butler's pantry, where there had never been a butler. Beyond this was the huge dark kitchen, with its drab walls and enormous black range. Mamma's planning stopped completely at the kitchen door. She had no interest in culinary affairs.

Another room on the first floor of the Dean house was Papa's Smoking Room. It was a meager little den, sparsely furnished with a wobbly black stand just large enough to hold Papa's smoking equipment. The floor was covered with cold brown linoleum. An uncomfortable ancient steamer chair stood beside the smoking stand. Mamma disapproved of tobacco; she could see no earthly sense in anyone's giving into his baser desires by puffing on a pipe or a cigar. Perhaps if Papa had to repair to this inhospitable nook in order to indulge himself, he might be persuaded to give up the filthy weed.

Every once in a while Mamma would notice that the ferns in the hall and library appeared to be pindling in health. Then she would invite Papa to come in and puff his pipe above their yellowing fronds. As soon as this medicinal act was completed, he would be hurried back to his chilly den, so that the "fumes" would not permeate the brocade hangings.

The upper floors of the twin houses were divided into sleeping apartments.

Flip Carmody, on the window seat in the nursery on that February afternoon, pondered upon bedrooms. In his house, Mom's room was a cheery place. A fire usually crackled on the black marble hearth, and Mom herself might be found rustling about in a taffeta petticoat and a pink albatross dressing sack. Often there would be exciting items visible—such as corsets lying on the bed. Flip enjoyed looking at corsets. Mysterious things they were, for a fact. There were pink ones to be worn with the pink satin evening gown; black ones embroidered in moss rosebuds to be worn with the black lace gown; and just plain white ones for everyday wear.

Pop's room was just beyond Mom's. The two were connected by a dressing room, which had in it a brown mottled marble washstand. Often Flip could hear Pop rustling around in his room and whistling as he puttered about. He liked to hear his mother and father laughing together, and they laughed a lot together, those two.

But the Dean bedrooms! No one seemed to live or breathe upstairs in the Dean house, and nothing here seemed to be done to the accompaniment of laughter.

Once in a long while Flip was allowed upstairs at the Deans', but not very often. He had gone up several times when Tony was housebound. He remembered that Mamma Dean's bedroom door had been open. He peeked

in and stared in horrid fascination at The Chair and The Stool in the bay window. The children all knew that carpet-covered stool. Tony and Laura had talked about it often enough, and the children regarded it as they might the block upon which a condemned criminal's head might rest before the ax came down. Mamma Dean cherished that footstool, for it was upon it her children had to sit when she wanted them to confess their sins, or ask a favor, or seek her advice.

Surely the Deans must wash and bathe and walk about in underwear and scrub teeth and take castor oil and stick pins in needed spots. They must even go to the toilet like other folks. But such natural acts seemed, somehow, not to be associated with people controlled by Mamma Dean.

Flip gave up pondering on the bedroom activities of the Deans, and looked across the Park toward the Collins house. It was supposed to be an excellent replica of the Collins home in New England, but Flip thought it looked like nothing but a big square hunk of brown bread. However, no matter how ugly their home, Flip was very fond of the Collins twins. They were jolly little people, younger than him, but friendly and affectionate. Furthermore, Flip felt free to like the Collins family, for they were merely friends, not relations.

Nicky, still banging along behind the iron train, disappeared beneath the table, which was covered with a large square of green plush.

"Gosh, there's cobwebs under here," he roared, as he burst into view on the other side of the table.

"There are not! There are never any cobwebs in this house," Laura responded firmly.

"There are too cobwebs!" Flip shouted, and added venomously, "and there are rats! Yesterday I met a fine big rat right under your back porch. He was trying to get out, though, and—"

"You're lying, Flip! If he was such a fine rat, why was he trying to get away?" Laura screamed.

"He was trying to get out to go over and eat out of our garbage can. Fine rats wouldn't want to eat old Dean garbage! And if Nicky says he ran into cobwebs under your old table, then he did run into cobwebs!"

"Oh, good gosh!" exclaimed Tony, "must you three be yamming at each other all the time? If you'll all shut up, I'll make everybody a valentine. I'll make one shaped like a train of cars for Nicky, and I'll make Cathy one built like a cobweb, and I'll make something nice for everybody." Tony dipped his brush feverishly into red paint and traced a line of careening cars across a white paper heart. He drew a balloon of smoke over the locomotive and wrote *Steaming with Love* in the circle, and poked the peace offering toward Nicky. Tony Dean, handing out that paper heart, was symbolic, for he was destined to go on through the years putting out peace offerings toward these children.

"Make me a valentine, Tony! Make me the prettiest valentine you know how! Better'n any you make for the other kids! Make me a pink heart and trim it with paper lace," Laura whined. "Mamma said you were to make me the best valentines, because I'm your only sister, and I deserve them."

Laura's voice continued to whine, but the children paid scant attention. They were accustomed to her ways, but to Tony they were always embarrassing. He rebelled against the domineering note in her voice. Never had he been free of Laura's domineering. He longed desperately for nine or ten other sisters. Such a galaxy of girls would soon put a stop to Laura's demands. She would no longer nod her sleek head and say, "Mamma says you must, because I'm your only sister."

It was disgusting, Tony thought, everlastingly being told to fall down and worship your sister exactly as if she were the Great Golden Calf in the Bible. He chewed his paintbrush and stared around. "For gosh sakes, Laura, leave me alone. Make a noise like a hoop, and just roll away." He put the finishing touches on his work, licked his brush, sighed contentedly, and said to no one in particular, "Say, what do you think of the new girl at school?"

"She's not a new girl at all," Flip said with authority. "I found out all about her. Her family lived here in Portland before any of us came out here to live. In fact, her folks have been here for just ages. I talked to her myself, and she told me all about everything. And then I told her about us, too. I told her how we were all old friends, and some of us relations, and how our people had always been together in business, and how we came here from New England, and that our ancestors came over on the *Mayflower*. And do you know what she said? She laughed and said, 'Well, don't you think that's pretty funny?' "

"What did she say that for?" Laura asked quickly. "I don't see anything funny about that. We've always had this *Mayflower* trip dinged into our heads by Mamma, who ought to know what she's talking about better'n a girl we don't even know at all."

"Well, anyway, she laughed about the *Mayflower* business," Flip responded. "She lives in that big brick house up at the head of the Park. Her father owns horses and dogs that are all purebreds. The reason she hasn't been at school since we came here is that they've been away from home. They've been traveling for a very long time, I guess. I like her."

"So do I," Tony agreed. "She may not be very pretty, but I like her just the same." Tony knew that he and Flip were stirring up the flames of Laura's jealousy by becoming champions of the new girl, but he didn't care. "She's a nice girl, and I think her hair is just grand."

"So do I," said Cathy, as she flipped her own stiff rebellious mane out of her eyes.

"I didn't like that new girl one single solitary bit," Laura said definitely. "I hated her from the first moment I laid eyes on her. First, I saw her standing

in the hall, talking to Flip, just as if she had known him for ages, and then a little later on, during recess, I went looking for Tony and there she was again, talking to him as if she had been good friends for life. And when I went to find Nick to get him to help me with drawing my geography maps, there was that new girl giggling with him in the corner of the playground. I hated her from the start, and I intend to go right on hating her. I don't think it's nice for her to giggle and talk with you boys just like it was me, or a sister, or something. I think she's horrid. I don't want her to get to playing with us. I'll never, never ask her to come down to our house, and you can mark my words on that."

"The new girl's name is Monica O'Neil," Flip said, brushing aside Laura's tirade. "She won't come down here unless Laura asks her, and Laura says she won't, so that's that. Anyway, her father took her traveling in Europe and she kissed the toe of St. Peter in Rome and—"

The story was suddenly interrupted when the door opened and Evelyn Ainslee appeared. With her was a small girl.

Mamma spoke of Evelyn Ainslee as "poor Cousin Evelyn," and seemed to take much pride in her charity toward an unfortunate relation. When Mamma was not present, however, people smirked and snickered, and wondered how poor Myra Dean stood for it. Everyone knew all about Cousin Evelyn and Papa. Everyone, that is, except Mamma, and the reason it was easier for her not to know was obvious.

Cousin Evelyn was indispensable in Mamma Dean's household. Evelyn did everything that Mamma disliked to do. She hired and fired the maids. She tutored the children and mended their clothes. She swabbed their throats when they had tonsillitis, and took care of the ringworm that attacked Laura and turned Mamma faint with disgust. She wound the clocks when they needed winding, and in the springtime she put the flannels and the blankets away in moth balls. Evelyn ordered the food and planned the meals, and saw that the monthly bills were paid, making out the checks for Papa to sign. She took the children to the dentist, and Tony to the barbershop. She pressed Mamma's dresses, and polished the silverware until the skin on her hands was parched and dry. Her room was a small one near the bathroom—a particularly handy arrangement if a child should feel vomity in the night. She was an unaccomplished, dependent female; a slight little woman with dark blond hair and a pair of soft lips that smiled across small, childish teeth. She never took or received praise or credit for her tasks. Mamma, it appeared, was always busy doing all of them herself.

Cousin Evelyn did have one accomplishment for which she received credit from just one person. She gladly stayed at home all through the hot summer and joyfully kept house, alone, for Papa, while Mamma took the children to the seashore for their vacation.

The children stared at the newcomer and—with the single exception of

Laura—grinned. Flip bounded off the window seat, shedding sawdust into a yellow shower on the floor. Cathy trotted toward the door, her dark face flushed with friendly welcome. Tony slowly and shyly rose to his feet and bowed comically. Nicky emitted a sharp, piercing toot of greeting.

The stranger peered into the room, an expression of mixed shyness and excitement on her face. This was a new realm—a world inhabited by children who had invaded her own province during her absence. Would she like them? Would they like her?

The children sensed that the stranger possessed something they desired. Instinctively they wanted the companionship of this child who so obviously brought something different into the room—something as rare as sunshine in a dark cave. The new child emanated a sensation of brightness. Brightness was enmeshed in her thick yellow-red hair. Brightness gleamed in her clear gray eyes.

The new girl's lips formed a thoughtful smile. She was hesitant about entering the nursery. Calling on strangers was always a fearsome task, and she had not relished trotting up the driveway of Twin House and ringing the doorbell. And now that she was within the portals she did not particularly admire the room she was about to enter. There was no explanation to her childish reaction. She merely felt pulled back, as if some unseen hand were resting upon her shoulder, drawing her away.

She became aware of Cousin Evelyn's gently shoving fingers on her arm. She turned and gravely thanked her guide for piloting her to this seemingly safe haven. She wanted to explain the reason of her visit to Twin House, but Cousin Evelyn anticipated her desire.

"This little girl has come to make valentines," Cousin Evelyn said pleasantly. "She says that she lives up at the head of the Park, and that today at recess Laura invited her to come here and play."

"Laura invited me when we met in the cloakroom after recess and insisted that I come down today and bring my valentine-makings. Besides, it was my place to come down here and call first. I've lived in Pentland much longer than you people have, and that's a rule my mother always sticks tight to about making visits."

Monica O'Neil spoke in a voice that seemed to bubble merrily up from her throat. She sounded happy when she talked, exactly as Laura Dean always sounded cross. She pushed one foot forward and, smiling cheerfully, crossed into the nursery.

Nothing sinister drifted into the room on Monica's heels. Instead there were sudden sounds of mirth, as the children gave way to slightly hysterical giggling. And Monica, ignorant of the cause, joined in their glee. Everyone shouted, except Laura, who remained seated and glared at the intruder.

"Laura lied! Laura lied! Laura told another fib!" Nicky screamed, as he

capered around the room. "Laura always lies! Laura said she'd never invite you down here to play! Laura lied!"

Then, because the children were so accustomed to Laura's fibbing, and because they knew better than to put faith in her hatreds, they turned their attention to their pleasure at the arrival of the newcomer. The giggling stopped as abruptly as it had begun.

Monica, however, was embarrassed and puzzled. Why had Laura lied? And why should she, Monica O'Neil, feel that she had upset the serenity of the nursery? Her breath came in a quick gulp of dismay, and with a gesture of defiance, she stumbled toward the door in a bewildered attempt to flee. But there was no escape; Cousin Evelyn had closed the door, and at sight of it, Monica's momentary panic fled. She turned again and smiled at Laura, then crossed the room to a chair at the table. She took off her round blue hat and from its insides produced a flat package. It contained materials for making valentines.

"I brought my own stuff," Monica said calmly. "I told Laura I'd make her some valentines when she asked me to come down here to play."

"Well, I just forgot that I asked you," Laura said glibly. Her curiosity outdid her sulkiness, and she deigned to join the group around the table.

"Gee whiz, ain't they beauts?" exclaimed Tony, crowding closer and watching with fascination as Monica quickly drew a tiny sleigh and heaped it with golden hearts. "Here, I bet I can make up a verse for that one. Listen, how's this: 'My heart is a sleigh which speeds down a hill, hoping its gold at your feet to spill'?"

"Don't be such a fool, Tony," Laura said crossly, but no one paid the slightest attention to her. The children were enraptured by the work of Monica's agile fingers.

Laura's face burned with fury. She sat silently biting her lips. One small hand crept up to her smooth hair and in a second she was twisting her immaculate hair ribbon until it dangled in a string above her ear. Only intense anger could make Laura destroy her own ornaments. Little drops of saliva collected at the corners of her mouth. She took her handkerchief and mopped vigorously at her lips and chin. She felt as if she might be going to vomit. Then in the midst of her anger, she remembered last year's valentines, which had been carefully kept in a box in the bookcase. She slipped across the room, found the box without much trouble, and demurely set about tracing pictures and verses from the valentines she most admired.

"Cheater!" Flip roared, as he pounced on her counterfeits. "Cheat! Cheater! Don't you know your mamma always jabbers about her little girl not doing anything dishonest?"

"Well, nobody can tell that these are traced, and they look as good as her old freehand drawings, anyway," Laura said coldly. She gripped her paint-

brush until the slender handle snapped. Her fingers ached to scratch at the new girl's smooth tan cheeks.

Laura suddenly raised her face, and looked at Monica with loathing and disgust. Monica caught the grimace, again experienced a sense of unwarranted rebuke, and for the first time in her life knew what it was to feel abashed. What had she done so to alienate this girl? She felt hot and queer and self-conscious. Laura disliked her. Why? No one had ever disliked her, and now, for no reason, a stream of hatred seemed to be stealing through this room. Monica's bright head bent over the valentines. She wanted to run out of this horrid house and never, never set foot inside it again. But something restrained her. It was as though she had been caught in a high wind and could not find shelter. She shivered and, seeking consolation, moved closer to Tony, who sensed her uneasiness. He pressed his fat leg against her bare knee.

Monica painted energetically, her poise returning as the pressure against her knee assured her of Tony's sympathy. She pondered on ways and means of placating Laura. If she did something very nice for Laura, would the hatred diminish? Monica's mother often said that by agreeing with cross people, peace could be attained. That might work with Laura, Monica decided. Anyway, she would give it a trial.

"We will now have our tea," Laura announced primly.

"Whoever heard of us having tea?" Flip bellowed contemptuously.

Tony, unhappy and ashamed, blushed. He knew that Flip was mocking his mother and his sister, and he could not bear it—not today, anyway, with this new girl present. Tea! Tony knew that in some homes tea was honestly a meal to be enjoyed—a companionable balancing of pretty cups and nibbling of dainty sandwiches, accompanied by pleasant chitchat. But in this house even the mammas were not having tea. He knew that at that very moment the mammas were grouped about the dining-room table, consuming vast quantities of salmon salad and charlotte russe and drinking innumerable cups of coffee.

It was Mamma who so often remarked, "The children adore their nursery tea—bread and butter, and cocoa, and sponge cake," when none of the children did anything but abhor sponge cake and cocoa. Today's tea consisted, as usual, of bread and butter and sponge cake and cocoa. Cousin Evelyn put these edibles on the table, but it was Laura, as daughter of the house, who poured. She raised the tall, narrow chocolate pot airily in her small hands. She never slopped when she poured. Each cup received its exact portion of brown sweetness, and each child gravely nibbled bread and butter and sponge cake, and sipped cocoa, and refused second helpings.

Monica thought the party oddly unpleasant. She felt as if she were taking communion in church. She had difficulty in swallowing; everything seemed to want to stick in her throat. Finally she put the dry sponge cake on the edge of her saucer, and Laura began to tidy up the tea things.

Then the door opened widely, importantly, and the mammas appeared.

MARY BARNARD

Born and reared in Vancouver, Washington, Mary Barnard (1909–2001) dedicated her life to poetry. After graduating from Reed College in 1932, she began corresponding with Ezra Pound for advice and ventured to Boston and New York, where she met William Carlos Williams and Marianne Moore. Following four years as curator of the poetry collection at the Lockwood Memorial Library at the University of Buffalo, Barnard worked as a research assistant for literary critic Carl Van Doren. She eventually returned to Vancouver, having published several volumes of poems, including A Few Poems *(1950). In 1958, she published* Sappho: A New Translation, *which introduced the Greek poet to several generations of poets and remains in print today. In the 1970s, she began working with small Portland-based Breitenbush Publications, which subsequently released much of Barnard's most significant work, including* Collected Poems *(1979). Barnard received a special recognition for her work from the Oregon Institute of Literary Arts. In these excerpts from* Assault on Mount Helicon: A Literary Memoir *(1984), Barnard traces her parents' early years in Portland and looks back on her growing up in Vancouver, which "has had to struggle hard for the light, being in the shadow of Portland."*

From *Assault on Mount Helicon*

Two years to the day after my parents met, they were married in Walton, Kentucky. They settled down at once in a rented house in Greenfield, with their new furniture, and their friends around them. Less than six months later they sold their furniture, purchased one-way homesteaders' tickets, and boarded a train for Portland, Oregon, where they knew nobody. They had not so much as a letter of introduction.

My family seems always to have had its fair share of the restlessness that is part of the American inheritance. My mother's people began to arrive in Virginia in the 17th century and gradually pushed westward until by about 1800 most of them were already in Kentucky. My maternal grandparents had moved on to Florida as soon as they were married, and my mother was born there. My father's people came from North Carolina to Indiana in time for my grandfather to be born a Hoosier in 1835. Earlier the Barnards may have come to North Carolina from Nantucket, but I have never tried to trace that journey. Perhaps my parents inherited a certain restlessness, but they were given a push by my father's employer, who saw fit to reduce his salary as soon as he was safely married and settled down. They chose Portland because my father wanted to work in the lumber industry, and my mother wanted to "really go some place," as she said, "not just move over into Kansas." She had no immediate family to leave, and was ready to go to the end of the world with her husband, the farther away the better. The Lewis and Clark Exposition of 1905 had helped to make Middle Westerners aware of

Portland's possibilities, and may have influenced my father's choice of Portland as a destination rather than Seattle.

It was a bold move, and a rasher act than they realized it would be. As they traveled westward into the Rockies (the first mountains either of them had ever seen) the Panic of 1907 swept across the country. Banks were closing, money was short, and jobs were scarce. They arrived in Portland in November. My reader will not be surprised to learn that it was raining and continued to rain steadily. They were in one of the little rooms at the top of the old Portland Hotel, where my tall father was continually knocking his head against the sloping ceiling. Things must have looked bleak, but my parents were young and very much in love, and my father, besides, was an incurable optimist. He remained one to the end of his life.

At that time the Masons were a powerful organization, and my father was a Mason. He found that the head of the Masonic Order in Portland was Mr. Henry L. Pittock, who was among other things owner of the *Portland Oregonian* and a partner in the Pittock and Leadbetter Lumber Company. My father accordingly made an appointment to see Mr. Pittock, who recommended that he apply at the Pittock and Leadbetter mill in Vancouver, Washington, where there would soon be a vacancy in the office staff. He applied, was hired, and they moved across the river to a rooming house near Esther Short Park in Vancouver.

Greenfield, if it was not a cultural paradise, was at least a pleasant, quiet town with tree-shaded streets and substantial houses. Vancouver, in those years, was a frontier town. East of Main Street lay Vancouver Barracks, a venerable army post which had succeeded the Hudson's Bay Trading Post on the same site; and to the west, where a railroad bridge was being built across the Columbia, there stood at least one large sawmill. Main Street itself was planked. According to my mother's count there were thirteen blocks of paved sidewalk in Vancouver when they arrived, and thirty-three saloons. For her, the first months of 1908, while they were still in the rooming house, were sufficiently grim. She told me how she looked from her window one bright spring day and was astonished to see a number of women in pretty dresses emerge from a house across the street and cross the lawn to disappear into a house next door. She could not imagine where all those nice-looking women could have come from. Was it possible that they actually lived in Vancouver? But where? Later she learned that the party she had observed was an annual affair. Two ladies who lived next door to each other entertained their friends with luncheon at one house and a card party at the other. "And the *next* year," my mother said with satisfaction, "I was invited."

By that time they had moved into the house on 11th Street where I was born. Also, by that time she had a number of young women friends who called on her and each other, wearing, of course, hats and gloves, and carrying calling cards. Soon most of them were pushing prams. They took

china-painting lessons, did all kinds of needle work, and made clothes for themselves and their children. They did their own laundry without benefit of any electric appliances except, perhaps, an iron. They cleaned without vacuum cleaners. They canned and they cooked and they got up picnics for the children.

After I arrived my parents built the house on E Street that was to be their home for most of the next forty-five years. However, my father's work for Pittock and Leadbetter ended when the mill burned, and we made a temporary move to Buxton, Oregon, in 1914. My own memories really begin with Buxton. I was four and a half when we moved there. . . .

I have been putting off the difficult task of saying something succinct about the city where I was born, received most of my schooling, and now live. The subject seems a difficult one to take hold of, partly, I know, because Vancouver has changed so much over the years that it is hard for me to summon up the town I knew before I left it. If I had never returned, I could probably recall it more vividly. Another reason why I seem to be confronting an amorphous blob is that Vancouver, poor girl, like many of our young people, has had a hard time trying to find out who she is.

In the beginning there was no problem at all. Fort Vancouver was in her early days the only settlement in the Pacific Northwest, or the area that was ultimately divided into Oregon, Washington, Idaho, and British Columbia. Vancouver can proudly assert that she is the oldest *continuously occupied* settlement in the Northwest, but, alas, there is that awkward modifying phrase. Astoria was founded first by the Americans although the settlement was abandoned by the time the Hudson's Bay Company founded Fort Vancouver at a site on the Columbia already named by Lieutenant Broughton for his captain, Vancouver. The history of my Vancouver while it was the capital of the Northwest fur trade is fascinating. There is no disputing that, but for the last one hundred years or more its citizens have had to explain again and again and again until they are exhausted that they are *not* Canadians. Vancouver U.S.A. had the name first and is proud of it; every proposal to change the name of the city has been rejected at the polls; but our younger and more successful sister has left us only the echo of her name. That in itself is enough to create an identity problem.

To add to the difficulty, Vancouver has had to struggle hard for the light, being always in the shadow of Portland, another johnny-come-lately that overtook and outstripped her long ago. Nothing interesting has ever happened in or near Vancouver that Portland did not appropriate it. When the Russians flew their red monoplane over the North Pole and landed at Pearson Air Field in Vancouver Barracks, Pearson Air Field made a still more astonishing flight across the Columbia and became a part of Portland. Not that it mattered. If the dateline had read "Vancouver," everyone would have

thought that the Russians had landed in Canada. We are still waiting to see whether Portlanders will decide that a live volcano has enough news value to make it worth claiming, or whether they will decide it is a liability as a pollutor of the atmosphere and may as well remain in Washington.

To make matters worse, Portland is across the state line. Unable to vote in Oregon, but with concerns more closely tied in with Portland than with the Puget Sound area or Spokane and the Tri-Cities, Vancouver is in the frustrating position of being the stepchild of two states. This again makes for an underdeveloped and even slightly schizoid personality. We listen to Portland radio, watch Oregon TV, and read the *Oregonian;* even our letters are postmarked "Portland, Oregon"; but we are represented in the Senate by the Senator from Boeing. Seattle knows very well that our team is the Blazers, not the Sonics, and washes its hands of us.

Downtown Vancouver remained stunted long after it should have been a respectable small city. We shopped in Portland, went out to lunch or dinner in Portland, went to concerts or the theater or movies in Portland. We even went to Portland doctors and dentists (some people still do). Yet we were not a bedroom suburb, we were an industrial suburb. We had no class. A number of wealthy and/or socially prominent people have from time to time lived on our side of the Columbia, especially after Oregon began to collect a state income tax (Washington has only a sales tax). However, these people seldom mix with the Vancouver citizenry to give us a little tone.

To make matters worse, like many small cities across the state line from a large city, Vancouver has long served as the place Portland people go to for pleasures prohibited at home. For many years Vancouver was Oregon's Gretna Green, when Oregon's marriage laws were stricter than Washington's. Later, when Oregon prohibited the sale of liquor by the glass, Vancouver supplied a felt want. Now Vancouver is Portland's convenient "little Las Vegas" with its card rooms, pawn shops and quick loan establishments on lower Main Street. We are also, as I mentioned, a tax haven. If Portland thinks of us at all, it is only to deplore our proximity.

While Vancouver Barracks was an active army post, Vancouver had its share of the women who were known to the relief office as "Reserve Street widows." On the other hand, the officers and their wives usually kept to themselves or infiltrated Portland society. The one commanding officer who ever gave a sign that he knew Vancouver was there was General George C. Marshall. He even joined Kiwanis. A poll taken in Vancouver would probably rank General Marshall next after General Washington in the ranks of our military heroes.

For all these reasons it is difficult for me to describe Vancouver. I can tell you what it is not better than I can tell you what it is. In the Twenties about 15,000 people lived and worked there, practised law and medicine, went to church and school, and held political office. It was the county seat, and the

site of state schools for the deaf and the blind. It had a port where ocean-going vessels loaded grain and lumber.

Vancouver had, like Portland, its rows of Caroline Testout rosebushes by the curbs, and its residential streets lined with ricks of cordwood waiting for the woodsaw. Some time after school started, the whine of the woodsaw was heard as it moved from street to street. Ice was delivered to the back door in big blocks; a card in the window told the iceman what size block to leave. When we made lemonade, we chipped ice off the block with a pick. An Italian vegetable man also made the rounds with his truckload of garden produce. Grocery stores were small, mom-and-pop affairs; meat markets were separate establishments, and they both *delivered.*

What else should I say? I lived within easy walking distance of both my grammar school and the one high school. I always came home for lunch and so did my father. For years my grandmother lived with us, and as she became more difficult to care for we had live-in "help" to take part of the burden off my mother. Sometimes it was a girl, sometimes a middle-aged woman; whichever it was, she was usually straight off a farm and completely untrained. With one exception these girls or women ate with us, so that we usually sat down five to the table, three times a day.

When I entered Arnada school in Vancouver I had, according to the records, completed two and a half grades at Hillsboro, but I was placed with a class just beginning grade 3. The reason given was that Oregon schools were behind Washington schools. There was something that Oregon pupils did not begin to study until fourth grade, whereas Washington pupils began with the third. This was really nonsense. I could have gone straight into fourth grade with no trouble at all, but the principal at Arnada was opposed to skipping anybody, any time, and I continued with my class all the way through high school.

A friend of mine who was skipped two full years feels that in her case it was a disaster, not because she could not do the work, but because she was not mature enough to move into a social group whose members were her seniors by two years. Recently, I believe, stress has been laid on the social development of the child; if he can do his work in double-quick time, he is given extra projects to keep him from getting bored or spending his time day-dreaming over the illustrations in his geography and history books as I did.

In my case, however, I think the casual decision to put me back half a grade was a mistake. In the first place, I had not started school until I was almost seven, so that I was almost a year older than many of my classmates. Furthermore, I was always extremely tall for my age, so that I was at least a head taller than other children of the same age, and with my extra year I was head and shoulders taller than my classmates. This must be difficult for a boy, but for a girl it is murder. When I entered high school at age fourteen

(nearly fifteen) I was approximately the same height I am now, five feet, eight inches. During the last two years in high school my friends shot up, and by the time we graduated I could for the first time look them in the eye instead of stooping to hear what they were saying. Of course I stooped, not, I think, in a vain attempt to conceal my height as people always assume, but because I had never had a school desk high enough for me, or friends I could walk beside without stooping to talk with them. If I had been pushed ahead half a grade instead of being set back half a grade, I would still have been too tall, but not that much too tall.

At that time creative writing courses had hardly begun to appear in the college curriculum. Creative writing was not encouraged in high school, and was never even mentioned in grammar school. No one ever suggested that I write a poem or a story, but I was scribbling all the time. During recess I would find a spot on a bench in a corner of the basement and start a story (a book, even) in my pencil tablet. Before I had got very far a teacher on duty would spot me and drive me outside to play. None of the stories were ever finished, but I also wrote verses and these I finished.

All my verses could only be characterized as doggerel. I don't see anything wrong with that myself. I liked rhyme and a swinging rhythm. I was creating a pattern in sound rather than expressing my deeper emotions if I had any. I disagree wholeheartedly with an approach to creative writing for children that denies them rhyme and lilting rhythms on the grounds that if they read that kind of poetry they will turn out doggerel. A child of eight or ten is most unlikely to produce a great poem. He, or she, had better be developing an ear for the technical aspects of poetry writing. I have quarreled (mildly) with one of my friends on this issue, but another who has a little granddaughter now just beginning to write poetry, advises me not to worry. She says: "Children will find what they want, whether it is given to them or not." The child in question uses rhyme very skillfully in the poems she writes for her own pleasure, but never for poems assigned at school. "If you use rhyme, they think you're repressed," she says. Oh God!

When I was in seventh grade I made my first friend. Until then I had only playmates, children chosen by my mother or thrust upon me by proximity, with whom I played games, or house, or paper dolls, or whatever. My first friendship, in which I shared my love of reading with someone else who also loved reading, was a great joy to me. Week after week for years we went to the library together.

The library was a small red brick Carnegie Library with one room and one corner of the one room devoted to children's books. I suppose I must have read almost everything in that corner a number of times before I outgrew it, but besides library books, and a few books of my own, I had a fresh copy of *St. Nicholas* every month. At this time the magazine had a rather romantic cast, with many poems and serialized historical novels for young people. I

loved it, especially a series of rather long narrative poems about the knights of the Round Table. When I was sixteen, I lost interest. The format had changed; it published more stories of the here-and-now and less poetry. In any case, I had before this moved out of the children's section of the library to read at random in the adult fiction. I was in no danger of being corrupted by salacious literature. The few "daring" books of the time, like *Grand Hotel*, were on the closed shelf behind the librarian's desk.

While I was in the eighth grade my interest in poetry was stimulated by two books, the first a newly-published reader which included poems by modern poets like Noyes and Masefield instead of relying entirely on the standard fare that had made up every eighth grade reader since my father's day: Longfellow, Bryant, Whittier, Poe, a bit of Tennyson and Scott. The second stimulus came from a book I found one dark, rainy afternoon when I was poking about in a particularly gloomy and unpromising corner of the library, brooding over shelves that I had never explored before. Most of the titles were forbidding enough, but my eye lit on one that held my attention: *The Art of Versification*. I wondered what versification was. Could it be . . . ? I looked inside and saw scansion, found the lovely words "iamb," "trochee," "dactyl" for the first time. I carried the book home in a state of high excitement and showed it to my mother. To my amazement I found that she already knew about iambs and trochees. For once, I cried out at her in anger: "But why didn't you tell me?" Whereupon she said, "But dear, I thought you learned that kind of thing in school!" *She* had, but sometime between her schooldays and mine someone had decided that having to learn about scansion put children off poetry, and the scanning of verse had been dropped along with the parsing of sentences. Even in high school, metric was hardly mentioned, but by that time I had pretty well digested everything *The Art of Versification* had to tell me.

As for art and music, up to this time you could hardly say that they existed for me. I have spoken of going to concerts in Portland, but that came later. At this time radio was still a toy. Symphonic and opera broadcasts were yet to come. A few families I knew as a child had phonographs and a few scratchy Caruso records. I had been taking music lessons, but nobody ever gave me a bit of Bach or Mozart, only "Falling Leaves" and the like, the kind of thing I was sick of long before I had mastered it. My teachers, of course, never thought of stimulating my interest by telling me that I could learn something from music that might help me to write good poetry. They only suggested that it would be most impressive if I were to become proficient in *two* arts. My interest flagged, and the lessons ceased when I entered high school.

Art was to become one of my major interests, but almost my only experience of it at this time came through full-page color reproductions in *The Ladies Home Journal*. The Caruso records were far and away better than the pictures people hung in their homes, and ours was no exception. There were

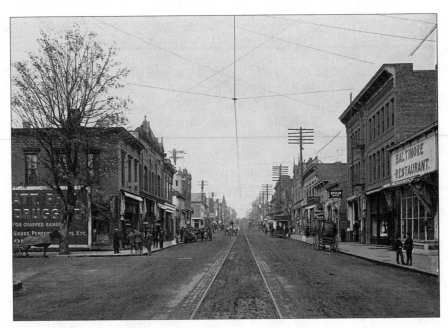

Downtown Vancouver, Washington, in about 1900

no reproductions of art works in our schools or our library, unless, possibly, "Washington Crossing the Delaware." It was fortunate for me that my talents lay in the literary line. Books were much more accessible to me than art or music.

Before I continue, let me emphasize that I thought myself a lucky child, and I was, compared with most of the children I knew—perhaps even compared to the young Henry James who looked back ruefully upon his youth as a "hotel child" being dragged through the capitals of Europe or parked temporarily in French and Swiss schools. He had cultural advantages, but I had other kinds of good fortune.

In the first place I had affection in abundance. My great-grandmother, who had the care of my mother after her parents died, considered that a display of affection denoted a weakness of character. She was a great hand with the peach tree switch. My mother realized only after she was grown that her grandmother had actually loved her—in her own way—and she was determined I should never be in doubt that I was loved. Both my parents were demonstrative with me and with each other. This was before the psychologists had hung out red flags warning parents of the possible danger to the young psyche inherent in too much loving. My mother, anyway, was aware from her own experience of the opposite danger. At the same time, neither of

them let me think for a moment that I came first with either of them. I was central in their combined regard, but they came first with each other. This relieved me of the terrible burden placed on only children by a parent (usually a mother) who puts the child first and the spouse second.

To continue, then, I had affection, family stability, and financial security. I had a better house to live in and better clothes to wear than most children in my school, some of whom were always in hand-me-downs. Not only that, I had traveled. By the time I entered high school I had been three times to the Midwest, and once to California. I had been several times to Vancouver Island, where we had relatives. I had been to Denver and Salt Lake City, and had crossed the Rockies on Canadian Pacific. I was at home in Pullman cars, upper and lower berths, dining cars, and hotels. Few children of my acquaintance could say as much.

Besides all this, I had Ocean Park and the excursions to the mills. It would never have occurred to me to be sorry for myself. For my time and place, a small town in Washington State in the Twenties, I was doing very well. I might have been worse off with teachers who, in encouraging my talent for writing, might have tried to shape the plant instead of just letting it grow. However, with this wave of nostalgia for the simple life of our ancestors sweeping over us, I think it is well to point out that if we had a better natural environment in those days (and in the days of my parents and grandparents) there were many desirable things that we lacked, things which increasing population and better technology have brought within reach. There are worse things in life than pumps and privies and a childhood devoid of books, even, as my grandmother's was; but when we cry out for the past and the simple life, we should remember what that life was like. . . .

I considered majoring in journalism. The University of Washington was said to have a good school of journalism, and I thought I might go there. However, even on the playground at Arnada, I had been taunted with the cry of "Oh, *you'll* go to Reed!" It was probably my destiny, and in spite of a natural desire to prove the prophets wrong, I did go to Reed.

Although Reed College was only seventeen years old, it already had its detractors, especially in the Portland area. It was looked upon by the young as a school for dreary drudges because there were no Greek-letter fraternities and sororities and no intercollegiate sports. (This was the era of the raccoon coat and the hip flask—the F. Scott Fitzgerald period in American higher education.) Parents, on the other hand, viewed Reed as extremely dangerous. It condoned immorality, for one thing, because women students were allowed to smoke anywhere on campus (some sorority houses at this time had a "smoking room," but for the most part girls were expected to smoke on fire escapes). Also, the Reed dormitories were unsupervised by house mothers. And then of course the Reed faculty was considered dangerously

radical. And to cap it all, the college was non-denominational. There was no compulsory chapel attendance, in fact, no religious services were held in the chapel, only concerts and lectures. Despite the staid gravity of President Coleman, a former clergyman, the rumor persisted that the principal subjects taught at Reed were "atheism, communism, and free love."

I was not frightened off by the reputation of Reed as a deadly place where no one had any fun, because two of my favorite teachers were lively, pretty, attractively dressed young women, full of fun, and right out of Reed. My parents were not frightened by rumors of Reed's radicalism and loose morals because they had common sense. But what really clinched the decision was a week-end spent as a visitor in a University of Washington sorority house. This was college? There was no privacy, no place to study. There seemed to be no books, no desks, nothing but a great flying about in dressing gowns, pealing telephones, and a general hurly-burly. By contrast, on a one-day visit to Reed I found dormitories with bedrooms *and* studies, the studies having proper desks, the desks loaded with books. I liked the small, quiet campus and the small student body, which was then about 450 (compared with 10,000 at the University of Washington). I attended one of Barry Cerf's Renaissance literature classes, and was in seventh heaven. There was no decision left to be made. I would go to Reed for two years at least if Reed would have me. My parents approved. They no doubt liked the idea of my being no more than fifteen miles away, though they put no pressure on me one way or the other. Reed, then as now, was expensive. Tuition was two hundred dollars a year compared with fifteen dollars a quarter at the state university. However, I had no qualms about that, and I doubt that my parents had any, though the lumber business in the fall of 1928 was already slipping off. Nobody, of course, had an inkling of the economic disaster waiting in the wings.

BEVERLY CLEARY

Beverly Atlee Bunn Cleary (1916–) was born in McMinnville, Oregon, and spent her early years on a farm near Yamhill. Her family moved to Portland, where she attended Fernwood and Gregory Heights elementary schools and Grant High School. She studied librarianship at the University of Washington before marrying Clarence Cleary in 1940, and worked as a children's librarian in Yakima, Washington. The author of over thirty books, her first, Henry Huggins, *was published in 1950. Perhaps Portland's most beloved author, Cleary is well known for her stories about Romana the Pest, about a young girl who lives in a Portland-like eastside neighborhood. This selection from Cleary's autobiography,* A Girl from Yamhill: A Memoir *(1988), describes her upbringing during the Great Depression.*

High School Freshmen

"Well, well, so you girls are going to be frosh," a neighbor said to Claudine and me when school was about to start. We exchanged knowing, amused looks. What an old-fashioned word, "frosh"! We were freshmen.

Having grown both up and out, I was now medium-sized, but my clothes were not. Everything I owned, except the sunburst pleated skirt, which Mother had insisted I buy to grow into, was either too short or too tight.

A neighbor gave Mother an old pink woolen dress, which she successfully made over into a jumper for me. She contrived a cream-colored blouse from something found in a trunk in the attic. One of her friends, now married to an eastern Oregon wheat rancher, had a daughter older than I who passed on two nice dresses. In our neighborhood, no girl would dream of entering high school in half socks. I used hoarded nickels and dimes to buy silk stockings. Five dollars from my Arizona uncle bought a raincoat.

Claudine was more fortunate. Mrs. Klum solved her wardrobe problem by buying her three knit dresses, at five dollars apiece. Three new dresses, not hand-me-downs, and all at one time; the Miles girls, passing their clothes to one another, and I were awed by such luxury. We began admiring one another's clothes by saying, "Is it new, or new to you?"

Then the Depression came to Claudine's house, for Mr. Klum, a steam fitter, lost his job when construction came to a halt. A family friend offered him a job as a night watchman at a pharmaceutical company at a small salary he was not too proud to accept. My father had no close friends, only acquaintances.

And so, the day after Labor Day, when smoke from forest fires dimmed the atmosphere, the sun was a sullen orange ball, and ash drifted over the

city, Claudine and I walked on our silken legs up the steps of Ulysses S. Grant High School, where we both were enrolled in a college preparatory course—with no possibility of college. "Things will get better in four years," Mother said with her usual determination. "They have to."

As we entered the building, Claudine and I tried to pretend our insecurity was invisible. Everyone else looked so confident, mature, and sophisticated. Girls wore lipstick. Some even pinned up their long hair. Boys in long, dirty, cream-colored corduroy pants with ink lines doodled between the ridges of the fabric seemed worldly because they had resisted their mothers and washing machines.

The horrible boys from the eighth grade suddenly looked subdued and self-conscious in their new, clean corduroy pants. Some, poor things, still wore knickers and probably suffered as much as girls who wore lisle instead of silk stockings.

Grant High School, Claudine and I soon discovered, was not the friendly, tolerant place that Fernwood had been. Grant was snobbish and full of cliques. Sororities and fraternities with silly initiation rites dominated the social life. Girls were admired for being cute, peppy, and well-to-do, and, most of all, for driving cars. Popularity required energy I lacked. All I wanted was a few good friends. Claudine was occupied with her music.

Grant High School arranged everything possible in alphabetical order. Claudine and I went in different directions to find our registration rooms, which we quickly learned to refer to as our "reg rooms." I was filed with students whose last names began with *A* or *B*, while Claudine took her place with *J* and *K*. Since the boy alphabetized in front of me and I were enrolled in many of the same classes, I went through four years of high school staring at the back of his neck, which I came to know very well. It was a slender, sensitive neck that supported an intelligent head of softly curling brown hair. I grew fond of that neck and of the boy it belonged to.

Life was better at school than at home. Grant High had excellent teachers—well-informed, efficient, strict, and caring—although I had some doubts about a couple of coaches who taught history and seemed to have a prejudice against girls. Except for English, I worked just hard enough to keep Mother from nagging; but on the whole, I enjoyed school, but not physical education, taught by a woman who wore blue rompers and long cotton stockings. I never succeeded in learning to climb a rope, and thought volleyball was tiresome. When trapped into playing basketball, I made my own rule: always run away from the ball. No one ever complained, or, as far as I know, noticed.

In freshman English, tiny Miss Hart led us through *Treasure Island,* which pleased the boys. The book bored me. This was followed by *As You Like It* and *Silas Marner.* We also waded into a compact little green book, *The Century Handbook of Writing,* by Garland Greever and Easley Jones, a valuable

book that was to accompany us for four years. Completeness of thought, unity of thought, emphasis, grammar, diction, spelling, "manuscript, etc.," and punctuation—we went over it all every year.

Claudine and I, who were inclined to giggle at almost anything, found *The Century Handbook* entertaining. We often quoted examples. If I said, "Phone me this evening," she replied, " 'Phone. A contraction not employed in formal writing. Say *telephone*.' "

After a test, one of us quoted, " 'If I pass (and I may),' said Hazel, 'let's celebrate.' " This, from a rule on the use of quotation marks, was worth a fit of giggles.

Mother insisted on coaching me in Latin, the foundation of the English language, she kept telling me. I liked the sound of Latin and danced around chanting, *"Amo, amas, amat,"* but Mother could not understand my listless attitude toward declensions and ablative absolutes. Mother loved Latin, truly loved it, and coaching me took her mind off her troubles. She also kept an eye on my algebra and wanted to study along with me. I flatly refused her company. If there is one thing a fourteen-year-old girl does not want, it is her mother studying algebra with her.

We also studied poetry and discovered Carl Sandburg, so different from Kipling and his moralizing "If" and the nineteenth-century poets we had studied in grammar school. No rhymes, and it was still poetry. What a relief! We were required to write a poem, and after reading "Chicago," the class was inspired to rousers such as

> *Portland.*
> *Shipper of wheat,*
> *Grower of roses.*

or

> *Oregon.*
> *Feller of trees,*
> *Catcher of salmon.*

We also memorized one hundred lines of poetry of our own choice, a requirement for each year of high school.

For an assignment in original writing, I wrote a little story, "The Diary of a Tree-Sitter," following Mother's advice, "Make it funny," and "Always remember, the best writing is simple writing." Sitting in trees, on houses, or atop poles to set records was popular at the time. My story was based on an incident in the *Journal* and had the advantage of not having to be concerned with spelling. When the paper was returned, Miss Hart had written, "E+. This is very funny. I hope it is original. You show talent." I was ecstatic.

The inspiration for my next story, "The Green Christmas," was a newspaper account of a boy who fell into a river below a dye works that dumped

green dye into the water. In my story, being dyed green saved the boy from playing the part of an angel in a Christmas program at church. To my surprise, Miss Burns, the chairman of the English Department, called me out of class to ask where I got the idea for the story. Puzzled, I explained the source of each part. She told me she had wanted to make sure the story was original. I was a little hurt that she could think it might not be original.

"The Green Christmas" was published in the *Grantonian,* the school paper, but another girl's name was given as the author. I did not hesitate to point out, in indignation, the error. A correction appeared in the next issue, but somehow that small boxed paragraph was not the same as seeing my name on my own story, a story which, much altered, became a chapter in my first book.

The recognition I was winning at school helped balance the unhappiness at home. My father still had not found work. Money from the sale of the car was running low. The house was always cold, as wood and coal were fed sparingly into the furnace to try to make it last through the winter.

Then one day, Meier & Frank's green delivery truck pulled up in front of our house. The driver handed my surprised mother a package with her name on it. "What on earth . . ." she puzzled as she tore off the wrapping. The package contained a ham sent by my father's sister Minnie. Mother smiled, it seemed to me, for the first time in days. "Minnie always knows just what to do," she said, and Aunt Minnie always did know. She was that kind of aunt.

We ate ham baked, fried, ground, made into a loaf with plenty of bread crumbs, scalloped with potatoes; and when we were finally down to split-pea soup made with the bone, Dad came home smiling. In the darkest Depression, he had actually found work managing the safe-deposit vault at the Bank of California. The vault, with its heavy steel door and time lock, was located in the basement. It was a sad place for a man who had spent so much of his life working outdoors in the Willamette Valley. But the job brought home a paycheck. smaller than he had earned before, but one that put food on the table, made mortgage payments, and paid taxes. We were luckier than many. Dad whistled to a livelier beat and ordered a few more sacks of coal.

Wise Fools

All of Portland felt blue that year. Businesses failed, banks closed their doors to prevent runs, and more weary gray men selling shoelaces or seeking work, any work, rang our doorbell. Mother managed money very, very carefully, but she did buy a bottle of vanilla extract to give us relief from almond flavoring.

Mother and I continued to argue. I needed new school shoes and insisted on brogues like those other girls wore. Nobody wore Buster Brown oxfords

or galoshes in high school. Mother stiffened my determination by poking fun at any girl wearing brogues who walked past our house. "Beverly, just come and see how silly that girl looks."

Finally Mother had to admit that thick soles would wear well and keep my feet dry. I got the brogues, wing-tipped, with soles half an inch thick and a fringed tongue that buckled over the laces. I clumped through the next three years of high school in them. Dad polished them for me every Sunday evening.

Claudine and I felt very sophisticated in our brogues as we plodded off to our sophomore year. Nervous freshmen looked immature as they huddled in groups, the chalk dust of grammar schools seeming to cling to them. Boys our age had grown, and their corduroy pants, guarded from their mothers' washing machines, were fashionably dirty. Seniors were less forbidding than they had been a year ago. Our teachers reminded us that the word *sophomore* came from the Greek and meant "wise fool."

Mother was exasperated when I signed up for a course in freehand drawing in addition to English, Latin, mathematics, and biology. I took the course over her objections, but I did not learn to draw, even though the teacher gave me an E, perhaps for properly sharpening a set of pencils for drawing. The teacher was keen on pencil drawing.

Biology showed me with fresh eyes the world of nature around me; and even though we dissected night crawlers with their five pairs of beating hearts, biology was one of my favorite high school subjects. Geometry to me was more interesting than algebra. Mother could not understand my lackluster attitude toward Caesar, his cohorts, and his legions.

The second semester, I decided to take typewriting, which Mother did not consider frivolous because I was going to be a writer. Before the class was allowed to touch typewriters, we memorized the keyboard letters by pounding away on their arrangement printed on heavy paper. When we finally got to real typewriters, which had blank keys, the room was so noisy I understood why the class was hidden away in a corner of the basement. Speed and accuracy were the goals, but for me all the nervous clattering of typewriters and pressure to hit the right keys faster was so exhausting I just managed to squeak through the semester with a grade of G for Good. I could not face the second semester, so I still have to peek to type numbers. Today, when I am asked the most difficult part of writing, I answer "typing," which is taken as a joke. It is not. There is nothing funny about typewriting.

Claudine and I studied *The Century Handbook of Writing,* giggling all the way. Examples seemed even funnier. When we came to Rule 68, "Avoid faulty diction," we studied the examples: "*Nowhere near.* Vulgar for *not nearly.*" "*This here.* Do not use for *this.*" "*Suspicion.* A noun. Never to be used as a verb." Our conversation became sprinkled with gleeful vulgarisms we had never used before. When I announced my presence by noisily tap-dancing on the

Beverly Cleary in 1954

Klums' wooden porch and probably annoying all the neighbors on the block, Claudine said she was nowhere near ready for school.

"I suspicioned you weren't."

Claudine's reply was something like, "This here shoelace broke."

We thought our dialogue hilarious. Mrs. Klum sighed as she looked up from *Science and Health* and said with a smile, "Oh, you silly little girls."

The best part of English that year was the study of the short story, but when the time came to actually write a story, my mind was a blank. The hardest part was having to hand in an outline of a story first. "Make it funny," advised Mother as usual. I sighed, bit my hangnails, crumpled paper, and when the final day came, turned in an outline of a feeble tale of mistaken identity involving cats instead of people. The outline was returned marked F for Fair, a grade I was unused to receiving. Still, I could not think of anything better. In despair, I wrote the silly story. It was returned with an E-, which I did not think it deserved.

My standards were higher than those of the teacher. To this day, I cannot

outline fiction. I find that an outline limits the flights of imagination which are the joy of writing. I write and then rewrite, bringing order to the second draft.

In my sophomore year, students with G averages were permitted to join clubs. Claudine, who had escaped Latin because her mother did not care which language she studied, joined the Spanish Club, the Dondelenguas. I chose the Masque and Dagger, a dramatic club that put on a silly play in which I was cast in the role of a debutante. I also joined the Migwan, a literary club whose name we were told was a Dakota Indian word meaning "written thought." I had trouble producing any extracurricular written thought for the meetings, at which we were expected to criticize one another's work. Criticism usually degenerated into an awkward pause until someone ventured, "I think it is very good." I cannot recall a single thing I wrote for Migwan meetings, even though I was a member for three years and served as secretary and president.

Clubs were not our only fun. Claudine and I went by chartered streetcar to high school football games in the Multnomah Stadium, where we yelled for Grant's team as it slithered around in the rain and mud. We walked to the high school gym to cheer the basketball team. We continued to read, study, and listen to the radio, especially "One Man's Family" on Sunday evenings. Claudine, when her parents were out, practiced Gershwin's "Rhapsody in Blue," which she borrowed from the library, instead of "Marche Slav," by Tchaikovsky.

Mother's objections to my spending so much time at Claudine's house grew bitter. "All you girls do is get together and criticize your parents," she complained unfairly. Claudine wasn't critical of her parents. And I was too thoroughly schooled in keeping up a front for the benefit of neighbors to admit any unhappiness at home, even to my closest friend. We had begun to talk about boys—what a boy had said to us by our locker, which was the handsomest, who were the biggest twerps—even though we did not really expect to get to know them outside of school.

One rainy night during Christmas vacation, Claudine and I went with her mother to help deliver Christmas decorations to the Masonic Lodge. Music from a Demolay dance floated down the staircase. While Mrs. Klum arranged her fir boughs downstairs, Claudine and I slipped upstairs into the hall to watch the college-age dancers, like little girls watching a party.

As we sat whispering, a young man in a tuxedo appeared before me, bowed, and asked, "May I have this dance?"

Me? A girl in a woolen school dress and brogues? Claudine poked me. Hypnotized, I rose as the music began and stepped into his arms, terrified. I had never been so close to a boy before. I did not know how to dance. My tongue seemed to fill all the space in my mouth not taken up by bands and wires. As we circled past Claudine, I dared not look at her. I longed for the

music to stop, to let me out of this young man's arms, to let me take my icy, sweating hands from his, and let me escape. A boy who smelled so nice did not deserve to have his shoes wrecked.

The music did stop, finally. I gave my partner what was meant to be a smile and left him in the middle of the floor. I grabbed Claudine by the hand and fled the hall. She whispered, "What was it like?"

"Terrible," I said, "but he smelled awfully nice." I was struck by a revelation. "He *shaves*." Claudine and I went into fits of giggles.

"Oh, you silly little girls," remarked Mrs. Klum.

When I returned home, still laughing, I described my evening to my parents. Mother laughed, too, and Dad chuckled. He rarely laughed, but he had a delightful chuckle.

After that, Mother found the money to enroll me in Mr. Kofeldt's ballroom dancing class at the Irvington Club. She took me overtown to buy me some black pumps with heels and, being a practical woman, made me a red dress sure to be noticed in a crowd. No daughter of hers was going to be a wallflower.

I teetered around the living room in high heels, and on Friday evening I put on my new red dress. Mother and I took the bus to the Irvington Club, where she sat on a bench with another mother or two to watch the class.

The boys, a glum bunch, were neatly dressed in dark suits. They all wore white cotton gloves to prevent their sweaty hands from soiling the girls' dresses. The girls, most of them in dark dresses and praying for tall partners, stood on one side of the room while the boys, praying for short girls, advanced in a horde and made their selections.

Mr. Kofeldt explained the waltz square, which was then demonstrated by his assistants, Mr. Muckler and Miss — (what girl can remember the name of a female dancing assistant, no matter how graceful?). The pianist played "Whispering." Whenever I hear that old tune, I have an almost irresistible urge to rise and go through the waltz square.

If a couple stumbled through the steps or could not keep time to "Whispering," Mr. Kofeldt was beside them, clicking his castanets and telling them not to watch their feet. I learned that the best way to spare the unhappy, dogged boys misery and Mr. Kofeldt's castanets was to lead *them* from my position. For years afterward, dancing partners embarrassed me by asking, "Who's leading, anyway?"

Because 1932 was leap year, Grant High School was giving a leap year dance in the gym. Girls were expected to invite boys, something I had no thought of doing. Although I was being taught, more or less, to dance, the idea of actually going to a dance was so daunting it was not to be considered. School dances were for other people.

Then one day the boy with the sensitive neck turned around to face me. "Why don't you ask me to go to the dance?" he said.

He must be joking. Why else would he say such a thing to me?

He continued to look expectant. I very much wanted to ask him, but I could think of more reasons for not inviting him. How would I get him there? We had no car. I would stumble all over his toes and take over the leading. He wouldn't have a good time, and I would still have to sit behind him while he was thinking of the terrible time he had had at the leap year dance.

I did not know how to answer, so I simply smiled, shook my head, and pretended to be looking for something in my notebook. He turned around, leaving me bemused. Was he teasing? Was he trying to be funny? Could he possibly have meant what he said?

As Friday nights at the Irvington Club passed, I began to resent the presence of mothers on the sidelines, smiling and whispering behind their hands. Why couldn't I go alone? Because I could not go out alone at night and travel by bus. On the ride home, Mother enjoyed talking over the evening—which boy danced with which girl, who was disappointed, how girls had learned to run past short boys when partners were chosen by the grand-right-and-left, which girl needed a more becoming dress or something done about her hair.

One evening a young man older than the high school boys appeared in the class. He was blond, nice-looking, slender but muscular. Sometime during the evening I found myself plodding through a waltz with him. Neither of us spoke.

Later, when Mother and I were waiting for the bus, the young man offered us a ride home in his Model A Ford coupe with a rumble seat. Mother accepted for us. I felt strange sitting beside a young man and uncomfortable trying to keep my knees away from the gearshift.

Mother was delighted.

Love and the Spelling Bee

I began to see Gerhart more and more as a way of getting away from Mother. On warm summer evenings we drove to the airport on Swan Island in the Willamette River, which Charles Lindbergh had inspected and pronounced a poor location for an airport. It was a popular spot for waiting to see the ten o'clock mail plane arrive from California. We searched the stars for its lights and, when we found them, followed their descent to the runway and watched the small brave plane that had flown all the way from California taxi to the little terminal. Then Gerhart drove me home.

One day, Mother said, smiling, "You know, Daddy doesn't like Gerhart. I think he's jealous." That my father should be jealous of Gerhart seemed so ridiculous I paid no attention. Mother must be imagining things. However, when Dad bought a radio of our own so Gerhart could take his away, I won-

dered if he hoped Gerhart would have one less excuse for spending so much time at our house. Perhaps Dad wanted more privacy, I thought.

One day, Gerhart suggested a picnic at the beach. Mother agreed I could go, provided she went along as a chaperone.

"What for?" I asked impatiently. "We don't need to be chaperoned." Hand-holding, a few kisses, mild embraces—that was as far as I ever intended to go. That was the way it was in the movies, and I had no knowledge of what might come later.

Mother ignored me. She set about making a huge bowl of potato salad and suit box full of sandwiches. "People get hungry at the beach," she said.

We set off for a day, with Mother and myself beside Gerhart, and in the rumble seat a wind-tousled, sunburned couple, friends of Gerhart. We often took his friends on outings; my friends were never included.

When Gerhart parked his car among the salal bushes and we carried blankets and the picnic lunch down to the sand and were racing around on the beach, Mother called me back and gave me the only advice or information on sex she ever gave me. "Never play leapfrog with boys," she said. "They might look up."

CLYDE RICE

Born in Portland, Clyde Rice (1903–1997) published his first book in 1984, when he was eighty-one years old. A Heaven in the Eye, *which won the Western States Book Award for Creative Nonfiction, is a memoir of Rice's life in Oregon and Northern California between 1918 and 1934. In 1987, Rice published the short novel* Night Freight *about hopping trains through the Siskiyou Mountains. In 1990, he published* Nordi's Gift, *which tells the story of Rice settling his family along the Clackamas River. Rice was honored in 1992 with the Charles Erskine Scott Wood Retrospective Award in recognition of his distinguished career in Oregon letters. After Rice's death, the Friends of Clyde Rice was formed to promote his literary legacy and maintain a writers' retreat on Rice's farm along the Clackamas River. In this excerpt from* Nordi's Gift, *Rice recounts moving his family to a house on Interstate Avenue in Portland.*

From *Nordi's Gift*

Finally, out on Southeast Belmont, we found a building with a great deal of plaster fallen from the walls and ceiling because of a leaky roof. We put on a new roof and I taught myself to plaster and was able to repair the building. It had two other occupants—a shoe repair shop and a small neighborhood grocery.

Eventually, winter could no longer produce the sterner stuff. Spring came. Pop's efforts in wholesale extracts began to payoff. We still had a lot of grocery trade, but it was the twenty- and fifty-gallon barrels going out that really helped. Then we started selling pure vanilla in small three-gallon oak kegs with a plum-wood spigot. I coated the kegs with heavy dark varnish. They went over big. Each customer owned his own keg and was proud of it. From a bottle, vanilla was a flavor, but from his own rich looking little keg, it was a gift from the gods—an elixir. This helped us out of the doldrums. That year we did very well. With the rearrangements that I had made we were much more efficient, though it seemed that Pop and the Little Lady hated every improvement and, when it worked, accepted it with reservations that lasted for years. The increased wages we were to receive if the company prospered came niggardly when they did come, but now we were tied to Acme Flavoring Company. How, I still don't understand, but we were. It seemed to have a future for us. I was given to understand that I would run the business with the Little Lady taking care of the books and that he would soon retire. He was sixty-two and on crutches.

About this time, too, we had to leave the Mount Scott place, since the owners planned to do some remodeling to the house. Our next move was to a house on Interstate Avenue in Portland. It was a noisome place—bordering a main thoroughfare—and too close to the city for me, but it gave Nordi a chance to be closer to the Nordstroms. We had no garden now, and she would often walk over to her mother's house at dusk. Olga and Jack lived with her, and there were always friends in and eternal coffee klatches with gossip dear to Nordi's heart.

As for me, it was here on Interstate Avenue that whatever talents I had reached their peak. Now in the evening I had time to do whatever I wanted. I remembered the psychiatrist Kisdork's dictum: "Let your mind range in fields you've educated it in. Get a job. Write out your problems in poetry. Use your mind to its utmost. You've been short-changing it for years." And what my mother said to me as she lay dying: "Cut a broad swath, my dear."

These phrases had been imprinted indelibly in my mind. Now I was in a position to respond to their clarion calls. I responded quite timidly, I admit. Neither my materials nor my mind were equipped to make heroic responses to these urgings, but rather to make muted echoes of them.

I made my son a carpenter's bench with two vices and sufficient drawers and a heavy broad top on which to manfully smite wood. He was enthusiastic and very pleased with it, fiddling around on it with a carving set Nordi had given him, but really my son at that early age proved he was not a smiter of wood. He preferred things with moving parts—engines, if you will—so I used his bench and some wood, rather deftly if I do say so. But broad swath? Not by this midget.

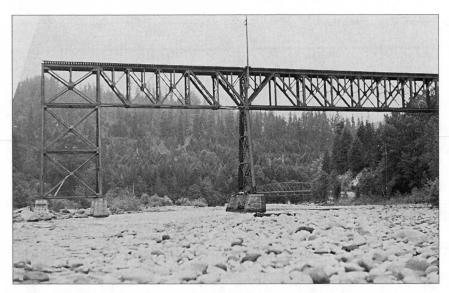

Dodge Park on the Sandy River in Troutdale, 1935

We had heard of some flat crocks—bedwarmers they were, squat and nicely glazed that one filled with boiling water, corked and slipped between the sheets. They warmed the bed much longer than hot water bottles and certainly were more pleasing than hot bricks. Passing the kilns one afternoon I drove in and bought two for one dollar and asked for and was presented with some of the clay that they used in their wares.

At home several days later I began making a lounging figure of one of the pigs that we had raised, fondled, and eaten, and I got Nordi to pose for a seated figure to be a bookend. We were happy with the result and made a gelatin mold from it that came out badly. I wanted to do a rubber mold of the original, but Bunky, thinking I was through with the clay, worked it all up into a birdbath, well-designed, but too big to bake in the oven. The bookends from the gelatin mold were certainly second rate, but they got me planning to do more modeling with clay.

Also, I was up to making some intricately carved picture frames that I covered most carefully with gold leaf. They dignified three pictures that Nordi had painted while in California. Goldleafing over intricate surfaces for a guy who had never been particularly dexterous presented a problem, but when the frames were done Nordi was delighted; and where there was a gold leaf mistake I found that you could cover it with another gold leaf without the sense of impasto. Broad swath! Sweet mother! I hope you can now see that I'm not up to it.

Nordi and I had avoided our old art school friends when we came back to Portland. Our clothing was wretched. We couldn't ask anyone to have dinner with us, for we needed whatever food we had to sustain us. When Catherine hunted us up and helped us so marvelously, we found we had to be cool to her overtures for a deeper friendship, for we couldn't repay in kind. We hadn't yet found our friend, Heaney, so we were in a position where relatives from whom we couldn't hide our condition were our only social outlets; but my father and his wife were a couple of sticks. Their life was from nine to five, then they went home and hibernated. She cooked, they ate, he even watered the lawn, but they did these things as if they were operating on twelve heartbeats a minute; so to bed. In the morning he bathed, climbed into his suit, tied his tie, buttoned his vest, shook himself. His eyes brightened as he became once more J. M. Rice. They left the baby daughter with the Little Lady's mother and headed for Acme Flavoring Company and life.

They had two sets of friends who sometimes called on them in the evening. These people fitted perfectly into a framework that I have just described. The women, Lillian and Thelma, were people with whom the Little Lady had worked before she had come to Acme. Their husbands were singularly dull, not even enlivened by a religious mania, political interest or sexual quirk. We could not fit in with their friends. When we were alone with Pop and the Little Lady one evening, they beset us with arguments about why we should become Christian Scientists, which, by the way, killed my mother and would kill my father and my two sisters, each with a different form of extreme medical neglect. We saw my parent and his lady eight hours a day—that was more than enough—so we followed Nordi's desires and flitted on the outskirts of Mrs. Nordstrom's tight little clan. We did this of necessity, for whether one likes it or not, man is a social animal. Still, for my wife and me, even semi-compatible members of the race were hard to come by.

As I've mentioned, the Nordstrom clan insisted on calling Nordi "Evelyn." I had named her Nordi way before we were married. Couldn't they see that for years she'd been queen of Waterspout Point and was a dead shot, and that, when in our small open boat we were caught in a sudden storm out in the Golden Gate, she faced it with a grin that the cut of storm-driven spindrift could not erase? She was my well-rounded lovely, my own little Pee-ang, but she was becoming in time among these Swedes that resurrected creature of the adenoidal past, Evelyn. She bore up under it with equanimity, while I, who had made her a thousand lovely names, hated the damned name Evelyn and felt I'd been foully treated. This Evelyn stuff could be legal all right, but there's something to *fait accompli*. They were taking her back as an Evelyn, not adding to but making a hole in that marvelous accumulation, Nordi.

One day I felt sullen about this—and I mean sullen—and I left them to get drunk. Having accomplished that, I drove over to my father's house and found them unexpectedly gone. What I did next I know only from the

accounts of the neighbors, who were happy to inform my father of his son's drunken behavior. Apparently, I worked the screws and hinges loose from the basement window, got in and opened up the house and came out, took all the lawn furniture to pieces, wrapped it up in bundles, put it down the basement window, stored it, locked up the house and drove away. A half an hour later I came back, worked the screws out of the basement window, brought up all the lawn furniture, put it together just as it had been, locked up the basement window and drove away again. I know of no relationship between the word *Evelyn* and my father's lawn furniture, but there must be one, for after that I was able to accept the name without shuddering.

After several weekends on Milk Creek, Mrs. Nordstrom and Olga, who was her mother's lieutenant, decided that the family should camp at Dodge Park on the Sandy River. The plan was that, while the women stayed at the Park, we men would go back and forth in one car to our various city jobs. After a sweaty day in town we would return to a cool swim in the river and with ravenous appetites consume the smoke-flavored dinner cooked over the campfire, then an evening around the fire and so to our tents.

There were two pools in the Sandy River at Dodge Park. The lower one was more constricted and deeper than the other. We preferred it. On the day that it was my turn to provide transportation, I hid two gallons of concentrated red food color that had developed mildew in the bottles' necks. We were going to throw it out, but I took them secretly to Dodge Park. Hurrying before the others, I ran down and dumped the red dye in our favorite pool, then stirred it up by swimming around and splashing until the pool was a bloody-looking mess. I waited for the family to come over to the ballgrounds toward the bank of the pool. I spied on them and when they were about to look down into the pool, I dove under and stayed down as long as I could, then came to the surface yelling: "Help me, help me! Help me get him out. Man's been bitten by an enraged salmon."

They all rushed in to do what they could for the poor fellow—that is, for the half a minute before they realized the absurdity of it and ran me out of the pool and up the road.

Today if you were to dye a pool of a tumbling river scarlet, you'd be in trouble with the environmentalists. Most people leave such mischievous stunts in childhood, but I am certain I will carry the tendency to my grave. It is more than that. My great joy is to get a group of people or a single individual so prepared by shock or months of instruction that for a moment they are completely confused and accept an absurdity as truth.

TOM MCALLISTER
AND DAVID B. MARSHALL

A Portland native and graduate of Oregon State University, Tom McAllister (1926–) was the Oregonian's *outdoor editor for forty years, reporting on wildlife, fishing, and outdoor recreation. He has written on a variety of Oregon historical topics, including the earliest explorations of the Pacific Northwest, especially the Lewis and Clark Expedition and the fur trade era. McAllister is a member of the Oregon Geographic Names Board, the Oregon Parks Foundation, and the Oregon Wildlife Heritage Foundation and has been a member of Portland Audubon since the age of twelve. His mentors are naturalists Willard Ayres Eliot, Stanley G. Jewett, William L. Finley, Ira Gabrielson, and Leo Simon. Raised in Portland, David B. Marshall (1926–), a consulting wildlife biologist, spent thirty-two years as a biologist for the U.S. Fish and Wildlife Service. A longtime member of Portland Audubon, he has written extensively on Oregon ornithology and wildlife and was co-editor of* Birds of Oregon: A General Reference *(2003). In this essay, written in 2000, McAllister and Marshall recount their pre–World War II birding expeditions in Portland.*

Hometown

As boys growing up before World War II in a Portland that was more over-grown hometown than city, we had unlimited freedom to roam on our bicycles. The one parental admonition was, "Be sure you're home by din-nertime."

Our passion was birding. The connection began for David through his family and for Tom in the Portland public schools when Nature Study was part of the curriculum. There were terrariums, aquariums, plant presses, and small animal cages for the specimens we collected for study and dis-play. Mineral, agate, and fossil specimens were big swap items in our varied collections. We used aromatic cigar boxes for our insect collections. It was a hands-on period for young naturalists. Oregon Audubon Society (now Audubon Society of Portland) supplied the schools with nickel leaflets about each bird, including glorious color prints matched by an outline page that could be hand-colored.

David went to Glencoe Grade School and Tom to Laurelhurst Grade School, but we connected at the Multnomah County Library lecture hall, where Audubon members heard from noted area naturalists like William L. Finley, Stanley G. Jewett, Leo Simon, and Alex Walker. They were keen to encourage youthful interests and set the course for our careers. In 1936, David could walk to school listening to western meadow-larks in the old pasture between 49th and 53rd Avenues on Southeast Belmont. David's ear-

liest field trips were after school into Mt. Tabor Park. It was fine habitat for California quail, Cassin's and Hutton's vireos, and orange-crowned, yellow-rumped, black-throated gray, and Wilson's warblers. David showed Tom his first MacGillivray's warbler and lazuli bunting on the brushy west slope of Mt. Tabor. The city reservoirs were a stopover for perky bufflehead ducks. In later years, removal of the natural understory made the park less attractive to a variety of birds.

During spring lunch breaks at Laurelhurst, Tom walked into the old apple orchard and pasture between Glisan Street and Sullivan Gulch, an ice-age flood channel that now holds Interstate 84. Rooster pheasants crowed, house wrens scolded, and his first western bluebird was there on a fence post. It was as sky blue as in the Audubon pamphlet. Another exciting first in that orchard was a migrant northern shrike. We called it "butcher bird" because it impaled its prey on thorns. The background was there from Nature Study class. As youngsters, this was adventure first hand — pre-television or Internet. Providence Portland Medical Center now covers that area. Birding was not sophisticated in the 1930s. Keyed field guides, powerful binoculars, spotting scopes, and tape-recorded bird calls were all to come. Tom had 4X field glasses, and David scored when his dad bought him 6 x 30 World War I surplus artillery binoculars with solid brass frames.

Our guides were *Birds of the Pacific States* by Ralph Hoffman and *Birds of the Pacific Coast* by Willard Ayres Eliot, the latter illustrated with the Bruce Horsfall paintings now displayed at Audubon headquarters on Northwest Cornell Road. Tom received the two-volume *National Geographic Book of Birds* for his twelfth birthday, and the challenge was to match as many birds as possible with those in the color plates.

Our territory expanded with narrow-tired Columbia bicycles and New Departure two-speed gearshifts. All the other kids had balloon-tired bikes. We were going the distance. There were no bike lanes, but traffic was not a problem. We were joined by another lad, Bill Telfer, from the Garthwick District. As a trio we camped and birded around Portland, the Pacific beaches, and the Cascade Mountains on our bikes. This continued until we went our separate ways in the Army, Navy, and Air Force in World War II.

The edge of town was 82nd Avenue. Beyond were cultivated fields and extinct volcanic buttes. Short-eared owls that resembled giant bouncing moths and harriers swept the fields for voles. Vesper and savannah sparrows nested in the grass, and seasonal flocks of horned lark and pipit rose from underfoot. In the tall timber and margins of hazelnut, alder, and dogwood on Kelly and Powell Buttes and Mt. Scott, the blue grouse hooted and ruffed grouse drummed when the red flowering currant bloomed.

The bluffs under North Willamette Boulevard overlooked Mocks Bottom, now supplanted with Swan Island Industrial Park. We scrambled

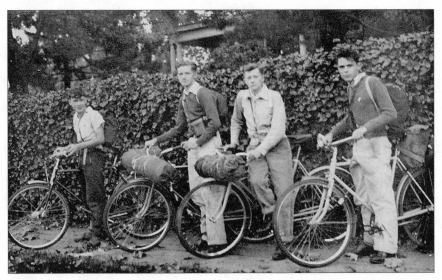

Albert W. Marshall, William H. (Bill) Tefler, Tom McAllister, and David B. Marshall with their bicycles in about 1941

down a slope of Oregon white oak and Pacific madrone, avoiding poison oak en route, to get to this back bay of the Willamette River. Mocks Bottom drew an array of wintering waterfowl. Showy hooded mergansers gathered here for courtship display. The southwest-facing bluff gets the winter sun, and it attracted flocks of yellow-rumped warblers and sometimes a Townsend's warbler. The oak woodland was a perfect niche for white-breasted nuthatches.

If there was one wildest spot for us in that boyhood interlude, it was the Columbia lowlands drained by the Columbia Slough, and especially North Portland Peninsula, converging at Kelley Point where the Willamette and Columbia Rivers meet. Lakes, sloughs, seasonal ponds, Oregon ash and black cottonwood forest, sedge meadows, and willow and red-osier thickets intertwined and confused a sense of direction.

After ditching the bikes, we hiked and waded through a holdover of what the naturalist John Kirk Townsend experienced while collecting out of Fort Vancouver in the 1830s. Western painted turtles lined floater logs to absorb the solar heat. A blue heron rookery that filled the cotton-woods was a cacophony of clacking, clicking, and squawking. We called it the "heron factory." Deer, raccoon, mink, otter, and beaver left fine track impressions along silty margins. Wood duck pairs squealed and twisted upward through the hardwoods. Green heron crouched in the bank shadows. Bullock's orioles brought a splash of tropical color to the green mansions. We focused on

a new bird song of rising and falling phrases, as if in conversation, and got our first red-eyed vireo.

Bill recorded one of the last yellow-billed cuckoos in this region. The once-common cuckoo summered in the understory willow thickets and dined on tent caterpillars. The cuckoo's willow habitat, which tolerated prolonged deep flooding, faded with the taming of the Columbia and Willamette Rivers and an invasion of hybrid reed canarygrass and Himalayan blackberry. In June, prior to its harnessing, the Columbia River, fresh and swollen from melting snowpack far in the Rocky, Teton, Bitterroot, and Wallowa Mountains, shut us briefly out of our lowland haunts.

Young ears are tuned to sound in all registers. We had a game of running down every natural sound and attaching it to bird, amphibian, or other animal call. We could camp and make a breeding bird list by lying in our sleeping bags and listening to the morning chorus. Night ended with screech and pygmy owl calls and the dawn song of violet-green swallows and purple martins. David's brother Albert, who later played in the Portland Symphony, brought his flute and called pygmy owls to us when we camped in Audubon's Pittock Bird Sanctuary.

By August the lowland lakes shrank and exposed mud flats and beds of smartweed and wapato. The best was Ramsey Lake for its assembly of shorebirds en route from tundra nesting grounds. Pectoral sandpipers spread through the sedges to pick insects. Flocks of long-billed dowitcher, least and western sandpiper, and dunlin probed the lake bed before it dried into polygon patterns. Watchful yellowlegs waded belly deep. The sound of their downscale whistle alarm took the smaller shorebirds with them.

To catch the shorebird show on Ramsey meant an early arrival. By the time the sun burned off the morning cloud cover, the flocks were away, the pectoral sandpipers to the pampas of Argentina. Ramsey Lake is now part of the Port of Portland's South Rivergate industrial area. But adjoining Smith and Bybee Lakes have been encompassed into nearly two thousand acres of protected urban wetland.

Some things have changed in our sixty years of city birding. There is the loss of nighthawks that hunted insects in the neon-lit sky over Southwest Broadway when we came out of the movie theaters. The wing rush and boom as the male nighthawk dove toward a rooftop where the female laid her two eggs was part of a downtown Portland June or July night.

David's Grandmother Marshall, who lived in a big family home with numerous aunts and an uncle on Southwest Summit Drive, lamented the disappearance of the western bluebirds that used her birdhouses and the mountain quail that ran through her yard. She also remembered the blue and ruffed grouse, but they can still be found in Forest Park.

The yellow warbler's incisive songs from the tops of the elms lining our residential streets were pure summer music. Those waves of migrating warblers we anticipated each spring are sadly diminished. The largest of our warblers, the yellow breasted-chat, hid in the tightest cover and was common in the spirea thickets west of Rocky Butte. Its staccato burst of chucks, chortles, and hews could be heard any time night or day, and especially on moonlit nights. That cover is gone, and so is the chat.

When we ranged the city on our bikes the "sip three beers" call of the olive-sided flycatcher rang from the tallest fir tops, native brush rabbits grazed at wooded road margins, and Swainson's thrushes filled the summer twilight with song. House finches extended their range north and within a few years displaced one of our finest songsters, the purple finch. David found the first house finch nest in 1939. In a few years they frequented every bird feeder in town. The starling invasion followed. One of our trio's best days was the discovery of a spring-fed marsh off Southeast Linwood Avenue. It held nesting sora and Virginia rails, pied-billed grebes, and an eastern kingbird that was feasting on dragonflies. Don't look for that marsh now; it is filled and gone.

The wild was part of our city life, bringing us the pleasures of discovery and connection with nature that we knew in our hometown.

ELIZABETH MCLAGAN

A co-founder of CALYX, a feminist journal and book publisher in Corvallis, Oregon, Elizabeth McLagan (1947–) is a graduate of the Inland Northwest Center for Writers MFA program at Eastern Washington University. She has published numerous poems in literary journals and the poetry chapbook The River Sings Like Rock *(1990). She is also the author of two works on minority history in Oregon:* A Peculiar Paradise: A History of Blacks in Oregon, 1788–1940 *(1980) and* Notes Toward a Biography: The Papers of John Hiram Jackson *(1998). She has won several awards for her poetry, including one from the Oregon State Poetry Society. In this excerpt from* A Peculiar Paradise, *McLagan considers Portland's African American community during the first few decades of its settlement in Oregon.*

Sober, Industrious, and Honest

January 1, 1900 marked the beginning of a new century, and optimism reigned. Black people in Portland could assess their accomplishments with pride. The small, struggling community had seen some progress and the beginnings of change. Churches and other social institutions were estab-

lished, and the effort to secure the repeal of racist laws had at least begun. Two years later, they were reminded of the task that lay ahead of them:

> It has been difficult for the colored race to get a right start, and [it] is also difficult for many of them yet to realize the necessity of right living and earnest steady efforts for their betterment, and to prepare themselves for the duties and responsibilities of citizenship.

Between 1890 and 1900 the number of black people in Oregon had decreased slightly, from 1,186 to 1,105, but in the same decade the proportion of the black population living in Multnomah County rose from 44% to 70%, drawn by increased job opportunities at the Portland Hotel and with the railroads. Since 1896, they had a voice in the press in the person of A.D. Griffin, owner and publisher of the *New Age*. Griffin had been the editor of the Spokane *Northwest Echo* before coming to Portland, and was a prominent Mason. While living in Oregon, he became the first black man to attend a Republican state convention, and was a stockholder in the Enterprise Investment Company.

Published weekly, the *New Age* was not designed to appeal strictly to a black audience; the front page carried general news from the national telegraphic services. News of specific interest to black people was featured on the inside pages and the editorial page. The paper reflected the activities of the local black community and also contained news of black people throughout the Northwest and in the rest of the nation. Coverage was given to events in the South; lynchings and other racist activities were reported as well as news about the accomplishments of black people. Advertisements were often solicited from white-owned businesses, which Griffin urged his readers to patronize. Black-owned businesses advertised in the paper as well. . . .

Outside the black churches, the social life of the community was centered in the fraternal lodges and their women's auxiliaries, women's clubs, the Williams Avenue YWCA, and political organizations, the most important of which was the local chapter of the National Association for the Advancement of Colored People. These organizations all provided needed social, educational, political and charitable functions within the black community.

Masonic and Odd Fellows lodges were organized in Portland in 1883, and a black Elks lodge, the Rose City Lodge, was organized with its women's auxiliary, the Dahlia Temple, in 1906. There was a local Knights of Pythias, the Syracuse Lodge, and in 1916 a second Elks lodge was organized.

These fraternal organizations provided important functions within the community. The Enterprise Lodge was composed of the more stable citizens of the black community; among other qualifications members had to be "free born," to pay their dues in cash, be of high moral character, and able to

read and write. A lodge did not grant membership to transients; a man had to have a "settled abode" to be accepted. Dues collected provided for charity to the members, should they become sick or disabled, and for help to needy orphans and to the widows of deceased members. Lodges provided graves in the lodge cemetery plot, and conducted funeral services. They sponsored social events such as charity dances and excursions up the Willamette River, and helped to shape the moral standards of the community. It was an honor to be invited to join a fraternal order, and a person could be evicted for bad behavior or public drunkenness. Lodge sisters had to do charity work, and on a rotating schedule provided nursing care to members who were sick. This was particularly important as many black people did not have access to hospitals, and private nursing care was expensive and often unavailable.

In 1896 a conference was held in Boston, Massachusetts, attended by a group of black women in order to refute charges made by a white southern woman concerning the morality of black women. That meeting marked the beginning of an organization of black women's clubs to promote their common goals of self-education, high moral character, and the education of women and young girls. In 1897 the National Association of Colored Women's Clubs was formed, with the motto: "Lifting Others As We Rise".

A national conference of white women's clubs was called in 1902 to discuss integrating black and white clubs, and to allow black club members to attend national conferences with white women. Prior to this conference, each state's association of women's clubs voted on this proposal. Oregon's white club women voted to exclude black women's clubs, and the national conference, after much debate, also voted to continue the exclusion of black women from their organization and affiliated clubs.

In 1912 the Colored Women's Council was organized from a chapter of the Lucy Thurman Temperance Union. This group resolved to work for high ideals and morality, civic concerns and a Christian homelife. In 1913 this organization held its first charity ball. A clubhouse was established in 1914, and the group joined the National Federation of Colored Women's Clubs. In 1917 nine Portland clubs organized the Oregon Federation of Colored Women's Clubs, to strengthen their organization and to unite to work for their common interests, including betterment of the race and the education of black women and girls.

Club leaders were well-educated women and passed on what they knew to other women and girls. Like Girl Scouts and 4-H Clubs, they stressed arts and crafts, education, and community service. Funds were raised to provide scholarships for young girls, and the clubs participated in various political and social activities. During World War I many black women's clubs did volunteer war work. The Literary Research Club collected books and read and researched various topics of common interest, including a study of the laws of Oregon relating to minorities.

Dining car cooks in about 1919

In 1921 a branch of the Portland YWCA was established in a portable struc-
ture on the corner of Williams and Tillamook Streets, and five years later
work was begun on a new building on this site, funded primarily by a gift
of $12,000 from a white woman active in the YWCA, Mrs. E.S. Collins. There
was some opposition to the idea of a segregated facility, fueled by rumors
that the gift, originally anonymous, came from the Ku Klux Klan. An effort
was also made to deny the YWCA a building permit, prompted by white
citizens who didn't want black people to build on the site. The protest was
taken to the city council and the city attorney denied the request, saying that
the city had no right to refuse to issue a building permit simply because it
was for a black organization.

The idea of a segregated facility was not without its critics, but the Wil-
liams Avenue YWCA was managed by black women and became a community
center. Many social and political clubs utilized the facilities of the YWCA for
their meetings. The building had a gymnasium and auditorium with a stage,

a kitchen, office, lounge, and locker rooms and showers for both boys and girls. $1,300 was raised by local black organizations to furnish the building. The YWCA had clubs for grade and high school girls. There were classes in Spanish, sewing, hat making, Bible studies, musical programs, dancing, games, exhibits featuring black artists, and activities celebrating Negro History Week.

Black people began to organize into political groups as early as 1870, when the Sumner Union Club was organized and endorsed the platform of the Union Republic party. It dissolved soon after, during a dispute over a local school board decision to prohibit black children from attending public schools. An organization called the Bed Rock Political Club was formed in the late 1870's, and was active until the waiters at the Portland Hotel organized the New Port Republican Club. This club had a membership of eighty, and was able to secure the employment of George Hardin, a black man, on the police force in 1894. A chapter of the Afro-American League was organized in Portland in 1900, and in 1919 sponsored a civil rights bill which was presented to the state legislature. The Colored Republican Club of Multnomah County was organized in the early years of the twentieth century, and in 1904 had a membership of 200. In the 1930's two groups calling themselves the Colored Democratic League were organized. . . . The National Association for the Advancement of Colored People was created in 1909 from an interracial group, including W.E.B. DuBois, leader of the Niagra Movement. It was founded to work for an end to segregation and discrimination in housing, education, employment, voting rights and transportation, to fight racism and to secure full constitutional rights for black people. The Portland branch was organized in December, 1914, with 165 members. It was not the first western branch; chapters in Tacoma and Seattle, Washington, and northern California and Los Angeles had been established between 1912 and 1914. Dues were originally fifty cents per year, making membership within the reach of almost every person. Total membership fluctuated from year to year, and a good deal of local activity was given over to recruiting new members. The most successful campaign before 1940 was conducted in 1928, organized by J.L. Caston, a young minister of the Mt. Olivet Baptist Church. At the end of the year the total membership was 694.

Internal disputes threatened the organization's continuity several times during the 1920's. Mrs. E.D. Cannady, one of the original members of the branch and the most visible advocate for interracial understanding in Portland, criticized local blacks for a "do nothing" attitude. She in turn was criticized for using *The Advocate* for her personal advancement, and only reporting NAACP activities in which she had a major role. Her criticism of the segregated Williams Avenue YWCA lost her the respect of many black people in Portland, although she remained a prominent advocate for black people

in the white community. She organized branch chapters of the NAACP in Vernonia, Oregon, and Longview, Washington, and was appointed Branch Organizer for the national office. She was inactive in the local branch after 1929, although *The Advocate* continued to cover NAACP events and activities.

Attempts to buy the black vote also threatened to split the organization. In 1930, *The Advocate* reported the activities of the Political Committee, disrupted by the resignations of various members after Joe Keller, a white member of the committee, was rumored to have promised the entire black vote to one candidate for governor of the state. *The Advocate* reported:

> Mr. Keller cannot be blamed for his political aspirations, but it is the opinion of many that colored voters ought to be able to reach their own decision as to whom they care to support, without the aid of outsiders . . . when a candidate runs for office, whose record is known of the Association to play politics, to be against Negro rights, the Association urges such a candidate's defeat . . . But the Association does not work for the election of candidates. This course seems to be the only wise one for such an organization to pursue, as it is a well-known fact that the Association is composed of both colored and white members representing every kind of political and religious affiliation. To play politics with the organization would soon wreck it upon the rocks of misunderstanding.

Despite these internal disputes, the Portland branch is the oldest branch west of the Mississippi to be continuously chartered.

KATHRYN HALL BOGLE

Born in Oklahoma, Kathryn Hall Bogle (1906–2003) arrived in Portland at the age of four and grew up in a small house on Southeast Tibbits Street. Gaining a love of reading from her mother and stepfather, she spent many childhood hours in branches of the Portland Public Library. In her twenties, she began writing for various publications, including the Pittsburgh Courier *and the* Chicago Defender. *Bogle's concern for issues of race and racial justice profoundly informed her journalism. Her regular contributions to the* Oregonian *began after she protested the newspaper's scant coverage of Portland's African American community and was invited to submit a piece for publication. In her first article for the paper, "An American Negro Speaks of Color" (February 14, 1937), Bogle addresses the difficulties and limitations that African American students face in Portland's public schools and in seeking employment.*

An American Negro Speaks of Color

Recent discussion in the press of the difficulties, real or imagined, of Negroes while attending school prompted the *Oregonian* to ask me for my own reaction to this problem. Perhaps my own experiences, both in school and later, will give readers an insight into the conditions the Negro child faces, for it is when he starts to school that he gains an inkling of a situation destined to confront him all through life.

It is my belief that the high schools present more difficulties for the Negro student than the elementary grades, unless he is an athlete or particularly talented. In that case his pathway is smoothed to a great extent.

The casual speaker during assemblies is an unknown quantity and a hazard to a brown-skinned student, until the guest has told his warming-up jokes. If it is a "colored" story, the speaker often uses offensive terms, and the theme of the tale is usually a colored man's laziness or ignorance. (These stories cannot be compared to the tales told on other races, for in the main, their shrewdness and thrift are played up.)

During the telling of this sort of yarn the colored youngster sits stony-faced, his soul shrivels, as his young neighbors turn amused eyes on this the representative of such a race. Certainly whatever else follows cannot be enjoyed by the young Negro listener, and his smile is on only his *face* for the rest of that day.

Textbooks the students use are not designed to help the colored boy or girl regain any lost "face" after such an experience. About the only reference any of the regular textbooks make to the Negro is his enslavement and the granting of his freedom.

The pictures shown, if any, are always of bowing, scraping, cap-in-hand

creatures who have been denied any opportunity whatsoever to better their underdog positions, and whose earthly deity is quoted as being "Massah!"

Hardly one white student in a thousand knows that the first man to give his life for the new country in the revolutionary war was a Negro—Crispus Attucks.

If there is any time a Negro high school student would like to skip class it is his history class during the study of the Reconstruction period following the Civil War. If the teacher happens to be a thoughtful one, no undue emphasis is laid upon the doings of this period.

Perhaps she points out that no people could have succeeded, given such power with no training for it. Perhaps she explains that any man who has been under bondage all his life may be boisterous on finding himself really free, and that the reaction is perfectly normal. She may tactfully draw as a parallel the actions of the students themselves as the bell rings releasing them at the close of a school day. She certainly does not minimize the work of rascally "carpet-baggers."

During this period perhaps no rocks are thrown by hand, but there are subtle omissions, exceptions, and other differences made that wound the spirit. No attempt is made to help him to real pride of his own race. Rather, outside of his home, he is bombarded by assaults and propaganda against his race.

When at length the Negro student receives his diploma the extra applause usually accorded a colored student at this time is to him at once a recognition of his having surmounted (we hope) inconveniences encountered because of his color and approval of his accomplishment, and an expression of a hope that he may continue onward and upward!

Yet the student knows that this expressed hope for his future advancement is but a delicate wisp of nothingness, for where, in that throng of hand-clapping enthusiasts, is there one businessman who will hire that graduate in his office, or anywhere in his business with a real chance to advance?

The man does not exist.

The Negro student knows that as he says good-bye to those friends he has made in high school, it is a real farewell, for, unless he plans to enter one of the colleges in his own state, he has lost all contact with the members of his graduation class. When they enter the workaday world in this land where men are born free and equal, the white student and the brown one become as separate and as distinct as the two poles.

There would be nothing to weep over if these distinctions and separations were merely those of social contacts, for the brown student's happiness does not depend on being included in the social activities of his white friends.

But the separation and distinction which are discrimination do not end there.

For Negro folk are denied their first desire—an equal chance to develop

well-rounded lives and the equal chance to provide their children with the same sort of atmosphere any other American parents can choose and claim as a right that has been earned by sweat and blood.

On the other hand, anyone coming here from foreign shores can exercise all his rights as an American citizen as soon as he is naturalized.

Let two students who received their educations at the same local institution together seek employment. Let one be white, the other brown. Perhaps at first neither is successful, but at last they are fortunate in being present where an employer admits he needs two new employees.

The white girl steps forward, and, after answering routine questions satisfactorily, is hired. The brown girl steps forward, happy in her friend's good fortune.

She is stared at in open-mouthed astonishment. She is told quickly and firmly, "We have no place for you."

These words echoed and reechoed in my own ears when I looked for work [in Portland].

I started out buoyant and fresh with the dream of finding an employer without prejudice. I opened each new door with a hope that was loath to leave me. I visited large and small stores of all descriptions. I visited the telephone company; both light and power companies. I tried to become an elevator operator in an office building. I answered ads for inexperienced office help. In all these places where vacancies occurred I was told there was nothing about me in my disfavor—except the color of my skin.

Here is an odd thing to balance. Several of those denying me employment in town offered me employment in their homes. There my color is not a bar! My employer will not be criticized if I am employed in his home in contact with his nearest and dearest!

Were it not for this little quirk in a white man's discrimination against a brown skin, many thousands of Negroes could not earn the bare necessities for life.

With nothing to renew it, my hope began to fade, but still I would not admit defeat. Perhaps if I attended a first-class business school to become the very best stenographer or secretary they could turn out, success would be certain.

A trim little Negro girlfriend and I visited one of the two largest business schools in town [Behnke-Walker Business College]. We were stunned when we were told without delay that because of our race we could not register there! We went to their nearest competitor, only to meet with the same statement.

We anxiously consulted the telephone directory and visited each school listed. Many told us in lowered voices, "Of course I myself have no prejudice. It is my partner in business"—or perhaps the buck was passed to the students registered there. Evening found both of us soul weary.

Kathryn Hall Bogle in about 1976

Subsequent discoveries did not help us. We found that no Portland hospital will accept the application of a Negro girl for nurse training; there are no Negroes in the employ of the state of Oregon; Negroes have not one representative in the clerical departments of the city.

Finally to gain regular employment I put an ad in the *Oregonian*. I was offered a good many places to do "general housework," but declined them in favor of a place where I could be a helper. I stayed exactly three weeks, for I found that my day there began at 6:30 a.m. and ended when I dropped down on a hard, narrow day bed at 10:30 at night. If this came of being a "helper," I decided to hire out to do general housework and be paid for it.

Before I had attempted another job of this sort, a friend gave my name to an official of a large concern [Meier & Frank Co.]. He was contemplating placing a girl in the dispensary of one of the departments [beauty shop] and thought I could fit in. The pay was good, and the work was a cut above what I had been doing; so I was glad to take it.

I stayed there several years and made a number of friends within the organization and among its customers.

Some other cities have dealt differently with their Negro populations. In

Los Angeles one sees Negro policemen, Negro window decorators in white stores, many brown-skinned salespersons, and a goodly number of Negro nurses in the county hospital. In Seattle there are several Negroes working harmoniously in white establishments.

Here in Portland there is one Negro secretary [Norma N. Keene]. This young woman has been in the employ of the same busy man [Joe F. Keller, National Automobile Theft Bureau] for several years. She is a model secretary in her quiet, genteel, and highly efficient manner.

Here, also, one large store has departed from custom and has employed a young Negro in a position with some responsibility, albeit behind the scenes.

An official declared that the young man is "one of the best" and "does his work as well as anyone and better than most."

Those are isolated cases, but they do point the way. They have proved that Negro help is efficient and loyal and that harmony can exist among mixed employees.

Upon what does a color discrimination stand when a white girl returns from her vacation with her skin darker than some of my colored friends and makes a purchase in a downtown store from a blonde colored girl who is so fair no one in the store dreams that two little brown girls are her own daughters? The brown white girl goes unmolested, but if it were known that the white brown girl is brown she would lose her job. A little complex, isn't it?

My own voice does not betray my color to one who does not see my face. Letters I write to my friends and those I receive from them do not suffer for having been written by brown hands—they still convey thoughts from one soul to another. My personal belongings will not tell I am colored.

My own home only says the occupant is poor in the world's goods; it does not shout to anyone that I am dark while my neighbor is white. My dog will not tell you that he is dissatisfied with my color, for, real friend that he is, he sees only me. Our canary does not glance around at his audience to ascertain its color before he trills his song.

The flowers in my garden do not turn away their bright heads when I walk among them, nor do they withhold a single breath of their sweetness when I pluck them.

It is left for people to make a difference.

Now that I myself have a little son [Richard Bogle, Jr.], I am glad to know that he attends school [Hosford] where there is a just man as principal and a group of real teachers who have been fair to other Negro children before him. I shall see to it that he has as firm a foundation in pride of race as I can give him, so that when he meets with an occasional blow later on he can stand steady and strong and have only pity in his heart for those few who cannot see him because they see only his color.

AUGUSTA CLAWSON

In 1943, Augusta Holmes Clawson (1903–?) wrote about her experiences working in Portland's shipyards and attending welding school to encourage other women to join the ranks of the welders who built liberty ships at Swan Island during World War II. Her account, Shipyard Diary of a Woman Welder *(1944) also intro-* · *duced women to what Clawson calls in her preface "the environment in which that [newly acquired welding] skill would be used." Enthusiastic about her topic, Clawson declared with a passion for the country and for the employment of women that "today women are building ships, welding on the ways from double bottom to fo'c'sle deck, in fuel and ammunition tanks, everywhere from stem to stern."*

From *Shipyard Diary of a Woman Welder*

Thursday evening:

By accepted time schedules, it may be eight o'clock here and eleven o'clock in New York, but if I were to go by my feeling I'd call it nearer two o'clock in the morning. Perhaps starting my day at 5:00 A.M. has thrown me off. You asked for candid reactions, and I am giving them. My reaction right now, 100 percent, is weariness. I'm surprisingly tired; more so than can be explained by the work itself. But the experience is worth it, *definitely*.

"My Day" started when the alarm clock made nasty remarks to me at four minutes of five. I pulled on the bed light to be sure not to fall asleep again, and was yanked back from an imminent doze by the telephone (my second precaution). A cheerful voice (entirely too cheerful for such an hour) said: "Good morning. It is five o'clock." That did it.

At exactly 5:26 I walked into the Park Avenue Grill for breakfast. Don't let the name mislead you—it's the only place I've been able to find that opens at such an inhuman hour. The sign said "Open 5:30 A.M."; but it lied, for I got no action until a quarter of six. While I waited for my order I chatted with a man on the next stool, who is an electrician at the Northwest Yard. He asked what work I planned to do. I told him welding. He looked me up and down, chuckled quietly and said, "You'll do. Yes, you'll do." He was a nice-looking person from Colorado. He got me a paper from the counter and we read the news and discussed all sorts of things till his waffle and my coffee and toast arrived. In spite of what the Company Counselor had told me, for some unknown reason I had insisted on bringing my overalls with me. So under my counter stool I propped my paper bag with overalls, jacket, socks, and leather gloves. All I needed was a red-and-white bandana so I could tie them all on the end of a stick and "hit the road."

I caught the 6:00 A.M. Shipyard bus, not the James St. The latter would have necessitated transferring; the Shipyard bus went direct. It was so crowded that I had to stand, and equally was so crowded that I didn't have to

hang on to a strap, for there wasn't room to fall. The trip was probably four or five miles, and I stood and looked down at a sea of metal and plastic hats and wondered what kind of people lived inside those hard shells. It looked like a turtle convention. I asked a woman where the vocational school was, and she promptly assumed full responsibility for me, called my stop, and saw to it that I got off. The driver was a woman, and the men ragged her about the risk they were taking by riding with her.

When I reached the school, which is just inside the Yard, I took up yesterday's relay race. I reported to an office at one end of the building, was sent outdoors to a little white "checking station," was bounced back to another office in the school, and there given another form to fill. This asked that I list past employment: "*Most important jobs.*" (I hope Uncle Sam won't feel slighted that I didn't mention my employment with him.) I had to circle also the figure indicating the highest level of education I had reached, and tell what I had majored in at college. Then I was told to wait in the next room. Everyone was very courteous and very businesslike.

By this time people began to pour in dressed for work. Nary a skirt in a yardful. I was glad I had brought my overalls. I changed them in the women's rest room and spent ten minutes trying to find a safe place to leave my suit and topcoat so they wouldn't be stolen. The man who presided over the supplies and issued welding hoods to the trainees finally let me stow them away in a corner back of his counter. I have learned; after this I come to work dressed for it. I felt pretty foolish with silk stockings emerging from under the overalls. Why hadn't I put in my socks?

Two more greenhorns joined me, and presently we were sent back to Checking Station No. 1 for our badges. Mine is faceless, as the photo hasn't come through yet. I think I'm happier without it. Every time a camera clicks at me the same thing comes out. There must be some reason for such amazing coincidence, but it is not reassuring. Next we went to another room in the school and were given hoods and steel brushes, for which we signed. This time we reached the home plate—the welding shops back of the school building. It was an eerie sight, for dawn was just breaking behind the rim of black hills surrounding the place, and here sparkling through the semi-darkness were dozens and dozens of flashes like giant sparklers.

Back to work and more welding. I "dis-improved" as rapidly after lunch as I had improved during the morning. One girl stopped to ask, "How you doin'?" and watched me critically. "Here, let me show you, you're holding it too far away." So she took over, but she couldn't maintain the arc at all. She got up disgusted, said, "I can't do it—my hand shakes so since I been sick," and I took over again. But she was right. I held it closer and welded on and on and on.

My silk stockings were now a ribbon of runs from the tiny sparks. My new blue denims and my ankles were dotted with pin-point burns; but I

was learning not to jump every time a spark bit me. Most of the girls wore denim overalls. Only one or two of the men wore leather overalls; probably not many can afford to buy leathers yet. It got monotonous, just laying one line of beads after another. By 1:30 I thought it should be night. About then we were all called back to the school for the General Electric movies on arc welding and a brief lecture on economy of material. And then back to the stinger again.

By this time I was getting just a trifle bored and two trifles tired, until I noticed little spots appearing all over the bench and looked up to find that a heavy but very fine rain was pouring in. It was chilly, too. Having come only half prepared, I had no jacket, and the blue denim was hardly warm enough for Oregon's breezes. But we welders are like the postmen: Come rain or snow or sleet or cyclones or fatigue or sleep or the judgment day, we still feed that insatiable beast one rod after another. Anyway, 3:30 did come at last. We checked hoods and brushes back in, turned in our badges, and waited hopefully for each "next" bus to have room for a few of us. Finally I wedged in (and I mean *wedged*) and stood up for the return trip. The five blocks from bus stop to hotel were much longer than they had been at 5:00 A.M. By now the sun was out bright and not a sign of the rain left.

I went up to my room, peeled off shoes and suit, grabbed an apple from the desk, and stretched out on the bed. The apple was hardly gone before I fell sound asleep.

I woke with a jerk, and with a panicky feeling that it was past time to go to work and that I had missed my alarm. But it was only the alarm clock clicking as it passed the 5 o'clock mark at which it was still set from twelve houses ago. I pulled myself up, showered, dressed, and had dinner.

My conclusions on this day are: It was very exhilarating being part of the gang, especially this morning. But I'm glad I didn't have to come back tonight to a husband and four children all waiting for me to cook dinner. I'm glad I didn't have to do a family laundry. In fact, "Jingle, Jangle, Jingle— thank God I'm single!" Guess I'm soft. But give me time—I'll harden up. And in the meantime it's a lot of fun. I find tonight's tiredness a very different kind from last night's; tonight I'll sleep like a top. Last night I woke up five or six times, each time to find myself wondering whether to take working clothes or not—whether we'd have lockers, or whether to leave topcoat and pocket-book at home—how we'd get lunch—how often the buses ran, etc. Tonight my only wonder is "How long will it be before 5:00 A.M.?" . . .
Sunday:
I am back from my first day on the Ways, and I feel as if I had seen some giant phenomenon. It's incredible! It's inhuman! It's horrible! And it's mar-velous! I don't believe a blitz could be noisier—I didn't dream that there could be so much noise, anywhere. My ears are still ringing like high-tension wires, and my head buzzes. When you first see it, when you look down Way

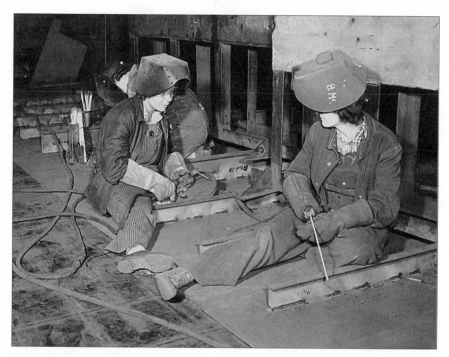

Women welding at Albina Engine & Machine on October 25, 1942.

after Way, when you see the thousands each going about his own business and seeming to know what to do, you're so bewildered you can't see anything or make sense out of it.

First came the bus ride to the Yard. Crowded as usual. I was intrigued by knowing that this time I was going to Mart's Marsh. The name has always fascinated me. I gather that it refers to bottom or marshy land once owned by a family named Mart. From the school our road led along the water where I could see several of the ships already launched and now lying at the outfitting dock to receive the finishing touches. It was easy to spot the various stages of completion; each ship gets moved up one when a new ship arrives for outfitting.

When the bus came to a stop I followed the crowd across a pontoon bridge between rails at which stood guards checking for badges. The far side of the bridge brought us to the part of the Yard where the prefabricated parts are stored, right in the open, pile upon pile. I saw a huge building marked "Assembly Shop," another "Marine Shop," and still another "Pipe Assembly." There were lots of little houses marked with numbers. Most of them seemed to be in the sixties. And I was looking for check station No. 1.

I hunted and hunted without success, and finally asked someone where "new hires" check in. He immediately directed me. I showed my badge, told my number, and was given another badge to be picked up and turned in daily as we did at school. It was marked "New Hire." About then who should come along but Redheaded Marie and the Big Swede! We went together to the Welders' Office where our off days were assigned to us. I was given "C" day and told that it was the only day available. This means that I get Tuesday off this week, Wednesday next, and so on. The Big Swede said she had to have "D" day to get a ride to work and to have the same day as her husband. Although "C" day was "the only one available," strangely enough *she* was given "D" day. One has to learn to insist on what one wants even when told it is impossible.

The Big Swede is a real pal. She had not forgotten the patch for my overall trouser leg. She had cut a piece from an old pair of her husband's, scrubbed it to get the oil out, and brought it to me with a needle stuck in the center and a coil of black thread ready for action. "Here," she said, "I knew you wouldn't have things handy in a hotel room. Now you mend that hole before you catch your foot in it and fall."

We were turned over to Marie because she knew her way around—was familiar with the Yard and acquainted with lots of the people already. She was "riding high" and "fresh as paint." She took us first to get our rod boxes. Just for deviltry, I'm sure, she said we'd have to go "this way"— which was through the skids; a space so small that even the average-sized person would have to lie flat and roll through. And neither the Big Swede nor I could claim to be average-sized. She started to balk. "I'm not going that way. Marie's just trying to show off." "I know it," I answered; "that's why she's not going to get a rise here." The Big Swede shrugged agreement and we crawled through.

We went to some subterranean shop which I know I couldn't find again and sat while a man stenciled our numbers on gray "rod boxes." A thick rope furnishes a loop which goes over the shoulder to carry this box. A pretty brunette whose speech seems to be limited to "Hell, no" and "Hell, yes" waited with us. Next stop was at a tool crib where we signed for stinger and brush. From there to a rod shop to get rod and glass for our hoods. And finally to a lunchroom where we left our lunchboxes.

At last I was ready to go up on deck and meet my leadman. It was some time before I could find him. He seemed a pleasant, straightforward sort of chap, and very businesslike. I had a feeling that when he looked at me he thought, "Ye gods, another woman!" But all he said was "Wait here and I'll find you a job."

I waited about three-quarters of an hour. I stood at the rail and stared out over the Yard. It all looked like chaos and confusion to me. I counted a number of people who were idle and wondered why. Presently a shipfitter's

helper came to take me to my first job. "What's it like out here in a shipyard?" I asked; "I've never worked in one before." She shrugged her shoulders. "You'll earn your pay just by dodging being killed. There are so many green workers it's a wonder something doesn't happen to you every day." Lugubrious thought.

Today my book on welding came from the Washington office. I read that a welder's qualifications are "physical fitness which insures a reasonable degree of endurance during a full day of work; steady nerves and considerable muscular strength." For a *shipyard* welder I'd amend that to read: "an unreasonable degree of endurance during a full day of strain, plus muscular strength, plus *no* nerves." If you haven't the muscular strength before you start, you will have it afterward. If you haven't the nerves before, you *may* have them afterward, though I doubt it. By tomorrow I shall be "reasonably" acclimated, but tonight I'm quite frankly "ain't."

I, who hate heights, climbed stair after stair after stair till I thought I must be close to the sun. I stopped on the top deck. I, who hate confined spaces, went through narrow corridors, stumbling my way over rubber-coated leads—dozens of them, scores of them, even hundreds of them. I went into a room about four feet by ten where two shipfitters, a shipfitter's helper, a chipper, and I all worked. I welded in the poop deck lying on the floor while another welder spattered sparks from the ceiling and chippers like giant woodpeckers shattered our eardrums. I, who've taken welding, and have sat at a bench welding flat and vertical plates, was told to weld braces along a baseboard below a door opening. On these a heavy steel door was braced while it was hung to a fine degree of accuracy. I welded more braces along the side, and along the top. I did overhead welding, horizontal, flat, vertical. I welded around curved hinges which were placed so close to the side wall that I had to bend my rod in a curve to get it in. I made some good welds and some frightful ones. But now a door in the poop deck of an oil tanker is hanging, four feet by six of solid steel, by *my* welds. Pretty exciting!

The men in the poop deck were nice to me. The shipfitter was toothless. The grinder had palsy, I guess, for his hands shook pitifully and yet he managed to handle that thirty-pound grinder. The welder was doing "pick-up" work which meant touching up spots that had been missed. An inspector came through and marked places to chip, and the ship's superintendent stopped and woke the shipfitter's helper.

Then I went down more stairs, and still more, and finally crawled through a square hole in the floor and down a narrow ladder held by the shipfitter below and emerged into a little two-by-twice room. I felt as if we were a thousand leagues under the sea. In the "dark, dank dungeon" two decks above, there had been a hole in the ceiling through which the air lines came, and around the lines one could just make out sky and sunlight. I realize now

what Oscar Wilde meant when he wrote of "that little tent of blue which prisoners call the sky."

I do know one thing from just today. There is nothing in the training to prepare you for the excruciating noise you get down in the ship. Any who were not heart and soul determined to stick it out would fade out right away. Any whose nerves were too sensitive couldn't take it, and I really mean *couldn't*. There are times when those chippers get going and two shipfitters on opposite sides of a metal wall swing tremendous metal sledge-hammers simultaneously and you wonder if your ears can stand it. Sometimes the din will seem to swell and engulf you like a treacherous wave in surf-bathing and you feel as if you were going under. Once I thought to myself, "If this keeps on, I wonder—" It makes you want to scream wildly. And then it struck me funny to realize that a scream couldn't even be heard! So I screamed, loud and lustily, and couldn't even hear myself. It was weird. So then I proceeded to sing at the top of my lungs (I'm discreet usually, for my pitch is none too good) and I couldn't hear the smallest peep. It's an ill wind that blows nobody good, and I decided to make the most of it, so I hauled out my entire seafaring repertoire and sang "Rocked in the Cradle of the Deep," "Anchors Aweigh, My Boys," and "The Landlubbers Lie Down Below." You could almost doubt your sanity sitting there making an unholy din, and not even hearing it.

At the school I'd considered chipping slag slightly noisy. But when I chipped slag today, I couldn't hear my hammer hit. It does to your hearing what an arc flash does to your vision. After a flash you can't see a thing for a few seconds. And after all this racket stops, you can't hear anything for a short space of time. Then your hearing flows slowly back and you find you're still sane and normal. And people wonder whether it involves "adjustment" when a housewife takes up ship welding. It does—and I am sure we can prepare her better for it. She can take it, but I think she'd do better if she were ready for what's coming. . . .

Monday:

At lunch the talk got on education. One of the women (Ella Zavoral) referred to something that had happened when she "was in High School." There was no indication how much schooling the others had had. We all agreed that "education's swell if you can get it," and I added that you could get it in plenty of places other than school. Whether it is a compliment to what academic training I have had, I don't know, but certainly no one suspects I have two degrees. I wonder if they think I even got to high school.

I think we college graduates flatter ourselves when we think our academic degrees somehow set us apart from other people. I've honest respect for education that people have gained the hard way. Too many confuse formal schooling with education. If my college sisters could know how much I've

learned working with these shipyard people, they'd climb out from among their degrees and do the same thing. These are real people and I like them.

Then the lunch group went on to discuss waitress work; all who had been waitresses agreed that welding is easier. They also expressed in outspoken terms their opinion of some of the less fastidious habits of the men. As one girl put it, "They're the spittin'est animals I've ever seen." Young Tommy, a clean-cut, rather refreshing boy who came into the Yard when we did, used to have nice manners, without being at all a sissy. But now, when you see him he says "Hello" in a bored tone and spits expertly. Must be an assertion of manhood. In any case, this is perhaps the most disagreeable practice we encounter. One spirited young woman who was working with a tobacco-chewer said that he "spat" on the deck with nonchalance and then told her to do some tacking on said spot. She answered with conviction: "Not this gal. You get someone else. If you don't stop chewing tobacco and spitting around me, you can get another welder." And she stuck to her guns.

JOHN OKADA

Born in Seattle, John Okada (1924–1971) earned degrees from the University of Washington and Columbia University. During World War II, he served in the Pacific with the Army Air Corps, earning the rank of sergeant. After President Franklin Roosevelt signed Executive Order 9066 in 1942, Okada's family, along with more than 120,000 Japanese Americans, were interned at a War Relocation Authority camp. After his discharge from the army, Okada worked at the Seattle Public Library and wrote his only published novel, No-No Boy, *released posthumously in 1976. The novel tells the story of Ichiro, a Nisei who, incarcerated for refusing to serve in the U.S. military during the war, returns to the Northwest to try to recover his life. In this excerpt, Ichiro goes to Portland in the hope of finding job opportunities and a confidence that are not available to him in Seattle.*

From *No-No Boy*

Alone and feeling very much his aloneness, Ichiro drove the Oldsmobile back into the city proper and found a room in a small, clean hotel where the rates seemed reasonable. Having picked up a newspaper in the lobby, he turned to the classified section and studied the job ads. Most of them were for skilled or technical help, and only after considerable searching was he finally able to encircle with pencil three jobs which he felt he might be able to investigate with some degree of hope. Putting the paper aside, he washed, shaved, and put on a clean shirt.

I mustn't hesitate, he told himself. If I don't start right now and make

myself look for work, I'll lose my nerve. There's no one to help me or give me courage now. All I know is that I've just got to find work.

With the folded paper under his arm, he walked the six blocks to the hotel which was advertising for porters. It was a big hotel with a fancy marquee that extended out to the street and, as he walked past it, he noticed a doorman stationed at the entrance. He went down to the end of the block and approached the hotel once more. He paused to light a cigarette. Then, when he saw the doorman watching, he started toward him.

"If it's a job you want, son, take the employee's entrance in the alley," said the doorman before he could speak.

He muttered his thanks a bit unsteadily and proceeded around and through the alley. There was a sign over the door for which he was looking, and he went through it and followed other signs down the corridor to the employment office. Inside, two men and a woman, obviously other job seekers, sat at a long table filling out forms. A white-haired man in a dark suit, sitting behind a desk, looked at him and pointed to the wall. On it was another sign, a large one, instructing applicants to fill out one of the forms stacked on the long table, with pen and ink. He sat opposite the woman and studied the questions on the form. With some relief, he noted that there was nothing on the front that he couldn't adequately answer. As he turned it over, he saw the questions he couldn't answer. How was he to account for the past two years of the five for which they wanted such information as name of employer and work experience? What was he to put down as an alternative for military duty? There was no lie big enough to cover the enormity of his mistake. He put the form back on the stack and left without satisfying the questioning look on the face of the white-haired, dark-suited employment manager, because there really was nothing to be said.

Over a cup of coffee at a lunch counter, he examined the other two ads which he had selected for investigation. One was for a draftsman in a small, growing engineering office and the other for a helper in a bakery, the name of which he recognized as being among the larger ones. He figured that the bakery would give him a form to fill out just as the hotel had. As for the engineering office, if it wasn't a form, there would be questions. No matter how much or how long he thought about it, it seemed hopeless. Still, he could not stop. He had to keep searching until he found work. Somewhere, there was someone who would hire him without probing too deeply into his past. Wherever that someone was, it was essential that he find him.

Before further thought could reduce his determination to bitterness or despair or cowardice or utter discouragement, he boarded a trolley for fear that, if he took the time to walk back to the car, he would find a reason to postpone his efforts. The trolley, a trackless affair which drew its motive power from overhead wires, surged smoothly through the late morning traffic with its handful of riders.

It was a short ride to the new, brick structure which had recently been constructed in an area, once residential, but now giving way to the demands of a growing city. Low, flat, modern clinics and store buildings intermingled with rambling, ugly apartment houses of wood and dirt-ridden brick.

Striding up a path which curved between newly installed landscaping, Ichiro entered the offices of Carrick and Sons. A middle-aged woman was beating furiously upon a typewriter.

He waited until she finished the page and flipped it out expertly. "Mam, I . . ."

"Yes?" She looked up, meanwhile working a new sheet into the machine.

"I'm looking for a job. The one in the paper. I came about the ad."

"Oh, of course." Making final adjustments, she typed a couple of lines before she rose and peeked into an inner office. "Mr. Carrick seems to be out just now. He'll be back shortly. Sit down." That said, she resumed her typing.

He spotted some magazines on a table and started to leaf through a not-too-old issue of *Look*. He saw the pictures and read the words and turned the pages methodically without digesting any of it.

A muffled pounding resounded distantly through the building and he glanced at the woman, who met his gaze and smiled sheepishly. He returned to the flipping of the pages, wondering why she had smiled in that funny way, and she bent her head over the typewriter as soon as the pounding stopped and went back to work.

When the pounding noise came again, she muttered impatiently under her breath and went out of the room.

She was gone several minutes, long enough for him to get through the magazine. He was hunting through the pile of magazines in search of another when she stuck her head into the room and beckoned him to follow.

There was a big office beyond the door with a pile of rolled-up blueprints on a corner table and big photographs of buildings on the walls. They went through that and farther into the back, past a small kitchen and a utility room and, finally, came to stop by a stairway leading down into the basement.

"I told Mr. Carrick you were here. He's down there," the woman said, slightly exasperated.

As he started down, the same pounding began, only it was clearer now and he thought it sounded like a hammer being struck against a metal object of some kind. The object turned out to be what looked like a small hand-tractor with a dozer blade in front, and a small man with unkempt gray hair was whacking away at it with a claw hammer.

"Mr. Carrick?" It was no use. There was too much noise, so he waited until the man threw the hammer down in disgust and straightened up with a groan.

"Cockeyed," the man said, rubbing both his hands vigorously over the top of his buttocks. "I guess I'll have to take her apart and do it over right." He smiled graciously. "Doesn't pay to be impatient, but seems I'll never learn. That there blade isn't quite level and I thought I could force her. I learned. Yup, I sure did. How does she look to you?"

"What is it?"

Mr. Carrick laughed, naturally and loudly, his small, round stomach shaking convulsively. "I'm Carrick and you're . . . ?" He extended a soiled hand.

"Yamada, sir. Ichiro Yamada."

"Know anything about snowplows?"

"No, sir."

"Name's Yamada, is it?" The man pronounced the name easily.

"Yes, sir."

"*Nihongo wakarimasu ka?*"

"Not too well."

"How did I say that?"

"You're pretty good. You speak Japanese?"

"No. I used to have some very good Japanese friends. They taught me a little. You know the Tanakas?"

He shook his head. "Probably not the ones you mean. It's a pretty common name."

"They used to rent from me. Fine people. Best tenants I ever had. Shame about the evacuation. You too, I suppose."

"Yes, sir."

"The Tanakas didn't come back. Settled out East someplace. Well, can't say as I blame them. What brought you back?"

"Folks came back."

"Of course. Portland's changed, hasn't it?"

"I'm from Seattle."

"That so?" He leaned over the snowplow and tinkered with the bolts holding the blade in place.

Thinking that spring was not far away, Ichiro ventured to ask: "Does it snow that much down here?"

"How much is that?"

"Enough for a plow."

"No, it doesn't. I just felt I wanted to make one."

"Oh."

Adjusting a crescent wrench to fit the bolts, he grunted them loose and kicked the blade off. "Let's have some coffee." He rinsed off his hands at the sink and led the way up the stairs to the kitchen, where he added water to an old pot of coffee and turned on the burner. "The Tanakas were fine people," he said, sitting down on a stool. In spite of his protruding belly and gray hair, he seemed a strong and energetic man. As he talked, his face had a way

of displaying great feeling and exuberance. "The government made a big mistake when they shoved you people around. There was no reason for it. A big black mark in the annals of American history. I mean that. I've always been a big-mouthed, loud-talking, back-slapping American but, when that happened, I lost a little of my wind. I don't feel as proud as I used to, but, if the mistake has been made, maybe we've learned something from it. Let's hope so. We can still be the best damn nation in the world. I'm sorry things worked out the way they did."

It was an apology, a sincere apology from a man who had money and position and respectability, made to the Japanese who had been wronged. But it was not an apology to Ichiro and he did not know how to answer this man who might have been a friend and employer, a man who made a snow-plow in a place where one had no need for a snowplow because he simply wanted one.

Mr. Carrick set cups on the table and poured the coffee, which was hot but weak. "When do you want to start?" he asked.

The question caught him unprepared. Was that all there was to it? Were there to be no questions? No inquiry about qualifications or salary or experience? He fumbled with his cup and spilled some coffee on the table.

"It pays two-sixty a month. Three hundred after a year."

"I've had two years of college engineering," he said, trying frantically to adjust himself to the unexpected turn of events.

"Of course. The ad was clear enough. You wouldn't have followed it up unless you thought you could qualify and, if you did, we'll soon find out. Don't worry. You'll work out. I got a feeling." He pursed his lips gingerly and sipped his coffee.

All he had to say was "I'll take it," and the matter would be settled. It was a stroke of good fortune such as he would never have expected. The pay was good, the employer was surely not to be equaled, and the work would be exactly what he wanted.

He looked at Mr. Carrick and said: "I'd like to think about it."

Was it disbelief or surprise that clouded the face of the man who, in his heartfelt desire to atone for the error of a big country which hadn't been quite big enough, had matter-of-factly said two-sixty a month and three hundred after a year when two hundred a month was what he had in mind when he composed the ad since a lot of draftsmen were getting less but because the one who came for the job was a Japanese and it made a difference to him? "Certainly, Ichiro. Take all the time you need."

And when he said that, Ichiro knew that the job did not belong to him, but to another Japanese who was equally as American as this man who was attempting in a small way to rectify the wrong he felt to be his own because he was a part of the country which, somehow, had erred in a moment of panic.

"I'm not a veteran," he said.

Mr. Carrick creased his brow, not understanding what he meant.

"Thanks for the coffee. I'm sorry I bothered you." He pushed himself back off the stool.

"Wait." His face thoughtfully grave, Mr. Carrick absently drew a clean handkerchief from his trousers pocket and ran it over the coffee which Ichiro had spilled. He straightened up quickly, saying simultaneously: "It's something I've said. God knows I wouldn't intentionally do anything to hurt you or anyone. I'm sorry. Can we try again, please?"

"You've no apology to make, sir. You've been very good. I want the job. The pay is tops. I might say I need the job, but it's not for me. You see, I'm not a veteran."

"Hell, son. What's that got to do with it? Did I ask you? Why do you keep saying that?"

How was he to explain? Surely he couldn't leave now without some sort of explanation. The man had it coming to him if anyone ever did. He was, above all, an honest and sincere man and he deserved an honest reply.

"Mr. Carrick, I'm not a veteran because I spent two years in jail for refusing the draft."

The man did not react with surprise or anger or incredulity. His shoulders sagged a bit and he suddenly seemed a very old man whose life's dream had been to own a snowplow and, when he had finally secured one, it was out of kilter. "I am sorry, Ichiro," he said, "sorry for you and for the causes behind the reasons which made you do what you did. It wasn't your fault, really. You know that, don't you?"

"I don't know, sir. I just don't know. I just know I did it."

"You mustn't blame yourself."

"I haven't much choice. Sometimes I think my mother is to blame. Sometimes I think it's bigger than her, more than her refusal to understand that I'm not like her. It didn't make sense. Not at all. First they jerked us off the Coast and put us in camps to prove to us that we weren't American enough to be trusted. Then they wanted to draft us into the army. I was bitter—mad and bitter. Still, a lot of them went in, and I didn't. You figure it out. Thanks again, sir."

He was in the front room and almost past the woman when Mr. Carrick caught up with him.

"Miss Henry," he said to the woman at the typewriter, and there was something about his manner that was calm and reassuring, "this is Mr. Yamada. He's considering the drafting job."

She nodded, smiling pleasantly. "You'll like it here," she said. "It's crazy, but you'll like it."

He walked with Ichiro to the door and drew it open. "Let me know when you decide."

They shook hands and Ichiro took the bus back to the hotel. He had every reason to be enormously elated and, yet, his thoughts were solemn to the point of brooding. Then, as he thought about Mr. Carrick and their conversation time and time again, its meaning for him evolved into a singularly comforting thought. There was someone who cared. Surely there were others too who understood the suffering of the small and the weak and, yes, even the seemingly treasonous, and offered a way back into the great compassionate stream of life that is America. Under the hard, tough cloak of the struggle for existence in which money and enormous white refrigerators and shining, massive, brutally-fast cars and fine, expensive clothing had ostensibly overwhelmed the qualities of men that were good and gentle and just, there still beat a heart of kindness and patience and forgiveness. And in this moment when he thought of Mr. Carrick, the engineer with a yen for a snowplow that would probably never get used, and of what he had said, and, still more, of what he offered to do, he glimpsed the real nature of the country against which he had almost fully turned his back, and saw that its mistake was no less unforgivable than his own.

He blew a stream of smoke into the shaft of sunlight that slanted through the window and watched it lazily curl upward along the brightened path. Stepping to the window, he looked down for a moment upon a parking lot with its multi-colored rows of automobile hoods and tops. And beyond was the city, streets and buildings and vehicles and people for as far as the eye could reach.

Then he drew the shade and found himself alone in the darkness, feeling very tired and sleepy because he had been a long time without rest. It was all he could do to remove his clothes before he fell on the bed and let himself succumb to the weariness which was making him dizzy and clumsy.

He slept soundly, hardly stirring until he awoke in the quiet which was the quiet of the night, disturbed only by the infrequent hum of an automobile in the streets below. As the drowsiness faded reluctantly, he waited for the sense of calm elation which he rather expected. It did not come. He found that his thoughts were of his family. They were not to be ignored, to be cast out of mind and life and rendered eternally nothing. It was well that Kenji wished him to take the Oldsmobile back to Seattle. A man does not start totally anew because he is already old by virtue of having lived and laughed and cried for twenty or thirty or fifty years and there is no way to destroy them without destroying life itself. That he understood. He also understood that the past had been shared with a mother and father and, whatever they were, he too was a part of them and they a part of him and one did not say this is as far as we go together, I am stepping out of your lives, without rendering himself only part of a man. If he was to find his way back to that point of wholeness and belonging, he must do so in the place where he had begun to

lose it. Mr. Carrick had shown him that there was a chance and, for that, he would be ever grateful.

Crawling out of the bed, he switched on the light and started to search through the drawers of the dresser. In the third one he found a Gideon Bible, a drinking glass in a cellophane bag, and two picture postcards. Lacking a desk, he stood at the dresser and penned a few lines to Mr. Carrick informing him that, grateful as he was, he found it necessary to turn down the job. He paused with pen in hand, wanting to add words which would adequately express the warmth and depth of gratitude he felt. What could he say to this man whom he had met but once and probably would never see again? What words would transmit the bigness of his feelings to match the bigness of the heart of this American who, in the manner of his living, was continually nursing and worrying the infant America into the greatness of its inheritance? Knowing, finally, that the unsaid would be understood, he merely affixed his signature to the postcard and dressed so that he could go out to mail it and get something to eat.

Outside, he walked along the almost deserted streets. It was only a little after ten o'clock but there were few pedestrians and traffic was extremely light. He came to a corner with a mailbox and paused to drop the card. Lifting his eyes upward along the lamppost, he saw that he was on Burnside Street. In a small way, Burnside was to Portland what Jackson Street was to Seattle or, at least, he remembered that it used to be so before the war when the Japanese did little traveling and Portland seemed a long way off instead of just two hundred miles and the fellows who had been to Portland used to rave about the waitresses they had in the café on Burnside. He could almost hear them: "Burnside Café. Remember that. Boy, what sweet babes! Nothing like them in Seattle. Sharp. Sharp. Sharp."

He ambled up the walk past a tavern, a drugstore, a café, a vacant store space, a cigar stand, a laundromat, a secondhand store, another tavern, and there it was. Just as they said it would be, Burnside Café in huge, shameless letters plastered across two big windows with the door in between.

A young fellow in a white apron with one leg propped up on the inside ledge smoked his cigarette and looked out on the world, waiting for business to walk in. When he saw Ichiro, his eyes widened perceptibly. He followed the stranger through the door and said familiarly: "Hi."

Ichiro nodded and walked to the rear end of the counter where a middle-aged woman was standing on a milk box and pouring hot water into the top of a large coffee urn.

The young fellow pursued him from the other side of the counter and greeted him with a too-friendly grin: "Hungry, I bet." He plucked a menu wedged between the napkin holder and sugar dispenser and held it forth.

"Ham and eggs. Coffee now," he said, ignoring the menu.

"Turn the eggs over?"

"No."

"Ma, ham and eggs sunny side up." He got the coffee himself and set it in front of Ichiro. He didn't go away.

Thick as flies, thought Ichiro to himself with disgust. A Jap can spot another Jap a mile away. Pouring the sugar, he solemnly regarded the still-grinning face of the waiter and saw the clean white shirt with the collar open and the bronze discharge pin obtrusively displayed where the ribbons might have been if the fellow had been wearing a uniform.

"You're Japanese, huh? Where you from?"

He could have said yes and they would have been friends. The Chinese were like that too, only more so. He had heard how a Chinese from China by the name of Eng could go to Jacksonville, Florida, or any other place, and look up another Chinese family by the same name of Eng and be taken in like one of the family with no questions asked. There was nothing wrong with it. On the contrary, it was a fine thing in some ways. Still, how much finer it would be if Smith would do the same for Eng and Sato would do the same for Wotynski and Laverghetti would do likewise for whoever happened by. Eng for Eng, Jap for Jap, Pole for Pole, and like for like meant classes and distinctions and hatred and prejudice and wars and misery, and that wasn't what Mr. Carrick would want at all, and he was on the right track.

"I've got two Purple Hearts and five Battle Stars," Ichiro said. "What does that make me?"

The young Japanese with the clean white shirt and the ruptured duck to prove he wasn't Japanese flinched, then flushed and stammered: "Yeah — you know what I meant — that is, I didn't mean what you think. Hell, I'm a vet, too"

"I'm glad you told me."

"Jeezuz, all I said was are you Japanese. Is that wrong?"

"Does it matter?"

"No, of course not."

"Why'd you ask?"

"Just to be asking. Make conversation and so on. You know."

"I don't. My name happens to be Wong. I'm Chinese."

Frustrated and panicky, the waiter leaned forward earnestly and blurted out: "Good. It makes no difference to me what you are. I like Chinese."

"Any reason why you shouldn't?"

"I didn't say that. I didn't mean that. I was just trying to . . ." He did a harried right face and fled back toward the window grumbling: "Crissake, crissake . . ."

A moment later, the woman emerged from the kitchen with his plate and inquired in Japanese if he would like some toast and jam. She did it very naturally, seeing that he was obviously Japanese and gracefully using the tongue which came more easily to her lips.

He said that would be fine and noticed that the son was glaring out of the window at a world which probably seemed less friendly and more complicated than it had been a few minutes previously. The woman brought the toast and jam and left him alone, and he cleaned the plate swiftly. He would have liked another cup of coffee but the greater need was to get out and away from the place and the young Japanese who had to wear a discharge button on his shirt to prove to everyone who came in that he was a top-flight American. Having the proper change in his pocket, he laid it and the slip on the little rubber mat by the cash register and hurried out without seeing the relief-mixed-with-shame look on the waiter's face.

From the café he walked the few steps to the tavern next door and ordered a double shot of whisky with a beer chaser. He downed both, standing up, by the time the bartender came back with his change, and then he was out on the street once more. On top of the ham and eggs and toast with jam, the liquor didn't hit him hard, but he felt woozy by the time he got back to the hotel. He had to wait in the elevator for a while because the old fellow who ran it also watched the desk and was presently on the telephone.

On the way up, the old man regarded his slightly flushed face and smiled knowingly. "Want a girl?" he asked.

"I want six," he said, hating the man.

"All at one time?" the old man questioned unbelievingly.

"The sixth floor, pop." The hotness in his face was hotter still with the anger inside of him.

"Sure," he said, bringing the elevator to an abrupt halt, "that's good. I thought you meant you wanted six of them. That is good."

The old man was chuckling as Ichiro stepped out of the elevator and headed toward his room.

"Filthy-minded old bastard," he muttered viciously under his breath. No wonder the world's such a rotten place, rotten and filthy and cheap and smelly. Where is that place they talk of and paint nice pictures of and describe in all the homey magazines? Where is that place with the clean, white cottages surrounding the new, red-brick church with the clean, white steeple, where the families all have two children, one boy and one girl, and a shiny new car in the garage and a dog and a cat and life is like living in the land of the happily-ever-after? Surely it must be around here someplace, someplace in America. Or is it just that it's not for me? Maybe I dealt myself out, but what about that young kid on Burnside who was in the army and found it wasn't enough so that he has to keep proving to everyone who comes in for a cup of coffee that he was fighting for his country like the button on his shirt says he did because the army didn't do anything about his face to make him look more American? And what about the poor niggers on Jackson Street who can't find anything better

to do than spit on the sidewalk and show me the way to Tokyo? They're on the outside looking in, just like that kid and just like me and just like everybody else I've ever seen or known. Even Mr. Carrick. Why isn't he in? Why is he on the outside squandering his goodness on outcasts like me? Maybe the answer is that there is no in. Maybe the whole damned country is pushing and shoving and screaming to get into someplace that doesn't exist, because they don't know that the outside could be the inside if only they would stop all this pushing and shoving and screaming, and they haven't got enough sense to realize that. That makes sense. I've got the answer all figured out, simple and neat and sensible.

And then he thought about Kenji in the hospital and of Emi in bed with a stranger who reminded her of her husband and of his mother waiting for the ship from Japan, and there was no more answer. If he were in the tavern, he would drink another double with a beer for a chaser and another and still another but he wasn't in the tavern because he didn't have the courage to step out of his room and be seen by people who would know him for what he was. There was nothing for him to do but rollover and try to sleep. Somewhere, sometime, he had even forgotten how to cry.

LAWSON FUSAO INADA

A third-generation Japanese American from Fresno, California, Lawson Inada (1938–) is the Poet Laureate of Oregon. During World War II, he and his family were interned in camps in three states. He graduated from Fresno State University and the University of Oregon and is a professor of English at Southern Oregon University. A co-editor of The Big AIIIEEEEEEE! *(1975), a groundbreaking collection of Asian American writings, Inada is the author of* Before the War: Poems As They Happened *(1971), the first book of Asian American poetry published by a major American press. His* Legends From Camp *(1992) received the American Book Award and two National Endowment for the Arts Poetry Fellowships. In 2004, he was a Guggenheim Fellow in Poetry. "The Flower Girls," a short story, depicts the precarious relationship between two young Portland girls at the beginning of World War II.*

The Flower Girls

I. The Meeting

This is the story of Cherry and Rose, the two little girls who were almost sisters. They were almost twins, actually, because although they came from different families, they were both born on the very same day in the very same city of Portland, Oregon.

They met in the first grade on the very first day of school. They sat in the front row, right next to each other. They both had on pink dresses and white shoes. They even had their hair combed the same way—parted right down the middle. When the teacher saw them, she said, "Well, well, well—so you're Cherry, and you're Rose. Looks like we have a couple of real flower blossoms here. Why, I'll just call you my Flower Girls—and you can help me right now by passing out these pencils to the class. Come on, Flower Girls—let's go!"

Naturally, Cherry and Rose became best friends. From the very first day, they did everything together. They did very well in school, they ate lunch together, and during recess they jumped rope, played jacks, and played hopscotch together. They were good at things by themselves, but together they were even better.

II. After School

Now in those days, everyone walked home after school. The kids all lived close to school, but they went in different directions. Cherry went one way, and Rose went another. But one day, when school was over, Cherry said to Rose, "Rose, why don't you ask your mother if you could come over to my house to play tomorrow? I live just down over there and around the corner. We could have lots of fun, and I'll walk you home for dinner. Okay?"

"Okay!" said Rose.

So the next day, Rose went home with Cherry. As they got close, Cherry said, "I bet you can't guess where I live."

Rose said, "Over there?"

Cherry said, "No, silly—that's a newspaper office. Guess again."

Rose said, "Over there?"

Cherry said, "No, silly—that's the fish store. Guess again."

Rose said, "Over there?"

Cherry said, "No, silly—that's the manju-ya. You only get one more guess."

Then Rose said, "Well, how about that place?"

"Right," said Cherry.

"But what does that sign say?" said Rose.

"Don't be silly," said Cherry. "That sign says 'Sakura Tofu Company.'"

"But what does that mean?" said Rose.

"Don't be silly," said Cherry. "That means 'Cherry Blossom Tofu Company.'"

"But what is a tofu?" said Rose.

"Don't be silly," said Cherry. "A tofu is a tofu, don't you know?"

"But where do you live?" said Rose.

"Don't be silly," said Cherry. "We live in back of the store. Come on! My mom is waiting!"

Sure enough, Cherry's mom was waiting for them. A little bell tinkled when they went into the store. Cherry's mom said, "My, oh my—don't you Flower Girls look pretty today! Cherry, here's ten cents for you and Rose to spend. Why don't you show your friend around?"

"Okay!" said Cherry. "Let's go!"

III. Snow Cones and Manju

The girls had a great time that afternoon. It was a nice, warm day, and they walked around the busy neighborhood, looking in stores and saying hello to people. After a while, Rose said, "Cherry, what are we going to do with the ten cents?"

Cherry said, "Come on—I'll show you!"

They went into the place called the manju-ya. There were many good things to eat on the shelves—everything looked so pretty and colorful, and everything smelled so good and tasty. Rose said, "Boy, oh boy—I've never seen anything like this! What are we going to get?"

Cherry said, "I'll show you."

When the man came out from the back, Cherry said, "We'll have two snow cones, please—with rainbow flavors."

The man went over to the snow-cone machine, put in a big, shiny piece of ice, and cranked the ice around and around. He made snow, scooped the snow into paper cones, and poured all the flavors of the rainbow on top of the snow. The girls watched with wide-open eyes, and licked their lips.

Cherry gave the man ten cents, and they got their cones. Then the man said, "Just a minute." He got a small paper bag and put in some of the prettiest manju for them to take home, for free.

Naturally, the girls said, "Thank you, very much!"

They had to eat the snow cones pretty fast because it was a hot day, but if they ate too fast, it hurt their heads. So they walked down the sidewalk very slowly, being careful to eat with good manners, to not slurp too much, and to not spill anything on their dresses. Rose bumped into an old lady coming out of the fish store, but since nothing was spilled, they all laughed.

At the street corner, though, as they were finishing their snow cones, tipping the cones upside-down, Rose looked at Cherry and started to laugh.

"What's the matter?" said Cherry.

"You should look at your mouth!" said Rose.

"You should look at *your* mouth!" said Cherry.

And both girls went and looked into a mirror in the window of the beauty shop. They laughed when they saw their colorful mouths. They laughed some more when they saw some old ladies inside with curlers on their heads. The old ladies were laughing at them.

On the way to Rose's house, they stopped in the park and sat on a bench.

Rose said, "I hope that snow cone won't spoil my supper. Now why don't we try some of that stuff in the bag?"

Cherry said, "Sure." They shared bits of one that was very soft and white, with something sweet and red inside. Cherry said, "Why don't you take the rest home to your mother?"

"Okay!" said Rose.

IV. Shaving the Ice

Rose had a lot to tell her mother that night about her best friend's neighborhood, and, before long, Rose was visiting Cherry almost every day after school. They played in Rose's neighborhood, too, doing what they called the "regular things"—like going to the grocery store, going to the butcher shop, and walking by the noisy factory full of big machines and boxes—but they both agreed that Cherry's neighborhood was much more interesting, so they played there most of the time.

At school, their teacher said, "My, oh my—you Flower Girls are almost like a secret club, always talking about things like 'manju' and 'tofu.' Can you girls explain some of that to me and the class?"

Rose said, "Manju is manju and tofu is tofu, but eating a snow cone is like eating Mount Hood!" Everybody laughed. Then Rose said, "And after eating a snow cone, you look like a clown because your mouth is all orange and purple and red!" Everybody laughed. Everybody wanted to try eating a snow cone.

Then the teacher said, "Class, a snow cone is just shaved ice." That made the class laugh even more, because who ever heard of shaving the ice?

One boy put his hand up and said, "Teacher, my daddy shaves his face every morning, but I didn't know that the ice had to shave!" Everybody laughed again.

V. Learning Names

As the year went by, all the children learned to read and write and count at school. But the Flower Girls also learned how to count in Japanese, from Cherry's mother, and they could point to their fingers and say "ichi, ni, san, shi" just like that. Then Cherry's mother taught the Flower Girls how to write their names in Japanese. It took practice, over and over, because it was almost like drawing a picture, but when they learned how to do it right, their names looked very fancy, very beautiful, and the Flower Girls felt very special when they showed the kids at school. The other kids tried to write their names in Japanese, too, and made a lot of funny marks on paper. The teacher couldn't write her name, either.

Cherry's mother was like a teacher at home, but a fun teacher, and she would explain things to the girls as they went with her to make deliveries. They would walk down the sidewalks carrying packages of tofu, and when

Cherry's mother got paid, the girls would also say, "Arigato." That always made the customers smile.

Sometimes, the girls would play with dolls in the kitchen in back of the tofu store, and Cherry's mother would teach them interesting things like how to make cinnamon toast without burning the toast or spilling the cinnamon, or how to blow soap bubbles without making too much of a mess, or how to make glue and clean up afterwards, or how to answer the phone even though your mouth is full of peanut butter, or how to fold and cut newspapers into snowflakes and birds.

One day, Cherry's mother told the girls that Japanese names had very interesting meanings in Japanese, like "Ricefield" and "Pine Forest" and "Mountain River" and "Rocky Seashore." She said that everybody's name means something, and that names like "Portland" and "Multnomah" and "Oregon" mean something, too. And the same for "Columbia" and "Willamette" and "Roosevelt" and "Studebaker" and "Chevrolet" and "Ford."

"How about 'Burnside'?" asked Rose.

"Yes," said Cherry's mother, "that must mean something, too."

"How about 'Atkinson School'?" said Cherry.

"Yes, that must mean something, too," said Cherry's mother. "And the same for 'Atlantic' and 'Pacific' and 'Blitz Weinhard' and 'Jantzen Beach' and 'Washington Park' and 'Meier and Frank.' "

"How about 'Nabisco'?" said Cherry.

"Yes," said Cherry's mother, "that just means National Biscuit Company. Na-Bis-Co—you get it?"

"Sure we do!" said the Flower Girls.

VI. More Places and Names

Actually, Cherry's neighborhood had so many people, places, and names that the girls couldn't remember everything. There were places upstairs, there were places downstairs; there were places in front, there were places out back. There were barbershops, beauty shops, bathhouses, laundries, fish markets, dry goods stores ("What's dry goods?" asked the girls), grocery stores, stores full of appliances, shoe repair shops, auto repair shops, many restaurants, very many hotels, one newspaper office called the *Oh Shu*, one newspaper office called the *Nippo*, another newspaper office called the *Ka Shu*, doctors' offices, dentists' offices, and pharmacies ("What's a pharmacy?" asked the girls).

Sometimes, the Flower Girls would just walk around, saying names like songs. "*Oh Shu* and *Nippo* and *Ka Shu*—step right up and get your latest news!" At other times, they would play a game to see if they remembered all the churches. Portland Buddhist Church—that was easy. It was also called Bu-kyo-kai. Then there was Japanese Methodist Church—that was easy. But how about Ken-jyo-ji, Kon-ko-kyu, Minori-nakai, Nichiren, and Sei-cho—

those were not as easy. So the girls would have to count them all on their fingers, like a test, and they would always pass.

One time, Cherry's mother said, "Girls, listen to the names of these clubs: Fukuoka-kenjinkai, Hiroshima-kenjinkai, Okayama-kenjinkai, Wakayama-kenjinkai, and Nippon-kenjinkai. Do you think you can remember all that?"

And the girls said, "Sure! We'll try! Say those again! You can't trick us!" And Cherry's mother said, "Well, go-men-na-sai, Flower Girls!"

VII. The Dog Named Cat

One day, when Rose got home, she told her mother, "Mother, did you know that Cherry has a new puppy? It's brown and very soft and furry, but guess what she named it?" Her mother couldn't guess, so Rose said, "Cherry wanted a kitten instead, but since she's allergic to cats, she named her puppy Nekko. And Nekko means 'cat.' Do you get it, huh? Do you get it? Isn't that funny? Don't you think that's funny? She has a dog and a cat at the same time!" And then, after a while, Rose said, "Mother, can I get a dog or a cat?"

Another day, Rose came home and said, "Mother, did you know that I was a hakujin? That's just what I am. And Cherry is a nihonjin. That's what she is. That's all. But we're both Americans. Isn't that interesting? And Cherry's mother says that we're *both* her Flower Girls."

Another time, Rose said, "Mother, did you know that where Cherry lives is called Shi-ta Machi? That means 'bottom town' or under or below. Isn't that interesting? Cherry's mother says that's because they live down by the river."

VIII. The Creature in the River

The teacher read a story to the class about the man in the moon. After it was over, Cherry raised her hand and told the class, "My mother says there is not a man in the moon but instead there are two rabbits with their hammers pounding rice." Some kids said that wasn't true, but Cherry said that when the moon was full they should go outside and *see* those rabbits that her mother showed her.

Cherry also said, "My mother says that the kappa is a creature who lives in the Willamette River. When you go down by the river, you can see his tracks. The kappa lives in the river, swimming under the boats and bridges, but he walks around on land at night. He likes to dump over garbage cans and play tricks on people."

One boy asked if the kappa likes to hurt people. Cherry said, "No, because he likes kids, but not even the police can catch him."

Another boy asked Cherry if she had seen the kappa.

Cherry said, "No, because I can't stay up at night. But one time I heard him. And in the morning, the garbage can was turned over."

One boy said that he had seen the kappa late at night, and that the kappa

was big and hairy like a monster. Cherry said, "No, that's not the kappa, because the kappa is small, like a first-grader. Besides, he has a shell, like a turtle."

One girl asked if the kappa wore any clothes.

Cherry said, "No." Everybody laughed. Then Cherry said, "But you have to look out, because the kappa is very strong."

Then one boy said, "If the kappa ever came to my house, me and my dad would beat him up, just like that!"

Another boy said, "I would shoot him with a gun! Boom!"

And Cherry said, "Nobody could ever shoot or catch the kappa, because he's too fast. He could jump right into the river and swim right back to Japan. Or, if he wanted to, he could put on some clothes and walk around in a disguise, like a man."

One girl raised her hand and asked, "But why does he tip over garbage cans? Does he eat garbage?"

Cherry said, "No, he just does that, for fun."

One boy said, "But if he wears a disguise, how does he hide his face?"

Cherry said, "He wears a big, black hat. Besides, he could change his face to look like a man. And he wears a big overcoat to cover his shell."

Rose said, "One time, me and Cherry found a big overcoat in the alley. We didn't touch it. We ran home! The next day, it was gone!"

Everybody was quiet.

IX. The Celebrations

One day, after New Year's, Cherry told Rose that there was going to be a Girl's Day celebration in Shi-ta Machi, and that there would be many beautiful dolls on display, but not to play with. Then there was also going to be a Boy's Day when everybody would go on a picnic to a place called Montevilla, out in the country, to fly kites and play games, and that Rose could come with them. Then Cherry said that they could both dance in the Cherry Blossom Festival, too, but they would have to practice dancing after school.

"Oh, that will be fun," said Rose. "Yes," said Cherry, "and we also get to wear special clothes." Rose couldn't wait to get home to tell her mother. On the way home, she sang her own cherry blossom song. "Sakura, sakura," she sang, as she skipped along. "Sakura, sakura. . . ."

The Flower Girls had a lot of fun at those special celebrations, and everybody said, "My, you Flower Girls are so beautiful!"

And one day, in the summer, Rose came home and told her mother, "Mother—guess what! Our teacher says we get to be in the Rose Parade! Isn't that great? We get to ride on a float! And Cherry says she's going to ride on the Shi-ta Machi float! Her float is going to have roses, too, but it is also going to have lots of fruits and vegetables on it, like strawberries and radishes and onions! Oh, I can't wait! Won't that be neat?"

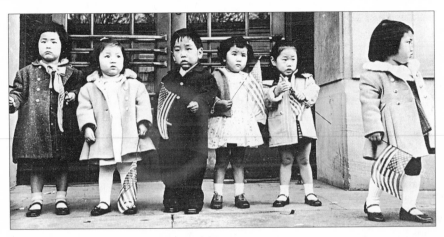

Children watching a parade in Portland in about 1963

X. In the Second Grade

So the Flower Girls rode in the Rose Parade, and they had a lot of fun playing together all that summer. Then, when school started again, they were both in the same class in the second grade, and they even sat in the same front seats, right next to each other. On the first day, the new teacher said, "Well, well, well—looks like we have the Flower Girls together again. Now, Flower Girls, will you help me pass out these brand-new books?"

School was so much fun, as usual, but one day, after Thanksgiving, when the class was going to start practicing on a Christmas play about Santa Claus and all the good little children, the teacher said, "Class, as you all know, America is having a war against Japan. But let's be good boys and girls and put on the best Christmas play we can. Okay?"

And all the kids said, "Okay!"

But that day, at recess, there were fights among the older kids in the playground, and a lot of kids got called "Jap!" Then a sixth-grade girl came up to Rose and Cherry and said, "You guys aren't supposed to play together because *she's a Jap* and *you're enemies!*"

And Rose said, "No we're not! *We're friends!*"

And the older girl said, "No you're not! You're enemies! You're having a war! Ha, ha, ha—you're having a war-ar! You're having a war-ar! Boo hoo hoo! Enemies, enemies, enemies! Ha, ha, ha—you're having a war-ar!"

XI. Just Because

The Christmas play was canceled, and it was not a very happy Christmas for anybody. The Flower Girls did not visit each other anymore, and one day,

after New Year's, Cherry said to Rose, "We're not going to have a Girl's Day or a Boy's Day or a Cherry Blossom Festival this year."

And Rose said, "Why not? How come?"

And Cherry said, "Just because. Because we're having a war."

Then, on a fine, spring morning, the teacher said, "Class, as you know, some of you kids are going to be moving away soon, so this week let's all have a real nice good-bye party, okay?"

Nobody knew what to say.

At recess, Rose said, "Cherry, where are you going?"

Cherry said, "I don't know."

Rose said, "What do you mean you don't know? How come you don't know?"

"Because I don't know, stupid!" said Cherry. "All I know is that we're going down the river."

"But how come you're going down the river?" said Rose.

"Because we're going down the river, stupid!" said Cherry. "Because we're going to war."

"But how come you're going to war?" said Rose.

"Because we're Japs, stupid!" said Cherry.

"But how are you going?" said Rose. "I know—maybe you get to float on a boat! Maybe you get to float on a float!"

"Don't be stupid, stupid!" said Cherry. "I bet you wouldn't want to go."

"Yes, I would!" said Rose.

"That's because you're stupid, stupid!" said Cherry.

"I'm not stupid!" said Rose.

"Yes, you are!" said Cherry. "You're stupid, stupid, stupid!"

The next day, Cherry said to Rose, "Rose, my mother wants to know if you could take care of Nekko for us."

"Why?" said Rose.

"Because we can't take her with us, stupid!" said Cherry.

"Why not? How come?" said Rose.

"Just because!" said Cherry. "Just because!"

XII. The Letters

On a warm, beautiful summer day, the mailman brought a letter to Rose. The letter said:

Dear Rose,

How are you? I am fine. How is Nekko? This place stinks. P U GARBAGE. Are you my friend? I can see Portland.

> *Your friend,*
> *Cherry*

With the help of her mother, Rose wrote a letter back to Cherry. The letter said:

Dear Cherry,

How are you? I am fine. Nekko got ran over. She went to heaven. I am your friend. You are in the map of Portland.

Your friend,
Rose

XIII. More Letters

On a lovely fall day, with a warm wind blowing, Cherry sat up in a bed and wrote a letter. The letter said:

Dear Rose,

How are you? I am fine. I am in the third grade. Who is your teacher? My teacher is American. We live in Idaho. I went to the hospital. This is my picture of you and Nekko. She is eating a manju. You are eating a snow cone. This is my picture of you in the Rose Parade. The float is beautiful. You are my friend.

Your friend,
Cherry

The letter was never answered.

XIV. No One Knows

No one knows what happened to Cherry. No one knows what happened to Rose. Shi-ta Machi is no more. The buildings are still there, with different stores and businesses in them, but the Shi-ta Machi people did not return to Shi-ta Machi. Shi-ta Machi is no more.

There are still Shi-ta Machi people, though, living in all parts of the city, and if you want to see Shi-ta, you have to look deep into the eyes of the Shi-ta Machi people. You have to look deep into the eyes, under the surface; you have to look deep below the surface of the shining eyes. You have to look deep down to the bottom of the eyes of the Shi-ta Machi people, and you will see Shi-ta Machi shining in their eyes. You will see the shining streets, the sidewalks full of people. You will see children like Cherry and Rose, playing after school.

You will see the tofu store, you will see the manju-ya (you can even smell the sweet manju, you can even hear the manju-man shaving the ice, you can even taste the snow cone, oh, so cold, with all the flavors of the rainbow). You can walk down the sidewalks past all the stores and offices, and when you stop at the corner, you can look into the window of the beauty shop and see your face in the mirror.

Then, in the blink of an eye, Shi-ta Machi will be gone. Shi-ta Machi is no more.

XV. The Song of Cherry and Rose

There is a beautiful park in the hills of Portland. It is full of trees and lawns, with many places to sit and play and walk and run. In one part of the park is

a Japanese garden, full of beautiful plants and rocks, with a beautiful pond. In the Japanese garden, a very special cherry tree grows.

In the same part of the park, there is a beautiful rose garden. There are roses with all the colors of the rainbow, and in that garden grows a very special rose.

When the park is quiet, you can walk through the Japanese garden, and you can hear the wind blow. When the park is quiet, you can walk through the rose garden, and you can hear the wind blow.

The song you hear is the song of Cherry and Rose.

It is a beautiful song of friendship, of being best friends together, of going to school together, of playing together, of growing up together. It is a beautiful song of being the Flower Girls, of being sisters. It is a beautiful song of becoming women together, of always being sisters.

The song you hear is the song of Cherry and Rose.

XVI. The Continuing Story

On a fine summer day, a family was on a picnic in the park. After lunch, the little girl said, "Mother, I'm going for a little walk through the rose garden. Okay?"

The little girl went walking through all the beautiful roses. Everything smelled like roses, felt like roses, everything was colored like roses. When the little girl was right in the middle of the rose garden, right when she was sniffing a big, red rose, she looked up and saw another little girl doing the same thing.

Both girls said "Hi!" at the same time. One girl said, "My name is Cherry. What's your name?"

The other girl said, "My name is Rose."

And Cherry said, "Do you want to walk over to the Japanese garden?"

And Rose said, "Okay. I'll ask my mother."

And Cherry said, "Okay. I'll ask my mother."

And Rose said, "Okay. I'll meet you back here. Okay?"

And Cherry said, "Okay. I'll meet you back here."

And off they went.

MARIE ROSE WONG

With degrees in planning and development from Iowa State University, the University of Colorado, and the University of Washington, Marie Rose Wong (1954–) understands cities. She is an associate professor of Urban Studies and Asian American History at Seattle University, where she is the director of the bachelor's degree program in the Institute of Public Service. The author of Sweet Cakes, Long Journey: The Chinatowns of Portland, Oregon *(2004), Wong is currently working on a book that examines residential hotels in Seattle's Chinatown and International District. She is also collaborating on an article about the Chinese burial site at the Lone Fir Cemetery in Portland. The encroachment of the Pearl District and the city's transportation improvement project, Wong worries, is detrimental to Portland's historic Chinatown, making "it pretty clear that the spirit and urban fabric of Chinatown is dying." In these excerpts from* Sweet Cakes, Long Journey, *Wong examines the history of Portland's Chinese community and considers the relationship of Portland's "Old Chinatown" to its "New Chinatown."*

From *Sweet Cakes, Long Journey*

The current Chinatown of Portland, Oregon, is a modest district within the downtown, and most people are not even aware that such an area exists. Chinatown lies west of the Willamette River and covers a rectangular area of ten blocks. Its borders are Glisan Street to the north, Third Avenue to the east, Burnside Street to the south, and on the west, Fifth Avenue. Like many Chinatowns, it is fighting to retain its historic ethnic identity and preserve the economic viability of its shops and restaurants under the pressures of urban change. It struggles with transient populations attracted to nearby neighborhood missionary organizations and X-rated facilities that discourage pedestrian traffic.

It has the official Chinatown Gateway, a striking piece of artistic cultural expression that is not present in all Chinatowns. Adorned with golden glazed tiles on the five tiers of its pagoda-style roofs, the structure marks the entrance to the district at Fourth Avenue and N.W. Burnside. The gateway, dedicated in 1986, is thirty-seven feet high and sixty feet wide, one of the largest of its kind in any U.S. city. Its contemporary building materials display the traditional red and gold colors, and it is flanked by lions that guard the passageway. Among other intentions, the gateway commemorates those Chinese immigrants who first settled in the city and contributed to the development of the state. But the present Chinatown district in Portland is not the original settlement site of the first group of immigrant Chinese who made that city their home.

In beginning the study of Portland's Chinatown, I became aware that many longtime residents assume that the area referred to as "New China-

town," which they see today, is the one that has always been there. Most certainly, this is not the case. But then, given Portland's history of development and redevelopment and the efforts made to preserve many of the historic downtown buildings, who would guess that an entirely different urban and social community ever existed within the current business and financial district? That first Chinatown is an *extinct* urban environment, meaning that the majority of its buildings have long ago and over a period of time been removed or altered. And that first generation of Chinese immigrants has all passed away, leaving behind generations of Chinese Americans who may or may not be able to conjure up the remnants of stories about the lives of those first Chinese settlers.

In the few accounts that mention the ethnic district of "Old Chinatown," there is consensus that the community inhabited a demarcated enclave area, but its precise location has been a mystery. The size is also approximated in textual references, sometimes described as a twelve-block area south of Burnside Street or as an area that occupied as many as thirty-five blocks downtown. In all cases, it is depicted as rectangular and similar to the urban pattern of San Francisco's Chinatown or the current Chinatown in Portland's central city. Even the location of the core business area of the first Chinatown has been uncertain, identified as being at First and Washington Streets or at Second and Alder Streets. All these speculations and approximations have left a central question: Where was Portland's first Chinatown? . . .

[B]efore the turn of the twentieth century and for many years after, Oregon's Chinese population was the second largest in the United States. Geographically, the community had an amorphous urban shape and was the largest Chinatown in the nation by the 1900s. Moreover, and unlike any other Chinese American settlement, Portland possessed two spatially and economically independent Chinese immigrant districts. One was urban and the other rural, and both were thriving within the city limits during the same period of time.

As with other cities with Chinese American communities, Portland was subject to the same national political and economic influences that dictated immigration policy between 1870 and 1943, which in turn affected the social and urban development of the community. Primary among these influences were organized labor unions, public reactions to economic recessions, and legislative lobbying that culminated in a series of federal exclusionary laws. Enacted between 1882 and 1904, these laws curtailed Chinese immigration and eroded family life by severely restricting and eventually eliminating the immigration of laborers' and merchants' wives, thus reinforcing and perpetuating a skewed male-to-female demographic profile for a community that was already primarily male. These exclusionary policies combined with

antimiscegenation laws in the western states to encourage moral collapse in the immigrant district, with prostitution, gambling, opium use, and graft replacing the long-standing tradition of extended family units. The fact that such vices became a part of day-to-day living for these "bachelors" is not surprising, nor is it amazing that Chinatown earned the reputation of being a dark, depraved, and disgusting environment where decent people would not go.

But these same federal laws affected the Chinese and their settlements differently in Portland than in San Francisco and other towns in the Pacific Northwest. The resultant spatial structure was created out of interactions between the white community, local politics, and, most significantly, public opinion and popular media, which shaped the city's viewpoint on future growth and how to pursue it. These key factors contributed to the social and urban morphological development of the Chinese community, which created a different urban pattern in Portland than in any other city. . . .

Because the Chinese faced so much adversity, violence, and discrimination, it is popularly assumed that they were "sheep," docile and submissive, easily led, who somehow accepted the abuse of vigilantes and the American justice system. They have also been portrayed as a people without property, with no stake in community life other than what was to be found in the urban ghettos of Chinatowns, and with few controls over their urban location. Without question, the obstacles they faced represented daily challenges, as immigration laws closed their communities and random acts of prejudice reshaped their occupations, traditions, and lifestyles. While all Chinese faced hardships in all settings, rural as well as urban, it is more accurate to assess these conditions relative to the peer white community. . . . The Chinese had the ability to choose and, to a high degree, to manipulate the system. There is substantial evidence to indicate that the Chinese in Portland had the opportunity to advance socially and could connect with a politically savvy and active community that fought for social justice. They were involved in decisions relevant to operations within Chinatown and the location of Chinatown buildings. Some Chinese immigrants and their American-born children also achieved substantial economic and professional success alongside Portland's white merchant society.

As history continues to be written, these individuals and the uniqueness of their Chinatown will find a well-deserved place in the chronicles of American urban development as an ethnic group that helped build and shape Portland and Oregon through their labor and their commitment to the overall community. . . .

District associations had been active since the early arrival of the Chinese in the 1850s. They provided emigrants with loans to help pay off the sums they

owed to employers for their tickets to the United States. Laborers used bank drafts and money orders from district associations to send part of their earnings to China to help support extended families. The associations assisted in finding jobs, aided the sick and elderly, established schools, functioned as arbitrators in disputes among the Chinese, and arranged for the shipment of bodies to China for burial.

Portland citizenry viewed this last practice as peculiar but recognized that it honored the final request of a dying man. In Portland, the Chinese burial ground was a segregated three-acre section of the Lone Fir cemetery, located to the far west of the downtown. In many cases, interment here was merely temporary until the remains could be exhumed, placed in zinc containers, marked, and sent back to China for permanent burial.

In 1869, the *Oregonian* had already recognized Chinese associations as filling a critical need that was not being met by American courts. There were considerable differences between the treatment received by Americans in China and the treatment received by Chinese in America. For example, disputes involving Americans in China were handled through consular courts, with the Chinese empire waiving its jurisdictional rights of interference and powers of arbitration. In America, however, the situation was very different, and the Chinese Consolidated Benevolent Association (CCBA) served as a major forum for arbitrating disputes in Chinatown and also hired white attorneys to handle legal matters involving the peer community.

In San Francisco, the CCBA consisted of representatives from six of the largest district associations and was known as the Chinese Six Companies. Formed in the 1860s as an arbitrating board responsible for resolving disputes between family and district associations, it was supported and supervised by the Chinese merchant society. These merchants made sure that individuals in the community contributed financially to Six Companies programs and collected taxes from immigrants who were returning from visits to China. In addition to settling internal disputes, the Six Companies, in many respects, was the entity that pursued equal justice for the Chinese in America, particularly before consular offices were established. In these years, the Six Companies served as a direct link between Chinese immigrants in the United States and the Chinese imperial government.

Portland's consolidated benevolent association, a branch of the CCBA, was known as the Jung Wah Association. The Jung Wah constituted the collective voice of the community; it hired white attorneys to represent community members in legal matters, including issues of broad interest such as restrictive immigration legislation and unfair treatment by immigration officials, and sought recompense for violent acts against the Chinese and their properties. In 1882, in the wake of tightened immigration, the Six Companies acted as a labor contractor and arranged for the arrival of 6,000 Chinese workers in Oregon at the request of the Northern Pacific Railroad.

Family associations were made up of people who were related by blood or marriage and who shared the same surnames. Similar in function to district associations, family associations helped set up communal boardinghouse-type living arrangements in which the all-male residents shared expenses.

The tong was the most mysterious and secretive of the three types of organizations, and the behavior of its members ranged from the defiant to the illegal. Possibly modeled on the Triad Society of 1674 in Guangdong province, tongs were founded in the early 1850s in California. Originally, they were antiestablishment in political stance, and one of their aims was to overthrow the Manchu dynasty in China. In America, tong membership was based on a common interest rather than on the blood or family ties that defined district and family associations. Tongs were involved in the illegal operations of Chinatown, and they frequently opposed decisions made by the Six Companies. Some tongs functioned as defensive organizations and were formed by family associations or merchants to supply paid protection for members and businesses. As representatives of the Chinatown under-world, they often used force and covert methods when settling disputes. Sel-dom were their actions in the best interests of the overall community. Some tongs earned the dubious distinction of being involved in smuggling, opium dens and houses of prostitution, and the racketeering associated with games of chance such as fan-tan, faro, and lotteries. Sadly, these activities flourished primarily because of the preponderance of males seeking relief, relaxation, and companionship within Chinatown. The illegal nature of these ventures made them all the more lucrative and therefore attractive to both Chinese and whites. When rival tongs fought for control over these businesses and territories, conflict was rarely limited to the city where the dispute origi-nated. What began as a local tong war quickly spread to other Chinatown districts as the interests of various tong members expanded to other cities. The ensuing fighting and rumors about the tongs made Chinese districts appear to be dangerous places and deepened the scorn and mistrust of white society.

Given that the physical characteristics of the Chinese and their organiza-tional structures were viewed as overwhelmingly strange, it is not surpris-ing that their environments were attacked as the urban dens of a depraved people. The Chinese could change their manner of dress by adopting a West-ernized expression, but their language, physical appearance, and traditions were not altered by the dominant white European culture in America. Being perpetual foreigners prevented their complete acceptance or acculturation into any community, and in many West Coast cities, their contributions toward industrial and urban development were ignored by the peer society, a misconception that is just now beginning to be corrected.

PORTLAND PROPER

Neighborhoods, Activists,
Nature, and Beer

ROBERT DIETSCHE

Robert Dietsche (1937–) has taught courses in jazz history at Portland State University, Reed College, and Mt. Hood and Clackamas community colleges and taught at Beaverton and Oregon City high schools from 1962 to 1971. He is the founder and former owner of Django Records in Portland and the longtime host of "Jazzville" on Oregon Public Broadcasting radio. His writings about jazz have appeared in Jazz Journal, *the* Oregonian, Willamette Week, Pittsburgh Press, *and the* Toledo Blade. *Most recently, he wrote* Jumptown: The Golden Years of Portland Jazz, 1942–1957 *(2005), a history of jazz in Portland. This essay "Where Jump Was A Noun: Jazz in Portland in the 40s," appeared in* Open Spaces *(1999).*

Where Jump Was a Noun

In the words of the late Hollywood actor, George Sanders: "There never was, nor will there ever be, anything quite like the Dude Ranch." It was the Cotton Club, the Apollo Theatre, Las Vegas and the wild west rolled into one. It was a shooting star in the history of Portland entertainment—a meteor bursting with the greatest array of black and tan talent this town has ever seen. Strippers (called shake dancers then), ventriloquists, comics, jugglers, torch singers, world renowned tap dancers like Teddy Hale and, of course, the very best in Jazz.

Oh, for a tape recorder and a front row table to Sammy Davis Jr., Coleman Hawkins, Porkchops and Gravy or the Buddy Rich of boogie woogie, Meade Lux Lewis. What a jazz buff wouldn't give to have been there that August night, hours near the end of WWII, when the whole Count Basie big band appeared. Or the night the Charlie Barnet Orchestra featuring two local prodigies, Ernie Hood and Francis Shirley, took over the place.

In July of 1945 the Ranch, with its tap dancing emcee and celebrity clientele, was the hottest black and tan supper club west of Chicago. Fourteen months later the doors were locked—"A public nuisance," exclaimed *The Oregonian.* Billy Holiday had to be cancelled.

The building is still there, the last monument to a time and a place pretty much written out of Oregon history and jazz history in general. What is now called the Rose Quarter used to have a lot of other names, and any cabbie worth his fare would have known that "Black Broadway," "the other side," and "colored town" all meant the same thing: the Avenue—namely Williams Avenue, a black commercial center and entertainment strip that used to be among the cheapest land in the city; now it's among the most expensive.

Fifty years ago you could stand in the middle of what is now the Rose Garden (home of the Trailblazers) and look up Williams, past the chili parlors, barbeque joints and jazz clubs, all the way to Broadway and see nothing

but people, all dressed up as if they were going to a wedding. It could be four in the morning; it didn't matter; this was one of those "streets that never slept." And what were all these people looking for? JAZZ. There were ten clubs in as many blocks, not counting the ones in the surrounding area. There used to be The Frat Hall at 1412 N. Williams where building inspectors were called in the morning after Ernie Fields brought the house down with his rendition of "T-Town Blues." Across the street was the Savoy (later called McKlendon's Rhythm Room) where saxophonist Wardel Gray blew twenty-two choruses of "Blue Lou" never once repeating himself. Down the street was Lil' Sandy's where T-Bone Walker liked to play, and around the corner was Jackie's where one night "Brownie" Amadee showed a young Washington High School student by the name of Lorraine Walsh Geller, who later became a highly acclaimed piano player, how to play bebop. On the corner of Williams and Russell was Paul's Paradise famous for its after hours cutting sessions.

It's all gone now, bulldozed away to make room for freeways and other manifestations of urban renewal—buried like some kind of Jazz Pompeii.

Except the Dude Ranch, that triangle shaped building on the pie shaped block that divides Weidler from N. Broadway—two hundred yards north-west of the Memorial Coliseum. Born to be a Hazelnut ice cream factory in 1908, it became a speakeasy in the 20s. Until recently, it was called Multi-Craft Plastics. So instead of dining, dancing and gambling, it's plastics—resi-dential, commercial and industrial.

The outside hasn't changed much since the days of the Dude; the inside has, and only an opening in the newly arranged false ceiling reveals the elab-orately carved ceiling that once overlooked an even more elaborate dance floor. It was mirrored and slippery and led to an elevated bandstand banked by rows of tables. Above and to the rear was an imposing balcony; that's where you had dinner.

Photographers were everywhere. Folded cards in the middle of each table read: "You ain't nuthin' 'til you had your photo taken at the Dude Ranch." Nod your head at the wrong time, and you could find your face on the cover of matchbooks, calendars or in "Let's Go," Portland's main entertainment guide. There were hatcheck girls and cigarette girls and cowgirl waitresses dressed to look like Dale Evans, cardboard six shooters snug in their hol-sters. Huge handpainted murals of black cowboys lassoing Texas longhorns covered the walls.

"Pat" Patterson, the first black ever to play basketball at the University of Oregon, owned and managed the Ranch along with his pal, Sherman "Cow-boy" Pickett. They were inspired by a 1938 *Life* magazine featuring pictures of heavyweight boxing champion Joe Louis learning to ride a horse at an all black dude ranch in Victorville, California. Louis was the Michael Jordan of 1945, even bigger: "If you want to know, watch Joe" was the '40s version of "Be like Mike."

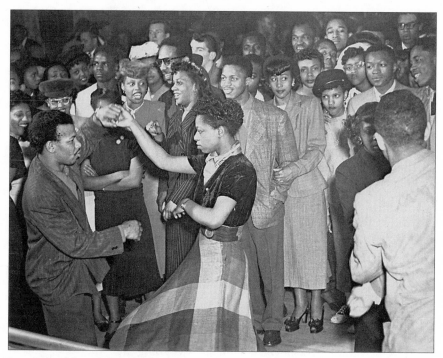

Jazz dance club in about 1949

The Ranch was packed like every other place in this post-war boom town. Tens of thousands of people, many black and from Texas, came to Portland to work in the Kaiser Shipyards or other related areas of defense. On top of that, there were thousands of servicemen passing through, home from the battles in the Pacific and crazy for entertainment. The money was easy; the housing was impossible. All-night movie theatres were converted into sleeping lodges. Restaurants were telling people to stay home. Portland, once thought to be the wallflower of the west coast, had become a twenty-four hour, three-shift, transport city going at about 78 rpm.

The fast and free-spending crowd at the Dude Ranch was a reflection of all that. Among the well-dressed shipbuilders, maids and Pullman porters were Bugsy Siegel-like characters in sharkskin suits and broad Panama hats, in from St. Louis for a friendly game of cards or dice on the second floor. There were pin-striped politicians with neon ties, Hollywood celebrities and glamour queens in jungle red nail polish and leopard coats, feathered call girls and pimps in fake alligator shoes, zootsuited hipsters and side-men from Jantzen Beach looking to get "the taste of Guy Lombardo out of their mouths," Nobel prize candidates and petty thieves, Peggy Lee's "Big Spender"

and Norman Mailer's "White Negro," racially mixed party people, dancing and exchanging attitudes, who could care less that what they were doing was on the cutting edge of integration in a city called "the most segregated north of the Mason-Dixon line."

Years later the former nightclub owner/civil rights activist Bill McKlendon remembered how important his club and the Dude Ranch were in the area of human relations: "The big name acts at my club and others brought people in from all over. It was the first time that white folks from the west hills and downtown saw that what we were doing here was valuable."

The music of choice at the Ranch was the blues in its many forms. There were also standards like "Body and Soul" and novelty numbers inspired by the recordings of Louis Jordan and Slim Gaillard, a six-foot-six lunatic who spent the better part of 1943 in the army at the barracks in Vancouver, Washington. Weekends he was at the Frat Hall on Williams Avenue playing piano palms up and singing his big hit "Flat Foot Floogie" (with the Floy, Floy). He was in L.A. in 1945 mostly working at Billy Berg's. Every month or so he would appear at the Dude unannounced talking that goofy talk of his where everything ends in "O-Rooney" or "O-Voutey" and singing nonsense songs like "Cement Mixer," which came to him, he confessed, while he was listening to a construction crew outside his studio window: "They were repairing the street, and a cement mixer was going 'put, put,' so I started singing 'cement mixer—putty, putty.'" It became a million seller.

There's a great description of Gaillard in Jack Kerouac's *On the Road* which contains a couple of lines that are among the best in jazz literature: "Slim sits down at the piano and hits two notes, two C's, and then two more, then one, then two, and suddenly the big, burly bass player wakes up from a reverie and realizes that Slim is playing 'C-Jam Blues' and he slugs in his big forefinger in the strings and the big booming beat begins and everybody starts rocking. . . ."

Slim always had a soft spot in his heart for Portland, even lived here for a while in 1972 playing piano, guitar and bongos at the Travel Lodge near the Lloyd Center. Ten years later he shows up at a jazz party for a radio station as a guest of writer John Wendeborn. Slim walks into the room, looks at the executives in suits, the DJs and sales people, turns his head toward the bar, and yells out, "Hey! Bartender o-voutey got any bourbon o-rooney?"

Eighty, maybe ninety percent of the music at the Ranch was based on the twelve-bar blues, not the down in the dumps country kind played on a guitar or harmonica, but urban blues with horns and sophisticated lyrics. It came in three flavors: bop (now considered to be the beginning of modern jazz), boogie woogie and jump.

When the Ranch opened in May of 1945, just a couple of months before the end of WWII, there was very little bebop in Portland. There were sightings of this revolutionary music as early as October of 1943, when the Benny

Carter big band with J.J. Johnson, Freddy Webster and Curley Russell played at McElroy's ballroom. The next glimmer happened the following year when Tiny Bradshaw and his orchestra with the great Sonny Stitt and Big "Nick" Nicholas hit town.

The first local musician to play this difficult style was Carl Thomas who played off and on here for ten years before leaving to join rhythm and blues star Lloyd Price. He died in obscurity in Seattle without ever receiving recognition as the pioneer of Portland bebop, the first in a line of bop alto saxophonists including Les Williams, George Lawson (the great might-have-been), Dan Mason.

According to two of his best students, trumpeter Bobby Bradford and trombonist Cleve Williams, Thomas was into bop as early as January of '45, already experimenting with some of the advanced harmonic and rhythmic innovations of Charlie Parker, Dizzy Gillespie and Thelonious Monk. "I don't know where he came up with it so early," says Bradford. "They weren't playing bop on the radio; he may have heard Gillespie's 'Bu-Dee-Daht' (1944) at Madrona Records on Broadway and Williams, the only place in the state where you could find black music." Cleve added, "I think he got hip at Slaughter's who always had the latest in jazz records on his juke box; a whole lot of people listened to their first jazz on the box in his pool hall."

Carl's big night at the Ranch was on Halloween of '45, remembered years later as the night his Frantic Five improvised on "The St. Louis Blues" for one hour. The five included multi-instrumentalist Big Dave Henderson, who left Portland for Oberlin Music Conservatory shortly after this concert, and two students from Fort Vancouver High School: drummer Lee Rockey, an introverted Elvin Jones type who went on to play for Herbie Mann, and bassist Keith Hodgson, who ended up playing with the symphony in Washington, D.C.

Come to find out there were more of the young at bop in the halls of Vancouver High, most of whom were learning their trade on the Avenue or at the Dude Ranch: Bonnie Addleman and Norma Carson went on to jazz fame in New York; trombonist Quen Anderson found his way into the great Georgie Auld's sextet; and tenor saxophonist Dick Knight got to play with his hero, Duke Ellington sideman Barney Bigard.

Why should this high school have so much talent? Lead alto saxophonist Ray Spurgeon graduated from there and thinks he knows the reason: "The music department was ahead of its time thanks to Chester Duncan and Wally Hanna. They were the ones that developed the program and inspired those whiz kids."

Bop's biggest night at the Dude Ranch was December 5, when Norman Granz, "the P.T. Barnum of jazz", brought in an early edition of Jazz At The Philharmonic—a traveling jam session named after its place of origin in Los Angeles. Some of the biggest names in jazz were there that night: Roy Eldridge; Coleman Hawkins; the ex-Count Basie singer, Helen Humes; and

on piano the unknown, undiscovered "high priest of bebop," Thelonious Sphere Monk, whose bizarre chords had some people laughing and others, like Eldridge, grinding their teeth. Hawkins had convinced Granz to hire Monk for the tour, but it was a mistake says Al McKibbon, the bass player that night: "He was just too far out; I knew where he was going with those funny chords, but I don't know if anyone else did."

Apparently the former Quincy Jones trumpet star Floyd Standifer did, as he relates in a recent telephone interview from Seattle where he now lives: "Here was this odd looking guy that was making everyone laugh. I learned about Monk from one of those yearly *Esquire Jazz* magazines. I hitchhiked in from Gresham, where I was going to high school and playing in a band called East Multnomah Swing Machine. It took me a while as I sat there to realize that what I thought were mistakes and missed notes were right, according to what he was trying to do. He was getting a sound and an energy out of the piano that couldn't be heard any other way."

Another musician whose career was turned around that night was Leo Amadee, a round-faced, quiet jazz pianist from New Orleans by way of San Bernardino. Boogie woogie and swing piano were his specialty when he arrived in 1943. After he heard Monk at the Dude, "Brownie," as he was called, disappeared, Sonny Rollins style. When he returned to the Ranch, he had absorbed the elements of bop piano. He stayed in Portland until 1948, when he left for San Francisco, but not before introducing many young aspiring jazz piano players to the world of Monk and Bud Powell. His influence on the history of jazz piano in Portland cannot be overestimated.

The blues, boogie woogie style, was ten times more popular than bebop with the crowd at the Ranch. Bop came out of New York; it was intellectual and, unless you were Teddy Hale, not recommended for dancing. Boogie woogie, on the other hand, was a by-product of lumber camps and railroad yards. The repeated eight to the bar figures in the pianist's left hand echoes a train rumbling over the track. It was working-man's music that could substitute for a whole orchestra when times were tough; it was down to earth, even funky, as is the history of the word itself. To "boogie" today is to enjoy oneself or to move and dance in a lively manner. A century ago, in certain parts of the South, it meant the second stage of syphilis and later was a synonym for sexual intercourse. Meade Lux Lewis, always a favorite at the Dude, revived boogie woogie with his "Honky Tonk Train" in 1938, but it was no longer just a piano style. Now every band, no matter how bad, had three or four boogie woogie arrangements in the band book.

The popularity of boogie was its ability to integrate itself into just about every playing style. But it was the jump bands that got the most mileage out of boogie-woogie's eight to the bar feel, jump bands like the Tympany Five that came into being at about the same time as boogie's revival and took

advantage of its momentum. Sometimes seventy percent of the material used by these small bands were boogie arrangements.

Jump is small band jazz and novelty numbers usually aimed at dancers. It evolved out of big bands such as Lucky Millender and Lionel Hampton and, like big bands, even uses repeated phrases called rifts to back up soloists. Jump tries to do with three horns and three rhythm instruments what a sixteen piece band does, but for a lot less money, which made these bands very popular with agents and ballroom managers during the shortages and rationings of WWII. They lasted until the early '50s. Tab Smith, Earl Bostic, Roy Milton and the Johnnie Hodges' Castle Rock Band were some of the final acts, all of whom, by the way, played on the Avenue.

The dancers were the jump groups' reason for being, as swing expert Stanley Dance noted: "Everything that got in the way of that was pared away." Art Chaney, a Portland saxophonist, once said that if he couldn't get the dancers out on the floor, he took it personally: "We were insulted and don't think we didn't let 'em know it." Great jump bands inspire great jitterbugs and vice-versa.

The best dancer was a wall-eyed, five-by-five clubfoot by the name of Tate Bey. Originally from Gary, Indiana, he landed here out of the service in 1945 and quickly became a favorite at the Dude and McKelroy's, an independently owned ballroom on the comer of SW Fourth and Main. The veteran jazz broadcaster Ray Horn was also a competitive swing dancer in those days and remembers Tate vividly: "He was best I ever saw around these parts. I mean, guys would come from Boise and Seattle to take him on, but he was too slick. He had what they used to call the New York style, and no one could keep up with his casual but quicker-than-lightning moves. He'd do a running floor-slide and overhead snatches and his competition would end up like everyone else, just standing in a circle watching him. And when he and his partner got too heated up, the crowd would cool them off by getting out their handkerchiefs and waving them. He danced like he had some of that 'empire green' the porters used to bring in.

"Women used to line up waiting for him to arrive, and get this: he was short and odd looking, and one leg was six inches longer than the other, but it didn't matter 'cause he could always make everyone around him feel so good with that howling laugh of his and that cigar hanging out the end of his mouth. He could think up things to say that would make you feel like a million dollars. One time right after I finished a jazz show he walked up to me and said, 'Ray, you shouldn't be a D.J., you should be a preacher or a famous politician.'"

When his competitive dancing days were over you could find him holding court at the Stadium McDonalds on Burnside or practicing a new step on the broken-down porch of his home—a dilapidated flat that used to sit

thirty-five yards away from the left field fence at Civic Stadium in direct line with home plate.

In the world of jump the tenor sax is king, and what someone said of jazz trumpet on Bourbon street could also be said of the tenor saxophone at the Dude Ranch: "It practically blew itself." There was more talent on that instrument than on any other: Ralph Rosenlund, the great Roy Jackson who backed up Dinah Washington, and later, Kenny Hing who is still with the Count Basie band.

The main tenor man at the Dude, Illinois Jacquet, never even played there. He was from Texas and played the saxophone as if he had heard Lester Young, Herschel Evans and more than a few hell and damnation sermons. Lionel Hampton hired him in 1941 and let him loose on a 78 rpm Decca record called "Flying Home." The music world has never been the same. In person, he would get up from his chair, point the bell of his horn at the mike and turn the place into a revival meeting, a mass orgy. The band would be riffing in the background like a congregation saying "amen." People actually fainted. Critics now say that Illinois Jacquet's solo was the beginning of rock and roll. Perhaps, but it sure did a lot for jump. Almost every tenor player at the Dude after that sounded like Jacquet.

The best of the lot was Texan Buddy Banks and his "Block Rhythms." There may have been a more popular group at the Dude, but I can't think of any. When he wasn't on Central Avenue in Los Angeles playing "Fluffy's Debut" and "Banks Boogie," he was at the Dude Ranch, sometimes for weeks in a row. And there would always be a line waiting to get in. His secret—a shrewd amalgamation of bop, boogie woogie, and sassy vocals from Fluffy Hunter. He used a trombone that made his group sound different from all the rest. Frosty Pyles, his guitar player, could play like Charlie Christian one minute and T-Bone Walker the next. But it is the bass player and the piano player who are of most interest to the students of Portland jazz history. Basie Day, owner of one of the great names in jazz right up there with pianist Preston Keyes, stayed in Portland for the rest of his life. Not since the arrival of LeRoy Vinnegar has there been a more in-demand bass player than Basie Day. Earl Knight, the piano player, was in and out of Portland for the next three or four years after that and then went on to record with Lester Young and Coleman Hawkins.

Banks' rival, fellow Texan Jack McVea, sat next to Illinois Jacquet in the Hampton Band during the recording of "Flying Home." McVea also played on a lot of Norman Granz recordings. His act at the Dude, which included costumes, honking saxophones and comedy routines, was more entertainment than art, but everybody went for it. While he was playing at the Dude Ranch and the Vancouver Barracks, he wrote, or more like compiled, his biggest hit and one of the best selling records of the decade, "Open the Door Richard." It became a national catchphrase. There were fifteen versions in all, and five of them became best sellers.

The house band for many weeks was the Banjosky Adams Jump band out of Seattle. It featured yet another Jacquet exponent, saxophonist Tootie Boyd who had played in Portland with Palmer Johnson in the 1930s. Boyd's rendition of "On the Outskirts of Town" was one of the highlights of a night at the Dude. As in the Buddy Banks band, two of the side men became a permanent part of the Portland jazz scene: Art Bradford, a snappy little show drummer who later joined the Hamiltones, and Ernie Longoody Austin, a rock-solid member of many jazz groups in Portland.

The patriarch of Portland jump was Al Pierre who spent half his time in Seattle and the other half in Portland. Originally from Tacoma, Washington, he arrived in Portland in 1930 and quickly put together what jazz writer Paul de Barros calls "the first indigenous Black swing group in the Northwest." His trumpeter was Bob Russell who played in Portland in the 1920s. The tenor saxophonist was Jabo Ward and the drummer was Vern Brown who advertised himself as "the best time around." Portland's Prince of the Blues, Clarence Williams, said that it was fitting that Al Pierre should have opened the doors of the Dude in May of '45. "He was such a class act and an excellent pianist, too. He was the leader of us all. He taught ya' how to be a working musician. How to be a professional. Something your normal music teacher never gets around to telling you. His mom taught him how to read music using just the fingers of his right hand. A baby could learn to do it. I couldn't read billboards before I met Al. He showed me the five finger approach to reading and it changed my whole approach to the blues. Ask anyone that is still alive from the Avenue days. Hey, you know who Pierre reminds me of? Big Jim Wynn in the way he used to take youngsters aside and tell them about the basics of music." Jump was taken over by exhibitionist tenor soloists and doo-wah vocal groups as it turned from rhythm and blues into rock and roll.

As for the Dude Ranch, it moved to an unfortunate location on Union Avenue (now Martin Luther King Boulevard) where it finally died. The Dude Ranch on Broadway was closed down in '46. The papers said it was a shooting, although no one was hurt. And all the big time gambling. I think it was the mixed couples, the flirting, those racy dances, those happy bottoms "shakin' the African." . . . *"If you don't learn this dance / What a pity . . . a pity!"*

DON CARPENTER

Born and reared in Berkeley, California, Don Carpenter (1931–1995) moved to Portland in 1947, where he graduated from high school. After serving in the Air Force, he attended the University of Portland and Portland State College (now Portland State University). In the early 1960s, he moved to San Francisco, where he became involved in the Bay Area literary scene and published his first novel, Hard Rain Falling *(1966). Carpenter worked for a dozen years as a Hollywood writer (most notably on the film* Payday*) and published several books, including* Blade of Light *(1967),* The Murder of the Frogs and Other Stories *(1969),* The True Life Story of Jody McKeegan *(1975), and* From a Distant Place *(1988). In this excerpt from* The Class of '49: A Novel and Two Stories *(1985), Carpenter narrates a Portland high school girl's failed rise to the Rose Festival Court.*

May Fete Day

Every spring each of Portland's high schools would hold a competition to select a Rose Festival Princess. The selection would be from senior girls who were beautiful, talented, poised, and got good grades. Ten girls would be chosen by the administration of the high school in consultation with student government, and then, at an assembly, the student body itself would vote for the girl they would like to represent them at the annual Rose Festival Parade, and of course it was from these ten Princesses that the Rose Festival Queen herself was chosen. The Queen reigned over Portland's most exciting and famous annual event. It was a week of festivities, beginning with the crowning of the Queen and climaxing with the Rose Festival Parade through downtown Portland.

Mothers ambitious for their daughters recognized that becoming Queen of the Rose Festival could well be that first big publicity push their daughters would need to be launched into a career in show business, and so, many girls were groomed for the event well in advance.

Janet Satterlee, for example, had been in training for almost fifteen years. In 1934 she had been a beautiful child with a facility for memorizing little songs, and so her mother took her to Hollywood by bus and train, determined to get her into the pictures. It did not work out that way, and they had to come back to Portland several hundred dollars poorer, but Alva Satterlee did not give up. Child stars had questionable careers anyway, adored for a few years and then forgotten. Alva would groom her child to burst onto Hollywood a full-blown star, and the first jack up the ladder would be her Rose Festival crown.

Janet Satterlee, therefore, took dancing lessons, singing lessons, French lessons, fencing lessons, poise lessons, and of course acting lessons. She grew into a beautiful and popular girl with the inbred confidence that her beauty

Rose Festival Queen Jean Wallace and her entourage in rose-covered bathing suits on the Jantzen Knitting Mills float in 1952

would carry her through life as it had through childhood, unconsciously aware that her mother's fierce devotion and support would remain as a strong foundation to her confidence. Her father was the executive vice-president of Cadwell's Department Store, and so Janet was brought up in a quiet, well-to-do neighborhood among polite, well-mannered boys, several of whom she was allowed to date, and during her senior year, one of whom she was allowed to go steady with. The boy Alva chose for her daughter (from among a gratifyingly large supply) was Douglas Grant, a blond, tanned boy who was a member of Delta, a student body officer, and so clearly insipid that Alva did not fear her daughter would actually fall in love with him. Douglas took her to all the dances and games, and so Janet was properly exposed to the student body which would, after all, have to vote her into the competition. For fifteen years, then, Alva and her daughter Janet had a common destination, and life was rich for them.

It would be inaccurate to say that Janet herself wanted to win: she *knew* she was going to win, just as she knew that some day she would go to Hollywood, have a career, marry and have children, and be rich and world famous and deliciously happy forever. She did not give such things second thoughts. Instead, she concentrated on her studies and on being nice to everyone she came in contact with. She did not consciously seek votes but neither did she allow anyone at all to think she was a snob. No one did. Everyone liked her, from the lowliest outsider to the principal of the school himself.

Janet's best friend was Sissy Rysdaal, the cheerleader. Sissy also knew that Janet was going to be Rose Festival Queen, although the two girls never talked about it, and Sissy's only ambition was to be a member of her court at Adams High School, to be among the ten girls from whom Janet would be chosen. These girls, with Janet as their Queen, would reign over May Fete Day, which was the climax of the school's own competition, and was the last major school event before the Senior Prom and graduation itself. Sissy knew she was not beautiful—she was cute. Saucy, slender-limbed, merry-eyed, cute. She could not compete with Janet's graceful beauty, but she thought that in a popularity contest, which was all it really amounted to, she could beat out most of the other girls in the school. Her only real problem was that she was coming to an emotional crisis in her life, and she was afraid it was showing on her face. The truth was, she was getting weary of games and cheerleading.

Sissy's life was mapped out, too, although not nearly as tightly as Janet's, and she was beginning to wonder if the life she had chosen was really the right one. She planned to enroll at the University of Oregon, hopefully be asked to join a good sorority, and then, when her opportunity came, become a college cheerleader. After that, a man and marriage. But sometimes even now she would awaken in the night seized by emotions she could not control, hot visions of love-making and adventure, of sailing to the South Seas or living in New York, of clasping handsome young men to her body and groaning with delight. She always managed to feel ashamed of herself later, but more and more these feelings would come over her, and more and more she would abandon herself to them and allow the guilt and remorse to be put off until later.

Sissy had gone steady four times and did not like it. Always the boy would get fresher and fresher, until finally she would have to cry and be taken home. To her, going steady entitled the boy to touch her breasts from the outside and put his hands on her legs, but nothing more. She wanted to remain a virgin, and she understood that if you let boys go farther than this, your own powers of resistance might lessen, and you might go all the way. Then the boy would not respect you anymore, or you might get pregnant, and from there to suicide was only a step. Not one of the boys she had gone steady with had seen it that way. Finally, she gave up going steady, and the boys she dated received a kiss on the second date, if they were nice, and on the third date, if they were particularly nice, she would open her mouth.

Sissy never dated boys who were not fraternity members, unless they were on the football or baseball teams and exceptionally well-behaved, but as her senior year began to come to an end, she wondered more and more what she was missing. All her time was taken up with the same people, doing the same things, going the same places, and sometimes in moments of madness she wondered if jumping up and down yelling slogans was really worthwhile. She did not dare mention any of this to her best friend, Janet

Satterlee, for fear Janet would think she was losing her mind. Together they spoke only of social matters and studies.

When Tommy German began calling her up she tried to imitate Janet and be as polite and nice to him as she was to everybody else, but it was difficult. Boys like Tommy German did not bother Janet, they knew she was too far above them. Until now, in fact, they had not bothered Sissy either, and she wondered if her secret dreams had somehow managed to reflect themselves in her face, if she was walking around with a wanton expression that everybody but she could see. Tommy German persisted until finally, with a tiny thrill of meanness, she told him he could pick her up after a Theta Psi meeting. She had already made a date to be picked up by Ted Winters, who would take no nonsense from people like Tommy German. It worked, and Tommy stopped bothering her for a while. But then one afternoon he came over to her in the hall and began speaking to her as if they were old friends, and there was something different about Tommy, something almost frightening, as if he had peeked into her dreams. She found herself accepting a date with him.

Although Sissy never told her, Janet Satterlee found out about the dates with Tommy German, and even knew that one night they had gone out to Marine Drive in Tommy's father's car with a couple of quarts of beer and parked. Janet's source of information was Jud Baker, who had more or less adopted Tommy German as his mascot. Janet was amused by this, and she mentioned it to her mother as they prepared dinner together.

"Tommy German?" Alva said. "I don't believe I know him."

"Oh, you wouldn't, Mama. He's a real nobody."

"I do hope you don't treat him as if he were a nobody, Janet darling," she said.

Janet laughed. "I wish you knew him, Mama. It's so funny, the idea of Tommy German all dressed up in a tuxedo escorting Sissy on May Fete Day. He's *short.*"

Alva did not speak for a few moments, and then, rather oddly, said, "I wonder how he would look in the Parade."

"Oh, *Mother,*" Janet said.

Alva whirled on her daughter, unaware that she had a butcher knife in her hand. "*Oh, Mother,* my eye! This thing isn't over by a long shot!"

They stood frozen in this ultradramatic pose, the mother holding the menacing butcher knife and the daughter holding a carrot, until finally the words had a chance to fade out of the room, and then, odder still, Alva began to cry.

"What's going to happen next?" she sobbed. "What next? Fifteen years!"

"Mama, I don't know what you're talking about."

Alva looked at her beautiful, innocent daughter. "Has it ever occurred to you," she said in a hoarse voice, "that you might lose? And then it's all over. All over."

Janet drew herself up coldly, put the carrot on the sideboard, and said, "Mother, I've always faced the fact that I might not be selected for the Rose Festival Court. After all, it wouldn't be the end of the world. I plan to continue my studies at the University of Oregon, and then, if I have evinced sufficient talent, perhaps I will try to make a career of acting. That, of course, depends on the advice of my teachers, family, and friends." Then she too began to cry, and the two of them spent an hour calming each other down.

But the first crack had appeared, and after all those years of calm, the terrible anxiety of stage fright or something very much like it crept into the lives of the Satterlees, a tension that rose every day, and, on the morning of the actual voting, was so intense as to be unbearable. Janet, backstage in her white gown, looked at the other nine girls, and saw reflected that same deep anxiety. What was it all about, she thought; why are we here? Sissy, whose tan did not go well with white, rustled over to her and squeezed her on the arm. "We're all behind you," she said. She smiled nervously and then said, "After this is all over I think I'll go somewhere and have a drink." Janet stared at her. This was not the Sissy she knew. She looked around at the other girls again. They were all looking at her, and she realized that they were all pulling for her, they all wanted her to win. But it was out of their hands; it was up to the student body. Training, pressure, influence, all were of no more use. The girls all wanted her to win because they wanted her to be the Queen of the Rose Festival, and they knew she was the only one of them who had a chance. *Chance!* At this moment, she had to step out into the light, and she never looked more regal, more beautiful. Something had been added to her normal beauty, something like that which transfigures a bride, a kind of trembling anticipation mixed with fear, and the election was in the bag.

Everything went fine, as expected, until the dance in the cafeteria that was to cap the afternoon. The Princesses and their boyfriends, all dressed up in formals and tuxedos, gave the afternoon dance a nostalgic feeling, and most of the other students fell in with that spirit and danced quietly, savoring the mood, remembering these tunes as their tunes, and this time as their time. Janet was a vision and her boyfriend Douglas looked as if he had been made for a tuxedo. Sissy's escort (thank heaven) was Ted Winters, and even his fierce expression was flattered by the outfit. Then the boys came back from the tavern and broke up the dance.

Douglas got Janet out of there quickly and took her home, where Janet's mother was lying on the couch with an ice bag on her forehead. Janet started to tell her mother that a riot had started at the dance, but Alva said in a dry distant voice, "Get out of here," and so they went out into the backyard in their formal clothes, and finally Douglas went home.

Sissy told her what happened after Janet left, or at least she told her what she thought had happened. It was all very confusing. The boys, Jud Baker, Colby and Heller, Mike Maloney (of all people), and Tommy German had

apparently left school after the assembly (or perhaps even before) and gone to some tavern where they could get served. They sat there and drank beer for two or three hours, and then came back to the dance drunk. The idea was that they were going to dance with the Princesses, and the fighting started when Tommy German came up to Sissy and Ted Winters, his eyes bleary and his mouth loose and wet, grinned, and said, "Beat it, you fruit," to Ted, and grabbed Sissy. Ted growled and picked Tommy right up off the floor, slugged him, and threw him halfway across the room. Then Jud Baker and Mike Maloney piled on Ted and a lot of screaming started and Sissy ran. She stayed in the girl's restroom until it was too crowded to bear, and then went outside the building, hoping to walk around the outside to the main entrance, go in and get her things from her locker, and wait in Ted's car. But the fight was out in the field now, and she saw several of the men teachers and the vice-principal trying to segregate out the drunk boys. She stayed to watch for a while and saw Colby and Heller running across the field and then saw the vice-principal catch Heller, who had fallen down, and saw Colby turn and slowly walk back. That was when Jud Baker, covered with blood, his shirt gone, yelled the dirty words at the vice-principal. Sissy told the story as if it were the most important and tragic event in her life, alternately crying and sniffling, and at the end she said, "Oh, my God, it's ruined, our last chance, it's ruined. And it's all my fault for going out with that awful boy!"

"What's ruined?" Janet said.

Sissy looked at her with something like hatred. "You don't know," she said. "You don't care. You go on to the God damned Rose Festival."

She got up abruptly and left.

RICHARD NEUBERGER

Born in Multnomah County, Richard Neuberger (1912–1960) attended Portland public schools and the University of Oregon. He was a member of the Oregon House of Representatives and during World War II was commissioned a lieutenant and then a captain in the U.S. Army. In 1948, Neuberger was elected as a Democrat to the Oregon Senate and five years later to the U.S. Senate, where he represented Oregon until his death. Neuberger was also a prolific journalist and author, working as a Pacific Northwest correspondent for the New York Times *and contributing hundreds of pieces to such publications as the* New Republic, The Nation, The Progressive, Harper's, *and the* New York Times Magazine. *He also wrote six books, including* Integrity: The Life of George W. Norris *(1937) and* Adventures in Politics: We Go to the Legislature *(1954). His essays were collected in* They Never Go Back to Pocatello: The Selected Essays of Richard Neuberger *(edited by Steve Neal, 1989). In this essay from that collection, which originally appeared in the* Saturday Evening Post *(1950), Neuberger explains why, when offered a job in Philadelphia, he chose to remain in Portland.*

My Hometown Is Good Enough for Me

One of the discoveries of the census was that more Americans are on the move than ever before in the country's history. It's become such a national habit that two-thirds of the folks along the Pacific Coast are wayfarers who were brought up elsewhere. I may be hopelessly behind the times, but I can't put in with these millions who have itchy feet.

I live right where I was born and raised. I intend to keep on doing so. What's more, I commend it to all my fellow citizens who can't wait to shake the hometown dust from their oxfords and sandals.

I recall visiting a man and a woman who had left our city shortly after their marriage and gone to New York, where they had prospered greatly. In fact, many of us envied their imposing success. But when I knocked on the door of their Park Avenue apartment, they fell on my neck and shouted in unison, "How are things back home?"

Home! All my jealousy vanished in that instant. I looked around me at furnishings which probably rivaled the assessed valuation of our neighborhood school district. And yet this splendor wasn't home. To these expatriates home always would be Portland, Oregon—a place three thousand miles away, where the alpine firs marched like a green-clad host up Mount Hood's glacial apron. Through the windows I could see other huge monoliths of New York's most exclusive apartment house district, with lights lit in Pullman rows. I wondered how many people in those luxurious tiers still thought of home as some distant spot far out on the broad expanse of America.

I have had several tempting offers to leave my hometown and toil elsewhere, an opportunity probably commonplace in a land so vast and diverse as the United States. Always these chances promised more money than I had been earning, yet no regret attaches to having refused them. The compensations of living in one's native community cannot be measured in coin of the realm.

When I drive to work, I pass the lot where I first learned the pleasures of one-old-cat and workup, played with an indoor baseball split at the seams. A supermarket stands there now, but it cannot blot spine-tingling remembrance of the afternoon I hit a home run off the neighborhood bully, who was pitching.

A few evenings ago I waited in line at the supermarket with the family groceries. Several places in front of me was the statuesque blonde I never quite could manage to date in high school. She wouldn't even let me buy her a soda. Too many backfield heroes beat my time. A man was with the blonde, meekly pushing a cart loaded with canned goods. He was her husband, I gathered. I studied him intently, and a warm, happy glow swept over me as I realized he was infinitely fatter of paunch and balder of head than I am. Nor could I overlook the fact that the blonde, once statuesque, had widened to the extent that the description no longer applied.

These are petty satisfactions, you may say, and I agree. Yet where could I experience them except in my hometown, and particularly in the exact neighborhood of that town where I was born thirty-eight years ago?

In Portland I have a genuine sense of belonging. The whole atmosphere is *gemütlich*. I am sure I could feel this way in no other place. To begin with, the attachment does not stem from superficialities—political affinity, for example. Indeed, I am a Democrat in the only city of the Far West with a local government that is exclusively Republican. Nor do these roots of mine depend on a propitious climate.

I like to play golf and my wife is an inveterate swimmer; yet all too often neither can be done comfortably outdoors in Portland's interminable drizzle.

The factors in my allegiance are more subtle than this. Everywhere I go in Portland, some scene stirs a remote memory. Here is the store where I wheedled a doting uncle into buying my first electric train; there, down the street, is the bank where my grandfather took me ceremoniously to deposit the first dollar I earned lugging his big leather golf bag. I never pass a shaded building of red brick without thinking of the patient and understanding first grade teacher, who kept a desolate boy from breaking into tears the grim day that his parents went off to the Canadian Rockies without him.

Yet I suppose these adventures in nostalgia would not be sufficient to anchor me, unless I believed that other people also had the feeling that I belonged right where I was.

Maureen and Richard Neuberger in front of the state capitol building

I have not forgotten the night at a well-attended Community Club dinner that I debated my adversary for a seat in the Oregon State Senate. The opposing candidate spoke first and, perhaps influenced by some zealous cohorts, accused me of every possible crime except the murder of Arnold Rothstein. I could feel the audience eying me suspiciously, if not with actual hostility.

Then came my turn. Almost by rote, I began with the statement: "I was born and raised less than a mile from this hall, and I got my education in the Portland school system."

The tension went out of that meeting like gas out of a dirigible. I had planned replying to my adversary in kind, but suddenly it no longer seemed necessary. If I was a hometown boy, I couldn't be quite so bad as I had been

painted. I admit this is irrational, for the native son could make off with the courthouse safe just as readily as the interloper. But blind trust in a product of the hometown is a fact of American life and cannot be ignored. Even on the Pacific Coast, a region of migrants, all the reigning governors boast local school diplomas as part of their political arsenal. And although the nation as a whole may be on the move, seventy-three of the members of the United States Senate can cite representation of their birthplaces as cogent reason for another term in office.

In fact, this residential double standard has been applied to nothing more momentous than the brevity of a dancer's garments. My wife and another high school teacher performed a bare-legged hula as the feature of a PTA benefit. All was serene for both are local girls. When a new teacher, born beyond the state line, shook her hips in a similar costume, the protests of parents and ministers made the school board tremble. My wife now serves with me in the legislature, the first such family representation since Oregon attained statehood, and she says that a firm rooting in local soil tided her over many turbulent riffles during her campaign.

Yet despite the confidence which hometown nativity assures, does not a person owe it to himself to take advantage of opportunity which beckons from afar? How else can he develop his talents and capabilities?

Sherwood Anderson once wrote: "It seems to me that a man like Lincoln would have been Lincoln had he never left Springfield, Illinois; that he grew naturally, as a tree grows, out of the soil of Springfield, Illinois, out of the people about him whom he knew so intimately."

This might have been true of Lincoln, but what of ordinary mortals? Can we afford not to pack the family luggage when the will-o'-the-wisp flutters beyond the horizon?

In 1940 I was offered a job in New York which would have practically doubled my income. At first I was tempted to accept by return wire. Then I looked at my hiking boots in the closet, at the tentative crayon marks I had scrawled on maps of the Cascades and the Olympics. I examined the hateful, rusty lawn mower which I might never curse again. Our friends in Portland came to mind, those with whom we went camping, swapped recipes and argued politics. And I thought of the cold, impersonal glances of all those millions in New York whom we didn't know and who never would know us.

In my dilemma I wrote for advice to a man I had yet to meet, but whose career always has epitomized the American who stayed put and let the world come to him.

William Allen White, born in 1868 in Emporia, Kansas, could have had any editorial position in the land, but he preferred to remain with his *Emporia Gazette*. He died in 1944 only a few blocks from his birthplace, yet his influence had been felt in every part of the globe. His brief letter still is framed over my desk.

"My advice instinctively is don't go East," he began. "Make your name out West. You will find a place out West. As you live longer, you will find that from sheer geography your standing there will be higher up above your surrounding plain than in New York. If you can eat with some regularity and sleep at nights, stick to the West."

My waistline is too tight and I don't need barbiturates, and William Allen White's counsel was sound. I have had fun in my little puddle and there have been rewards. Although my success has been far from spectacular, I have been able to ride for many miles with a President of the United States and go yachting with a famous British industrialist. These men did not know me, but they had read material from my typewriter about regional subjects which interested them. When they came West, they sent word that they wanted to talk to me.

Had I gone to New York, my work would have been lost among the myriad of contributions from journalists far more illustrious than I can ever hope to be. But in Oregon, as the wise old *Emporia* editor foresaw, "sheer geography" has been my ally. The competition is less stern. Furthermore, I know the area as only a native can know it. This gives me that brief start along the base paths which decides many pursuits of a story or topic.

I wonder if this same soul searching does not confront many Americans who are offered impressive opportunities to leave the realm of their youth?

I have a friend named Irving Dilliard whom the *Baltimore Sun* once nearly lured from the *St. Louis Post-Dispatch*. This native son of St. Louis finally sat down with two sheets of copy paper staring up at him from his library table. He listed the reasons for moving to the *Sun* and the reasons for staying at the *Post-Dispatch*.

One reason ultimately seemed to take precedence over all others. Dilliard phrased it in this way: "To live and work in the region in which I was born and which I know best and for which I can speak, upon occasion at least, with some authority; to do what I can to improve that area and to help its people live better lives."

And in his letter to the *Sun* the newspaperman explained, "I have made the decision that William Allen White made many years ago." In this instance it unquestionably was a sage verdict, too, for Dilliard since has become editor of the famous crusading editorial page of the *Post-Dispatch*.

But what if everyone through history had shared these sentiments? Who would have started for Ohio in a canoe or for Oregon in a Conestoga wagon?

Each man to his taste. If I had lived in the era of the pioneers, I probably would not have put on buckskin and braved the frontier. I like to think this would have been attributable to no fear of grizzly bears or Indian hostiles, for the wilderness often calls to me today. But I would have been one of those fellows content with their friends, their books, their pipes and the rather

mediocre fishing down at the village creek. Gold in California never would have induced me, even in younger years, to leave behind mother's cooking and all the girls to court at home.

When I am away from Portland now, I compare other communities with Portland, and invariably to their disadvantage. Good Democrat though I am, I miss the Republican editorials in our local papers. If I am in a metropolis of skyscrapers, I note the superior safety of Portland's modest-sized office buildings. But in a city of buildings as flat as sardine tins, I comment on the majestic height of Portland's fifteen-floor rooftops.

Although millions of Americans may be looking for a new address, pride in place still must be a dominant national trait. Once we were pulling trout out of an Alaskan lake like women tugging at a bargain counter. The catch was limited only by the strength in our arms. Yet a homesick lieutenant insisted this couldn't muster up to the fishing back in his native Colorado.

"What?" we yelled accusingly.

"Well," he replied, "the climate's better there, anyway."

I hesitate to leave Portland, even for greater opportunities in money and prestige, for fear I will abnormally romanticize the place I have left behind. This was the case of the married couple I visited on Park Avenue. Their notion of the city of their birth bore no resemblance to reality. This, I imagine, was why they never had returned for a visit. The illusion would be shattered. During the war I was ordered to advise Robert W. Service—who no longer lived in the Far North—that American troops in the Yukon would be delighted to have the author of *The Shooting of Dan McGrew* as a guest. He politely declined.

"I want to remember it the way it was," he explained.

Allegiance to a hometown frequently has little or nothing to do with creature comforts. It relies on such intangibles as memories, friendships and a sense of belonging.

Last summer I visited a retired officer of the Royal Canadian Mounted Police, who was brought up in the bleak solitudes of the Northwest Territories. He lives today in a pleasant green neighborhood of one of Canada's great prairie cities. His routine might be considered idyllic—polo, puttering in a garden of flowers, lunch at an exclusive club, a movie or bridge at night. Yet this man's heart is in the North Country, in the isolated detachments along the broad Mackenzie River—outposts a thousand miles from a theater or a polo field.

"That was where I felt I really amounted to something," he said. "I guess you take to a place where people know you from way back, and you don't have to tell them who you are or what you are."

Recognition is an important human value. We all crave it. What if I go to New York and succeed prodigiously? Who will really care? Should I start all over again to create friendships, I should be an old man before I enjoyed the sort of loyalties I now take for granted. The Mountie mourned for the distant

Arctic, because that was where a trapper's eyes might glisten at mention of his name.

I want to protect myself from this kind of loneliness, which is the worst loneliness of all. The Mountie officer admitted that he was never so alone on the Barren Lands as in a metropolis full of strangers.

So I am staying in Oregon. I may be provincial, but aren't we all? A few years ago a newspaper syndicate conducted a symposium under the heading: What I Like About America. Every preference, without exception, was local. People in Seattle nominated Mount Rainier. Bostonians whooped it up for planked steak at the Parker House. A girl in Brooklyn picked the Dodgers. A Miami resident selected bathing beauties. Californians named Yosemite or the Golden Gate. I chose the Columbia Gorge with its bastions of lava and granite.

Oregon is the place with which I am the most familiar. I studied its history in school and in college. I have driven over its plateaus and hiked across its mountains and rim rock. Whether I write essays or sell life insurance policies, why should I move to a strange locality? A prophet may be without honor in his own country, but I can shoot a hole in one and walk down Portland's streets the next day collecting cigars. I would be eligible for the Townsend Plan before I achieved this same recognition anywhere else.

If I ever was going to rip up my roots, I should have done it many years ago as a boy, when I possessed the flexibility and resilience of youth. But that was before I had any freedom of choice. Now it is too late, and I am glad of it.

When I look out across the slanting ramparts of the Cascade Range to Hood's frosty peak I feel like Antaeus, the mythical giant who gained strength merely by touching the earth. This is my own special corner of my native land. This is where my bearded grandfather came from the Old World in 1870, even ahead of the railroads. Eventually homesickness for a hamlet in far-off Baden drove him back to Germany. One of his descendants wants to avoid that kind of dark, desperate yearning, and so he is just staying put.

PHIL STANFORD

Phil Stanford (1942–), who has lived in Portland for twenty years, writes the "On the Town" column for the Portland Tribune. *In* Portland Confidential: Sex, Crime, and Corruption in the Rose City *(2004), he uncovers Portland's violent and sordid history of vice and corruption through the 1950s. In these excerpts from* Portland Confidential, *Stanford traces the careers of Portland's mobsters and public officials on the take, looks back on some of its "burlesk" history, and visits several of the city's more notorious gangster hangouts.*

Back to Business As Usual

It was business as usual again in the Rose City. As it had been for decades, the well-oiled rackets machine was now free to operate, more or less openly, under the protection of the city government.

At the head of the new administration was Fred Peterson. If he didn't understand the payoff system, no one did. Operating directly under Peterson was the new chief of police, Diamond Jim Purcell. Now that he was chief, he was even shaking down the gypsies, who at that time lived somewhat illegally in storefronts off West Burnside. For a mere $500 a month, Diamond Jim agreed to look the other way. And directly under Purcell, as head of the vice squad, was a wiry, intense man with a pencil-thin mustache by the name of Carl Crisp.

According to an officer who worked for him, Crisp was an extremely capable police officer and a meticulous reader of reports. If you didn't write something up in exactly the prescribed manner, he'd hand it back to you until you got it right—even if it meant that you had to stay up all night. The old vice cop says he learned a lot about police work from Crisp.

Unfortunately for all concerned, however, Crisp was also quite venal and never missed an opportunity to use his position to weasel a few extra bucks out of anyone who depended on the good offices of the police. Perhaps it was due to his hardscrabble upbringing in Eastern Oregon, where his German-immigrant mother worked as a ranch cook—although there were certainly others, in those post-Depression times, who had experienced greater poverty. Or perhaps it had something to do with his reputed drug habit. If so, that would explain a lot. Elkins made a practice of getting those he worked with hooked on drugs. Hospital reports show that Crisp favored barbiturates in combination with alcohol.

Crisp kept a record of his multifarious illegal transactions in notebooks, with entries written in a German-based code. Whatever else you might wish to say about him, Crisp was undoubtedly the right man for the job.

Archie Erskin, a bookie and gambler, found himself sitting in a patrol car with Crisp one night shortly after the Jo Ann Dewey murder, which every-

one assumed was drug related. Erskin, who was opposed to drugs, asked Crisp why he didn't clean up the narcotics business in Portland.

"Why cut off the hand that feeds you?" asked Crisp. After that, says Erskin, he didn't trust the man. His instincts were good. Erskin would later be arrested when he refused to open up a gaming room downtown under Crisp's direct control. . . .

The Tantalizing Candy Renee

By today's standards, the burlesque shows of the '50s were all a bit tame. Dancers usually started fully clothed and worked down to a G-string and pasties. At the time, though, it was hot stuff. There was usually a comedian or tap dancer who did the warm-up. Then the house lights would dim. Down in the pit, the band, consisting of a piano player and drummer would strike up something like "Night Train" as, one by one, the dancers would sashay into the spotlight.

Like all leg shows, as they were called, the Star had a buzzer system to warn the girls if cops were in the house. The Portland Women's Protective Unit, an all-woman force, regularly sent officers to check out the performances. At the Star, the buzzer went directly from the ticket window in the front to the guy in the projection booth, who could then, in turn, warn the girls via an intercom speaker in the dressing room to keep it clean.

The Star, however, probably had less use for the buzzer these days because the new chief of police, Jim Purcell, had taken a special interest in Candy. On any given night at the Star, you could expect to find Diamond Jim sitting in the third row. It was evident, especially to members of the police force who worked downtown, that Diamond Jim had taken an interest in the Star in general, and Miss Renee in particular, because he'd put out the word that he didn't want any of them backstage.

One night a police officer named Harlon Davis, who moonlighted transporting dancers to and from stag shows, had to enter the forbidden territory to pick up a purse one of the girls had left behind. To his dismay—because he knew he was toast if he was spotted—he saw Candy Renee in the dressing room, her dress half off, talking with the chief. And then he heard her say: "Shut up, you son of a bitch, and zipper me up." As Davis remembers quite vividly, Purcell did as he was ordered—and Davis took off while the getting was good.

Now, it is entirely possible that Diamond Jim, who fancied himself quite the ladies' man, was simply smitten by the tantalizing charms of Candy Renee. On the other hand, perhaps he was conducting an undercover investigation. At the time, the police bureau was responsible for passing judgment on the moral qualities of Portland entertainment. A board of nine officers—the Censor Board—routinely reviewed all burlesque and stag shows within

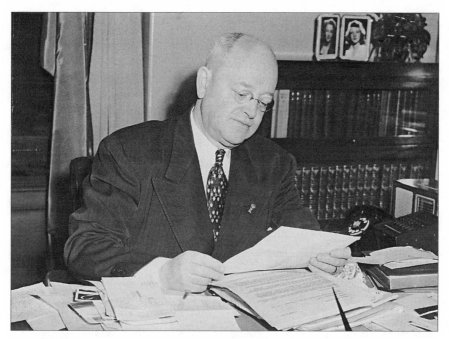

Mayor Fred Peterson working at his desk in about 1953

the city. Police officers had the duty of censoring movies as well. So perhaps Diamond Jim was simply being especially diligent in this regard.

In any case, this seeming idyll came to an abrupt halt one March night in 1954, when Candy and an ex-con by the name of Donald Vance Larson, who happened to work for Jim Elkins, were apprehended on McLoughlin Boulevard after a high-speed chase. There was, first of all, the matter of the drugs that had occasioned the chase in the first place: Candy, sad to say, had a bit of a habit. And then there was the loaded revolver the cops found on the seat between the two lovebirds when they finally stopped the car. According to police records, the two had managed to outrun four squad cars before finally being stopped. Candy, it was noted, was scantily clad.

When all was said and done, Vance was sent back to Washington, from which state he was currently on parole. As for Candy, not even Diamond Jim Purcell could save her after she claimed ownership of the pistol. She had to leave town, too. But we're getting a little ahead of our story.

Shortly after he took office, Mayor Peterson got a visit from his pal Swede Ferguson, who wanted to open up an after-hours club in town. This, by the way, is the same Swede Ferguson who just three years earlier had owned and operated the Clover Club, at the corner of Tenth and Taylor, where the

offices of the *Willamette Week* are now. This is where Little Rusty and Justice Douglas watched Sammy Davis Jr. performing with the Will Mastin Trio—so it wasn't as though he was just starting out.

But Ferguson had lost his backing at the Clover Club and now he wanted to open up a new joint—and without having to go through Elkins. So before he did anything else, he stopped by city hall to see his old friend, the mayor, who assured him that everything would be just fine. But no sooner had Swede opened for business than he was raided by the police.

When he was released from custody, Swede got back in touch with the mayor, who told him there must be a misunderstanding somewhere. He'd have a talk with the chief and straighten everything out. When he called in the chief for a little get-together, however, Purcell told Peterson the facts of life: The only way Ferguson could operate was with Elkins's say-so. Eventually, Ferguson was allowed to stay in business—but only after he agreed to give Elkins 75 percent of the take.

Elkins was "the fix." If you wanted to run a gambling or after-hours joint or a house of prostitution, you had to get his permission. The usual start-up cost was $10,000, sometimes $20,000. But he didn't stop there.

According to an old rounder named Tony Ricco, one of Elkins's favorite tricks was to contact some madam outside the city and offer her a "perfect location" for about $10,000 down. He would let her operate for about three weeks, then have Lieutenant Crisp, his man on the vice squad, knock her off. Elkins would then repossess, complaining all the while that he apparently didn't have the control over the police that he thought he had, and start all over again.

Elkins ran the same routine on would-be coin machine operators as well. Harry Huerth, the old safecracker, recalls how out-of-town operators would come to Elkins, wanting to buy in with him. "Then he would sell them the business and say he would fix it with the police so they could operate. The guy would run it for a couple of weeks and then the bulls would come and tell them that the town was too hot. Such and such a church is screaming so you will have to shut down."

After a couple of months, the guy would get wise and try to sell out. But since everyone in town already knew the game, no one would buy. Finally, Elkins would repossess. Huerth says he knew of this happening five or six times.

Under Al Winter, and for decades before that, the payoff had been a well-ordered affair. Everyone understood his place in the scheme of things and knew better than to try to take more than his fair share. But with the mayor and chief of police in his pocket, Elkins didn't have to play by the old rules. In addition to the time-honored payoff, which according to custom was administered by city hall and the police, he instituted his

own—with Carl Crisp, lieutenant in charge of the vice squad, as his personal bagman.

The cost of doing any sort of illegal business was going through the roof—and not everyone was liking it.

One day Paul Halperin, who had a little smoke shop downtown at Sixth and Oak and did a little bookmaking on the side, ran into his friend Alfred Battalini at the dog track. Battalini managed the Market Club, over on produce row, for Joe Gatto. "Those dirty bastards," said Battalini, "they want to raise my payoff from $600 to $800 a month."

People were complaining all over town.

But if you really wanted to get an earful about the unfairness of it all, the place to go was the Desert Room, where Nate Zusman held forth.

Hot Times at the Desert Room

The hot spot in town, now that the Pago Pago and the Turf Club were gone, was the Desert Room, at Southwest Twelfth and Stark. That's the triangular building across from Jake's where the Silverado is now located. The Desert Room was owned by Nate Zusman, a banty rooster of a guy, who called himself the Mark of Stark—in recognition, he would tell you, of the fact that he was a soft touch for anyone who was short a few bucks. Fat chance. His longtime bartender, Johnnie Bazzutti, said he had to be constantly on guard to keep Zusman from stealing his tips.

Zusman was a thief, a fence, and a pimp—and by all accounts, he ran one of the most fascinating nightclubs Portland has ever seen. On any night of the week, you could expect to find a good portion of the Portland underworld hanging out at the Desert Room. The pimps and madams all made the scene every night, and there was always a contingent of safecrackers, who in those days were considered the princes of the rackets.

That being the case, it only made sense that the intelligence and vice squads camped out there, too—drinking for free, of course—because how else are you going to find out what the other side is up to unless you get to know them? Not too surprisingly, most of the city's politicians and any prosecutor from the DA's office worth his salt could be found there as well, drinking with the boys and taking in the floor shows, which usually featured out-of-town musical acts and some of the finest strippers in town.

Conveniently located across Twelfth Avenue from the Desert Room was the Bellevue Hotel, which was actually a whorehouse run by Blanche Kaye—short for Kazinski, the police records say—a member of one of the city's most successful crime families. The Kayes didn't like the way things were going now that Elkins was running things, either—taking so much off the top that you were working for hardly more than wages.

Blanche's brother Eddie had connections to the L.A. mob. Another brother,

Barney, was the preeminent local bootlegger. He and his wife, Gloria, operated an after-hours club, with a little prostitution on the side, at Seventh and Fremont.

Every week or so, Barney would take off for Reno and come back with the back seat and trunk of his specially built Cadillac loaded with booze. One night, as he was driving back from Nevada, the State Police stopped him for a broken taillight. Once they saw what he was carrying, they had no choice but to charge him with violating the liquor laws, too. When Barney got back to Portland, he ran into Jim Elkins. "You dumb punk," said Elkins, "don't you know that when you're breaking the law, you don't break the law?"

Good advice at any time, no doubt.

GARY SNYDER

Born in San Francisco, Gary Snyder (1930–) grew up in Seattle and Portland and attended Reed College and the University of California at Berkeley. A one-time seaman, trail-crew member, and forest-fire lookout, Snyder is one of America's leading poets and translators. He is known for his association with Beat writers Jack Kerouac and Allen Ginsberg, and his work is recognized for its interest in Zen Buddhism and its commitment to environmental concerns. Snyder received the Pulitzer Prize in poetry for Turtle Island *(1975) and the Before Columbus Foundation American Book Award for* Axe Handles *(1984). His most recent books include* Danger on Peaks: Poems *(2004) and* Look Out: A Selection of Writings *(2002). In this excerpt from* The Practice of the Wild *(1990), Snyder recalls attending his first dance at St. Johns High School in Portland.*

The Same Old Song and Dance

I was standing outside the wood-frame community hall of the newly built St. Johns Woods housing project in Portland, Oregon, on a Saturday summer eve, 1943. It pulsed, glowed, and wailed like a huge jellyfish—there was a dance going on. Most of the people who had come to live in St. Johns Woods were working in the shipyards, but there were a few servicemen home on leave, and a lot of teenagers from the high school. Most of them were from the Midwest or the South. I was from farther north, up by Puget Sound, and had never heard people speak southern before. I hung around and finally got up my nerve to go in and listen to the live band play swing and jitterbug. At some point they were playing the Andrews Sisters song "Drinking Rum and Coca Cola." A girl from St. Johns high school saw me. I was a smallish thirteen-year-old freshman and she was a large gentle woman of a girl who

(for what reason I'll never know) relentlessly drew me out on the floor and got me to dance with her.

I had no social confidence or experience. My usual pastimes were watching the migratory waterfowl in the sloughs along the Columbia River or sewing moccasins. The war and its new jobs had brought my family off the farm and into the city. I was first exhilarated and then terrified: as I reached around this half-known girl—taller than I—I could feel her full breasts against my ribs. My hand settled into the unfamiliar triangle at the base of her broad back and I smelled her sweet and physical odor. I was almost overpowered by the intuition of sexuality, womanliness, the differences of bodies. I had never danced before, never held a woman. I could barely get my breath. She simply kept me moving, swinging, swaying, with infinite patience, and as I got my breath back I knew I was, now, dancing. I exulted then, knowing I could do it. It was "our era, our dance, our song." I didn't dance with her again, she was soon gone with an older boy. But she had given me entry to the dance, and I had with astonishing luck passed a barrier of fear and trembling before the warmth of a grown woman. I had been in on adult society and its moment.

Each dance and its music belong to a time and place. It can be borrowed elsewhere, or later in time, but it will never be in its moment again. When these little cultural blooms are past, they become ethnic or nostalgic, but never quite fully present—manifesting the web of their original connections and meanings—again.

PAUL PINTARICH

Paul Pintarich's grandparents arrived in Oregon at the turn of the century, and he was raised in Portland. A graduate of Lincoln High School and Portland State College (now Portland State University), Pintarich (1938–) spent four years in the U.S. Navy and worked as a journalist for thirty years as a reporter, including eighteen years as book review editor, for the Oregonian. *In 1992, he received an honorary award from the Oregon Institute of Literary Arts and is currently working on* Aloha, *an autobiography. In his introductory essay to* History By the Glass *(1996), an exuberant review of Portland's taverns and bars, Pintarich paints a familiar portrait of the city he knows intimately.*

From *History By the Glass*

When I begin to recall the history of Portland's old saloons, bars and taverns, I think about my father, 82 years old and living in the house he was born in.

He was quite a drinker in his time, the old man. And though both of us downed our last beer years ago, the stories he tells are the yeasty stuff of someone who drank long, hard and frequently in places that are no more.

Many of his stories begin in Michael's Saloon, which before it was overwhelmed by a freeway in the late 1950s was a popular gathering place for the wild young blades of South Portland—notably the old man, whose house is just two blocks away. Built early in the century, Michael's was located on Southwest Corbett Street, near Slavin's Road, and its beer parlor was built on stilts above the tracks of the old Oregon Electric Railway—the "black train," my father called it—overlooking the Willamette River and with a spectacular view east to Mt. Hood.

Throughout its long history, Michael's and its generations of customers represented significant periods of Portland's drinking past. From being a saloon in the bad old days, during Prohibition it became a benign purveyor of soda pop and "near-beer" ("a lot better than some of the real crap they make now days," the old man claims), and after the repeal of Prohibition in 1933, Michael's became a saloon, or tavern, once again.

In its heyday, which according to the old man was when he and his buddies used to drink there (and settled their disputes outside on the corner), it was one of the most popular taverns in town, drawing beers for a clientele attracted from all over the city.

When my father was a boy he and my aunt walked to Michael's for pitchers of birch beer on tap, which my grandfather, who made his own wine, favored while sewing pants and vests in his tailor shop in the family home.

When I was a boy, and Michael's had evolved into a mom-and-pop grocery, I walked with nickels clutched in my hot little hand for the huge ice cream cones they sold there.

Soon after, Michael's simply disappeared. Today, many years later, looking down from my apartment where I can see my father's house and the overpass where Michael's used to be, I remember those stories and keep them in my mind.

And, remembering, I realize how much the old drinking places of Portland, captured in stories from my father and his father before him, as well as many others—perhaps even my own—have contributed to our city's rich and enduring history.

Who knows for certain when it began?

We may be sure, however, that in the 19th century cutting a city from a stand of virgin timber was thirsty work.

Perhaps some buckskin-clad entrepreneur paddled up the Willamette with a canoe full of booze and began selling it over the top of a stump somewhere? For early Portland was known as "Stumptown," after all.

It was also known as "The Clearing," which by April, 1851, when the city was incorporated, was a clear-cut strip 500 yards wide and one-half mile

long: a "rather gamey, one-sided community" of some 800 souls, as it was described; one-sided because 730 of those souls were men, and many of them undoubtedly thirsty.

Within the clearing were 120 one-story frame buildings, including 30 retail and business establishments, six boarding houses, five hotels and eight saloons, including one with billiard tables.

Many early hotels also served liquor, and one of the first was "Pettygrove's," established in 1846 in a double-wide log cabin at the corner of Southwest Taylor Street and Front Avenue. And by 1851, the Warren House Hotel, also on Front Avenue, was advertising in *The Oregonian* (est. 1850) that it offered "the finest liquors and wines."

Portland's first real saloon, however (though again, no one is absolutely certain), was probably that of Colbrun Barnell, a former farmer, who in 1851 was serving drinks from his grocery store on Front Street.

Barnell, who also started Portland's historic Lone Fir Cemetery, was most likely selling liquor supplied by William Ladd, another Portland founder, who arrived the same year with a shipload of booze brought up from San Francisco.

About this time (perhaps because of Ladd's arrival) sprouted Eli Morrill's "Shoe Fly Saloon and Billiard Room," Sam Sykes' colorfully named "Eagle Brewery Depot and Dolly Varden Saloon," Charlie Knowles' "Oro Fino Saloon," as well as the renowned "Eureka Saloon," on Washington Street between First and Second, which *The Oregonian* described confidently (perhaps because of its advertising) as Portland's "original thirst emporium."

Soon there were many more, serving beer provided by the Liberty Brewery (1852), the first in the Northwest; joined in 1856 by Henry Weinhard's City Brewery, now the nationally famous Blitz Weinhard Brewery, which began operations at its present location on Southwest Burnside Street in 1863.

Following custom, Weinhard also owned several saloons: the "Hof Brau," "Oregon Grille," "Quelle Bar," the "Headquarters Saloon" and the "Germania."

(A reminder of those days is Kelly's Olympian, a venerable workingman's bar that remains on Southwest Washington Street, its name lingering from its former direct affiliation with the Olympia Brewery in Tumwater, Wash.)

. . .

Of all of Portland's turn-of-the-century saloons, brothels and boarding houses, however, none remains more legendary than Erickson's, revered in its time as "a cathedral of the working class."

The saloon was established in the 1890s by Augustus "Gus" Erickson, a Russian-Finn and onetime logger, and according to one newspaper account, "It was an institution where men from the great outdoors and the finest gentlemen who ever walked the face of the earth came to meet, drink, gamble, socialize or sample one of the joint's hostesses for a night."

But "joint," certainly, it wasn't.

In its day it was the finest saloon Portland had ever known, a "house of all nations" known around the world, and it was said that if given a choice between Erickson's and Heaven, its patrons would choose Erickson's any day. Erickson's bar was 684 feet long, the longest in the world, and above it was a huge oil painting, "The Slave Market," whose partially clad figures were the toasts of thousands of lonely, hardworked, hard-drinking men.

The saloon covered a full block on Southwest Burnside Street, between Second and Third avenues, and was a city within a city, boasting not only of its bar, billiard room, card room and ice cream parlor, but of its shoeshine stand, restaurant, barber shop, dance hall, and a stage for musicals (with its own orchestra)—and Gus had spent $5,000, a fantastic sum in those days, on a Wurlitzer organ that boomed out over the raucous crowd.

Erickson's even provided its own scrip, which was good for anything purchased inside the saloon, including the ladies who worked upstairs.

For the Dutch lunch that came free with the drinks, Erickson's featured thick slabs of roast ox in sandwiches made from bread baked in its own bakery, which was renowned for its apple pie.

So vital was Erickson's to Portland's saloon society that, during the flood of 1894, when the Willamette River rose to an all-time high and inundated the district, now Portland's Old Town, Erickson's fitted out a raft to serve those undaunted customers who arrived by boat.

But Erickson's had its darker side as well.

Filling six floors in the building above the bar was a combination hotel and brothel, while on the mezzanine were thirteen tiny "cribs" curtained off and available for "quickies." Hard-loving men and women reluctant to leave off from their one-night stands were served food and liquor raised to their rooms by dumbwaiters from the saloon below.

From Erickson's there were also some incidents of Shanghaiing, most likely from the saloon's own drunk tank, which was filled by two formidable bouncers of near-mythical reputation: "Jumbo" Reilly, a man of some 300 pounds who simply sat on miscreants, and the indomitable "Patsy" Cardiff, a former bareknuckled prizefighter who once fought the great John L. Sullivan.

Both, ironically, had reputations for being "soft-spoken" men.

The saloon's grand epoch ended in 1913, however, when the building, since sold by Gus Erickson, was razed following a fire. It was quickly rebuilt by its new owners, Fred Fritz and Jim Russell, but never regained its former splendor.

Though legends of its golden age have endured, Erickson's eventually deteriorated into a skid road bar. Down on his luck, Gus Erickson later worked for Fritz and Russell, but eventually succumbed to booze and like his once-great saloon descended onto skid road where he died a common drunk.

Prohibition also ended the golden age of Portland's other saloons. Some became restaurants, like Huber's, the city's oldest, which survives to this day; while others, like Michael's and the more famous Dahl & Penne's, long since gone, simply regrouped to sell soda pop and non-alcoholic beer.

As were other Americans, hardcore Portland drinkers were forced by Prohibition into a demi-monde of speakeasies and bootleggers, home brew and bathtub gin—some finding sustenance in the city's once extensive Chinatown, where they frequented gambling and opium dens. As my father, who admits to having visited such places, pointed out, "Hell, they were all illegal for years anyway."

Immediately following repeal, however, Portland drinkers surfaced to enjoy a proliferation of taverns, bars and nightclubs that overnight seemed to spring up everywhere.

Along Southwest Broadway, for example, much livelier than now (Where can you buy a six-pack in a bank or at Nordstrom's?), my father recalls small joints and larger beer halls packed with customers thirsty for legal beer.

"I bought my first legal beer in Dahl & Penne's," the old man remembers. "They had a bartender left over from saloon days, with a white apron and a long handlebar mustache. That guy was so good he could slide schooners of beer down around the corner of the bar and not spill a drop."

There were singing waiters too, in some places, and the places had names like "The Pub," "The Ratskeller," "Roxy's" and the "Valhalla"—which was on Third Avenue and Burnside Street, across from what used to be Erickson's, and until the late 1950s had replaced Erickson's as the most popular workingman's bar in town.

The "Alaska Card Room and Lunch" was a block away, and also in the old district other bars, clubs and card rooms catering to loggers, working men and pensioners who burrowed into the hotels and rooming houses that identified "skid road."

Skid road, as Northwest historians will remind you most adamantly, is a regional term never to be confused with "skid row," a more generic label used today to identify down-and-out districts almost anywhere.

Portland's was the original skid road (though Seattle's Pike Street claims to be a contender), harkening back to much earlier days, when loggers used teams of oxen to skid logs down along a greased track from the West Hills to the waterfront (though by the 1940s and '50s much of Portland's skid road had evolved, or deteriorated—depending on who you talk to—into a more desperately verifiable skid row).

The Valhalla remained, along with a whiff of old Erickson's, but skid row was identified now by such dangerous and hard-drinking places as "The Caribou Club" (recently revived in name only), the "Apache Club" ("Check all knives and guns at the bar," read a sign over the bar), "The Lotus" (recently gentrified), "The Old Glory" (no longer waving—thank God!), "The Stock-

man's Club," "Little Brown Jug," "Dinty Moore's," and a plethora of other dowdy bars, taverns, card rooms and former saloons.

Many have disappeared, though others, with names retained from the past are being transformed into hip, trendy places as skid row becomes Old Town, its fortified winos slowly replaced by clearer-eyed, more affluent individuals who "do lunch" and prefer wines of a gentler vintage.

World War II revitalized Portland. Its humming shipyards attracted thousands of workers from across the country, the vanguard of our present population boom, and these were later joined by servicemen and merchant seamen, who had visited during the war and now returned to live in the bustling port city.

Portland was a friendly and lively place during the war, and after the long Depression, with everyone working round-the-clock in the war economy, people had money, and they spent a lot of it on booze.

My father remembers the activity, the streets crowded with people night and day, filling the nightclubs and dance halls, which attracted the big-name big bands of the day: the Dorsey Brothers, Harry James, Woody Herman, Benny Goodman and Artie Shaw, playing for crowds at the Jantzen Beach Ballroom, McElroy's, the Uptown and Crystal ballrooms—and many more.

Portland nightclubs were jumpy and jivey, and seemed to be on every corner downtown: places like the bamboo-infested "Zombie Zulu," the "Pago Pago," "Club Portland" and the "Clover Club," "Amatos," the "Diamond Horseshoe," the Washington Hotel's "Timber Topper," and the "Rose Garden," in Portland's once-fashionable Multnomah Hotel.

And many more, too many and too long ago to recall.

Until the early 1950s, most Portland nightspots were "bottle clubs." This required that you bring your own bottle (purchased with a license at a state-owned liquor store, or "green front") and check it with the bartender who sold you "setups" of mixer and ice.

Meanwhile, lurking on the dark side of respectability were a number of after-hours joints, shadowy places like Tom "Pop" Johnson's "Blackberry Patch," "Barney Kay's" and "Rampoos," where you brought your own bottle and could drink until dawn.

Until the '50s encouraged the automobile-driven diaspora of suburban sprawl, finding action in Portland meant, for the most part (there were roadhouses), going downtown. For no matter how much you had drunk, the wonderful old streetcars would get you home.

Most Portlanders then lived conveniently close to the urban core, however, and denizens of the city's still quite liveable neighborhoods enjoyed the conviviality of corner taverns, many of which, in original or altered versions, remain today: unique interpretations of what an American pub might be.

But back in their bad old days, before the reforms of the infamous Dorothy McCullough Lee, the taverns were unique in many other ways as well.

According to former Mayor Bud Clark, who has owned Portland's popular Goose Hollow Inn for many years, some were little more than gambling dens offering games of chance in the form of punchboards, and payoffs to high rollers who scored on the once ubiquitous pinball machines.

The militant Mayor Lee would change all that—though now she might roll over in her grave. Ironically, now, with Oregon's State Lottery games, taverns, bars and clubs are often chancier than they were before.

The straight-laced '50s are also remembered for the decade's oppressive ambiance. Though it may seem ridiculous to the young exuberant drinkers of today, singing was not allowed, nor was dancing and live music. In those days you hummed quietly, whistled under your breath or tapped your toes (softly) to tunes restricted to the jukebox.

(Ironically, with all these restrictions, children were allowed in taverns with their parents, and I remember spending some of my formative years bellied up to the bar next to the old man.)

Then, in the late '50s, at the beginning of my own drinking days, things began to change. After four years in the service, returning with a thirst that seems dangerous to me now (and was), I would soon see my hometown's drinking places dramatically transformed.

Oh sure, some of the old nightclubs remained, but they were fading, giving way to some newer, more vibrant, often rowdier clubs—"Elmo's," "The Turquoise Room," the "Three Star" and "The Town Mart" come to mind—while other chic watering holes were springing up with the growth of suburbia.

But downtown in Old Town, near Union Station, no place was filled with more fun than Harvey Dick's lively, vastly entertaining and richly fitted out Hoyt Hotel, still a wonderful memory though it has been gone for more than thirty years. Not since the heyday of Erickson's had Portland seen such splendor: a grand and glorious, brashly irreverent, no-holds-barred watering hole that rocked with elaborate floor shows and rolled with the infectious laughter of its irrepressible impresario, the legendary Gracie Hansen.

If suddenly resurrected in the Hoyt, the spirits of men who had sought Heaven in Erickson's would find paradise in the hotel's gas-lighted Barbary Coast and Roaring Twenties rooms; in a restaurant with thick steaks you could select yourself; or in the Hoyt's exclusive Men's Bar—where today's feminists might die, perhaps thinking themselves in hell.

Dick was an entrepreneur of ribald humor, and his Men's Bar restroom was fitted out with an inspiring running waterfall, and next to it a gaping-mouth bust of Cuban dictator Fidel Castro for inspiration of a different kind.

I once spent a New Year's Eve there and I'm recovering from it still. Once, I interviewed actress Jane Russell there, and Miss Russell, who had been around, told me she'd never seen anything like it.

Nor, I replied, had I.

Particularly one night in the Men's Bar, when, drinking with my father after a rather bizarre evening, we prevented our guest, a frolicsome Croatian ship's officer and Russian-trained ballet dancer, from plunging a wickedly long knife into the capacious girth of a man blowing cigar smoke in his face.

Grabbing him from each side, we hustled him out to the sidewalk, where he displayed a masterful pirouette and sang a few loud bars from "I Pagliacci" in Serbo-Croatian before we put him in a cab and sent him back to his ship.

True story; but everyone who has been there has stories of their own, for it was that kind of place: delicious, decadent, sometimes dangerous, but . . . oh, such fun!

The art of stripping, or "exotic dancing," as we know it today, was taking off about this time and oldtimers remember the talents of such memorable ecdysiasts (H.L. Mencken's term) as The White Fury, Jeannie the Bikini (she of the whirling tassels), the Eiffel Tower Girl and the immortal Tempest Storm, whose blazing red hair lighted the runway at the old Star Theater. Their legacy would be assumed by a short-lived phenomenon known as "go-go dancing," with the genre grinding eventually into today's bumper crop of totally nude (and totally artless) "dancers" who adhere to the dictum that "less is more."

More or less.

And for less there is still "Mary's Club," a resilient strip club on lower Southwest Broadway; where as a young police reporter I once spent Christmas morning among a group of desperate, heavy-breathing men, all of whom I remember wearing sunglasses.

From personal observations, however, I came to realize that more is often better in matters erotic, especially as I grew older. Still locked in my fantasies is a beautiful young blonde woman who danced above the bar at "Ray's Helm" years ago, when it was a popular jazz club on Northeast Broadway. Wearing nothing but a skirt, sweater, high heels and a single strand of pearls, she danced with the sensual abandon of a secretary at a Christmas party, lifting the roof off the place and driving me wild.

About this time Portland had acquired a well-deserved national reputation as a jazz town. There was an abundance of local talent, and the city attracted nationally known musicians who were featured in clubs like Ray's (with vocalist-pianist Jeannie Hoffman and her partner, bass player Bill Knuckles) and others, including "The Hobbit," "Parchman Farm," "The Jazz Quarry" (with the venerable Eddie Weed), and "Sidney's," owned by Sidney Porter, an extremely tall, thin, long-fingered pianist of consummate skill, who featured vocals by his wife Nola, who sang like a bird.

(I remember bouncing into Sidney's late at night to be greeted by Sidney, who would require that I wear one of his sports coats for the evening. I am

six-feet-four, but Sidney's coats dangled to my knees and the sleeves covered my hands.)

Good music and dancing could also be found in Portland's black district, which in the old days was concentrated along North Williams Avenue and had grown considerably following the influx of shipyard workers up from the South during World War II.

Black clubs jumped to a rhythm of their own, and in those days invited white customers to lively places like the "Cotton Club," the "Savoy," "McLendon's Rhythm Room" and "Geneva's," where both races mingled congenially, but places, sadly, that are no more.

"Those days were somethin'," says my old friend Mary Lockridge, who at 80 still sings around town and bills herself as "The Million-Dollar Grandma."

"I knew all them people then," she said. "I knew Pop Johnson, I grew up with Sidney Porter's family . . . all of those oldtime black Portland families, I knew 'em. It was different then. I used to sing at the old Desert Room. Everybody had a great time, black and white. It wasn't like nowadays. You remember?"

I do, but that's a story I'm not going to tell here.

Gone, too, are the Beatniks.

Remember them?

They were big back in the '50s, favoring dark clothes, black berets and grim expressions to remind themselves that life at best was an absurd existential nightmare—at least until you drank enough beer.

"Grass" was good, cheap, but hard to get, and until the 1960s, wine and beer were their drugs of choice. The beer was dark, like the stuff drunk by Kerouac and company down in "Vesuvio's" ("we're glad to get out of Portland, Oregon," the sign read) or the "Co-Existence Bagel Shop," both down in San Francisco where the whole beatnik thing began.

Portland's beatniks, never a large contingent, gathered like moths around the dim flame of the appropriately named "Fungus Room" in Old South Portland, where they snapped their fingers (remember that?) in appreciation of the classical music played by the room's bartender.

Compared to the pap available on most tavern juke boxes, classical music was an innovation right up there with dark beer, and when the oft-requested "War of 1812 Overture" was cranked up, fingers must have snapped like a swarm of crickets in heat.

Though its existential angst was brief, the Fungus Room inspired dramatic changes in Portland's tavern scene as it moved into an era of beards, bell bottoms and beads, while folk singers sang laments of social and ethnic concern.

By the time the '50s became the '60s, and the beatniks had metamorphosed into "hippies" (hippies, according to Ken Kesey, Oregon author and

former Merry Prankster, being beatniks who didn't know how to read) the city's taverns were rife with innovations encouraged by more daring bar-keeps. At "The New Old Lompoc House," for example, which was near the Fungus Room, comedian Brian Bresslar (who would later appear on "Laugh In") offered customers silent movies with their popcorn and dark beer, which he served along with jerky imitations of the actors on the screen.

Just up the street, hamburgers were being served to beer drinkers at "Jerry's Gables," as they were at "Montgomery Gardens," over by Portland State College (it wasn't a university yet), where on Fridays poor students like myself could forget a week of classes over glasses of nickel beer.

PSC students and the old neighborhood denizens they drank with were blessed with a bounty of taverns that would soon be swept away by the I-405 freeway and the school's own rapid metastasis eating into what was once a sweetly comfortable downtown community.

Within lurching distance of each other were "The Cheerful Tortoise" (expanded, but still on its corner), the "Round Robin," "Green Spot," "The Chocolate Moose" (whose owner's proboscis matched exactly the shape of his tavern's stuffed namesake on the wall), and "Lydia's," with its matchless Reuben sandwiches, and later, "Sam's Hofbrau"—all of them college hang-outs raucous with laughter and conversation that drifted through clouds of smoke floating above an ocean of beer.

Just down the street, across from *The Oregonian,* was the "Broadway Inn," a hangout for newspapermen, where Jeannie twirled her tassels above cyni-cal ink-stained wretches discussing the agonies of their days, and in the other direction, across from Civic Stadium and adjacent to the City Morgue, Bud Clark's first tavern, "The Spatenhaus."

Though Portland was introduced to pizza at the "Caro Amico" restaurant in 1949, Clark claims his Spatenhaus was the first tavern in the city to serve pizza, now a ubiquitous staple of tavern life.

Old Portlanders will also recall "Shakey's Original Pizza Parlor," on South-east Foster Road, which before its recent demise spawned a chain of knock-offs that stretched from coast to coast.

Also about this time, Oregon tavern rats were cheering the State Legis-lature for easing restrictions to allow singing and dancing, live music, later hours and the serving of wine, all of which enticed more women into a new age of wine and song (the ferns would come later), to the delight of every-one.

And while many neighborhood taverns stubbornly retained their funky character, dear to the hearts of oldtime customers, many of whom inher-ited the stools of their fathers and grandfathers, newer places appeared with characteristics more appealing to the young at heart.

"The Wurst Haus," my favorite watering hole for a time, had pizza, chess-boards and classical music on the juke; the little-known "Netcap Tavern"

was on stilts overlooking the river (it burned when its owner tried thawing pipes with a blow torch); "Dante's Inferno" in South Portland featured "Chef Gino" (formerly of the Wurst Haus) and a menu of international delights; you could drop in and chat up the ladies at the "Blind Onion," out on Northeast Broadway, or in "The Dandelion Pub," in Portland's Uptown district; while at Bud Clark's "Goose Hollow Inn . . ."

Well, everybody knows about "The Goose," still attracting gaggles of drinkers after all these years.

Sports fans could catch the Tuesday night turtle races at "The Faucet" out in Raleigh Hills, mingle with a loud profusion of jocks in "Claudia's," Portland's original sports bar, and once the most popular tavern in town, out on Southeast Hawthorne Boulevard; and farther up the boulevard, drop in for a "coney" and talk baseball with Frank Nudo at "Nick's Coney Island," a remnant of the late '40s that remains unchanged after all these years.

Moving downtown, one could find "Peter's Inn" and "Peter's Out," sports bars owned by former professional baseball player Frank Peters, a glib, lively but now infamous raconteur who for a time was Portland's version of "Cheers" bartender Sam Malone.

And on the city's underbelly were places I remember from my days as a young police reporter: "Kelly's," "The Harvester," "O'Connor's" (the old one), the "Golden Dragon," "George's," "Van's," "Tom's," "Bob's," "Nobby's," "The Lovejoy," "The New Moon," "Hal's" "Satan's Cellar," "LeFebvre's;" while on the way home I might stop at "The High Time," "The Chat-n-Nibble," "The Cider Mill," "The Firestone," "The Ship," the "Leipzig" and "Pogo's" in Moreland . . . and others, ad infinitum, which I've simply forgotten.

But I'll never forget "Renner's," in Multnomah Village, where I drank my last beer—my last drink ever—nearly 14 years ago.

God! I must have been thirsty.

MIKAL GILMORE

Born and reared in Portland, Mikal Gilmore (1951–) attended Portland State University before becoming a contributing writer for Rolling Stone *magazine, where he became an editor and senior writer. Gilmore's memoir* Shot in the Heart: One Family's History in Murder *(1994), which received the* Los Angeles Times *Book Award and a National Book Critics Circle Award, chronicles Gilmore's relationship with his brother Gary, a convicted murderer, and details life in the brothers' troubled household. Gilmore is also the author of* Night Beat: A Shadow History of Rock and Roll *(1999). In these excerpts from* Shot in the Heart, *Gilmore tells of his parent's move to Portland and delves into his childhood memories of growing up in the city*

Settling Down

There was another side effect to my father's newfound sobriety: He became less agitated about traveling all the time. He now started staying put in one place longer than a few weeks. This was fine with Bessie. She had long been weary from all the migrations. She wanted a home and possessions, like the ones her sisters had back in Utah. She also wanted to see what it would be like for the boys to have a stable life—to spend a whole grade year in the same school and be able to develop some uninterrupted friendships. This became a dream for my mother.

In 1948, my family moved to Portland, Oregon, and set up residence at a housing project just north of the city. Frank had come up with an idea for a publishing venture: He would collect all the various statutes and regulations regarding the construction and development of residential and commercial property in the city of Portland and the outlying county of Multnomah, rewrite them into a readable language, and then publish them in a handy guide, full of advertising from contractors, builders, and architects. The publication would be distributed by the advertisers to their clients, and by the city and county's official licensing departments to prospective developers and builders. The idea attracted advertisers quickly, and Frank was raising hundreds of dollars in revenue each week—more steady income than the family had ever seen. After he accumulated several thousand dollars, Frank told Bessie it was time to move on again and try the same idea in another town. They could make a lot of money real fast this way, he said.

It was one of those times that Bessie Gilmore put her foot down. "No," she said. "You could actually *do* this book. You have everything you need to make it work. You have advertisers who trust you, you have the city's endorsement, and you have the skill. This is your best idea, Frank, and it is your creation. It doesn't have to be something you do just once: You could publish it every year or every other year and make good, regular money with

it. We could finally have a home. If you do this book legitimately here, I'll help you with it, and if you want to take it to other places later, I'll support you in that too. But if you hundred-percent on this one and run off with the money so that none of us can ever come back, then I may as well stay here with the boys. I'm tired of all the running."

Frank didn't like ultimatums, but he *did* like Bessie's idea of making the book an annual event. In 1949 Frank Gilmore published his first copy of the *Building Codes Digest* and, with the money he raised, made the down payment on a small house on Crystal Springs Boulevard, in southeast Portland. It wasn't much of a home: two bedrooms, small yard, on the city's industrial fringes—more a wasteland than a neighborhood. Not quite the big, handsome house that Bessie dreamed of, but she realized that Frank was still too skittish for anything that ambitious. Frank and Bessie put a fence around the yard, bought a dog, and bought a brand-new Pontiac. They put the boys in school, and come Christmas time, they put up a tree and bought a Nativity scene. It was my family's first real home, after a decade of marriage and three children, and it was the closest to a conventionally happy time they would ever know.

Frank's son Robert was now an army lieutenant, stationed at Ft. Lewis, one hundred and fifty miles away, near Tacoma, Washington. Robert now had a wife of his own and three children—two girls and a boy. He started bringing his family down every couple of weeks to visit his father's family, and sometimes made the trip alone. Robert liked the changes he saw taking place in his father. The two of them were getting along better these days. They could talk to each other for more than ten minutes without the bitter recriminations and suspicions of a few years before. One day, Robert—who aspired to a career as a professional photographer—gathered my parents and brothers in the backyard of the home on Crystal Springs and took a picture of them all together. It is perhaps my most treasured artifact of my family. Separately, everyone in the picture is in the role that would fit him or her best in life. My father looked no-nonsense, my mother looked like this was not a fun moment, my brother Gaylen wore a darling and irresistible smile, and Gary was already rehearsing his menacing stare. It is my brother Frank, though, who has the most fitting expression of any of them: a goofy, clownish smile that says, *Isn't this ridiculous—all of us posing like a real family?* Nobody in the photo is touching anybody else. And of course, I'm not there, I'm not in this picture yet. In fact, I never would be. This is the closest thing to a family portrait we would ever have. There would never be a photo taken of all of us together. . . .

Strangers

My first memory of my brother Gary goes like this:

I must have been about three or four years old. I had been playing in the front yard of our home in Portland on a hot summer day, and I ran inside to

get a drink of water. When I came into the kitchen I saw my mother and my brothers Frank and Gaylen sitting at the kitchen table, and seated with them was a stranger. I remember that he had short brownish hair and bright blue eyes and that he gave me a shy smile.

"Who's that?" I asked, pointing at the stranger.

Everybody at the dining table laughed. "That's your brother Gary," my mother said. She must have seen the puzzled look on my face—the look that said, *My brother Gary? Where did he come from?*—because she added: "We've kept him buried out back next to the garage for a while. We finally got around to digging him up." Everybody laughed again.

The truth was, he had been at a reform school for boys for the last year or so, and nobody wanted to explain that to me.

For years afterward, that's how I thought of Gary: as somebody who had been buried in my family's backyard and then uncovered.

In 1952, my family bought another house on the outskirts of Portland, and my father returned to publishing his building codes book. In this case, the term *outskirts* is no exaggeration. The house, which was located at one end of a rural-industrial highway called Johnson Creek Boulevard, literally sat on the line that divided Multnomah County from Clackamas County. In fact, the perimeter line ran right through the bedroom in which my three older brothers slept. When it came time to decide which nearby school the boys would attend, a county official came out to examine the situation. He decided that the side of the county line the boys slept on would determine which school they would be assigned to. Gary and Frank ended up going to junior high in Multnomah County, and Gaylen wound up going to grammar school in Clackamas.

The house itself was one of those weather-wasted dwellings that my father seemed to have a mystifying affection for. It was a two-story, dark-brown-shingled place with an unfriendly-looking face, and it sat with one or two other homes between a pair of large industrial buildings that filled the night with an otherworldly lambent glow. Across the street lay the train tracks that carried the aging trolley between downtown Portland and Clackamas County's Oregon City. Just past the tracks ran Johnson Creek—in those days, a decent place for swimming and catching crawfish—and beyond that there was a large, densely wooded area. It was rumored that teenagers gathered at nights in those woods and drank and had sex in hard-to-find groves. It was also rumored that a gruesome murder had taken place there years before, and that some of the body parts from the crime had never been recovered and still lay buried somewhere among the trees.

On the far side of the woods was a lengthy range of small, cheaply-built houses that made up the poor part of a neighboring town called Milwaukie. Beyond that was an area of rolling hills, full of stately, privileged homes—the

better half of Milwaukie. Up the hill behind our house was a neighborhood known locally as Shacktown, where laborers' families dwelled. Drive a few blocks past that and you would hit the old moneyed district of Eastmoreland, where you could find the state's most prestigious school, Reed College. If you were to draw two concentric circles on a map—the outer ring, a loop of wealth; the inner one, a wheel of privation—then our home on Johnson Creek Boulevard would lie at the core point of those circles. A null heart, in the inner ring of the city's worst back country.

This is the home where my first memories come from. This was also the place that we would live the longest as a family, before imprisonment and death and hatred began to sunder us. . . .

Though I would later see indelible signs of my father's violence, I never experienced it in the unrestricted way that my brothers did. In fact, I remember being hit by my father on only one occasion. The cause of the spanking is vague—which only goes to support Frank's belief that all you truly carry away from such an incident is the bitterness of the punishment. I think I probably did something like drawing on a wall with a crayon or sassing my mother, and my father deemed that the act called for a whipping. I remember that he undressed me and stood me in front of him as he unbuckled his belt—a wide, black leather belt with a gleaming silver buckle—and pulled it from around his waist. This whole time he was telling me what my whipping was going to be like, how badly it was going to hurt. I remember I felt absolute terror in those moments—nobody had ever hit me before for any reason, and the dread of what was about to happen felt as fearful as the idea of death itself. My father was going to *hit* me, and it was going to hurt. It seemed horribly threatening—like the sort of thing I might not live through—and it also seemed horribly unjust.

My father doubled his belt over and held it in his hand. Then he sat down on his chair, reached out and took me by the arm and laid me across his lap. The next part is the only part I don't recall. I know I got whipped and that I cried out, but I can't remember a thing about the blows or the pain, or whether it was even truly bad. All I remember is that a few moments later I was standing in front of him again, this time held in my mother's embrace. "That's enough, Frank," she said. "You've gone too far. You're not going to do to *this* one what you did to the others." I stood there, looking at my father, rubbing my naked, sore butt, crying. I remember that what had really hurt me was that I felt I had lost my father's love, that the man I trusted most had hurt me in a way I had never expected. My father was smiling back at me—a smile that was meant to let me know that he was proud with what he had just done, that he enjoyed the power and the virtue of this moment. I looked back at him and I said: "I hate you."

I know it is the only time I ever said that to him in my life, and I cannot

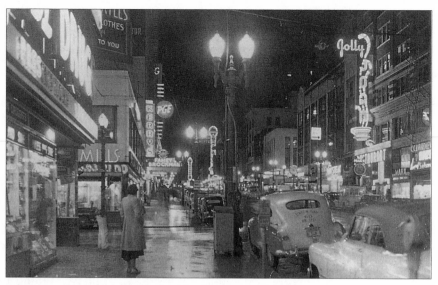

Broadway at Washington at night, in about 1945

forget what those words did to his face. His smile fell—indeed, his whole face seemed to fall into a painful fear or sense of loss. He laid his belt on his desk and sat studying the floor, with a weary look of sadness.

My mother led me out of the room and dressed my nakedness.

My father never hit me again. After that, he touched me only in love. I realize now I was the only one in the family that he saved that touch for, and to this day I still feel guilty for that singularity.

That was it—the one and only childhood beating I ever received within my family. It might have proved less memorable had it been a weekly occurrence, as it was for my brothers. At the same time, had I been beaten as much as they were—in particular, as much as Gary, whose pain and fear only seemed to gain him especially savage thrashings—there's a good chance that I also would have ended up as a man who spent his whole life preparing to pull a trigger. When I think of what my brothers went through almost every week of their childhood and young adolescence, the only thing that surprises me is that they didn't kill somebody when they were still children.

The difficulty Gary had gotten into back in Salt Lake was a fairly unremarkable sort. "He was doing stuff a lot of kids would do," said Frank. "The sort of trouble people would talk about for a couple of hours, then forget. They figured he was just a kid growing up." Chances are, Gary would have found

worse trouble in Salt Lake, though he might have had to look a little harder for it. In Portland, trouble was easier to find.

By the early 1950s, Portland had been Oregon's largest and most important city for more than a century, though it was still groping in many ways to define itself. It didn't have the sort of history or ambition of other West Coast cities like Seattle, San Francisco, or Los Angeles—in fact, Portland was a town that pointedly decried ambition. The city's sense of conservatism was a carryover from its earliest days, when its original New England settlers had sought to build a place that would be a refuge of civility and comfort in the midst of the rowdy Northwestern frontier. That attitude of smugness held sway in Portland for several generations, keeping the place hidebound and insular. Consequently, Portland was largely unprepared for the influx of population and the resulting cultural change that followed the end of the Second World War. In the time we settled there, much of Portland still looked and felt like a prewar town that did not want anything to disrupt its heart of fearful pettiness.

Still, a little disruption was inevitable. The postwar sense of release—plus all the new citizenry—had temporarily forced a crack in the city's Victorian veneer. By day, downtown Portland was still a conventional shopping and business district, though like many American urban centers it was starting to lose its prominence to the outlying suburbs. By night, though, downtown Portland changed its character. Along the main drag of Broadway there was a strip of bustling bars and restaurants, and many of them stayed open all night. Inside these spots, you could find an interesting late-night social life: a mix of Portland's rich folks and aspiring bohemians, plus a colorful smattering of its would-be criminal types. In the blocks off Broadway, down toward the Willamette River, there were other all-night emporiums, if you knew where to find them. Places like twenty-four-hour movie houses, where the last thing anybody did was watch the movies. Instead, various hustlers worked the patrons, dispensing oral sex or hand jobs for a few dollars, or selling marijuana or harder drugs to the more daring customers. There were also all-night gambling dens and crowded brothels that weren't shy about servicing teenagers. I wish I could have seen this Portland. It seemed like a somewhat sordid place in those days, instead of the dull and mean town it struggled to become in later years.

The police knew about all these vice dens and tolerated them as long as there was a kickback in it for them. At the same time, they never let major organized crime get a foothold in the area, if only because they didn't want the competition. Eventually, a newspaper-led, politically motivated morality campaign changed the city's night life forever. The all-night bars were shut down, the whorehouses were moved to the northwest corner of the city and the around-the-clock movie houses simply became cheap sleeping quarters for drunks and transients. Meantime, the city's murder rate began to grow.

In short, Portland became a lot like other midsized Western towns: a place hell-bent on believing that the darkness of its nights held nothing more provocative than the protected decency of American family life.

The early 1950s were also, of course, the period that saw the rise of juvenile delinquency—the term that many people used to describe the perceived upswing in dissatisfaction and violence among American adolescents. By the middle of the decade, the adventure called rock & roll would come to signify the growing enterprise of youth rebellion, and it would upend American popular culture in ways that it still has not fully accommodated or recovered from. My older brothers were coming of age in the midst of this time, and Gary and Gaylen in particular did more than merely enjoy or consume rebellion; they brought it home. They wore their hair in greasy pompadours and played Elvis Presley and Fats Domino records. They dressed in scarred motorcycle jackets and brutal boots. They smoked cigarettes, drank booze and cough syrup, skipped—and quit—school, and spent their evenings hanging out with girls in tight sweaters, or racing souped-up cars along county backroads outside Portland, or taking part in half-assed small-town gang rumbles. Mostly, they spent their time looking for an entry into a forbidden life—the life they had seen exemplified in the crime lore of gangsters and killers—and more and more, those pursuits became dangerous and scary.

In time, I wanted to be a part of my brothers' late-night comings and goings, wanted to share in their laughter and friendship. I also remember being frightened of them. They looked deadly—like they were beyond love, like they were bound to hurt the world around them or die trying.

For Gary, none of this would end up as a simple youthful passage. It became instead a sensibility that encased him, like a creature caught in the ice of another age. Gary's ideal of badness was formed in this time, and for him it would always remain a guiding ethos.

As I said earlier, it is tempting to try to find a moment in this story where everything went wrong—an instance that gave birth to my family's devastation, and especially to Gary's. My mother held to the belief that Gary's ruin was born during the brief move to Salt Lake, and even my brother Frank believes that something crucial changed in Gary during that period. For my part, I believe that the beatings were a decisive turning point, though I also suspect the simple (and more frightening) truth is, Gary's fate was finished at about the instant in which my parents conceived him.

Gary himself, though, had his own view of the moment that made all the difference. It's a strange instance, and it took place during the first year or so that we lived on Johnson Creek. Toward the end of my brother's life, Larry Schiller—through Gary's lawyers—asked him: "Is there any one event in your early life that you remember as fateful, that might have totally changed

your life?" Gary replied by telling about a time when he was around twelve or thirteen years old and was heading home from parochial school and decided to take a shortcut. He crossed over from 45th Avenue—the long, winding road that connected Johnson Creek Boulevard to the street where his school was—and made his way to the top of the hill that loomed about a block behind our house. Gary started down the hill and hit a thicket of brier bushes, full of blackberries. From the hill's top, the berry brambles had looked relatively small, but once Gary had entered them he saw they weren't small at all. Some of the briers had apparently been there for years and formed a tangle of thorns that stretched up the hill's incline, as much as thirty feet above his head. The farther down the hill Gary went, the more dense the brush became, and he saw that there was no easy path through all the overgrowth.

At first Gary might have climbed back up the hill, but he decided to push on. An hour and a half later, he was hopelessly mired about halfway through the brier patch. He thought about screaming, but it was unlikely anybody would hear him. He figured he could keep pushing on and work his way through, or he could die in this place. Hours later, Gary came out the other side, torn to pieces and bleeding. "I finally got home about three hours late," he told Schiller, "and my mom said, well, you're late, and I said, yeah, I took a shortcut."

When Schiller later related the story to my mother, she said: "And that changed the course of his life, because he figured he could get into things and get out of them? Is that it? That was a dangerous thing for him to do, and it was a dangerous thing for him to think."

Gary himself told Schiller that the story represented the point at which he became aware that he would never get afraid. "It left me with a distinct feeling," he said, "like a kind of overcoming of myself." Of course, whether he knew it or not, my brother was only telling half the truth. By talking about an overcoming of himself, Gary might have meant an ability to surmount his own fear, but I don't believe that's something he ever truly accomplished. I saw his face every day in the last week of his life. I knew how to look into his eyes, because I'd been looking into those same eyes throughout my own life, in my mirror. Those eyes would never lose their terror, not for a moment, even when they terrified other people.

The truth is, Gary wasn't talking about overcoming himself so much as he was talking about having learned to kill or silence the part of himself that needed to cry out in fear or pain. When Gary overcame himself in that manner, he finally found the power to ruin his own life and to extinguish any other life that it might take to effect that destruction.

I went back to Johnson Creek Boulevard during my recent stay in Oregon and found the area greatly changed. Almost nothing is left of the old neighborhood. The dingy, brown house we lived in is long gone, as are all the

other dingy houses in the immediate vicinity. They have been torn down and replaced by sprawling industrial constructions. Maybe it's just as well. Johnson Creek was never much more than a strip of wasteland. Now it's simply another ugly city boundary road that people drive through as impatiently as possible, to get from one barren place to another. About the only thing that still survives from those days is the stretch of bramble bushes, growing down the backside of the hill above Johnson Creek. Those bushes look as primordial and fateful now as they did forty years ago, and somehow it doesn't surprise me that nobody has dared to remove them. They still stand, an ugly relic of the moment a boy realized his life was a thicket, and that no matter how much he screamed, nothing would save him from his fear. . . .

In Portland in those days, if you were a teenager interested in proclaiming your lawlessness or toughness, the hippest thing you could do was join the Broadway Gang. A combination street gang and car club, the Broadway Boys—as they were also known—dressed in pachuco-style clothes and hung out late at night on Portland's main avenue, outside a restaurant called Jolly Joan's. Though some of its members occasionally stole cars, sold drugs, and ran prostitutes, the Broadway Gang was perhaps more obnoxious than it was genuinely dangerous. "They were just little street bastards," one of Gary's friends told me. "They used to raise hell downtown, you know, push people around, and they were just bastards. Every once in a while one of them might flash a switchblade. But they were not used except for show. I never heard of any of the Broadway Boys ever using a knife on anybody."

My brother Gary longed to join this gang. Whether he actually knew any of the group's members at the time, nobody seems to know. Still, even to talk about enlisting in such an outfit enhanced his outlaw standing among his peers. After school, when Gary and his friends would meet at the swimming hole and drink beers, my brother boasted that he knew that the Broadway Gang members needed guns. If Gary could supply them with a few pistols, he claimed, then he could join their league.

Gary took on an after-school paper delivery route, for the purpose of finding homes that might have guns he could steal. He learned to watch the houses on his route carefully, to become familiar with the comings and goings of the residents—when they took dinner or left on a vacation. It was at this time, at about age twelve or thirteen, that Gary began to break into houses. He would look for an unlocked or easy-to-jimmy window, then he would pry it open and climb inside. He liked those first few moments, standing in the stillness and darkness of somebody else's home, feeling the power of violation that he brought to their world. He soon learned that breaking into homes was a good way of learning other peoples' secrets—where the residents hid their money or dirty books or photos, what size brassiere the blond girl in his homeroom class wore, whether her parents were heavy

drinkers or Bible freaks, or both. He'd feel the intimacy of their underwear, he'd taste their liquor, he'd pocket some of their pornography. To Gary's disappointment, though, he never found any handguns in those homes. It was a time when most Americans hadn't yet armed themselves, in fear of the world outside.

For some reason, Gary became convinced that the house down at the corner of our street, right next to the small grocery store, had a collection of guns stowed away in a trunk in its garage. One night, Gary talked a friend of his named Dan into breaking into the garage with him and cracking the lock on the trunk. They didn't find any guns, but the family that owned the house somehow figured out that it was Gary who violated their place, and they went to the police with their suspicion. The neighbors raised a lot of hell, but since nothing had been stolen and nothing could be proven, the juvenile authorities let Gary off with a warning: He was starting to get a bad reputation for himself, they told him, and from here on out, they would be keeping an eye on him.

One night around Halloween 1954, Gary was waiting for the trolley back home, at the depot in downtown Portland. It was close to Portland's Skid-row, a rough slum area of town. The trolley only came once an hour, so it was a long wait—long enough to look at all the shop windows in the nearby district. Down the block from the station there was a pawn shop, its window full of .22 rifles. Gary saw a Winchester semi-automatic he liked. A beautiful gun, but at a price much higher than he could afford. It was already past midnight. The streets were quiet, deserted. He was the only person within howling distance. He wandered over to a deserted building and sorted through its rubble until he found a brick and then came back and threw the brick through the window. No alarm went off, nobody reacted. He climbed in, grabbed his Winchester, then filled a paper bag with a few boxes of cartridges. He cut his hand in the process of climbing through the window, but he didn't much mind.

Gary found a newspaper in the shop. He dismantled the gun—it broke into two parts—wrapped it in the paper and stuffed it in a large shopping bag. It looked like a paper bag of laundry or groceries. Then he waited for the trolley and rode with his rifle and bullets back to Johnson Creek. When he got off the trolley, Gary walked into the woods and hid his gun and ammunition in a place where he also often hid the items he stole from the neighborhood's homes and grocery stores. He could not chance having the rifle in our house, in case my father might discover it.

The next day Gary told his brother Frank and a few of his friends—Dan and two other pals, Charlie and Jim—about the rifle he had stolen. Frank wanted nothing to do with the matter; he didn't even want to see the gun. But Gary's other friends felt differently. One night, as the Oregon sky was turn-

ing from indigo to black, Gary met his friends at Johnson Creek's swimming hole and showed them his gun. The small group made their way through the woods over to the tracks and then up the tracks to the Johnson Creek trolley station, which was located across the road and a few hundred feet down the way from our home. The station was a three-sided timber construction—a weather shelter, with an overhanging light. Gary lay on the tracks, with his friends behind him. He aimed at the station's lamp through a side window in the building. He squeezed the trigger, and the lamp exploded. A woman came running out of the station as fast as she could. Gary kept shooting her way, laughing all the time.

For the next couple of weeks, Gary and his friends would meet at the swimming hole and Gary would fire his rifle at tin cans and paper targets. He got to be a good shot. But he soon tired of having to hide his treasure. One afternoon he sat by the swimming hole with Charlie and Jim, and he stared at his rifle. It felt spoiled to him, and he no longer wanted it. He asked his friends: "Listen, if I throw this gun here in the crick, do you guys have the guts to jump in there and dive for it?"

"You're goddamn right," said Charlie. "As soon as you throw it in."

Gary could tell they thought he was kidding. He took the rifle barrel in his hand and swung the gun in a long arc over the creek. It hit the water about six feet from the bank, right past a big, sharp rock that jutted up out of the swimming hole. His two friends just stood there, staring at the place where the gun had disappeared. They were amazed that Gary had tossed away the rifle he loved so much. "Go on," said Gary. "You can have the gun if you dive for it." Jim jumped for the place where the gun had sunk, but he landed on his knee on the sharp rock. It gashed his leg open, and Charlie had to help him back to the bank. Gary laughed his head off. Thought it was the funniest thing he'd ever seen. Nobody ever retrieved the Winchester. It still lies past the sharp rock, at the bottom of Johnson Creek's swimming hole.

KIM STAFFORD

After growing up in the West and Midwest, Kim Stafford (1949–) attended the University of Oregon, where he earned a Ph.D. in medieval literature. He has worked as an oral historian, letterpress printer, photographer, and editor. Since 1979, he has taught at Lewis & Clark College, where his father, the poet William Stafford, taught for thirty years before him. Stafford is the founding director of the Northwest Writing Institute at the college and the William Stafford Center, which "cultivates clear and ethical language for public life." He is the author of several volumes of poetry, including A Thousand Friends of Rain: New & Selected

Poems *(2005), as well as prose, including* The Muses Among Us: Eloquent Listening and Other Pleasures of the Writer's Craft *(2003). Stafford has received fellowships from the National Endowment for the Arts and a Governor's Arts Award for his contributions to Oregon literary culture. This essay is from* Having Everything Right: Essays of Place *(1986), which won a citation for excellence from the Western States Book Awards.*

The Separate Hearth

After school I stopped at home to change my outfit—shucking my slacks for jeans, tossing aside my polite cotton shirt for the buckskin one my grandmother had sewn, pulling on my boots—and lit out for The Woods on the run. We called it *The Woods,* just as we called a nearby slope *The Big Hill;* the limited territory of childhood is exact, and therefore mythic. Two blocks from home the human world dwindled to a path threading through nettle and alder. A spider web across the path meant no one was there before me. I crawled under its fragile gate to solitude and was gone.

This was my routine from third grade to high school—to straggle home after dark and stand in the cold garage, shivering and balancing on one foot to shed my muddy clothes. It was a certain evening in my junior year that I realized with a shock I could walk directly into the kitchen; I had somehow not fallen—or leapt—into the creek, had not slithered up a mossy tree, hugging the trunk with my thighs and arms, or spilled down a bank of mud. I had politely walked in the woods and returned. I mistrusted my sincerity. Something had changed. Something had gone wrong.

"What did you find today?" my grandmother (we called her Boppums) would ask, as she sat picking at a crust of cockleburs in one of my socks. I would run to my mud-stiffened pants to dig through the pockets for a rock an Indian might have used, or a leaf I liked, crumpled and fragrant, or a waterlogged stick turning into a fossil, a furry length of twine I had braided from cedar bark.

"I could use this to snare a rabbit, if I had to."

The Woods was a wild tract developers had somehow missed in their swathe through old Oregon. It probably stretched about three miles long by two miles wide, and was surrounded by the city of Portland and its suburbs. Raccoon, beaver, salmon, deer, awesome pileated woodpeckers, and exotic newts were among the secret lives of the place. Once, in the fifth grade, four of us decided to head north through unexplored territory toward the edge of the world. Lewis and Clark had nothing on us, on our glorious bewilderment when we emerged, near dark of a long Saturday, to find a broad, dangerous road, a tall house covered with ivy, and a giant in blue coveralls mowing his lawn.

"Where are we?" Bobby Elliott shouted over the roar of the motor.

Walkway leading into the Southwest Woods

The man looked down at a row of muddy, scratched little savages. "Terwilliger Extension," he shouted. We were stunned to silence by this bizarre name for most of the long detour home, past the ice-cream store.

What *did* we do down there all those hours multiplied by weeks and years? When we went together, we often hatched a project—more like Robinson Crusoe than John Muir in our use of the wilderness:

"Let's find the charcoal-wagon boy's old road!"

"Let's find Indian relics!"

"Let's *make* Indian relics!"

"Let's go to the Old Mill and make a fort!"

"Let's wade as far as we can without stepping out of the creek—so no one can track us!"

"Let's roast a skunk cabbage root and try to eat it!"

"Let's make a path with steps in the hill and signs so an eighty-year-old woman could follow it!"

"Let's make elderberry pipes and smoke leaves!"

"Let's steal those real estate signs and hide them!"

Although our research into history, botany, anthropology, and geography almost got us poisoned or arrested on several occasions, we lived by joy. Once we ate a kind of wild carrot, then came home to look it up in Pat O'Shea's

father's medical text. The only plant we could find of similar description was called *hemlock*: "A piece of the root the size of a walnut can kill a cow." I never read a sentence in school that had such impact. The dizzying image of a stricken cow lurching heavily to its knees will inhabit my brain whenever I am about to taste a new food. That time, we were spared.

When I went to The Woods alone, my experience was shaped by a book Boppums had given me, Theodora Kroeber's *Ishi in Two Worlds*. It told the story of "The Concealment," a last cluster of five Yahi Indians in northern California living in the mountains at a place they called *wowunopo*, "the grizzly bear's hiding place," and finally of Ishi himself, alone in an empty world. Like Ishi, I was the last man, the only man of a lost tribe. I too had a small, sacred geography hidden even from my friends. If America ended, I would be there in my shelter of boughs. A huge tree had fallen, and where the root-mass tore out from the earth a hollow was left that no one could see, roofed over with the arched limbs of fir, woven by my hands with sword fern and moss, with leaf litter, until the roof became a knob of the earth itself. Like Ishi, I approached by a different way each time, so as not to wear a path others might see, and I covered the entrance to my den with boughs broken, not cut in a human way.

Inside, I would kindle a fire—only along toward dark so the smoke could not be seen—and be utterly alone with it, staring into the flame, nudging twigs together as they crumbled into ash, then letting it die and stumbling home along the ways I had memorized, to shed my clothes in the garage, to find my dinner in the oven and the family dispersed for the evening around the house.

My apocalyptic fantasy was nourished by the Cold War that filled the time—the air-raid drills in grade school, the evasive answers by adults, their troubled looks and few words about the greatest terrors of our world. In seventh grade we cornered our history teacher in the hall and demanded, "Will the bomb fall?"

"No."

"How do you know?"

"If I thought it would, I couldn't live my life."

Why did Boppums encourage my life in the woods that harvested so many cockleburs? She was a small, genteel woman, a minister's widow who stood humming at the ironing board while she watched a black and white *Edge of Night* on our tiny television. As a young bride, she had spent a desperate season trying to homestead in Wyoming, and she had few illusions about the glories of primitive life. Yet she had sewn this elaborately fringed buckskin shirt for me, and had given me my own bible of the primitive, *Ishi*, which taught me to be separate among my countrymen and distinct from my kindest friends, about wilderness skills and beliefs, about a kind of existential

fortitude that could keep one alive when the universe is wrenched awry and all people die. What was her lesson for me?

I learned a lot in the kitchen, working with my mother and with Boppums around the stove. I called myself my mother's company-boy, the one who would be there to stir, or crack an egg, or knead, grease the pan, lick the beater, help wash up. I loved to pour the oil into the batter; then I could see down into the secret center through the amber window it made. And I loved to open the oven to slide a toothpick into brown bread, my face hot, lungs filled with a nourishing fragrance of steam. This was the hearth where the family would gather when the bread was done to cut the first crust away, butter it, divide it. There were many lessons beyond the recipe.

Once when I came home from The Woods my mother stared hard at my face. "What happened to you? You look different! Your eyelashes are gone!"

I had to admit they were. I explained that I had begun to build my fire, but it wouldn't catch. As I knelt over the tinder to blow, it suddenly flared about my face. My hair crackled in an acrid smoke, and my face felt like the sun, but I fell back unhurt.

My parents discussed the use of matches—both at this point, and later, when Van Dusenbery and I tied my sister to the tetherball pole and *pretended* to burn her at the stake. My parents decided I could continue to carry matches, if I would promise to be careful. I promised, both times.

But why were the matches, kept dry in a slim match-safe with a screw-cap in my pocket, such an essential part of my get-up that I dared not venture forth without them? Of course, there was my motto as a Boy Scout: Be Prepared. "For what?" one might ask. But that's not how the saying goes—just Be Prepared. Carrying matches, and a knife, and some string, and a book in case I got bored, and a dime, and a magnifying glass, a stub of hacksaw, a little measuring tape that rolled into itself, and other tools that made my pockets bulge was the way I lived. I sauntered so equipped to school, to The Woods, and even to the city where I went for my clarinet lesson. I really needed a purse for it all, and I envied girls the amount of private stuff they could carry in the big handbags of the time. I finally made myself a bag from the waxy canvas covering of a war-surplus life preserver and trudged to school with it slung over my shoulder. Not fire, not a carving, but the ability to make fire, to cut, to tie things into a bundle—these were what Boppums and Ishi, and my parents, and my own sense of fear and mission in the world had taught me.

"If you are lost and have a knife," my father said, "you can make anything you need. First whittle a figure-four to catch a rabbit; then from rabbit sinew, braid a bowstring, and carve your bow from a yew limb. Then with the bow catch a deer, and make a coat from the skin. *Then* you'll be snug."

What a strange message to give a child. Now I remember that my father himself was alone like that during World War II—a conscientious objec-

tor isolated in a camp in northern California with other dissidents, fighting fires and planting trees in the very mountains Ishi roamed. My father felt the dangers, and the exhilaration of such isolation, and its required self-reliance. One time he was nearly hung by a mob made bold by wartime frenzy. And when the bomb fell, and the rest of America shouted and rang bells, he looked at his friends in confusion. And my mother, with her beautiful smile and her one good hand—did she feel alone in the world, for all her grace and articulate success? And Boppums, her mother, who gave me the book that somehow told our story? Did they, together, silently, teach me to be Ishi, to be a pacifist Hansel with no crumbs, to be a monkish "soldier of the cross," to be a bear boy gone far from others to live alone and discover from scratch what being a true spirit in a wild place might mean?

In the woods by myself, fire was the heart of it all. In my secret den, or in some refuge off the trail—in The Moss Forest, on The Island, beside The Stockade, on the sand beside The Second Creek, or near The Spring—I would seek out the low, shade-killed twigs of a hemlock tree, and the ritual of isolation and sufficiency would begin. I would hold a broken branch to my lips to see how dry it was. The lips, not the fingers, could tell. I would lay a ring of stones dug into mineral soil and arrange perfect sticks one over the other. I would slip out one match from the gleaming steel safe in my pocket, peel off the paraffin cap from its head with my thumbnail, and shield the hearth with my body from the wind—this the repeated prelude to my identity. When the match burst open in my cupped hands, and the flame climbed obediently through the precise architecture of my kindling, I had made, again, my own portable world in the world. The small fire talked, it warmed, it required care and responded well, it made me smell smoky and wild, and as evening darkened around us its coals were the small landscape of my thought.

Here was my private version of civilization, my separate hearth. Back home, there were other versions of this. I would take any refuge from the thoroughfare of plain living—the dollhouse, the treehouse, the hidden room under the stairs, the closet, tunnels through furniture, the tablecloth tent, the attic, the bower in the cedar tree. I would take any platform or den that got me above, under, or around the corner from the everyday. There I pledged allegiance to what I knew, as opposed to what was common. My parents' house itself was a privacy from the street, from the nation, from the rain. But I did not make that house, or find it, or earn it with my own money. It was given to me. My separate hearth had to be invented by me, kindled, sustained, and held secret by my own soul as a rehearsal for departure.

Is this a necessity for education—that each child must have some kind of separate hearth, some separate fire to kindle in secret? My friends had their own small worlds I knew a little about. They would spend their private hours under the hood of a car, or between earphones of the Grateful Dead.

To make a dead car speak is akin to the miracles we are asked to perform in adult life. To kindle pleasure in a lover's body, to kindle a vision in the mind through drugs—these were the forbidden ways some chose. For each of my friends, the separate hearth might be alcohol, religion, TV, crime. Theft and vandalism were ways of knowing and proving. Most went out on some kind of vision-quest in those days. Some didn't come back clear. But some never went at all, and these were the ones who obeyed only voices from outside themselves.

The world did end. My friends died, or changed, sold out, moved away. They became their parents or hurt their parents. Today my own clothes are clean. I walk in through the front door and leave no tracks. My pockets are flat. I carry money and a comb. I carry a driver's license with my picture on it. I don't carry matches to my clarinet lesson. I don't even play the clarinet. So what did Boppums teach? What did the fire teach? What is Ishi to me now, and how am I made ready by my years at the hearth hidden in the dark woods?

My first answer came when I heard Boppums falter, heard her suffocation-cough, alone with the doctor where she had collapsed in my sister's room. I heard my mother cry somewhere far off in the house. My father was trying to comfort her. And I held my little sister, telling her the lies of my wish.

"She will be all right. Isn't the doctor there? Don't let her hear you cry!" But Boppums was hearing nothing then. That time, we were the ones to stay behind, while she went on alone.

Twenty years passed before my turn came, and a kind of light filled my body, though I lay in our dark tent at six thousand feet, my eyes closed, my brother beside me and the last flash of lightning sizzling away to thunder. I knew. I knew I was about to die. The next bolt would run down the tree above us and blast through our bodies into the ground. The light began in my head, then flowed out along the ravines and caves of my chest, arms, legs. The glow within me meant I was chosen, perhaps my brother, too. There was no need to wake him. It would be too soon.

As I remember that moment now, I wonder why it didn't happen, why the glow within me faded to darkness and the storm passed without staking me to the earth with flame. Gripped by expectation of death—it was a fact, not a possibility—I had felt utterly easy. I had felt a joy beyond success. I had seen that moment as a gift to me, had known with brilliant clarity my brother beside me, my sister's husband in the next tent, the tree dead but standing above us, my wife and child distant and spared. I had visited—no, I had become the separate hearth. I had suddenly fit into history and been content.

As the storm passed, I needed to know what the fact of my death could mean for my life. How should I talk now, matured by this fact? How should I

drive, or cook, or pay taxes? Was I still an American, a member of the twentieth century? I had to reach back somewhere and answer.

After Boppums died, after my mother reported from the funeral, one of my needs was to step outside after dark. The street light would be there, courted by moths; the moon would be above me, or a tree or ragged cloud. One of my needs then was to look back at the pod of the house from a distance—say, from across the school ground, or from the top of the water tower I had climbed. That house down there was the compartment of human life, was the world Boppums made so calm, but she was gone and I was gone. I had been borne outward.

Now the match-safe I carry must be something about memory. With memory, with words I whittle and bind, hide, magnify, kindle—kindle the path beyond the spider web. Kindle the stump-cave with its roof of fern. Kindle the log high up over the creek, the ribbon of certainty my feet knew by dark. I kindle Boppums who died. I cup my hands around the soft light of her face. At the sink, I wash my daughter's face. "What did you find today?"

Boppums made me a leather shirt, then sent me somewhere she could never see. Grandmother, mother, daughter—I learn so slow: part of our love must be to teach each other how to live alone.

SHANA ALEXANDER

Born in New York City, Shana Alexander (1925–2005) was a graduate of Vassar College and a respected journalist and columnist for such publications as Life Magazine, Flair, McCall's, Harper's, *and* Newsweek. *In the late 1970s, she became widely recognized for providing the liberal counterpoint to conservative James J. Kirkpatrick on the television program* 60 Minutes. *Alexander has published nine books, including* The Feminine Eye *(1970),* Anyone's Daughter: The Times and Trials of Patty Hearst *(1979),* The Pizza Connection: Lawyers, Money, Drugs, Mafia *(1988), and* Happy Days: My Mother, My Father, My Sister & Me *(1995). Astonishing Elephant (2000) is an appreciation of the life of elephants, inspired in 1962 when Alexander witnessed the birth of an elephant at the Portland Zoo, an event she covered for* Life. *In this excerpt from that work, Alexander describes her assignment to cover "The Great Portland Elephant Watch."*

The Elephant's Child

I heard about it first on the radio, listening to the twenty-four-hours-a-day news broadcasts to which I had by then become addicted. An elephant in Portland, Oregon, was 1,000 pounds overweight and believed soon to give

birth. Very likely the zoo's three other female elephants were pregnant, too. If true, the story was big zoo news. Elephants are notoriously hard to breed in captivity, said the reporter, and all the "newborn" elephants exhibited here, at least in my lifetime, had in fact been babies captured in Asia. A genuine infant elephant had never been seen in America, not even by other elephants.

I got the news in Los Angeles, in my office at *Life* magazine. It was shortly before Christmas 1961, and I had recently been elevated to the exalted rank of staff writer, after having toiled at the magazine for more than a decade as a researcher and bureau correspondent. For the first time I had a byline and some say in choosing my assignments. My editors back in New York City agreed that the zoo was worth a look, and soon I was on a plane to Portland.

I found the city in a delirium of anticipation. Newspapers waved banner headlines: ELEPHANTICIPATING! and ELEPHANTRICIANS ALERT! One local radio station was broadcasting hourly "Belle Bulletins," and another had launched a "Name the Baby" contest. Toy departments were completely sold out of stuffed elephants. As Portlanders came to realize that their zoo's elephant house had become a vast maternity ward, a carnival mood swept the city, and the zoo was being deluged with gifts for the new-born—everything from gigantic, gold-plated diaper pins to hand-knitted baby elephants. School-children were assigned to draw pictures of what they imagined the baby would look like. Portland is proud to call itself the Rose City, and the morning I arrived the local florists' association had constructed a gigantic papier-mâché baby-bootie, filled it with 300 long-stemmed roses, and delivered the tribute as cameras rolled. The Washington Park Zoo (now the Oregon Zoo) was shrouded in heavy mists and intermittent rain as I sloshed my way for the first time to its pink-painted elephant house. On this chilly, miserable day, the elephants had retreated from their outdoor patio to their heated indoor quarters. The line of people standing out in the wet, waiting to get in, was sixty or seventy yards long, but the doorkeepers were moving it forward at a steady pace. I got in line and soon found myself staring into a gloomily lit, hay-strewn concrete chamber twenty feet deep and eighty feet long. The long wall nearest us was solid, unbreakable glass. Seven feet inside the glass was a row of stout, concrete-filled, floor-to-ceiling, four-inch steel pipes set just far enough apart for a man in a hurry to slip through sideways. Separating the spectators from the glass was a narrow alleyway that was beginning to fill up with camera crews and equipment. Workmen on ladders were installing a strip of floodlights on the ceiling so that the momentous nativity could be recorded on color film.

I stared through the glass and past the pipes at four looming, gray beasts. Two were slowly rocking back and forth on stout, pillar-like legs, while the other two languidly patrolled their quarters, rhythmically swishing the con-

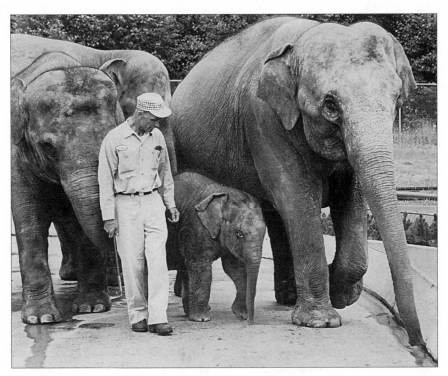

Elephants with a zookeeper at the Washington Park Zoo in about 1962

crete floor with their trunks as if wielding invisible long-handled dustpans and brooms.

It was difficult at first to determine which one was Belle. In profile, her condition was not especially notable; a thousand or so extra pounds on six thousand pounds of well-fed elephant is not as eye-catching as one might suppose. But viewed head-on, Belle could be seen to bulge amidships as if she had just swallowed a dozen watermelons. Seemingly ignored by her three ponderous ladies-in-waiting, the expectant mother strolled heavily around her quarters, nibbled hay, and occasionally glanced back over her shoulder at the slowly moving line of spectators. Once or twice Belle seemed to focus her mild gaze directly on me, an experience I found disconcerting. Her small eyes had wrinkled lids thickly fringed with long, Betty Boop-style lashes.

Outdoors again, I ducked around behind the elephant house and found a large rear storage room piled high with bales of hay, first-aid supplies, and other zoo paraphernalia. By now Belle's condition had attracted worldwide press attention, and a score of reporters and photographers were perched at varying heights on a twenty-foot-high haystack that filled one corner of

the otherwise bare concrete chamber. Facing them stood a handful of zoo officials.

The slim, weary-looking man in work clothes and high-top boots, his gray hair rumpled, was Dr. Matthew Maberry, the zoo's veterinarian, and he was introducing the other members of his team: the zoo's director, two doctors from the University of Oregon Medical School, a professional wild-animal importer, and the zoo's head elephant keeper. As I listened, I thought of the fabled six blind men of India. "Very like a fan, " said the man fingering the elephant's ear. "Like a tree," said the man feeling the leg. "Like a serpent," said the man at the trunk. Each one knew something about an elephant, but none had the whole picture. . . .

From January 25 onward, Maberry and one or more of his aides and a gaggle of reporters maintained a day-and-night vigil that became known as The Great Portland Elephant Watch. Headquarters was the back room of the elephant house, and we were forced to share the smelly space with two extraordinary wild animals. In a cage on the floor not far from where the unfortunate Thonglaw lurked, and occasionally lunged, squatted an Abyssinian ground hornbill, a turkey-sized, black, morose-looking bird with a beak like an iron banana. Periodically it shuffled around in the debris of its dinner and ran its beak along the bars of its cage, making a sound like a policeman's nightstick on an iron fence. Portland's hornbill was temporarily not on exhibition because the public found it too boringly revolting to look at.

At the start of our vigil, participants in The Great Portland Elephant Watch were a group of healthy, alert, eager animal experts and reporters, I the only female. We lounged in the hay pile swapping elephant tales; we read avidly through the scant elephant literature available; we catnapped occasionally, and rose often to poke, fondle, and feed the female herd. We munched our way through one hundred pounds of peanuts that a Portland nut merchant had sent to Belle, drank innumerable half-cups of coffee (the second half invariably saved for the expectant mother), and watched local TV on Keeper Tucker's grainy little black-and-white set. Life on The Great Portland Elephant Watch became mind-numbing, as well as olfactorily paralyzing. We elected ourselves members of a secret order called SPOPE, the Society for the Preservation and Observation of Pregnant Elephants, and devised and practiced a series of secret handshakes and grunts. Nothing helped.

The zoo switchboard was by now getting more than 500 Belle calls a day. Many callers were people in betting pools seeking hot tips on the likeliest day and hour of birth. Others were amateur obstetricians offering hot tips to the zoo men. Fill the enclosure with teak logs, suggested one, so Belle "would feel at home in the jungle." Another affirmed that all elephant babies are stillborn, but come to life if the other elephants are allowed to toss the

infant back and forth with their trunks. A number of callers said it was well known that the gestation period of an elephant is three, or six, or nine years, so the Elephant Watch might as well go home. This particular suggestion soon came to have a strong attraction for the Watchers. We were all irritable, groggy, emotionally strung out, itchy from the hay, and sickest of all of the inescapable smell of elephant.

Although an adjacent twenty-by-twenty-foot maternity chamber was in readiness for Belle, if necessary, Maberry preferred to leave her for as long as possible with the other pregnant females. Elephants are herd animals, sociable by nature, and the doctor believed that the companionship of Belle's ladies-in-waiting would reassure her.

"Preservation of the young is the greatest instinct of all wild animals," he said. "But if you interfere, they'll often switch and try to destroy the young. The best procedure is to keep your mouth shut and your eyes open."

On the afternoon of Thursday, February 1, Belle had a sudden seizure. She moved away from Rosy, Pet, and Tuy Hoa to the opposite end of the enclosure. The seizure lasted two and a half minutes, then subsided.

That night Belle's temperature remained steady, but the temperature outside the elephant house dropped to 20°F, and an icy wind swirled snow along the deserted pathways of the zoo. Inside, Maberry, his aides, and the waiting press sipped black coffee and walked the floor. So did Belle. From time to time, Thonglaw charged the bars of his cage with a force that shook the building. Once he trumpeted so fiercely he roused the guard at the zoo gates, a quarter-mile away. At 5:10 A.M., Belle moved off alone again and squealed in the grip of a mighty spasm. This one lasted four minutes. Half an hour later, she had a third attack. An elephant in labor exerts about four times the force of a horse, and Belle's pains must have been gargantuan. Every time Belle squealed, the other females crowded close to her flanks and petted her with their trunks.

By morning all was quiet again. When there was absolutely no change in Belle's behavior throughout the rest of the long day, the six-man team decided again to consult the wonderfully named Dr. Amoroso in London. He said that, since this was Belle's first baby, her labor might last twelve hours. He added that the cord would break automatically, and told Maberry not to worry about tying the umbilical knot; Belle would do that job herself, with her trunk. He warned the Portland team to remain on the *qui vive* because, once Belle got into high gear, "it will be a rather precipitous birth."

Alas, it was about as precipitous as a glacier crossing the polar ice cap. On Friday, February 2, Maberry and Metcalfe ran another electrocardiogram. Belle's great, fifty-pound heart was thumping steadily at about thirty-eight beats per minute; the fetal heartbeat was eighty-five. On Monday, at 2:20 P.M., Belle trumpeted loudly twice. It seemed as though she had entered the acute stage of labor at last, but in retrospect Maberry feels that these early

symptoms were false labor, perhaps stimulated by the unsettling presence of so many pop-eyed journalists.

For some reason, Belle always suffered most on Thursdays. After the first pains on Thursday, February 1, she slept little, ate little, drank little, and spent most of her time executing a curious, three-legged rocking motion. She kept her left rear leg half-cocked—whether to fend off meddlesome medics or just to relieve the well-known leg cramps of pregnancy no one but Belle knew for sure. Blood tests showed that Belle was becoming slightly anemic, so her diet was fortified twice daily with a pailful of diluted molasses. Belle took each dose with a single slurp of her trunk and downed it with the ecstatic expression of a child swallowing cough medicine on a TV commercial.

The next Thursday, February 8, Belle suffered several unusually severe contractions and for some hours stopped eating and drinking altogether. When Maberry and Metcalfe attempted to obtain a second blood sample, Belle bellowed and charged. The doctors ducked back outside the steel bars in the nick of time. "She snapped three steel chains just as if they were thread," Maberry said later.

The following Thursday, February 15, Belle had her worst night yet. She rocked and walked the floor until dawn. One of her elephant midwives always paced alongside and kept the miserable beast company, while the other two lay down and slept, snoring loudly through their trunks.

The next night, Maberry crawled into his bedroll just outside the bars, notebook in hand. When Belle's pains appeared to become especially severe, she "lay down flat and little Pet knelt beside her and gently massaged Belle's belly with her knee for fifteen or twenty minutes." During the massages, both elephants made odd snorting sounds. Pet even tried half-sitting on Belle's head. "Later Belle half-sat on Pet." Nothing seemed to help. When the pains were sharpest, all four elephants crowded close together and cried in unison. Sometimes the muscles between Belle's eyes knotted into a tremendous bulge, and tears rolled down her trunk. Although Maberry could see "very severe muscular contractions," the baby's kicking was no longer apparent. The doctor thought the baby probably couldn't kick because he was now holding in a vertical position, almost directly head down.

The assembled newsmen had also begun bellowing loudly. In a rout of journalism by science, the reporters had been banished from the elephant house, and armed guards had been posted to assure Belle's privacy. Maberry was doing everything in his power to prevent having a premature elephant on his hands. By then I had decided on a routine of my own: spend weekends in Portland, taking off every Friday evening after my husband came home, and leaving him to watch over our baby until Monday morning. Maybe I'd get lucky in my timing. My other problem was the perpetual, all-pervasive smell of elephant. One weekend at the staid old Benson Hotel, where I was

by now a familiar figure, the grinning room clerks handed me the key to a single room that had two bathrooms.

On the evening of Friday, April 13, I called the zoo from the airport, as usual. All was quiet in the elephant house, so I went directly to the hotel and checked in. At midnight, I later learned, Dr. Maberry had made his regular check on bulging Belle and, noticing nothing at all unusual, had bedded down. Near 1:00 A.M., Doc was roused by an urgent telephone call: across town, a pet poodle was gravely ill. Leaving the regular night guard on duty at the elephant house, Maberry drove to the stricken dog's bedside. While he was attending to the poisoned poodle, the zoo guard telephoned and reported that Belle had suddenly begun thrashing around her quarters and throwing water over her head with her trunk, and that her three elephant midwives appeared greatly agitated. Maberry got back to his obstetrical patient about 2:00 A.M. The guard woke me at the hotel. "Better get on over here, ma'am."

I arrived by 3:00 A.M., by which time there was no question but that acute labor was under way at last. Belle was bellowing, her eyes were wide and bulging. She had been moved to her private room, and continually strained and pushed against the walls, throwing her head from side to side, alternately kneeling and standing. We watched through a small viewing window in her concrete wall. Doc had already telephoned Zoo Director Jack Marks and sent for two more keepers to help him control the three rambunctious midwives. Morgan Berry was in his pickup, driving down from Seattle.

By 5:30 A.M., the three excited females next door were still squealing shrilly, but Belle had quit bellowing and was busy rapidly crossing and uncrossing her hind legs. At 5:56 A.M., she suddenly began spinning rapidly and silently in circles, pivoting on her forefeet. After two minutes of this dervishing, abruptly at 5:58 A.M., Belle's 225-pound infant quietly dropped to a heap on the floor—hind feet first, and backside front—and gazed about him with bright red but wide-open eyes. As he lay huddled under Belle's great belly, his mother swiftly knotted or clamped the umbilical stump with her trunk. Then she gave her newborn son a couple of swift kicks in his fuzzy flanks. Slowly but firmly he rose up on his stout legs. He was hairy all over, and the color of boiled veal. His pink-tipped trunk was so small he looked as much like a fatigued anteater as a baby elephant, and he seemed to have no idea what to do with the strange appendage dangling before him, and no control of its movement.

We heard a high, thin squeal, like a leaky balloon. Gently shoving the baby with her trunk and forelegs, Belle was nudging his head around to her breast. At 6:30, the baby managed to get his trunk out of the way and took his first swallow of elephant milk, a thin but very rich liquid that is said to taste like diluted coconut milk. He seemed to enjoy his first breakfast, though much of it was lost dribbling down the fringes of his hairy chops.

Occasionally his tiny, flabby, pink-tipped trunk seemed to quiver with gourmet appreciation, and he emitted more high squeals of delight.

At 7:00 A.M., Zoo Director Marks was manning the telephone, describing the blessed event to the press, when he got so excited that he collapsed to the floor in a dead faint. He was rushed to the hospital, put to bed for a couple of hours, and sent home to rest.

Soon a brilliant spring sun was shining over Portland. A blue elephant flag fluttered from a shopping center flagpole, and the city's children were trooping to the zoo grounds to view the newborn elephant, and also to take part in the annual Easter egg-rolling contest on the zoo lawn. Inside the elephant house, the newcomer was alternately nursing and stumping sturdily back and forth through his mother's legs. The mayor announced that, by a vote of the city's schoolchildren, the little fellow's name was Packy. His proud owner, Morgan Berry, finally dashed in from Seattle, clutching a tape measure, and soon revealed that the baby stood thirty-five inches high, measured forty-six inches at the chest, fifty-three inches at the abdomen, and eight inches at the trunk. Later he announced that Belle and Packy could be purchased for $30,000, and the schoolchildren of Portland immediately started a fund-raising drive to meet the price. At 10:00 A.M., Keeper Tucker forked Belle her morning meal of hay, bread, apples, and lettuce, and she devoured the mess with gusto. After twenty-one months of pregnancy, she appeared within four hours to have returned completely to her old, sweet-tempered, high-spirited, gentle-hearted self. So indeed had Dr. Maberry. The lines of fatigue and tension from attending a 6,000-pound female through three months of on-and-off labor had vanished from his face. As Maberry, Belle, and Packy lounged amid the hay wisps, regarding one another with an air of total contentment and pride in a job well done, the director of the egg-rolling contest poked his head through the doorway. He suggested that Belle, as Portland's first lady, should have the honor of stepping out onto the lawn and rolling out the day's first Easter egg.

"I don't think so," said Maberry. "Belle has already rolled her egg for today."

RUTH BARNETT AND
DOUG BAKER

Ruth Barnett (1894–1969) was one of the most renowned and glamorous figures in Portland's demimonde and a leading provider of abortions in Oregon for fifty years. From her house in the Southwest Hills, she hobnobbed with the city's politicians and businessmen, its gamblers and prostitutes. Her life has been chronicled in Rickie Solinger's The Abortionist: A Woman Against the Law *(1994).* They Weep on My Doorstep *is Barnett's life story, as told to Doug Baker (1922–1986), a columnist for the* Oregon Journal *and the author of several nonfiction works, including two guides to Portland. In these excerpts, Barnett recounts her family's move from Hood River to Portland in 1911 and, upon learning she was pregnant, her search for a doctor who performed abortions. She also details her marriage and her own emerging practice as an abortionist, including her meeting with Dr. Marie Equi, an outspoken Socialist and anti-war activist in Portland.*

From *They Weep on My Doorstep*

I was in high school when Dad decided to move his family from Hood River, a small town in Western Oregon, to Portland. I can't recall what prompted his decision, but I was all for it. I had been to the big city several times with Dad, but only for brief visits. Today, the drive from Hood River to Portland can be made easily in two hours. Then it was an all-day trip, generally by boat.

My childhood goes all but unmentioned in these memoirs. Dad was a grocer in Hood River and I was born over the grocery store. My brother, sister and I did a lot of riding, a lot of fishing. Nothing about my childhood is particularly memorable. It was as smooth as glass.

Now, I was to become an actual part of the city, and I could swing onto street cars with nonchalance. I must admit I spent more time day-dreaming than assisting with the necessary moving preparations—the packing of chinaware, crating of furniture, rolling and wrapping of rugs and other chores. . . .

Romance came into my life again less than a year after my abortion. I was still working in the dentist's office where my recovery, a few months before, had mystified and intrigued my boss. He became bolder in his advances but I knew how to fend them off. He salved his wounded ego by demanding extra work and criticizing the way I did it. The job was becoming onerous. I determined to look for a change and found it—by getting married.

It would not be accurate to say I married Harry Cohen to get out of the dentist's office. I was sincerely fond of Harry. And while that may not be the same as love, I thought it was—or would, eventually, become love.

Dr. Ruth Barnett in July 1951

At my wedding reception at the old Oregon Grill in 1913 I met a woman who was to be a great influence in my life. She was Dr. Alys Griff, a physician and surgeon of considerable prominence. As Dr. Alys Abigail Bixby, she had been graduated from the University of Oregon Medical School in 1902, becoming one of the earlier women physicians in the Northwest.

Dr. Griff was married to Floyd Griff, Harry's best man for the wedding and it was Alys who gave my reception at the cabaret where Trader Vic's Restaurant is located nowadays. I was immediately taken with Alys. There were more beautiful women at the reception, but there was something in Dr. Griff's bearing, a vivaciousness she possessed in spite of being a heavy-set woman, which set her apart from others of her sex. Her severe brown suit was expensive and perfectly tailored. She handled herself with charm and confidence in a room crowded with happy, relaxed, laughing people. I was most impressed by her eyes. They were the first cold, brown eyes I had ever seen.

Soon after our marriage, Harry and I moved to Seattle. He was the sales representative in the Northwest for Can't-Bust-'Em overalls and Argonaut workshirts. We settled down to a fairly bourgeois mode of living.

I found myself making frequent trips to Portland, ostensibly to see Mother and Dad. Actually, I spent most of the time during my visits to Oregon with Dr. Griff.

I was still a youngish thing and the doctor was an idol of sorts. In turn, she seemed to like my company. She would take me along on her house calls and to Good Samaritan Hospital where we would visit the maternity wards. I would sit up in the gallery above the operating room and watch her perform appendectomies, hysterectomies and Caesareans. She was a jolly, wonderful woman and I enjoyed her company.

She had been specializing in diseases of women but so many women were coming to her for abortions that she had less and less time for the rest of her practice. Shortly after my marriage to Cohen, she had been divorced from Floyd and was living alone in the Oregon Hotel. After her day's work we would sit for hours in her suite and talk. Rather she would talk and I would listen. These conversations, all dealing with her work, increasingly stimulated my interest in medical matters, particularly when we discussed abortions, for, from the time of my own abortion, my interest in this operation had grown. It seemed to me to be the most wonderful work in the world. The sub-conscious urge to make this my life's work must have been growing fast, although I did not realize it. The thought that I might actually be of help to women in this way began to obsess me.

Each time I would return to Seattle during those five years my marriage lasted, I would notice a growing rift with my husband. He spent most of his time on the road with his sales work or playing interminable pinochle games with his friends. So our married life continued until my baby was born.

The arrival of baby Margaret created intense excitement in my in-laws' house. Even Harry became, for a while, a family man, handing out the traditional cigars and playing the proud father with typical aplomb.

But this phase passed quickly. When he first began neglecting me, I was hurt and humiliated. After Margaret's birth, I became indifferent to him. I permitted things to drift for almost two years. Inevitably, the thin pretense of being married could no longer be maintained. I sued for divorce. Harry did not contest the suit, and agreed to pay me a small monthly allowance.

Margaret and I returned to Portland, to my old room at Mother's, and I did some thinking about the future. It did not appear too rosy. I had a two-and-a-half year old child, a mother and father growing older, a small alimony and little savings. What I needed was a job. But what kind of job? What was I best fitted for? The only work I had done was in a dentist's office, so I turned my planning to that experience.

My brother was commanding officer of the Student Army Training Corps at Reed College and North Pacific Dental College. I decided to enroll at North Pacific for a course in prophylaxis—the treatment of pyorrhea and scaling and cleaning of teeth. After six months I got a job with an advertising dentist with a big suite of offices in the Lafayette Building over Rich's Cigar Store. It was interesting work and the pay was fairly good for those days—$27.50 a week. I was managing well. Life was serene and the future looked

secure until one day the dentist told me the state legislature had changed the dentistry laws and my diploma no longer covered the many additional subjects required of dental hygienists.

"And what does that mean?" I asked.

"That I must let you go," he frowned, "much as I hate to do it. You've done an excellent job." He got up from his desk, adding, "You'll want to go back to school anyway, to learn those new-fangled didoes. But see me when you finish."

I never saw the inside of a dental office again after that—except as a patient. My short career in dentistry ended before it really started. Going back to school for another three months to take additional subjects was out of the question. I had no savings and I had to earn some money for living expenses as quickly as possible.

I was changing from my dental assistant's uniform when I was called to the telephone. It was Dr. Griff, inviting me to dinner. I had not seen her in three months. Her clinic had been terribly busy. World War I had left many women with unwanted pregnancies. When I saw her, I was shocked at the change. It showed itself in little ways: she snapped at the waiter, abruptly terminated phone calls—things like that.

But she was cordial and pleasant to me and I still admired her, especially for the work she was doing. I told her about my enforced "retirement" from the dental profession. She told me about her clinic and how busy she was. All through dinner we must have been mulling over the same idea. By the time we got to the dessert one of us—I can't remember which—had broached the subject of my coming to work for her.

"I think you know I'm dedicated to my work," said Dr. Griff. "It demands dedication. And that can't be just a word. You've got to care, about the patient, about the work itself."

"I know," I answered. I did not tell her then, or ever after, about my personal experience with abortion.

She lit a Chesterfield and sat, staring at the window, rolling the cigarette back and forth between her tobacco-stained fingers.

I watched her reflection in the restaurant window. Beyond it, I saw couples passing by, some laughing, some quarreling, others silent. The street was more crowded than during any peace-time Saturday night. And there seemed to be more hysteria than real happiness.

"There's a great deal to learn," she said, after a while. "There is so much you don't know. You couldn't be of any real help for quite some time." She looked at me with those cold, brown eyes. "I wouldn't be able to pay you much."

"I don't care," I said. "I'll work for anything you say." I watched her as she looked at me closely. "I learn quickly," I added with confidence. Then, suddenly, I thrust out my hands, palms up, saying, "And my hands are steady."

She looked at my hands and smiled. "Suppose I pay you fifty a week to start."

"Starting as of now!" I insisted.

And so, I began to learn the technique of abortion. And I began to learn many other things. I learned not to be shocked at the sordid, not to be surprised at the ludicrous. Rapidly, I learned that I must put aside a lot of youthful illusions.

After just a few weeks I was permitted to get the patients ready and to stand by Dr. Alys while she operated. As time went on, I assisted in difficult cases. Sometimes, Dr. Griff would become so nervous she would have to leave the patient before finishing the procedure. I would then complete the surgery, a responsibility I was glad to assume.

During these years I became fully acquainted with the woes and ways of women in trouble. At the time I thought I would remember each case, but I find, now, I have forgotten most. I do not say that they were commonplace, because no pregnant woman's plight is commonplace, at least to herself. It was only a case of today's experience overshadowing yesterday's as tomorrow's will erase today's.

Of course, random memories remain—incidents and sidelights on human nature more vivid than the clinical details. I remember looking over my desk one morning at a very pretty girl of about 19. She was dressed in a becoming, obviously-new suit. Pinned to her lapel was a wedding corsage of forget-me-nots. She held back the tears as I questioned her. I asked her if she was married and, "Does your husband know about your coming here?"

"I don't know," she began and the tears came. "I mean, I don't know if he's going to be my husband. We were to be married at noon, but he said to come here first."

This was an emergency—and a novel one. "Is your husband-to-be the father?" I asked. She said he was. "Then you have nothing to worry about," I assured her, and I called Dr. Griff.

After an hour with Dr. Griff, quite recovered and radiant instead of tearful, the bride was back in my office, asking to use the phone. She dialed a number and asked for "Edward." For a full minute she listened and her face grew white. Then she hung up without saying another word.

"What's the matter?" I asked. "Anything wrong?"

"Not a thing, not a thing," she said, "except, the marriage is cancelled. Edward left me standing at the altar, the sonofabitch."

Those eleven years with Dr. Alys Bixby Griff began in the final year of the Great War and continued through most of the tumult of the Roaring Twenties.

For me, still a young woman, they were exciting years. Dr. Griff was a nervous woman but a jolly person with a great zest for life.

Nothing creates patients for an abortionist like a war with its whirlwind

romances, hurried leave-takings and increased promiscuity. Patients came to Dr Griff's offices in the Lafayette Building at S.W. 6th and Washington in a steady stream. At times, there were three or four girls waiting in the waiting room and another two or three on couches in the inside offices.

Our office hours in those days began at 11 a.m. and ended at four o'clock in the afternoon. But there was other work, too. Many a night I would go to one of the Japanese hotels or another and take care of some girl with a miscarriage.

We worked hard and we played hard. After work we would whoop it up until all hours of the morning.

We all lived in the old Oregon Hotel in those days. Dr. Griff had Rooms 225 and 226, beautifully-furnished rooms on the second floor right at S.W. Stark and Broadway. My room was 227 and Dr. Marie Equi, the famous Socialist, lived in 228.

Dr. Alys was a wonderful cook She could go into the bathroom with just a breadboard and a chafing dish. She'd put the breadboard across the bathtub and a half hour later she'd come out of there with as fine a dinner as you've ever seen.

Night after night, we'd go to parties. Those were Prohibition days and we'd drink all kind of things. We used to drink from vats of homemade brew that were alive with gnats. We'd just ladle the beer right out of the vat with a big dipper and drink it. We had a Japanese janitor at the hotel and he could always get us a bottle of sake.

We'd go out to the roadhouses—Twelve Mile or the Clackamas Tavern. There were four or five wonderful roadhouses out on Linnton Road in those years. The doctor always had a big car, either a Winton or a Pierce Arrow. We had some great times. When you work hard, you appreciate the laughs, the big dinners and the booze.

There were so many funny things that happened in those days, it's not easy to remember them all. I remember one time a girl came to the office for an examination and Dr. Griff told her to get up on the operating table. The girl didn't know what position to assume.

"Just get up on the table in the same position you were in when this happened to you," said Dr. Griff.

"But I had my feet through the windshield," said the girl. We laughed over that one for years.

During those years in the Lafayette Building, Dr. Marie Equi was our office neighbor as well as our next-door-neighbor in the old Oregon Hotel. She and Dr. Alys were close friends, and I came to know her in that way.

Mary Equi—we always called her "Mary," not Marie—was a "Wobbly," a member of the International Workers of the World and a dedicated Socialist with a raft of friends among working men. She also numbered some of the greats of the earth among her acquaintances. I recall Margaret Sanger, the

courageous woman who pioneered birth control, coming to see her. Another friend of hers, as I remember, was Eamon de Valera, the fiery New York-born revolutionary who became president, and later prime minister, of Ireland.

Federal investigators used to come into the office and ask me about Dr. Equi. I always told them I knew her, but knew nothing about her business. I've always been one to keep my nose out of matters that don't concern me and I've never been a stool pigeon for anybody.

During World War I, Dr. Equi rode around town on the back end of a truck, speaking out against the war and urging men not to enlist in the army. She was beaten up by a mob and arrested under the Espionage Act.

She appealed her conviction all the way to the Supreme Court, but finally went to San Quentin. President Woodrow Wilson had reduced her three-year sentence to a year and a day and she was in the federal prison for 10 months.

From what I heard, Dr. Equi was a terrible inmate, always rebelling against the rules. Dr. Griff and I took care of a lot of her patients for her while she was in the federal penitentiary. I remember that first Christmas she was there she wrote me and asked me to buy Christmas presents for about 20 of the other women prisoners. I bought mostly things for them to embroider and a lot of stockings.

After Dr. Equi was released from prison, she continued to do nice things for the inmates there, sending turkeys for Christmas along with candy and other things. She continued for some years to be featured in the newspapers. In 1927 she was arrested at the Heilig Theater during a performance of "Mitzi." They charged her with being "drunk and disorderly." I never understood the drunk part of the charge because she certainly wasn't a drinking woman. She was a very heavy smoker and her hands were always black from cigarette tar. At the time of the Heilig arrest she said she was merely protesting the showing of the play which she said was "risque." The court finally issued an order restraining her from ever reentering the Heilig.

I once wrote a little song about Dr. Equi. The lyric went like this:

> *Mary was the queen of the Bolsheviks.*
> *Everywhere she went her name was known.*
> *Blue eyes, hair the color of gold*
> *And disposition strictly all her own.*
> *She'd stand atop a soapbox,*
> *A red flag in her hand,*
> *She'd teach democracy throughout the land.*
> *She always caught the nickels and dimes*
> *And gave the boys a cheer,*
> *And all at once the boys began to sing,*

"Let Mary alone, alone, alone,
Let Mary alone, Uncle Sam. . . .
. . . Keep her out of the pen. . . ."

On September 15, 1919, which was 13 months before Dr. Equi went to jail, President Wilson and Mrs. Wilson visited Portland. President Wilson was touring the United States in his campaign to win the people to his idea of a League of Nations.

I remember the parade down Broadway distinctly. Dr. Alys and I had an excellent view on the second floor of the old Oregon Hotel. We were wearing our kimonos and Dr. Equi, two windows away from us, was in her pajamas with a suit coat over the top of them. I remember it so well, because Dr. Equi shouted to Dr. Griff when the Wilsons came by, "Mrs. Wilson looks like you, Al'." There was a resemblance and it was accentuated because Mrs. Wilson was wearing a big floppy hat and Dr. Griff always wore floppy hats.

But that afternoon when I bought a copy of the *Portland Telegram*, there was a story which said, "Among the witnesses to the parade was Dr. Marie Equi who stood at the curb in a little, chic blue suit, and said, in a quavering voice, 'I wanted to see him,' and then sped on and was lost in the crowd."

From that time on, I've never really believed a newspaper version of anything.

ALBERT DRAKE

Born in Portland during the Great Depression in the Charity Ward of Multnomah Hospital (now Oregon Health and Sciences University), Albert Drake (1935–) returned thirty years later as a research assistant in the Bone Tumor Registry at the hospital. Drake graduated from Lents Grade School and Franklin High and worked in gas stations, garages, warehouses, and a cemetery, where he was a gravedigger. He attended Portland State University and graduated from the University of Oregon. The author of two novels set in Portland, One Summer *(1981) and* Beyond the Pavement *(1981), Drake received two major grants from the National Endowment for the Arts. His most recent book is* Fifties Flashback. *This piece from* One Summer *is set in Lents.*

Lost Lake

Early, under a dull, leaden-gray sky, he walked for the last time the familiar blocks to Lents' School. In the building his steps echoed along the empty, dark hallways, and when he thought how many years he had spent in this school, and that his class was the last of a long, shadowy line to graduate

from it, that it would soon be demolished, he felt quivery. He was finished with it, and it was finished. He saw a friend floating like a ghost at the far end of the hall and wanted to call out; the door closed and he was left in that early-morning gloom he had known so often in this building.

In his old classroom he got his report card and, almost running, emerged from the building into sunlight. The air was cool and moist, and he began to run across the hardened dirt of the playground. He felt a breathless excitement: he had finished something, was done with it, and now looked forward to new adventures.

At home he ate a quick breakfast, made sandwiches for lunch, and got his weapons; he carried a .22 Savage rifle and wore a .22 H&R pistol on a belt which also held a hunting knife and canteen. His mother wanted him to go with her to help finish decorating a Rose Festival float, but he had his own plans.

Today he would find Lost Lake.

By 9:30 he was crossing the empty fields of the neighborhood, the sun cutting through the high mist and lifting the dew from the weeds. Horace waited in his front yard, and together they walked across Foster Road and down 99th Street through Dwyer's mill. Johnson Creek was sluggish with mill refuse. A Hyster driver waved and yelled something; the saws whined and steam pumped from a dozen outlets drifted into the sky. Past the mill they walked in the shadow of logs stacked forty feet high.

Beyond the logs the road led them into the country.

To their right was Indian Rock, an old stone quarry, and then the road narrowed, turned, and they began their ascent up Mt. Scott. There were a few houses, but the land was undeveloped. On the corner, overlooking the mill, was a modest house, distinguished because it had the only swimming pool in Lents; it was Chris's impression that the owner had bought this piece of land because he could easily drain his pool down the hill. Farther on was Nigger Tom's shack, a dilapidated eyesore. There were only a few houses between, but these two showed the extremes: from what passed in Lents as affluence, to what was certainly poverty.

At the end of the road was Lincoln Memorial Cemetery. They walked under the wrought-iron gates and began the steep climb, sometimes following the road, sometimes cutting across the graves. The oldest graves had tall stones and ornate Gothic lettering; they dated from the nineteenth century, and this concept of time and death made Chris's scalp crawl. Under the tall firs the stones were partly covered with a thick green moss. They climbed upward past newer graves, with flat stones, and got to the four silver World War I howitzers.

They were now high enough to see Portland. The eye followed the main streets, 82nd to Foster, Foster to Powell, westward to the river; downtown tall buildings shimmered in the sun. The *Journal* building with the clocks in

its tower; the PGE building, Meier & Frank's, Lippman Wolfe, and above the city Council Crest and Skyline Drive.

They rested, then walked over the ridge and downhill toward the reservoir which marked the edge of the cemetery, and past it; entered the definite line of mature Douglas Fir which was the edge of the woods. Chris looked up before entering the trees, to see Mt. Scott rising steeply, the tops of its thick woods reflecting the sunlight.

Once inside that line of trees he felt changed, moved back in time; where there had been sunlight there was now darkness, where he and Horace had been exposed they were now hidden. They followed the familiar foot-trail through the trees, moving like Indians single-file, not speaking, the carpet of needles cushioning their steps. The woods were cool, dark, illuminated only where a thin sunshaft could filter through the high trees. He carried his rifle ready in the crook of his right arm, felt the weight of the pistol on his hip. In these woods he was not pioneer or cowboy or legioneer, but all those and more as he padded through silent woods, armed, alert, content.

Usually they walked about a half-mile along this trail and then turned back, but today they followed it along a ridge and through a clearing. When it broke into the open they saw only blue sky; the firs cut off their view of the city, and they could well imagine it didn't exist. There were no houses on Mt. Scott, and they had never seen any people on the trails; the only things which moved in the dense woods were gray tree squirrels or birds.

Beyond the clearing the trail ended and they pushed through the dense undergrowth; they stumbled, cursed, held their rifles high so they wouldn't get scratched. They struggled uphill, stomping bushes back, sweat pouring through shirts until, about noon, quite by accident, they found Lost Lake.

They broke through the brush and saw dark water below them, a small, spring-fed lake tucked among the trees. Chris had been all over the mountain many times but he had seen the lake only once before, when Mal had shown it to him.

They ate lunch beside the lake. Peanut-butter sandwiches, cookies, and an apple tasted great after the long, arduous climb. Chris drank from the canteen, the water metallic-tasting and warm, and imagined himself hunting in the Rockies. Beside the small lake they talked about the movie, *Beau Geste,* which they had seen the week before at the new Century theater, and *Four Feathers,* which they hoped to see. They talked about going downtown on Saturday, and relived an especially harrowing descent they had once made on bikes down 112th Street hill. A breeze moved the trees' upper branches, and the heat sifted down; fir needles oozed a warm, rich odor. Chris lay back and looked straight up into the blue sky and wished that the world would never change.

Later they began to wander down the mountain. They found their familiar trail after an hour of struggling through brush, and were soon out of the

trees. Now the route was unobstructed and it was all downhill. They walked past the reservoir, through the cemetery, past Indian Rock and Dwyer's mill.

They stopped to play in Johnson Creek and found a water-dog struggling along the bank; Horace grabbed it before it could get away. He said he was going to take it home but when they crossed the Galloping Goose tracks they heard the distant rumble of the trolley. Chris laid a penny and two nails on the tracks, and Horace, with a grin, tied the water dog in place with long strands of grass.

The steel tracks began to hum, and they saw the Galloping Goose, heard its mournful hoot as it approached Foster Road; it came toward them, the headlight like a single eye, the car swaying from side to side until it threatened to tip. They stood beside the tracks, fearless in the face of this danger, and as the trolley thundered past it blew its whistle to warn cars crossing 99th Street: the noise of whistle and steel wheels on tracks was terrific, and then it was past and in the ominous silence they looked down at their trophies.

Scotch Broom

During the night a heavy rain had fallen, and as he walked through the fields wet grass beat against his pant legs. The tall stalks bent with the weight of water, and spider webs were etched in bright patterns. Overhead the sky was blue, and as the sun broke from the low clouds in the east the field sparkled.

He had awakened early, a sense of excitement building. He had eaten breakfast quickly, and was out the door as his father left for work. He hurried across the fields toward Horace's house, wondering about the beautiful, nervous excitement that made him want to shout.

He began to run, shattering the delicacy of wet grass. As the sun rose a ground mist began to grow, rising to knee-level before it dissipated. There were four blocks of fields between his house and Horace's, and their growth ranged from grass to Scotch Broom and Oregon Grape to wild blackberries. As he crossed into the second he saw that the Scotch Broom had blossomed overnight, changing the field into a profusion of yellow. The bushes drooped with the weight of the rain but they were still over his head. Then he was standing within the bushes, the world shut off, the odor of alfalfa and sage overpowering, and he saw that each tiny yellow blossom was encased in a perfect drop of rain.

Smells

The cinnamon odor of lilac and roses drifting through the screen reminded him of Kool-Aid popsickles he had made in the refrigerator using toothpicks for sticks.

In the chickenhouse the smell of whitewash, Lysol, and chicken crap filled the darkness, and the thickness of straw forced itself into his nostrils.

On cold nights, while he listened to the radio in the front-room, he enjoyed dropping fragments of airplane dope, dried like snot, on the oil heater. The tiny transparent trailing would curl, begin to smoke, and suddenly burst into flame. His own spit danced against the hot metal with a scorched smell.

He loved the smell of cordite, shell cases, gun oil; he would sniff the greenish brass shells of his .32 rimfire. He loved the smell of leather: his revolver holster and belt, the loops of bullets, the heavy sling of his rifle. A familiar odor was the metallic smell at the end of his B-B gun, where the blue metal became a copper-colored sunburst.

Old paper: the stale smell of his comic books and pulp magazines, like ear wax. The oily smell of old *National Geographics*. The books in the Lents library all smelled of institutional must, as if they were often damp. He found these odors, and their associations, pleasant.

The beautifully sharp odor of tobacco against his lips; the illicit taste of Loganberry wine and Olympia beer.

Some of the best times he associated with the strong, pitchy odor of fir trees: lying in a bed of brown needles on a hot day, the air charged with the pungent smell, or standing under a fir in the rain. Every field had a different smell, depending upon the weather and temperature. The smell of Oregon Grape in the fall, the seeds popping. The smells of rain: steamy on a hot sidewalk, green and pungent during the spring, constant during winter, the leaves wet and rotting underfoot like fish scales. On Halloween the masks got wet and sagged around the wearer's face, the fake hair a sodden mass, the over-whelming odor of cheesecloth.

The odor of dust cooking on the tubes of his radio late at night.

At the Branch

When he got to the corner he began to pedal faster and he swung into view pedals flashing, leaned the bike over, whipped it from the street around the corner and up onto the sidewalk and slid to a stop in the gravel beside the branch office. The five boys who sat in the shade on the east side looked up at his arrival, then continued to flick stones onto Foster Road in a bored, aimless manner. The door was still locked.

"Where's Allen?" Chris asked. Allen was the Branch Manager and it was his responsibility to get here early, to open the branch, and to distribute the papers.

"He quit," Billy said.

"No he didn't, he got fired," Cal said. He was Billy's brother, and fought

with him as well as with everyone else. "He was letting the guys piss on that stove and the morning crew was raising hell."

Although it was summer, often someone would stuff the tin stove with the papers which were wrapped around the bundles and start a fire; when the stove's thin sheet metal began to glow red hot there was always someone who would urinate on it. The smell was bad enough at 5:00 p.m.; it was terrible twelve hours later when the morning crew arrived.

"He quit," Billy insisted. "He's going to start high school and he doesn't want a paper route anymore."

"You're out of your gourd, pud," Cal said, and slammed his fist into his brother's shoulder. They began to scuffle in the gravel and the others looked on with mild interest.

Chris sat in the shade and picked up a length of wire which had been used to bind a bundle of papers; he straightened it, found another wire, and tied the two together. He did this with six pieces, until he had made a single long wire, and when he had finished he walked to the edge of the sidewalk. Traffic was light on Foster Road, and when no cars were in sight he swung the long wire in an arc and let it fly into the air; it flashed, swinging, and dropped across both overhead trolleys for the electric bus. There was a bright flash and crackle. The wire rocked in the air, like a silver fish out of water. No matter how many times he had wired the trolleys he always felt the same intense excitement.

Allen still had not arrived when the beat-up yellow *Oregonian* panel arrived and the man threw the bundles of papers on the sidewalk and sped off. Two boys who were in a hurry to get going picked up bundles and took them into the shade where they struggled with the wire; the cutters were locked inside the branch, but after they bent the wire back and forth for several minutes a strand broke. They ripped out a handful of papers until there was enough slack to remove copies intact, and they began to roll them.

A bus came down Foster; the trolleys hit the wires, carried them along the cables and at every intersection of cross cables there was a flash and puff of smoke.

Chris had begun to pick up more pieces of wire when a black Chevrolet Fleetline pulled to the curb and Fowlwick got out. He was the Assistant District Manager and a senior in the high school where Chris would be going next fall. Fowlwick brushed back his sharp crew-cut, flipped his cigarette on the sidewalk and stepped on it without breaking stride, the toe of his gleaming oxblood-colored brogue mashing it into the cement. He wore spotless white cords and an Hawaiian shirt. Without a word he unlocked the door to the branch.

"Where's Allen?" Billy said. "He quit?"

"He got fired, right?" Cal said.

Fowlwick looked at them, and then smiled. "Let's just say that Allen is no longer associated with the company."

The air inside the building was roasting, and when Chris had got his papers for his two routes, 1551 and 1552, he went back outside to roll them. He was filling the handlebar bag when Fowlwick rapped on the window and motioned to him. He looked around to see if the gesture was meant for someone else, and then went inside wondering what the hell was up now.

Fowlwick leaned against a desk in the corner. "Chris, you know that Allen is no longer branch manager." He paused, reached into the pocket covered with a large palm tree, and drew out a pack of Luckies. He lit one while Chris watched, confused, knowing that Allen was gone but unsure why he was gone and what it had to do with him. "We're going to need a new man, and I've been watching you." He lit the cigarette and blew out smoke, his eyes narrowing as if he could see through Chris. "What do you think?"

"What do you mean?" Chris asked, understanding but not quite.

"How'd you like to be Manager? Pays $4.65 a month. There are some responsibilities; for example, you'd have to be here every day, arrive early to unlock the branch, check out the papers, and tidy up after the boys have left. It's a management job, and could lead to something better."

Chris knew he meant the job of Assistant District Manager, or even District Manager. "Sure, okay," he said, awed and excited by the prospect of earning money and of being chosen from all the other boys.

"Good," Fowlwick said, reaching to grasp Chris's hand while his other hand gripped Chris's shoulder, a movement which embarrassed Chris but which also made him feel like an adult. "I knew I could count on you. By the way, there's one other thing." Chris looked up as he sensed rather than heard the shift in tone. "You have to keep these guys from pissing on the stove. It smells terrible in here when the morning guys get here."

"I can do it," Chris said, sure that he could. With that extra money he could buy a Civil War sabre from Horace, or two Fiji throwing spears which were at Dicken's Curiosity Shop, or a .32 calibre Bulldog pistol from Robert Abels, or—no, he told himself, he needed the money to buy a pair of English Brogue shoes for high school.

"Good," Fowlwick said, looking around the small room. "Hell, they don't even *need* a fire in the summer."

URSULA K. LE GUIN

Born in Berkeley, California, Ursula K. Le Guin (1929–) has lived in Portland since 1958. She attended Radcliffe College and received an M.A. from Columbia University. She received national recognition for her work with her novel The Left Hand of Darkness *(1969), which won the Hugo and Nebula awards, as did* The Dispossessed *(1974). Among her most popular fantasy works are the three novels of the* Earthsea Trilogy *(1968, 1970, 1972). In 1990, she published a fourth Earthsea novel. Le Guin's literary production has made her one of America's most critically distinguished writers, and her work is often noted for its feminist and ecological themes. This selection from* The Lathe of Heaven *(1971) depicts a futuristic Portland, where the Columbia and Willamette rivers have been thoroughly harnessed, where the weather becomes warmer and wetter due to the greenhouse effect, and where the city's population has reached three million.*

From *The Lathe of Heaven*

Those whom heaven helps we call the sons of heaven. They do not learn this by learning. They do not work it by working. They do not reason it by using reason. To let understanding stop at what cannot be understood is a high attainment. Those who cannot do it will be destroyed on the lathe of heaven.—Chuang Tse: XXIII

George Orr left work at 3:30 and walked to the subway station; he had no car. By saving, he might have afforded a VW Steamer and the mileage tax on it, but what for? Downtown was closed to automobiles, and he lived downtown. He had learned to drive, back in the eighties, but had never owned a car. He rode the Vancouver subway back into Portland. The trains were already jam-packed; he stood out of reach of strap or stanchion, supported solely by the equalizing pressure of bodies on all sides, occasionally lifted right off his feet and floating as the force of crowding (c) exceeded the force of gravity (g). A man next to him holding a newspaper had never been able to lower his arms, but stood with his face muffled in the sports section. The headline, "BIG A-1 STRIKE NEAR AFGHAN BORDER," and the subhead, "Threat of Afghan Intervention," stared Orr eye to I for six stops. The newspaper-holder fought his way off and was replaced by a couple of tomatoes on a green plastic plate, beneath which was an old lady in a green plastic coat, who stood on Orr's left foot for three more stops.

He struggled off at the East Broadway stop, and shoved along for four blocks through the ever-thickening off-work crowd to Willamette East Tower, a great, showy, shoddy shaft of concrete and glass competing with vegetable obstinacy for light and air with the jungle of similar buildings all around it. Very little light and air got down to street level; what there was was warm and full of fine rain. Rain was an old Portland tradition, but the warmth—

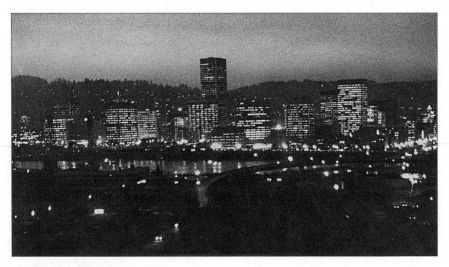

The Portland skyline at night in about 1980

70° F. on the second of March—was modern, a result of air pollution. Urban and industrial effluvia had not been controlled soon enough to reverse the cumulative trends already at work in the mid-Twentieth Century; it would take several centuries for the CO_2 to clear out of the air, if it ever did. New York was going to be one of the larger casualties of the Greenhouse Effect, as the polar ice kept melting and the sea kept rising; indeed all Boswash was imperiled. There were some compensations. San Francisco Bay was already on the rise, and would end up covering all the hundreds of square miles of landfill and garbage dumped into it since 1848. As for Portland, with eighty miles and the Coast Range between it and the sea, it was not threatened by rising water: only by falling water.

It had always rained in western Oregon, but now it rained ceaselessly, steadily, tepidly. It was like living in a downpour of warm soup, forever.

The New Cities—Umatilla, John Day, French Glen—were east of the Cascades, in what had been desert thirty years before. It was fiercely hot there still in summer, but it rained only 45 inches a year, compared with Portland's 114 inches. Intensive farming was possible: the desert blossomed. French Glen now had a population of 7 million. Portland, with only 3 million and no growth potential, had been left far behind in the March of Progress. That was nothing new for Portland. And what difference did it make? Undernourishment, overcrowding, and pervading foulness of the environment were the norm. There was more scurvy, typhus, and hepatitis in the Old Cities, more gang violence, crime, and murder in the New Cities. The rats ran one and the Mafia ran the other. George Orr stayed in Portland because he had always

lived there and because he had no reason to believe that life anywhere else would be better, or different.

Miss Crouch, smiling uninterestedly, showed him right in. Orr had thought that psychiatrists' offices, like rabbit holes, always had a front and a back door. This one didn't, but he doubted that patients were likely to run into one another coming and going, here. Up at the Medical School they had said that Dr. Haber had only a small psychiatric practice, being essentially a research man. That had given him the notion of someone successful and exclusive, and the doctor's jovial, masterful manner had confirmed it. But today, less nervous, he saw more. The office didn't have the platinum-and-leather assurance of financial success, nor the rag-and-bottle assurance of scientific disinterest. The chairs and couch were vinyl, the desk was metal plasticoated with a wood finish. Nothing whatever was genuine. Dr. Haber, white-toothed, bay-maned, huge, boomed out, "Good afternoon!"

That geniality was not faked, but it was exaggerated. There was a warmth to the man, an outgoingness, which was real; but it had got plasticoated with professional mannerisms, distorted by the doctor's unspontaneous use of himself. Orr felt in him a wish to be liked and a desire to be helpful; the doctor was not, he thought, really sure that anyone else existed, and wanted to prove they did by helping them. He boomed "Good afternoon!" so loud because he was never sure he would get an answer. Orr wanted to say something friendly, but nothing personal seemed suitable; he said, "It looks as if Afghanistan might get into the war."

"Mhm, that's been in the cards since last August." He should have known that the doctor would be better informed on world affairs than himself; he was generally semi-informed and three weeks out of date. "I don't think that'll shake the Allies," Haber went on, "unless it pulls Pakistan in on the Iranian side. Then India may have to send in more than token support to the Isragypts." That was teleglot for the New Arab Republic/Israel alliance. "I think Gupta's speech in Delhi shows that he's preparing for that eventuality."

"It keeps spreading," Orr said, feeling inadequate and despondent. "The war, I mean."

"Does it worry you?"

"Doesn't it worry you?"

"Irrelevant," said the doctor, smiling his broad, hairy, bear's smile, like a big bear-god; but he was still wary, since yesterday.

"Yes, it worries me." But Haber had not earned that answer; the questioner cannot withdraw himself from the question, assuming objectivity—as if the answerer were an object. Orr did not speak these thoughts, however; he was in a doctor's hands, and surely the doctor knew what he was doing.

Orr had a tendency to assume that people knew what they were doing, perhaps because he generally assumed that he did not.

"Sleep well?" Haber inquired, sitting down under the left rear hoof of Tammany Hall.

"Fine, thanks."

"How do you feel about another go in the Palace of Dreams?" He was watching keenly.

"Sure, that's what I'm here for, I guess."

He saw Haber rise and come around the desk, he saw the large hand come out toward his neck, and then nothing happened.

". . . George . . ."

His name. Who called? No voice he knew. Dry land, dry air, the crash of a strange voice in his ear. Daylight, and no direction. No way back. He woke.

The half-familiar room; the half-familiar, big man, in his voluminous russet gernreich, with his red-brown beard, and white smile, and opaque dark eyes. "It looked like a short dream but a lively one, on the EEG," said the deep voice. "Let's have it. Sooner the recall, the completer it is."

Orr sat up, feeling rather dizzy. He was on the couch, how had he got there? "Let's see. It wasn't much. The horse again. Did you tell me to dream of the horse again, when I was hypnotized?"

Haber shook his head, meaning neither yes nor no, and listened.

"Well, this was a stable. This room. Straw and a manger and a pitchfork in the corner, and so on. The horse was in it. He . . ."

Haber's expectant silence permitted no evasion.

"He did this tremendous pile of shit. Brown, steaming. Horseshit. It looked kind of like Mount Hood, with that little hump on the north side and everything. It was all over the rug, and sort of encroaching on me, so I said, 'It's only the picture of the mountain.' Then I guess I started to wake up."

Orr raised his face, looking past Dr. Haber at the mural behind him, the wall-sized photograph of Mount Hood.

It was a serene picture in rather muted, arty tones: the sky gray, the mountain a soft brown or reddish-brown, with speckles of white near the summit, and the foreground all dusky, formless treetops.

The doctor was not looking at the mural. He was watching Orr with those keen, opaque eyes. He laughed when Orr was done, not long or loudly, but perhaps a little excitedly.

"We're getting somewhere, George!"

"Where?"

Orr felt rumpled and foolish, sitting on the couch still giddy from sleep, having lain asleep there, probably with his mouth open and snoring, helpless, while Haber watched the secret jigs and prancings of his brain, and told him what to dream. He felt exposed, used. And to what end?

Evidently the doctor had no memory at all of the horse-mural, nor of the conversation they had had concerning it; he was altogether in this new present, and all his memories led to it. So he could not do any good at all.

But he was striding up and down the office now, talking even louder than usual. "Well! (a) you can and do dream to order, you follow the hypnosuggestions; (b) you respond splendidly to the Augmentor. Therefore we can work together, fast and efficiently, without narcosis. I'd rather work without drugs. What the brain does by itself is infinitely more fascinating and complex than any response it can make to chemical stimulation; that's why I developed the Augmentor, to provide the brain a means of *self*-stimulation. The creative and therapeutic resources of the brain—whether waking or sleeping or dreaming—are practically infinite. If we can just find the keys to all the locks. The power of dreaming alone is quite undreamt of!" He laughed his big laugh, he had made that little joke many times. Orr smiled uncomfortably, it struck a bit close to home. "I am sure now that your therapy lies in this direction, to *use* your dreams, not to evade and avoid them. To face your fear and, with my help, see it through. You're afraid of your own mind, George. That's a fear no man can live with. But you don't have to. You haven't seen the help your own mind can give you, the ways you can use it, employ it creatively. All you need to do is not to hide from your own mental powers, not to suppress them, but to release them. This we can do together. Now, doesn't that strike you as right, as the right thing to do?"

"I don't know," Orr said.

When Haber spoke of using, employing his mental powers, he had thought for a moment that the doctor must mean his power of changing reality by dreaming; but surely if he'd meant that he would have said it clearly? Knowing that Orr desperately needed confirmation, he would not causelessly withhold it if he could give it.

Orr's heart sank. The use of narcotics and pep pills had left him emotionally off-balance; he knew that, and therefore kept trying to combat and control his feelings. But this disappointment was beyond his control. He had, he now realized, allowed himself a little hope. He had been sure, yesterday, that the doctor was aware of the change from mountain to horse. It hadn't surprised or alarmed him that Haber tried to hide his awareness, in the first shock; no doubt he had been unable to admit it even to himself, to encompass it. It had taken Orr himself a long time to bring himself to face the fact that he was doing something impossible. Yet he had let himself hope that Haber, knowing the dream, and being there as it was dreamed, at the center, might see the change, might remember and confirm.

No good. No way out. Orr was where he had been for months—alone: knowing he was insane and knowing he was not insane, simultaneously and intensely. It was enough to drive him insane.

"Would it be possible," he said diffidently, "for you to give me a posthypnotic suggestion not to dream effectively? Since you can suggest that I *do*. . . . That way I could get off drugs, at least for a while."

Haber settled down behind his desk, hunched like a bear. "I very much doubt it would work, even through one night," he said quite simply. And then suddenly booming again, "Isn't that the same fruitless direction you've been trying to go, George? Drugs or hypnosis, it's still suppression. You can't run away from your own mind. You see that, but you're not quite willing yet to face it. That's all right. Look at it this way: twice now you've dreamed, right here, on that couch. Was it so bad? Did it do any harm?"

Orr shook his head, too low-spirited to answer.

Haber went on talking, and Orr tried to give him his attention. He was talking now about daydreams, about their relationship to the hour-and-a-half dreaming cycles of the night, about their uses and value. He asked Orr if any particular type of daydream was congenial to him. "For example," he said, "I frequently daydream heroics. I am the hero. I'm saving a girl, or a fellow astronaut, or a besieged city, or a whole damn planet. Messiah dreams, do-gooder dreams. Haber saves the world! They're a hell of a lot of fun—so long as I keep 'em where they belong. We all need that ego boost we get from daydreams, but when we start relying on it, then our reality-parameters are getting a bit shaky. . . . Then there's the South Sea Island type daydreams—a lot of middle-aged executives go in for them. And the noble-suffering-martyr type, and the various romantic fantasies of adolescence, and the sadomasochist daydream, and so on. Most people recognize most types. We've almost all been in the arena facing the lions, at least once, or thrown a bomb and destroyed our enemies, or rescued the pneumatic virgin from the sinking ship, or written Beethoven's Tenth Symphony for him. Which style do you favor?"

"Oh—escape," Orr said. He really had to pull himself together and answer this man, who was trying to help him. "Getting away. Getting out from under."

"Out from under the job, the daily grind?" Haber seemed to refuse to believe that he was contented with his job. No doubt Haber had a lot of ambition and found it hard to believe that a man could be without it.

"Well, it's more the city, the crowding, I mean. Too many people everywhere. The headlines. Everything."

"South Seas?" Haber inquired with his bear's grin.

"No. Here. I'm not very imaginative. I daydream about having a cabin somewhere outside the cities, maybe over in the Coast Range where there's still some of the old forests."

"Ever considered actually buying one?"

"Recreation land is about thirty-eight thousand dollars an acre in the cheapest areas, down in the South Oregon Wilderness. Goes up to about four hundred thousand for a lot with a beach view."

Haber whistled. "I see you have considered—and so returned to your daydreams. Thank God they're free, eh! Well, are you game for another go? We've got nearly half an hour left."

"Could you . . ."

"What, George?"

"Let me keep recall."

Haber began one of his elaborate refusals. "Now as you know, what is experienced during hypnosis, including all directions given, is normally blocked to waking recall by a mechanism similar to that which blocks recall of 99 percent of our dreams. To lower that block would be to give you too many conflicting directions concerning what is a fairly delicate matter, the content of a dream you haven't yet dreamed. That—the dream—I can direct you to recall. But I don't want your recall of my suggestions all mixed up with your recall of the dream you actually dream. I want to keep 'em separate, to get a clear report of what you did dream, not what you think you ought to have dreamed. Right? You can trust me, you know. I'm in this game to help you. I won't ask too much of you. I'll push you, but not too hard or too fast. I won't give you any nightmares! Believe me, I want to see this through, and understand it, as much as you do. You're an intelligent and cooperative subject, and a courageous man to have borne so much anxiety alone so long. We'll see this through, George. Believe me."

Orr did not entirely believe him, but he was as uncontradictable as a preacher; and besides, he wished he could believe him.

He said nothing, but lay back on the couch and submitted to the touch of the great hand on his throat.

"O.K.! There you are! What did you dream, George? Let's have it, hot off the griddle."

He felt sick and stupid.

"Something about the South Seas . . . coconuts Can't remember." He rubbed his head, scratched under his short beard, took a deep breath. He longed for a drink of cold water. "Then I . . . dreamed that you were walking with John Kennedy, the president, down Alder Street I think it was. I was sort of coming along behind, I think I was carrying something for one of you. Kennedy had his umbrella up—I saw him in profile, like the old fifty-cent pieces—and you said, 'You won't be needing that any more, Mr. President,' and took it out of his hand. He seemed to get annoyed over it, he said something I couldn't understand. But it had stopped raining, the sun came out, and so he said, 'I suppose you're right, now.' . . . It *has* stopped raining."

"How do you know?"

Orr sighed. "You'll see when you go out. Is that all for this afternoon?"

"I'm ready for more. Bill's on the Government, you know!"

"I'm very tired."

"Well, all right then, that wraps it up for today. Listen, what if we had our sessions at night? Let you go to sleep normally, use the hypnosis only to

suggest dream content. It'd leave your working days clear, and my working day is night, half the time; one thing sleep researchers seldom do is sleep! It would speed us up tremendously, and save your having to use any dream-suppressant drugs. You want to give it a try? How about Friday night?"

"I've got a date," Orr said and was startled at his lie.

"Saturday, then."

"All right."

He left, carrying his damp raincoat over his arm. There was no need to wear it. The Kennedy dream had been a strong effective. He was sure of them now, when he had them. No matter how bland their content, he woke from them recalling them with intense clarity, and feeling broken and abraded, as one might after making an enormous physical effort to resist an overwhelming, battering force. On his own, he had not had one oftener than once a month or once in six weeks; it had been the *fear* of having one that had obsessed him. Now, with the Augmentor keeping him in dreaming-sleep, and the hypnotic suggestions insisting that he dream effectively, he had had three effective dreams out of four in two days; or, discounting the coconut dream, which had been rather what Haber called a mere muttering of images, three out of three. He was exhausted.

It was not raining. When he came out of the portals of Willamette East Tower, the March sky was high and clear above the street canyons. The wind had come round to blow from the east, the dry desert wind that from time to time enlivened the wet, hot, sad, gray weather of the Valley of the Willamette.

The clearer air roused his spirits a bit. He straightened his shoulders and set off, trying to ignore a faint dizziness that was probably the combined result of fatigue, anxiety, two brief naps at an unusual time of day, and a sixty-two-story descent by elevator.

Had the doctor told him to dream that it had stopped raining? Or had the suggestion been to dream about Kennedy (who had, now that he thought about it again, had Abraham Lincoln's beard)? Or about Haber himself? He had no way of telling. The effective part of the dream had been the stopping of the rain, the change of weather; but that proved nothing. Often it was not the apparently striking or salient element of a dream which was the effective one. He suspected that Kennedy, for reasons known only to his subconscious mind, had been his own addition, but he could not be sure.

He went down into the East Broadway subway station with the endless others. He dropped his five-dollar piece in the ticket machine, got his ticket, got his train, entered darkness under the river.

The dizziness increased in his body and in his mind. To go under a river: there's a strange thing to do, a really weird idea.

To cross a river, ford it, wade it, swim it, use boat, ferry, bridge, airplane, to go upriver, to go downriver in the ceaseless renewal and beginning of cur-

rent: all that makes sense. But in going under a river, something is involved which is, in the central meaning of the word, perverse. There are roads in the mind and outside it the mere elaborateness of which shows plainly that, to have got into this, a wrong turning must have been taken way back.

There were nine train and truck tunnels under the Willamette, sixteen bridges across it, and concrete banks along it for twenty-seven miles. Flood control on both it and its great confluent the Columbia, a few miles down-stream from central Portland, was so highly developed that neither river could rise more than five inches even after the most prolonged torrential rains. The Willamette was a useful element of the environment, like a very large, docile draft animal harnessed with straps, chains, shafts, saddles, bits, girths, hobbles. If it hadn't been useful of course it would have been con-creted over, like the hundreds of little creeks and streams that ran in dark-ness down from the hills of the city under the streets and buildings. But without it, Portland would not have been a port; the ships, the long strings of barges, the big rafts of lumber still came up and down it. So the trucks and trains and the few private cars had to go over the river or under it. Above the heads of those now riding the GPRT train in the Broadway Tunnel were tons of rock and gravel, tons of water running, the piles of wharves and the keels of ocean-going ships, the huge concrete supports of elevated freeway bridges and approaches, a convoy of steamer trucks laden with frozen bat-tery-produced chickens, one jet plane at 34,000 feet, the stars at 4.3+ light-years. George Orr, pale in the flickering fluorescent glare of the train car in the infrafluvial dark, swayed as he stood holding a swaying steel handle on a strap among a thousand other souls. He felt the heaviness upon him, the weight bearing down endlessly. He thought, I am living in a nightmare, from which from time to time I wake in sleep.

The smash and jostle of people getting off at the Union Station stop knocked this sententious notion out of his mind; he concentrated wholly on keeping hold of the handle on the strap. Still feeling giddy, he was afraid that if he lost hold and had to submit entirely to force (c), he might get sick.

The train started up again with a noise evenly compounded of deep abra-sive roars and high piercing screams. The whole GPRT system was only fifteen years old, but it had been built late and hastily, with inferior materials, dur-ing, not before, the crack-up of the private car economy. In fact the train cars had been built in Detroit; and they lasted like it, and sounded like it. A city man and subway rider, Orr did not even hear the appalling noise. His aural nerve endings were in fact considerably dulled in sensitivity though he was only thirty, and in any case the noise was merely the usual background of the nightmare. He was thinking again, having established his claim to the handle of the strap.

Ever since he had got interested in the subject perforce, the mind's lack of recall of most dreams had puzzled him. Nonconscious thinking, whether in

infancy or in dream, apparently is not available to conscious recall. But was he unconscious during hypnosis? Not at all: wide awake, until told to sleep. Why could he not remember, then? It worried him. He wanted to know what Haber was doing. The first dream this afternoon, for example: Had the doctor merely told him to dream about the horse again? And he himself had added the horseshit, which was embarrassing. Or, if the doctor had speci-fied the horseshit, that was embarrassing in a different way. And perhaps Haber was lucky that he hadn't ended up with a big brown steaming pile of manure on the office carpeting. In a sense, of course, he had: the picture of the mountain.

Orr stood upright as if he had been goosed, as the train screamed into Alder Street Station. The mountain, he thought, as sixty-eight people pushed and shoved and scraped past him to the doors. The mountain. He told me to put back the mountain in my dream. So I had the horse put back the mountain. But if he told me to put back the mountain then he *knew it had been there before the horse*. He knew. He did see the first dream change reality. He saw the change. He believes me. I am *not* insane!

So great a joy filled Orr that, among the forty-two persons who had been jamming into the car as he thought these things, the seven or eight pressed closest to him felt a slight but definite glow of benevolence or relief. The woman who had failed to get his strap handle away from him felt a blessed surcease of the sharp pain in her corn; the man squashed against him on the left thought suddenly of sunlight; the old man sitting crouched directly in front of him forgot, for a little, that he was hungry.

Orr was not a fast reasoner. In fact, he was not a reasoner. He arrived at ideas the slow way, never skating over the clear, hard ice of logic, nor soar-ing on the slipstreams of imagination, but slogging, plodding along on the heavy ground of existence. He did not see connections, which is said to be the hallmark of intellect. He *felt* connections—like a plumber. He was not really a stupid man, but he did not use his brains half as much as he might have done, or half as fast. It was not until he had got off the subway at Ross Island Bridge West, and had walked up the hill several blocks and taken the elevator eighteen floors to his one-room $8\frac{1}{2}$ X 11 flat in the twenty-story independent-income steel-and-sleazy-concrete Corbett Condominium (Budget Living in Style Down Town!), and had put a soybeanloaf slice in the infrabake, and had taken a beer out of the wallfridge, and had stood some while at his window—he paid double for an outside room—looking up at the West Hills of Portland crammed with huge glittering towers, heavy with lights and life, that he thought at last: Why didn't Dr. Haber *tell* me that he knows I dream effectively?

He mulled over this a while. He slogged around it, tried to lift it, found it very bulky.

He thought: Haber knows, now, that the mural has changed twice. Why

didn't he say anything? He must know I was afraid of being insane. He says he's helping me. It would have helped a lot if he'd told me that he can see what I see, told me that it's not just delusion.

He knows now, Orr thought after a long slow swallow of beer, that it's stopped raining. He didn't go to see, though, when I told him it had. Maybe he was afraid to. That's probably it. He's scared by this whole thing and wants to find out more before he tells me what he really thinks about it. Well, I can't blame him. If he weren't scared of it, that would be the odd thing.

But I wonder, once he gets used to the idea, what he'll do. . . . I wonder how he'll stop my dreams, how he'll keep me from changing things. I've got to stop; this is far enough, far enough. . . .

He shook his head and turned away from the bright, life-encrusted hills.

KENNETH STERN

Born in New York, Kenneth Stern (1953–) moved to Portland after graduating from Bard College. He entered law school at Willamette University in Salem, because of its proximity to good fishing. Stern was on the board of directors of Multnomah Defenders, Inc. in the early 1980s and represented Portland political activists Jack and Micki Scott in their civil suit against Symbionese Liberation Army member Patty Hearst. He was also counsel for Portland's homeless community in a federal civil suit against an "anti-camping" ordinance. Stern was active with the American Jewish Committee and became a member of the national staff in 1989. His books include Holocaust Denial *(1993),* A Force Upon the Plain: The American Militia Movement and the Politics of Hate *(1996) and* Antisemitism Today *(2006). This excerpt from* Loud Hawk *(1994) details life at the American Indian Movement defense headquarters on Southwest Hood Street.*

A Bullet in a Guy's Head

After weeks of searching, Lena finally found a Portland landlord who would rent to the AIM Indians.

The two-story building was an old frame home on SW Hood Street, fifty feet from the Interstate 5 cutout. It sat on a sloping corner lot and had a long front porch and a small stoop by the kitchen door. Inside, the floors and arches and moldings and banisters were hardwood, and someone had once started refinishing them, then given up or moved. Except for a few spots of uncovered wood, everything else, floor to ceiling, was painted in a hodgepodge of color—yellow, mustard, reds, blues, and greens. It was a poor person's house.

Furniture had been donated and an office set up downstairs. The desk

had half its drawers, and the chairs were missing underpinnings or backs. The living room's three large windows looked out to the front porch and a jungle of unattended bushes beyond, an illusionary buffer from the interstate. An old rust-colored couch, leaking stuffing, sat against one wall, across from two foul-smelling upholstered chairs. The chairs were camouflaged with torn blue and white tie-dyed sheets. A black and white television, missing knobs, balanced on a Day-Glo blue plastic milk box in the corner.

When the defense committee met (once a week now), everyone tried to squeeze into the living room. That space, the adjoining office, and the kitchen were the "public" places. The back bedroom/office downstairs and the entire upstairs were off-limits except to known and trusted AIM members.

Between meetings, people socialized in the kitchen. It was the brightest room, with unobstructed southern windows.

"Look," Lena showed me, "sitting at the table here, you can see people coming up the side stairs or parking on Hood Street. And see that brown trailer across the street there? That was a vacant lot when we moved in."

Everyone watched that trailer from the kitchen table in the weeks to come. Its windows were always dark. No one ever saw anyone going in or coming out. Mail was never delivered. Yet fresh footprints were always nearby: men's flat leather soles and standard issue Cat's Paw heels.

The AIM house's kitchen stove did not work well, just the two burners on the right. No one seemed disturbed. There was a large hole in the ceiling directly over the two burners on the left. If you bent over it just right, you could peer into the room above, the upstairs bathroom. "AIM means something else up there," one male Indian said, chuckling. The ten-inch hole was in front of the toilet bowl.

The house was a nerve center. Poor Indians from out of town stayed there. One of the first to arrive was Lena's mother, Ramona.

"She was the master chef of Wounded Knee," Lena said proudly. "There was no food. The FBI tried to starve us out, but Mom always found something to cook, and it always tasted great!" Ramona was a skinny, short woman who chain smoked Camel straights. She overheard her daughter and looked embarrassed. I watched from the kitchen table as she stood at the stove, boiled a gallon of water in a pitted aluminum pot, then dropped the last half of a coffee tin in.

"Want some coffee?" she asked, stirring, looking toward me but not at me.

I hesitated. If she made coffee that way, she must be expecting a lot of people soon. "No, thank you," I said, feeling appropriately polite.

She looked wounded, turned off the stove, and walked out of the room.

The next time I visited, Lena led me to the back bedroom and closed the door.

"I knew you didn't mean anything by it," she said, "but you hurt Mom when you didn't drink coffee the other day."

"I just wanted to make sure there was enough," I explained.

"Indian people don't worry about such things," she said. "It's considered impolite to refuse."

Thereafter, I was one of Ramona's favorite people. I ate everything she offered. Her specialty was donated food: rabbit, venison, salmon, spaghetti, sweet fry bread, the smelt that came by the bucketful in late winter. . . .

The defense house was more lively now. Russ and Lena Redner lived in an upstairs bedroom with Tsi-Am-Utza. KaMook was downstairs. Loud Hawk had just moved in. Diane Ackerman spent a lot of time there. Susana Gren, whose unspoken reason for coming to Portland was Kenny, had quietly left town.

Other AIM members were arriving. The older women were particularly interesting and strong.

Ellen Moves Camps, a Sioux woman in her fifties, was an AIM fixture. She was fifty pounds overweight. No one could figure out how. She was always expending energy going, moving, shaking things up. Her tongue was acerbic. She was one of the "women from the districts" KaMook often spoke of who had been thrown into the spotlight at Wounded Knee and needed to retain some residual brightest. All of the politics had not been glamour, though. Ellen's son had gone over to the other side, committing perjury at a Wounded Knee trial under the tutelage of two FBI agents. She had disowned him in open court.

Ten minutes after arriving at the defense house, Ellen was already shrieking.

"What's this empty beer can doing here?" she demanded of Redner. She didn't give him a chance to answer, as she opened the window and threw it outside.

"And what kind of crap is going on in this house anyway? What the hell do you think you're doing, Redner? You can't have alcohol or drugs here. Redner, go post a sign on the door saying, 'NO DRUGS OR ALCOHOL OR INFORMANTS ALLOWED.' Got it? What the hell have you been doing since you got out of jail anyway? Get your fat ass moving!" she yelled, as she actually shoved the six-foot, dumfounded Redner out of the room.

Before I met Ellen, I had been forewarned. She had berated the lawyers for two hours for not working more feverishly. "You're representing Indian people, goddamn it, get off your lily white asses!" she had screamed.

I worked hard and did not smoke marijuana or drink around Indian people, so I felt safe. Her attack on me was unforeseeable.

"You!" she screamed, two minutes after Lena introduced us. I had said "Hello," then excused myself to read cases in the office. She pulled me up from my chair by my shirt collar.

"You!" she hollered again. "You think Dennis Banks was there, don't you! You think he was in that motor home!"

I had never discussed the "facts of the case" with anyone. It was not my job to speculate. I did not need to know. Besides, whether Dennis Banks was or was not there did not matter. The others had been.

Shocked at her accusatory tone, I said, "No. I have no idea if Dennis Banks was there or not, nor do I particularly care."

She howled, "No, that's not good enough! He wasn't there! You have to believe that, or you can't work on this case!"

Lena watched from the corner of the next room, telegraphing her sympathy and her powerlessness to intervene. I chose my words carefully. If I gave in, Ellen might think I was an informant.

"Ms. Moves Camp," I said, "I don't know if he was there or not. It truly doesn't matter."

Her venom was now undistilled disdain. "Are you prejudiced against Indians? Are you? Tell me!" she shouted, moving closer. Spit landed on my cheek and on my glasses.

I thought for only a second. "Ellen," I said, "I don't think anyone can say they're entirely free of racism. At least, I can't say that. I try not to be racist, but I can't guarantee that I have no racism. I think we all do. We should just do our best to fight it."

That was sufficient. Ellen turned her back and walked out of the room. I was not accepted, but at least I was no longer a prime target. I felt as if I had survived a test. My second.

Two weeks earlier, I had driven Linda Coelho to her mother's home in Northeast Portland. Linda invited me in for a cup of coffee. I walked into her living room (all the curtains were drawn for security after the "Where do you want to be buried?" affair), where Linda's sisters, her mother, and two older Indian women sat. One was Dorothy Ackerman, Diane's mother. The other was an attractive woman in her late forties. She was alone on the couch. That was the only vacant seat.

"Hello," I said, as I sat down. She continued to talk, ignoring me.

This woman, Janet McCloud, looked to Dorothy, and said, "You know, I'm always sitting next to white men. I never understand it. I don't want to sit next to them. I don't understand them at all, what they want, what they do. Sometimes they sit next to me. I don't ask them to. If I never see another white man, I'd be happy. But I always seem to be sitting next to them."

It was a contest. How much abuse could I take without responding? I sat, sipping my coffee purposefully. I finished, got up, said "Good-bye" to everyone as if nothing had happened, and left.

The reason that Ellen and Janet had come to Portland was Dennis Banks's arrest. Even though he was not in Oregon yet, he was now part of the case. Banks was the leader. His impending arrival (Judge Belloni had pushed the

trial date back to May 12 so that he could be included) generated excitement—and more work.

Banks had two cases to fight. Like the others, he had federal firearms charges: Hawk alleged that Banks drove the motor home away. And South Dakota would also file an extradition request, as it had in California. Banks had to convince the governors of both California and Oregon to refuse extradition. Only a few times had governors denied requests for prisoners wanted by other states. Those involved blacks wanted for racist reasons by southern states in the 1960s. Banks needed to prove that his claim paralleled theirs. Roberts had compiled affidavits, judicial rulings, articles, letters, and transcripts proving that South Dakota was racist toward Indians, that Banks's life was in danger there, and that his so-called riot conviction was a racist travesty of justice.

The Portland defense committee had speakers, educated with the facts, convincing people to sign petitions for the governor. We had already collected hundreds of signatures. The pitch was easy. Indian life was demonstrably cheap near the Pine Ridge reservation and throughout South Dakota.

Raymond Yellow Thunder, an older Indian man in neighboring Nebraska, had been kidnapped by American Legion members, stripped, and forced to dance naked for them. Then he was kicked, burned with cigarettes, and dumped into a car trunk, where he died.

Wesley Bad Heart Bull had been in a bar near Custer, South Dakota. A white man named Darold Schmidt had threatened to "get himself an Indian" that night. He knifed Bad Heart Bull to death, in front of eyewitnesses. He was only charged with manslaughter.

Banks had led a delegation to Custer to complain. A meeting with city officials had been scheduled, then called off at the last minute. Dennis was allowed in to discuss why. Wesley Bad Heart Bull's mother, Sarah Bad Heart Bull, also tried to enter the courthouse. A burly state cop shoved her down the granite steps. All hell broke loose.

Banks was in the city officials' office. A tear gas canister bounced in, and Banks picked up a stick, broke a window, and let the gas out. That was his "riot while armed" conviction. That was what South Dakota wanted to sentence him for.

The attorney general who prosecuted Dennis Banks was William Janklow. Janklow had been a legal services attorney on the Rosebud reservation years before. A young Indian girl named Jancita Eagle Deer had accused him of rape. Another time, two police officers said they had found Janklow driving through the reservation, drunk. Supposedly, he had no pants on, could not explain why, and screamed, "No son of a bitch Indian is going to arrest me!" when taken into custody.

The Rosebud Trial Court disbarred Janklow. He did not come to his own trial. The tribal attorney who prosecuted him was Dennis Banks.

Then Janklow ran for attorney general on an anti-AIM, anti-Indian plat-
form. A law student named John Gridley III attended a coffee for him.
According to Gridley's sworn affidavit, Janklow said that in his opinion, the
way to deal with AIM leaders (like Russell Means and Dennis Banks) was to
put a bullet in their heads. He said, "Put a bullet in a guy's head, and he won't
bother you any more." Janklow was elected.

South Dakota prison guards said Banks would not survive in jail. And that
was just the beginning. According to AIM activists, nearly two hundred AIM
members had been attacked or killed since Wounded Knee. Byron DeSersa,
the latest victim, a legal worker, had been run off a road, where he bled to
death. DeSersa was not even an AIM leader. Dennis Banks was. If he were
returned to South Dakota, the extradition warrant would double as a death
warrant.

ALEXANDER PATTERSON

*A progressive activist and writer, Alexander Patterson (1963–) has a B.A. in
anthropology from Reed College and an M.B.A. from Portland State University.
He was co-chair of the Pacific Green Party for three years and the statewide coor-
dinator of the Ralph Nader presidential campaign in Oregon in 2000. He lives in
Portland and is a candidate for Multnomah County Commissioner. A former KBOO
community radio programmer, a freelance reporter from Central America from
1989 to 1991, and a former columnist with the* Oregonian, *he is also on the board
of directors of the East Multnomah Soil and Water Conservation District and a
financial and management consultant for nonprofits. Patterson played a lead role
in organizing peace demonstrations in Portland prior to the Iraq war as executive
director of the Oregon Physicians for Social Responsibility and is the major author
of PSR's multimedia* Health Effects of War and the SMART Alternatives. *This
excerpt is from a piece published in the* Oregon Historical Quarterly *(2000).*

Terrasquirma and the Engines of Social Change in 1970s Portland

In the late spring of 1972, a group of young Portlanders traveled to Seattle to
participate in an anti-war, direct action campaign called the People's Block-
ade. The protesters had been trained by the American Friends Service Com-
mittee (AFSC), a Quaker organization founded in 1917 that had a spiritual
commitment to nonviolence. Throughout the summer, groups of activists
paddled small fleets of rowboats, canoes, and kayaks into the Hood Canal
on Puget Sound to block the passage of U.S. Navy supply ships headed to
Vietnam out of Bangor Naval Ammunitions Depot. During that time, they

convinced at least two sailors to abandon their ship, faced down several ships, some as big as the eight-hundred-foot *U.S.S. Sacramento*, and were dumped into the icy waters of the Sound. Although the protestors did not succeed in preventing any ships from leaving for Vietnam, a group of them formed tight bonds. When they returned to Portland, they joined with other anti-war activists to create Terrasquirma, an urban commune of energetic activists earnestly engaged in fomenting a nonviolent revolution.

Though their revolution never came, in the process of working toward it the radicals who created and lived in Terrasquirma created not only the first household recycling collection operation in Portland—and perhaps in the United States—but also a number of other organizations and movements. At the time, the activists' efforts were considered iconoclastic, impractical, or bizarre, but some of the programs they started have since become deeply woven into Portland's progressive identity. Terrasquirma lasted only seven years and was probably not terribly well known when it existed, but it can be argued that today's Portland cannot be fully understood without an awareness of Terrasquirma's history and the mid-1970s urban commune movement it exemplified.

Ben Richmond, a founder of Terrasquirma, had been raised as a Quaker in Washington, D.C., and was an AFSC activist who participated in the People's Blockade. After dropping out of Reed College in Portland, he had continued to live in the city and to work for the AFSC. In the fall of 1972, Richmond and some friends he had met through his anti-war activities called a series of meetings to examine how American society had produced the Vietnam War and to discuss how the struggle against war—and a myriad of other products of American society they considered unjust or oppressive—should continue. Although few of the activists he gathered together were Quakers, they shared a white, middle-class background, some college education, and nonviolent opposition to the war.

The group met every Sunday through the fall of 1972 for potluck dinners. Richmond introduced his friends to a new, Quaker-influenced organization called Movement for a New Society (MNS), which had sprung up in Philadelphia. MNS brought together veterans of two organizations, the Southern Christian Leadership Council and a Quaker direct-action group organized by George Lakey, a social critic, anti-war activist, and political organizer. The goal of MNS was no less than a "nonviolent revolution," much like the one the group believed Martin Luther King had championed in his final years and similar to the one that would sweep over Eastern Europe and topple the Soviet Union in 1989–1991.

In the mid-1970s, MNS had a multi-pronged approach to bringing about a nonviolent revolution. The three missions of MNS, as Main Street activist Molly Libby remembers them, were "to challenge, to heal, and to find

alternatives." It would examine all aspects of what it considered social-structural oppression in "macro-analysis" study sessions. Through workshops, the organization would train a dedicated cadre in nonviolent direct action and civil disobedience. This core would then raise the public's socio-political consciousness through "the propaganda of the deed," as MNSers liked to call nonviolent direct actions such as the People's Blockade. At the same time, MNS would create experimental collective organizations and communities that would provide models for the radically democratic institutional structures and life styles they envisioned for a new, nonviolent society. To complete the picture, as Sarah Barnett paints it, MNS adopted the feminist maxim that "the personal is political" and fused the 1960s social revolution with its alter ego, the "personal growth" movement. By confronting internalized features of oppression in discussion groups and by living and working in collectives, MNS members would train themselves to live in the new society they were trying to create. Scott Burgwin, a founder of Terrasquirma, was attracted to MNS primarily because of "the core belief of the group that it's all connected: your personal relationships, politics, lifestyle, everything. We tried to pull it all together in a nice, neat package."

Richmond's introduction of MNS to the group in Portland set the agenda and the approach for the Sunday potluck study sessions. Through the fall of 1972, the group explored the connections between what it judged to be social oppressions, including racism, sexism, militarism, social stratification, imperialism, and environmental destruction. Bruce Nelson, an informal historian of the group, put it this way: "These were times of 'nonviolent revolution fanaticism.' It was a time of macro-analysis sessions to study societal problems together. But mostly it was a time of secureness [sic] in being around people who were perceived as having similar criticisms of American society."

The group achieved this "secureness" not just because the members agreed on what was wrong with American society but also because MNS "actually taught you how to hold open discussions," as participant Norah Renken explained in 1996. MNS drew on the Quaker meeting principles of "clarity," of deliberation until all members are satisfied that they understand each other and have been understood, and of consensus decision-making. To those traditional practices, George Lakey explains, MNS added techniques generated in the group dynamics field, which had been gaining steam in sociology and psychology circles since the 1930s, and feminist tenets then coming into vogue. The result was a democratic, participatory decision-making process that MNSers codified, mimeographed, and distributed, from the Pacific Northwest to the East Coast and even to the German Greens in the 1980s. Under the MNS format, now quite familiar to countless grass-roots activists and co-op members—though only a few would know its origin—meetings start by determining an agenda through

consensus and by allocating time to discuss each item. The positions of scribe and facilitator rotate among all members of the group from meeting to meeting. At the end, a few minutes are set aside for each participant to evaluate the meeting's effectiveness.

At first, the Portland group followed the MNS meeting process as best as it could based on brochures, some training from AFSC, and what Richmond had picked up during a visit back East. But an important improvement to the process was made when an MNS representative from Philadelphia visited the group midway through the fall 1972 series of Sunday study sessions. Renken later remembered that after sitting quietly through a meeting, he asked: "Is it always like this where none of the women say anything?" Until that point it had been. "There were just the three women and a whole lot of men," Renken says. Men had been in the kayaks and canoes in the People's Blockade, with women mostly relegated to support roles such as painting signs and making coffee. The peace movement, like most institutions and organizations in American society, had been heavily dominated by men and was sometimes hostile to the goals of the women's movement. MNS was one of the few groups in the peace movement to couple its critique of militarism and imperialism with a concern with what it considered dependent groups, including women. "Once an outsider came and noticed" that none of the women said anything, Renken recalled,

> it gave us permission to talk in the group, and it made the other men, the other people, have to listen to us. . . . It gave our issues a reality, a right to be heard. That was extremely important. For me the group would not have happened if MNS had not had an analysis that included women's liberation in the work that was also being done for the peace movement.

MNS's vision of a nonviolent revolution, its holistic analysis, and its open meeting practices provided a solid foundation upon which to build a national—perhaps even an international—network of locally based organization. The first MNS chapter, a community of households called the Philadelphia Life Center, grew over time to nearly two dozen households. There, according to Sarah Barnett, "you had people living in community, living communally, and using it as a base for community organizing." Members believed that by living together they would be able to support each other emotionally and logistically as they worked for social change. From the security of their community, they were convinced, the group could organize the larger community and build the revolutionary institutions of a New Society. Communal living would allow them to learn how to free themselves of internalized oppression, hierarchical habits and attitudes ingrained from growing up in what they saw as an obsessively individualistic culture that valued competition and personal gain over cooperation and mutual aid. With the Philadelphia Life Center serv-

ing as a base and a model of the cooperative society they wanted to create, MNSers taught receptive radicals the philosophy and techniques of nonviolent political action and community organizing.

At the end of 1972, the group Richmond had called together in Portland formed a Portland chapter of MNS called the Main Street Gathering. As Richard Nixon was celebrating his landslide victory to a second presidential term, this group of Portlanders "decided to try to build a small, concrete community of people, including small, collective households, work-related groups, and goal related groups" dedicated to a nonviolent revolution. They were not alone. By 1975, a New Society Network directory listed twenty-one MNS-affiliated organizations and households in Oregon, fourteen of them in Portland. Hundreds more were scattered through ten countries around the world and across thirty-four of the United States.

Among the founders of the Main Street Gathering was a group of young and radical core members: Ben Richmond, Norah Renken, and Scott Burgwin from the People's Blockade plus May Wallace and Greg Davis. At the end of 1972, this group created a new household at 4012 Southeast Main Street in Portland based fastidiously on New Society principles. It would serve as a hub for the Main Street Gathering, with someone always there to answer the phone, handle inquiries, and dispense project information. They called their new household "Terrasquirma," or "earthworm," in environmentalist homage to composting and the group's commitment "to replace what they take from the earth." According to Renken, the group also adopted the name to spoof the affectation of the wealthy of naming their estates in "something more than English.". . .

Naive as the hope for an imminent nonviolent revolution may seem today, there was enough happening in the early 1970s to encourage Gathering activists—and others less peaceful—to believe that revolution was not just a distant dream but the inevitable culmination of a popular insurrection that was happening right then and in which they were playing an important part. In January 1973, while the Gathering was organizing a blockade against trains carrying munitions through Vancouver, Washington, en route to Vietnam, the Paris Peace accords were signed, signaling an end to direct U.S. involvement in the war. At the same time, the draft ended. A month after that, on February 27, 1973, the American Indian Movement (AIM) took over the town of Wounded Knee on the Pine Ridge Indian Reservation, demanding that the government remove a corrupt tribal president and honor the Fort Laramie Treaty of 1868, under which the Oglala Sioux still owned roughly half the state of South Dakota. In Portland, a vibrant counterculture was in full bloom, and collective businesses and households were cropping up like mushrooms in the Oregon rain. To the members of the Gathering who saw

auspicious interconnections between all these disparate events, it seemed the spirit of protest was on the move. Idealism was not something that required apology, they believed; and if it was a utopian dream of a New Society that led them to act, then they were more than ready to do the hard work necessary to bring that dream to America. . . .

Over the summer following the uprising at Wounded Knee, interest in MNS grew around the country, in Oregon, and in Portland. New members and new households joined the Gathering, and new activists moved into Terrasquirma. Toward the end of the summer of 1973, Terrasquirma confronted a serious and unexpected crisis: the house they lived in was sold. The new landlord mailed the seven young activists a new lease to sign, along with official notice that the rent on the six-bedroom house would be hiked from $185 to $215 per month. The household, according to Bruce Nelson in his informal history of Terrasquirma, "actively struggling against a different form of oppression that they encountered, was angry with the rental agreement that they were being asked to sign." The group convened a meeting to consider their response. As Nelson described it, "none of them really had ever dealt with trying to live in capitalist society. Utopian outlook prevailed." The group decided to return the onerous lease, amended to be more just. The landlord, equally incensed at the audacity of the group's unilateral revisions, replied with a thirty-day eviction notice. The friendly intervention of the landlord's business partner peacefully resolved the crisis, but it focused Terrasquirma's attention on what they viewed as another, fundamental oppression of capitalist society: private property.

After much discussion and analysis, the seven members of Terrasquirma determined that the only way to be free of the landlord-tenant power relationship was to buy a house themselves. As it happened, one of their Main Street Gathering colleagues, Tina Buetell, had recently returned from New York where she had worked for AFSC and squatted in a tenement on Manhattan's Lower East Side. Having become sensitized to the powerlessness of tenants in conflicts with landlords, she offered to lend the group $8,000, interest free, to use as a down payment on a house of their own. One of Buetell's conditions was that the deed be transferred to a land trust. An extensive search of southeast Portland failed to turn up a nice, big house with room for a garden for the $20,000 the group could afford. Once they realized they would have to look in lower-rent districts, however, Norah Renken soon found a large, light-green house in northeast Portland's Walnut Park. Some members of the group were concerned that this section of town was not safe to live in, but eventually they all agreed that they should seize the opportunity to live in a racially mixed area.

But there was still the question of private property. "We didn't feel comfortable with any one of us owning the house," Burgwin recalled, "so we

put all our names on the contract." On November 21, 1973, Burgwin, Ben Richmond, Lilly Stevens, Greg Davis, Norah Renken, Doug Longhurst, and May Wallace signed the title to 5124 Northeast Cleveland and immediately relocated Terrasquirma to a new neighborhood. Five months later, the New Society Gardens Land Trust Corporation gained title to the property. This nonprofit corporation's board of directors consisted of Main Street Gathering members charged with managing the house in the Main Street Gathering community's interest. The charter stipulated that a central goal of the land trust was to preserve the utopian commune as a haven from the speculative real estate market. Terrasquirma would be privately rent controlled, so to speak, and forever affordable to activists. No longer would the property be a means of exploitation, an investment from which inhabitants or, worse, some absentee landlord, might personally profit. The rent the residents paid to the land trust would pay back Buetell and the bank. If all went well, the rent would be saved to buy more property to house the ever-swelling legions of New Society revolutionaries. Should New Society Gardens feel compelled to sell the property, any profits would be donated to AFSC. Now, with a communal home base from which to work, the young activists of Terrasquirma began to experiment with programs that would be prototypes for the New Society they hoped would emerge with the triumph of nonviolent revolution.

One of the first and most influential of the new enterprises Terrasquirma created was Sunflower Recycling Collective, perhaps the first sustained operation in the United States to collect recycling directly from households. Sunflower illustrates how Terrasquirma linked the student radicalism of the 1960s with the recycling system that Portland and many other Oregon communities are so proud of today.

In Oregon, modern recycling began on university campuses. In the fall of 1970, a few months after the first Earth Day, Jerry Powell established on Portland State University's campus the first full-service recycling depot in Oregon. Multi-material recycling services soon followed at Oregon State University in Corvallis and the University of Oregon in Eugene. Scott Burgwin, then a freshman at PSU, was the first steady volunteer to join Powell's rapidly expanding program. Other volunteers joined the crew, including Doug Longhurst, a future Terrasquirma resident. In March 1972, three months before the People's Blockade took place, the campus-based recycling outfit moved to a parking lot on Southwest Twelfth and Montgomery and became an independent nonprofit corporation called the Portland Recycling Team (PRT). The following fall, while Burgwin was attending the potluck study sessions that led to the founding of Main Street Gathering, he also led PRT's effort to set up a second recycling depot in southeast Portland at an old gas station on Southeast Twenty-second and Hawthorne Boulevard.

To Burgwin and Longhurst, the recycling center was a perfect expression

of the Movement for a New Society. They hoped to educate customers about the connection between their own personal consumption and the degradation of the environment around them while providing them with a practical alternative to a throwaway lifestyle. To global ecological problems, it offered a local, community-based, worker-controlled solution. By emphasizing conservation and thrift, recycling even recalled Quaker simplicity. On part of the new site, Burgwin and Longhurst planted a big garden to prove what bounty could grow even from the polluted soil of an old gas station.

When Terrasquirma moved to northeast Portland in November 1973, Burgwin and Longhurst set up another PRT recycling depot in an unused Oregon Department of Transportation (ODOT) service garage. As he set up the new depot, Burgwin resolved to bring the opportunity to recycle to his new neighbors. He would collect all recyclables door-to-door at people's houses for free. Recycling advocates had already recognized that any system that hoped to divert a significant portion of the waste stream from the landfill would have to be easier for people to use and more efficient than one requiring recyclers to drive to drop-off centers. The only problem was that all the early pilot projects that had experimented with household collection had found that the value of recyclable materials could not come close to covering the cost of collection. PRT's user-delivery public depots only remained solvent—barely—by shifting the expense of collection onto the public and by using volunteer and underpaid labor to operate the sites and to truck the materials to market. In the much simpler garbage disposal industry, in which all refuse is mixed together and tipped at the dump for a fee, collection still accounts for 80 to 90 percent of the costs.

Burgwin resolved, with the support of his Terrasquirma family, to start a household collection service. To make collection efficient, he required his customers to "source-separate" their garbage into newspaper, glass, and tin cans. He would also take any material his customers sorted out, including food scraps, which he added to a compost pile that enhanced the polluted soil of his ODOT lot. The more economically rational elements of PRT, including Jerry Powell, became irate at Burgwin's insistence that PRT offer such a foolhardy service. After a series of acrimonious meetings, one of which nearly broke out in a fistfight, according to Powell, PRT factionalized and split. Burgwin took over the new PRT site on Northeast Russell Street and named his household operation Sunflower Recycling.

Burgwin's interest in providing household service was not merely, or even primarily, to advance recycling to its next logical step. He saw it as a means of community organizing, of educating his neighbors on their own porches about the ecological crises he believed were confronting the planet—and whatever other issues he could interest them in—and of involving them in finding solutions. He also wanted Sunflower to be a true collective, not a loose team dominated by a single leader as Burgwin believed PRT had

become. To Burgwin, the nonviolent revolution would be brought about by building collective, egalitarian institutions that helped the local community recognize its own capacity to change the world.

It was with this idyllic image of Sunflower that Burgwin soon recruited two fresh immigrants to Portland into his project and, shortly thereafter, into Terrasquirma. One of them, Lee Lancaster, claims that with the help of AFSC he had recently become the first soldier at Camp Pendleton, California, to receive a conscientious objector discharge from the armed services. In January 1974, Lancaster and Diane Wells joined the countercultural migration to the Northwest in search of Ecotopia. A month later, they attended a nonviolence workshop hosted by Doug Longhurst at the Quaker meetinghouse on Southeast Forty-third and Stark in Portland. At the workshop, Lancaster and Wells met Burgwin and shortly thereafter joined him and another Gathering colleague, Ruby Smale, in forming the Sunflower Recycling Collective.

Because there was no model for household collection, this band of activists with little business experience had to figure out how to start a whole new industry with little or no capital. What they lacked in funds, however, they made up for with a knack for improvising with low technology. Burgwin had "appropriated for the people," as he put it, a shopping cart from a local grocery store to use as his first collection vehicle, but Lancaster and Wells immediately recognized the need for greater payload and spent thirty-five dollars to build a pushcart out of plywood, two-by-fours, and motorcycle wheels.

The vision of Sunflower as it pioneered household collection was that it would operate gas-free. The nation was in the midst of an oil crisis that appeared to confirm environmentalists' predictions of rapidly vanishing resources and lent credence to their call to develop recycling programs. Sunflower's cart ran on muscle power. By virtue of the low-tech economy of the pushcart and with the cooperation of their source-separating customers, the members of the collective believed that hard, volunteer labor (supported by their income-sharing Terrasquirma housemates) could build a viable neighborhood business sustained strictly by the revenues generated from the sale of the recyclables collected door-to-door.

Despite the Sunflower group's enthusiasm and the temporarily high prices that newspaper and cardboard fetched on the international scrap-paper market, Sunflower never would have survived without the help of a PSU assistant professor of systems science named Rich Duncan. Duncan had recently quit his job at Boeing to extirpate himself from collaboration in arms production for the Vietnam War and had become a self-described "environmental freak." He bubbled with systems science enthusiasm for Sunflower's low-tech, labor-intensive, community-based approach to recycling. In Sunflower, Duncan saw a model for a comprehensive recycling system he called the ORE Plan, which was to create two hundred Sunflower-like neigh-

borhood operations throughout Portland. To test the feasibility of recycling Sunflower-style, Duncan obtained a grant from the Western Interstate Commission for Higher Education that allowed the group to push the cart for a summer and analyze the results. In addition to the grant money, Duncan visited the ODOT site to boost their spirits with reminders that Sunflower was the wave of the future. He later convinced PSU's engineering department to build the collective a new pushcart, and then, when that proved insufficient, he persuaded Alsport, a manufacturing company, to donate a golf cart, which they modified for the job. Duncan published articles on the ORE Plan, spoke at recycling conferences, and attracted media attention for himself and Sunflower, including endorsements from Oregon Governor Tom McCall and Senator Mark Hatfield.

For Sunflower to survive that first year was in itself an accomplishment, but it was still many years from creating a model of recycling that would attract a significant number of customers and convince government and industry that household collection was the viable, desirable future of solid waste disposal. It would take two more generations of Terrasquirma and Sunflower recyclers to do that. In the meantime, the Gathering and Terrasquirma had other programs of the New Society to put in place.

ED EDMO

A member of the Shoshone-Bannock tribe, Ed Edmo (1946–) was born on the Duck Valley Indian Reservation in Owyhee, Nevada. He grew up at Celilo Village on the Columbia River and, with the building of The Dalles Dam and the destruction of Celilo Falls in 1957, witnessed the displacement of the Celilo community and the loss of Native culture. Edmo is a poet, playwright, performer, lecturer, and traditional storyteller. Among his plays and one-man performances are Through Coyote's Eyes: A Visit with Ed Edmo *(which toured internationally),* Bridge of the Gods *(1988), and* Grandma Choke Cherry *(1994). Edmo was a consultant to the Smithsonian Museum of the American Indian in Washington, D.C., and the Oregon Folklife Program at the Oregon Historical Society. He has published poetry, short stories, and plays, and his book of poetry,* Crawling Man, *was published in 1968.* "After Celilo" *first appeared in* Talking Leaves: Contemporary Native American Short Stories *(1991, edited by Craig Lesley).*

After Celilo

I'm not sure what it was that caused my going. Maybe youthful exuberance. I'd like to think it was the quest for knowledge and creativity. Lightning was my guide, and the moon was my protector as I stood by the road, sticking

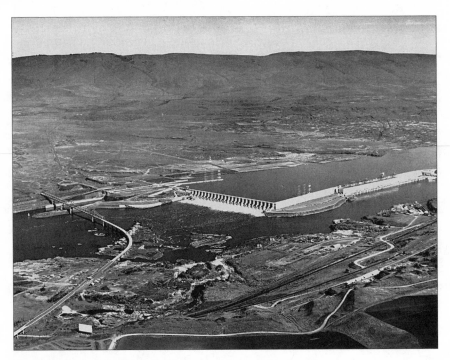

The Dalles Dam on the Columbia River

my thumb out to the world. It was the spring of 1964, when all the glories of high school football were over and there was only the dull future facing me. As I looked to the Columbia River, I remembered the many times I had gone there. The river was a welcome friend that never had to be called in for supper.

Celilo Falls attracted white tourists. Tourists in baseball caps, straw hats, pith helmets. Some were bald-headed. Tourists came to the falls to watch Indians fishing off of scaffolds. Tourists with sunglasses hanging from their sunburnt necks; their knobby knees bulging from beneath Bermuda shorts. They handed us silver quarters to pose with their children and their grand-children. I liked to get next to a little white girl. If she was afraid, I'd move closer to her, and when she would get tears welling in her eyes, I'd reach out and grab her and giggle. You know, being next to a real Indian is really a frightening experience! The river was calming. I'd watch the soothing current and see the sun reflect off the silver waves.

In 1957, the government built The Dalles Dam and flooded us Indians out of our traditional fishing places, We didn't want to be flooded out, but they

called it progress. I remember that they held meetings in people's houses. Then we Indians would talk about our future and wonder what would happen to us. It was a hard time.

My father had seen the plans at The Dalles Chamber of Commerce and he tried to warn the people at Celilo. But the people only teased him and called him an ol' Chinaman because my father didn't wear braids like the other Indian men of the village. When the engineers began leveling the earth to make a new right-of-way for the Union Pacific Railroad, the Indians of the village saw that the government meant to do as they had planned. Many remembered that when Bonneville Dam was built in the 1930s, the Herman Creek Indians were forced to move but not compensated for any of their fisheries or their homes.

My father organized the Indians at Celilo Village to meet on a regular basis. We didn't want the government just to move us out and not compensate us for any of the fishing or our houses. My father wrote to Senator Neuberger of Oregon, who introduced a bill in Congress to have the government pay us for our fisheries and buy us new houses. At the time we were negotiating the amount of payment, the chief's son said, "You should pay us fifty dollars for every board in our drying sheds, because this is our way of life." The government man got angry and told us Indians that we should accept their "fair" offer, and that if we didn't, he would go to the judge at Wasco County and have our land condemned and bulldoze everything without paying us anything.

When the workmen finished surveying at the end of the day, some of us boys would pull out the stakes from the ground, fill the holes, and make a small fire out of the stakes. Others would climb the cliffs and shoot BB guns at the big dump trucks as they hauled dirt. We would laugh when a driver stopped his truck. In our own small way, we tried to stop the dam.

Finally, when we were moved out, we had to burn our house. I had to choose what to take and what to leave to get burned up. Just as Dad started the fire, I ran back into the house to get my bedside stand. It was an old commode. Later I was to get it refinished and it became an antique. We watched with mixed happiness and sadness as the old house went up in flames. We were to get a new house across the river.

We moved into an all-white community—Wishram, Washington. After a year of fighting, my brother and I were accepted into school. One time a little white girl got mad at me for some reason. She spit on me and told me to go back to where I came from. I couldn't go back because there was a freeway where my house used to stand. I couldn't understand why she said that.

I grew up in tough times. I learned how to escape into books and I knew the library. I was not hurt by the characters in the books. I could pick and choose from a world that accepted me and didn't put me down because I was an Indian or came from a poor village.

It was a bright sunset as I stood on the north side of the Columbia River and a blue car stopped.

"How far you goin'?" a young man asked.

"Portland," I said hopefully.

"Get in," he said.

He handed me a cigarette. The car ride was filled with country and western music and chitchat. We crossed the Hood River Bridge and drove west. He said that he was only going as far as Cascade Locks. I was glad for the ride. He dropped me off at the freeway exit.

"Good luck," he exclaimed.

"Thanks, man!" I replied.

The sun had set and it was almost dark. I began to get scared. A cop might be looking for a runaway from a small town.

Headlights shone on me as a car pulled over. I saw it was a pickup. I got to the side. I peered in and a tall black man sat behind the steering wheel.

"Get in, kid," he commanded.

I hesitated, but he asked wearily, "Do you want a ride or not?"

I got in and we made small talk until we got to Portland. He drove me to the east end of the Burnside Bridge, where the transients and homeless stayed, and dropped me off.

"Walk across the bridge, kid, an' you'll find your people." He said it matter-of-factly.

I thanked him and began walking across that bridge.

RICHARD HUGO

Richard Hugo (1923–1982) was born in White Center, Washington, a suburb of Seattle. After serving in World War II in the Army Air Corp, he attended the University of Washington, where he studied under poet Theodore Roethke. He worked as a technical writer at Boeing and was a professor of creative writing and head of the Creative Writing Program at the University of Montana. His volumes of poetry include Death of the Kapowsin Tavern *(1965),* What Thou Lovest Well, Remains American *(1975), and* The Right Madness on Skye *(1980). He also wrote two important nonfiction books,* The Triggering Town: Lectures and Essays on Poetry and Writing *(1979) and* The Real West Marginal Way: A Poet's Autobiography *(1982). In* Death and the Good Life, *a mystery novel he wrote toward the end of his life, Hugo follows the investigations of retired Seattle cop Al "Hush Heart" Barnes as he makes his way through the inland Northwest and eventually to Portland.*

From *Death and the Good Life*

It would be good to see Mrvich again and the Hammers, too. Mrvich had kept writing poems all these years. Every so often, he'd send me a copy of some little magazine with a poem of his in it. Then, about a year before I got shot up in Seattle, he'd sent a book he'd published with a small press in California. He'd inscribed it to me, "For Al Barnes, best poet on the Seattle force. John." It made me feel good for him and a bit lousy that I hadn't kept writing myself. It was a good book and got good reviews in the Seattle and Portland papers and even a very favorable one in the *Los Angeles Times.*

John was right about one thing. I was the best poet on the Seattle police force, and I hadn't written a line in years when his book arrived. Mrvich had no doubt taken some ribbing from his fellow cops, but John was a dignified guy and had a good sense of humor. He could handle it. Now he was a captain of detectives. No one kids captains.

The trip was splendid. We flew near Mt. Rainier, Mt. Adams, Mt. St. Helens, and the day was clear, a bright, open, hard October day. All three mountains shone blue and early-fall white and looked appropriately pompous. Well, if I were a mountain I'd be pompous, too. I winked at Rainier as we crawled past and told it to hang in there. It said it would and stop winking at me, you dumb bastard, I'm a mountain.

John Mrvich grabbed my hand and then my bag at the head of the exit ramp. "Lord, you are putting it on," he said, looking at my waistline. "Home cooking?"

"Home something," I said, thinking of Arlene. "How the hell are you, Murv? You look great." He did, too, his face having gotten more handsome

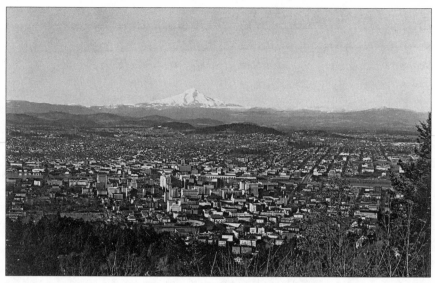

Downtown Portland in the late 1940s, with Mt. Hood on the horizon

and interesting with the years. He was as big as I remembered him, and he still moved easily, as if he had lots of energy in reserve.

We picked up my other case at the baggage pickup. "You got a gun in there?" Mrvich asked.

"Yeah, I got a gun. I couldn't very well carry it on the plane without showing a bunch of stuff. Seemed easier this way."

"Keep it, but if anything comes up, I didn't know about it, OK?"

"Right you are." We drove along in his car for a while, catching up on who had died or retired or remarried or divorced. "By the way," Mrvich said, "where are we headed?"

I gave him the address.

"Jesus. That's Portland Heights in the West Hills. Who do you know there?"

"The Hammers, brother and sister. They bought the mill in Plains and saved the town from getting wiped out. They live there four months a year. Nice people. They're putting me up."

"The lumber people? Hammer-Index Plywood. Hammer Pine Products. Hammer Lumber Supply. Those Hammers?"

I nodded. "That's them."

"You've improved the company you keep."

We talked about some of the lower orders of citizens we'd known in Seattle, the junkies and pimps and stoolies.

From a high bridge over the Willamette River, the city of Portland was beautifully ablaze in the October sun which seemed just about two inches off on my right. From that perspective it appeared beautiful, the aggregate of tall, sparkling buildings. It was good to be in a city again, and, as cities go, you can do much worse than Portland. But I knew if I got into it for long and began to see the life inside that glittering wall, I'd long for Plains again. For right now, Portland looked good. I decided I must not be too old if I still found a city exciting.

"You sure made the papers here, Al. That must have been some bust in Kamiah."

I told him all about it, including how drunk I'd gotten. He took it in quietly.

"It was a lucky shot, first time. A lot of good guesswork. Have you ever been in a motel room alone in a night with a beautiful naked girl six-six who was trying to kill you, and so drunk and bewildered you forgot you had a gun?"

"Sure," Mrvich said. "Lots of times." We both laughed all over the car. Mrvich's dark, Slavic face and big body shook with laughter.

"I'm looking into that killing years ago for you. Your friend, Medici, by the way, controls the distribution of porno in Portland, and he makes a hell of a lot of money doing it."

"If it's the right porno, he is my friend," I said. We'd passed the metropolitan business area and were going up some tricky roads that switched back and made sudden 180-degree turns. I was lost in the maze of roads and huge hedges that restricted my view. I could glimpse big private homes in back of the hedges, with enormous trees in the yards. Mrvich drove with absolute assurance. I felt I couldn't find the Hammer house if I lived in Portland one hundred years and drove there once a week. West Hills is a bewildering network of well-paved roads winding in no appreciable pattern through thick woods and high hedges. Many of the homes seemed from another time, but they were huge and still very expensive.

"Listen, Al. If you can, have dinner with me tomorrow night at Jake's; it's a seafood place in Portland. I should have something for you on that old killing. A defense lawyer named Petrov will join us. He's a pal of mine who writes poems, too. We'll give you what help we can. The food is real good, Al. And Petrov is a great guy."

"I'll be there. I sure appreciate your help."

"Do you think it will help you with the killing of—?" he trailed off uncertainly.

"Tingley. Robin Tingley. I don't know. It's just a hunch. There're a couple of people might have wanted him dead, and they're in Portland, and both were at the Koski killing years ago—I mean at the party where the Koski girl was killed. But it seems remote. We know the Calk girl didn't kill Tingley,

and we can't decide who might have. They're working on the possibility that someone in Montana might have wanted him dead, but he wasn't up there all that long, and besides, everyone liked him there."

We took more turns and twists than a pinball and finally stopped at a big hedge with a huge brown house far in back of it. Roses and ivy were crawling the walls of the house, obscuring much of the brown board. When we passed through the gate, I spotted Mycroft trimming the hedge from the inside, eyeing it with the same imperious look. He turned and looked at me, no recognition in his rigid face.

I gave him as phony an informal American wave and a "Hi" as I could, hoping it would annoy him. He said, "Good afternoon, sir."

"What's he doing here?" Mrvich whispered. "Did Louis the Fourteenth die?"

Lynn threw open the door. "Al. Good to see you. Come on in." She looked very classy in a white dress and black pumps. Her dark features, hair and skin were set off by the dress.

"Al," she said again and gave me a hug. I introduced John. "Pleased to meet you, Miss Hammer," he said a bit uncertainly;

"Lynn, please. No one calls me Miss Hammer, or Mrs. Ponce," she said, and I could see John succumb immediately to her charm and relax.

He mumbled something about lots of paperwork, reminded me of our dinner tomorrow night and took off. I walked in, feeling good. . . .

Outside, I looked at my watch. It wasn't even two-thirty. I checked the address of Joyce Clueridge. At a gas station I got directions to Lake Oswego and set out. I crossed a high bridge called the Sellwood Bridge over the Willamette, then headed south on a beautiful wooded street that ran high above the river. I could glimpse the water now and then out to my left through the thick trees and bushes that bordered the road. For several miles there were no houses visible, just that dark, thick, green, near-tropical growth of the Pacific Northwest, ivy, grass, bushes and trees.

It would be worth knowing where all these people were the night Tingley was killed. Mrvich had a couple of detectives working on that. What bothered me were the connections between most of the old gang and Tingley. They'd been broken years ago. Only Medici and Marnie seemed possible suspects and, as far as the present was concerned, only Marnie seemed possible. It bothered me because I'd gotten interested in the Koski killing, and the facts staring at me told me there was no connection between the two cases. That meant my excuse for pursuing this—that it might lead to something vital in the Tingley case—was just a damned lie, and I knew it.

At Lake Oswego, I stopped at another gas station and got directions to the Clueridge place. Lake Oswego is one of Portland's better bedrooms. Hopelessly respectable homes and yards sit block after block. Huge, towering

pines and firs rise up out of the yards, and well-kept flower gardens ring many of the houses. The leaves had started to fall from the maples and alders, and they lay sodden and mealy on the roads. A threat of rain was in the air. That didn't mean it would rain. It meant you think it's going to rain, and if it doesn't, you'll think it did. I remembered that from my Seattle days.

The Clueridge house was one of those red-brick homes built in the thirties and, because it was brick, still in good shape. A big place. The driveway swept in under a brick archway that had had to be widened as cars got bigger. There was no porch, and I parked almost in front of the door, I found the house cold-looking. No friend could live there.

In front of the house, just beyond the archway, stood my least favorite natural thing: a monkey tree. A lot of people would, had they the opportunity to eliminate one creature or piece of vegetation from the face of the earth, choose the mosquito, or the coral snake, or poison ivy, nettles, skunks—oh, you name it. But me, I'd not hesitate to choose the monkey tree. It must be the most loathsome-looking tree in all the world.

This maid was black, too, and definitely not like Lila. She was about forty, and her face was twisted by what could have been a stroke, though to me it appeared to be bitterness. Her hostility was so evident I had the urge to tell her I was not wealthy, I had many black friends, the Mercedes wasn't mine, and I worked for an Indian I liked very much. That would have melted her heart about as fast as the polar ice cap.

She showed me to a seat in a room that was very clean and neat and terribly uncomfortable. Little china dogs, about a hundred of them, were arranged on doilies on glass shelving about the room. The walls were a loathsome shade of pink, and the fireplace was a bright red brick that didn't belong with the pink or with any other color I could think of. The carpet was blue and expensive and so soft I wanted to peek under it to make sure there was flooring before I took another step. The furniture, including the chair I sat in, had a precious look about it, as if it belonged on display in an antique show. When I sat down, I was sure the chair would break.

"Mrs. Clueridge asked me to offer you whatever you wish to drink," the maid said in a voice cold enough to pour a triple slug of gin over. "A drink, sir? Coffee?"

"Coffee will be fine, thank you." The coffee came before Mrs. Clueridge. Quite a bit before. I was beginning to think I'd been tricked when Mrs. Clueridge swept in.

There are women who get better looking as they get older, like Lynn Hammer. There are women who manage to preserve that pert girlish quality of their youth for years, like Marnie Ross Tingley. Then there are the Joyce Clueridges.

She looked at least fifteen years older than Lynn or Marnie. Her hair would have been gray if she left it alone, and she should have left it alone.

She was two pounds short of being fat and many contour lines beyond being simply shapeless. She wore a pink gown that was almost as insufferable as the wall. Ruffles of white jiggled on the cuffs and collar. Faintly it reminded me of some costume I'd seen in a movie, only then it was in black and white, and someone like Billie Burke was wearing it and simpering.

OK. Don't get on me. I don't want all people to be beautiful, women or men. A lot of ugly people are fascinating, and a lot of pretty people are dull. But Joyce Clueridge looked like she thought she was beautiful, and to me she had as much character as the monkey tree outside, which had about as much character as all other monkey trees. She looked as interesting as a can of cleaning fluid.

"Mr. Barnes," she said in a high voice that was trying for elegance. "Sheriff Barnes isn't it? Lynn Hammer called. Such a surprise. Such a lovely woman. It's a shame how we drift apart over the years, isn't it? Many good friends, scattered." She sat down, and I, who'd risen to greet her, sat down, too. She was so respectable, I slipped into my diplomatic voice. I started out in a low tone of confidentiality.

"Mrs. Clueridge, I'm here on a somewhat delicate matter, and I really would appreciate your help. I realize how painful the past can be, for all of us. I've things in my past I'd just as soon forget, but under the circumstances I'm going to ask—with your permission, of course—I'm going to ask you to try to recall some things you'd probably just as soon not think about any-more." I was afraid my voice was getting too unctuous, but she seemed to think I was speaking normally. I wondered why all people couldn't talk like the Hammers, or Medici, or Mrvich or Petrov. Her reply told my why she thought my speech had been normal.

"I understand, Sheriff Barnes. I'm sure your work takes you into some forbidden corners of people's lives, where you'd just as soon not go. But it has to be that way, doesn't it? I mean, if we are to live in a world of order, we must allow those who are charged with maintaining that order to proceed with their work."

It seemed impossible she'd once been called Cuddles. Her grave white face that makeup couldn't do much for was earnestly waiting for my questions. It struck me that I knew that hairdo: Shirley Temple curls. She looked as absurd as she was.

"You're quite right, Mrs. Clueridge. That was very well put. Our work would be much easier if all citizens were as understanding and intelligent as you are." I really couldn't stand myself. "Perhaps you recall a party nineteen years ago at Cannon Beach at a home owned by Lee and Lynn Hammer's father. A girl was killed that night, Candy Koski."

She flustered a bit. "Oh, yes. My goodness. Lynn said you were investigating the death of Robin Tingley."

"I am, Mrs. Clueridge. But certain matters have led me to the Koski mur-

der. I fear there may be a connection. " I fear there is no connection at all, Mrs. Clueridge, and I'm just kidding myself. "One of the participants at that party," I went on, wondering if I'd ever used the word "participants" before, "was Robin Tingley, as I'm sure you recall. He was recently murdered in Montana."

"Goodness, what a terrible world. Murders. Rapes. Holdups. It's enough to make you think, isn't it?"

"It is indeed, Mrs. Clueridge. Mrs. Clueridge, I'm going to ask you something I don't want to ask. But as you yourself so elegantly put it a few moments ago, I have the responsibility to ask you this question."

"I understand, Sheriff Barnes. Please proceed."

"I understand you were on the beach with Dale Robbins and Lynn Hammer when the murder happened?"

"Yes, I believe so. We were roasting wieners over an open fire, I recall. A sort of late snack, so to speak."

No, you weren't, you lying, hypocritical broad. You were doped on marijuana and drunk with booze and you were screwing Dale Robbins. I said, "Are you certain, Mrs. Clueridge? It's very important."

"Well, of course, none of us were certain exactly when the murder happened, but I'm sure when poor Candy died, we were down there on the beach roasting wieners."

"Mrs. Clueridge," I tried to make my voice soft and. intimate, "do you think Vic Medici killed her?"

"This is in confidence, isn't it, Sheriff Barnes?"

"Yes, Mrs. Clueridge, it is." My voice was so earnest, I wondered how I might do in politics.

"Well, then, Sheriff Barnes, in the strictest confidence, I'll tell you that Vic Medici is certainly the one who killed Candy Koski. I have no doubt of it. He was vile-tempered and a violent man. But then, most of those people are, aren't they?"

"Those people?"

"Italians. They're not like white people, I don't care what anyone says. Haven't you known many violent Italians, Sheriff Barnes?"

"There certainly are some violent Italians in this world," I said.

"They really aren't white people, you know, but they pass for white."

"I wasn't aware of that, Mrs. Clueridge."

"Oh, yes. Look how dark they are. Think of all the violent Italians you've known in your line of work."

"Yes. I remember a lot of them over the years." I was trying to think of some, and the only one I could remember was a guy named Canvas Jaw Garricci, a welterweight who had a twelve and forty-six record before he finally called it quits. He sold newspapers at a big stand in downtown Seattle and outside the ring was just a sweet, slightly punchy slob.

"Vic Medici was a terribly violent young man. He beat up several nice boys in high school. I'm sure he murdered Candy Koski."

"Were you surprised he wasn't convicted?"

"Yes, but you know what our courts have become. They let criminals go every day. And especially those who aren't white, like the Negroes and Indians and Italians."

I hoped my feelings weren't showing. I felt like using a little violence on her, like punching her in the mouth.

"We were a strange group, about to break up. Some of us were in high school and some in college. We'd sort of banded together in high school, and the gang stayed together the first year some of us were in college. It seems odd who you are friends with, doesn't it, Sheriff Barnes? The only ones of that group I'd ever care to see again are the Hammers and the Tingleys. Sorry. Of course, only Marnie is left, isn't she? I talk to her on the phone once in a while."

I thought, yes, just those with money and respectability, right, Joyce "Cuddles" Bebar Clueridge? Well, people as classy as the Hammers wouldn't give you first base if they were fifteen runs ahead in the ninth. And they are.

"Mrs. Clueridge, do you think Vic Medici is capable of holding a grudge for nineteen years?"

"Oh, yes. He's capable of carrying a grudge forever."

"Do you think he could have murdered Robin Tingley after nineteen years because Robin testified against him at the trial?" I asked, already feeling a bit hopeless and remembering Tingley's testimony had helped Medici.

"Oh, yes. I'm sure of it."

"Did you testify?"

"No. None of us except Robin. We gave our statements to the police at Cannon Beach, but we weren't called on later, except for Robin."

We sat in silence for a moment.

"Can you think of anyone else who might want to murder Robin Tingley?"

"No. Of course, I haven't seen the Tingleys in ages. What was Robin doing in Montana?"

I told her. We sat in silence again.

Suddenly she said something that was almost touching. "I was pretty then. Would you like to see how I looked?"

"Of course I would, Mrs. Clueridge," I lied.

"Excuse me a moment." She pushed out of the room and in a moment was back with an old high school annual. She opened it and thumbed a couple of times. "Here," she said.

The book was opened to a page that had in large block letters the words "seniors" printed on the wide outside margin. She pointed to a photo of herself taken nearly twenty years ago. I never would have recognized her.

The face was one of those meringue-pussed darlings that are in every high school.

"There I am. Joyce Bebar," she said a bit wistfully.

"Most recognizable," I said. "You haven't changed all that much."

She turned back to the juniors. "And here is Vic Medici," she said, pointing at his photo. He was recognizable. Even then he looked tough.

She turned back to the seniors. "Lee and Lynn," she said. I looked at their two Eskimolike faces side by side. They looked fresh and alive. I found Rasmussen and Marge Appleton, who had been a doll, and Betty Huff. I had the book now, and she released her grip on it. I found Marnie and Dale Robbins. I found Candy Koski in a group picture of sophomores. Her face was so small it meant nothing. It might have been the face of Calvin Coolidge. I kept staring at the book, wondering if it held some secret. Then I realized how ridiculous I was being and put the book aside.

"Well, you've been most helpful, Mrs. Clueridge," I said. Like hell. "Thank you for your cooperation. I wish all our citizens were as helpful as you are."

"And thank you, Sheriff Barnes. I've certainly enjoyed our talk. Mary," she called. "Mary."

The hostile-looking black woman came in.

"Mary, would you show Sheriff Barnes to the door, please? Thank you again, Sheriff Barnes," she said, offering me her hand. I took it as much as I could without touching her for over a second.

"My pleasure," I said. And so help me, I bowed.

I was almost through the door of the room when something struck me as odd.

"Oh, Mrs. Clueridge. One other matter. Who of the Hammers was behind?"

"I beg your pardon?"

"Which one of the Hammers was behind in school? I mean, they were both seniors at the same time. One of them must have been behind. Which one is older?"

"Why, neither, Sheriff Barnes. Lee and Lynn Hammer are twins. "

"Twins?"

"Why, yes. They were very close, the way twins are, you know."

"Thank you, Mrs. Clueridge."

At the door, just because I felt like it, I whispered to Mary, "You must really need the money."

It was the right thing to say. She burst out laughing. It made me feel good. I imagined she didn't get many laughs. . . .

The High Mountain Club turned out to be an old estate that had belonged to some high muck-a-muck back in the early part of the century. Probably some guy who cut down all the trees he could find, sold them, used the

money to start a prostitution empire, then retired, perfected his manners and entertained only the best people. The approach was too much, A white gravel road wound gracefully through very tall cedars and alders and firs. I can't remember seeing more magnificent trees. It took about three minutes to reach the mansion from the gate. My '72 Chevy seemed out of place. I didn't feel like a fixture myself.

I had two "ins," one from Mrvich and one from Petrov. I'd decided to use Petrov's. Petrov's "in" was an invitation from an old member named Byron Oswald. Rick had defended him once from a charge of stock fraud. Petrov told me Oswald had been innocent beyond doubt and wouldn't have been charged had not the D.A. been two weeks from a mental breakdown when he filed charges. Not only had Petrov proven Oswald's innocence in court, he had managed to point the finger at the guilty party right in the courtroom and had been called Perry Mason by his colleagues for a year or so after the trial. Happily, the nickname hadn't stuck.

The mansion was huge but sedate. Inside, it was quiet. The closest thing to a guard was a good-looking, middle-aged man who sat at a desk inside the hallway. The walls were dark panels of some kind of expensive-looking wood and highly polished. The good-looking man wore a dark suit, and he graciously asked me if he could help me. The place was too confident to bother with suspicions. I had the feeling the members didn't worry about anything. They assumed that this was exclusive in a way understood by all.

The man at the desk directed me to Mr. Oswald, who was in a room I suppose you'd call a study. A big study. Around twenty-five deep leather chairs were placed so that people could sit apart and not notice each other. I found Byron Oswald deep in one of the chairs, a small man with a kindly face. He was reading a book of poems by William Stafford. I liked him immediately. His hair had been blond once but was now a wispy silver and quite fine. His gentle face said life had been good to him, and when it hadn't he had learned something.

"Mr. Barnes." He gripped my hand, and his eyes sparkled, "Mr. Petrov said you would be coming to see me. Please sit down." A leather chair had already been pulled next to his, and I assumed I'd been expected since they were the only two chairs close together.

"I see you're reading William Stafford," I said. "Do you like his poems?"

"Oh my, yes. He's one of my favorites. I came from a small Midwest farm myself, came West many years ago and settled. So Mr. Stafford's poems speak specially to me."

"Me, too, Mr. Oswald, and I'm strictly big-city west coast until I moved to Montana."

"He lives here, you know, not far from here. I had the honor to meet him once. A lovely, mild-mannered man. One of my nieces was a student in his class, and she's very fond of him. Have you met him?"

"No. I heard him read once in Seattle years ago. I've never forgotten it. I wanted to be a poet myself once."

"Really. And instead you became a policeman. What an unusual diversion."

"Well, I could have kept writing but didn't. You can be both. A friend of mine on the Portland force is."

"I tried once myself but instead became a financier," he laughed quietly. "What can I do for you, Mr. Barnes?"

"Mr. Oswald, I wonder if you could tell me a bit about the club. Do you know all the members?"

"Oh my, yes. We only have about sixty. I don't know some of the new ones very well."

"Is Marnie Ross Tingley a member?"

"My, yes. A lifetime member. Her parents bought her a membership years ago. Sy Ross and Elaine. Both dead, alas. Well," he sighed, "time for everyone."

"Mr. Oswald, I realize you're obligated not to talk about the other members to a stranger, but I'm investigating three murders and—"

"Good lord. Really?"

"Yes, sir."

"Heavens." He looked a bit depressed. I had the feeling moral failure always depressed him.

"Might I ask you some questions, Mr. Oswald? It's very important to me. If you feel you can't answer, I'll understand."

"Surely no one in the club is suspected?"

"I'm not sure who to suspect at this point," I said. It seemed as close to being honest as I could be and still not cause him alarm.

"I understand," he said. I doubted he did.

"You mentioned Marnie's parents. Can you tell me about them, anything at all?"

"Sy? Sy was a nice man. He made a lot of money, and he gave much to charities. I liked Sy"—then he laughed—"except on the squash court."

"Why didn't you like him on the squash court?"

"He was so serious. Had to win at all costs. You'd have thought he was playing for his life. He usually won, too. The only time I beat him, he stormed off the court. It took him an hour and three drinks before he could bring himself to speak to me. Elaine wasn't much different."

"Mrs. Ross?"

"Yes. She was club tennis champion for years, and she played with a vengeance. Once, she slammed a forehand into the face of her opponent who was crowding the net. Poor woman couldn't have been more than a few feet away. She was stunned and needed a few minutes to recover, I remember. Elaine stood there coldly, waiting. Offered no assistance and acted as

if her opponent was an enemy in some war. She seemed impatient for the poor woman to get up so she could continue the game. Later on in the locker room, I understand she apologized. Would you care for a drink, Mr. Barnes?"

"No, thanks."

"It's about time for my crème de cacao. That's all I can take anymore, and the doctor limits me to one a day." He signaled ever so slightly with his hand. A waiter was there almost immediately with the drink. "I do wish you'd join me, Mr. Barnes."

"Well, a Scotch would be good."

"Ah, splendid. Hal, bring Mr. Barnes a Scotch. Ice and a bit of water?"

"Fine." The waiter, young, dark and with dignity, walked off. "I take it you found the Rosses' competitive attitude strange, Mr. Oswald?"

"Well, naturally you run into it, but theirs was so advanced it seemed just a bit out of place here at the club among friends who—I'm sorry, Mr. Barnes. I'm afraid I'm just a stuffy old man. Forgive me."

"You seem awfully nice to me," I said with meant feeling. Hal put my Scotch beside me on the small table.

"You're nice, too, Mr. Barnes. I always assumed the police were crude and tough."

"There are all kinds. A lot of cops have to be tough. They deal with tough people."

"I'd thought being a policeman would make one jaded about people, look for only the worst in others."

"It affects some that way over the years, and they start looking at everybody with suspicion. But others are like me. I've found over the years that the big, big majority of people are fairly decent. They just want to be left alone and get along. For me, it's given me a pretty positive view of people."

"That makes me feel good," he said. He tipped his glass toward me. I returned the toast.

"Do you have a membership list, Mr. Oswald?"

"I suppose we do. I've never seen one but"—he gestured again—"Hal, do we have a typed list of the members here?"

"Yes sir, we do."

I said I'd like to see it, and Oswald nodded Hal on his way to get it.

"Murder is terrible, isn't it, Mr. Barnes?"

"The worst."

"Do you know, William Stafford somewhere says 'our lives are an amnesty given us,' or something like that. When you murder someone, you break their amnesty. You take away their right to stay out of war—isn't that what that means?"

"I'm not sure," I said. I felt embarrassed because I wasn't sure what Stafford had meant by that, though I liked the line. Hal handed me the list.

"Would you excuse me for a moment, Mr. Oswald?"

"Surely, Mr. Barnes."

I went down the list. What amazes me is that there are so many rich people, and no one knows who they are. Except for Marnie's name, none were familiar, but one other I hadn't expected. Randall Clueridge. Randall Clueridge? Randall Cleaver?

"Do you know Randall Clueridge, Mr. Oswald?"

"Yes, but not well. He's one of our more recent members. A handsome fellow, financier, I believe, like me."

I didn't bother to correct him, but I doubted Randall Cleaver was anything like him.

"Does he come here often?"

"Oh, yes. He practically lives here. He's usually in the bar."

"How about his wife?"

"His wife?"

"Yes, Joyce Clueridge."

"I don't believe I know her," he said diplomatically.

"Is he here now?"

"I'm sure he is." He gestured, and Hal came. "Hal, is Mr. Clueridge in the bar?"

"Yes, sir, he is."

I made some polite good-bye gestures, thanked him to a point of what I thought he would find good taste. As I was leaving, he said, "I hope you catch your murderer, Mr. Barnes."

"Even if it's someone in the club, Mr. Oswald?"

"Especially if it's someone in the club," he said.

I decided not to hug him, but it took some effort.

JEWEL LANSING

Jewel Lansing (1930–) was Multnomah County auditor from 1975 through 1982 and the auditor for the City of Portland from 1983 through 1986. She was a founder of WIN-PAC, a political action committee created to support women who were first-time candidates for the Oregon legislature and the co-founder of the Oregon chapter of the Accountants for the Public Interest. Lansing is the author of six books, including Campaigning for Office: A Woman Runs *(1991) and* Portland: People, Politics, and Power, 1851–2001 *(2003). In this excerpt from* Deadly Games in City Hall: A Murder Mystery *(1997), a newspaper reporter tracks leads through Portland's neighborhoods and halls of power.*

From *Deadly Games in City Hall*

It may seem strange, or even rude, that I call Zelma and Phil and Tom by their first names. But everyone who works with their royal highnesses. as the council members are nicknamed behind their backs, calls them Zelma and Tom and Sue and Phil. Not to their faces, of course. To their faces, it's Commissioner Dozart and Commissioner Jamieson and Commissioner Godwin. Talking about their staffs or bureaus, last names are used: Jamieson's bureaus or Dozart's staff or Godwin's fiefdom. The mayor is Your Honor or Mr. Mayor to his face; otherwise, he's Jesse or "The Grinch" and "The Grouch."

So it would be odd for me to think of the council members by anything but their first names, even though the *Sentinel* requires last names alone for newspaper stories. And never did I mention in print that Sue was African-American and the other four commissioners Caucasian. Television cameras pick up those kinds of facts about us automatically, without anyone saying a word.

I drove south on Macadam toward my apartment, watching sailboats skim along the Willamette River.

Zelma was a mischief-maker, no doubt about it, but her spreading rumors to her council cohorts was no worse than my taking pictures of a corpse.

My mom used to say I parachuted first, then looked for a landing place. I haven't changed much.

My worst mistake was giving up custody of Mario without a fight when Harold and I divorced six years ago. (My Mexican ancestors would have shamed me deeply about getting a divorce had they been alive—especially my father—but that's a separate story.) I was twenty-eight, struggling with my Chicana identity, and got the "noble" idea that Mario needed a strong father's influence and the advantages that Harold's money could buy. Harold was a doting father, and would doubtless be a good parent, maybe even better than I. So not only did I give up custody, but gave Harold my blessing

to move to San Diego half a mile from his parents. Now I see Mario only once or twice a year—mostly for the three weeks he comes to Oregon every summer.

At first after the divorce, I was consumed with guilt over giving up custody, and spent all my money flying down to California twice a month and renting a motel room. I had no car when I got there and Mario lived a mile from the closest bus line, which didn't run on Sundays. It was frustrating, futile and crazy. Little by little, I stopped going to San Diego and relied instead on letters, the phone and our annual three-week visits.

I still dream about Mario a lot. Sometimes I'm holding him, sleepy, in my arms, and I'm totally happy. Then I awake and try to go back to sleep so I can recapture that warm feeling, but I can't. He's a friendly, trusting kid with curly brown hair and freckles. Frank and open. A born idealist in contrast to Harold and me with our cynical views.

The hard truth is that Mario is being raised not only by my former husband, but by two doting Anglo grandparents and a career-minded Anglo step-mother. This last part is ironic, because my wanting a career was the nub of our problem, Harold's and mine. By the time Mario was six months old, I was eager to get back to work, but Harold insisted I stay home. We spent nearly three years arguing about our mother vs. father roles before we finally separated. Harold also wanted more children and I didn't—although he and Allison don't seem to be in any hurry to reproduce.

Sometimes I think about trying to obtain custody, but I can't deny that Harold and Allison are doing a good job. I've even thought of moving to San Diego, but that might make things worse. Mario's California family of parents and grandparents and friends comprises a world I'm not part of. Sometimes I resent that California Mafia—maybe "am jealous of" describes it better. I worry I'm not teaching Mario more pride in his Hispanic roots like I should.

I crossed the Sellwood Bridge and turned right off Tacoma onto a tree-lined street.

The sixty-year-old house I live in was remodeled into apartments a few years ago by a couple in their early seventies. Carl and Reba Wiedakehr. Good landlords, cheap rent. My apartment is one of two upstairs units. The Wiedakehrs live underneath me in the back of the house, where we're shaded by a giant Douglas fir. All four apartments are accessible from community hallways.

In the front hall, I picked up my mail from the metal slot marked Apartment D and sorted letters as I climbed the stairs. The air grew hotter and stuffier as I climbed. My door lock stuck, as usual, and I worked the key back and forth three times before the door swung open.

I always got a good feeling when I walked into my castle. A comfortable,

lived-in feeling. Faded, but well kept, with pots of green plants hanging from the ceiling and a window box of white and purple petunias. Everything in this apartment I chose myself. True, my Aunt Dora paid for the three pieces of Mediterranean furniture—sofa, arm chair, and coffee table. The modernistic oak kitchen table and chairs were a holdover from my life with Harold. Posters of Diego Rivera and Frieda Kahlo in Mexico, plus landscapes of Spain and Brazil (places I wanted to visit someday) covered my walls. Mario grinned from an oversized picture above the TV set—the clean, pressed look of his Little League uniform undoubtedly the handiwork of his Grandma Novak.

I tossed into the wastebasket a post card advertising carpet cleaning, a notice to call my dentist for a six-month check-up, and a packet of coupons for discounts from Sellwood stores along 13th Street, a once-thriving, then long-neglected commercial area that had made a come-back as antique dealers' row.

I sat down to read the post card from Aunt Dora. She and Mom were on a month-long trip to Mexico. I would love Copper Canyon, Aunt Dora said. I should go there soon, and take Mario, to show him where his Grandfather Hernandez grew up. Mom said she thought family members of my dad's still lived around Los Mochis, but she never made any effort to contact them herself.

Mom acted younger now than when she used to save up grocery money to send Orcillia and me to ballet classes thirty years ago, determined as she was not to let our poverty or bronze skins stand in the way of success. She smothered all of us, living her life through Orcillia and Dad and me. I wanted Mario to have more breathing room than that, wanted him not to feel guilty for having his own life and interests that didn't include me or his father.

The red light was blinking on my answering machine and I punched a button to learn I was the lucky winner of a handsome piece of luggage if I would call 596-4182 to claim my prize.

"Something for nothing, eh?" I said to the machine. "You can't fool this cunning mechanism of organic parts."

I switched on the noisy air conditioner in the kitchen window and turned it to high. I poured myself a glass of wine and carried the glass toward my favorite easy chair near the living room window. The phone rang before I sat down.

"Novak here," I said.

"Sweetness," Morgan drawled. "Glad to catch you home."

"*Buenos tardes, mio amigo,*" I said. "What's up?"

"I'm really sorry, believe me, but I'm not going to be able to make it tomorrow. I'd much rather spend the day with you, but I have to escort a group of visiting dignitaries to Timberline Lodge. How about if I drop by tonight, instead, with a bottle of Johnny Walker Red?"

"I'm honored you could work me in," I said.

"Don't be so touchy," Morgan said. "I can't stay more than half an hour, forty-five minutes, because I'm having dinner at my daughter's. She gave strict orders to there by seven-thirty, latest."

I hung up and carried my shoes into the bedroom. There I wiggled into cotton shorts and well-worn Birkenstocks. His daughter would undoubtedly wear a skirt and frilly blouse to please her dad, but he would have to take me as I was.

Morgan and I had fallen into the habit of spending Saturdays together— often driving to the coast or mountains and occasionally booking separate rooms for an overnight stay. But missing out on a trip was not what disappointed me most about Morgan's absence for dinner tonight or for longer hours tomorrow. I needed people around right now. I didn't want to be alone.

I hung up my suit and the clothes I'd tossed over the chair last night before I went to bed. Maybe my friend Carol would join me for dinner. She'd been working closely with Phil, and would be shattered by his loss. I should have called her before.

From my side kitchen window I watched two children climb a jungle gym on a green lawn across the street. Everything appeared calm and normal, as if Phil Baylor had not ended his life two nights ago at the end of a noose. I pulled the drapery shut.

I moved to the living room window and stopped to watch the stream of automobiles creeping across the Sellwood Bridge four blocks north. To the west, above the rooftops and trees of my neighbors, lay the forested three-hundred-acre River View Cemetery across the Willamette River. Phil would be buried there soon.

I dialed Carol at City Hall and caught her still at work. She would be delighted to join Morgan and me for a drink, she said. As Phil Baylor's executive assistant, she had suddenly become hot media property, an honor she would love at any other time, but found onerous right now. She was devastated by Baylor's hanging himself and had little chance to reflect on that grief.

Now, I need to explain about Morgan.

Morgan: My mentor, as well as avid suitor.

Perhaps I had a father fixation for him, as Carol insisted—he was twenty years older than me. He had been a TV reporter for fifteen years before his promotion to Channel 5 news director, and he still retained a loyal following among the station's million and a half viewers. I had learned a great deal about journalism from Morgan.

He'd separated from his wife last Christmas, but she was dragging her feet about giving him a divorce. Morgan didn't want to pay alimony, so was try-

ing to keep our dating secret from his wife. Delores didn't need his money, he said—she made more money selling real estate than he did at Channel 5—but she was vindictive.

I told Morgan he ought to pay Delores alimony as a matter of principle, in return for the years she'd stayed home with their children. In fact, I secretly hoped Delores would find out about Morgan's dating me because I didn't like hiding from lawyers and his daughters and their mutual friends. Morgan's cloak and dagger act had seemed a harmless-enough game at first. It was getting tiresome now.

One of Morgan's favorite games was not booking dinner or theater reservations under his right name. He used the names of popular authors or famous literary characters. His childish pleasure over using these pseudonyms was blunted by having to pay by cash instead of plastic so he wouldn't be found out. Morgan earned three times as much money as I, so I let him pay two times out of three. Nothing male or female about it, just simple economic reality.

He avoided going to reporters' hangouts or to the suburb of Troutdale where he and Delores had lived for thirty years. But Morgan's coworkers sometimes surprised us in their choice of night spots, such as the night we were dancing at the Red Steer Lounge near Jantzen Beach until Morgan spied a Channel 5 reporter coming in the door. Morgan left the dance floor and headed for our dark table in the corner and, to my disgust, refused to leave his seat until the reporter departed. Then he declined to dance the rest of the evening.

Carol met Morgan when she dropped by my apartment unannounced one Saturday afternoon. After that, Morgan and I sometimes asked Carol to join us when we met for drinks after work. Often, our conversations with Carol turned to politics.

Congress was Carol's dream. Congresswoman Carol Rondthaler. Maybe President Rondthaler. (She tried to interest me in a political career, but I demurred. Even Barbara Bush's support couldn't lure me into that theater. Personal freedom was too important to me.) Carol's plan was to run for Congress in Oregon's Third District, where the incumbent congressman expected to retire soon. Morgan advised Carol to gain name familiarity and campaign experience first, by running for school board or the state legislature or even city council, but she was determined to start closer to the top.

Carol arrived before Morgan. The two of us shed tears for Phil and found it hard to talk. But when Morgan got there, the words started flowing freely, and the three of us sat around drinking toasts to Phil and recalling old Phil Baylor stories.

"My favorite is still the time Baylor got his picture in *Time* magazine sitting on the lap of King Kong," Morgan said. "Twenty stories up. Remember that? Playing a violin yet. The grand opening of the Portland Building."

"'The Fiddler and King Kong,'" I said. "Such a great sense of humor! Was there anything wrong with the guy? Am I guilty of selective memory, or was he really Mr. Perfect?"

In that instant my mind flashed onto contradictory memories, and I almost blurted out Zelma's rumor about Phil and Boyd. Here I was with two of my best friends, and I hadn't told them that most shocking story. Something held me back. Something kept me from speculating about gossip that could stain not just Phil's reputation, but that of others, too.

"Of course he wasn't perfect," Morgan said. "Nobody is. You know *why* Phil did those King Kong shenanigans? On a dare. I just heard this yesterday. A dangerous stunt like that. On a dare. Dangling twenty stories above ground. His wife was furious. The guy was a sucker for a dare, especially after he'd been drinking. I wouldn't be surprised if his whole stint with King Kong didn't start at a late party somewhere."

"That's not the kind of guy we saw on the job," Carol said. "At work, he was just the opposite. Left nothing to chance. A stickler for details; never let go."

Strands of blond hair escaped from the French twist at the back of Carol's head. She took off her plastic-rimmed glasses to wipe her eyes, then blew her nose with a honk. The folds of a turquoise silk dress draped across her square shoulders still managed to look elegant. Today she looked younger than thirty-one. Perhaps it was the lost look and the honking of her nose.

"Don't get me wrong, I really loved the guy," Carol said, "but he always wanted everything done his way. Even the little stuff. The staff complained a lot, including me. He wrote his own speeches and edited our drafts until we didn't recognize our own work. He was too mired down in detail to be perfect."

"Not anymore," Morgan said. I sat up abruptly and cracked my knuckles, a nasty habit. "I wish I had a cigarette," I said.

"Have another drink instead." Morgan disappeared into the kitchen. The refrigerator door creaked and ice cubes clinked.

Carol and I sat looking at each other.

Carol brushed back the hair from her face. "I don't believe he committed suicide," she said.

"I don't either," I said. "Why on earth would he? Wouldn't we have seen some tell-tale signs?"

Morgan handed us fresh drinks. "He had everything a man dreams of," Morgan said. "Money. Power. Security. A great wife."

"He planned to run for governor some day," Carol said.

"Suicide doesn't figure," I said. "But neither does anything else. Why would anyone want to kill Phil? That doesn't seem possible either."

"Even people who weren't his buds respected him," Carol said.

"I'm going to do some asking around," I said. "On my own time."

"Watch out you don't get in over your head," Morgan said. "Private lives can be messy stuff and you may not like what you find." He looked at his watch and jumped up. "Damn, I'm late, got to run." He gulped down his Johnny Walker and wrestled his stocking feet into shoes.

"I'll walk you to your car," I said. "Back in a minute, Carol. Help yourself to cheese and crackers. I'm getting hungry myself."

Morgan and I were silent going down the stairs. I had something private to say and didn't want to chance my neighbors overhearing us.

When we got to the sidewalk, I said, "Why don't you take me along to Mt. Hood tomorrow? I need to get away after the last couple of days. It's supposed to be great weather for a drive."

"Sorry," Morgan said. "This is strictly business. I'll be squiring around a couple of big-wigs who are up to their ears in sales figures. The station is nothing more than a cash cow to these dudes."

"Why don't they dump on the advertising department, then? That's where sales data belongs. Why involve the news?"

"Because news is where it's at for local stations like ours. I keep telling you. Everything follows the ratings for news. We're not in the news business, we're in the audience business. It's entertainment. You newspaper folks don't have competitors anymore, while we have *five* TV stations covering the same news. We're in a tough business, my dear. You don't know how lucky you are."

LOUIS MASSON

Since 1970, Louis Masson (1970–) has taught writing and literature at the University of Portland, where he is Tyson Distinguished Professor. He is the author of many stories and poems and has written two collections of essays, Reflections: Essays on Place and Family *(1996) and* The Play of Light: Observations and Epiphanies in the Everyday World *(2006). Masson is a contributing editor to* Portland Magazine. *This essay from* Essays on Place *meditates on the Willamette River from the perspective of a tugboat pilot on the* Western Cougar.

From the Wheelhouse of the *Western Cougar*

From the wheelhouse of the *Western Cougar*, the Willamette River looks narrow. Like a ranger's firewatch tower, the wheelhouse sits high above the deck on metal stilts and is reached by climbing a series of steep metal stairs. This is a workingman's view of the Willamette.

Despite the nomenclature, the wheelhouse has no wheel. Captain Jim Bennett maneuvers the *Cougar* with two throttles. There are other curiosities for

the landlubber: oak paneling and molding, carpets, and in the corner a carpet sweeper.

The *Cougar* was built as a logging boat, for herding and towing log rafts and booms on the river. She has been rebuilt (her wheelhouse raised, her sides widened) to push barges. She is not the pride of the Western Transportation Company fleet. Of the *Comet*, a sister ship, Captain Bennett and Lamar Gardner, his deck hand, speak with admiration; the *Cougar*, however, is to be endured. Though I cannot feel it, Bennett senses more than her usual contrariness this morning and suspects a shorn rudder. He backs her out of the dock into the main channel of the river. She is not fast, but the power of her two giant diesels vibrates through the entire boat. This is the power of *Little Toot*, the tug that could, and riding here is a child's tale come true, like being in the cab of a tractor trailer or the engine of a train. As we pull out into the river, towering above the pleasure boats that cruise even at this early hour, we attract the same attention and respect that trains do. Everyone waves. Bennett is too busy to wave back, so I do.

In a real sense, perhaps there are several Willamettes. Certainly there are several visions of the river. The maritime industry, the sportsmen, the pleasure boaters—each has different expectations. They do not always coincide. What is obvious to one man is a surprise to another. For those who work on the river the immediate and the practical come first.

Earlier in the summer I asked Captain Buck Modrow, president of the Pilots' Association, what his favorite parts of the river are. His answer: "The easiest parts."

In the hierarchy of rivermen, the pilots hold a position of eminence and envy. The captains speak of them as an exclusive fraternity. Only after a long apprenticeship on a river, perhaps after years as a tug captain, does a man qualify for pilot apprenticeship. On the Willamette, the pilot has not only the skill to be captain of a tug, but also a knowledge of the river's currents and moods so that he can dock the ships that load and unload in the port. Modrow grew up on the river. Typically, a pilot's life is spent on one river, and to ask him to compare his river with another is a fruitless question. A pilot cannot be a fickle man. Modrow is a courtly and articulate voice for rivermen. His vision of the river is practical, but tempered with a sense of tradition acquired from experience—his own and his predecessors'. His advice: "There hasn't been great river writing since Mark Twain, and if you want to begin to know a river, spend some time with men who work on it."

Piloting on the Willamette is not physically dangerous, but dangerous nonetheless because a mistake may represent thousands of dollars. The Willamette is a long harbor and a tricky one—the water level varies, and at low water the docks are high and the pilings tender. A boat has to be eased into a berth. The hands of the pilots and captains rein immense power and tonnage. In the close quarters imposed by the narrow banks of the Willamette,

the work demands experience and timing and a deft touch. What takes place on the river parallels the activity of the rail yards and trucking lots that occupy the immediate banks, but the scale on the river itself is considerably larger.

Unlike Pilot Modrow, Captain Bennett is a rather taciturn man whose eyes rarely leave the water. In manner and dress he reminds me more of a farmer than a boat captain. As we move along the river he shares apples grown on his property (he is, in fact, a gentleman farmer as well as an officer and gentleman of the river). He has worked the Great Lakes as well as the Willamette.

Below the Sellwood Bridge the Willamette exhibits a decidedly urban and industrial character. Her drydocks and terminals manifest her maritime lineage. The freighters, tankers, tugs, and barges are the traffic of a major shipping lane.

Upstream, a different character reveals itself. No longer a busy commercial thoroughfare, the river and its banks become suburban and residential. Sometimes she seems an alley of water more than a street. Riding in the wheelhouse here is like driving down a residential street in the cab of a truck. You see over the fences. More often than not you are looking into the back yards and kitchens from where the neighborhood watches you with its real face. Bennett and Gardner eye the banks out of habit, their interest drawn to changes that a visitor would never see. As we pass an oversized white Cape Cod on the west shore, Bennett pulls the horn cord twice. No one is in the yard, no one waves from the picture window which gives us a view of two chairs and an unset table. "I'll bet the old lady died," Bennett says, more to the river than to his deckhand or me. Gardner explains that an old couple lived there. Every morning they would get up from their breakfast and wave to the tug. In warm weather they walked out on their patio. A year ago the old woman must have had a stroke because she was in a wheelchair and didn't raise her arm. Then they didn't see the old woman for several weeks and now the old man is gone. "Must be in a nursing home." One small ritual of river life ends.

At the narrowest point the river is deepest, well over a hundred feet. Through this section Bennett is even more alert, if that is possible. This stretch of river he and Gardner refer to as "The Sisters." "The Sisters, that's where the going is tricky," they say. The river crooks and curves and does not seem much wider than the double barges that Bennett must look over as he steers his course. The banks are rocky and sometimes sheer. And in this especially dry summer, rocks appear that have been in hiding for years. The water, like the skin of an ancient woman, has shrunk so that the bones beneath it protrude. "We call it Sisters," they say, "because of all the nuns that used to be there." And midway through this series of curves we reach Marylhurst. In a not-too-distant past the postulants and novices took their

recreation on the promontory that we now pass. I have been told by one who was there how they gathered in their white habits and how they sang. Today, a single lawn chair sits like an idle throne. No one waves to us here.

Most notable in the neighborhood is the old Walton house, a landmark left by Bill Walton of professional basketball fame. The house that Bill built is a sprawling affair in glass and cedar. Even now, carpenters hammer away at an addition. "The new people must have a lot of kids." Ten years do not age a house the way they do an athlete; age is relative, especially from the perspective of the river. Oblivious, the river flows on in a frame of time that dwarfs one man's or one generation's experience.

We pass the mouth of the Clackamas River. A fisherman is launching his boat, a road crew is installing a culvert. Once a town was born here, but it never grew up. Flooding in 1849 discouraged continued settlement of Clackamas City. At this moment perhaps I am the only person in the world to think about a town swept away and forgotten by the Willamette.

Another fisherman follows in our wake as we approach Oregon City, trolling, I suppose, for fish that we might frighten. Common practice, I am told by Bennett, but a ploy that rarely works. He gives me a bit of fishing advice that I file away: Always fish in front of the boat. His theory is that fish are bothered by the pitch of the turning screws.

On an inclement day such as today there is room for a fisherman and the barges, but it is not always so. At the height of the fish runs, the fishermen span the river in a "hogline," and they have traditionally held their spots with a tenacity and recklessness reminiscent of Oregon's pioneer days. The sheriffs' patrol must open a path for the barges.

And if the river is a thoroughfare and fishway, it is also a great playground. Bennett is continually on the alert for water skiers who dart in front of the barges like children running into a street from behind parked cars. They laugh and wave at the blasts from the *Cougar's* horns, and Bennett wipes his brow and frowns. "You can't stop a tug and two barges on a dime." In high summer, sails dot the Willamette like lily blossoms on a pond. Yet the craft that the rivermen watch with admiration are the sculls. They glide across the river like a gallery of Thomas Eakins paintings come to life. Man, boat, and water join, and in the moment and the movement they seem to glide from the bounds of time into the realm of timeless beauty.

At the falls we exchange our empty barges for full ones. We are now pushing the equivalent of two warehouses of Spillmate Towels, enough to wipe every counter top in the state. The falls loom in the background, and though they do not rival the Niagaras of the world, they share in their power.

Our return trip downriver has only little adventures. Two fishermen catch fish in front of us (proof enough for me that Bennett's theory is sound). A gang of boys, who look as if they have ridden their bikes right out of a modern movie, drop their fishing gear and their jeans to "moon" us (the first

time in my life I have been so honored—I wonder if Mark Twain shared the same fate). Bennett radios ahead to have a diver waiting for us to check the rudders.

On the return journey, our perspective is reversed. From any angle the river offers contrasts. Old moorings and tumbling foundations whisper of the past. The brilliant tile roof of the new Spaghetti Factory restaurant and the pastels of Portland speak of new investments. Above McCormick Pier the clock tower at the rail station asks us to "Go By Train." Without its wheel, the *River Queen* floats out her retirement as a restaurant, and across the way the *Global Sun* fills its great belly with wheat for the Orient. And as the menus of the *River Queen* are perused for the day's specialty, hobos move out from under the bridges to forage in dumpsters and trash bins.

At the terminal, Bennett eases the barges toward the pilings where they will be moored for the night. I watch Gardner maneuver the huge gray barges with his long boat hook. A mahout of the riverway, he nudges these behemoths into their berths and secures their ropes. A diver awaits the *Cougar.* He steps off the stern, and the Willamette accepts him with a muffled gulp. Dark water hides him from our view. He surfaces and reports that one rudder has been shorn off and sketches what he has seen below. I leave the deliberations to the crew, the diver, and the mechanics. I have my own deliberations, my own reflections. I am fascinated by the diver (and perhaps a bit envious). So much of the river eludes us, and the diver is a witness to scenes that we will never see.

DAVID JAMES DUNCAN

*Born in Portland, David James Duncan (1952–) describes himself as a "writer,
conservationist, father, fly fisherman, contemplative," and he lectures widely on
wilderness, the writing life, fly fishing, and the nonreligious literature of faith.
His stories and articles have appeared in such magazines as* Harper's, Outside,
Orion, Big Sky Journal, *and* Gray's Sporting Journal. *He is the author of two
novels,* The River Why *(1983), which the* San Francisco Chronicle *lists as one of
the twentieth century's 100 Best Books of the American West, and* The Brothers K
*(1992). Both novels won the Pacific Northwest Booksellers Award. Duncan is also
the author of* River Teeth: Stories and Writings *(1995),* My Story as Told by
Water: Confessions, Druidic Rants, Reflections, Bird-Watchings, Fish-Stalk-
ings, Visions, Songs and Prayers Refracting Light, from Living Rivers, in the
Age of the Industrial Dark *(2001), and* God Laughs & Plays: Churchless Ser-
mons in Response to the Preachments of the Fundamentalist Right *(2006). In
these excerpts from* The River Why, *the narrator reveals his long and complicated
relationship to Johnson Creek, here called "Grant Creek."*

Little, But Strong

When I headed out the door it was two in the afternoon and drizzling. In
that godforsaken suburb there wasn't anyplace much to walk to. I strolled
along by some mud puddles for a while pretending there were fish in them.
But there weren't, so it got depressing. Not that it hadn't been depressing in
the first place. Then I remembered U.S. Grant Creek. It was a suburbanized
creek, but it was water. I headed for it.

These suburbs, just a century ago, were a wetland—a wide interlacing
of ponds, creeks, sloughs, bogs and meadows providing homes for more
mink, muskrat, beaver, ducks, deer and herons than you'd find in all the
Willamette Valley now. But gradually it had been subdivided, drained, filled,
imprisoned in pipes, buried alive. U.S. Grant was the only nontroglodyte
creek left within miles. And before twenty-four hours passed they may as
well have buried it, too . . . because U.S. Grant Creek was about to die. I
know this for a simple reason: I killed it.

U.S. Grant Creek was almost ten miles long, but that didn't stop me from
killing it. I was glad I did it, too—not because I managed to out-macho
a thing thousands of times bigger than me, but because I released some-
one I loved from unending, intolerable misery. I call the creek a "someone"
because it was a living body—more a him or a her than an it. But I called it
an it after I killed it.

When I was a kid I called it "Sisisicu." It means "Little, But Strong," and it
had been that creek's name for centuries. But the white settlers didn't speak

Indian. They didn't speak it so well they didn't know the Indians didn't call themselves Indians, and they never found out what the Indians did call themselves. But the Indians and the creek are dead now, so maybe it didn't much matter. It's a funny coincidence that the settlers chose to rename Sisisicu after kind of a "little, but strong" guy—a guy with a stale cigar reek about him, kind of like the creek came to have. It's almost as if the settlers knew that before their grandchildren were through with Sisisicu, "U.S. Grant" would be a damned good name for it.

The corpse was a big, unwieldy thing—impossible to move and too big to bury. But nobody thought of this till I finished it off, and probably nobody but me thought of it even then. Anyhow, it's still lying there in the suburbs of Portland—gallons and gallons of slithering liquid carrion. A creek stiff.

It still looks something like a creek. People still call it "creek." "Don't play in that filthy creek!" mothers tell their kids. But you know how kids are. They play in it anyway, cutting their hands and feet on the broken glass and shredded metal in it, going to the doctor when the cuts start to fester. It's a problem of semantics at this point: "creek" isn't accurate anymore, but there isn't a word yet for what creeks become once they die. I guess the makers of English didn't plan on creeks dying. But I think "U.S.G." is a good name for Sisisicu's corpse. It's almost onomatopoeic: has both the prez's initials and a certain M.S.G./U.S. Certified Color sort of ring to it.

Slogging along through the drizzle I met the creek in the middle and started hiking upstream. I hadn't seen it, except from a car, in years; hadn't fished it since I was twelve; used to catch some nice native cuts and a lot of crawdads in it. But I saw that those days were long gone. . . . "Water," according to the Random House Dictionary, has forty definitions ranging from liquid H_2O to urine, with cosmetics, adulterated whiskey and tears in between. Poor Sisisicu looked like it was full of all forty of them. By an uncanny but probably meaningless coincidence, "Dead" also has forty Random House meanings—and the bulk of them seemed also to apply to little Sisisicu. Even in the least frothy rapids the creek foamed at the mouth, dull yellow-brown bubbles coating everything they touched with a rabid scum. I put my hand in—and gloved it with a tepid, oily film that smelled like a hot street.

I kept heading upstream, moved now by a melancholy urge to see the worst, to feel and smell it all. I would journey to the source of my childhood creek. I would find, for better or worse, what had become of the waters of my past.

It was tough going. I was trespassing every step of the way, mostly in suburban backyards—incurring the glares and suspicion of every dog and homeowner. But I kept on: the Indians had no word for "trespassing," so the trespasses of their neighbors needed no forgiving. And I had walked this riparian before these candy-coated houses ever stood; I had fished this little water; I had loved it. I figured this gave me the right of passage. This

pilgrimage was between no one but Sisisicu and me. Whoever made the laws protecting these backyards from intruders made no law to protect Sisisicu from poison, filth and sewer. They weren't my laws. To hell with them. I trudged upward, resolute.

I had to leave the water when it passed under streets. This was not in keeping with the self-imposed laws of my pilgrimage, but the culverts reeked, and they were dark, so I crossed the streets and continued my trek on the upstream sides. The rain fell harder.

After a slow, sad two hours I reached a big pipe pouring out of an embankment. At the top of the embankment was a four-lane street running through a wide, flat shopping district. I crossed this street, but no creek continued on the other side. Was this the source—squalid square miles of lots and plots pimpled with real estate offices, fast food chains, gas stations, shopping malls, factories, tickytack churches, funeral parlors, concrete schools? I wasn't satisfied with such a conclusion. There was water in the pipe. It was coming from somewhere. I would find where.

In the center of the street was a manhole-cover. When the traffic lights stopped the flow of cars I ran to it, listened, heard a muffled gurgling. Was this Sisisicu, or just a random sewer? I found a grocery receipt in my pocket. I rolled it into a ball, pried up the manhole cover, dropped it in, ran to the embankment where the pipe poured out: there came the paper, covered with greasy scum. I returned to the street and stumped along from manhole to manhole, checking now and then to be sure Sisisicu still gurgled below. Then I came to a place where the manholes ended but the stream at the curb ran strong: obviously a higher tributary. I followed the gutter stream for half a block, then it vanished into a hole in the curb. I turned slowly in a circle: in every direction the suburb lay lower than where I stood. The only thing higher was the three-story bank building there beside me. It was a Benjamin Franklin bank—a true-to-scale replica of Independence Hall. So, the pipe in the curb must come from the bank. I sighed, sniffed, sucked up my courage and strode up the walk into the Benjamin Franklin: like a Burton seeking the source of the Nile, I had to make inquiries of the natives. I was rain soaked and creek spattered; my hair and beard were a dripping mess. But this was no time for self-consciousness. I went straight to the manager's desk.

The manager was a short, broad-beamed fellow with a shiny, good-natured face before he looked me over and a shiny, not-so-good-natured face afterward. He said, "May I help you?"

I said, "Yeah. I'd like to ask a few questions about your building here."

He nodded coolly: his eyes darted round the room, caught sight of the security guard and bulged with meaning. Seeing the guard nod, he turned back to me. I asked, "How many floors you got here?"

He frowned. "Three, not counting the basement. All equipped with multiple alarm systems and cameras. *Why?*"

I grinned as stupidly as possible. "I'm doing a paper for school. About, uh, Independence Hall. This is a model of it, right?"

"Ah!" He smiled like a Sears santa, muzzy with relief. That's the trouble with lies: they're so soothing.

"Is there a, um, bathroom, up in the tower?"

He frowned again. "No. But there are several service stations just down the street."

I turned on the grin. "Oh, I don't need one. I just need to know."

It didn't quite work: he looked at the wet scuz all over me, one side of his face staying where it was while the other side smiled. Out of the diagonal slash of mouth came the word, "Bathrooms." That was all he said.

"It's an architecture class," I lied. "I'm gonna be a plumber." He was soothed again, and his mouth returned to horizontal.

"Any sinks up in the tower?"

"No, no sinks," he said, helpful now. "No water pipes higher than the faucet on the second floor. Will that be all?"

"Yeah. Yeah, I guess. Thanks."

I went back outside and stood in the rain, looking up at the bank, down at the gutter, back at the bank. The pilgrimage felt unresolved. Faucets and toilets go into sewers. don't they? But Sisisicu had entered that curb, and they don't pump shit from banks right onto the street. Not yet they don't. So where had the creek gone?

Then I saw my mistake, realized the interview with the manager was unnecessary, realized my Second-story-faucet Theory was, like Burton's Lake Victoria Theory, a blunder born of haste. . . . For up on the bank tower was a replica of the Liberty Bell. And rain poured onto that bell, cohered on it, grew heavy, rolled slowly down the brassy sides, off onto the roof, down the roof to the gutters, to a drainpipe, to a drainfield (and perhaps a buried spring, where deer and Indians once drank), then into and out the underground pipe at the curb. Here was the uttermost source of the waters that had been Sisisicu: an imitation Liberty Bell on top of a mock Independence Hall.

The security guard came out the glass doors and lolled nearby. He looked at the passing cars, at the rain, at the sidewalk to my right, to my left, in front of me, behind me. I could see he was embarrassed; I could see that the manager told him "Keep an eye on that guy," so he did, because he had to to get paid; I could see he could see past the muck on me; I got the feeling he might even be a fisherman; I got the feeling he might like walking back into that bank all mucky and sopped himself. I said, "See that bell up there?"

He said, "Yeah."

I said, "It's the source of a creek. I followed it all the way. U.S. Grant Creek it's called. The Indians called it 'Sisisicu.' "

He said nothing. I pointed at the bell. "Used to catch some nice trout out of there," I told him.

The security guard looked up at the bell. He was still standing in the rain there, looking up at the bell, when I rounded a corner three blocks away. . . .

Closing the Door

The following morning I set out again for the mid point of U.S. Grant Creek, this time journeying downstream, bound for the mouth. The weather had cleared in the night, which meant that even more people would see me trespassing, but today I'd brought equipment to assist me: I had a bag of beef ribs to keep the canines busy with something besides my calves; I wore a baseball cap, carried a Big Chief 500 tablet on a clipboard and had numerous pens and mechanical pencils clipped conspicuously in my shirt pocket, the idea being to come off as some kind of meter-reader or county official.

I covered the six miles quickly, including all the places I'd fished as a kid, and I saw beyond doubt that U.S. Grant had had it. There was scunge, car bodies, garbage, sewage and shredded plastic everywhere; there were no kingfishers, ouzels, crawfish, not even any skippers. Not even any mosquito larvae. The water was strangely clear, but slick and greasy, nothing alive in or near it. Three hundred yards from where it scuzzed into the Willamette was a hole where I'd invariably taken a cutthroat or two in springtime—a short gravel run ending in a shallow pool created by a log and garbage jam, and in the center of the pool, an underwater spring. I snuck up on hands and knees, figuring if there was a fish left, this was the place. Where the spring rose was an area the size of a bathtub where healthy moss and algae still grew. And lo and behold, there hovered a solitary seven-inch cutthroat. The last trout in U.S. Grant Creek. The last living thing in it. I slipped up to watch how it lived.

It wasn't up to much. It hardly swam at all—just finned in its bathtub oasis. God knew how it got there. There were 300 yards of deadly water between it and the Willamette and nine miles of poison creek-corpse confronting it upstream. It was trapped. It was alone. It was the last. Half-angry, half-brokenhearted, I watched, the singing mouse song singing itself interminably in my head. One trout, one mouse, one kid—they were all that was left of the world I'd grown up in. The rest was all sick and crazy, dying, or already dead. That Bill Bob and this trout had survived intact in their respective environments seemed to me a fact more miraculous than mice humming Beethoven.

Yet when a flying ant drifted over the oasis the last trout rose and took it with all the confidence of its Tamanawis cousins. Which gave me an idea. The idea was to perform euthanasia: this doomed trout was all that let me call the creek *alive*; given the state of the creek, its source, its foreseeable future, it seemed better to save the trout and kill the creek.

I found a gallon milk jug to put the fish in if I caught it. I pulled out the hand line I carry in my wallet. But when I went foraging for bait there was nothing alive in the streamside garbage. All I found was a rotted, waterlogged navy-blue pea coat. Which gave me another idea. I sat on a tire, pulled a long thread from the coat, jammed my #10 bait-hook into a board, held the board between my knees, took up the thread and tied a fly—a #10 Ant of sorts. A derelict ant, in a tiny pea coat.

My fly wouldn't float, I'd no rod to cast with and a direct cast would spook the fish anyway; so I got out my pocketknife; cut an elderberry twig and whittled it into a little boat for my pea-coated fly to ride in—a three-inch canoe, with an outrigger. I readied my line, stowed the fly on board, slipped upstream and sloughed the booby-trapped canoe down toward the trout in the oasis. . . .

Once upon a time on an afternoon dismal as any afternoon, the last trout in U.S. Grant Creek was treading water when it found itself confronted by a remarkable spectacle: a little elderberry outrigger canoe was floating down into its pool! This trout was a young trout, a trout unacquainted with canoes. Nevertheless it was able to identify this one, through the operation of its Racial Memory. This trout was also a nervous trout. It had had no one to talk to for a year; its creek was filthy; it knew it might be dead by now if a rain hadn't cleaned things up a bit. This trout was, in a word, a wreck. And now this—a canoe! When would it end?

The trout's first reaction was to spook, but its second reaction was to recall that there was nowhere to spook to: last time it left its oasis it nearly suffocated before finding its way back. So it stayed where it was. Still, it didn't like the idea of it—a three-inch outrigger canoe; a three-inch canoe dragging an anchor rope that ran so far astern you couldn't see an end to it. It was a bad business, to the trout's way of thinking. It was about to get worse:

When the canoe was dead overhead it capsized. An ant fell out. "I'll be swiggered!" thought the trout. "I didn't know ants could canoe!" The trout eyed the ant warily; the ant clung to the anchor rope; the canoe drifted away; the ant began to sink; it was sinking right in the trout's face. . . . The trout's mind began to race: it must be an exceptional ant that could teach itself the science of canoeing; should such an ant swim to safety, what would prevent it from teaching countless other ants how to canoe? and if other ants learned to canoe, what would prevent one of them from learning the closely related science of angling? and if one ant learned to angle, what would prevent it from teaching tens of thousands of other ants? "It's a terrible drink of water!" thought the trout, and its Racial Memory pictured dominoes—hundreds of thousands of ominous black dominoes in a row, falling, falling, one after another—ant after ant after ant in canoe after

canoe after canoe killing trout after trout after trout. . . . "I've got to stop it!" thought the trout. "I've got to *kill that ant!*"

Deploying two troops of teeth, the trout clamped down viciously upon the ant, but just as it did so it perceived another bad business: the ant was wearing a navy-blue pea coat. "Judas Priest!" thought the trout. "The ant can sew!" The trout crunched the ant again and again, but as it did so there came a whole bevy of bad businesses: the trout was swimming down, but it was going up; this sort of thing should never happen. And there was a pain in its mouth which its Racial Memory identified as toothache, a malady the poor trout had believed itself immune to. Then the trout realized the anchor rope was fishing line, and that the ant had a hook; adding one and one together, the trout got three: "*Holy Moses!*" it thought, "*the ant already has learned how to angle!*"

I landed the last trout in U.S. Grant Creek—a feisty, confused-looking little scrapper less interested in escape than in snapping the pea-coated ant. I slipped the hook from its jaw, dumped it in the water-filled milk jug and raced to the Willamette, noticing as I went a silhouette in a VW bus watching me from a parking lot; I supposed whoever it was would start fishing the creek-stiff after seeing me score—good luck to them! I went far enough upriver to escape the stream's vile outflow and poured out the trout: when it found itself free it hesitated, darting back and forth near shore, but as its gills began to work, as it began to breathe the comparative purity of the river, as it sensed something of the vastness of its new home it hung near the surface for a long instant, then darted forward, disappearing like a thought in the marbled green depths.

I sat on a rock and watched the river lap and glide. The sun found an opening in the clouds and began to warm my back, and I smiled, feeling I'd never done a better morning's fishing. . . . But the sun soon vanished. A cold gust and a shadow passed over me. And I was suddenly afraid, suddenly aware that I stood outside an open door. Back through the door was everything familiar to me—this creek, my parents' house, the self-conjured fisherman's world I'd grown up in. But here before me were the swirling greens and grays of a wide, unresting river, and beyond the river a wide and ancient and unknown world that I must now enter. The time had come to close the door—but the wind was gusting, the water was the shade of steel—

Yet the last trout had had no choice. And it, too, was a timid, creek-bred suburbanite. It might have liked its little oasis there in the dead creek. I didn't ask: I forced it to go free. I saw then that I'd no choice either. There was nothing back through that door to sustain me. I stood up, reached into the air and swung the door shut across the mouth of little dead Sisisicu and all that lay upstream. The silhouette in the VW bus was still watching, prob-

ably thinking I was crazy. I didn't care: I reached again into the wind, locked the door, threw the invisible key into the river, walked to the highway without once looking back and stuck out my thumb for the Tamanawis.

WALT CURTIS

A lifelong Oregonian, Walt Curtis (1942–) attended Oregon City High School and has been writing about Portland for more than three decades. He began as a street poet, selling his self-published first collection of poems, The Roses of Portland *(1974). He came to national prominence when his novella chapbook,* Mala Noche *(1977), served as the basis for director Gus Van Zant's first film. A friend of Oregon writer Ken Kesey, Curtis was associated with many Beat writers, including Allen Ginsberg and William Burroughs. He is the author of* Peckerneck Country *(1978),* Rhymes for Alice Bluelight *(1984), and* Salmon Song, and Other Wet Poems *(1995). In 1997, the year Curtis published* Mala Noche: And Other "Illegal" Adventures, *Bill Plympton released an hour-long film,* Walt Curtis, The Peckerneck Poet. *These excerpts are from* Mala Noche: And Other "Illegal" Adventures.

Immigrants

In 1975-76 I worked as a store clerk in a small grocery, in Portland's Skid Road area, just off Burnside Avenue. Today the area is euphemistically called Old Town. Boutiques, fine restaurants, and bistros gentrify the scene along Sixth St. and all the way to the river. Gone are The Caribou Inn, The Alaska Cardroom, Club 101, Onion John's, The Grecian Gardens, and The Lumbermen's Club. Demetri's Grocery has lost its license to sell alcoholic beverages. Its doors are shut, too. The Satyricon—the last holdout on the block—is an active rock-and-roll tavern where we hold Wednesday night poetry readings. It used to be called Marlena's and before that Demetri, the older brother of my Greek friend, had operated it as a successful and rowdy Skid Road tavern whose customers were mainly drunken Indians and Mexicans.

After a decade, the ghosts of the past barely linger. Sixth Street has changed so much that if the Mexican kids returned, they'd barely recognize the place. It's better that they are gone for good. Living in Mexico. But it is sad to recall the great flashing neon sign and star, which proclaimed JESUS—The Light of the World, perched above the Union Gospel Mission. A relic since the 1920s, it's been removed! *Was it a beacon to the Mexican kids?* The mission auditorium and building have been turned into the moderately successful music club called Starry Night. At one time, Sixth St. teemed with Mexican farmworkers, blacks, Native Americans, hobos, whores, and sailors from for-

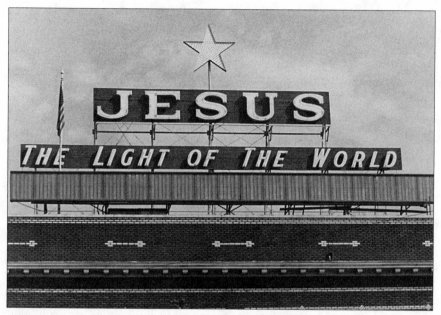

Sign at the Union Gospel Mission

eign ports buying bars of soap, shaving cream, candy bars and beer and wine and cartons of cigarettes.

They all came into Demetri's Grocery—the busiest point on the block— the focal point for activity in the community. Many of the Greek sailors returned year after year to converse and share information about the home country with the brothers Dino, Demetri, or George. Because I had met the youngest brother George at Portland State University in 1967, I was trusted to work part-time in the wino grocery. I saw the most *amazing* things! Sometimes it seemed like hell selling fifths of fortified wine to stupefied men down on their luck, out of work, and killing themselves on Skid Road. At other times the store was the most compassionate and democratic place in all of America because of the working class and ethnic others who passed through its doors.

The Greek brothers gave the pensioners and workingmen credit to get from one paycheck to the next. They'd take money out of the till and have faith that the man would return it the following week or whenever he could. Sometimes they got "burned," and other times they gained loyal and steady customers. It was then that the wino grocery seemed the most humane and humanistic institution in all the world. The epitome of the American dream, owned and operated by immigrant brothers from across the ocean.

I was a privileged participant in the store's heyday. And sleazy glory. That's ironic, considering that we Americans claim to have a handle on Democracy, and for a guy like me born on the Fourth of July, that a Greek immigrant family showed me how America got to be the way it is today. They taught me to make money by giving the customers what they wanted and needed: a cheap bottle of Tokay or MD 20/20 to blitz their troubled minds. In my writing, I have already immortalized George in *Journey Across America,* the 1972 account of our VW busride back East where he would reunite with boyhood friends from his Greek village. Fifteen years later George Touhouliotis, the owner of The Satyricon, remains the staunchest friend I have.

Why a Greek family would allow a skinny, balding, perpetual student type to run the cash register at their place of business, I'll never know! It must have been their humanizing, easygoing, democratic Mediterranean ways which gave the go-ahead. Greeks are that way, if they trust you. They practice the motto: "Live and let live." Also, the picture of me working there must have been damned funny: my dealing with babbling derelicts with snot running down their noses, belligerent street blacks and bombed-out-of-their-minds Native Americans, loggers on a toot, pimps, runaway girls, pregnant and battered women, dying veterans, old Chinese pale as parchment, petty criminals, embittered working class white men with chips on their shoulders, alcoholic hookers on the make, and weirdo perverts. The entire gamut of the human condition. With no place to go except Demetri's.

Oftentimes customers would gather out front ten-deep, yowling, arguing, fighting and guzzling from brown paper bags. When it looked like it was getting out of hand, I usually called the police! If I saw a knife or a broken bottle being used, men falling down and beating on each other. Blood. My most nagging fear was that they'd come through the door and sweep me and the cash register away. It was *groundless!* Winos don't have a revolutionary political consciousness. They are as passive as rain-soaked sacks of Bull Durham. Sprawling dead-drunk in doorways or passed out flat on concrete sidewalks. Hopelessly pushing a shopping cart of meager belongings. They'd rather kill each other off, drink themselves to death or die of pneumonia in the cold and wet—than challenge the political authority which has led them to such a sorry state of social ruination.

For a street person—without a nickel in his pocket or a place to sleep, except under the bridge or in an empty cardboard box near the dumpster—Sixth St. must have seemed a nightmare. The dream of a decent life gone broken and sour. A situation in which he might not survive the night. Still I feel lucky to have been there and to have viewed that horrific and wondrous scene firsthand. Working in the store and experiencing Skid Road, for at least a decade and longer, has enormously influenced my work. Perhaps it is the reason I have been given the epithet "street poet." *Do I live in the street? Or read my poems on the street?* Am I uneducated? No. I have a university degree

in English, I think it's that my writing deals with real life and that's what the term "street" means. After all would Jack London, John Steinbeck or H.G. Wells—if they had the opportunity as I have had—to express the truth of the human condition in that pathetic yet energetic neighborhood—be labeled "street poets"?

It was at Demetri's Grocery where I first met Johnny and Pepper and Raul. This was their neighborhood as much as it was mine, or the Greeks, or the winos, or the Indians, or the working class white poor. Many migrant Mexican-American workers shopped for groceries at Demetri's. When the yellow school buses came from outlying agricultural areas, such as Gresham or Sauvie Island, the illegal Mexicans and our own citizens would go out to the farm fields together to pick strawberries, beans and cucumbers. Some of the young Mexicans got themselves Native American girlfriends who received monthly government checks. Brown skin loves brown skin. Burnside was a melting pot, a fairly contented cross-cultural ghetto back in 1975-76 until the Immigration Service started making sweeps, picking up brown skin people, and shipping them back to the border.

Later, the jackrollers and the pimps, the heroin and cocaine dealers would erase the last traces of innocence. *"Calle Sixta,"* as the Mexicans called it, would never be the same.

Before Johnny and Pepper sauntered into the scene, I met many Mexicans shopping in the store. After work in the fields, entire families used to buy tortillas, tomatoes, avocados, and green chili peppers. Perhaps a chicken or some hamburger. With my halting Spanish from the university—I was forced to learn the vernacular, the street lingo—in order to converse with the kids and young men. The receptive ones. I'd joke with them and ask questions, testing my language skills. They appreciated the effort—a gringo taking the trouble to do that. They appreciated a white store clerk saying, *"Muchas gracias"* to them after a purchase.

There was a young man named Ricardo who transcribed for me an illiterate "dirty" poem in Spanish. I still have the piece of paper, nearly indecipherable. He used to sleep with overweight white women for room and board. There was an entire family of handsome youths who lived at the Broadway Hotel. Angelito said he was from Puerto Rico. Luis, maybe 15—a cute kid with a bright smile and quick remarks—would come into the store barefoot and try to pinch the tits of the female clerk Marian. There was Fernando and Jose from Sonora. Ramon. I used to ask each one, "Where is your hometown?" One guy just called himself *"Jalisco."* He'd sing *ranchero* songs at the top of his lungs.

I recall an old plump Mexican queen with long black hair, coy glances and lisping speech—who maintained "her" dignity and a sense of humor. I don't know how "she" did it.

I guess it was mid-August. I was really jolted! The Portland police started

coming around with paddy wagons and questioning anyone with brown skin. They'd ask a Mexican for a piece of I.D. and if he didn't have it, they'd collar him and put him in the wagon. It figures, I said to myself. The crops are picked. They don't need these wetbacks for labor anymore, so they're going to send them back to Mexico. The "soul" just went out of the place! When the Mexicans were carted off. All that was left on the street was dumb-ass bums, drunks, losers and stone-faced Indians. The police even asked Native Americans for their identification! It really broke my heart and I wrote some bitter notes entitled "Gestapo Wetback Wino Portland."

The funny thing—I had to admire the resiliency of those Latino young men! Shipped all the way to the border, some were back on Sixth St. in four or five days, a week at the most.

Well, toward the end of 1975, into this scenario strolled Johnny and Pepper. Johnny looked about 17. He had an impish face, with a mischievous smile. Pepper, his buddy, was older and more serious. His face a bit like a chipmunk's. As soon as I saw Johnny, I became madly infatuated. I was obsessed with his welfare. Would the Immigration grab him and send him back? *How were these guys to survive?* I had to get to know Johnny, become his friend. What if he and Pepper left on their own? I'd never see him again! Sixth St. was dangerous in those days. There were shootings and stabbings. The police patrolled the beat looking for thieves, dope peddlers, rowdies, and petty criminals. After conversing with them, I realized they could get in trouble with the police.

On Skid Road, for years, cops have been called "the bulls." And I'd heard a Mexican macho saying, *"If you fuck with the bull you get the horn!"* It's a farmboy and cowboy expression, too. I thought, for sure, these boys are asking for trouble! Johnny mentioned something about having a gun for sale. I'd hear gossip like that at the store. Drugs were being sold and stolen goods fenced. Johnny's attitude was very bad. When I tried to warn him, he replied in a cartoonish accent, "I don't care." This image, then, became the subtitle for the blow-by-blow diary of my friendship with them. Every word is exactly how it happened—or how I felt it was happening at the time. . . .

Notes on the Mexican Kids

They *liked* me! I know that now, For their own good, almost too much. What could I do for them? Give them pocket change, a ride in the country, buy them a hamburger. The parameters of our friendship were both fragile and durable at the same time. I kept worrying about what was going to happen to them. When would the *Migra bust* them? or would they get arrested by the Portland police? Skid Road was such a lousy place for kids to be! I was still working at the store, and I saw Johnny and Pepper had no place to stay. I let

them move in with me at The Lawn Apartments.

Johnny and Pepper brought along a friend, Alberto from Acapulco. That's where he said he was from. He was kind of cute, good-natured. All three slept on the small mattress right in the middle of the floor! Three bugs in a rug. They were alley cats with some blankets tossed over them. They clambered up and down the wooden fire escape outside my windows. They carried around a noisy portable radio—a "ghetto-blaster." And they would pop the window open and slam it shut at all hours of the night and morning.

Because they were kids, needing a place to stay, I trusted them. They had me outnumbered three to one! I guess they trusted me, too. When I would try to grab onto Johnny to give him a hug, his eyes would beam energy into mine. Playful and boyish defiance. He'd leap up on the armchair with pogo-stick-like leaps. When my hands would grab for him, he'd jump over onto the mattress as if it were a trampoline. I could never catch him! He bounded about like a boxer or a kangaroo. He was a boyish Don Juan, the Yaqui sorcerer. I envisioned him somersaulting over my shoulder, leaving me bug-eyed in disbelief.

I found out so many things about him and Pepper. Their real names, where they lived. They would write me letters, later on. You know, Johnny was part Yaqui Indian! In fact, his name is *"Yaqui."* I had thought it was "Jackie," and then a year or so later I realized what it had been all along. He scrawled his mark on a Portland bus shelter in chalk. Both he and Pepper—whose real name was Roberto—were from San Luis de Rio Colorado. (When I would visit Mexico in 1977 at Christmas, the bus drove right through their hometown. I expected to see them, lounging on the street.)

For a month, the situation was "cool" at The Lawn even though the other tenants began to give me weird looks. They were wondering what was going on. Fortunately, Terry D—, the manager of the apartment house, was an aspiring actor and he respected my poetry. Philosophically he had some understanding of my sexual predilection, my liking young males. So he allowed the Mexican boys to "crash" in my room, until eventually even his patience wore thin. I still appreciate his relaxed attitude about teenage "aliens," camping out in #207.

Alberto was okay. I didn't mind him. I kinda felt sorry for him, too. He would wax eloquently about his overweight Indian girlfriend. How much he loved her and how they would get married. Someday soon. However, I wondered if he and Roberto—they acted awfully "chummy" on the mattress—giggling and hugging like two girls weren't getting it on? Maybe when I'm not around. It's possible. Johnny points to them and says, *"Se cojen!"* Perhaps they were only showing off to tease me, their homosexual host.

Johnny didn't mind sleeping between the two of them, wearing his pants and unwashed socks. He would coyly turn out the light bulb dangling above the mattress, jerking the string and giving me a quick glance. Elbowing his

two *compañeros* aside, he pulled the red quilt over his head. Bed-time.

The boy was an exuberant juvenile animal. He was part coiled metal spring, able to sleep on the hard steel floor of a journeying boxcar. Or anywhere else. He was tough as nails with a sweet-tooth smile. He knew that I was obsessed with him and that he had me in his clutches. He was intrigued by the power he had over me—an older *gringo* man, an American. My fascination for him caused him to laugh, made him curious. He never abused my helplessness around him. But he'd always point to Pepper and tell me that *"La Pepper"* liked me. I should be with him! Johnny made it clear that he himself wouldn't be homosexual, but it didn't matter to him if Pepper and I were. That was just a fact of life, no big deal.

Johnny jumping-jack! My lovely boy leaps on the mattress, doing karate kicks. He spins around, shadow-boxes, punches the air, bobs and weaves. The other two inform me, "He killed someone in Mexico." Fighting, boxing?

Johnny felt real contempt for Gringoland, Portland. It was an alien territory to him and he felt confident that he could survive and make do even if the *Migra* or the police busted him. He always carried around the transistor, blaring popular music. He littered the sidewalks of Portland. He tossed wrappers from fast-food hamburgers out the window of my car, pop cans. I told him not to do it. "I don't care!" he'd reply. The few American words he knew. Garbage covered the floor of my room, apple cores. Peanut shells. Empty tin cans. The kitchen nook—with its gas stove and small sink and mirror—was littered with dirty dishes, blackened pans with burnt food stuck in the bottoms. These Mexicans couldn't boil water properly, barely heat a can of refried beans on the gas jet without incinerating the beans and themselves.

I loved their attitude: They'd survive no matter what, even an attack of ptomaine poisoning! Cokes, Kentucky Fried Chicken, doughnuts, pies—all the sugary, greasy and meaty food they love to eat. No vegetables! Especially not onions or tomatoes. Johnny picks the vegetables out of his *hamburguesa* and tosses them on the sidewalk. How can he be so goddamned healthy and good-looking, I wonder, eating mainly meat and sugar?

DANIEL CHACÓN

Born in California, Daniel Chacón (1962–) grew up in Fresno. He graduated from California State University–Fresno and received an M.F.A. from the University of Oregon. Chacón taught at Modesto Junior College in California and Southwestern State University in Minnesota and is currently on the faculty of the Creative Writing Department at the University of Texas–El Paso. His short stories have appeared in such publications as Zyzzyva, Americas Review, Bilingual Review, New England Review, The River's Edge, and Callaloo, and his plays have been produced in California and Oregon. His two works of fiction include Chicano Chicanery *(2000) and* the shadows took him *(2004). In this story from* Chicano Chicanery, *Chacón writes about Portland's first Chicano newscaster.*

Aztlán, Oregon

When white people in Portland stared at Ben Chavez as if they had never seen a Mexican, it pissed him off. He had fantasies about coldcocking them, feeling their noses explode on his fist. Pulling open the doors of the Cafe del Cielo and walking in, sure enough, a white boy with round glasses and a head shaped like a pencil looked up from his book at Ben. It didn't occur to him that the guy might have recognized him from TV.

Mara Solorio sat in the corner reading a newspaper. She too looked up at Ben, who now stood across from her.

"Aren't you getting coffee?" she said.

"No, I'm fine," he said.

"Are you sure?"

"Really. I'm fine. Maybe we can go somewhere else."

She neatly folded up the newspaper.

"Where do you wanna go?"

"I don't know. I guess this place is fine."

Reluctantly he sat.

"Somebody's been asking about you, Ben," she said, pushing away a plate with a half-eaten blueberry muffin. "But before I tell you about it, you have to promise me two things. Two things, Ben, promise two things. Okay?"

"Are you going to eat that?"

"No, you want it? Two things: One, you listen to my advice without getting defensive. Two, nobody knows that I told you this. You gotta promise that. Ben, are you listening?"

Ben noticed that she'd taken only two or three bites of the muffin.

"So you're just going to waste it?" he said.

At fourteen he had learned not to waste food. One afternoon, he had plopped an egg into the pan, but the yoke broke, so he dumped it into the garbage

and tried with a new egg. Looking up, he noticed his father's figure blocking the doorway. "Why did you throw that away?" his father asked.

A TV sitcom blared in the living room.

"I wanted it sunny side up. I like dipping the tortilla in the yoke." He was certain that his father who loved to eat would understand.

"What?" His chest expanded.

"The yoke broke."

"You threw away an egg because the yoke broke?"

"I wanted it sunny side up."

"Who the fuck you think you are, boy? A Rock-in-feller?" He stepped into the kitchen and raised a fist.

"I'm sorry," Ben said, shielding his head with his arms, stepping on the edge of the water pan underneath the fridge, spilling slimy water on the floor.

"Do you wanna buy the eggs from now on? Huh?" He tightened his lips around straight, white teeth, teeth that were not his own. His own had been knocked out in a bar fight.

"I'm sorry, Dad."

"I oughta hang you by your balls!"

"I just wanted an egg."

Mr. Chavez looked into the garbage and saw three of them, splattered with grease on the side of the brown, paper bag. "How the hell many did you waste?"

"I'm a lousy cook."

He saw the floor rising. Heard the laugh-track laughing. When he woke, he was on his bed, his mother holding a damp towel to his head.

"Are you okay?" she asked.

"Where is he?"

"Watching TV," she said.

"It ain't right what he did," he said.

"What'd *you* do?"

"I cooked an egg. That's all."

"And for that your father wants to kill you? Are you sure you're not leaving out some detail?"

"I like 'em sunny side up. That's the only way I like 'em. Well . . . sometimes I like 'em scrambled, but I wanted them sunny side up today. He must have hit me pretty hard."

"I heard it from the front yard."

He sat up on his bed. "I forgive him. Don't be mad at him, okay? I think I'll go watch *Starsky and Hutch* now."

"I wouldn't if I were you. He's likely to hit you again."

"Now wait a minute. If I'm willing to forget about it . . ."

"You must have done something. He gets carried away, but he's not cruel. What did you do?"

He told her.

"You little shit, how could you waste food like that?"

Now Mara's muffin made him angry. When Ben had been hired by the station, he had made it clear to his boss, Brad Myers, that he couldn't feel comfortable unless there were some brown people around, so Brad hired her, Hispanic token number two. Ben believed that the only differences between her and the white people were her accent and last name. Her rich family from Nicaragua had fled to the U.S. before the revolution in 1979. Her skin was the color of weak tea, and her eyes were blue. On Sunday nights when he anchored the news, she directed. She was brilliant because she saw everything through a camera. When she looked in Ben's eyes, even if she smiled and said something personal, he saw a director looking at him.

Whatever she wanted now, it wasn't personal.

"The network's looking for a station to host the 24-hour news," she said. Her pony-tail lay across her shoulder.

He pulled the muffin toward him and took a bitter bite.

"They're thinking about Portland. It'll run from two a.m. to five. They're talking about you as a possible anchor. This is national, Ben. Not all affiliates, but a lot of them."

"Who told you this?"

"Remember. Nobody knows you know this."

"Who told you?"

"Okay, here's the thing, Ben. Now take this as concern, okay?"

"Brad told you, right?" He resented the way she and the boss got along so well.

"I care about your future with the station. You're letting yourself go. You have to watch it."

"What do you mean?"

She sipped her coffee. "Physically, Ben. You're getting . . . chubby."

"I'm not chubby."

"You're chubby, Ben."

"You're crazy. I mean . . ."

"Look at your gut, Ben. Look down and see your gut. The camera sees that. You know, the camera adds to it. You're getting fat."

"Now it's fat?"

"Deny it if you want, fine, but not for too much longer or the network is going to pass you up. Ben, one of the things they're going to consider is your physical appearance."

With both palms he touched his face. "Are my cheeks getting fat?"

"Your cheeks *are* fat, Ben."

"Oh, my God. I didn't even notice."

"Life's been good to you."

"I mean, I don't care. I mean, who cares what I look like ultimately, you know?"

"Well, the network cares. I care because if you blow this deal, you blow it for me too."

"That's not fair."

"That's the way it is. Listen, it shouldn't take you long. Spend some time at the gym, start eating right. The station is sending tapes of you to the network. They want recent ones, and frankly, Ben, we don't have a lot of great stuff lately. It's like your enthusiasm is draining. Let's do some good features next week, something that shows you off. I have some ideas. Do you want to hear them?"

"Whatever."

"Hispanic street gangs. This of course has been done before, but by people too out of touch with the streets to dig deep. But you. Didn't you used to be in a gang in California?"

"Something like that."

When they walked to her car, Ben looked into the eyes of the white men he passed on the sidewalk, as if daring them to mad-dog him, but the one man that did look at him smiled, and Ben couldn't help but smile back. They were everywhere in Portland. He got so lonely that he would drive around towns where some Mexican farmworkers lived, Woodburn, Gervais, Independence, sometimes stopping in cafes or pubs. At these times, he never said anything, he just sipped his coffee or beer, looked straight ahead, and listened to their Spanish, trying to guess by their accents which part of Mexico they came from: Jalisco, Michoacán, Guerrero.

"You going to be all right?" Mara asked, unlocking the door to her Corolla.

"Of course," he said. "I was just thinking how much I hate this town."

"Too white for you?"

"Yeah, that's it."

"You're such a racist," she said.

"But for the good side."

"Really, Ben. You need to get over it. Before you do something stupid."

She got in and drove off. He watched her car disappear in traffic, and he ate the rest of her muffin.

In high school, his teachers hated him. They judged him because he dressed like a *cholo*: baggy pants, crisp white T-shirts, and work boots. One woman requested that he be transferred from her English class before she even read his writing. By the time he was a senior, now a leader in his gang, he was used to it. He attended school more for his personal amusement, he believed, than a desire to get educated, and he began to enjoy living up to their expec-

tations of him. Mr. Shell hated him the most. He was the civics teacher, and from the first day he was short with Ben, threatening him with expulsion when he laughed at the wrong moment or said something the rest of the class thought was funny. Mr. Shell didn't like that the students in class—the Chicanos at least—paid more attention to Ben than to him.

The students were required to volunteer four hours a semester working for a presidential campaign. Ben didn't like any of the candidates, so he wanted to work with an old radical named Marta Banuelos who had a platform telling white people to go back to Europe and leave Aztlán to the Indians. Mr. Shell, a bald man with sad eyes and sagging cheeks, said no, that Ben had to work for a legitimate candidate.

"Anderson doesn't have a chance at being elected," Ben argued in class. "Yet to you he's a legitimate candidate? Could it be because he's white?"

"Yeah," a few Chicanos in class murmured.

"I'm not required to explain myself to you," Mr. Shell said.

"Well you better tell me why."

"Or what?" Mr. Shell said, dropping his roll book on his desk with a thud and walking closer to Ben. "Or what, Ben? Are you threatening me?"

"Lighten up, old man. I just wanna know."

"I'm the teacher here. Not you."

Suddenly a white girl from the front of the class raised her hand and said Mr. Shell's name.

"What?" he answered.

"Why can't he work for whomever he wants?" she asked.

"Well, uh, this Banuelos person sounds like a protest candidate."

"So what's your point?" Ben asked.

"Okay, Ben, go ahead, I don't care."

When Marta Banuelos—who looked like Ben's *abuelita*—drove him through the neighborhood behind the Veteran's Hospital, he told her no Mexicans lived there, just retired white people. He knew, he said, because his mother worked at the hospital.

"Brown people are everywhere," she said in Spanish, hunched over her steering wheel, her face old. She dropped him off in front of a chain-link fence surrounding the hospital parking lot.

As he walked by the tiny homes and duplexes, he read the names on the mailboxes. One box carved from wood said, "Godishere." He thought that was an interesting name, but they weren't Mexicans, so he didn't go to the door and knock.

He walked across the hospital lawn through the parking lot where a fat security guard looked at him suspiciously. Ben walked cool, *cholo* style, his legs in front, his upper body falling behind, as if he were kicking back, and he had a tattoo on his forearm that said NSF, North Side Fresno. He was aware that the fat security guard was following him, so he walked like he

owned the damn place down the ramp to emergency, through the automatic doors, past a man screaming on the floor surrounded by nurses and held down by orderlies. He pushed through double doors into a hallway where moans mixed with machine noises, typewriters, a toilet flushing, and his soles sweeping the floor.

The double doors at the end opened onto a large bright room with orange couches, and TV sets braced on the walls. Alicia Chavez, behind the counter on a stool, was talking in Spanish to an old nun. The nun left the counter, Ben approached it. "Are you registered to vote?" he asked his mother.

"Did I forget something at home?" she said.

"No. I was canvassing the neighborhood."

Her line rang. She told him to hold on and started talking, checking information from filing cabinets and reading it over the phone. He waited on one of the orange couches across from the TV and watched a soap opera. The volume was too low to hear it over the sound of patients moaning and coughing. Through the double doors, the fat security guard walked in, looked around, spotted Ben and walked over to him. "What are you doing here?" he said, attempting to sound intimidating, although to Ben he sounded like a little boy trying to be tough. Ben ignored him.

Alicia came up and said hi to the security guard and introduced them. "Ben," she said. "This is Roy. Roy, this is my son."

"I heard a lot about you, son." Suddenly Roy was friendly and animated, and sincerely so. He shook Ben's hand heartily. "So you make sculptures from clay? I hear your dragon won first prize at the fair."

"That's his brother," Alicia said. "This is the one that wants to be a movie star."

"Used to," Ben wanted to say, because now it sounded so childish to admit what his dreams had been.

"You're the one that reads those detective novels?" Ben asked.

"Why, yes," Roy said, surprised and pleased that he should know something about him. "I love reading."

He wanted to tell Roy to quit giving them to his mother. They were all over the house, and he picked them up sometimes and read them. In one, some sleuth was on an airplane over the California coast with a Mexican pilot, who turned out to be one of the bad guys. He said to the hero, "*Señor, I theenk your time she is up,*" and he tried to push him out of the plane, but a struggle ensued and the Mexican got pushed out instead. "*Adios, amigo,*" said the hero as he watched the Mexican drop.

Roy told Alicia he had to get back to the parking lot. "Bye, Ben," he said, shaking his hand again. They both watched him waddle away.

"You have to get back, I guess?" she asked.

"I guess."

"Ben?"

"Yeah?"

"Do you still want to be an actor?"

"I don't think so."

"What do you want to do?"

"I don't know."

"Maybe you should be on the news. An anchorman."

"Why do you say that?"

"You have to do something that shows off that handsome face of yours."

"Whatever."

When Banuelos picked him up, he told her that everyone slammed doors in his face. Next she dropped him off in the barrio on a street lined with houses and apartment buildings. He got out and started walking.

Here he is, he thought, ace reporter wandering the way of Aztlán, *con los Chicanos, la gente,* seeking the stories behind the headlines. He would go deeper and deeper, to the roots of the people's problems.

Three *cholos,* gang members, stood in front of their car across the street, their music so loud the bass beat with his heart. They stared at him, and his knees went weak because he was banging from another barrio, so they would assume he was disrespecting them. This was a death sentence, especially with his shining North Side tattoo. The three crossed the street, coming at him, one of them huge, built like a bulldog, with a flannel shirt untucked and buttoned at the top, *cholo* style.

"Where you from, eh?" the big one said. Ben nodded greetings.

"North Side," he said.

"What you doing in our barrio?"

"Yeah, *ese,* we oughtta slice you," said a short skinny kid, not more than fourteen, who kept one hand in his pocket. To get away clean, Ben knew he could knock the big guys down and run, but he wouldn't know where the kid was. He would just know to expect a sharp blade cutting and slicing from all sides until his clothes were soaked with blood.

He took two steps back. "Listen, *vatos,* I don't mean no disrespect to your barrio. I'm campaigning for Banuelos. She's a Chicana, man, running for president."

With one hand in his pocket, he grasped the handle of his knife, just in case.

He told them that *gabachos* had been running Aztlán since they took it from Mexico in 1848. Even before that, he explained, the Europeans of Mexico ran the lives of Indians, of brown people. And today things are just as bad. He gave them a few examples of injustices he had seen in his own barrio, police brutality, poverty, hard-working Chicanos accused of being lazy. They nodded their heads.

As long as other people ran things, he said, Chicanos were always going to be fighting each other. Even though they didn't have a chance in winning

the national election, the process, he said, was a means of unification. Even if only for a moment, he said, we need to come together and acknowledge who the enemy truly is. He went on and on and at some point he ceased to know what he was saying; all he knew was that he was using words to do the one thing he had to do: survive.

Giving him the Chicano handshake, they said he could stay, and they even pointed out houses of people they knew. "If they give you any problem about being in the neighborhood, just tell them 'F 14' sent you."

When the elections were over, Ben turned in an essay on the importance of the Banuelos campaign to Chicano unity, an historical perspective. One day Mr. Shell held the report in his hands. To the surprise of everyone in the class, he said, "This is the best paper I've ever read on this assignment, Ben. This is college-level work. I hope you're going to college, Ben."

He looked into the turtle eyes of the teacher. "I was thinking of majoring in journalism," he said.

Twenty-four-hour news. It was a start. But to what? Where would he wind up? The Chicano Walter Cronkite? When he arrived at his condo after meeting with Mara, he was both excited and depressed. He hated himself, but he didn't know why. He picked up the phone and called home. His father answered. "Yeah?"

"Hey, Dad."

"Junior?"

"No, Dad, the other one."

"Hey, hey, the reporter. Benny boy!"

"How you doing?" Ben asked.

"Your dumb brother got beat up again. Third time in three months."

"Is he all right?"

"Yeah. Just a little bruised."

"How'd it happen?"

"Pulled him out of his car this time. You still got that Cadillac?"

"It's a Honda. Yeah, I still got it."

"How much did that thing cost?"

"Eighteen."

"Hundred?"

"Thousand," Ben said.

"Woo. Bought this house for less than that," his father said. "You should be buying property with your money. Don't be an idiot all your life."

"Guess what, Dad?" He wanted to say something dramatic, like, "I'm going to be famous," but he couldn't say anything about it, in case it didn't come true. He found himself saying, "I'm coming home. I have a week's vacation coming up."

"Yeah. So, why are you spending it here? I thought you went to Europe for your vacations."

"That was only once."

"How much did you spend on that vacation?"

"I don't remember."

"More than I paid for my Oldsmobile, I'll bet."

"Anyway, I'm coming home."

"Why?"

"I need to be with family."

His father understood that. "When you coming home?"

"I could probably drive out there in a few weeks. Where's Ma?"

"She went to get Junior. He was in the drive-thru at Arby's. Wanted to get a sandwich."

"You sure he's okay?"

"Yeah, yeah."

"Okay, Pop. Expect me, huh? I'll be seeing you."

"Okay. Bye."

"Bye."

He heard himself say "Pop." He had never used that word before.

Pop.

Why didn't he speak Spanish with his father? Was he getting rusty? Plenty of white people in Portland spoke it, but what was the point when they could talk more easily in English? In fact, every time some white person tried to talk to him in Spanish, it pissed him off, although he wasn't sure why.

He flicked on the lights in the hallway and saw his full-body reflection in the mirror at the end. Walking closer, he got bigger and bigger until he stood in front of himself. He pulled off his shirt and tossed it on the floor. His pants dropped. His thighs were fat. And his waist: Fat.

He *was* getting fat. Fighting for his people is what he used to be about, but ever since he'd been away from Aztlán, all he took care of was himself.

Stepping out of his underwear, he picked up the phone to call Mara's home.

"Guess what I'm doing?"

"Why are you talking Spanish?"

"Guess what I'm—"

"I don't know."

"Looking at myself. You were right."

"You see it?"

"I do."

He asked her to arrange a vacation, but she said it was impossible. The network hadn't made their final decision.

"Come on, Mara, please."

"You do want this, don't you?"

"I do. I want it."

"I'll tell you what," she said in English. "Let's do something substantial first, something we can show the network, something that shows not only how smart you are, but how good you look. They're also considering an African-American woman in Phoenix. You can have your vacation later. Have you thought about any of the ideas?"

"I like the gang thing," he said.

"Let's drive around tomorrow, you know, through the gang neighborhoods."

"The angle might be radical," he warned. "Tell it like it is. I know in *Califas,* most of those gang members are pretty political. They know what's going on. And the fact is, they don't like white people."

"Any way you want."

"I want . . ."

He wanted to get there early. He followed the click of her heels. She pulled keys from her coat pocket, and whispered, "Be patient."

She didn't need to be there, he told her.

"I want to be there," she said, flicking on the lights of her office. After checking her messages and returning one call, she said, "Okay, let's go," but then she stopped again to drink from a water cooler, and he wondered if she was trying to make him angry, as if she knew that somewhere on the streets of Portland was his answer, his reason for being so far from Aztlán, so far away.

Before they could get out of the studio, the station manager, Brad Myers, walked up to them. "Hi, Ben," he said, smiling big. Although in his late thirties, Brad looked like a twelve-year-old boy dressed up in his father's suit.

As Brad and Mara stood there, Ben walked down the hall to a couch. He sat and waited while they spoke in hushed voices, and he could make out what they were saying.

Brad: "What did he do when you told him he was fat?"

Mara: "What could he do?"

Ben grabbed a fistful of flab above his belt.

Then he heard a voice calling from outside. At the end of the hallway stood Mara. "Come on, Ben," she said, holding the door open, sunlight coming through. "Let's get going."

They drove through narrow streets lined with shabby homes and corner stores. They spotted a small group of teenage Chicanos dressed like gang members hanging around on the sidewalk in front of a brick building.

"That's them," he said, pulling the van to the curb.

"Be careful," she said.

"You mean *they* better be careful," he said.

He got out of the van to greet them, but they weren't looking at him. They

looked at Mara. So he looked too.

Watched her step out of the van.

She smiled at everyone, wondering why all the attention was on her.

Ben approached the homies. "Wuz happening?" he asked.

They looked him up and down, then they looked back at Mara. One of the boys had flaring nostrils and he was tall, dark, and thin; and as he leaned against the brick wall, he looked at Ben with suspicious eyes, and said, "What you want, man?"

Ben guessed he was the leader.

"*Orale!* That's Ben Chavez, man. The *vato* on the news," said one of the gangsters, a small guy with a skinny face and shoulder-length hair that curled like Geri curls.

"That's right," Ben said. "What's your name?" he asked the leader.

"What you want, man?"

"He wants to interview us, I betcha, homes. Huh, ain't that right? You're doing a story on gangs and shit, huh?"

"Chicano street gangs," he confirmed.

"*Chale,* man. I don't want to be interviewed," said the leader. Ben felt the gold watch heavy on his wrist, the necktie tight around his collar. "Listen, *ese,*" he said, removing his tie and stuffing it in his pocket. I'm from the barrio, too. *Serio.* I'm from *Califas.* Involved in the same damn shit. I wanna tell it like it is. White people don't know shit about us. I understand why you guys are in gangs, man. It's this *pinche* society, *verdad?* Brown people don't have a chance in this white, racist society."

The leader looked at Mara then back at Ben. "What the fuck are you talking about?" He turned around and entered the building.

The guy with curls stood alone as his homeboys filed into the building behind the tall boy. "Hey, man don't pay no attention to Rafa, man. He hates everyone. *¿Sabes?* But I'll talk to you, man. I tell you everything, eh. When's this coming on TV and shit?"

Ben looked to Mara. "Get the camera," he said, entering the building.

The dim room was lit by the lights above the pool tables and the screens of video games. An Asian woman sat on a stool behind a bar where soft drinks and cigarettes were sold. Some of the boys were setting up a game of pool, Rafa sitting on a wooden chair against the wall, his legs extended, arms crossed, like a hoodlum bored in class. Behind him pool cues hung on a wooden rack.

Ben undid his watch as they watched, tossed it on the middle of their pool table, and rolled up his sleeves, exposing his tattoo. Rafa looked up at him, shaking his head slowly. "You're crazy, man."

"Listen," Ben said. "I don't know what impression you have of me, but I'm just a Chicano, all right? I mean no disrespect to your barrio, all right? I'm here because I need to tell your story. Please, let me tell your story."

Mara said it was the best interview Ben had ever done. They followed Rafa home, to school, out with his gang, and one night behind an abandoned building, they got some footage of his gang in a fight with an African-American gang. The report took a week to complete. Mara said that what Rafa talked about was wise and sad and naive all at once, a real testimony to society. It was a great piece.

Ben hated it.

He had wanted it to say something radical, but when Rafa got to the heart of what *he* wanted to say, Ben didn't want to hear it. Rafa had a dream of owning a house, having a wife and kids and "nice things." He had no consciousness of a political struggle, no concept of the Chicano Movement. He didn't even know who Ché was. Rafa said that if he could go to college he would want to major in business. He could see himself as a businessman, "making all kinds of money and shit." Whenever Ben tried to get what he thought of society into the interview—whenever he suggested that it was racist and responsible for the condition of Chicanos—Rafa looked at him funny, looked at Mara, and back to Ben. "Well, I don't know about that," Rafa would say, "but . . ." and he'd continue saying things that hurt Ben to hear.

After Mara had taken the footage for editing, she called him and told him to come see it. He hadn't eaten at all that day because it didn't occur to him to eat. He was pacing his condo, naked, back and forth, faster and faster, full of energy but with no way to expend it. The curtains and windows were open, the cold breeze flowing through.

"Brad wants to see it too," she said.

"You can watch it together. I'm staying home."

"Come on, Ben, be there. It really looks good. I'm serious. This is the best feature on gangs I've ever seen. Come see it. It'll blow you away."

He walked past the security desk of the station. He walked down the hallway to the viewing rooms and entered a door. Mara and Brad quit talking and looked at Ben. "Hi, Ben," Brad said.

The room was small with a large video monitor.

Ben sat down and looked at the screen. Mara started the tape. It ran for four minutes, each minute more and more painful to him, full of things he hated. When the tape was over, he felt like picking up the monitor and throwing it across the room.

"My God, Ben! That was incredible," said Brad.

The voice grated on him like a shovel on hardpan.

"Excellent. Excellent," Brad continued. "Ben, let me shake your hand."

Brad appeared in front of him, a sickeningly sincere look on his face, his hand extended. "Oh, Ben, the network's going to love this. And you look good in this piece. That coat compliments you."

"What do you mean by that?"

"You look good, that's all," he said, patting Ben on the shoulder, looking at Mara and smiling.

"Don't touch me," Ben said. "What the fuck do you mean that coat compliments me?"

"Er . . ." Brad looked at Mara.

"Don't look at her, I'm talking to you. You think I'm too fat?"

"Ben," Mara said, putting her hand on his shoulder.

"Stay out of this." Then he looked into Brad's face. "You think I'm too fat?"

"Ben, I don't like this," Brad said.

"Of course you don't like it, stupid, I'm about to kick your ass." He didn't remember the first hit to Brad's stomach, but somewhere he must have been thinking of holding back most of his rage because he didn't hurt him as bad as he could have. He didn't break his legs or kill him. He simply punched his body with a *thud thud thud* like in the movies, again and again.

DOUGLAS COUPLAND

Born on a Canadian military based in Germany, Douglas Coupland (1961–) was raised in Vancouver, British Columbia. He graduated from Sentinel Secondary School in West Vancouver, attended Emily Carr College of Art and Design, and studied at the Hokkaido College of Art and Design in Sapporo, Japan. A noted sculptor and designer, Coupland's first novel, the critically acclaimed Generation X: Tales for an Accelerated Culture *(1991), reached an international audience. Coupland has written more than a dozen additional works of both fiction and nonfiction, including the novels* Eleanor Rigby *(2004) and* JPod *(2006). In this excerpt from* Generation X, *Coupland's X-er characters hang out in Portland during the Christmas season and visit the city's Vietnam memorial.*

MTV Not Bullets

Christmas Eve. I am buying massive quantities of candles today, but I'm not saying why. Votive candles, birthday candles, emergency candles, dinner candles, Jewish candles, Christmas candles, and candles from the Hindu bookstore bearing peoploid cartoons of saints. They all count—all flames are equal.

At the Durst Thriftee Mart on 21st Street, Tyler is too embarrassed for words by this shopping compulsion; he's placed a frozen Butterball turkey in my cart to make it look more festive and less deviant. "What exactly *is* a votive candle, anyway?" asks Tyler, betraying both dizziness and a secular upbringing as he inhales deeply of the overpowering and cloying synthetic blueberry pong of a dinner candle.

"You light them when you say a prayer. All the churches in Europe have them."

"Oh. Here's one you missed." He hands me a bulbous red table candle, covered in fishnet stocking material, the sort that you find in a mom-and-pop Italian restaurant. "People sure are looking funny at your cart, Andy. I wish you'd tell me what these candles were all for."

"It's a yuletide surprise, Tyler. Just hang in there." We head toward the seasonally busy checkout counter, looking surprisingly normal in our semi-scruff outfits, taken from my old bedroom closet and dating from my punk days—Tyler's in an old leather jacket I picked up in Munich; I'm in beat-up layered shirts and jeans.

Outside it's raining, of course.

In Tyler's car heading back up Burnside Avenue on the way home, I attempt to tell Tyler the story Dag told about the end of the world in Vons supermarket. "I have a friend down in Palm Springs. He says that when the air raid sirens go off, the first thing people run for are the candles."

"So?"

"I think that's why people were looking at us strangely back at the Durst Thriftee Mart. They were wondering why they couldn't hear the sirens."

"Hmmm. Canned goods, too," he replies, absorbed in a copy of *Vanity Fair* (I'm driving). "You think I should bleach my hair white?"

"You're not using aluminum pots and pans still, are you, Andy?" asks my father, standing in the living room, winding up the grandfather clock. "Get rid of them, *pronto.* Dietary aluminum is your gateway to Alzheimer's disease."

Dad had a stroke two years ago. Nothing major, but he lost the use of his right hand for a week, and now he has to take this medication that makes him unable to secrete tears; to cry. I must say, the experience certainly scared him, and he changed quite a few things in his life. Particularly his eating habits. Prior to the stroke he'd eat like a farmhand, scarfing down chunks of red meat laced with hormones and antibiotics and God knows what else, chased with mounds of mashed potato and fountains of scotch. Now, much to my mother's relief, he eats chicken and vegetables, is a regular habitué of organic food stores, and has installed a vitamin rack in the kitchen that reeks of a hippie vitamin B stench and makes the room resemble a pharmacy.

Like Mr. MacArthur, Dad discovered his body late in life. It took him a brush with death to deprogram himself of dietary fictions invented by railroaders, cattlemen, and petrochemical and pharmaceutical firms over the centuries. But again, better late than never.

"No, Dad. No aluminum."

"Good good good." He turns and looks at the TV set across the room and then makes disparaging noises at an angry mob of protesting young

men rioting somewhere in the world. "Just *look* at those guys. Don't any of them have jobs? Give them all something to do. Satellite them Tyler's rock videos—*anything*—but keep them busy. Jesus." Dad, like Dag's ex-coworker Margaret, does not believe human beings are built to deal constructively with free time.

Later on, Tyler escapes from dinner, leaving only me, Mom and Dad, the four food groups, and a predictable tension present.

"Mom, I don't *want* any presents for Christmas. I don't want any *things* in my life."

"Christmas without presents? You're mad. Are you staring at the sun down there?"

Afterward, in the absence of the bulk of his children, my maudlin father flounders through the empty rooms of the house like a tanker that has punctured its hull with its own anchor, searching for a port, a place to weld shut the wound. Finally he decides to stuff the stockings by the fireplace. Into Tyler's he places treats he takes a great pleasure in buying every year: baby Listerine bottles, Japanese oranges, peanut brittle, screwdrivers, and lottery tickets. When it comes to my stocking, he asks me to leave the room even though I know he'd like my company. I become the one who roams the house, a house far too large for too few people. Even the Christmas tree, decorated this year by rote rather than with passion, can't cheer things up.

The phone is no friend; Portland is Deadsville at the moment. My friends are all either married, boring, and depressed; single, bored, and depressed; or moved out of town to avoid boredom and depression. And some of them have bought houses, which has to be kiss of death, personality-wise. When someone tells you they've just bought a house, they might as well tell you they no longer have a personality. You can immediately assume so many things: that they're locked into jobs they hate; that they're broke; that they spend every night watching videos; that they're fifteen pounds overweight; that they no longer listen to new ideas. It's profoundly depressing. And the *worst* part of it is that people in their houses don't even *like* where they're living. What few happy moments they possess are those gleaned from dreams of *upgrading*.

God, where did my grouchy mood come from?

The world has become one great big quiet house like Deirdre's house in Texas. Life doesn't *have* to be this way.

Earlier on I made the mistake of complaining about the house's lack of amusement and my Dad joked, "Don't make us mad, or we'll move into a condo with no guest room and no linen the way all of your friends' parents did." He thought he was making a real yuck.

Right.

As if they would move. I know they never will. They will battle the forces of change; they will manufacture talismans against it, talismans like the paper

fire logs Mom makes from rolled-up newspapers. They will putter away inside the house until the future, like a horrible diseased drifter, breaks its way inside and commits an atrocity in the form of death or disease or fire or (this is what they *really* fear) *bankruptcy*. The drifter's visit will jolt them out of complacency; it will validate their anxiety. They know his dreadful arrival is inevitable, and they can see this drifter's purulent green lesions the color of hospital walls, his wardrobe chosen at random from bins at the back of the Boys and Girls Club of America depot in Santa Monica, where he also sleeps at night. And they know that he owns no land and that he won't discuss TV and that he'll trap the sparrows inside the birdhouse with duct tape.

But they won't talk about him.

By eleven, Mom and Dad are both asleep and Tyler is out partying. A brief phone call from Dag reassures me that life exists elsewhere in the universe. Hot news for the day was the Aston Martin fire making page seven of the *Desert Sun* (more than a hundred thousand dollars damage, raising the crime to a felony level), and the Skipper showing up for drinks at Larry's, ordering up a storm, then walking out when Dag asked him to pay the bill. Dag stupidly let him get away with it. I think we're in for trouble.

"Oh yes. My brother the jingle writer sent me an old parachute to wrap the Saab up in at night. Some gift, eh?"

Later on, I inhale a box of chocolate Lu cookies while watching cable TV. Even later, going in to putz about the kitchen, I realize that I am so bored I think I'm going to faint. This was not a good idea coming home for Christmas. I'm too old. Years ago, coming back from schools or trips, I always expected some sort of new perspective or fresh insight about the family on returning. That doesn't happen any more—the days of revelation about my parents, at least, are over. I'm left with two nice people, mind you, more than most people get, but it's time to move on. I think we'd all appreciate that.

Transform

Christmas Day. Since early this morning I have been in the living room with my candles—hundreds, possibly thousands of them—as well as rolls and rolls of angry, rattling tinfoil and stacks of disposable pie plates. I've been placing candles on every flat surface available, the foils not only protecting surfaces from dribbling wax but serving as well to double the candle flames via reflection.

Candles are everywhere: on the piano, on the bookshelves, on the coffee table, on the mantelpiece, in the fireplace, on the windowsill guarding against the par-for-the-course dismal dark wet gloss of weather. On top of the oak stereo console alone, there must be at least fifty candles, an Esperanto family portrait of all heights and levels. Syndicated cartoon characters rest amid silver swirls, spokes of lemon and lime color. There are colonnades

of raspberry and glades of white—a motley gridlock demonstrator mix for someone who's never before seen a candle.

I hear the sound of taps running upstairs and my Dad calls down, "Andy, is that you down there?"

"Merry Christmas, Dad. Everyone up yet?"

"Almost. Your mother's slugging Tyler in the stomach as we speak. What are you doing down there?"

"It's a surprise. Promise me something. Promise that you won't come down for fifteen minutes. That's all I need—fifteen minutes."

"Don't worry. It'll take his highness at least that long to decide between gel and mousse."

"You promise then?"

"Fifteen minutes and ticking."

Have you ever tried to light thousands of candles? It takes longer than you think, Using a simple white dinner candle as a punk, with a dish underneath to collect the drippings, I light my babies' wicks—my grids of votives, platoons of *yahrzeits* and occasional rogue sand candles. I light them all, and I can feel the room heating up. A window has to be opened to allow oxygen and cold winds into the room. I finish.

Soon the three resident Palmer family members assemble at the top of the stairs. "All set, Andy. We're coming down," calls my Dad, assisted by the percussion of Tyler's feet clomping down the stairs and his background vocals of "new skis, new skis, new skis, new skis . . ."

Mom mentions that she smells wax, but her voice trails off quickly. I can see that they have rounded the corner and can see and feel the buttery yellow pressure of flames dancing outward from the living room door. They round the corner.

"Oh, *my*—" says Mom, as the three of them enter the room, speechless, turning in slow circles, seeing the normally dreary living room covered with a molten living cake-icing of white fire, all surfaces devoured in flame—a dazzling fleeting empire of ideal light. All of us are instantaneously disembodied from the vulgarities of gravity; we enter a realm in which all bodies can perform acrobatics like an astronaut in orbit, cheered on by febrile, licking shadows.

"It's like *Paris* . . ." says Dad, referring, I'm sure to Notre Dame cathedral as he inhales the air—hot and slightly singed, the way air must smell, say, after a UFO leaves a circular scorchburn in a wheat field.

I'm looking at the results of my production, too. In my head I'm reinventing this old space in its burst of chrome yellow. The effect is more than even I'd considered; this light is painlessly and without rancor burning acetylene holes in my forehead and plucking me out from my body. This light is also making the eyes of my family burn, if only momentarily, with the possibilities of existence in our time.

"Oh, Andy," says my mother, sitting down. "Do you know what this is like? It's like the dream everyone gets sometimes—the one where you're in your house and you suddenly discover a new room that you never knew was there. But once you've seen the room you say to yourself, '*Oh, how obvious—of course that room is there. It always has been.*' "

Tyler and Dad sit down, with the pleasing clumsiness of jackpot lottery winners. "It's a video, Andy," says Tyler, "a total *video*."

But there is a problem.

Later on life reverts to normal. The candles slowly snuff themselves out and normal morning life resumes. Mom goes to fetch a pot of coffee; Dad deactivates the actinium heart of the smoke detectors to preclude a sonic disaster; Tyler loots his stocking and demolishes his gifts. ("New skis! I can die now!")

But I get this feeling—

It is a feeling that our emotions, while wonderful, are transpiring in a vacuum, and I think it boils down to the fact that we're middle class.

You see, when you're middle class, you have to live with the fact that history will ignore you. You have to live with the fact that history can never champion your causes and that history will never feel sorry for you. It is the price that is paid for day-to-day comfort and silence. And because of this price, all happinesses are sterile; all sadnesses go unpitied.

And any small moments of intense, flaring beauty such as this morning's will be utterly forgotten, dissolved by time like a super-8 film left out in the rain, without sound, and quickly replaced by thousands of silently growing trees. . . .

Welcome Home from Vietnam, Son

The Vietnam memorial is called A Garden of Solace. It is a Guggenheim-like helix carved and bridged into a mountain slope that resembles mounds of emeralds sprayed with a vegetable mister. Visitors start at the bottom of a coiled pathway that proceeds upward and read from a series of stone blocks bearing carved text that tells of the escalating events of the Vietnam War in contrast with daily life back home in Oregon. Below these juxtaposed narratives are carved the names of brushcut Oregon boys who died in foreign mud.

The site is both a remarkable document and an enchanted space. All year round, one finds sojourners and mourners of all ages and appearance in various stages of psychic disintegration, reconstruction, and reintegration, leaving in their wake small clusters of flowers, letters, and drawings, often in a shaky childlike scrawl and, of course, tears.

Tyler displays a modicum of respect on this visit, that is to say, he doesn't break out into spontaneous fits of song and dance as he might were we to be

at the Clackamas County Mall. His earlier outburst is over and will never, I am quite confident, ever be alluded to again. "Andy. I don't *get* it. I mean, this is a cool enough place and all, but why should you be interested in Viet*nam*. It was over before you'd even reached puberty."

"I'm hardly an expert on the subject, Tyler, but I do remember a bit of it. Faint stuff; black-and-white TV stuff. Growing up, Vietnam was a background color in life, like red or blue or gold—it tinted everything. And then suddenly one day it just disappeared. Imagine that one morning you woke up and suddenly the color green had vanished. I come here to see a color that I can't see anywhere else any more."

"Well *I* can't remember any of it."

"You wouldn't want to. They were ugly times—"

I exit Tyler's questioning.

Okay, *yes*, I think to myself, they *were* ugly times. But they were also the only times I'll ever get—genuine capital *H* history times, before *history* was turned into a press release, a marketing strategy, and a cynical campaign tool. And *hey*, it's not as if I got to see much real history, either—I arrived to see a concert in history's arena just as the final set was finishing. But I saw enough, and today, in the bizarre absence of all time cues, I need a connection to a past of some importance, however wan the connection.

I blink, as though exiting a trance. "Hey, Tyler—you all set to take me to the airport? Flight 1313 to Stupidville should be leaving soon."

ROBIN CODY

Robin Cody (1943–) was born in St. Helens and grew up in Estacada, Oregon. A graduate of Yale, he taught at the American School of Paris for a decade and was Dean of Admissions at Reed College in Portland. He lives with his wife, Donna, in Portland. Cody is the author of Ricochet River, *a novel, and* Voyage of a Summer Sun, *which won the 1995 Oregon Book Award for literary non-fiction, and the 1996 Northwest Booksellers Association Book Award.* Voyage, *from which this selection is taken, is an account of the author's 82-day solo canoe trip down the Columbia, from its source in Canada to its mouth at Astoria.*

The Urban Waterway

Ahead lay the low plain of Portland-Vancouver, 1.3 million people living in close proximity. A working-day haze yellowed blue sky at the edges. A whiff of bad eggs, soon gone, came from the paper mill at Camas, and the Reynolds aluminum plant guarded the Oregon shore. I passed chic houseboat colonies, the river sucking at the undersides of Astroturf decks. Swimmers,

tanners, and boaters flocked to the river. Lazy sailboats did what they could with a gentle breeze, and ornery speedboats did more, faster and louder, than anybody could want. Waterskiers looped the wide river and landed near bright tents and Perrier parasols on Government Island. The yellowy haze of population was no longer detectable once I was in it, under it, and it occurred to me, as if I didn't live here, that Portland would be a good place to live.

I paddled close to the Oregon shore. A tall levee kept the river in its place, away from low wetlands where the river used to meander and flush. Lewis and Clark paused here for a November night in 1805 and got hardly any sleep at all, wrote Clark, for the "swans, Geese, white & Grey Brant Ducks &c . . . were imensely numerous, and their noise horid." Now Boeing 737s and DC 10s nosed into and screamed out of Portland International Airport.

On the left came the site of Vanport, which once housed Kaiser shipyard workers. Vanport was erased by the famous flood of Memorial Day, 1948, when the Columbia breached a dike, wiped out $100 million worth of property, and left thirty-three dead. My own memory—a child's dim memory—of the Vanport Flood is strangely at odds with history. Dad drove us to the city to look things over, and the lasting impression is one of great triumph, not disaster. Clearly we were rooting for the river. The floating houses were prefab wartime shacks. Poor people lived there, and it was good riddance, like what you might call today urban renewal. I wouldn't have thought *anybody* died. A bloated cow drifted among the sticks and flotsam. *It just goes to show you,* my dad might have said, and we watched without mourning what a river has every right to do.

Now that all the dams are in place, they say, such a flood couldn't happen. The city of Portland has spread closer to the river and put golf courses, a racetrack, softball diamonds, and soccer fields on reclaimed floodplain.

Great blue herons, from a rookery in tall cottonwoods, looked down on a golfer in white shoes and lime slacks, lining up a putt. Across the river stood pole walls and log blockhouses in replica of Fort Vancouver, where the British ruled Columbiana for thirty years.

Farther up that Vancouver slope—hidden, you'd have to know it's there— is the control center where BPA coordinates the Columbia River power system. The brain of the beast is bunkered into a hillside to withstand earthquake or nuclear blast, stocked and sealed to outlast sixty days of radioactive fallout. Take the elevator down, and the door opens to a Stanley Kubrick movie set with wall-mounted mapboards the size of stretch tennis courts, color-coded for high-voltage and low-voltage power lines, showing the current status of the entire Northwest grid. Lights flash on the mapboards. Blue, yellow, red, green. Buzzers buzz. Computers whirr. Power dispatchers stare at cathode-ray display terminals that sense and remote-control 14,500 miles of transmission lines and 385 power-switching substations. Electricity needs

scheduling—yearly, weekly, daily, and then moment-by-moment computerized adjustments, and the moments are measured in nanoseconds—to keep the system pumped up.

Trust these people. Not just power but also irrigation, barge traffic, flood control, the Kettle Falls Sailboat Regatta, flows for fish and wildlife. . . . All this gets factored in. The people and computers in the basement here run the river as if its dams were the stops on a massive pipe organ. They're playing the song that we all, without hearing it, dance to every day of our lives.

I'd traveled this way many times before, by car down Marine Drive, by bicycle, and by motorboat. But now I brought the whole river with me and saw it connected to the world. The I-5 freeway bridged the Columbia on its way north to Seattle, south to San Francisco. Past the railroad bridges, I paddled in the shadow of cargo ships lading wood pulp bound for Europe, whole logs bound for Japan, grain headed who knows where. New Hyundais and Hondas shimmered in the heat-squiggles from a lake of asphalt off Terminal 4, and a ten-story Hitachi crane lifted red and green containers the size of boxcars into the hold of *The Evergreen*. I turned the sharp corner at Kelley Point and paddled up the Willamette River toward downtown Portland, still miles away. Here were tankers linked to oil storage tanks, and flying Panamanian and other foreign flags; more Asian car carriers; and a navy destroyer drydocked at Swan Island.

The city is here because this is as far up the river as ocean-going ships can probe. And Portland is called Portland because a pair of founders from Massachusetts and Maine flipped a coin among the stumps, and Boston lost. When Captain John Couch, another of the city's founders, crossed the Columbia River bar and set up residence at this junction of the Willamette and Columbia rivers, he knew full well the site's potential for commerce. But what really got Couch was he could shoot ducks from his front porch.

Even today, nature is the hero among Portlanders. Nature makes us different. Salmon and steelhead surge through the heart of the city. Within an hour and a half's drive is year-round skiing, ocean beaches, or virgin timber. The idea of wilderness runs through everyday life as a kind of muffled hum, a constant low-grade emotion, even when we're stuck in town. The eruption of Mount St. Helens gave an enormous boost to Portland's collective psyche by reminding urban frontiersmen that life out here is savage, and we are trailblazers. We are still Captain Couch shooting ducks from his front porch. The myth that sustains us is that we have just emerged to a clearing in the wilderness, the sons and daughters of pioneers, self-selected for rugged individualism.

The people of a city blessed with all the good things nature has can grow smug about who they are, can find complacency in livability polls, as if we did a lot to deserve it. Paddling through, I was struck by how little man has

contributed to the natural beauty of the place. A stark gray seawall separates downtown from the river, and city-center bridges are a series of uninspired connectors, one bank of the Willamette to the other. The freeway runs the east bank, blocking access from that side and marring view from the west. What beauty we have here is in spite of, not because of, the hand of man. And Portland has its environmental problems. Smoke from field and slash burning comes wafting over town when the wind is wrong. The city is outgrowing its water supply, which falls from the west slope of Mount Hood through a series of aging reservoirs, and the backup—wells along the Columbia Slough—is threatened by toxic seep from industrial plants. The sewer system is so overloaded that whenever it rains—or more than a hundred days a year—storm water and raw human sewage spill straight into the Columbia Slough and the Willamette.

Yet Portland today is much more in tune with nature than it was when I was growing up. Restrictions on burning have cleared the summer air. The Willamette River, which used to be an open sewer for all the city's human and industrial waste, is now swimmable. Fish that once couldn't find oxygen in the sludgelike flow are back. Land-use laws and cleaner logging and bottle bills and the recycling ethic have cleaned things up. Bike paths, marine parks, and riverside restaurants bring people to the river as never before in this city. The hopeful thing is that the river can, when we let it, come clean to the heart of urban life.

I checked in at home and loitered about for large parts of two days. But rest was out of reach. The river was still going—another hundred miles from Portland to the sea. I paced the house and made a nuisance of myself. Beached in the city, I slept fitfully and found in familiar surroundings only unexpected change.

The world was different. And the difference was me. Life on the river had opened up a huge gap between how we view ourselves and how we are. A string I hated to pull on, because the more I did the more things unraveled, was rugged individualism. The government's investment in the control of nature can't be subtracted from the world as it is. When we talk about survival now, we're talking about economic survival of a people dependent upon government subsidy for using nature up. The U.S. Forest Service sells logs from National Forests at prices below the cost of replacing them. The Bureau of Reclamation waters land at little cost to farmers. The Army Corps of Engineers subsidizes river shipping, and the Bureau of Land Management gives out mineral and grazing rights as if it were still 1890. BPA pumps out the cheap electricity that keeps the aluminum smelters competitive. Now that we can do with nature what we will, the guts have been sucked from the central metaphor. The taming of the West has come less at the hands of rugged individualists than from the continuing legislative clout of Western

senators and a more and more strange-seeming idea, driven by the frontiersman myth, that the river and the land are somehow unlimited, still ours for the taking.

For the symmetry of it, I paddled up the Willamette to Oregon City and the end of the Oregon Trail. Just ten miles from downtown Portland, Willamette Falls drops over a riverwide fault where the natives once fished and urban man still does. Here's where the Territorial government hanged the five Cayuse for the Whitman Massacre, and where the world's first "long distance" electric power lines carried juice from a dynamo at the falls to the streetlights of Portland in 1889. Now the falls are flanked by paper and lumber mills. Along the way to Oregon City I paddle past log booms cabled to the banks, and the wealth of suburbia laid itself out in golf courses and private properties that reached the river with wide green lawns in front of wooded mansions. Saws whined with new construction, out of sight, more people coming into the country.

On the way back from Oregon City, I poked the canoe into the mouth of the Clackamas River, my home stream. The Clackamas ran low in August. I paddled far enough for current to cancel my strokes and put me stationary, paddling but not moving.

Up the Clackamas, just twenty miles by road, maybe thirty by twisting river, River Mill Dam backs the water into a steep canyon and makes a narrow green lake next to Estacada, the mill town my folks moved to from St. Helens when I was five. You could live there and not be too taken with fish and how they get along unless your father, like mine, watched fish very closely. Dad's job as the grade school principal was just a front. The house was on the lake, and the drive to school each morning took us along the potholed lake road. Dad's way of facing the world was to gauge the color and height of the lake each morning. "River's up," he'd say. "River's clearing," or "Still too muddy." He had the clear blue eyes you'd see only in babies or very old men, and he had a great capacity for indirection, for not saying what he meant. I liked him a lot. I understood he carried another person inside him, and that person was always fishing below the dam.

Sometimes you'd see the other person go right inside him as the back screen banged and he came in in hip boots and washed his hands of fish-egg smell and changed to school clothes and caught up with breakfast.

I was the boy and could go fishing with him anytime I wanted. Truth is, I didn't like it much. You'd get up when it was still dark, and cold, and you had to cross under the spillway, inside the gloomy dam. On the other side you had to know where the poison oak was, and if you caught a fish the procedure was usually to release it. Let it go. What was the point?

I've tried to excuse my lack of interest in fish-catching by thinking Dad

breathed so deeply of that passion he left none in the air for me. But that's not it. True passion is generous. Surely he wanted as desperately for me to like fish-catching as I yearned to like it, and just didn't. We never talked of such things, so I developed a slow aching failure at not living up to part of what it meant to be a man. This was not a life-scarring issue. There were other ways—in school, playing ball—I could do well the things he admired. But not the core way. Dad's fishing codes were deep and not spoken, and sometimes it was better to go fishing without him.

Once when I was little he was going below the dam for steelhead. Gary Barden and I were heading up Wade Creek for trout. I had a secret. I said to Dad I'd bet him that I'd catch more inches of fish than he did. "Good," he said. A dollar. He liked that. The secret was that Gary and I knew where big fish collected in Wade Creek below Harberts' pond. The fish there were so thick you could wade in and catch one with your bare hands. And I did. It was an ugly fish, all beat up and white-blotchy, but it was huge. I knew Dad wouldn't keep more than one steelhead, so I had him. I also knew my fish was a spawner, but I hadn't thought it through.

I lugged it home, this spring chinook, and triumphantly held it up for Dad. His face got red. Veins stood out on his neck. "It's a spawner!" he said. He put those blue eyes on me in disbelief. "You knothead," he said. *Knothead*, from this man who seldom showed anger, was extremely strong language. As the dollar fluttered to the floor between us, I was cast free to float alone in the galaxy, never to be connected to the world.

WILLIAM LEAST HEAT MOON

Born in Kansas City of English, Irish, and Osage ancestry, William Least Heat Moon (1939–) earned a B.A. in photojournalism and a Ph.D. in English from the University of Missouri. His epic travel writings about America include Blue Highways: A Journey into America *(1992),* PrairyErth (A Deep Map): An Epic History of the Tallgrass Prairie Country *(1991), and* River-Horse: The Logbook of a Boat Across America *(1999). His books have won awards and honors from the American Library Association, the Mountains and Plains Booksellers Associations, and the* New York Times, *drawing comparisons with Alexis de Tocqueville's* Democracy in America *and Jack Kerouac's* On the Road. *In these excerpt from* River-Horse, *Least Heat Moon makes a log entry about his brief stopover in Portland.*

Robot of the River

That next morning was my hundredth day of the voyage, eighty of them on the water, and when I woke I decided to leave the river for a Sunday on the old poorhouse porch so I could work on my logbook and sit rocking in a chair like a pilot retired from boats who spends his days just watching the water; down the long slope from the verandah I could see the Columbia making its way oceanward free of us. When I announced a holiday to the crew at breakfast, to my astonishment there were hats in the air, and it came to me that our recent difficulty in getting out of bed had more to do with exhaustion than apprehension of the Bar or anything else. But, as the day would reveal, I was only half right. Things unacknowledged were about to claw into the light like moles desperate in a flooding field.

A young friend, a writer for the *Los Angeles Times*, joined us for the push to the Pacific; having such a wordsmithing crew about, I offered to take them in the afternoon to downtown Portland and that Beulahland of bibliolatry called Powell's City of Books. Despite my forewarnings, my sailors lost their bearings in the place and did not again heave into view until four hours later, whereupon I led them a couple of blocks away to a century-old seafood house, Jake's Famous Crawfish, with an excellent menu and a bar that is one of the historical sights of the city. We took a table by a window blessedly free of any views of water, but I soon went to the brass rail to stand against such good bibulous history and mull over a voyage nearly done. Next to me was a couple, he reading *The New Yorker* and she a worn copy of *Fear of Flying*. Readers are to Portland as musicians to New Orleans—everywhere. The woman was winsome but wore a mute sorrow that seemed to admit no hope, an expression painted by Modigliani. She turned to me and without prologue or preamble began speaking openly about her life as if I'd been present on all but a few days of it. I grew uneasy and finally said, Your friend here

may be missing your attention. He, who had not turned a page since she began talking, was deep into a Pisa-like lean toward the conversation, a tilt ready to topple him onto the floor. He said emphatically, "I'm not with her." She: "Don't you two guys talk over me. I'm too much of a bitch for that." Her conversation, devoid of humor and wholly and relentlessly about her life, nevertheless compelled me as honest words usually do. She suggested we go someplace quieter, and I pointed to the crew and mentioned our long tour. "A hundred days?" she said. "I think they'll understand." I must admit I suddenly felt the deprivations of river travel as I hadn't before and considered the invitation. After all, none of my jolly jack-tars, even Pilotis, had gone the entire five thousand miles; they had found respite, escaped the river, seen family, bussed a spouse, so maybe they really would understand.

I turned back to say something to her, I don't remember what, and she threw her arms around my neck and pulled herself close and gave me a smashing, open-mouthed kiss. I had to pull hard to extract my agape face. She stepped back, stared angrily, and said for all to hear, "You're a robot! A robot!" In that instant I was indeed an automaton incapable of speech, my machinery fully engaged in putting every ounce of internal propellant into a blush that even a hundred days of wind and sun couldn't hide. Then it got worse. "You need a cure!" Now we had the attention of management. It was a moment to decide fast whether to treat this as conscious comedy or to dive for cover, so of course I did neither. "Get yourself a cure!" Can we drop the word "cure"? I whispered. The crew, figuring I'd provoked things, watched impassively. Before she could lash out again, I ordered her a drink, excused myself, and fumbled back to our table. I said, Let's not any of us ever throw a frigging life ring to a drowning friend.

When we returned to the quondam poor farm, I found a quiet rocker in a dark corner of the porch, but there was no escape any longer from a certain unacknowledgment. The bar incident had nudged me, not for what happened but for what it shook free in me, something kept in restraints for the last months. The woman was unwittingly correct: I *had* become a robot, a robot of the river. What it commanded, I did to the exclusion of almost everything else. Seventeen years earlier, I'd passed through Portland on a long trip I'd set out on largely because my marriage had failed; here I was again, this time on a long trip that flattened another marriage. On that hundredth night I understood that I had gone and had entered a place, and I knew where I'd gone, but where I'd entered I had no idea. When our voyage was only memory, where would I wash up? Just where is the great delta of old river travelers? When the journey is done, *quo vadis?* That's a question adventurers leave out of their accounts, and if you read of their later days you can be glad, because often their after-life seems to be aftermath. From the poor-farm porch, I couldn't see the Columbia rolling on in the night, but I could feel it—and all the other waters—as if they ran in my veins. Why

not? The backs of human hands are nothing if not pulsing river maps. It then came to me to read the writing on my own bulkhead: Proceed as the way opens.

The next morning we set out under fair skies over a course free of Sunday boaters. We followed the big bend past industrial tailings and then on north beyond the mouth of the Willamette, above which, ten miles up, lies downtown Portland. The city *on* the Columbia is Vancouver, a smaller town but older, the descendant of the Hudson's Bay Company trading station and a later military post, a place in its earliest days once described as the New York of the Pacific. As we rolled northward up the forty-mile deviation the Columbia makes from its westering, the last we'd do, we could see four of the big Northwest volcanoes, an astounding view: behind us Mount Hood, and to starboard at various bearings Adams, Rainier, and St. Helens, the last still charry, its symmetry blown away fifteen years earlier, the result of things kept too long under restraint.

We passed docks with marine cranes swinging their cables and hooks through the August morning, passed broken pilings of dilapidated and dead industries, and we overtook freighters both under way and moored, the empty ships with Plimsoll lines far above our pilothouse, but *Nikawa*, a fingerling among leviathans, held her own in the deep-water lane and showed them a sassy stern. Against the Oregon shore lay the biggest island in the Columbia, Sauvie, fifteen miles long. Beyond, we entered into reaches of smaller islands, bosky and full of ponds and sloughs, each a lure to exploration. The Coast Range trailed down wooded hills and approached the river on one shore only to fall away on the other, then reverse itself to give an equality of ridgeland to both states, and along the riverbank here and about lay narrow beaches—one of them, Hewlett Point, the place where picnickers in 1980 turned up a decaying boodle of twenty-dollar bills, some of the two hundred thousand dollars stolen nine years before by the soi-disant D.B. Cooper who had parachuted from a hijacked airliner into the night only, according to one theory, to be swallowed by the black cold of the Columbia and flushed out to the Bar. On we went in a rising wind, on under the courthouse cupola of St. Helens, Oregon, high on a bluff, on past stick nests of herons, our approach sometimes stirring a bird from the shallows into a slow flap upstream; behind us, gulls dipped to inspect our wake for whatever gnawables it might thrum up.

By afternoon the wind and water conspired to pound *Nikawa*, so after a spell of nasty bouncing, I made for protection in the small-boat harbor at Kalama, and we left the Columbia. The town was gritty, drab, and overwhelmed by the roar of Interstate 5, a place only blasted river could drive us into. When we found quarters for the night in a motel Elvis Presley once used—photographic proof of the miracle everywhere like crutches affixed to walls of the grotto at Lourdes—I spent some time apart from the crew.

The winter before I had heard, "Are you going to trade a boat trip for our marriage?" an impossible question for me since to walk away from the river, once the idea of crossing took hold of me, was to walk away from a long dream, a deep aspiration. The voyage was not more significant than the marriage because it had become one pillar of it—or, at least, one pillar of my life. Either way, I believed the long rivering necessary to my continuance as a man. To the question I said, If I fail even to try the trip I won't be worth being married to. And I heard, "Then you've made your life contingent on rivers." To that I could say nothing.

When I found the crew for dinner, one so poor it got us to laughing in the way desperate people laugh, the Reporter said, "If the wind keeps us here tomorrow, you'll find me hanging by my neck from the shower rod," to which someone said, "One more Kalamaty."

CONTEMPORARY PORTLAND

Scenes and Reflections

ELINOR LANGER

An award-winning journalist, Elinor Langer (1939–) has written for the New York Review of Books, *the* New York Times Book Review, The Nation, *and* Mother Jones. *She received fellowships from the Guggenheim Foundation, the Bunting Institute, the MacArthur Foundation, and the Open Society Institute. Her biography of the American radical novelist and journalist Josephine Herbst was nominated for the National Book Critics' Circle Award in 1984. A resident of Portland and a member of the faculty of the Mountain Writers Pacific Low Residency M.F.A. program, she taught at Reed College and Portland State University. A Hundred Little Hitlers (2003) was a finalist for the J. Anthony Lukas Award for work-in-progress and a finalist for the Book of the Month Club's Best Non-Fiction book award of 2003. These selections from that book describe the stirrings of neo-Nazism in Portland and the 1988 murder of Mulugeta Seraw.*

The Death of Mulugeta Seraw

The Pine Terrace Apartments is a flimsy, two-story motel-style building where when the toilet flushes in one unit you can hear it in another, and if the neighbors had wondered "What's the rush?" as the skinheads raced up the outside stairway back to Nick and Desiree's shortly before one in the morning, they would not have wondered long. After a day of drinking that for some of them started as much as twelve hours earlier, their stomachs have caught up with their kidneys. In the scene that follows someone is always in the john. They put on some music and try to party but all that male bonding is exhausting even to skinheads and their energies are rapidly slipping away. Nick, skinhead by night, is a student at the local museum school by day, and a few of his friends browse with him through his work of several years—beautiful, delicately drawn, death-haunted fantasy illustrations of stories by H.P. Lovecraft and Michael Moorcock, as well as stories of his own. Others play "quarters," a low-budget drinking game on the order of spin the bottle. Around the edges of the smoky room the rest sprawl aimlessly in clumps of two or three, their moods as volatile as their intestines. Steve Strasser, charged up both by the trip downtown and by the great beer robbery, is busy bullying one of his friends. Kyle Brewster, so drunk that every time he has sat down over the last several hours he has fallen asleep, awakens and begins longing for his girl. Mike Barrett is vomiting in the bathroom. About the only one on whom the beer and hours have not left their mark is Dave Mazzella, who is trying to reverse time and turn the party back into a meeting, once again urging Nick to send some of his drawings down to Metzger's newspaper in California, while Nick, intent on nothing so much as how to explain this drinking party to Desiree, who will be thinking about the terms of his probation, is scarcely nodding along. It is a hopeless effort. This

meeting is simply adjourned. Everybody is waiting, but nobody knows what for. The one member of East Side White Pride who can always be counted on to make things happen no matter where or when—Ken Mieske—is not even in the room.

Suddenly there is a loud car on the street, more loud steps on the stairs, a loud pounding at the door, and there he is on the threshold, the missing member, Ken Mieske. Ken has not yet found his girlfriend, but at least he has found his party. He is just bounding down the stairs calling out to the others to come up when a second car pulls up to the intersection and out pile the girls—Julie, Ken's; Patty, Kyle's; Heidi, Steve's; Deanna, Pogo's; and Desiree, Nick's—and just as Nick has feared, Desiree is raging because Nick has been in jail for a burglary and Desiree, who has waited for him through his imprisonment, is not eager to wait again. Slamming the car door, running up the stairs, shouting "I want those assholes out of my apartment!" she commands the high ground of her doorway like an MP busting a bar and issues her order, which is "GET THE FUCK OUT!" Not far behind her are the other girls, searching amid the sluggish ruins of a skinhead evening for their respective mates. Ken signals his driver friend "Forget it, there's no party," and the longhair, mistakenly thinking he has been snubbed, guns the motor of his loud, mufflerless car and takes off, disturbing the sleepers in every house and apartment in sight. Desiree yells again and the skinheads obey her. Jarred by their sudden eviction, they swarm drunkenly back down the stairway, the couples reunited, the others alone. They stand around for a moment at the bottom, trying to regroup. . . .

On Saturday night both sides of the 200 block of Southeast Thirty-first Avenue are lined with cars and as you enter it heading either south from Ankeny or north from Pine you have to drive in the middle because the lanes have been obliterated by the cars parked on either side and the middle is all there is. Facing south toward the corner, only half a block away, the Ethiopians in the car outside the Parklane could perhaps have seen the skinheads as they trooped across the intersection to their cars or at least heard them as many of the neighbors did but in their hearts they are in another country far from Portland, Oregon, and it seems that they did not see them down the street, nor do they either see them or hear them when Patty pulls her car up directly in front of their car in the middle of Southeast Thirty-first Avenue and honks her horn. Tilahun Antneh and Wondwosen Tesfaye are bending down in the front seat, perhaps over a light, and they do not respond, so she honks again and Kyle rolls down his window and shouts, politely the first time, "Would you move? Would you please move?" and Tilahun Antneh looks up and blinks his lights, which have been off, on and off, and he tries to start his engine but it fails, so he tries again, and it is at this point, when they are already staring into each other's windshields, that everyone realizes

that some of them are black and some are white and it is understood that a new ingredient has been added to the Saturday night brew. So swiftly that it is practically simultaneous the civil "Move your car!" becomes "Move your fuckin' car!" and there is an answering "Bitch!" hurled at Patty and now the windows of both cars are down and there are "Fuck you, niggers!" and "Fuck you, assholes!" back and forth and when Mulugeta Seraw, who has always been a peacemaker, gets out of the car so his friends can leave he turns to the occupants of both cars, gesturing to them to settle down as he does so because something ugly is already in the air. In order for the cars to be on their way, they first have to back up to reposition themselves, which they do, but as they pass each other in the narrow roadway, Wondwosen Tesfaye, in the passenger seat, leans across Tilahun Antneh toward Patty Copp and gives her the finger and Kyle Brewster, who, having snapped himself out of his earlier stupor, has more or less assumed the captaincy of the whites, leans across Patty and gives it back and, sliding back toward his own side, grabs a gun that he himself placed between the bucket seats earlier and waves it around until Patty wrestles it away from him, shouting, "Asshole! That's MY gun!" and now there are birds being flipped by everyone and more and more racial shouting and now that they are close enough for the skinheads to hear the accents and know that it is not the local Crips or Bloods, of whom they are afraid, they are shouting, "Sand Nigger!" and "Hodgie!" and even the war cry of the skinheads of the British National Front, "Paki!" and Kyle, who has recently written a poem against immigrants titled "STAY OUT," shouts, "Go back to your own country!" and Tilahun Antneh, who is described in immigration papers as a freedom fighter against Mengistu, shouts, "I fought to get here and I'll fight to stay here!" and as the cars, traveling in opposite directions, move apart, both stop, and although the timing is so close here it would need a cosmic replay to guarantee it, it is probable that the Ethiopians stop first and Tilahun Antneh and Wondwosen Tesfaye get out of the car, fists clenched, and run back up the street, and Kyle yanks up the brake on Patty's car and flies out of the front seat and Steve Strasser flies out of the back and they run down, and as the four men meet in the middle of Southeast Thirty-first Avenue between the corner and the Parklane suddenly no one is tired anymore, they all are exhilarated, because if you are a skinhead this is what you have been slouching toward all week, violence, and if you are an Ethiopian exile you have been humiliated once too often already and you need a release, and for a few moments it is like every other street brawl going on across America at that hour, they agree on the ground rules, they expect no real harm.

But there is something about a street fight that cannot stop until it has played itself out and this one is not stopping, it is growing, for as Steve Strasser is fighting with Wondwosen Tesfaye and Kyle Brewster is fighting with Tilahun Antneh, Mulugeta Seraw turns back from where he has started to

enter his apartment and races down toward Brewster and Tilahun Antneh, and Patty Capp turns to Kenneth Mieske, who is still in the car, and says, "WELL, aren't you going to do something about it, Ken?" and Ken Mieske grabs a bat he finds on the floor of the backseat by his feet and races down in the same direction, and Nick Heise and Desiree Marquis, who have not yet gone to bed, recognize their friends' voices from the shouting and run down the stairs of the Pine Terrace to the street, and Heidi Martinson, dislodged from the car by the exit of Steve Strasser, also runs over, and Strasser has Wondwosen Tesfaye on the ground on the east side, where he is crawling under a car, and Brewster and Tilahun Antneh are fighting face-to-face on the west, and someone is yelling, "Kill him! Kill him! Kill him!" and someone else is shouting, "You're a dead man!"; but of everyone who is present at this point and of everything that is happening the only thing that really matters is that as he runs down the street toward the action something in Kenneth Mieske explodes and he takes that bat and he smashes out the taillights of Tilahun Antneh's car and he next smashes out the right rear window and goes after Antneh himself while Steve Strasser crosses over from the other side and smashes out the left window with his boot, and as a horrified Tilahun Antneh leaps back into his car to escape the bat and drives away, Ken looks up and when he does he sees his white friend, his skinhead comrade, Kyle Brewster, struggling with the black Mulugeta Seraw, and he races down the few more steps to where they are fighting and with all the force of his burly body he brings the bat down between them, hitting Mulugeta Seraw on the side of the head from behind, and when Mulugeta crumples to the ground Ken stands over him with the bat for a moment more, bringing it down once, twice, maybe more, and Steve Strasser is in there too, kicking, and when they are finished a little pool of blood is already forming and Mulugeta Seraw, who only two minutes earlier was urging all of them to stay calm, is nearly dead. The only one who understands what has really happened before they see it on television later is Kenneth Mieske. With those swings of the bat he has lifted himself out of obscurity into history, not, as he has dreamed, as a rock star, but as a racial murderer. "Ken Death," a name originally given to him by a friend in the Portland music world for his attraction to the heavy metal subgenre "death metal," is the name he will now be known by forever. . . .

Underground

Ken Mieske was practically a legend. Of the waves of street kids and semi-street kids who made up the Portland underground music scene in the 1980s, some had identities and some did not yet and never would have identities no matter how many safety pins or earrings they wore, or where, or what they did with their hair, and it was plain to everyone who met him as soon

as they met him that Ken was one of the ones who did. He had arrived in Portland from Seattle in 1981, at sixteen, been taken up by an older acquaintance, Jim Cartland,* and when Cartland joined with Mark Wells* to form the booking company CartWellShows* two years later, Ken came along with the territory, a link between the two promoters and their younger audiences. Stage crew, bouncer, discoverer of the hardest, farthest-out, "cutting edge" rock bands that he found in Seattle and elsewhere and persuaded Cartland and Wells to bring to Portland, he was visible to everyone in the rock scene, known by the stage name "Ken Death" for his love of the loud, fast, violent, not-for-the-squeamish death-metal music that drove away all but the most intense listeners. With Machine his reputation was becoming solidified, and there had been a previous band, Sudden Infant Death, but it was not so much either as stage crew or as musician that Ken Mieske stood out, it was by force of personality, energy, for there was an aura about him, a presence, that made those who knew him feel that he might have what it takes to be a star. Loud, funny, wild, and reckless, pound for pound there was more of him somehow than of most of the people in town. Filmmaker Gus Van Sant, then part of a loose Portland underculture, even starred him in a film personifying street life on the occasion of his release from prison on a burglary charge in 1987. A two-minute rumination on women and prison written by Van Sant and spoken by Ken from the middle of a highway, it was called *Ken Death Gets Out of Jail*.

The year between the fall of 1987, when he got out of jail for the burglary, and the fall of 1988, when he went back in for killing Mulugeta Seraw, was probably the happiest year of Ken Mieske's life. He had Machine, which was developing a new sound and which in the novelty-driven, ever-evolving world of American rock music might possibly, just possibly, have been going somewhere. He had East Side White Pride, a haven for the racist theories and feelings, unspeakable elsewhere, he had sharpened in prison, as well as a band of brothers he could trust on the streets. And he had Julie. Julie and Kenny were a natural match. They had met in 1984, when she was twelve and he was nineteen, at a smoky, drug-filled apartment known as "Homicide House" for the ambience favored by their mutual friend Tray Tanas, aka Tray Bundy (after Ted), to whom it belonged, and when they met again, same place, after Ken got out of jail they knew that they wanted to be together. Not only did they have a common history—they were dropouts, they drank, they sniffed, swallowed, or injected any drug in sight—they had a common vision, for Julie's racism was independent of Ken's, she had come to it on her own through study and investigation during the time he was pursuing it in prison, and unlike many of the girls who hung around East Side White Pride she was not a follower but a comrade. She could easily have been in POWAR,

*These names have been changed

the girl-dominated skinhead crew started about then, but both in her own right and through Ken she was accorded a status in ESWP granted to no other girl, and she liked being associated with the boys. Delicate, feminine, with the kind of sharp, fine-boned beauty that with a change of dress could have placed her on the arm of an executive or in the pages of *Vogue*, she was strong, bold, and scrappy as well, sometimes she even carried a gun, and if necessary in a street fight she could get out there with the best of them and do her part. . . .

Five years after the first swastikas and a few months after the death of Mulugeta Seraw I was standing in line with some friends at the Pine Street Theatre when there emerged from the parking lot a platoon of ten Nazi skinheads. Black-jacketed, black-booted, with shining heads and faces, they stood by in formation, a strange contrast with the disheveled punks also waiting in line, as their leader conferred with the club bouncer, who held his ground firmly: No Entry. I do not know who those particular skinheads were, nor does it matter to this story. What I do know is how frightening they were, and all the more so because they were young and drunk. Their leader was a round-faced, rosy-cheeked all-American teenager who looked as if he had just stepped out of a Hitler Youth recruiting poster. The followers looked all too eager to be led. Standing only a few feet away from them in a loose crowd, I felt my sense of myself as a particular individual with a partic-ular history seep away into something that I can only describe as a universal vulnerability: a fear that I would arbitrarily be singled out. What if, rebuffed by the bouncer, the little storm trooper would cast about for a way to retrieve his wounded honor and, scanning the crowd, alight on me, shouting out the words shouted by the skinheads' girlfriends in this very parking lot the night Seraw was killed: "So, you're a Jew!" It could have happened. It often has happened. And what would have happened next? And if this fear affected me, a middle-aged woman with some experience in holding on to a sense of self under shifting circumstances, how much more must it have affected the young punk rockers, flotsam to begin with, who, caught in what might well have become a standoff between the ten of them and the hundred or so of us, seemed to be doing exactly what I was: staring out past the drunken skinheads across the space between us, hoping not to be noticed. The ability of a small group to control the behavior of a larger one can be described by only one word: Power. In the years that followed the first graffiti, starting around 1985, the skinheads had it.

SUSAN ORLEAN

Susan Orlean (1955–) has written for such publications as Willamette Week, The Globe, Rolling Stone, Esquire, *and the* New Yorker. *Her essay collections include* Red Sox and Bluefish: Meditations of What Makes New England New England *(1987),* The Bullfighter Checks Her Makeup: My Encounters with Extraordinary People *(2002) and* My Kind of Place: Travel Stories from a Woman Who's Been Everywhere. *Her other books include* Saturday Night *(1990), which received a New York Times Notable Book award, and* The Orchid Thief: A True Story of Beauty and Obsession *(1998), which was adapted for film. She received the* PEN/New England Discovery Award *in 1984. In this essay, Orlean portrays figure skater Tonya Harding and her home ice rink at Clackamas Town Center.*

Figures in a Mall

One of the last happy meetings of the Tonya Harding Fan Club took place at Nancy Welfelt's house, around her dining-room table. The meeting had actually begun at Clackamas Town Center—the mall, in Clackamas County, Oregon, where Tonya skates—on the morning of the day before Tonya's on-again, off-again ex-husband, Jeff Gillooly, began his sixteen hours of inter-views with the FBI. That was several days before Tonya announced that she knew about the plot to attack Nancy Kerrigan only after it had unfolded, and about a week before Jeff pleaded guilty, but several days after Shawn Eric Eckardt complained to the Portland *Oregonian* that Tonya had browbeaten him for not getting around to arranging the assault as quickly as she wanted. It was a golden moment. It was probably the last moment when the fan club members could believe that Tonya had been completely uninvolved.

On the morning of the meeting, January 25, as on most mornings since all the bad news, some of the club members went to the rink to watch Tonya practice. The ice was empty except for Tonya, who was bent over in the corner, fixing a skate. She was wearing a stretchy black sleeveless catsuit over a stretchy gray tank leotard. Every contour of her body was outlined in black—her thick back, her strong upper legs, with their blocky muscles. She stood up and started down the length of the rink, her skates cutting feath-ery grooves in the ice. Her lips were pressed tight, and her chin was thrust forward. Her expression was wan and stubborn. Her ponytail fluttered out behind her. No other part of her seemed to move, but she was crossing the ice with tremendous speed. A snatch of music came over the loudspeaker. At the end of the rink, where a hundred or so people were gathered, she turned sharply, bent her leg, and then spun until the ice beneath her skate began to make a sizzling sound. Suddenly she stopped, skated toward the other end of the rink, spun again, pulled at the waist of her catsuit, then circled the ice

once more. For an hour, she practiced pieces of her program—a spin, a leap, a movement of her leg or hand. The pieces were never fused together into something fluid or pretty. They were just explosions of motion between long silent moments, when Tonya would stand alone in the huge, blank rink, kicking at a frosty patch or tightening her skates. She didn't look happy, but she also didn't look rattled or embarrassed or shy. At the end of the hour, when she stepped off the ice, the club members told each other that she seemed composed and steady.

The club was meeting that day because the members had a lot of work to do. Since the attack, and since Tonya's victory at the nationals, the club, four hundred strong, had received hundreds of requests for membership information. Elaine Stamm, the club's founder and president, had printed up more copies of the flyer describing the memberships—ten dollars for adults, one dollar to join Tots for Tonya—and suggesting additional opportunities to support Tonya, by fund-raising, or by giving her cosmetics, hair care, and nail care, or by making calls about her to sports talk programs, or by mailing her encouraging cards. There were also scores of requests for Tonya buttons and bumper stickers, and for tapes of "It's Tonya's Turn," written and recorded by Linda and Greg Lewis, local songwriters who a few years ago composed a hit song about Desert Storm. Linda and Greg had stopped by that morning to make some last-minute arrangements with Elaine about the song. Linda was saying, "We're not skating fans so much, but we're Christians, and we thought this was the right thing to do."

The mall was a good place for the club to gather and get all this done. There really isn't a town of Clackamas. There are acres of Douglas fir forest and grassy idle pastures, and balding hills now sprouting subdivisions, and ranchettes on lawns of chunky red mulch, and squat new apartment complexes with tan siding and shiny driveways, and featherweight trailers perched on rough concrete blocks, and there are tumbledown old farmhouses on weedy tracts waiting to be seized and subdivided, and there are little strip malls and fast-food restaurants and glassy health clubs and tanning salons standing alone in enormous parking lots, and there are bushy fields of huckleberry, blackberry, sumac, and salal, and there are pockets of businesses having to do with toys and mufflers and furniture, but there really isn't any town to speak of, or even a village to drive through. Unlike an old-fashioned town, which spreads out organically, Clackamas County's settled areas look as if they had emerged abruptly, hacked out of the tangle of blackberry bushes and firs. Around the mall, new things are cropping up so fast that the place seems kinetic, as if everything had gone up, and could come down, in a day. Even where the county is overbuilt and busy, emptiness is the feeling it conveys.

Portland is half an hour's drive away from here. It is an old, compact city that was settled by Yankee merchants, who fashioned it after Boston. Port-

land is the largest city in Oregon, but it is of very little consequence to people like Tonya and Jeff and Shawn, who live in and rarely leave Clackamas and east Multnomah Counties. News reports that say Tonya is from Portland have missed the geographical and sociological point. The world that Clackamas County is part of starts somewhere in the Great Plains, skips over cities like Portland and Seattle, and then jumps up to Alaska—a world where people are plunked down on harsh or austere or overgrown landscapes and might depart from them at any moment, leaving behind only a few houses and some gear. Alaska, desolate and rugged and intractable, feels like an annex of Clackamas County, and Portland seems a million miles away. Alaska, not Portland, is also where many people from Oregon have often gone to get more land, or to make quick money by working for a summer in a fish cannery or on a logging crew. There is a Yukon Tavern in Clackamas County and a Klondike Jewelers, and at the nearby thrift stores you can find old table linens with Alaskan motifs—huskies, oil rigs, Eskimos—and old postcards of Alaskan landscapes and photographs of Juneau cannery crews and of log camps, scribbled with messages to the family back in Clackamas.

The winter weather in this part of Oregon is gray and drizzly, and the light is flat and filtered through a low ceiling of clouds. Occasionally, the clouds bust up, and it will rain in spats—you can be driving around and the rain will pour on your car but not on the car behind you. The most monumental thing in Clackamas County is Mount Hood, a mostly dormant volcano, which is 11,235 feet high and is snow-covered year-round. Mount Hood has several active, constantly creeping glaciers. Otherwise, the only ice regularly found in the county is the skating rink at the mall.

Clackamas Town Center is a giant mall, the largest collection of retail stores in the state of Oregon; the space it encloses, more than a million square feet, is so much bigger than any other enclosed space nearby that when the mall opened, in 1981, it provoked a little local hysteria. Rumors went around the county that a band of hippies or Satanists was kidnapping children and taking them into the mall rest rooms and either castrating them or cutting off their hair, then painting their faces and letting them go. Psychologists later attributed the rumors to the unease of people who were accustomed to being isolated and outdoors, as they always had been in this part of Oregon, suddenly making regular visits to a place that was crowded and contained.

There is very little irony in the name Clackamas Town Center. Anything that goes on around here goes on at the mall. There are stores, of course, and also conference rooms where community groups like Alcoholics Anonymous and the Egg Artists of Oregon meet. And there is the skating rink, which the developers put in to satisfy local requirements for recreational facilities. In 1988, the developers proposed replacing the rink with a carousel, but at the public hearing on the matter, Tonya, who was only seventeen but already

a nationally ranked skater, made a compelling plea to save it. The rink is Olympic-size, with big bleachers along one side. On the lower level of the mall, behind the bleachers, is a branch of the Clackamas County Library; a sign outside the door says, "YES! THIS REALLY IS A LIBRARY!" On the upper level of the mall, ringing most of the rink, is the food court, which may make this the only place in America where an Olympic contender trains within sight of the Steak Escape, Let's Talk Turkey, Hot Dog on a Stick, and Chick-fil-A.

On the morning of the meeting, Elaine Stamm, the president of the club, watched Tonya practice for an hour or so. That morning, when Tonya first came out on the ice, she was carrying a video camera to film the film crews who were in a press corral near the door to the skate shop. "Wasn't that cute?" Elaine said, on her way to the meeting room. "Wasn't that brave?" She was setting out boxes of flyers and tapes and Tonya buttons when someone quietly took her aside to say there was a problem: Somebody else needed to use the room. This was not a development as bad as, say, Jeff's guilty plea would eventually be, but it eroded morale. The club liked the idea of doing its work in the very spot where Tonya had developed into an Olympic contender. Nancy Welfelt, one of the members, suggested reconvening at her house, so the members got their coats, and fanned out through the parking lot to their cars, and formed a small convoy to the Welfelts'.

They drove up Eighty-second Avenue, past the Lovelier You Beauty Salon and the Beavers Inn and the Moneyman and the Junk-a-Rama, and then turned east, past Lincoln Willamette Funeral Directors, which had a digital sign flashing the time, the temperature, and then the message COMPARE! COMPLETE CHAPEL SERVICE WITH CASKET $1,997. A few blocks west of Eighty-second Avenue, on the edge of Multnomah County, is the neighborhood known as Lents. This is one of the places Tonya lived when she was growing up, and it's also not far from where Gary Gilmore lived for a time. Lents was settled first by farmers and then, in the 1930s and '40s, by shipyard and sheet-metal workers; today it consists of narrow, pitted roads that peter out into gravel alleys, with houses so tiny that some look as if they had been built for dolls or chickens, or were really meant to be one-car garages. In the neighborhood nearer the mall, where Tonya lives now, the houses are scant, speckling open acreage that used to be farms and woodlots. In Lents, everything is shoved together; nearly every house is on a parcel the size of a napkin, hemmed with a high chain-link fence, and in the yard there is usually a motor home and a dog kennel, and a toolshed, and maybe a car chassis that someone has lost interest in fixing. Every block or so, squeezed between the houses, there is a church: New Testament Church of God and Christ, "Preaching a Living Christ to a Lost and Dying World"; the Church of Christ; the Bethel German Assembly of God.

The Welfelts' house is east of Eighty-second Avenue, in the Mount Scott neighborhood, which is on the steep side of Mount Scott, a small extinct

volcano. On this side of Eighty-second Avenue, the houses thin out and are newer and nicer, with bright aluminum siding, and carports, and picture windows, and decorative screen doors. The convoy stopped at Nancy's driveway, and the club members lugged in the boxes of flyers and buttons and bumper stickers, and then pulled chairs up to the dining table. Along with Elaine, a former charm-school teacher, who has frosted hair and narrow, square shoulders and a striking imperial posture, and Nancy Welfelt, who has a cheery face and fading blondish hair, there were four other middle-aged women, and the husband of one of them: a jittery guy with wire-rimmed glasses. He never sat down at the dining table and never even took off his coat, and then suddenly left during the meeting to go visit his parents' graves at the cemetery across the street. Someone complimented Nancy on the view from her living-room window, and she said, "You want to see something? See out there? You can see Shawn's house. Shawn, the bodyguard. He lives behind me, with his parents." Everyone crowded to the window and looked in the direction Nancy was pointing, across the side of the hill and over the tops of some houses wrapped in fog.

One of the other women said, "Have you ever seen Tonya's mother's trailer? It's just up the road here, and it is meticulous. It is lovely. It is tidy. You would never even know it's a trailer."

"Trailer trash is what they call people out here," another woman said to me. She sat down and started tapping on the table with her fingernails. They were long and burgundy-colored, and each one had a different small image painted on it—a shooting star, a sun, a lightning bolt. She said, "There are plenty of people who think we're scum because we live out here on the east side. Well, I live in a very non-scum neighborhood. It's actually a so-called good neighborhood, but it's always going to be thought of as trash, because it's east side." She tapped. Her fingernails clicked: lightning bolt, star, sun.

"I wouldn't say trash," Elaine said. "I would say . . . I would say . . ." She paused. "Well, my heart just went out to Tonya when I first saw her skate. I just see that little gal out there, the abused child spanked by her mother with a hairbrush, and when they would do the up-close-and-personals for the Olympic skaters, they showed Tonya in her jeans at her little house fixing her car, and I could just feel her sink. When I started the club, the people I heard from were women with abusive husbands, and Vietnam vets who had come home and felt displaced, and they'd see that little gal and feel really good about themselves. So it's funny that people would think of her as trash."

"Scum," the nail woman snapped. "That's what they call us. It's a class difference—that's what all this mess is about Tonya. She's just a regular Clackamas County girl. In my opinion, she's a modern gal, what we would call a tomboy. She can hunt, she can fix a car. She calls herself the Charles Barkley of figure skating, and she's right. She's a stud."

Another one of the women said, "I'll tell you, you know who I cannot stand is that Kristi Yamaguchi." Everyone groaned. She rolled her eyes, and went on, "She is just so prissy. Tonya is so tough. She *is* a stud! She really is!"

The nail woman said, "You know, there are a lot of us who look at Tonya and think to ourselves, There's a gal who pulled herself up, who had some tough times with her folks, and whatever, and she still did great by her dreams. I know what it's like to have dreams and to perform. When I was a kid, I was a performer. I was on that radio show *Stars of Tomorrow*, and I got tons of trophies for my singing."

Nancy said, "You were a singer? You sang?"

"All the time—oh, yeah, all the time," she said. "I had just tons of trophies. I don't have them anymore. My dad threw them all out."

Elaine said, "Why did he do that?"

"Well," the woman said, shrugging and tapping, "we just don't get along."

Tanya Utberg, the Clackamas County Fair and Rodeo Queen, said to me recently, "I think Clackamas County is a very warmy place," which makes it sound soothing and regular, but often it seems to be a more haphazard and disjointed place than that. The day I talked to the Rodeo Queen, I drove out to the neighborhood where Tonya Harding and Jeff Gillooly used to live, and where Tonya still lives. Her house is in a part of Clackamas County called Beavercreek. Beavercreek isn't shown on any street map—it's just an area, not far from a small city called Happy Valley, which is where Tonya's mother is currently living. Tonya's road in Beavercreek is a skinny rib that runs along a foothill, past a spread of newish one-story houses. Tonya's house, an A-frame chalet, is at the end of a long driveway and is not visible from the road. At the end of her driveway were a white farm gate, a big homemade heart-shaped sign left by some fans, and several No Trespassing notices. A few miles farther along the road, not far from the Savage Mini-Mall, I stopped at a new housing development, and the real estate broker gave me a tour of one of the houses. When it is finished, the development will be called Sunset Springs Estates. The broker didn't know what had been on the property before it was subdivided, but a few scraggly fruit trees out back provided a hint. In bright weather, the Sunset Springs houses will have a distant view of the wolf-fang shape of Mount Hood and a close view of a new development called McBride Estates, and of a woeful old farm undoubtedly in line to have the earth turned up under it so someone can sow some more houses. The broker said, "Sunset Springs Estates are going to be real lovely places when they're done." Then he gazed out the window and said, "It is sort of funny around here. Everything is such a big mix-match. You have one kind of thing right next to another kind of thing, like lots of money beside poor.

That's what I call a real mix-match. Things don't always fit together as well as they should."

Tuesday and Thursday are Cheapskate Nights at the skating rink—for four dollars, you can rent skates and skate for two hours. A big banner advertising Cheapskate Nights hangs above the ice, next to one, paid for by the fan club, that says HOME OF TONYA HARDING—U.S. FIGURE SKATING CHAMPION. Saturday evening isn't for cheapskates, but it's the busiest night. On the Saturday after the fan club meeting, the ice was packed. You can watch the rink from the mall's upper level, standing between a kiosk with a public-service poster that says SUPPORT THE U.S. OLYMPIC TEAM: GO SHOPPING and a small business called All About Names, which is set up on a rolling cart. For a couple of dollars, you can get printed on a number of different items, such as beer steins and key chains, or on a piece of fancy paper, a little legend about almost any name. I asked the woman working at the cart to do the name Tonya on pink paper with a drawing of a fairy castle, and she said, "Tonya? Ton-ya? *Tonya?* I've never heard of that before. What a nice, interesting name." That morning's *Oregonian* had had a story about Nancy Kerrigan on the front page for the seventeenth day in a row. The woman at the cart punched some buttons on a computer, and after a moment the paper came out. It said that "Tonya" was Latin for "priceless," and that a Tonya was "a liberated spirit" who "has never settled down to anyone thing . . . is attractive, lively, and tasteful . . . sets high expectations and fulfills them." Down below, kids were whizzing around showing off, or inching along the edge of the ice, clinging to one another in wobbly packs. A lot of the girls looked like Tonya, with long multilevel blond hair and a puff of bangs, eyes rimmed in black liner, and stocky bodies in inexpensive-looking clothes. In the center of the ice, a few skinny girls in Lycra skating dresses were practicing spins. Until recently, Tonya sometimes practiced during open-skate hour, picking her way through the crowd. Now she skates only very late at night, but for a long time she usually practiced in the mornings, when the ice was empty but the bleachers were filled with people eating tacos and gyros and Dilly Deli sandwiches and looking on.

Around here, kids go to the movies, or they drive up and down Eighty-second Avenue, or they hang out at the mall. If they work at it they can get into trouble. A juvenile court counselor named Steve Houseworth told me that in the last two years, kids in the county, like kids in counties all over the country, have become increasingly hedonistic, defiant, and angry, and that juvenile arrests have boomed. "Our big problem is with antisocial preplanned deviant behavior," he said. "We've got an explosion of anger, intimidation, and aggression issues. I think we'll see more of it, too, because the county is growing real hard and real fast." The county, he went on, is trying out a privately run anger-management program called Temper Talk, which

offers counseling to juveniles charged with Assault 3 or Assault 4—causing harm to a person without intent or with intent, respectively.

The program director for Temper Talk, Derek Bliss, told me, "Kids here are looking for power and they want control. They're angry about dominance. They want to show the image and reputation of dominance." I asked him whether he recognized the likes of Shawn and Jeff and of Shane Stant, the twenty-two-year-old man who had been paid to attack Nancy Kerrigan. "Definitely," he said. "These are the kind of guys who lose their temper but don't know how to *use* their temper. Shane, the one who confessed to actually doing the assault—he's a very big boy. He's not behind physically for his age-group, but he's clearly behind empathetically. I'd bet there was a humongous amount of inconsiderate behavior in their lives before this assault."

On Saturday night, I talked with two young guys, D.J. Dollar Bill and D.J. Fast Eddie, who were standing on a platform beside the skate rental booth, playing tapes over the loudspeakers and calling out for the kids to reverse directions, and then to speed up, and then to get ready to line up for games. Dollar Bill said he was a delivery driver for an auto supply company. Fast Eddie said he worked in the produce section of a grocery store. Fast Eddie also said he could not comment on Tonya. "What I'm about is right here," he said, motioning to the ice, "and here is fun." He put on a Snoop Doggy Dogg song and then said, "We're going to play some great games later. We just finished a big one. It's the favorite around here. We break up into teams and compete in four events—the ringtoss, ice basketball, ice golf, and a finale, which is a snowball race with a snowball on your head. We call it 'The Olympic Ménage à Trois.'"

Celebration New Song Four-Square Church, a Pentecostal congregation, meets every Sunday in a room at the Holiday Inn in Gresham, a town just north of the Clackamas County line. The pastor of the church, Eugene Saunders, hadn't been seen in three weeks—that is, since shortly after the night that he was doing homework with Shawn Eckardt, the heavyset baby-faced bodyguard and self-described foreign espionage operative, who was a classmate of Gene's in a legal-assistant training program at Pioneer Pacific College. That night, Shawn had bragged to Gene that he was involved in setting up an attack on a figure skater, and played a garbled tape of a planning session for him. It was that conversation—which Gene repeated first to a Pioneer Pacific teacher, a private investigator (who repeated it to the Portland *Oregonian*), and then to the authorities—that broke the case open. The publicity that followed was so overwhelming and relentless that Gene decided to go underground.

On Sunday, I went to church, and Reverend Saunders reappeared. In the newspaper box outside the Holiday Inn, the headlines were still all about Tonya. Inside, nineteen people were gathered in a meeting room, among

them a weary-looking older couple with a strange, thin, shrill-voiced boy; a young woman with two restless redhaired children; a man with stringy blond hair that hung to his shoulder blades, sitting with a pretty woman who wore her hair in cornrows, and was the only black person I saw the whole time I was in Clackamas County; a ruddy-faced man with pinkish eyelids and full lips, wearing a worn-out chambray work shirt and holding in his lap a Bible and a Bible study guide; a man, maybe around seventy, with greased-back black hair and thick glasses, wearing a plastic windbreaker and a short striped necktie. In the front of the small room, a big, bearded man holding a zebra-striped electric guitar began strumming and singing in a tender voice. Everyone rose, scraping back tan metal folding chairs. Someone turned on an overhead projector, and a handwritten lyric sheet flashed in a crooked rectangle across the wall and ceiling, and then the congregation sang. The room was new and drab; the floor felt hollow. Outside, it was pouring. The motel was so new that there was no lawn yet, or even mulch—only mud and construction equipment, and fresh sidewalks, which looked silvery in the rain. After one of the songs, the man with the greased-back hair stepped forward and began a rhythmic declaration from the back of his throat. He was speaking in tongues, and he went on for several minutes, shouting and sweating and slapping his thighs. Finally, he paused, wiped his brow, and then translated what he had to say—that Jesus was coming, that Jesus was watching, that anyone who followed Jesus and resisted Satan would never go astray.

When he finished, Gene Saunders came to the front of the room. He is a handsome, fleshy young man with small, crowded features; he was wearing a dress shirt and suspenders, and holding an open can of Mountain Dew. He said, "I know you've been wondering a lot of things—some of you have known where I've been, but mostly you've known that I just needed to take a break from the publicity. We got calls from around the world. We got calls from Japan about this. I want to tell you folks a few things. First of all, you know that I am not Shawn's pastor. I think some of you read something saying that he was with us—that I was his pastor—and you were thinking, Hey, we don't know this guy. Well, we were classmates in school. I'm not his pastor." He chuckled. "I suppose he could use one now." People nodded, and bumped one another with their elbows. "Also, I want you to know I never changed my story. I always said I couldn't understand the tape. It was a garbled tape. It started getting into press reports that I could understand the tape, and then at the grand jury hearing I testified that I couldn't, and everyone is asking me why I changed my story. I didn't. It was misrepresented that way."

Someone called out, "That was Satan working! That's how the enemy works—confusing us with things we didn't say!" Gene nodded, and sipped from the can. He strolled around the front of the room. "It's been tough for

me, because I've had to neglect you and the church business during all of this, and I've had to make choices. I shouldn't say this in front of our treasurer, but I was offered fifty thousand dollars to tell my story to a television show, and I turned it down." From the back of the room, someone said, "Reverend, we could sure have used that money!" and everyone laughed. Gene said, "Well, I turned everything down. We'll just have to keep fundraising for ourselves. But, you know, that was real temptation."

"Why did they do it, Reverend?"

He looked down, kicking lightly at the carpeting. "Bitterness, I think. Bitterness that things weren't going their way."

The ruddy-faced man flipped his study guide open to Luke 14. "All the answers are right here," he whispered to me. He ran a fingernail across the page, to where it said, "Wanting a new car or hoping to be successful in your career is not wrong in itself—it is wrong only when you want these things just to impress others." He closed the book and then closed his eyes.

Gene finished speaking and shook everyone's hand, and said he would be back every Sunday unless things got too distracting again.

ED GOLDBERG

Born in the Bronx, Ed Goldberg (1943–) moved to Portland in 1991 after eighteen years in Washington, D.C. Served Cold *(1994), his first novel, won the 1995 Shamus Award for best original paperback fiction. As Alan Gold, he is the author of* True Crime *(2005) and* True Faith *(forthcoming). Goldberg works at two radio stations,* KBOO, *where he reviews movies, conducts author interviews, and does political commentary, and* KBPS-FM, *where he is a* DJ. *An early devotee of potboilers and science-fiction pulps, Goldberg is an avid fan of local microbrews and Triple-A baseball. This excerpt from* Dead Air *(1998) features detective Lenny Schneider, who confronts a murderer at a Portland radio station.*

From *Dead Air*

As we hit the road, Walter said, "It's too bad that it's overcast today. Usually there's a good view of Mount Hood from here, and Saint Helen's just as we get on the freeway."

"I wonder why highways are called 'freeways' here, and expressways and parkways back east?"

"Don't forget thruways. I don't know. On the parkways in New York you're stopped as much as you move. Maybe a parkway is a highway you park on."

Our conversation went on in this witty way as we headed into town on

Route 84. We passed an exit marked 43rd avenue, and Walter indicated that this was his normal exit, but that he needed to go to the radio station, and he thought that I might like to see it. I agreed. I'm a sucker for radio, having grown up listening to the last vestiges of network radio before it was done in by TV, and became the brainless, gutless aural wallpaper most Americans listen to.

After we got off the freeway, we drove around through city streets. My first impression of Portland was that it was like a city in Jersey. But the hills looming on the west side over a downtown skyline were like nothing I recalled back east. Pittsburgh, maybe.

We headed down Burnside Street. Walter spoke with an apologetic tone in his voice. "Uh, I'm sorry you have to see all these street people. There are a couple of missions in the area and . . ."

I held up a hand to stop him. "I guess you haven't been back to The Apple for a while. The place is getting like Calcutta, or someplace, where entire families live out their lives in cardboard boxes on the streets. This place seems relatively free of homeless people."

"There are more than you might think, but I guess it's worse in New York. Of course, a few more years of Republicans running things, and we might make Calcutta look like Palm Springs."

I grunted agreement.

We pulled up to a parking place, only to find a guy down on his hands and knees in the street. He was inspecting the asphalt minutely. We waited, as he was blocking access to the spot.

"He must've dropped a contact lens, or something," Walter mused. I squinted over the hood of the van.

"I don't know about that. He's wearing glasses. What's he got in his hand? It looks like, I don't know, road debris."

We watched for a second. He was picking up stuff off the street: matches, twigs, paper, cigarette butts. And he seemed to be collecting it. Walter lightly honked his horn. The guy glowered at us, and picked trash more quickly. After another few seconds, Walter cranked down his window and bellowed, "Get out of the street, you goddamn nut!"

Another vicious look from the guy. Then he bent over and began sucking water from little puddles on the street.

At the same time, Walter and I uttered, "What the fuck?" Then Walter said, "Welcome to Portland."

"I take it that this is standard behavior here?"

Walter cogitated before answering. "No, but the nutcases here have a peculiar inspired quality that I've never seen anywhere else." Here Walter tapped his horn lightly, and the Street Sucker finally relinquished his watering hole, albeit resentfully. We pulled in. "New York certainly has more than its share of loonies, and the protest crowd in front of the White House in

D.C. includes some of the most seriously pixilated individuals I've ever seen, but Portland . . . well, let's just say that the eccentricity here is equal to a much larger city in percentages, and is often far greater in creativity."

I was intrigued. "You'll have to tell me sometime, over some of your excellent beer."

"Done deal!"

We walked around the corner. The radio station was on the east side, not far, Walter said, from his house. A squat building with antennas and a satellite dish on the roof, the station was in a light industrial area featuring a rooms-by-the-hour motel and a collection of sorry-looking hookers who occasionally strolled by. Unlike their counterparts in New York, there was no flashy fake fur and spangled minidresses. Strictly jeans and down jackets. Very homey: Screw the girl next door. The only high heels I saw were on a pair of cowboy boots. The station's call letters were KOOK-FM, in chipped and faded paint on the front of the building next to the door.

The station lobby was crowded with people moving in a random fashion. The receptionist looked like the guitarist in a London punk band, circa 1978. Candy-cane red hair was arranged in a kind of rooster cut, with shaved sides. He had six earrings in his right ear, all silver hoops, and what looked like a severed finger dangling from his left ear. He had a stud *and* a hoop in his nose, and a stud piercing his lower lip. His beat-up black motorcycle jacket covered a torn Ramones T-shirt. He was busily engaged in a vain attempt to keep up with ringing phones, and growing increasingly snappish with each new caller. His lip stud clattered against the mouthpiece in a staccato accompaniment to his snarls. All the lights on the phone were lit up. We walked past him apparently without his taking any notice of us.

Then he raised a hand. "Hey!" he challenged. "Where are you goin'?"

Walter made a sour face. "Back to see the station manager. That okay with you? Hmmm?"

"You gotta sign in." He gestured to a clipboard. Then said into the phone, "I gotta call you back. Some old dudes are tryin' to sneak in." He hung up the phone, which immediately began to ring as soon as the line was free.

"Sign in," he demanded.

Walter leaned over the desk. "Listen, I've been at this station since before you got your brain pierced. Since when do we sign in?"

"Hey, pop, you got a problem with this, you can hit the street. They tell me to get signatures, I get signatures."

"Well," Walter replied unctuously, "it's nice that you do your job. America would be better off if more young people were as conscientious as you."

He signed "John Dillinger" with a flourish. I followed with "George Sand." The kid looked at the clipboard and nodded.

"Okay, that wasn't so tough, was it, pop?"

"Mr. Dillinger, to you."

"Yeah, whatever."

So much for security.

The interior of the lobby was dominated by a bulletin board of enormous size displaying everything from station manager and committee reports, to personal messages, to flyers for various events like concerts and benefits and protests, to angry letters directed at one program or another, or just ranting about how the station had failed this or that cause or community. The rug looked as if mud wrestlers had practiced on it, and the paint job was old and dingy.

All in all, a typical left-wing, listener-sponsored, community radio station. Not much different from a similar one in New York.

I followed Walter around a series of turns which led to a suite of small and squalid offices. Along with bunches of stapled, taped, and glued items, one door had a sign reading STATION MANAGER, under which someone had penciled an obscene suggestion. Walter knocked.

"Come in," said a muffled voice.

We entered a magnificently cluttered office, in which no horizontal surface including the floor was free of rubble, mostly paper and books, with some records, cassettes, and CDs distributed haphazardly. Sue thinks my apartment looks like a rummage sale in hell; she should see this place.

Walter gestured toward the thin, nervous man sitting at the desk. He looked like Don Knotts, only not quite so rugged or relaxed.

"Lenny, this is Slim Reed, our station manager."

Reed arose and extended his hand. His greasy and unraveling sweater couldn't cover the flayed, red skin on his forearm from recently scratched nervous eczema. I hesitated before shaking his pale hand, worried that bits of flesh would drop from his fingernails. Then I noticed that his fingernails had been bitten to the quick, so I took his cold hand. It was as limp as a nervous bridegroom.

"Good to meet you," he said in a quavery voice. "Walter told me that you and he are old friends from the sixties."

I looked at Walter, who had his trademark smirk working.

"Yeah, good to meet you, too. Walter and I go back to before we were hippies." I wasn't sure what else to say to this guy, and an awkward silence ensued. Walter stepped in and took over.

"So, Slim, anything new and horrible lately? What's with the sign-in sheet?"

Reed suddenly developed a tic in his left eye that twisted his whole face out of shape. "Somebody got attacked here last night."

Walter's eyebrows shot up. "What do you mean, 'attacked'? I came by here about nine to pick up my mail. Nothing was wrong then."

"We had a programming committee meeting last night. Broke up around ten-thirty. You know how it is, people straggling out the door, talking on the

street, hanging out. I left about ten minutes later. Well, finally it was down to about three people, Carl Gibbon and two pals of his."

Walter looked over at me and made a face. He turned and spoke to Reed. "So, did Gibbon attack someone?"

Reed shook his head. "Just the opposite. Someone popped out of the alley by the motel and took a swipe at Carl as he walked by. Cut him on the arm."

I was trying not to listen, but this was too good to ignore. Reed noticed my interest and said to Walter, "Maybe we should talk about this another time."

"One more thing," Walter asked, "did anyone see who did it?"

Reed shook his head, and scratched his forearm. "Nope. It was dark, Carl was in shock, I guess, and the guy, or whoever, was down the alley and gone by the time the other two got there."

Walter leaned in to speak quietly to Reed. "You know, I saw Augie Stabile's van parked around the corner when I got here."

Reed actually broke out in a sweat. "Aw, jeez. Don't tell me that. He's capable of anything."

"Yeah, well it is too bad about Gibbon. He hurt much?"

Reed shook his head. "Nope. Got a few stitches, but he's lucky, all in all."

"Yeah, too bad." Walter seemed oddly insincere. "Anything else?"

Reed gave a kind of spastic shrug. "Only if you want to read B.B.'s newest love letter. Actually, you figure quite prominently in it." He half-turned and began excavating the jetsam on his desk. "Aha!" he said, and pulled out a sheet of paper with thumb and forefinger, which dislodged several other items that promptly fell behind the desk. Reed gave them no notice.

"Here," he said to Walter, "you're welcome to xerox it for your files. It's the usual."

Walter took it and held it so that he and I could read it together. It was two pages of single-spaced typing, beginning with, "Dear Jack-Off Cretins . . ."

"Something tells me," I said to Walter, "that this will more than supply your maximum daily requirement of venom."

"Oh," he said airily, "I didn't know assholes oozed venom."

He read the letter, giving us the odd passage aloud.

"Blah, blah . . . can't hear anything but angry dykes anymore . . . discrimination against straight white males . . . violations of Oregon Law Number so-and-so, against your charter, violations of your own bylaws . . . censorship of views not approved by your Board of Fascist Directors . . .

"Ah, here's the good part: 'But these other morons are nothing compared to Walter Cocksucker Egon, whose father-in-law is a corrupt FBI storm trooper, and is probably a plant sent by the ghost of J. Edgar Hoover to destroy dissent in the Northwest and kill the institution of free radio.'"

Reed laughed a nasal little chuckle. "I told you," he said. "It gets even bet-

ter on the second page. He thinks you're the Antichrist, or something."

"He certainly has a way with words," I interjected. "Can you sue the guy?"

"I suppose so," Walter said after a couple of seconds, "but I'm not sure I could collect anything. Besides, it's attention that he craves. A lawsuit would give him a permanent erection. Nah, I'm just gonna forget it. I might send a reply, just to piss him off. Besides, there are worse than him."

Reed reached out for the letter. "I'm gonna post it on the bulletin board. I'll xerox it and put the copy in your mailbox."

Walter nodded. "Yeah, okay. Put it in an envelope with my name on it, just to avoid confusion. Things have a way of going astray here."

We took our leave of the station manager and wound our way back to the lobby, and its milling crowd. Just as I turned to say something to Walter, a microphone nearly got shoved up my nose. The mike was held by a long, porky, tattooed arm, which was attached to a body of excessive height and corpulence. As I followed the course of the body to the head, I was faced with a person of, um, *unusual* appearance. Her hair was in dreadlocks, each braid dyed a different unnatural color. The eyes, as malevolent as a starved rottweiler's, were sunk into fleshy cheeks, and the open mouth revealed uneven teeth, where there weren't gaps or decayed stumps. I was so astonished, it took me a second to realize that this person was talking to me.

I stammered, "Wha—what? Did you say something?"

"Yeah," she responded in an asthmatic wheeze, "I asked you if you think that PMS is a valid murder defense."

My higher centers finally caught up with my animal brain. "Not alone. I certainly think that PMS should be considered as an extenuating factor, if a woman is provoked enough to commit murder. But just to use it as . . ."

She made a disgusted sound and pulled away before I could finish my thought. "Hey," I asked, as she moved her vast bulk in another direction, "what's this for?"

Annoyed, she yelled over her shoulder, "I'm doin' a program on myths about menstruation."

"Oh, sort of a period piece."

She stopped, looked me over, and flipped me the bird. Then she was sticking the mike in some other poor schmuck's face.

I turned back to Walter, who looked like he was going to bust a gut laughing. "Let's get outta here, before I *plotz*."

We walked out. There was a fine mist falling. Several grunge types were hanging out in front of the building smoking cigarettes. One raised his hand in greeting to Walter, who returned a wave. Then he burst out laughing.

Between whoops, he made several attempts to start a sentence, but to no avail. Finally, he calmed down enough to talk.

"Congratulations, you've been ambushed by Bella Durke."

"Vastly amusing, I'm sure. What's *her* story?"

Walter shook his head and emitted another chuckle. "Bella is an old-timer at the station. She's even held one of the few paying jobs at this place. Basically, she's a professional lesbian. Very active politically, a real presence in the gay and lesbian community. But also a man-disdainer, if not a man-hater. Some say she treats everyone with equal contempt, but I don't think so. My take is that she has a hierarchy of values, and that straight white males rank just above septic tanks, but below rabid hyenas.

"The interesting thing about her is that she's a quirky, surprisingly good interviewer. She keeps everyone a bit off balance with her snide aggressiveness. Sometimes it works perfectly with certain subjects.

"But she's also a hypocrite. She's come on to just about every woman in the place, at one time or another. If she were a man, her considerable ass would have been banned from the station long ago." He shrugged. "Just one of our little double standards here at KOOK." He pronounced it like it was spelled, rather than as letters. It seemed fitting.

"That letter the station manager showed us?" I inquired.

"Yeah, the one from B.B. Wolfe. What about it?"

"The guy explicitly said that the place was run by a cabal of lesbians. Any truth to that?"

He made a face and waved a hand dismissively. "B.B. sees conspiracies everywhere. This month it's lesbians. Next month it'll be the logging industry that runs the station. Or the Rosicrucians. Or the Elders of Zion. He's just fulla shit. He's a big fish in a little pond, the number-one conspiracy nut in town, with a gaggle of followers ranging from serious paranoids to people who put aluminum foil under their hats to keep the Martian lizards from reading their thoughts. He's mostly harmless, but he's got a big mouth, and a jones for the station."

I nodded. "Did I hear you say that there were worse than him?"

"Worse than him? Shit, yeah! There are some fourteen-karat twistos out there. People who are beyond the counterculture malcontents our audience mostly comprises. This Gibbons guy who got cut last night? Biggest hypocrite I ever met. Claims to be a fervent proletarian, a friend of the underdog. The minute he got elected to the board of directors, he started voting himself privileges. You know, it's like Orwell said, 'We're all equal, but some of us are more equal than others.'" He made a retching noise. "When I said it was too bad he got cut, I meant it was too bad it wasn't his throat."

I winced. "Wait a minute, isn't that a bit harsh? Aren't there a lot of people who are sincerely interested in making progressive changes in—"

He waved a hand dismissively. "How can you still be so naive? The only thing the sixties taught me is that change is not possible, except in the short run. Where're all the goddamn improvements that we made? Nixon killed 'em, or Reagan. They made racism acceptable again. They stole from the

working class and the poor to give tax cuts to their fuckin' fat-cat friends, they—"

"Whoa! Enough. Let's go get a beer and something to eat."

Walter puffed out his cheeks and expelled breath slowly. The pink of his cheeks started to fade.

"Good idea," he agreed. "Do you need to go to the house first?"

"Nah. Let's just get some food and a beer."

"What do you want?"

"Surprise me. It's your neighborhood."

As we headed for the car, I could see a lot of myself in Walter. Maybe a lot of what I used to be, and especially what I could have become.

I wanted the world to be better, with an end to racism and poverty, and useless wars. I still do. Somewhere along the line I decided that things went in cycles, and that the only bit of received wisdom that I found to be true was: And this too shall pass.

More than one of my friends from the sixties considered this a cop-out. I kind of hoped it was "perspective."

We cruised up Hawthorne Boulevard. Walter, silent for most of the time since we left the station, asked, "Do you just want a beer, or do you need some food, too?"

"Food, please. The stuff they serve on the plane is probably designed to stay down during landings, rather than for taste or nutrition."

"Well, the reason I ask is that I could take you to a good Thai place with no draft beer, or a place with several draft beers but mediocre food."

I considered briefly. "Let's go for the Thai food."

As we drove along Hawthorne, I saw more and more young people in various forms of antisocial dress and attitude: grungers, punks, hippies, bikers. The stores began to change, too, from more light-industrial and standard stores to used record shops, used clothing shops, bookstores, and the ubiquitous coffee shops. Finally, I saw a sign for Thanh Thao, catty-corner from what could only be a head shop called the Third Eye. A head shop!

Walter pulled over to the curb, and we got out. "It's a good time to get here," he allowed, "because there'll be a line out the door in a couple hours."

The place consisted of a bunch of mismatched booths and tables in Formica. Ambience was at a minimum. Walter suggested the salted squid and eggplant in garlic sauce. I ordered a Singha, since the selection was in bottles, and all stuff I'd had before . . .

The conversation was getting old, so I changed the subject, indulging my curiosity.

"Answer me something. What's going on at the radio station? Is violence common there?"

I could see Walter's mental gears grinding. He sighed.

"No, not the physical kind. However, this incident is not the first in the so-called community."

"What do you mean, 'community'? Portland?"

He shook his head. "No, no, I mean the people who work, volunteer, or hang out at the station. Plus the active listeners, I guess. The KOOK Community."

"What else has happened?"

"Are you sure you want to know?"

I spread my palms. "I'm curious, and if it keeps you from tripping out on our mutual ex, it's cool with me."

He nodded. "Point taken. There have been at least two other incidents that I know of, although neither involved serious attempts at hurting people. And Stabile was somehow in on both of them.

"I got this secondhand, of course."

Before he could elaborate, the food arrived, carried by a tiny woman who was almost invisible under and behind the plates. It was not first-rate by New York standards, but it was certainly delicious, and I'm too much of a parochial food snob. The salted squid turned out to be fried in a tempura-like batter and not at all salty, and the eggplant was cooked in a thick, sweet-hot sauce. The cold Thai beer went down perfectly.

"Now," said Walter, "let's go get us a beer."

We drove back down Hawthorne until we got to a place called the Barley Mill. Walter said, "This is as good a place as any to start. I'm pretty sure it was the first brew-pub in Portland, or nearly. And the people that run it have several now, including movie theaters that serve beer and pizza, and only charge a buck for admission."

The place was festooned with Grateful Dead posters, posters for other bands, and the usual assortment of dreck found on barroom walls these days. We bellied up to the bar.

"What should I have?" I asked. The beers had names that didn't tell me much about them.

"What do you feel like?"

I shrugged. "I need to relax and get some sleep before tomorrow. Maybe a stout?"

Walter waved down the bartender. "Two pints of Terminator, please."

"Terminator? Sounds lethal."

He laughed. "Not really. But it's quite respectable stout."

The stout was more than respectable. Dark brown and rich, but not like Guinness. Less bitter. We traded war stories from the sixties. Even the bartender had to laugh at some of them.

KATHERINE DUNN

Born in Kansas, Katherine Dunn (1945–) attended high school in Tigard, Oregon, and Reed College in Portland. She is the author of many works of fiction, including Attic *(1970) and* Why Do Men Have Nipples? And Other Low-Life Answers to Real Questions *(1992). Dunn was the recipient of a Rockefeller writing grant, and her novel* Geek Love *(1983) was nominated for the National Book Award. She is a contributing editor of cyberboxingzone.com. In these excerpts from* Truck *(1971), Dunn portrays Portland youth in downtown Portland and at Fanno Creek.*

From *Truck*

"I'm gonna go to Los Angeles and study hypnotism." He is looking at his feet mostly. The shoes are wet black. His eyes slide toward me and then away. "You hit a bank president over the head and drag him off to your room. Tie him up." His voice doesn't change. It is low and runs on slowly no matter what he says. "When he wakes up you hypnotize him into opening the vault and filling up a suitcase. You can't make him take it or hand it to you but you have him put it on the table. You take it and truck off. Give him a posthyp-notic suggestion that it was a pink bunny rabbit. Also give him a suggestion that he can't be hypnotized again. He tells the police the pink bunny rabbit did it. They come and haul him off. No matter what they do he keeps holler-ing about the pink bunny rabbit. They haul him to the nuthouse and you're driving up the street in a Cadillac with a big seegar." I'm nodding trying not to show how cool all that is. I don't believe it but it's so cool and they all think I'm down here working. Dialing numbers, spieling magazines over the phone for thirty dollars a week and green stamps. He smiled when I told him that. They give you bonus green stamps when you make a sale, and only half a day's school if you have to work. Standing in the rain waiting for a ride into town, and they all running to class and the company folded after two weeks but I never told. Just keep coming into town. Nobody checks when I walk out of the library so easy with the books. I black out the numbers with a felt pen, cut out the flyleaves with the card envelopes glued in. Seventy-five cents for an illustrated *Don Quixote* in good condition. A dollar and a half for *The Great Books: Freud*. The little man in the bookstore doesn't look too care-fully. The dust and the *Illustrated Mechanics* in piles leaning over him. Thirty cents into town. Thirty cents back. Nothing if I hitch. Tell them I'm putting the money in the bank. . . .

He leans on his knees, hands flipping aimlessly to touch his points. "Hong Kong. Hypnotize a whole Chinese family. Tell them they're Easter bunnies. They go around breaking into paper houses with baskets of eggs. They all get arrested and you sail off in their junk. Become a pirate." He's even a little

interested in what he's saying. My guts are jumping with it. But he's going. Going away and I'll be here forever, scraping excitement out of Portland, Oregon, with no one to help and no way out and I'll marry a service station attendant and never see or go or know anything or do anything or ever feel myself all over full of possibility like now because he is so possible and anything is possible now but when he goes it will be high school again and the nothing and the nothing after that in the rain because girls cannot. Even girls who are not, because secretly they are. And will always be trapped and I want to be free. Why couldn't a girl be? Only because of the hole there and there can never be anything else. But maybe not even the hole, maybe nothing, and I could. "When do you think you'll go?" He puts his hands in his pockets and his legs flat out from the bench, lying on the bench and looks in the direction of his feet, being cool, being speculative and acting, always, but a good act and I'm not ashamed to believe even though I want to believe. "I've got a few hundred dollars coming from an insurance policy I'm cashing in. It should come this week or next. I'll get some good clothes. A pearl stickpin. You have to look like you don't need a job to get one. Even in crime you need money to make money. Then go down, scope out the crime scene." I don't know how to say it. He knows it but I have to say it and say it right. The fountain is squirting up and the rain comes down into it. His sweater is heavy with wet. I can't look at him. "I wish I were eighteen. I'd go too. I want to be free, you know? I don't know what from. But I'm not and it'll take a real move of some kind, something desperate to get me out." It's embarrassing. I can't look at him. He just sits. He won't help me. "And it's three years. I don't know if I can make it." I can't do it alone. He won't help me. It's so hopeless. The lovers stroll slowly, not noticing us or the rain, heads together, wet. And we wet sitting close but not touching anywhere. I am very sad and the time seems impossible, gray, too late already for me, because he's going. . . .

"Wish I was eighteen." Just wishing. He doesn't look at me, looks at his shoes. "Why wait?" "What?" "Why wait till you're eighteen?" He wants me to come. I can come. The rest doesn't matter, the why. He only steals from his friends and we are honored and steal for him. Fall. The sun. Walking in the streets electric because I'm with him. The farmers' market open. Humming. The fruit shining gold, red, orange, in numbered piles. The green is golden and not poisonous. The smell, the smell moves with us, ripe. Small scales hanging from the beams and the small men in the shadows in the stalls. He stands looking, head down. I waiting, expecting. "I want a banana." I can barely hear him. He turns and walks away, his feet pointing out, his shoulders hunched. I'm scared. It's pounding, all the people. He is almost at the corner, the bananas have black streaks arcing in the yellow. They lay in bunches on their bellies, fingers curving in bunches. The shopman is weighing tomatoes for the fat lady. Her children are nagging. His face is tired. The

gray circles under his arms and his hands on the scales. Maybe he puts his thumb on the scale. I edge through the crowd. Heydorf is out of sight. The table is pushing against my ribs. I lift my arm and with my whole forearm brush a bunch under my shirt, down from the table and up under the black jersey. My arm against the bananas, holding them against me, push directly out from the table into the crowd, away from the man at the scale. I'm not tall enough for him to see me through the crowd. Push, edge, too short to be seen, into the street so I can move faster, between the cars. I did it. I made it. Running, to the corner and around, down faster. If I miss him he's gone. He's looking in the window of the bakery. I know what he wants. I'm scared again. The bananas aren't enough. It's never enough. The briefcase is on the sidewalk leaning against his leg. It's unzipped. I go to it, crouch and drop the bananas in and then move away, not speaking, not looking at him, toward the entrance of the bakery. I can see him reflected in the window. He bends uninterested, picks up the briefcase and walks away. He'll be in the park. I wait till he's at the cross walk and then go in. There's a girl alone behind the counter. No one else. I take the bill folded into a tight thick square out of my back pocket. Five dollars. Five trips from the library to the secondhand bookshop. She is lifting the cake off the rack. "May I have it in a plain bag instead of a box?" She is careful with the dark cake on its thin cardboard. She doesn't notice me. She doesn't know I should have robbed her but am too chicken shit. I carry the bag flat on my palm. Stop in the next doorway to take off the stapled register slip. Tear the brown bag artfully, jounce the cake a little till cracks show in the frosting, wrap the bag haphazardly around the cake. Into a little grocery for a quart of milk. Ditch the milk bag. Put the carton up under my arm under the shirt. It's cold. Loose shirt, not very obvious. Cross the street, another block, another crossing, the park. He is sitting on the green bench by the water fountain. He expects the cake so he sat by the fountain. He's eating a banana. It's pale in his fingers, peeled, the yellow skin hanging in a crack in the bench. I sit down beside him, put the cake between us. He looks at it, puts the rest of the banana in his mouth and lifts off the brown paper. The cake is cracked raggedly across the middle. "It's broken." I look at my shoes, the toes white thick rubber glued to black canvas. "I had to get it off a rack instead of out of the window, almost dropped it." Take out my jackknife, being careful not to jingle the change or show him the side with the milk carton. He opens it and cuts a square out of the round cake, lifting it on the tips of his fingers. The frosting is thick and soft and his fingers sink in it. He bites and chews. I wait, looking at him. "Yeah, that's pretty good chocolate." He hands the knife to me handle first. I cut a wedge in the cake and lift it out, biting carefully to get the proper balance of cake and frosting. My stomach steadies and my breath is easier. Hold the cake in one hand and pull the milk carton out with the other. Prop it on my knee and open it, offer it to him. "Ah, that's a thought." He is a little surprised

and I'm very pleased with myself. He thinks I stole it all, I hope. But then, he gets cake whether I bought it or stole it. I take the risk, I pay. I'm the sucker. If I bought it I'm just a sucker. If he thinks I stole it then I'm a cool, handy, useful sucker. But I'd rather be his sucker than theirs. He gives me something, the excitement maybe. Not the other, not the touching or the other. He couldn't give that. If he knew I wanted it he wouldn't let me near him. But it's enough for now, since it's all I can get. The sun is warm. The grass is green. The gypsies are walking in the park. We are laying in the grass in front of the keep off sign. He is on his side, one hand holding his head. He picks at his lip with the other. Me on my elbows on my belly, picking clover, chewing it, spitting it out, fingering through the grass for clover. The gypsies take a long time to go past. Sing and play and talk and laugh. We look at them from the corners of our eyes. I want to ask, I know but I want to have it said. "You think I'm pretty dumb, hunh?" I look at him, at his eyes not looking at me. He wipes the tips of his fingers in the folds of his pants, picking at the corduroy. "Yes." The eyes flicker toward me, see how I'm taking it. I still looking. "You don't use the brains you've got." I try to decide whether he wants me to think that's a lot or a little, relieved he's not lying, looking for clover. "You find a guru. He's drunk in an alley, half dead, stinks. Follow him. Feed him. Live with him. Clean his shoes. When you're thoroughly guruized you kill him, so you can go on living." His eyes are open, looking at me. The cold blue chills my guts. Maybe he doesn't let people see them out of kindness. He looks away. "If he ever says he's a guru, he isn't." The gypsies are crossing the street against the light. Satin skirts sway over the asphalt, purple and crimson and scarlet. Only gypsies have those colors. For other people it's red, just red. "Wanta go down to the bus station, watch the old ladies faint in the heat?" Why wait? I'm scared. They'd drag me back and it would be worse after, watching me all the time, everybody mad, questions. Even without that I'm scared. "It's easier for a boy, and you're eighteen." He looks back at me, looks away, shrugs. He doesn't care one way or the other. Ain't his machine. "I'd have to wait till June. School lets out. It's a month and a half." Looking at him I can feel my eyebrows go up, asking. Put 'em down. I know he won't wait. "That'd give me time to get some money." "Yeah, you'll need money. Bus trip to L.A. is twenty-two forty. Need at least a hundred." He's interested now, knows I'm hooked. "I'll leave next week sometime. Write you when I get settled in someplace." His hands flop as he talks. "Need camping gear. Sleeping bag. Take the bus to L.A. I'll meet you. Pull a couple of jobs. Disappear into the hills. Walk into the Baja. Down to the tip. Get a fisherman to take us across to the mainland. Live like a king in Mexico on a hundred bucks a year." My bus pulls up. Jump up. He's picking up the briefcase, going now that I'm leaving. I put my hand out, square, grubby. "Deal?" He takes it, loose, his pale hand covering mine. He nods. Not interested anymore. "Deal." Bus moving in the dark. The rain. Inside the light is blue,

fluorescent, dark around the driver. The people old, tired, lavender in the light, and gray. They scare me. Three of them. Two women in white uniform shoes, man with a lunchbox. Going home. Every night. The same. The work. It makes me sick scared. I think of leaving and it's not scary compared to this. I'm the last one off. It's late. The town dark. Another mile in the rain home. The cars pass. The creek sounds big under the bridge. I'm a little scared of the dark. Nothing in it, just the dark. They're all watching TV. Yell "Hi" and up to shower. Not for the clean, for the warm. Come out cozy in flannel. It's good, the comfort, especially now after the rain. Peanut butter thick, soup, milk. She worries about me. I sit tasting everything, climb into bed with a brainy mystery. The comfort doesn't scare me now I'm leaving . . .

It hurts when I bite my sweatshirt. The hard gritty cotton grinds up through my skull and hurts. It says "PAX" on the back. All the Latin I know. My feet are in Fanno Creek. He leans against the abutment and looks down at the water. His hands push air when they move at all. He calls everybody by their last name. It eliminates intimacy. "Hittner's just like everybody else. He thinks he'll be out of town when he dies and somebody will send him a telegram to let him know." Me too but I nod and push my feet into the water further. The cars hiss above us and the boards in the bridge clunk as they go by. Maybe the bridge will collapse on us. Push us into the mud here. I take my feet out of the water and peer at them in the dark. The rain mists in a little, spraying off the wind. It feels like sweat. His voice is low. It slides under the wind and the cars and the brush scraping on the banks. It pours warm into my ears with creek sounds, soft and thick like breathing through phlegm. I don't have to listen, as though I were thinking the words to myself. "You're all screwed to begin with. They'll all get their diplomas and go to college a little bit. Then they'll join the army and get their asses blown off. If they survive it's nine to five and home to the fence and the kiddies for the rest of their lives. You're even worse. You'll marry the service station attendant at the first Flying A you come to. Never do anything. Never see anything." My eyes are sliding out at the corners. I can feel my face tight in the wind. I know he's right. I hate it. I can't. I can't do that. "What about you?" Keep the voice cool. No irony. No anger. "I'm gonna study law. Become a pirate. It's all a lie that you have to do anything. They just tell you that to keep you quiet. You don't even have to die. You can kill yourself." I can't see his face in the dark. His hands show a little. Pale blobs hanging at his knees. No use looking for his face.

LEE WILLIAMS

Born and raised in Portland, Lee Williams (1969–) graduated from the University of Oregon. His writing is permeated with an acute awareness of place. Portraying the difficult life of runaways living out a music- and drug-inspired life on the streets, his first novel, After Nirvana *(1999), concerns two teenagers surviving in Portland in the years after the death of Kurt Cobain. This bleak story of teen prostitutes Nikki and Davy is true to teenage slang, alternative music, and the gritty aspects of downtown Portland.*

From *After Nirvana*

A few mornings after we got Jody we had just enough to get the acid sheets from Max plus share a couple medium mochas at the Metro on Broadway before me and Branch headed up to the park and before Nikki and Jody headed down to Southeast Eighty-second. Under the COFFEEPEOPLE sign on the counter was a big chunk of cake, black, chocolate, on a plate on a stand, the kid that'd sold us our mochas on a stool, behind the counter, reading but looking up, at us, once in a while. Branch blew off steam over the cup between me and him and said low, "You could get him 'cause he *is* scammin'," and me and Nikki looked at the kid quick but he looked down fast back to his *Oregonian*. Branch said, "That tip glass's fairly full, other side of the counter, Davy. You could be talkin' him up on his side and I could pick out those singles in the glass."

I took a fast drink before the steam came back.

"You were lookin' at him," Branch said, and I shook my head, got my hands around the cup, blew a ring in the coffee and Nikki said, "I didn't catch that."

"I'm checkin' out that cake-chunk," I said. "Big, for all of us, maybe," then Nikki said, "Chocolate, nuts, like breakfast Snickers," and Jody leaned in, said that food in the city costs way too much, said we could get a whole cake—day old—Eleventh and Jefferson Safeway—for the price of that piece and Branch looked at her, said, "Hey, we can get that piece for nothin'," got up, said, "I mean, *I* can," walked over to COFFEEPEOPLE, put his arm up on the counter, leaned against it, started talking to the kid, *Oregonian* going down.

Jody said, "That's slither, isn't it?"

I said to Nikki, "I wasn't scammin'," and Nikki said, "I know, whatever," pushed the rest of her and Jody's mocha in front of Jody, said, "Here," and Jody said, "You've only had one sip," started to push it back but Nikki kept her hand up to the cup—Jody said, "Caring is *sharing*"—Nikki looked back at her hard, said, "So *let* me, bitch," and Jody bit her bottom lip, shook her head, drank the rest. Nikki looked at an open paper's comics page and I

Pioneer Courthouse Square in about April 1995

watched Branch talking and then Jody said she had to pee and right after she got up Nikki pushed the paper over, looked over at Branch, still talking, then looked back at the bathrooms, girls' door just closing, said low, "Knew she had to go, the way she was shaking her leg like she does," pulled something shiny out of her back pocket. Then she got in close on the table and I leaned in too. She opened her hands some and inside was a flat, shiny silver card that said FONECARD in raised letters, someone's name and a bunch of numbers underneath. I said, "Where'd—"

"Me and Jody, yesterday morning, pits and tits, Nordstrom girls' room, Jody was in a stall on the pot and this woman was changing her kid on the baby-table. Davy, she had her wallet out up by some shitty diapers, then left, left them and *it*, forgot the wallet 'cause the baby was cryin' *so* loud." She looked back around and behind—Branch was still talking, Jody was still gone. Nikki said, "No cash, but cards, chucked it all before Jody got out of the stall but I saved this one, this card, it was—"

"Shiny."

"*Yeah*—we could—I could or you maybe—if we ever had to—in case it gets weird here—"

"Weird?"

"For safety, in case it starts getting wrong—"

"Nothin's wrong—"

"Branch—maybe—" she looked around again, said, "You never said if he got weird, with the knife—"

"That wasn't anything—okay?" I said fast. "You weren't there." Over Nikki's head was Jody, out of the bathroom door, brushing her hands on the front of her dress.

"It wasn't anything?"

I looked at her—"Nothing. Total nothing." Over Nikki's shoulder came Branch, chunk of cake on a plate in one hand, piece of paper in his other, Jody coming up behind him. Nikki put her hands flat, pushed the card under into mine but I stopped it and she said low, "Just hold it," and I said low, "It's cool here," and she said low and fast, "Just in case," and I got my whole hand around it, reached back, scratched hard right above my butt, dropped the card in my back pocket. Branch put the plate down in front of me, sat by me, said, "*And* his fuckin' phone number," put the piece of paper down, tapped a finger on it.

Jody got back by Nikki, said, "Then, like, officially, that *was* slither," and Nikki said yeah, put a hand on one of hers.

I picked nuts out of the top of the cake-chunk, said, "You gonna use the number?" to Branch and Branch looked at me, scrunched his eyes and nose, "For what?" He looked over at the kid, up, helping people waiting in front of the counter. "He's got no money, Davy," Branch said. "He's almost just like us." He tagged my arm with a few fingers. "He's got a job, we got a job." He wrinkled up the piece of paper, chucked it under the table, and Nikki said to Jody, "Practice slither's what that was," and Branch got a gulp of my and his mocha, said, yeah, in the cup, and I got a few fingerfuls of cake, then Jody reached in, got some and Nikki reached over, picked and downed my nut-pile.

Later, Nikki and Jody gone to Eighty-second, me and Branch on swings in the park, swinging high, looking at cars coming in, Branch said something while I was up and he was down and I said loud, "What's what?" and he said louder, "I said we need to relax," and I yelled down, "How's that?" and he said, "The City—the club, the City," and I said up, "What's that?" and he said it was a dance-club for anybody—under eighteen, over eighteen—anything—gay, straight, bi, then he said, "It's Friday—you know it's Friday, right?" and I said, "No, I didn't know it was Friday." A line of three cars came in the start of the hill and I slowed swinging, looked at them close and Branch said, "'Cause we all need to take a night to chill, least a night," and I said, "Yeah, especially—" and Branch stopped—feet out, down—done swinging, looking at me.

I kept looking at the cars that were coming around, nodded to the middle one in the three and I said, "Is that him?"

The middle car stopped just after the big fountain and Branch said, "Max, yeah, that's him," then, "What'd you say?" and I said, "Especially . . . every-

body," and he smiled, faked elbowing my head, got up, then me, and we went down the hill.

Max gave us four big plastic Ziplocs, three with a full sheet in each, Simpsons—a mom, a Bart, and one the whole family—the other one another sheet, but already cut up in squares, chunks of everybody's faces, then Max flicked the rest of his cigarette out his car window between me and Branch, leaned in, over it. Branch put the bags with whole sheets under his shirt, flat, up to his chest, rolled up the bag with the cut-hits, stuck it down his pants-front, dropped his shirt over everything. Max looked up at me, said, "When you're slinging these cut ones, let your buyer do the reaching in, get their hit, then you close it, Davy," he moved a hand over Branch's pants-front—the cut-hits wad—and I said, "I know, your hands, it can go through your hands," then I looked at Branch, pointed at the rolled-up bag, said, "We had that shit in Eugene, A's not just up here," and Max said, "Absolutely right, Davy," got his hands in on the wheel. Max started the car and revved it a couple times, said to stay out of the Square today because bike cops were there, then said, "Later," drove up, out of the park on the road behind the tennis courts. Branch started walking us up the hill across from the swings and I said, "This way to the zoo?" and he said yeah, but we weren't actually going to be slinging at the zoo, but by the zoo-train, little train that picked up kids right over the trail we'd be at, said that people looking for A just know to go there, and heading into some trees I asked how come Max didn't do the slinging himself, and Branch laughed, pushed some bush-tops out of our way, said, "Because it'd look real stupid, some thirty-year-old freak hangin' out by the fuckin' kiddie-train. We just look like we're waitin' for our little brothers or somethin', and see, that's why he needs us," and I reached in front of him, felt up his front pants-wad, said, "Yeah, that's why he needs us."

Branch stopped a second, pointed down, said, "No, *that's* why we got this extra bag for nothin'.'" He walked back in front of me, and after a few seconds got fairly far ahead of me, up the brush, and I got the Fonecard out of my back pocket, ran it between a couple of my front teeth, popped out a nut from the cake at the Metro.

A kid about my age with his shirt off and a jacket with a big *L* on it, tied around his middle, reached into the Ziploc bag of hits I was holding and got two squares stuck on the end of one finger, then fingered around and got two more hits stuck on the end of another finger then pulled his hand out, said, "*Mark*," and the kid behind him, same age, no shirt, same jacket, stood up from leaning against a car, walked up to us, getting out his wallet, opening it up, and the kid that'd reached in the bag held up one of the fingers with two squares. Branch said, "Six," and the kid getting into his

wallet nodded, got out a five and a single, took his hits from the kid in front of him, then Branch took the money and I closed, zipped the bag, shook what was left, not much. The kid that'd paid put his hits in his wallet, said to the other kid, "Where're you stowin' yours?" right when the kid by me put his hits on his tongue, pulled his finger out of his mouth. Then the kid that'd taken the hits said, "Here," reached into his pocket, got keys, turned around and threw them at his friend and his friend caught them, said, "Man, Brian, you're gonna be fryin' before any of the party's even goin' on," walked around the car, got in the driver's side. The kid in front of me said, "Hopefully," tightened up his jacket and I said, "What's the *L*?" and he brushed at it, said, "Lincoln, Lincoln High," pointed over his shoulder, just out of the zoo parking lot, empty, except for them, late afternoon, and he started back to the other car-door, said, "Where d'you guys go?" and looked back at me and Branch when he got in, head out the window. Branch said, "Over there," pointed the other way, toward the rest of the park. The car started, the zoo-train whistle went off, Branch said we should move on, and they drove off, and the zoo-train, empty, came around tracks in trees above the lot. I looked down, and through tree-spaces I could see some of a mountain and I said, "Saint Helens," and Branch said, "Wrong—dude—Hood," and I said, "Bull-fuck—half of it's, like, gone, so it's Saint Helens," and Branch smiled, said, "Good, right, we're good," and I looked further down to the trails we'd been on under the parking lot and train tracks, asked him which way now. He cut from the parking lot back down to the trails, said loud, "Plaid Pantry on Vista." I rolled up the Ziploc bag, stuck it down my pants-front, cut down behind Branch, said, "To deal out the rest?" and he said, "No—Davy—dumb fuck—for *burritos*—I'm fuckin' hungry." Then he slowed up till I was walking with him and he said, "We'll get shit for Nik and Jody, too, they'll be back, and dude, we'll surprise them with a shitload of—burritos, nachos—and we'll drop change on a Burnside bum to get us booze—and we'll just take a night off—" And I ran my hand over my pants-front wad, said, "Get into this?" and he said, "Hey, yeah—one, or maybe a couple hits each—sure, 'cause we don't want to be cuttin' into profits," flicked my front wad fast with a couple fingers.

CARL ABBOTT

The author of many books on American cities and their development, Carl Abbott (1944–) is a professor at Portland State University and a national authority on urban history and urban studies. He is the author of several books on Portland, including The Great Extravaganza: Portland and the Lewis and Clark Exposition *(1981),* Portland: Planning, Politics, and Growth in a Twentieth-Century City *(1983), and* Greater Portland: Urban Life and Landscape in the Pacific Northwest *(2001). Abbott is the author (with William L. Lang) of* Two Centuries of Lewis and Clark: Reflections on the Voyage of Discovery *(2004), and* Frontiers Past and Future: Science Fiction and the American West *(2006). In this excerpt from* Greater Portland, *Abbott defines "Progressive Portland" through an examination of Beverly Cleary's Klickitat and Tillamook streets.*

Ramona Quimby's Portland: The Nicest City Possible?

The 1950s that I remember from my grade school years in Dayton, Ohio are alive and well in Portland. Kids walk to school and the branch library; neighborhood movie theaters show double features suitable for families; hardware stores, groceries, and florist shops still line old commercial streets. This is the city whose downtown and older neighborhoods remind many observers of a miniature Toronto.

It is also the city of Henry Huggins, Ramona Quimby, and their friends on Klickitat Street and Tillamook Street. Henry and Ramona are the creations of Beverly Cleary. In fifteen children's books published from 1950 (*Henry Huggins*) to 1984 (*Ramona Forever*), Cleary revisited the neighborhood of her childhood in Northeast Portland. With sales topping ten million copies, the books are almost certainly the most widely circulated representation of the city. In telling her stories about Henry, Ramona, Ramona's older sister Beezus (Beatrice, actually), and their classmates, Cleary recreated a neighborhood of everyday events. Its landmarks are defined by daily activities—schools, parks, houses with friendly dogs and unfriendly dogs, churches, stores. It is an everyday world in which kids act up, fathers lose jobs, moms go to work (a change from the earlier to the later books), teachers just don't understand, and older kids call you Ramona the Pest.

It happens that I live on a very real Klickitat Street in an almost-square white house that might have belonged to the Huggins family. We can map Cleary's fictionalized cityscape onto Northeast Portland as easily as we can map John Updike's industrial city of Brewer onto Reading, Pennsylvania or William Faulkner's Yoknapatawpha County onto Lafayette County, Mississippi. Portlanders will recognize that Ramona's Rosemont and Glenwood

schools are Beaumont and Fernwood middle schools. I know exactly the hill down which Henry hopes to coast on the Flexible Flyer he expects for Christmas. Grant Park is where the kids search for night crawlers. Westminster Presbyterian Church is where Ramona played a sheep in the Christmas pageant. I can find several candidates for the tan stucco and gray shingle houses Ramona passes when she tries a new route between home and first grade and meets the scary dog that steals her shoe.

Beverly Cleary's books picture a uniformly middle-class city of small business owners, skilled union members, office workers, and professionals. Here her depiction is still accurate, for the Portland area is well homogenized in terms of economic class. The business strength of the central city and the slow development of suburbs have damped the class dimension of city-county politics. The income disparity between city and suburban households is less in Portland than in most metropolitan areas of comparable size (1–2.5 million).

Economic classes also intermix at a relatively fine grain at the neighborhood level. Stable pockets of high-income housing flourish adjacent to a variety of middle and working class districts. Portland has fewer and less concentrated poor people than most cities. Within the boundaries of the fifty largest U.S. cities in 1989, 27 percent of all children lived in poverty—nearly two-thirds of them in poor, economically distressed neighborhoods. In Portland, 18 percent of children lived in poverty—with less than a quarter in distressed neighborhoods.

Despite the ease of mapping Ramona's streets and parks onto everyday Portland, we do need to add one new subtext to Cleary's homogeneous city. Her characters are white people who interact with other white people. None are even identifiably ethnic, for names like Huggins and Tebbitts are carefully Waspy.

Today the Quimby family's neighborhood remains comfortably middle class, but it is a mix of white and black, the result of a cycle of neighborhood change and revitalization between 1960 and 1990. Near to the northwest are not only African American districts but a settlement of Ethiopian immigrants. Just to the north are Mexican taquerias on Alberta Street and a Latino community development corporation in Parkrose. Vietnamese businesses line Sandy Boulevard, where an old Roman Catholic church and school have become the Southeast Asian Vicarate with 6000 parishioners.

The contrast tells us something about the balance of continuity and change in Portland. Even in the 1990s, it remained a magnet for white migrants from the northern Rockies and plains. People who tired of North Dakota winters in the 1920s escaped most easily on the Northern Pacific or Great Northern Railroad to Minneapolis, Seattle, or Portland. Interstate highways follow the same east-west grain. In the 1990s Portland was a refuge for white

Californians who cashed their real estate equity and moved to a more racially homogeneous place. Among the thirty-eight metropolitan areas with populations greater than one million in 1990, only Minneapolis–St. Paul had a smaller proportion of minority residents.

At the same time, contemporary Portland has more racial variety than since the early decades of the twentieth century. Hispanic and Asian population grew rapidly in the 1980s and 1990s, with the largest percentage gains in Clackamas and Washington counties. In 1990 minorities made up 15 percent of Multnomah County, 10 percent of Washington County, and 5 percent of Clackamas County. The western suburbs of Washington County will likely pass Multnomah County in ethnic and racial diversity before 2010.

As the suburbanization of minorities suggests, foreign-born Portlanders are distributed relatively evenly across the metropolitan area. In 1990 they constituted 7 percent of the population of Multnomah and Washington Counties, 5 percent of Yamhill County, and 4 percent of Clackamas and Clark Counties. In 1998–99 there were 4700 students with limited English in Portland schools, 3300 in the larger districts of eastern Multnomah County, and 5300 in larger Washington County districts. Although small by Los Angeles standards, there is a Little Korea in Beaverton, Little Mexico in outer Washington County, Little Vietnam in east Portland, and Little Russia in Clark County.

If we look more closely at change and continuity in Portland's demography and culture, we can distinguish at least four "Portlands." Progressive Portland, Albina, the Silicon Suburbs, and the Metropolitan Borderlands are sets of neighborhoods whose residents share some distinctive political values, opportunities, behavioral expectations, and definitions of the good community. The pattern is the result of historical layering and of self-selection in residential location. Different parts of the metropolitan region are dominated by and express different sets of social and cultural values. Residents in each of the four "Portlands" like different things in their neighborhoods and prefer different packages of public services. These shared values and hopes for the future derive in part from race and ethnicity, in part from sociopolitical or ideological commitments that transcend location, and in part from the industries on which different households depend. By this latter point I mean not their class position per se, but their connections to locally rooted or nationally networked enterprise. In a sense, this is the classic sociological dichotomy of locals and cosmopolitans as experienced in the real life of a specific metropolitan area.

These cultural and economic differences are manifested in cityscapes that express different views of the city region—different ideas about what it can and should offer as a place to work and live. This chapter explores how personal values and industrial affiliations have created communities of interest. It tries to understand how such communities locate in space and utilize

place. We can call the topic "social environment" or "cultural ecology" (with a bow to Rayner Banham's evocative description of the four "ecologies" of Los Angeles).

Progressive Portland

Barbara Roberts loves her neighborhood. When she returned to Portland from Boston in 1998, she picked a modest Dutch Colonial in southeast Portland's Westmoreland neighborhood. Built in 1911, the house is tucked onto a 5000-square-foot lot. There is stained glass in the front door and wicker furniture on the wide porch. A long established commercial street is only three blocks away. Roberts can walk to the grocery, the hardware store, a movie theater, and a choice of banks and restaurants, although the drug store and dime store closed soon after she moved in.

Barbara Roberts is a noteworthy representative of what I call progressive Portland—a set of people and neighborhoods that are characterized by civic activism. She entered civic life in 1969 as an advocate for handicapped children and schools. Politics was next, leading her to the Multnomah County Commission, to the state legislature, to statewide office as Oregon Secretary of State, and to the governor's office and mansion in Salem from 1991 through 1994. She worked for three years as a program executive with Harvard University's Kennedy School of Government before moving back to Portland to settle in Westmoreland, write, and run a similar program at Portland State University.

Roberts returned home because she wanted "to feel connected." Boston was "intellectually stimulating, socially stifling." In Portland's Sellwood–Westmoreland district she found a small town ambience that reminded her of Sheridan, the Oregon town where she grew up. Westmoreland, she says, "feels like a neighborhood should feel," with a mix of elderly, young couples, and children. Residents are politically active, with high voter registration and turnout. They notice what others do with their yards and gardens; when she took down an aging tree that threatened her house and her neighbor, *everyone* had a comment. People in the neighborhood restaurant/bar treat her as family, shooing away belligerent customers who want to upbraid her for her mistakes in Salem (she backed a deeply unpopular sales tax to fund state services). ·

Progressive Portland is both a place and a state of mind. Its ideological center is still moored to John Kennedy's inaugural challenge to place public service over individual gain. It covers many of the east side areas built up in 1870-1940 and consciously conserved since 1965, including Governor Roberts's neighborhood and Ramona Quimby's neighborhood. It also extends to the West Hills and close-in west side suburbs such as Beaverton, Tualatin, and Lake Oswego. It is a land of white Americans that maps closely with the distribution of high education levels. It has a wide range of family income but a shared sense of civic responsibility.

Mixed together in these neighborhoods are the groups that Oregon opinion poller Adam Davis calls socially concerned liberals and contented social moderates. The former think that Oregon is performing well, but they support stronger environmental protection and back social services for those not doing well in life. The latter are successful, like where Oregon is going, and sympathize with environmental issues, but they hold mixed views on government programs. Together, these folks are "progressive" in pushing Portland into the national lead on many aspects of urban planning and development, doing things that other cities imitate. Unifying issues are compact growth, environmental protection, good public schools, and the pleasures of a downtown that escaped modernist reworking. They are also Progressives—or neo-Progressives—in the historical meaning of a political movement aimed at combining democracy and efficiency. The economic base is an alliance of downtown business and real estate interests with professional and managerial support workers (e.g., college professors) to define and pursue a public interest through rational analysis.

Progressive Portland spans partisan allegiances, as did the progressivism of Theodore Roosevelt and Woodrow Wilson. Barbara Roberts is a Liberal Democrat in capital letters. She can speak as eloquently as Eleanor Roosevelt or Lyndon Johnson about the responsibility and capacity of government to extend the blessings of liberty to the poor, the sick, the poorly educated. But Oregon is also one of the last habitats of Dwight Eisenhower's Modern Republicanism. Republican Tom McCall, governor from 1967 to 1974. . . . He lived in Portland's upper income West Hills and led a crusade for environmental protection. Victor Atiyeh, Republican governor from 1979 through 1986, looked much more conservative in the Oregon context, but still moderate in a Reaganite nation. A downtown retailer who represented the older suburbs of Washington County in the legislature for twenty years before winning state office, he and his wife live in the house they bought in the 1950s. A fiscal conservative and social moderate who saw few needs for change, he also represents the other wing of Portland's political establishment—Rockefeller Republicanism but not Gingrich radicalism.

Portland mainstream progressives believe that government provides valuable services and trust Oregon's "good government" ethos to see that it works in the public interest. In 1996, for example, they dominated the neighborhoods whose residents voted to tax themselves for light rail construction and zoo improvements. The same neighborhoods voted against Measure 47, a property tax limitation measure that passed statewide in the same year.

They trust government because they *are* government. Portland area politics is open to broad participation. Weak political parties, nonpartisan city and county elections, and an absence of ethnic block voting mean that

elections are fought on issues and personalities. Candidates raise their own money, assemble their own cadres of campaign workers, and try to get the most impressive array of individual endorsers to list on their letterhead. Citizen activists can emerge as successful politicians, and citizen advisory committees are important sources of ideas for public action. In a self-fulfilled evaluation, the activists of progressive Portland characterize government as open, honest, and accessible. Alert citizens believe that their input counts, that newcomers are listened to. In the description of political analyst David Broder, Portland politics are "open, unpredictable, participatory. Portland is a big city but politics seem small town. Everyone seems to know everyone else, at least the political activists do, and there is a good deal of camaraderie and tolerance."

Broder's traits show in Portland's openness to leadership by women. In 1993–94, for example, women served at the same time as governor, mayor of Portland, chair of the Multnomah County Commission, and Metro executive director. David Sugarman and Murray Straus in 1988 ranked Oregon first among all states in equality for women, utilizing several indicators each for economic equality (fourth in the nation), political equality (fourth), and legal equality (first). The Institute for Women's Policy Research in 1998 found Oregon in the top quartile among states for political participation and representation, economic autonomy, and reproductive rights.

The private economy is also hospitable to women. Metropolitan Portland has slightly led the rest of the country in the proportion of adult women who work, moving from 44 percent in 1970 to 62 percent in 1996 (compared with a nationwide increase from 42 percent to 59 percent). The proportion of women in professional and managerial jobs is high, and the metropolitan area is tied for third in the proportion of business firms owned by women. Indeed, the number of woman-owned businesses increased 121 percent from 1987 to 1996, the fastest growth in any metropolitan area.

One subspecies among the progressives are "uptowners" from the affluent neighborhoods of the West Hills, a long crescent of expensive housing draped across a steep ridge west of downtown. In the early days of Portland, social status increased with distance from the river on the west side. The early homes of the well-to-do could be found around the Park Blocks and on Broadway, high enough for householders to enjoy views of Mount Hood from their front windows. By the early 1880s, however, tycoons began to create Portland's own "Nob Hill" in imitation of San Francisco. The mansion rows were Northwest 18th 19th, 20th, and 21st Streets—roughly the same distance from downtown Portland as Denver's Capitol Hill is from that city's center. Horse car lines followed the new houses and made for an easy commute to riverside offices. *Oregonian* editor Harvey Scott described the emerging elite neighborhood in 1890:

One is led rapidly on by the sight of grand and imposing residences in the distance, of costly structure and splendid ornamentation. Many of these are set upon whole blocks, beautifully supplied with trees, turf, and flowers, and supplied with tasteful drive-ways. . . . Among those of the spacious and magnificent West End are houses costing about $20,000 to $50,000—some of them $90,000 each—of three and four stories, and mainly in the Queen Anne style. It is upon the swell of the plateau that these fine houses begin to appear, and the views from their upper windows and turrets are extensive. . . . the region is, by popular consent—and still more by prevailing prices—forever dedicated to dwellings of wealth and beauty.

The advent of family automobiles opened the steep slopes to the west to residential development. By the 1920s the West Hills were Portland's new elite district. For three generations the affluent highlanders of King's Heights, Arlington Heights, Willamette Heights, Portland Heights, and Council Crest have enjoyed views of Mount Hood and ten-minute commutes to downtown offices. Separated by elevation from the lower income residents of the downtown fringe, successful businessmen, ambitious professionals, and monied families have been able to maintain social status and leafy living without needing to flee to suburbia.

These are Portland's mini-Brahmins. They include the heirs of old money from real estate, banking, transportation, and manufacturing, plus the successful practitioners of law, medicine, and business services. There is some big new money in Portland from growth industries such as running shoes, motels, and video stores, but this is no high roller culture. The people who get invited onto boards and commissions are those who have adopted Portland's style of conspicuous underconsumption. Perhaps the attitude reflects the New England roots of Portland's mercantile leadership in the previous century, or perhaps the difficulty of showing off mansions nested in ravines and greenery. Frances Fuller Victor observed the same pattern in the city's first century, commenting on the "snug and home-like appearance of the city" and streets that were too narrow "for the display of the fine structures already erected or in progress." With their homes often muffled in morning mist and fog from November to February, these cloud people tend investments rather than rollicking on Rodeo Drive. Many are the sort of moderate Republicans who made Oregon one of the very few western states where Nelson Rockefeller ran ahead of Barry Goldwater in 1964. They are tasteful in personal style, committed and conservative in support of the arts, contented with the basic character of their community, and open to moderate social change. Readers familiar with Philadelphia might think of parts of the West Hills as an extended Chestnut Hill without the dress code.

In the case of the West Hills, proximity breeds attachment. Residents pay attention to the health of downtown because it is their most convenient shopping district and often their place of work. They care about the city school system because their children live within its boundaries (and because Portland does not have a strong tradition of elite private schooling). Involvement in city politics protects their neighborhoods as well as their business investments. In simplest terms, they "claim" Portland because they can see the heart of the city from living room windows, verandas, and back decks.

The West Hills blend easily into a set of high status suburbs close to the central city. Because Portland's Urban Growth Boundary makes it difficult to create low density, high-cost martini farms for a semi-landed gentry, the metro area has no equivalent of the Connecticut or Bucks County, Pennsylvania exurbs. Instead, it boasts very nice houses on moderately sized lots. Dunthorpe, Lake Oswego, Tualatin, and West Linn extend the pleasant and relatively liberal neighborhoods of west side Portland beyond the city limits. A good comparison is the way that Bethesda and Chevy Chase extend affluent northwest Washington beyond the District of Columbia.

Two or three ticks to the political left are socially concerned activists (like me and Barbara Roberts) who earn their incomes in transactional and professional services. Old neighborhoods of business proprietors are now filled with new professional populations. On the west side these folks leaven the social and political mix of high status neighborhoods, helping elect Democratic legislators in what might superficially look like safe Republican territory. On the east side are upper middle class neighborhoods such as Eastmoreland, Laurelhurst, Irvington, Alameda, and Grant Park and mid-status neighborhoods such as Overlook, Ladd's Addition, Sellwood, University Park, and Piedmont (promoted a century ago as "The Emerald, Portland's Evergreen Suburb, Devoted Exclusively to Dwellings—A Place of Homes").

DAN NEWTH

Dan Newth (?–) lived homeless in Portland for over three years. By volunteering with Street Roots, *a newspaper that advocates for and hires the homeless, he learned to write and overcame his dyslexia. He represented Crossroads, a project of Sisters of the Road, on the coordinating committee of the Portland and Multnomah County Ten-Year Plan to End Homelessness. In 2005, he received the Cecil Shumway Award for his work for Crossroads from the City of Portland and the Oregon Community Foundation.*

Chillin'

Jan. 5, 2004 the high temperature was around 23 degrees. That evening a homeless couple lay huddled under a pile of emergency blankets, the cold east wind biting through the layers.

They were two doors down from the *Street Roots* office. I repeatedly offered to let them sleep in the office when I took hot coffee out to them. Each time they declined the offer saying that if things got too cold they could come inside. People surviving outside tend to be an independent, hardy lot.

Several grass roots organizations took it upon themselves to open their doors to people outside. You see, we recognize an emergency when the wind chill is at or below zero degrees. Different groups coordinated teams of people to sweep the streets looking for people and urging them to go to the shelters.

Why, you might ask, are those senseless homeless people so resistant to going to shelters?

Well, my experience has led me to stay as far away from the shelters as possible. This independence is born from a need for dignity as well as survival. When so many charity models are wounding to the human spirit, preaching condemnation instead of a message of hope, it is no wonder that many homeless prefer sleeping in the dirt to being humiliated in some church pew.

When the wind blows coldest, the shelters fill fast, leaving the slow and less savvy to shiver on the streets. If you depend on shelters, you are bound to spend some weary wet nights wandering the streets. You will most likely be sick with the flu or some other contagious disease, what little energy you have being spent shuffling down the street in an effort to stay warm.

That is why some folks like myself set up camp in an out-of-the-way spot. Having a tarp and sleeping bag stashed is not about comfort; it's about safety. I can understand why some people are upset about others sleeping out. I would have to pay a couple thousand a month to get the view I have from my camp. I'd be jealous of me, too.

I've heard raccoons howl at the moon and chase screaming mountain bea-

vers in a life and death race for survival. I've seen dragonflies dance, heard the owl hoot in search of a mate, Redtail hawks being harassed by crows who are badgered by sparrows, and felt my spirit's batteries recharge by the essence of nature that surrounds me.

It's a mixed bag of experiences, the stresses and pleasures of adventure intertwined, that the pioneer spirit thrives in. Shelters on the other hand are often used as a discharged destination from prison and mental institutions. They provide a ready reason to commit more crimes or aggravate the already stressed-out mental condition of those our society has cast out.

The system spends 30 times more money on maintaining people in homelessness than it spends on getting people housed. The same people, who through policy and procedure deny opportunities to those excluded from society, will rally support when asked for funding which primarily lines the pockets of middle-class social workers. The prejudice is echoed in policy, mainstream media and hate talk shows like Lars Larson.

The answer to ending homelessness must start with an end to the hate, ignorance and indifference that help to create and maintain it. Until that day, I'm at peace leaving a small footprint and sleeping in my modest camp.

JAN MORRIS

Born in Somerset, England, Jan Morris (1926–) attended Lancing College in Sus-sex and served in the British Army in World War II. He attended Oxford Univer-sity and was a reporter for the London Times. *In 1953, Morris famously broke the news that Sir Edmund Hillary and Tenzing Norgay had reached the summit of Mt. Everest. Since the 1960s, Morris has published some forty books, notably the Pax Britannica trilogy about the rise and fall of the British Empire and works of travel, memoir, and fiction. He has been a frequent contributor to magazines and periodicals in Great Britain and the United States. This essay first appeared in* Portland Magazine *(2001).*

The Other Portland

Having a day to kill in Portland, I set out from my hotel to saunter around the city. The hotel itself, named the Heathman after an old Oregon lumber baron, was a paragon of American hospitality, full of books and pictures, exquisitely mannered and succulently cuisined: and downtown Portland too, running away to the parks along the Willamette River, seemed to me delightfully civilized.

It is one of the few big American cities that never succumbed to the high-rise epidemic, and although the Portland Building, Michael Graves' original

exercise in post-modernism, cast a chill through me as an awful portent of what was going to follow it, for the most part meandering through the streets was very agreeable. The blocks are unusually short in Portland, making for pleasant serendipity, the architecture is mostly genial, there are plenty of coffee-shops, not all of them insisting that you drink their cappuccino out of plastic cups, and the gloriously rambling Powell's City of Books must be one of the best bookshops on earth.

Travel is free on the downtown public transport system, and what with the cleanness and sensibleness of everything, the evident prosperity and the prospect of a late lunch at the Heathman (red snapper, perhaps, with a glass of one of the excellent local whites), I thought what a lesson in civility Portland, Oregon, offered the world at large.

But following the tourist signs towards the Old Town district and Chinatown, and expecting the usual harmless flummery of restored gas-lamps and dragon-gates, I crossed Burnside Street and found myself in a corner of hell.

Suddenly all around me were the people of Outer America, flat out on the sidewalk, propped against walls, sitting on steps, some apparently drugged, some evidently about to vomit and nearly all of them, it occurred to me, idly wondering whether it was worthwhile mugging me as I passed. They were of all ages and several colors. They did not look exactly hostile, or even despairing, but simply stupefied, as though life and history had condemned them to permanent poverty-stricken sedation.

Every city has its seamy underside, and American cities more than most. The moment came as a shock to me in Portland because here the well-off and the poor, the hopeful and the hopeless, not to mention the whites and non-whites, are more than usually separated. A languid stranger could spend a week at the Heathman, with intermissions at the City of Books, almost without realizing that poverty, crime, or crack existed here at all, or any un-Caucasians except exquisitely urbane Asiatics. Portland has repeatedly been voted one of the most liveable cities in the United States, and if you choose the right part to live in, it undoubtedly is.

When I withdrew across Burnside again to a restorative coffee in a more soothing part of town, I found myself paradoxically reminded of another country altogether. In India, with the scrambled millions of the poor, there exists a complete modern nation, rich, sophisticated, worldly, which if it could be isolated and moved somewhere else, would constitute a formidably capable state of the middle rank.

This thought led me on to some uncomfortable conjectures: while educated India forms a small minority, civilized America is presumably a majority — but for how long, I wondered as I looked around me over my coffee cup at the kindly, comfortable faces of the American Center? And how civilized?

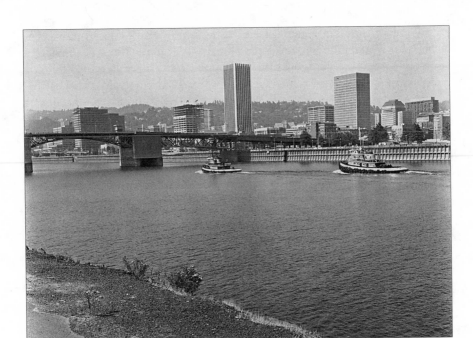

Downtown Portland from the east bank of the Willamette

The gods have loved America, but I sometimes think they are already making it mad. One expects insanity among those poor huddled masses of the sidewalk, but every time I come to this country I feel that the neuroses and paranoias are spreading, across all the Burnside Streets of the nation, into the amiable neighborhoods over the way. Suburban nerves twitch ceaselessly, downtown eyes flicker, as the monstrous contrasts and energies of capitalism unalloyed tear away at the communal composure.

The Americans, even those civilized Americans of the Center, have gone half-crazy already with legalism, feminism, and political correctness. They are well on the way to asylum with sexual obsessions. They are moonstruck by matters grotesque and macabre, from clowns to vampires. They are so addled by the allure of violence that in America now there are more federally licensed gun dealers than there are gas stations, and one of their incessant self-lacerating polls recently showed that half their school children knew how to get hold of a fire arm.

On the front of the Portland Building there is a truly colossal female figure, whom I now know to be Portlandia herself. I asked three passers-by, two men and a woman, who she was. The woman said that, although the found the figure "pretty," she had no idea of its identity. Both the men seemed never to have given the matter a thought. This struck me as odd, since the image

is the second largest hammered copper sculpture in the world, beaten only by the Statue of Liberty, but I later reached the conclusion that it was only a symptom of general alienation. If Portlandia were dripping blood, or in the process of being mutated into a dinosaur, everyone would know all about her; as it is, she is a robustly healthy and well-balanced, and so hardly worth noticing.

I pick up a newspaper, and here is a plastic surgeon assuring potential male clients that for $10,000 they can have chest implants, abdominal lipo-suctions, and calf implants which will ensure "a fine looking physique for the busy executive without spending endless hours in the gym." Buried away on an inside page is the news that a man who was about to be executed for a murder in Oklahoma has been temporarily reprieved because he first has to serve 20 years for a murder in New York. Almost every agony column displays self-questionings, religious ravings, breakdowns of trust, preposter-ous grievances of age, gender, race, or condition; even some of the comic cartoons have moved into a disoriented kind of surrealism.

You can be sure that at any hour of any day, one television channel or another will be showing scenes of appalling bloodshed, cases live from a criminal court, chat shows concerning child abuse, marital disharmony, sex-ual misbehavior, predatory lawsuits. No self-respecting best-seller is with-out its detailed evocations of couplings, masturbations, dismemberments or disembowellings, and nobody seems particularly surprised that a United States Senator resigned recently because of "sexual malpractice" (whatever that may mean in PC-speak) towards a sizeable number of his employees.

Mad! Yet this is the Great Republic whose founding principles were noth-ing if not rational, and whose purposes were all harmonious. From the very beginning the United States has satisfied many of the universal human yearnings, and shared with all of us the recipes of its success. Declaration of Independence to Frank Sinatra, skyscraper to Big Mac, Hollywood and John Cheever and the dry martini and the Freedom of Information Act — the list of American blessings is endless, and their adoption and imitation around the world has brought us infinite good.

They have been, though, the gifts of a culture supremely confident and logical, recognizably the culture that Thomas Jefferson and his colleagues created. What is emerging in America now, still to be exported willy-nilly around the globe, is a jumble of philosophies so distracted, so uncertain, that they seem to lack any cohesion at all, and are more like the nervous responses of hostages than any body of ruling values. The center, it seems to me, is only just holding, and is patently showing the strain: yet still it stands as exemplar to most of the world, copied in blind faith everywhere, and especially among peoples like the English and Canadians who share a language with the Americans, and whose own sense of identity is weakened or uncertain.

And waiting just over the street there is the other culture, America Ulteria, or perhaps America Ultima, the inchoate slouching presence which is giving the nation these disturbing jitters. It has no standards of its own. It has little to lose, and not much hope of winning. Its language is half-comprehensible, its reasoning is obscure, but one day America and the world may wake up to find that like the destitute masses of India, it is less the exception than the norm.

That evening I gave a reading in the Arlene Schnitzer Hall, a splendid concert hall next door to the Heathman. I never enjoyed an occasion more. The audience was immensely quick, generous, and entertaining, and at the reception afterwards people raised many penetrating points about the influence of travel upon the work of Virginia Woolf, and the proper place of the imagination in non-fiction.

PHILLIP MARGOLIN

Reared in New York City and Long Island, Phillip Margolin (1944–) earned a B.A. from The American University, served in the Peace Corps in Liberia for two years, and attended New York University School of Law. He came to Oregon as the clerk for the chief judge of the Oregon Court of Appeals and moved to Portland to practice law in 1971. From 1981 to 1995, he coached chess at Hayhurst Elementary School, and in 1996 he became a fulltime writer. Margolin has published twelve novels, including Gone, But Not Forgotten *(1993),* The Burning Man *(1996),* Wild Justice *(2000), and* Proof Positive *(2006), and three short stories. In 1978, he received an Edgar nomination for* Heartstone *from the Mystery Writers of America. His short story "The Jailhouse Lawyer" (1998) was included in* The Best American Mystery Stories 1999. *In these excerpts from* Ties That Bind *(2003), Margolin gives an insider's glimpse of Portland's legal scene and takes readers into the archives of the Multnomah County Public Library in search of clues that lead to the Vaughn Street gang.*

From *Ties That Bind*

Tim Kerrigan needed help from someone with power and connections. Hugh Curtin was Tim's best friend, but what could "Huge" do about Ally Bennett? William Kerrigan had power and connections, but telling his father about his sordid relationship with a prostitute would only confirm every belief his father held about his son's failure to measure up. When Kerrigan thought about it, there was only one person he could go to for help.

Harvey Grant lived alone high above city center, behind stone walls, in a secluded area of the West Hills. Tim stopped at the iron gate that blocked

access to the judge's estate and spoke into a black metal call box. Victor Reis, an ex-cop in his fifties, who acted as a combination butler, bodyguard, and secretary for the judge, answered. Moments later, the gate swung open and Tim drove up a long driveway before stopping in front of a three-story brick house of Federalist design.

Most of the windows in Grant's mansion were dark, but the house was often alive with light and sound. The judge was famous for his large parties and intimate get-togethers. An invitation to one of Judge Grant's soirees was eagerly sought and cherished because it signified that you were one of Portland's elite.

Tim parked in front of a recessed portico where Harvey Grant was waiting.

"Come into the study," the judge said solicitously. "You look like you can use a strong drink."

"I've done something incredibly stupid," Kerrigan said as they walked down a side hall to a wood-paneled den.

"Wait until you've calmed down," Grant said as he sat Tim in an armchair near a fireplace with a carved cherrywood mantel, in which a fire had been laid. Tim leaned his head back and soaked up the warmth. As soon as he closed his eyes he felt bone-weary.

"Here," Grant said. Kerrigan jerked awake. He had not realized how much the meeting with Ally Bennett had taken out of him. The judge pressed a cold glass into Kerrigan's hand and took a sip from a glass he'd filled for himself.

"Thanks," Kerrigan said as he gulped down half the glass. Grant smiled warmly. Kerrigan had always been amazed by his mentor's steadiness. Even in the most contentious courtroom situation, Harvey Grant floated above the fray, counseling the combatants with the calm, reassuring voice of reason.

"Feeling a little better?" Grant asked.

"No, Judge. It's going to take a lot more than a glass of scotch to fix my problem."

"Tell me what happened."

Kerrigan could not look Harvey Grant in the eye as he told him about his sordid evening with Ally after his speech at the trial lawyers' convention, and its aftermath. The judge took an occasional sip but his expression did not change as he listened. Kerrigan felt lighter after unburdening himself. He knew he was taking a risk going to an officer of the court, but he was certain that Grant would protect his confidence and he hoped that the judge would find a solution to his dilemma.

"Is this the only time that you've done this sort of thing?" Grant asked.

"No." Kerrigan hung his head. "But I've always been so careful. With Ally ... I don't know what I was thinking. I was drunk, I was depressed. . . ."

Kerrigan stopped. His excuses sounded weak and unconvincing.

"Cindy is a good person, Tim."

When Kerrigan looked up, there were tears in his eyes.

"I know that. I hate myself for lying to her. It makes me sick."

"And there's Megan to think about," Grant reminded him.

Kerrigan fought back a sob. Everything was tumbling down around him. Grant sat silently and let Kerrigan grieve.

"Have you talked to your father about Miss Bennett?" Grant asked when Tim stopped crying.

"God, no. I couldn't. You know how it is between us."

"So, you came straight here?"

Tim nodded.

"Is it your impression that Miss Bennett has kept what she knows to herself?"

"I don't know, but she'd lose her advantage over me if our relationship became public knowledge."

"What do you think would happen if she went to the press and you denied her allegations?"

"Do you mean can she prove we spent the night together?"

Grant nodded. Kerrigan rubbed his forehead. He tried to remember what had happened that evening.

"I registered with false ID, but the clerk at the front desk might remember me. And I went there again tonight. I may have left prints in the room. Fingerprints last a long time. They don't clean very thoroughly at that place."

"Most likely, though, it would be her word against yours, no?"

Kerrigan thought of something. "Phone records. I phoned Ally from my office the night I first saw her and I used a pay phone in the hotel where I gave my speech. No one could prove I made either call, but the phone records would be powerful circumstantial evidence that she's telling the truth.

"And what does it matter if she can prove what happened? Once that type of allegation is made it sticks with you forever, no matter what the truth is."

"You're right, Tim. If this got out it would be disastrous, and it would ruin your chance to be a senator."

Grant paused and took a sip of his drink. His brow furrowed. "What do you make of this business with the cassette?"

"Dupre ran a pretty high-scale operation. We know that politicians and wealthy businessmen used it. Bennett could have been in a position to tape incriminating evidence that Dupre could use for blackmail."

Grant nodded, then became pensive again. Kerrigan waited, exhausted, grateful for the pause. When the judge spoke, his tone was measured and thoughtful.

"You've acted very foolishly, Tim, and placed yourself and your family in a precarious position, but I may be able to help you. I want you to go home and let me work on this problem. If Miss Bennett contacts you, stall her.

Promise her that you are going to do as she asks but you need time to figure out how best to accomplish her purpose. I'll call you when I know more."

Grant got up and Tim rose with him. Standing was like climbing a mountain. His body seemed to be as heavy as stone and he felt a weakness of spirit that was close to a wish for death.

"Thank you, Judge. You don't know how much just talking to you means to me."

Grant placed his hand on Kerrigan's shoulder. "You can't see it, Tim, but you have everything that most men wish for. I'm going to help you hold on to it." . . .

As Amanda rode the elevator to the lobby of Dr. Dodson's building, she thought about The Vaughn Street Glee Club. The idea of a high-level conspiracy going back decades was fascinating but far-fetched. It was a stretch to think that there was a connection between Israel's death and Dupre's case.

The elevator doors opened. Amanda paused in the lobby. Connections— conspiracies were, by definition, acts of people working in concert. Sammy Cortez had told the police that the conspiracy between Pedro Aragon and the others went way back. Was there some connection between Aragon and Hayes that started before Hayes became a lawyer? Amanda walked outside and found herself in the shadow of the Multnomah County Public Library. An idea occurred to her. She crossed the street.

The library, which took up a city block, was Georgian in style, with a ground floor fronted by cool gray limestone, and upper stories of red brick. Amanda climbed the broad granite steps that led to the public entrance and went directly to the History Department on the third floor where she found the library index; row after row of low-tech, wooden drawers stuffed with musty index cards arranged by name, which gave citations to newspaper articles in which the individual on the card was mentioned. Amanda pulled out the drawer marked ANIMALS TREATMENT and flipped through the cards until she found several for Pedro Aragon. She listed every newspaper-story reference on her yellow, lined legal pad, then did the same for Wendell Hayes. When she was finished, Amanda made a separate list of all of the stories that mentioned both men.

Periodicals were on the second floor. Amanda decided to work from the oldest stories forward, and the oldest reference was an *Oregonian* article from 1971. The newspaper stories from that far back were only on microfilm. Amanda found the appropriate roll. She fitted it on a spindle attached to a gray metal scanner and turned the dial. The microfilm raced across the screen fast enough to give her a headache, so she slowed it down. Eventually she reached the Metro section for January 17, 1971. At the bottom of a column was an update of a story about the investigation into a massacre that took place in December of 1970 in North Portland, in which Pedro Aragon

was a suspect. The January story concerned the discovery of three handguns in a landfill on the outskirts of Portland. They had been positively identified as weapons used in the December shootout. The handguns had been traced to the home of Milton Hayes, a wealthy Portland lawyer and gun collector, who had reported the weapons stolen in a burglary that had been committed on the evening of the shootings. Buried in the story was an explanation of how the burglars had gained entry to Hayes's house. His son, Wendell, who was home from Georgetown University for the holidays, had forgotten to set the alarm when he left the house with several of his friends to attend a Christmas party.

Amanda found the microfilm spool for December 1970 and located the story about the drug-house massacre. Dead bodies had been found scattered around the first floor of an abandoned house. Most of the victims had been shot to death, but a man in the front hall had had his throat slashed. Traces of heroin had been discovered in several rooms. The police had been able to identify several of the victims as members of a black gang with Los Angeles connections, and the others as Latinos associated with Jesus Delgado, who was suspected of working for a Mexican drug cartel. One of the dead men, Clyde Hopkins, had ties to an organized crime family in Las Vegas. Pedro Aragon, a known associate of Delgado, had been arrested the day after the murders but had been released when the police could not break his alibi.

Could Hayes and Aragon have been involved in the drug-house massacre? Amanda had a hard time picturing a West Hills preppie wiping out armed druggies in a shootout in one of Portland's worst neighborhoods, but Hayes might have been at the house buying drugs, or he could have stolen his father's guns to trade for dope.

Amanda wondered who Hayes's buddies were in December of 1970. They were probably the friends he was with on the night his father's guns were stolen. It would be interesting to get the police reports and find out the names of the boys who were with Hayes when the B-and-E occurred.

Amanda took a break from viewing microfilm and found Wendell Hayes's obituary. Hayes had graduated from Portland Catholic in June of 1970, the same year as the drug-house massacre. He had attended college and law school at Georgetown University. Amanda asked the reference librarian where she could find the yearbook for Portland Catholic. She took it to a table and started leafing through the book.

Hayes had been the senior class vice president, and the president had been Harvey Grant. As she thumbed through the yearbook, Amanda found more familiar names. Burton Rommel and William Kerrigan, Tim's father, were teammates of Hayes on the football and wrestling teams. Amanda remembered that Grant was also a graduate of the law school at Georgetown, and she was pretty certain that he'd received his undergraduate degree from the school.

Amanda checked out the backgrounds of Burton Rommel and William Kerrigan. Neither had gone to Georgetown. Rommel had a BA from Notre Dame and Kerrigan had received degrees from the Wharton School at the University of Pennsylvania.

Amanda returned to the microfilm projector and threaded in another spool, which contained an early reference to Pedro Aragon. She was curious to learn how someone who started out running a drug house in Portland got to be the head of a cartel in Mexico. An hour later, Amanda had learned that Aragon's rapid rise had been made possible by a series of murders, which had started in 1972 with the assassination of Jesus Delgado, Pedro's immediate superior, in the parking lot of a Portland 7-Eleven.

Amanda spent more time going through stories that mentioned Pedro Aragon and Wendell Hayes, but the majority were accounts of cases in which Hayes had represented a client with connections to Aragon. She returned the microfilm and headed back to her office. Amanda had not really believed Sammy Cortez's story about The Vaughn Street Glee Club when she walked into the library, but one piece of information in the newspaper stories had really gotten her thinking: The drug house where the massacre took place was on Vaughn Street.

APRIL HENRY

Born in Portland, April Henry (1959–) is a second-generation Oregonian who graduated from Oregon State University. She has written mysteries and thrillers for juveniles and young adults., including Circles of Confusion *(1999), which was nominated for the Pacific Northwest Bookseller's Association Award, the Spotted Owl Mystery Award, the Agatha Award for best first mystery, and the Anthony Award for best first mystery. She is also the author of* Learning to Fly *(2002) and* Shock Point *(2006), a thriller set in Portland and Mexico, where the teenage heroine is sent to a boot camp. Her other novels in the Claire Montrose series include* Square in the Face *(2000) and* Heart-Shaped Box *(2001). In this excerpt from* Buried Diamonds *(2003), the heroine finds herself at a McMenamin's pub.*

From *Buried Diamonds*

Claire pressed the bottom of her beer glass on the wooden table, leaving behind a ring of condensation. She added another one to it, then a faint third, but there wasn't enough condensation to allow her to form the five rings of the Olympic symbol. Before they were due at Mercury, she and Dante were killing time by splitting a pitcher of India Pale Ale at the Hillsdale Pub. Like all the other pubs owned by Portland's McMenamin brothers,

the Hillsdale Pub featured beer brewed on site, signs from other countries and/or times, and funky paintings that looked like the artist had eaten a lot of acid before picking up his paintbrush. They were filled with smiling suns, dancing hammers, leaping rabbits, and lots of psychedelic colors.

"Allen Lisac's collection is truly fabulous. It's going to be the Oregon Art Museum's crown jewel, that's for sure. The Met would be happy to have it," Dante was saying. "Nineteen paintings and seven drawings. The paintings aren't that distinguished, but the drawings are exceptional. They told me he paid nearly seven million for the lot, and I'm thinking he got a bargain. There is a black chalk study of an infant's head that's just enchanting. And a beautiful pen and ink study of a seated female figure. And a sketch that I think may have been for an altarpiece that's now in Frankfurt. I wish I would have had more time to really look at them. What the director and Allen really wanted to talk about wasn't the art itself, but how to market it."

Claire flinched inwardly at every mention of Allen Lisac's name. "Market it? Isn't this supposed to be about the art?"

"I think they've moved beyond that. They kept asking me about how I would display them, what the initial marketing plan would be, what interactive events we could stage, et cetera, et cetera. When this wing opens, they want it to feel like the one must-see event of the year, not just for people in Oregon, but for art lovers all over America. The idea is to have something so crowded that only a limited number of tickets can be sold every hour. Something people will actually camp in line for. So that simply getting in to the new wing will be an event in itself, you know, with the TV cameras panning over the long lines, so that even people who normally never go to art museums will know they have to see this."

Doubt nibbled at Claire. "But is that the kind of thing you want, Dante?"

"I don't know if it matters what I want. That's what everyone wants now, a marketing plan, not a discussion of the scholarship. Museums are hurting for money like everyone else. Without money, they say they can't afford scholarship. Big museums today aren't necessarily about study. It's just as much about entertainment and politics. Spectacle has overwhelmed serious scholarship. Take the Jackie O. exhibit we had. It was ostensibly about her style, but it was more about the woman. And how much of it was about art at all? A blockbuster exhibition can underwrite a lot of scholarship, just like a blockbuster potboiler can underwrite the same publisher's putting out more scholarly works."

Claire said, "In some ways, don't you have to give people what they want? or in the case of the Jackie O. exhibit, you just know someone is going to do it, so it might as well be you. I mean, there's a place for both things, isn't there?"

"I think most museums are afraid they are in danger of being forgotten. So they court attention any way they can. Do you think anyone was really sorry when Guiliani denounced the Virgin Mary painted in elephant dung at

that Brooklyn show a while back? Far from it. When he started talking about obscenity and an outrage and threatening bans, a whole lot more people were suddenly willing to line up for three hours to see it. A scandal can be the icing on the cake."

Claire looked at her watch. In less than half an hour, she would be face-to-face again with the Lisacs—and she didn't know whether they would recognize her or not. Should she just keep quiet and hope that she went unrecognized? Or should she confess now, before she got into even worse trouble? Dante had asked her not to go with Charlie, and she had gone. Claire knew that he would consider her betrayal compounded if he learned about it from the Lisacs over dinner.

She interrupted him in midsentence. "There's something I need to tell you about before we go to Mercury."

Dante looked at her for a long moment, then sat back in his chair and folded his arms.

Deciding this was a bad sign, Claire poured herself a fresh glass of beer before she began. "It's about the Lisacs," she said, after taking a long sip.

He pressed his lips together, then opened them only wide enough to say, "You didn't."

It wasn't really a question, so Claire didn't answer it. Instead, she took another swallow of beer and tried to make a fourth ring on the table even as the others faded away.

Dante leaned forward. "You went to their house? Claire, this is the man whose collection I'm hoping to oversee. Are you trying to throw a wrench in the works? This is going to be very awkward."

"But I never gave my name. And I wore a disguise."

"A disguise! You sound like a child who thinks if she closes her eyes no one else can see her."

"They didn't even talk to me, just Charlie." Claire tried to sound innocent. "Are you saying you didn't want me to return Allen Lisac's ex-fiancée's ring, one that had been in the family for generations?"

"I'm not saying that, and you know it." Dante's tone was exasperated. "But Charlie could have gone over by herself. You should have just stayed out of it."

"Charlie asked me to go along. It was very important to her. She wanted me to be with her to see how they reacted when they saw the ring." Claire leaned forward. "Dante, there was a lot of blood on Elizabeth's head. Even though she fell after they cut her down, dead people don't bleed. That means whatever happened to Elizabeth must have happened *before* she died, not after. Maybe she didn't kill herself at all. Maybe someone strung up Elizabeth's body after she was already dead."

Dante's arms were still crossed. "Claire, are you sure it's really possible for Charlie to remember a little detail about something that happened decades

ago? And I'm sure the whole event was very confusing and upsetting for her. I can't even remember what happened last week."

"Charlie's memory is probably better than both yours and mine together. And she remembers things that happened decades ago as if they were yesterday."

"Yeah, but how do you know her memory is exact? This was more than fifty years ago." With exaggerated enunciation, he added, "Five-zero. If it was a murder, why didn't they pick up on it then?"

"Charlie says the police were never called, just the funeral home. Allen Lisac's father called in a few favors and had it all hushed up." Without quite remembering how it had gotten that way, Claire realized her beer was gone. She reached for the pitcher and poured another glass.

"It's still been fifty years. What can anyone prove now? It's not like there's a crime scene anyone can investigate. You've got no clues, beyond this ring showing up in the wall and Charlie's brand-new hunches."

"That's not true!" Claire set her glass down with a thump that was harder than she had intended. "Nova says Elizabeth was pregnant! That might have given Allen Lisac a reason to kill her."

"Who's Nova? And how does she know Elizabeth was pregnant? And why would that make Allen Lisac the killer? You said she was his fiancée."

"One possibility is that Allen Lisac got mad at Elizabeth when she turned up pregnant. But Howard's theory is that the killer was a thief."

"Who's How—" Dante started to ask, then stopped in midsentence. "Claire, listen to yourself. You're not making sense. Are these little bits of fifty-year-old hearsay enough to mess up my one chance to live in the same city as you? Is it that you don't want me to come to Portland, but you can't think of a way to tell me, is that it?" His expression was no longer angry, but pained.

Claire didn't want to screw up the chance for Dante to get this job. Or did she? Her thoughts were about as clear as creamed corn. What would happen to them if Dante did move here? Dante had told her it was common for curators to move from museum to museum to climb the ladder, but still, Claire was sure he wouldn't have looked twice at this job if it weren't for her. If he came here, would he grow to resent her for taking him away from his home? For his moving from a bustling city to one where the streets of downtown were deserted after ten at night? Was part of her secretly hoping that he wouldn't get this position, that they could continue their long-distance romance, not put it to a test she wasn't sure they could pass? If she had to choose between Dante in New York and no Dante at all, Claire knew which she would pick.

She didn't answer Dante's question, just reached forward and hooked the plastic handle of the beer pitcher instead. When she tilted it, she was surprised to find it held only enough beer to fill her glass halfway.

Dante heaved an exasperated sigh. "So, did Charlie lose any more contemporaries back during the Korean War? Were there any more suspicious deaths? Or just this Elizabeth's?"

It wasn't a matter of "just," Dante knew that. "Only her," Claire muttered. She knew she sounded sullen, but she couldn't help it.

"So it's not like you're hot on the trail of a serial killer. My guess would be that whoever did it—if someone did it, which I still think is questionable—has probably already paid the price. I can't imagine that you could kill someone and just forget all about it and go on to live a happy life." Dante shook his head. "And more than likely, whoever did this—if anyone did—is dead themselves after all this time."

"Let the dead bury the dead, is that what you're saying?" Claire drained the last of her glass and then looked longingly at Dante's, which was still three-quarters full.

"I'm just saying that sometimes a cigar is just a cigar. You're letting your imagination run away with you. I just don't understand how you could put some dead girl above everything we've talked about."

Claire found herself becoming angry, even though part of her knew she was over-reacting. It wasn't loyalty to a dead woman she would never know, could never know. "It's not Elizabeth I owe something to. It's Charlie. And if you don't understand that, you don't understand me."

MARTHA GIES

The stories and essays of Martha Gies (1944–) have appeared in such publications as Zyzzyva, The Sun, *and* The World Begins Here: An Anthology of Oregon Short Fiction. *She is the recipient of several grants and awards, including the* PEN *Syndicated Fiction Award. Gies teaches creative writing at Lewis & Clark's Northwest Writing Institute and at Traveler's Mind, an annual summer writing workshop in Veracruz. In* Up All Night *(2004), Gies explores nocturnal Portland to profile its night workers, from a baker and nude dancer to a longshoreman and zookeeper. In this essay, she acquaints readers with a Mexican immigrant who works night shift as a janitor at the Rose Garden arena.*

Obdulia at the Rose Garden

Traffic is stop-and-go on NE Broadway as people pour out of the huge sports arena. Every lane is jammed and the dark street glows red with brake lights. Crowds of pedestrians jaywalk between the cars, swarming to distant side streets where the parking is free. As traffic lurches forward, carrying away the exhilarated spectators, another group of people quietly enters the Rose

Garden and goes to work. These are the janitors, and all thirty of them are from Mexico.

One of them is Obdulia, a dark petite woman, twenty-three, with child-like hands and a voice that rarely rises above a whisper. She speaks Spanish, the language her parents share, though her father's first language is *cholcolteco,* a Mixtec dialect.

She doesn't know English, but working here at the sports arena, she has learned to recognize *Portland Trail Blazers (basquetbol)* and *Winterhawks (hockey).* In March, *el cantante* Billy Joel sang here. The concrete floor of the arena was *helado* for "Disney on Ice." Sometimes they bring *tierra* into the arena. Afterwards, big machines go through, scooping it all back up.

"I know they use the dirt for some kind of truck races," Obdulia says in Spanish, "but I don't know what they call them. They don't let us in to see them."

Obdulia does not attend any of the events. The tickets are expensive.

Tonight, as always, she is sleepy when she begins her shift. She's had only three hours of sleep and she feels the exhaustion in her feet, her back, her shoulders, her eyes. How easy it would be to just collapse on the floor, curl up in a quiet corner and go to sleep. But no. Her unit of eight workers is assigned the fourth floor, where they will clean *las oficinas,* as Obdulia calls them. She does not understand the purpose of seventy private rooms in an entertainment complex, but she does not ask questions. Each of these rooms has a wet bar and a private bath with television. A glass wall permits a view of the arena, and on the other side of the glass there are twelve seats in a private box. Obdulia begins by picking up the trash that litters the bar, counter top, and coffee table, and putting it in a big bag of clear plastic.

"It is very hard because they call us in to work different schedules every day. Sometimes they call us to go in at eleven at night. They let us know two hours beforehand. *Es muy difícil.* Sometimes they won't find me at home. Sometimes I have to run to leave off my son and get myself to work."

Her son, Oscar, is a healthy, pudgy two-year-old.

"He stays with the *señora*—I have to get all his food together—and I get him in the morning. I pay her ten dollars each time I leave him. I earn $6.50 an hour.

"Night work, they pay us once a month. I get about nine hundred dollars. I work with my sister as well, cleaning houses with her during the day. Even with the two arenas, the work isn't every night. There are some nights when I clean the arenas after I've cleaned houses all day.

"My friend, Susy, first brought me into this work. She went and put in an application, and they called her. She took me in and showed me how to apply and we just stayed on and worked.

"The houses are through my sister. She met some woman and told her she'd clean her house, and then met some of her friends. My sister speaks

English and does the driving, buys the cleaning supplies, everything. So she gets most of the money and pays me *el mínimo.*"

Cleaning houses, Obdulia works Tuesday through Saturday. "On Monday, I shop and wash. I've learned to use the buses. The laundromat is *lejos,* almost to the other Fred Meyer, up on Lombard.

"With the night work, it is hard sleeping in the daytime. Sometimes I arrive home at eight, seven, six in the morning. Then I have to go pick up Oscar. I come home and I can't get to sleep because of my son. I can't sleep with him running around. I can't leave him with the *señora* because I'd have to pay for that day, too."

When they are permitted a small break, Obdulia goes outside for a moment to see if the cold air won't wake her up. She stands on a concrete fourth-floor terrace, the outdoor smoking area for this floor, and looks out into the dark. Unlike her village, where there is always plenty to see in the sky, there are never many stars here in Portland. Obdulia grew up in the Mixteca, the rugged Oaxacan countryside where people live in small, scattered settlements. There her family struggled to grow subsistence crops in impoverished or eroded *tierra.*

"Oscar was born here, so he is *un ciudadano.* The truth is, I have no idea if I can become one. I wouldn't want to be turned down, but, sure, I'd like to be legal.

"It's difficult to work without papers. There's no problem cleaning houses because we don't work through a company. But the night work, that's through a company. All of us on staff have our so-called 'social security.' "

But because the social security numbers are not valid, people in Obdulia's situation cannot open a bank account.

"Sometimes when you go to rent an apartment they ask for a social security card. Even for an apartment! *No es fácil.*" Obdulia currently pays $475 a month for a small one-bedroom in north Portland. "*La verdad es,* I can barely pay the rent and living expenses," she says.

As she and Susy are letting themselves into yet another suite, Obdulia is told by her unit leader that they will be sent down to the arena, where they are short of help tonight. They take the elevator to the first floor and check in with the supervisor of that unit, a young man from a small town in Guerrero. He dispatches Obdulia to the top of the bleachers, and she makes the wearying ascent.

In the high reaches of the bleachers, she turns to look out over the catwalk and platform suspended 105 feet above the arena floor. From steel trusses hang wires, cables, metal bars, hinges, platforms, great chrome brackets and braces. But tonight, Obdulia sees something else has been added—rings, ladders, ropes, trapezes, harnesses, and nets dangle high in the night. Below, in one corner, she makes out the silent bandstand with its painted gold facade.

She stoops to pick up straws, popcorn, boxes, candy wrappers, and col-

orful candies—*popotes, palomitas, cajas, papeles de dulces, y dulces de muchos colores.* The floors are concrete, and the red cloth seats snap closed—unless they are broken. First the trash, then sweeping with a short-handled black broom.

"I would like to work with people who speak English because I never have. I could practice speaking. In Mexico, I had just six years of schooling, *básica,* and they didn't teach me much.

"For Oscar there are a lot of opportunities. Here one doesn't pay for school. I would work so he could study. I think he can go when he's four. I don't know much about it, but I can ask when I go to *la clínica.*

"What luck that Oscar has never been sick, because otherwise I wouldn't be able to work. He helps me a lot by not getting sick."

She kneels down to scrape up a wad of chewing gum that has been ground into the floor. The broom, which she leaned against a seat, slides to the floor.

"In Mexico, I came from a ranch, a small village, without light in the streets, with small houses there. Nochixtlán is maybe three hours away and it's larger.

"In the village, there are like maybe fifty or seventy houses, but all very spread out. There are ranches, trees, mountains. We raise *maiz, frijoles,* wheat, potatoes, and that's about it. String beans, but only when it rains. I grew up there, and my mother is still there." She is hit with a strong sense of her mother. She could be home with her mother in Mexico. Sometimes she thinks that's what she wants. "But not to be married. Anyway, I don't think so. Maybe it would just be more work."

When Obdulia was sixteen, she moved to Mexico City, where an older sister was already living with her husband. "I went with them to work because there's no work in the village," she says, "nor in Nochixtlán either." In the city, she worked for five years as a domestic.

"I would start at six in the morning by washing the cars. I'd feed the dog, then start cleaning and dusting. I prepared meals, made beds, and washed. It was the same routine every day. I worked until eight at night and I had my own bedroom. On Saturday and Sunday, I went to the house of my sister. They lived on the outskirts of the city, toward San Pedro, in the north.

"In Mexico there's a lot of work, but they don't pay anything," Obdulia observes. She was frustrated because she couldn't earn enough to help her parents.

"I had a sister who'd been living in the United States for five years. She came home to visit Mexico. She wanted the family to come to Portland with her. She said there was work.

"I wanted to come, but the journey frightened me. I came alone with my cousin, Leticia. It was expensive and it was dangerous, being two women crossing. *Está muy feo el camino.* We came through Tijuana. Really bad.

"We were ten people walking in the night. In the day we hid under

bushes. It was eight days crossing *El Cerro de las Águilas*. One whole day we had nothing to eat. The *coyote* was a kind man, but the journey was scary because of *la migra*. I was used to walking in the hills at home so I wasn't afraid of animals. I was afraid only of the border patrol."

Although she didn't know it, Obdulia was one month pregnant when she came across. She had gone home to her village to say goodbye to her parents and an old boyfriend. "That's when I got pregnant with Oscar."

"In Portland, I gave birth at the hospital on the hill. I told the father on the telephone, but he didn't want to come. So now my thinking is that he just won't have anything of Oscar. When Oscar turns eighteen, I'll tell him who his father is."

"Anyway, I arrived in Portland in January of 1997 and began working that same month. I worked in the country in a *nursería*. It was small potted trees, fruit or flowering trees. I didn't care for it but I stayed with it because *necesité el dinero*."

Needing the money, she worked until she was eight months pregnant, then quit the nursery and went to work cleaning houses with her sister until she delivered. After she had Oscar, the family made it possible for her to take four months off. "Then I went back to work with my sister."

Break time. Obdulia leaves her cleaning supplies and goes to the event level floor, where she retrieves her lunch from a blue plastic locker. In the employee break room, she doesn't spot Susy, and so she sits at a long metal table with a group of girls from Michoacán. They are talking about how they must be careful when they are using *los líquidos* because some have fumes and some are not supposed to touch the skin. Obdulia remembers how confused she was when she first saw at the grocery store all the chemicals available for cleaning.

"I had a lot to learn. In a lot of *las casas* we had to use different products on different types of furniture, in order not to damage them. Now I've learned to read the names on the labels."

She unwraps cold *tortillas* and eats them with *frijoles*. She has one piece of chicken, and she saves it for last. When lunch break is over, she stuffs the empty plastic bag into her jacket pocket. She can use it again tomorrow. She has heard that they have only *dos horas más* to clean, and she hopes that it's true. She's sent now to mop around the red arena seats with a string mop and an industrial mop bucket on wheels.

Trudging back to the upper level, she realizes eating has made her feel even sleepier. She fights the temptation to sit down on one of the cloth-covered seats. For just a moment, she closes her eyes. Opening them again, she sees the trappings of the circus far below. She saw a circus once in Mexico. She would like to bring Oscar to see one. She pictures his black eyes wide, sees him tossing up his hands in delight.

Amidst great sweeps of violet and silver light, an elegant black man wearing a top hat revolves on a high platform in el centro. *He is singing, and the music pounds dramatically. Gold sequins cover the lapels of his white tuxedo and spangle his coat, vest, and hat.*

A black mare trots jauntily in a circle with her head down. Her flowing tail as thick and shiny as Obdulia's grandmother's hair. A yellow-haired man rides her plump broad back, tossing balls into el aire.

Six white stallions, their black bridles studded with jewels, prance in formation, white plumes waving above their heads and shoulders. A tall, slim woman in a gown of powder blue cracks un látigo *over them, and they canter in a line,* CRACK, *now reverse,* CRACK, *now run in pairs,* CRACK, *now six abreast and, for a grand finale,* CRACK, *stand up on their hind legs, walk forward and take a bow, as her whip swirls above their nervous backs.*

Strobes of saffron, rose, and tangerine illuminate the wires high above the arena floor, where handsome white-toothed men in satin pantalones *are poised tense and ready, like constellations yet to be named.*

Far below, in the shadows, big cats pace their cages, waiting in the dark. Metal doors slam open and shut, and the solid flanks of Bengal tigers leap into the light of the center ring. White-throated, los tigres *yawn, preen, snarl, and bare their teeth.*

Fourteen velvet elefantes *with drowsy, bruised eyes turn circles on pedestals and then do headstands, their wrinkled flesh falling forward. Draped in gold and white tapestry, they line up by size, front feet positioned on the back of the larger elephant in front. For a finale, they trot in a linked chain, trunk to tail. Behind one small elephant, a clown runs with shovel and scooper.*

Los deshechos de los elefantes, Obdulia laughs to think. Glad that she doesn't have to clean that up, she goes back to her mopping, back to her other dreams.

"When I'm thirty, si *Dios quiere,* I'll speak English, and learn to drive, and have a good job. I'll clean several houses, or work with another company where it's easier. As Oscar gets a little older, maybe he'll settle down a little and I can devote myself to getting more things done."

It's quarter to five when the janitors finish cleaning the Rose Garden. They bring the *escobas* and *recogedores* to the maintenance office where they'll be stowed away until the next night.

Outside, the air is fresh. Her friend, Susy, drives Obdulia back to her neighborhood in north Portland, letting her off at the apartment of the *señora,* only a block from where Obdulia lives.

The woman lets her in, and Obdulia can smell coffee. She stands over the couch where her son sleeps and, without her saying a word, he opens his eyes. Seeing his mother, he tosses up his hands in delight, his black eyes wide.

KATHLEEN DEAN MOORE

A native Ohioan, Kathleen Dean Moore earned a B.A. at Wooster College and a Ph.D. in philosophy at the University of Colorado in Boulder. She teaches environmental ethics and the philosophy of nature at Oregon State University, where she is distinguished professor of philosophy and founding director of the Spring Creek Project for Ideas, Nature, and the Written Word. Raised with a strong environmental ethos, Moore has written extensively about the natural world, exploring people's cultural and spiritual connectedness to wild places. Her works include Riverwalking: Reflections on Moving Water *(1995), winner of Pacific Northwest Booksellers Association Book Award;* Holdfast: At Home in the Natural World *(1999), winner of the Sigurd Olson Nature Writing Award; and* The Pine Island Paradox *(2004), winner of the Oregon Book Award. She is also the author of* Pardons: Justice, Mercy, and the Public Interest, *a book about forgiveness and reconciliation. Moore's essays have appeared in* Orion, Discover, Audubon, North American Review, Hope, *and* Field & Stream. *In this excerpt from* Riverwalking, *Moore gives her take on the Willamette River.*

The Willamette

I wanted my daughter to lie in the tent, pressed between her brother and her father, breathing the air that flows from the Willamette River at night, dense with the smell of wet willows and river algae. I wanted her to inhale the smoke of a driftwood fire in air too thick to carry any sound but the rushing of the river and the croak of a heron, startled to find itself so far from home. I wanted the chemical smell of the tent to mix with the breath of warm wet wool and flood through her mind, until the river ran in her veins and she could not help but come home again. That is why, on the weekend before my daughter left for Greece, I made sure that the family went river-camping on the Willamette. . . .

By the time we got all our camping gear stowed away in the drift-boat, it was late afternoon. In the shadows of the riverside cottonwoods, the air was cold and sharp. So we drifted along the eastern bank of the river, glad for the warmth of the low light. We pulled up onto the gravel beach of an island thick with willows and set up the tent on a pocket of sand.

After supper, my daughter and I walked down the shore. We wore high black rubber boots and walked sometimes in, sometimes out of the water, the round rocks grinding and rolling under our feet. Far ahead, a beaver slapped its tail against the river. We talked quietly—about her visa, about loneliness, about how the skyline of the distant coast range seemed to glow in the dark.

Fog thickened the darkness, so even though it wasn't late, we turned back toward our supper fire. We didn't talk much on the way back, but we sang like we often do along the edge of a river, where the density of the air and the rush of the river make

the music rich and satisfying. We sang the Irish Blessing—my daughter sang the soprano part—and we did fine, the river singing the bass line, the rocks crunching under our boots, until we got to the last blessing: May the rain fall softly on your fields. Then I couldn't do it any more. I sent my daughter back to the fire alone. I lay facedown on the round rocks and cried until the steam from my lungs steeped down into the dried mud and algae, and the hot breath of the river rose steaming and sweet around my face.

Maybe the homing instinct is driven by traditions: hanging Christmas stockings each year on nails pushed into the same little holes in the mantel. Maybe it is driven by smells or tastes or sounds. But maybe the homing instinct is driven only by fear. On the road, at dusk and away from home, the foreboding, the oppression of undefined space, can be unbearable. Pioneers knew this dread; they called it *Seeing the elephant.* Starting out, the wide open spaces were glorious—the opportunities, the promise, the prairie, all fused with light streaming down from towering clouds. Then suddenly the clouds became an elephant, a mastodon, and the openness turned ominous. The silence trumpeted and the clouds stampeded. Dread blackened the edges of the pioneers' vision. They saw the elephant and turned their wagons around, hurrying through the dusty ruts back to St. Louis. They had to go back. They had to get home.

The French existentialists knew that feeling: *la nausée*, existential dread. The pioneers—they, we—walk out into a world we think makes sense. We think we understand what things are and how they are related. We feel at home in the world. Suddenly, without warning, the meaning breaks off the surface, and the truth about the world is revealed: Nothing is essentially anything. The prairie gapes open—"flabby, disorganized mass without meaning," Sartre said. Pioneers can create meaning by their decisions, but those decisions will be baseless, arbitrary, floating.

This discovery comes with a lurch, thick in your stomach, like the feeling you get when you miss a step on the stairs. When the feeling comes over you, you have to go home, knowing that home doesn't exist—not really, except as you have given meaning to a place by your own decisions and memories.

Robins singing woke me up in the morning, a whole flock of robins at the edge of the Willamette. Each robin was turned full into the sun. I climbed out of the tent and sat cross-legged on the gravel, my face turned toward the warmth, my eyes closed, bathed in pink light. Soon my daughter, in long underwear and rubber boots, ducked out of the tent and walked into the river to wash her face. She scooped up a pot of river water and carried it to the kitchen log to boil for tea. Crossing to the campbox, she rummaged around inside until she found matches, scratched a match against a stone, lit the stove, and set the teapot on the burner. Then she sat on the

broad log in a wash of sunlight, pulling her knees up to her chest and tilting her face toward the light. Her hair, in the sun, was as yellow as last winter's ash leaves in windrows on the beach.

Scientists say that a wasp can leave its hole in the ground, fly from fruit to fruit, zigging and zagging half the day, and then fly straight home. A biologist once moved the three rocks that framed a wasp's hole and arranged them in the exact same pattern, but in a different place. The wasp landed between the rocks, right where its hole should have been, and wandered around, stupefied.

My three rocks are the Willamette River. Whenever I walked out of the airport, coming home from a visit to my father's house, I could smell the river, sprayed through sprinklers watering the lawn by the parking lot. The willow-touched water would wash away the fumes of stale coffee and jet fuel and flood me with relief. This is what I want for my daughter.

DONALD MILLER

Donald Miller (1971–) is originally from Houston. His life in Portland is both a departure from and an ironic engagement with his past, and he credits the spirit of the city for shaping his faith and his politic. A postmodern Christian who renders a spiritual Portland in his writing, Donald Miller wrote Blue Like Jazz: Nonreligious Thoughts on Christian Spirituality *(2003) as an autobiographical account of the city and the philosophical implications of a jazz musician's solo saxophone performance outside the Bagdad Theater. The first excerpt from* Blue Like Jazz *considers the culture of Reed College, and the second describes his communal household in Laurelhurst, across from a statue of Joan of Arc.*

Shifts

Some of the Christians in Portland talk about Reed College as if it is hades. They say the students at Reed are pagans, heathens in heart. Reed was recently selected by the *Princeton Review* as the college where students are most likely to ignore God. It is true. It is a godless place, known for existential experimentation of all sorts. There are no rules at Reed, and many of the students there have issues with authority. Reed students, however, are also brilliant. Loren Pope, former education editor for the *New York Times*, calls Reed "the most intellectual college in the country." Reed receives more awards and fellowships, per capita, than any other American college and has entertained more than thirty Rhodes scholars.

For a time, my friend Ross and I got together once each week to talk

about life and the Old Testament. Ross used to teach Old Testament at a local seminary. Sometimes Ross would talk about his son, Michael, who was a student at Reed. During the year Ross and I were getting together to talk about the Old Testament, I had heard Michael was not doing well. Ross told me Michael had gotten his girlfriend pregnant and the girl was not allowing him to see the child. His son was pretty heartbroken about it.

During his senior year at Reed, Ross's son died by suicide. He jumped from a cliff on the Oregon coast.

After it happened, Ross was in terrible pain. The next time I got together with him, about a month after the tragedy, Ross sat across from me with blue cheeks and moist eyes. It was as if everything sorrowful in the world was pressing on his chest. To this day, I cannot imagine any greater pain than losing a child.

I never knew Michael, but everybody who did loved him. The students at Reed flooded his e-mail box with good-bye letters and notes of disbelief. Through the years after Michael's death, even after Ross and I stopped meeting because I moved across town, Reed remained in the back of my mind. Not too many years went by before I started thinking about going back to school. I wasn't sure what to study, but I heard Reed had a terrific humanities program. I am a terrible student. I always have been. Deadlines and tests do me in. I can't take the pressure. Tony the Beat Poet, however, told me he was considering auditing a humanities class at Reed: ancient Greek literature. He asked me if I wanted to join him.

At the time I was attending this large church in the suburbs. It was like going to church at the Gap. I don't know why I went there. I didn't fit. I had a few friends, though, very nice people, and when I told them I wanted to audit classes at Reed they looked at me as if I wanted to date Satan. One friend sat me down and told me all about the place, how they have a three-day festival at the end of the year in which they run around naked. She said some of the students probably use drugs. She told me God did not want me to attend Reed College. . . .

I felt alive at Reed. Reed is one of the few places on earth where a person can do just about anything they want. On one of my first visits to campus, the American flag had been taken down and replaced with a flag bearing the symbol for anarchy. As odd as it sounds, having grown up in the church, I fell in love with the campus. The students were brilliant and engaged. I was fed there, stimulated, and impassioned. I felt connected to the raging current of thoughts and ideas. And what's more, I had more significant spiritual experiences at Reed College than I ever had at church.

One of the things I cherished about Reed was that any time I stepped on campus I would find a conversation going about issues that mattered to me. Reed students love to dialogue. There are always groups of students discuss-

ing global concerns, exchanging ideas and views that might solve some of the world's problems. I was challenged by the students at Reed because they were on the front lines of so many battles for human rights. Some of them were fighting just to fight, but most of them weren't; most of them cared deeply about peace. Interacting with these guys showed me how shallow and self-centered my Christian faith had become. Many of the students hated the very idea of God, and yet they cared about people more than I did.

There were only a few students on campus who claimed to be Christians. Though I was only auditing classes, I was accepted into this small group. We would meet in the chapel to pray each week or hold Bible studies in one of the dorm rooms. It was very underground. Secret. There has always been a resistance to Christianity on the campus at Reed. The previous year, a few Christians made a small meditation room on campus on Easter Sunday. They simply turned down the lights in a room in the library, lit some candles, and let students know the room was there if anybody wanted to pray. When Easter morning rolled around, students decided to protest. They purchased a keg of beer, got drunk, and slaughtered a stuffed lamb inside the meditation room.

The perspective the students in our group had about the event was Christlike. They were hurt, somewhat offended, but mostly brokenhearted. The event was tough on our group. We did not feel welcome on campus. But I learned so much from the Christians at Reed. I learned that true love turns the other cheek, does not take a wrong into account, loves all people regardless of their indifference or hostility. The Christians at Reed seemed to me, well, revolutionary. I realize Christian beliefs are ancient, but I had never seen them applied so directly. The few Christians I met at Reed showed me that Christian spirituality was a reliable faith, both to the intellect and the spirit. . . .

I moved in with five other guys about a month after talking with Rick. We found a house in Laurelhurst, one of the houses on the traffic circle at 39th and Glisan. We lived across the street from the giant statue of Joan of Arc. You'll see the statue if you come to Portland.

I liked it at first. It was a big house, and I got the best room, the room with all the windows. My room literally had windows on every wall, about ten windows in all. It was like living in a green house. I set my desk in front of the huge window that looked down on the traffic circle and the statue. My friends used to drive around the circle and honk when they went by. I always forgot I lived in a glass room so I would pull my finger out of my nose just in time to wave back. I went from living in complete isolation to living in a glass box on a busy street.

One of the best things about living in community was that I had brothers for the first time ever. We used to sit on the porch and watch cars go around

the roundabout. We used to stare at the statue of Joan of Arc and wonder, out loud, if we could take her in a fight.

I have a picture on my desk of the six guys at Graceland, which is what we named the house. People thought we named the house Graceland because we wanted it to be a place where people experienced God's grace and unconditional love. But we didn't think about that till later. We really named it Graceland because that was the name of the house Elvis lived in, and, like Elvis, we were all pretty good with the ladies.

The picture on my desk is more than a picture of six guys; it is a picture of me in my transition, not a physical transition but more of an inner shift from one sort of thinking to another. I don't look all that tired in the picture, but I remember being tired. I remember feeling tired for almost a year. I was tired because I wasn't used to being around people all the time.

The picture was taken on the porch. We were all smoking pipes. I was wearing a black stocking cap, like a beat poet or a bank robber. Andrew the Protester, the tall good-looking one with dark hair and the beard, the one who looks like a young Fidel Castro, was the activist in our bachelor family. He is the guy I told you about with whom I go to protests. He works with the homeless downtown and is studying at Portland State to become a social worker. He is always talking about how outrageous the Republicans are or how wrong it is to eat beef. I honestly don't know how Andrew got so tall without eating beef.

Jeremy, the guy in the Wranglers with the marine haircut, is the cowboy in the family. He always carries a gun. You'd think Andrew and Jeremy would hate each other because Andrew opposes the right to bear arms, but they get along okay, good-natured guys and all. It is a shame because that would be a great fight. Jeremy wants to be a cop, and he went to college on a wrestling scholarship, and Andrew is a communist. I would try to get them to fight, but they liked each other.

Mike Tucker, whom we all refer to as Tuck, was the older brother in the clan, the responsible one. He is the one with the spiked red hair, like Richie Cunningham fused with a rock star. Mike was a trucker for years but always dreamed of a career in advertising. He moved to Portland and started his own advertising agency with just a cell phone and a Web site. He posed nude on his brochure, which got him gigs with Doc Martens and a local fashion agency. He freelances every other day and drives trucks the rest of the time. Mike is one of my best friends in the world. Mike is one of the greatest guys I know.

Simon, the short good-looking guy with the black hair and sly grin, was the leprechaun of our tribe. He's a deeply spiritual Irishman here for the year from Dublin. Simon is a womanizer, always heading down to Kell's for a pint with the lads or to the church to pray and ask God's forgiveness for his detestable sins and temper. Simon came to America on a J-1 visa. He

came to Portland, specifically, to study our church. He wants to go back to the homeland and start a Christian revival, returning the country to its faith in Jesus, the living God. After that, he wants to unite men and take England captive, forcing them to be slaves to the Irish, the greatest of all peoples, the people who invented honor, integrity, Western civilization, Guinness and, apparently, peanut butter and the light bulb.

Trevor, the young guy in the picture, looks like Justin Timberlake, like the lead singer of a boy band. He has tight hair that curls just out of the shoot, and he's died it blond. Trev is the kid, the rookie on our team of misfits. He is just out of high school a few years and rides a Yamaha crotch-rocket motorcycle so fast that when he lets me drive it, I can hardly keep the front wheel on the ground. He is a learner, with a solid heart like a sponge that absorbs, and he wants to become a very good man. Trevor is one of my favorite people. He is my Nintendo buddy. We yell profanities at each other while playing NFL Blitz. I usually win because he is slow with the fingers. Sometimes, after I beat him in the game, he crawls into his little bed and cries himself to sleep. After that I usually feel sorry for him, and I let him win a game or two. Rookie.

CHUCK PALAHNIUK

Born and reared in eastern Washington, Chuck Palahniuk (1962–) graduated from the University of Oregon in 1986 with a degree in journalism and moved to Portland. Active in the Cacophony Society, an anarchic-surrealist "network of free spirits," Palahniuk has worked various jobs in the city, from diesel mechanic to hospice volunteer. His writing career took off with the publication and eventual film adaptation of his first novel, Fight Club *(1996). The novel, which soon achieved cult status, was followed by* Invisible Monsters *(1999),* Survivor *(1999),* Choke *(2002),* Lullaby *(2003),* Diary *(2004), and* Haunted *(2005). Palahniuk is also the author of two nonfiction works,* Stranger than Fiction: True Stories *(2005) and* Fugitives and Refugees: A Walk in Portland, Oregon *(2003). His "transgressional fiction" is known for its disturbed, alienated characters. He has twice won the Pacific Northwest Booksellers Association Award and Oregon Book Award for Best Novel. In this selection from* Fugitives and Refugees, *Palahniuk examines the sex industry in Portland.*

Getting Off: How to Knock Off a Piece in Portland

"The jig's up—people are having sex in Portland," says Teresa Dulce. An advocate for Portland's sex workers and the publisher of the internationally famous magazine *Danzine,* Teresa says, "Instead of fighting the inevitable, let's try to prevent unwanted pregnancy and disease."

Teresa sits in the Bread and Ink Café on SE Hawthorne Boulevard, eating a salad of asparagus. Her eyes are either brown or green, depending on her mood. Since her car broke down outside of town in 1994, she's been here, writing, editing, and performing as a way to improve working conditions in the sex industry.

With her pale, heart-shaped face, her thick, dark hair tied back, she could be a ballet dancer wearing a long-sleeved, tight black top. With her full Italian lips, Teresa says, "The sky has not fallen when there's been trade before. There are plenty of guys who just want to knock off a piece and are grateful for sex. If there were as many of us getting raped and killed as people say, there wouldn't be a woman left standing on the street."

Ordering a glass of white wine, she adds, "Sex work *does* exist. It's going to exist with or *without* our permission. I'd just like to make it as safe and informed as possible."

According to history, Teresa's right. Sex work has always existed here in Stumptown. In 1912, Portland's Vice Commission investigated the city's 547 hotels, apartment buildings, and rooming houses and found 431 of them to be "Wholly Immoral." Another eighteen of them were iffy. The investiga-

tion consisted of sending undercover female agents to each business to look around and interview the managers. The resulting vice report reads like a soft-porn romance novel: scenes of naked young women wandering the halls in fluttering silk kimonos. Described as "voluptuous blondes," they strut around in "lace nightgowns, embroidered Japanese slippers and diamonds." Their workplace—called a bawdy house or parlor house—always seems to be paneled in "Circassian walnut and mirrors" and crammed with Battenberg lace, Victrolas, and cut-glass vases and chandeliers. The famous 1912 report refers to these women by their first names: Mazie, Katherine, Ethel, Edith . . . and says they each served twenty-five to thirty different men every night.

These were famous houses like the Louvre at SW Fifth Avenue and Stark Street. Or the Paris House on the south side of NW Davis Street, between Third and Fourth Avenues, a brothel that boasted "a girl from every nation on Earth." Or the Mansion of Sin run by Madam Lida Fanshaw at SW Broadway and Morrison Street, now the site of the Abercrombie & Fitch clothing store.

Richard Engeman, Public Historian for the Oregon Historical Society, says few of those brothels were documented, but the proof is hidden in official records like the census. "When you find forty women living at the same address, and they're all seamstresses, it's a brothel." He adds, "Sure, they're popping off a lot of buttons, but that doesn't make them seamstresses."

In hot weather street bands used to march through the city, leading men back to the bars near the river, thus "drumming up business." Along their routes working women would lean from windows, advertising what was available.

In the vaudeville theaters the actresses and singers would roam the curtained boxes between their acts onstage. Called "box rustlers," they sold beer and sex.

Portland police officer Lola Greene Baldwin, the first policewoman in the nation, attacked Portland's venerable department stores, including Meier & Frank, Lippman-Wolfe's, and Olds & King's, on the accusation that easy credit forced many young girls into debt and trading sex for money. She fought to keep young women from being displayed in parades during the Rose Festival and had the touring comedienne Sophie Tucker arrested for public indecency.

In 1912 an estimated three thousand local women worked as prostitutes, so many that Portland mayor Allan Rushlight campaigned to turn all of Ross Island into a penal colony solely for sex workers.

The moral crusade of 1912 was the city's biggest until the crusade of 1948, and the crusade of 1999, and the crusade of . . . well, you get the point.

It's a business cycle Teresa Dulce's seen since she started dancing at age twenty-three. Pragmatic, frank, and funny, she describes the Portland sex

Lola G. Baldwin in about 1954

industry in slightly more realistic terms than the vice report.

Free speech is so protected under the Oregon State Constitution that we have the largest number of adult businesses in the nation. And, thanks to our free-speech rights, pretty much any type of no-contact nude performance is legal. According to Teresa, Portland (aka "Pornland") has at least fifty nude dance clubs and twenty lingerie studios and shops with fantasy booths. This means a workforce of as many as fifteen hundred women and men make money performing naked. This means you'll see a much wider range of body types, ages, and races than in any other city. . . .

Started by Teresa in 1995, the magazine *Danzine* collects this professional wisdom that sex workers won't find anywhere else. It teaches workers before they have to learn—and maybe die—from their mistakes. *Danzine* is here to tell you—no, you can't tax deduct your tampons, even if you cut the string and wear them while performing. And yes, always wipe down the brass pole before riding it with your newly shaved coochie. One drop of even dried menstrual blood is enough to transmit hepatitis C or possibly HIV.

Danzine and Teresa also run the "Bad Date Hotline," where sex workers post the details of their shitty "dates" and describe the customers for others to look out for. Bad dates range from the bald driver of the silver Porsche

who's HIV positive and demands unprotected vaginal sex to the Honda driver who wears a tie and zaps women with his stun gun.

And the magazine's damn funny. In one feature called "You Know You've Been Stripping Too Long When . . ." Item Number Seven says you're banned from the playground after you teach the local kids how to work the pole. Item Number Ten says you go to the drugstore and automatically pick up your change with your teeth.

At 628 E Burnside Street, Teresa runs Miss Mona's Rack, a store that sells secondhand shoes, clothes, and jewelry, plus razors, condoms, and tampons. It also offers a staggering variety of lubricants, with all profits going to support community job training and risk-reduction programs that teach HIV and other STD prevention.

To date, Teresa says the city continues to increase the size of the prostitution-free zones, in order to arrest more sex workers for trespassing—a worse crime than prostitution. And the city recently tried to impose a raft of licensing regulations on everyone in the sex industry. According to Teresa, the city's effort is first to make money but ultimately to eliminate sex workers. Another irony, since the city also supports growing the local hotel industry and attracting large conventions while denying that conventioneers create and support much of the local sex industry.

In reaction to the new regulations, local sex workers rallied by forming a political action group they called Scarlet Letter. They contacted some seventy escorts through the ads in adult monthly magazines such as *SFX* and lobbied door-to-door in City Hall to convince the government the new law would drive sex workers even further underground, where they'd seek less protection from violence and disease.

On March 8, 2000, after a court battle, Portland's sex workers won an injunction that stops the city from enforcing the law. Now, all the years of organizing fetish parties and magazines have paid off by creating an effective political machine. It's the envy of sex workers nationwide who now want *Danzine's* help to fight similar laws in their own cities.

With her classic Mona Lisa eyes half lidded, her smoker's deep, sultry voice, Teresa Dulce is another example of writer Katherine Dunn's rule about every Portlander living at least three lives.

"Someday, I want to have a child," Teresa says. "I want to live by my own schedule. And I want to change some laws."

MATTHEW STADLER

The editor of Clearcut Press *in Astoria, Oregon, Matthew Stadler (1959–) lives in Portland. Raised in Seattle, he has published four novels:* Landscape Memory *(1990),* The Dissolution of Nocholas Dee *(1993),* The Sex Offender *(1994), and* Allan Stein *(1999). Stadler received the Richard and Hina Rosenthal Award for Fiction from the American Academy of Arts and Letters, the Whiting Foundation Writers Award, the Ingram–Merrill Foundation Award for Fiction Writing, and a Guggenheim Fellowship. His fiction has been widely anthologized, and his literary and social commentary have appeared in the* New York Times Book Review, Village Voice, *the* Seattle Weekly, *and the* Oregonian. *This essay first appeared in* The Stranger *(2004).*

Brown at the Edges with a Chewy White Center

Wax, a new hiphop club in North Portland, is one block off the light rail's Yellow Line, which means that Wednesday evening freestyle dancing attracts kids from suburban Aloha, Hillsdale, and Beaverton—all riding in on the Blue Line—to mix with a somewhat smaller crowd from nearby. The best dancers one recent Wednesday were two Laotian guys from Gresham, an oft-derided sprawl of strip malls in the eastern part of the city, along the road to Boring. The Blue Line goes to Gresham too and it is peopled with Laotian, Vietnamese, Lao, Hmong, Russian, and Latino Portlanders riding east and west to the hives of two-story, cookie-cutter row condos that sit back from the strip highways amidst stunted trees and planters and parking lots. Fewer of the recently arrived live near the city's center.

It is a paradox of most North American cities, and nowhere more so than in Portland, that the nominally urban downtown is home to a narrow elite, while the multitude that makes up the life and future of the city has been shunted to the periphery.

At the Beaverton Transit Center, Spanish is the common language and buses leave every few minutes for the polyglot strips of Beaverton, Hillsdale, and the Tualatin Valley Highway (known, sublimely, as the "TV Highway"). Manila imports, Korean *bulgoki*, Dutch *oliebollen*, taco trucks, nail salons, phone cards, instant credit, barbecue, and prayer candles in a dozen languages rise like a slow tide to fill these endless, outdated strip malls.

Cars flood the landscape; currents of traffic swirl along wide highways. On foot, the terrain is strangely indifferent, like wilderness, and the slow pace reveals an astonishing ecosystem: Behind drainage ditches, patches of meadow and orchard border closely packed rows of gray and white condos; serpentine dikes of bark chips and shrubs shape the terrain; tiny shops,

small as houses, are dwarfed to near invisibility by the gargantuan scale of their neighbors (Home Depot, Best Buy, Bi-Rite), whose signage alone could crush or entirely cover them; there are sudden stands of trees.

The stores are odd, their survival miraculous, like that of small exotic mushrooms. One sells only prayer candles, another incense, spices, and lamb from New Zealand. Another has obsolete computer parts and a pile of comics on a back table. A grocer sells nagelkaas, a special farmers' cheese impregnated with cloves, which he has had flown in from Holland. Along the TV Highway, at the end of a thick stand of condos, there is Rea's Ribs, like a warm cabin in the middle of a lonely wood.

Equipped only with the categories of the 20th century city, one is barely able to engage this plenitude. Is this the city? Here is the multitude, filling the tightly packed apartments and gray condos of Beaverton, the TV Highway, Gresham, and Troutdale—and Renton, Burien, or SeaTac—yet most city dwellers deride it as "the suburbs."

North Portland is polyglot too because it is cheap to live there. Houses that would cost $300,000 to $400,000 if they had risen two miles away, in the Northwest district of the city, go for half that or less in North Portland and so landlords can still rent cheap. There continues to be a mix of rich and poor, new and old, and different ethnic groups, which is entirely missing from the city's more deliberately planned neighborhoods, such as downtown's Pearl District.

In "the Pearl" the city has piggybacked its vision of urban livability onto a grid of disused warehouses and empty lots. As in other North American cities, urban living here seems to hinge on a notion of historical preservation that gets tricky when the past begins to run a little thin. What happened in the Pearl? There was a rail yard and then there were warehouses. The garbage dump might be older and richer in history than these ramshackle buildings, but warehouses suggest artists and artists suggest a whole cycle of change that can imbue a city with the emblems of urbanity.

By the mid-'90s this cycle was started: Artists had begun to colonize the warehouses; lofts would be built out; cafes and shops would gather; and slowly the rich, who are the endpoint of all these revitalizations, would arrive to pay high prices for the residue of a brief history of productivity—that of early-20th-century industry and late-20th-century art.

Instead of waiting and enduring this often-predatory process, Portland developers stepped in and built a kind of pre-gentrified arts district, moving so swiftly that many of the artists and galleries had to be imposed retroactively.

The great success of the Pearl lies in the seamlessness with which designers wove these newly minted tokens of urbanity into the area's scant residue of history. The problem they faced was essentially a sales problem: How

to signal the right things, the grit and brawn of industry plus the grossly enlarged abstract geometries of modern art, while making comfortable digs for an upscale clientele? The answer was largely decorative. History, just like the future, can be built.

Amidst the Pearl's remaining stock of two- and three-story brick warehouses, a loose survey of industrial building types has risen. The twelve-story Gregory (home to film director Gus Van Sant) replicates the step-backed art deco brick of New York's Terminal Sales Building; exposed steel beams wrap the Streetcar Lofts, beneath a great three-story retro neon sign reading "Go by Streetcar." The Brewery Blocks organize new curtain-glassed condos around the dead brick kiln of the brewery. Everywhere, brick, concrete, and raw stone are garlanded with bands of steel, burnished by the welder's flame. I-beams are the new belt-course.

The swiftness and coherence with which this alchemy was completed here distinguishes Portland from almost every other American city, thanks in large part to an unusual developer named Homer Williams. Williams (whose enthusiasm for the personal transport system, the Segway, has led to that company opening its first North American dealership here) is now spearheading an attempt to build a forest of Vancouver style, super-thin glass-and-steel condo towers at the south edge of downtown, on the banks of the Willamette River. A landmark funicular, the biggest and swiftest in North America, will carry residents up the steep hill to work at Oregon Health & Science University (OHSU).

The Pearl carries its fictions lightly, never straining to convince. The whole is coherent, without seeming false. The tram that connects it to downtown and Northwest perfectly evokes an earlier time, simply by being a tram. At the same time, it evokes Europe; the cars are made there, as are the city's light rail trains. Watching them slip across the long black expanse of the Steel Bridge one can't help but think of Rotterdam or Bonn.

The dream that has come true here is that of sleepwalkers lost in nostalgia for an image of the city that is as seductive as it is unreal. The city explodes outward even as planners legislate boundaries and concentrate its cultural institutions in the city center. It is the same in Paris as in Portland: Historic facades are preserved by law; customs become codified as tourist spectacles; bohemian life is conjured in every corner cafe and theater; and all the while the actual poor get pushed further and further into the overbuilt periphery.

On a recent Friday Elizabeth Leach opened her new art gallery in the Pearl. The rooms resemble a fabulous kind of archeological dig in which the bones of an actual warehouse have been brushed clean and tall white walls interposed, like great stiff drapery. The walls shape a series of 12-foot-high cubicle spaces, large linked tanks that, on this evening, were filled half-high with

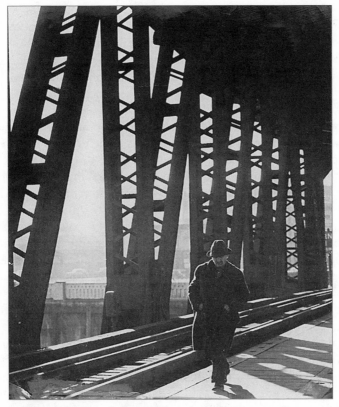

Wallking across the Steel Bridge in 1949

a sea of excited, drunk friends and colleagues. The space was designed by Randy Higgins of Edo.

Bob Frasca was there, the unassuming principal of Zimmer, Gunsel, and Frasca, an architectural firm that has shaped much of Portland's cityscape, from the imposing span of OHSU's V.A. Bridge to the twin glass spires of the city's convention center—a pair of absurd, luminous beacons that, for better or worse, now function as a trademark of the city's skyline. Frasca got his start fresh out of college, designing for the city planning office in the 1970s.

Also present, Camela Raymond, the young founder of the *Organ*, who has recently closed that lively, occasional journal of art in order to take on the real job she's been offered at *Portland Monthly*. This glossy lifestyle magazine, which has rushed to profitability in one short year, is now edited by Russ Rymer, a recent arrival who hopes to fill it with excellent prose.

Raymond hasn't had an office job in years and said she was too tired of sitting to leave Elizabeth Leach's standing-room-only party for the debut of

filmmaker Matt McCormick's new collaboration with James Mercer, of the Shins, scheduled that same night at the Portland Art Museum. Shins fans filled the hall, a crowd that averaged about half the age of the well-to-do drunks at Leach's opening. A popular melodic four-piece, the Shins moved from New Mexico to Portland last summer, apparently drawn by whatever it is that moves youth culture—cheap rents, relocated friends, a buzz of rumors circling the Internet like the rings around Saturn.

The mayor's office, under outgoing Mayor Vera Katz, has groomed those rumors and is assiduously courting what has come to be called "the young creative class," a potential economic engine that has its own needs and tastes. Focus groups were convened by the mayor's office, inviting Raymond and McCormick and their creative brethren to list their wants and needs so the city can satisfy them and keep the kids coming to town.

The whole operation was part politics, part anthropology, and part idealism. The mayor's office wants to create a habitat conducive to the lives and work of young creatives, both to win the city a new engine of prosperity and because it is the right thing to do. The kids were quizzed and sampled and observed and reports were produced. Developers are now at work strategizing ways the city can invigorate new housing without catalyzing the same cycle that got rushed to its logical endpoint in the Pearl.

Typical of Portland—which endeavors to give every partner some of what they want, rather than picking one winner who takes all—local developers have begun exploring new building types that could organize space in ways commodious to young artists, yet repulsive to the rich. That means profitable buildings which nevertheless protect poorer residents from displacement. As an example, housing in the burgeoning East Burnside and Central Eastside Industrial districts might have big common areas, including shared bathrooms and communal kitchens—permanent features that would effectively repel the dreaded rich whose arrival is usually cast by the "creative class" as that of the devil in Eden.

Other solutions have included small grants from the mayor to help artists get something practical done—launch a website, hire an accountant, or advertise their wares. The grants average about $750 and have been useful boosts for dozens of art/business projects in town. What the mayor hasn't done, and perhaps cannot do, is get the rich to buy more art and to buy more adventurously. There is a glut on the market and much of it is good.

The glut was evident at a recent celebration, dedicated to the outgoing mayor, housed in the cavernous box called Memorial Coliseum. This is the former home of Portland's major league sports team, the NBA Trailblazers (another "creative class" the city has always courted) who were given their own new stadium, a lavish monstrosity subsidized by the city and provided rent-free

to their owner, the Seattle billionaire Paul Allen. Allen's company, the Oregon Arena Corporation, has recently declared bankruptcy rather than pay the city some accumulated millions of taxes that were due as Allen's end of the bargain. Now Portland is left with a great carapace of a sports arena that must be filled whenever the Blazers are out of town.

At the Coliseum (one of the most beautiful international style buildings in town) curator Stephanie Snyder and artist Sam Gould presented videotaped testimonials about Portland: 40 or so artists said why they came here and what makes them stay or go. One, the enormously talented illustrator Zac Margolis, a Portland native, allowed that what could drive him away would be change. "Change makes me want to hide," he admitted. In another, transplanted Seattle writer Charles D'Ambrosio (who confessed in the course of his testimonial to being "an incredibly selfish shit") complained that the rain in Portland is inferior to the rain in Seattle. This is an exacting hair to split but D'Ambrosio, whose mind is sharp enough to split atoms, did it convincingly, while also praising his adopted home for being full of people generous enough to make up for his own selfishness.

Matt McCormick has been here 10 years. On a road trip from Albuquerque his money ran out in Portland. Now he lives in a decommissioned fire station on the east bank of the Willamette. He has—besides an astonishing eye—the gift of tremendous patience. His camera is never searching, always waiting, usually focused on something just outside the door of his home: the surface of the river, bicyclists, the shadows of birds, boats, concrete grain towers, the neighborhood's peculiar light. McCormick uses this largely industrial neighborhood as his own private *Cinecitta*, Fellini's remarkable film set in Rome. Like Fellini, he is able to make entire worlds out of the remarkable plenitude floating past the still point he occupies. Seattle architect Jerry Garcia, who had driven to Portland for the screening, likens McCormick to a bird watcher.

The night ended with Garcia, Liz Leach, sculptor Amanda Wojick, architect Randy Higgins, and bon vivants Stephanie and Jonathan Snyder (she, the curator of Reed College's Cooley Gallery) dancing drunk to a 70s cover band at the Candlelight Lounge, a smoky bar at the southern edge of downtown that contradicts every facile conclusion about race and vitality and urban mixing that the casual chronicler of Portland could have come to in the course of a few short years spent trying to understand this puzzling, and promising, city.

SALLIE TISDALE

Born and reared in Northern California, Sallie Tisdale (1957–) earned a B.S. in nursing from the University of Portland in 1983 and went to work as a registered nurse. She published her first book, The Sorcerer's Apprentice: Tales of the Modern Hospital, *in 1986, followed by* Harvest Moon: Portrait of a Nursing Home *(1987),* Lot's Wife: Salt and the Human Condition *(1988),* Stepping Westward: The Long Search for Home in the Pacific Northwest *(1992),* Talk Dirty to Me: An Intimate History of Sex *(1994),* The Best Thing I Ever Tasted: The Secret of Food *(2000),* Portland from the Air *(2000), and* Women of the Way: Discovering 2,500 Years of Buddhist Wisdom *(2006). Her work has appeared in such magazines as* Conde Nast Traveler, *the* New York Times Magazine, Harper's, *the* New Yorker, *the* Antioch Review, *and* Tricycle, *and she is a regular columnist for Salon.com. Tisdale, who lives in Portland, has been honored with a 1989 fellowship from the National Endowment for the Arts. This essay, which first appeared in* Portland Magazine, *offers an aerial view of the city's history and character.*

Portland from the Air

Only from the air can we see how the world is made. Heights are privileged places, where long cycles are revealed — we see how the earth is broken and put together again. The land is different, not the land we had thought it to be. Steep mountains turn out to be mere foothills; a wide plain turns out to be the narrow valley between them. We see the serpentine pathways of rivers, sliding into one another like paint. In the midst of this rare canvas, we see home.

Portland is confluence — rivers and watersheds meet here, valley floors flow together. Their collisions are slow and quiet, but not entirely calm. Here is a durable beauty and abrupt change. Here is dissonance. Are we country or city, rural or urban? Are we conservative or liberal, casual or sophisticated? Are we all these things? The rivers are full of hidden tides and dark currents. . . .

I've heard people describe Portland as "European" in character. At first, this seems an odd thing to say about a city so young and rough, a city that is still largely white and middle-class, but it has truth. Historians Terence O'Donnell and Thomas Vaughan pointed out that for a long time, Portland was "almost medieval in its plan — the city and then the fields." Its Old World qualities are especially evident downtown, in the short blocks and narrow streets, the small grassy squares, the brick and cast iron and terra-cotta facades of our old public buildings. In its latter days, as it was in its inception, Portland's

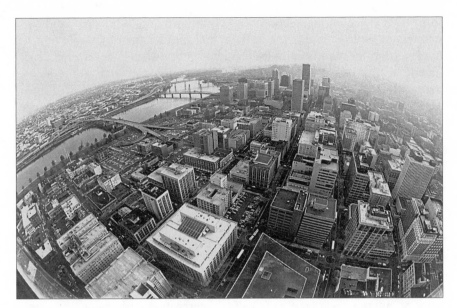

Portland from the top of the U.S. Bank tower in 1997

downtown is people-sized, with a lived-in quality — a fine place, but not exactly a commonwealth. The streets are still a bit muddy.

Are we city or country — urban or rural? Perhaps we're just a bit medieval. You can keep chickens and ducks and beehives here. You can have a cow or horse if you have the room in your backyard. There are still pockets inside the city boundary that seem more family farm than town. These are shrunken pastures, to be sure, tiny orchards under siege, but the whole city blooms in every season. Christmas tree lots spring up overnight after the corn field mazes and pumpkin patches disappear. Fruit stands appear on street corners and flower sellers at traffic lights and farmers' markets in bank parking lots, with bluegrass music and the faint hollering of children, like the faint hollering of children at harvest time anywhere.

At certain times, Portland has actually been European: Around the turn of the century, more than half of the residents were either foreign-born or the children of immigrants, and Chinatown here was second only to the great Chinatown of San Francisco. Frances Fuller Victor, like a lot of the city's staid establishment, resisted the implications. Portland, she wrote, was a "more American" city than places like San Francisco, and what she meant was that it was more white — a lot of the foreigners were Irish and Canadian and German, Slavic and Scandinavian.

On the surface, the city was gentility itself — parades and picnics. Underneath, it was a cauldron of opportunism and vice. Private property owner-

ship was a vague enough concept on a frontier dug out of stolen land — a vast region settled more by luck, theft, and murder than by noble notions of expansion. Portland's early leaders had, in the words of Malcolm Clark, "overly flexible ethics" leading to all manner of scandal "sufficient to amuse the cynical." Various government scandals have come and gone ever since, mostly involving double-dealing, patronage, and fraud. A cabal of railroad and utility magnates helped develop the city without a whit of altruism. For all that, for all the shady developers, con men and schemers in this town, even our vice wasn't really big-city style. Portland never had a great, wicked philanthropist, the kind who built the great libraries, museums, and universities of the east.

Victorian Portland had parades and picnics; it also had at least two public (and a number of private) hangings at the first Multnomah County Courthouse, built in 1864. Drunken men were routinely shanghaied for shorthanded ships — delivering them was known as "crimping." Portland was a harbor town in all kinds of ways, full of drugs and gambling, with many of its leading families supported in part by an extensive and prosperous network of brothels — at least one floating. Segregation, red-lining, and whole neighborhoods with deeds prohibiting "non-whites" are part of Portland's history, too. So is the Ku Klux Klan, which had a brief but public reign in local politics. So are the shantytowns and Skid Road, bleak housing projects and cruel strikes. The ever-present struggle of the homeless and the working poor and the serious decline of the public school system — these are all Portland, too.

People talk to each other here. In Portland, you are expected to converse — to give directions, tell the time, comment on the weather, and say "Happy New Year." On the MAX train, an East Indian visitor asks me where to get off for the zoo and the six other passengers in earshot all answer him at once and wish him a good time there. The local beer is good. The local wine is good. Coffee is essential; music is inevitable; books are unavoidable. You're expected to enjoy the local bounty, whether it's strawberries in season or cappuccino. We eat walking down the sidewalk, sitting on the curb, on the steps of Pioneer Square, riding bicycles.

The buses and trains are free downtown. You can get a ticket for jaywalking. Guides in green jackets troll the streets, alarming visitors who don't know about these smiling people in uniforms. The guides steer the lost tourists who are staring at the handsome police officers on handsome horses and shiny mountain bikes. We detour around the wet cement where the new wheelchair ramps have been built and ostentatiously holdup traffic for a squirrel. People take the time to make erudite analyses of bathroom graffiti. This is the kind of town where a gracefully aging drag queen commands as much respect as the mayor (and sometimes more, depending on the mayor).

And it is a city with endless gardens: streetcurb gardens, backyard gardens, window gardens, container gardens, community gardens. Master gardeners on call, traffic jams at nurseries, brave young trees sticking up out of Volvo sunroofs. Portland has a new Chinese garden, a well-regarded Japanese garden, a capacious rhododendron garden, a bishop's garden, a storybook garden, a koi garden, several estuaries and bird refuges.

Around 1901, the rose was chosen more or less at random to represent a city where an astonishing variety of flowers thrive. It quickly became, in Terence O'Donnell's words, "the object of a cult." Portland has one gigantic, famous, beautiful, public rose garden, and it has roses in nearly every yard, courtesy of a campaign by the women's Mystic Order of the Rose. Portland has a Rose Festival, a phantasm of rose royalty led by a Rose Queen. Today's city plan deems the rose an excellent symbol and suggests that people stick pictures of roses everywhere. "Portland design themes" (like roses and herons and raindrops and elks) are supposed to decorate our "street furniture" (lights, benches, manhole covers, bus shelters) and they do, most immoderately,

We like decoration. The city is dense with statuary: bears, beavers, elk, giant game boards, floating rocks, gentlemen with umbrellas, shiny and dull and bent and knotted sculptures. The giant auburn figure of Portlandia leans over from her perch on the Portland Building, reaching to the pedestrians and cars below. Joan of Arc wears a pumpkin on her head for Halloween and a Santa Claus hat in December. Murals, not all of them with roses, cover the city's walls. Water everywhere (all running down, down to the river in time): little four-bowl bronze fountains endlessly bubbling and house-sized block-wide fountains, for people to run in, slide down, hang over, and sit under. Big parks. Little parks. Parks with woods and forests, parks with islands, sand bars, and wetlands. Parks with a volcanic caldera or two. The biggest city park in the nation, an entire forest's worth of park.

We are most immoderate with our trees. In a city built over clear-cuts, a city made out of timber, a city once called Stumptown, we have trees. So many trees — the dark treed hills rise above the pale sea of houses from every view. Trees on every curb. From above, where the swifts dart and a pair of peregrine falcons soar, there are so many trees that almost half the city is under the trees' canopy. The treeless avenues stand out. So many trees, and the cutting of a single one provokes heated argument. In the spring the trees drip with faint green, limp and delicate. In the summer, they tower in full strength. In the fall, they are overnight washes of red and flood the streets with yellow. In the winter the bare bones whip in the wind, rattle with ice, crash into our cars, our living rooms, our roses.

I know from time spent in other cities, bigger and older cities, that Portland has been lucky — even wise at times. That doesn't mean we're going to be

lucky or wise again; this is a young place, still immature, still uncertain. The bright, wide valley of our rivers has drawn its immigrants here because it is a place of tremendous gifts. We who live here are marked by these gifts and by the endless urge to tinker with them. We will improve our Eden. Even the two divinely useful rivers needed fixing: the waterfalls had to be fixed with locks; the channels dredged, the rapids flooded, the banks walled and wharved.

The rivers are still central, still rising and falling with the tides of an ocean more than a hundred miles away. They will always be central.

Throughout the postwar years, Portland grew, steadily approaching the half-million mark, Today Portland's metropolitan region covers more than 460 square miles in three counties and holds more than 1.2 million people. In the last fifteen years, our population has grown at twice the rate of the United States as a whole.

Throughout the city are small spheres, once separate, with houses, stores and trees of a certain style and age. Portland proper has grown largely by annexation — Albina, East Portland, Sellwood, and various early subdivisions all taken in. St. Johns is annexed. Linn City and Multnomah City are part of West Linn now. Milwaukie, Oregon City, and St. Helens are suburbs now. Milton is flooded and gone. The outlying villages have been absorbed, soaked up — small local flavors intersecting each other inside the consecutive rings of urban growth.

Portlanders point to the fact that the city is inside the nation's first Urban Growth Boundary. The UGB is a zigzag line cutting across counties and around towns and suburbs, sharply dividing urban density and congestion from farmland and forest. The UGB is supposed to control suburban sprawl, that endless spread of strip malls and bad housing developments eating up rural land from which other cities suffer. The reality is something else again, because a city needs more than a wall to grow well.

Outside the boundary, much has been protected, although here and there the traveler finds strange exceptions to the rule: Wal-marts, factory outlet malls, enormous industrial complexes surrounded by pasture and field. But for the most part, the country outside remains country; it is the real and psychic context for the life lived within. But that life is increasingly one of bad growth; inside the boundary, almost anything goes.

In the growth of the last few decades, hills, meadows and commanding vistas have been swallowed by developments and office buildings. Spacious grasslands are now covered in houses. A giant's bouquet of fir and hemlock has been cut down. I follow narrow, winding roads designed long ago for sparse rural traffic, and I pass through unending urban congestion, along narrow sidewalks pressed between townhouses and sprawling apartment complexes. I wander oddly graded new streets dug out of the slopes of erod-

ing hills between inflated mini-mansions separated by wide, empty lawns. I drive — because there is no other choice — from one silent group of houses to the next, trying to find a grocery store, a bank, anything to make this more than sprawl — to make it that magic ingredient of cities, a neighborhood.

By the mid-1970s — a generation ago — the city was blossoming with new urban passions, with the angry love of people who refused to let the losses be. Led by Neil Goldschmidt — a leader the likes of which the city has not seen since — a grand renewal of the city center took place within a few thrilling years. A grassroots campaign to stop another cross-town freeway actually succeeded, and the money saved helped to build a crosstown commuter train line. "Metro" was born, the nation's first elected regional government, commanding a significant part of Portland's future along with that of three counties and twenty-three other cities. (Metro gave birth to the Urban Growth Boundary.) The Harbor Drive highway was paved over in a new way, with grass, and became a waterfront park. The parking lot in the center of downtown became a town square. Some of the one-way streets became a mass-transit mall, feeding new urban housing living in the midst of a century of truly beautiful architecture. Today, even the streetcar is returning.

Portland could still be a real city — not a big urban center, not an industrial leader or densely packed metropolis, but something else. Something unduplicated.

I stand on Overlook bluff and trace the impenetrable, dark reach of Forest Park. I count the thick-trunked conifers that still shadow the precarious manses of the West Hills. I gaze down on the ships below, so comfortable in their wide, wet berths. I look up the river and see the sandy reaches, the wetlands and islands, the flocks of migratory birds. I can hardly imagine the sweep of that original 640-acre claim, what wealth they contained, what glorious luck they held. Stumptown, a muddy, mean town smelling of the tannery and horse manure, its sticky streets a hazardous maze, slowly picked its way up and out and spread into the hills and along the flooding banks. But the slow sprawl left oases — deliberate and accidental — scattered about, and we still have breathing room between the towers.

From the air, the snowy expanse of sunlit morning clouds ends abruptly and there is only blue water below — the long Columbia, a seam between lives. Details appear — fields and clearcuts, the grids of small towns, thin roads. This distance, this particular vantage, contains the past and all possible futures. Down below is where the fish once swarmed so thick you could walk on their backs. There is where the first traders came to land. There is a clearing for a midday rest, with a view of the water and a beautiful white peak.

From this height, today, I see bounty, the land stretching out like a yawning cat, unconcerned. Two fine, wide rivers meet like no other rivers in the

world here, meet and merge and define this place — a city of confluence in a low, guarded clearing. I see the luminous glow of morning on the silent mountain, and I think it is so close that I could reach out, right now, and be there.

ELIZABETH WOODY

Elizabeth Woody (1959–) is a member of the Confederated Tribes of Warm Springs. Born in Arizona, Elizabeth Woody is director of the Indigenous Leadership Program at Ecotrust of Portland. She graduated from the Evergreen State College in 1991 after attending the Institute of American Indian Arts and Portland State University. Woody is on the board of directors of Soapstone, a Writing Retreat for Women, the advisory board for the Indigenous Ways of Knowing Project at Lewis & Clark College, and the Advisory Council for Native Programs at Willamette University. She is a leadership circle advisor for the Ford Foundation's feasibility study on a national Native American arts and culture fund. In 1995, she received the William Stafford Memorial Poetry Award from the Pacific Northwest Booksellers Association. Hand Into Stone *(1988), poetry on the Columbia River and tribal fishing rights, was awarded the American Book Award in 1990. She is also the author of* Luminaries of the Humble *(1994),* Seven Hands, Seven Hearts *(1994), and* Salmon Nation: People and Fish at the Edge *(1999). This short story first appeared in* Seven Hands, Seven Hearts.

Buckskin

Buckskin was a yellowish-tan behemoth, a '76 Galaxy 500 automobile. The family loved her. We still talk about the beast with affection. At best, she carried us all up the deeply rutted, dirt road on the mountainside to Lester's remote cabin, with ease. No dragging on bottom, the springs agile and strong. At worst, her transmission linkages popped out of place once during a manic Seattle rush hour traffic crisis. When this happened, Leslie would have to coast to a stop, jump out, hoist the hood, reach into the engine, balance on her solar plexus, skirt and legs up in the air, and pop the mechanism into its socket, check the hanger wires, then run like crazy back into the driver's seat. She was named "Buckskin" not to honor our Native American heritage, but because she was a bona fide, temperamental, restless War Horse, an Indian car. In that legacy, she had to earn her name.

She was faithful, with a face that only a mother could love, big enough to haul four 30-gallon garbage cans, and on occasion two or three generations of Palmers. The Palmers are big, no matter the age or gender. I am a good example of our size, six foot four, long black hair and round. A mountain of

womanhood, I have heard from my admirers, but back to my love story. This is a love story between a family and a car. Brief, true, and bittersweet, like all those sad occurrences when people meet their match and circumstances wrench them apart. Buckskin was a "spirit" car.

When one of us was blue, like Leslie, or SugarMom, or Tone, or Gladys, better known as Happy Butt, we would plan a trip to a Pow Wow or celebration, load up all the camping gear, dance outfits, cans of oil, in the massive space in the trunk, gas up and go. Nothing but a song and prayer, and the injinuitee of our collective genius, the product of the school of "Make-Do." You see, when we first acquired Buckskin, we had been carless for years. Tone said, "Yeah, she's going to be a collector's item, one of these days. She's a tank. A good old-fashioned American Gas-hog. God love her! Now we can go anywhere!"

Of course, he was the first to groan when her parts started to wear out and drop off. That is basically how she earned her name. Like any mechanic's staple, bread and butter, her parts wore out, or dropped off at inappropriate times. Tone and I were driving down "Sideburns," the nickname we had for Burnside, during another typical Northwest squall, and Buckskin flipped off her wiper, driver's side. Tone hollered and looked to me, as I clutched my seat. "Now what?"

"Pull over, Tone. We can't drive without a wiper, 'less you want to stick your head out," which was our previous solution in cars. So, we pulled over. Tone picked up the wiper, and tied it on. We weren't savvy to all of Buckskin's ways then, so we didn't have any coat-hangers in the car. I had a buckskin tie holding my hair, so I offered it to Tone. He rigged up a tie for the wiper. When we related the incident to SugarMom, who was angry, waiting in the rain for us, downtown, she exclaimed, in merriment, "Buckskin!!! Yeah, that's a good name for her. What a gal." Her mood changed to the better by the event.

So Buckskin became a character, well known, and all on her own. We learned how far she would go on the gas gauge's E. We lovingly cleaned her carburetor so she wouldn't stall. The kids squealed in delight as she backfired, resounding in the streets like a shotgun. We offered everyone who needed a ride, a ride they would never forget. She could go with ease down the freeway to Celilo Village at 80, no problem, nondescript, maybe even invisible to the Smokies, State Patrol. She even had a sister car at Ace Wrecking yards to donate parts to her in financial emergencies. One of our many Indian mechanics said, "The way her vinyl top is ripped off, it looks like Buckskin has a giant skid mark on top. HA HA HA!" Since he was laughing at her, and not with her, we dropped him off our list of mechanics. Eventually, he just left town.

Of course she became a celebrity. The most important trip was the trip that did her in. She came through for us, even though her front end was

going out. We needed to go to Lewiston, Idaho, to rescue Leslie from out-of-state justice. We drove carefully, made it in time to hear the Police Chief testify to Leslie's actions that led to her arrest. It was hard not to burst into outrage as he exaggerated a description of Leslie, screaming a karate yell, leaping ten feet to kick the officer in the groin, and finally slash him with her house keys. Of course Leslie was acquitted and we rode home, triumphant, in Buckskin, laughingly teasing Leslie, calling her "Leslie Lee," after Bruce.

Buckskin was with us, "all the way," as they say on the rez. A true-blood, so it hurt when we realized that we couldn't keep her any longer. Too much of our energies were tied up in willing her to keep running, so we could keep on with our rescue missions when one of our clan would get into trouble. We had to trade her off at Chevy Town. SugarMom cried. Leslie reported a resurrected Buckskin to us, her whereabouts, in which direction she was heading. Always, we could tell it was her by the Indian head decal on her backside. It was like an identifiable tattoo of a past lover's name. It did take years to forget her faithfulness, in spite of her temper, backfires, and flat tires.

We have a Toyota now, "White Buckskin," '89. You have to count the clicks in the automatic transmission to get in gear, and tell the passengers, as fast as you can, "Don't roll the window down any further than half, because the door pops open," and they could roll out. The "ejector seat," we call it. If you don't like your date, you can ask them to roll down their window and then turn sharply to the left. When SugarMom brought her home, Tone said, "God, those Japanese sure know how to make good American cars. God love 'em!" Happy Butt said, "Oh, geez, SugarMom, you bought a 'pop-together-car'." White Buckskin is an Indian car, though. We haven't had to tie her up, yet. A few more years and she will be broken in, just the way we like it.

MIRANDA BEVERLY-WHITTEMORE

The daughter of anthropologist Robert Whittemore, Miranda Beverly-Whittemore (1976–) was raised in Portland, where she lived until her graduation from the Catlin Gabel School. She graduated from Vassar College. This excerpt, from the juvenile fiction The Effects of Light *(2005), describes Myla Wolfe as she makes a fateful meeting that might alter the course of her life.*

From *The Effects of Light*

Myla believed that if she didn't go directly to the source, she'd find herself floating. At least someone had called her here, and even though she'd never met him, and didn't know for certain what he held for her, she knew this lawyer, this Marcus Berger, was the place to start. So she placed a call and was

surprised when Marcus Berger answered the phone, surprised at his straining vocal quality, so like a teenage boy's, surprised at his lack of surprise when she announced she was in town. He invited her to come immediately.

The office was in a neighborhood Myla had always remembered as poised on the cusp of being cool—cool, that is, in the eyes of daughters of college professors and the girl students who took care of them. So it wasn't such a surprise when, searching in vain for free parking, she witnessed flocks of yuppies with their strollers and cell phones herding through store after store. Stores with Italian names and designer dresses, stores with thirty-five-dollar candles in the windows, stores selling angular, uncomfortable-looking shoes ("Two pairs for $99!" although Myla did have to remind herself that this was considered cheap these days). Was it inappropriate to feel old at the age of thirty-one? The drive up and down Northwest 23rd was slow. None of the pedestrians seemed to know what a crosswalk was, so she read the names of the shops: Urbino Home, Slang Bette, Mama Ro's. Like a poem.

She found a side street with parking, a minor miracle, and backed into a space. On the opposite side of the street, nestled between two ostentatious Victorian houses patinaed with color like well-manicured toenails, she saw what looked like a halfway house. Stretching around the two monstrosities were large, white, disinfected porches, porches that disregarded dirt and the outdoors in general. The halfway house, on the other hand, was small and dark, and Myla imagined it was filled with flora and fauna. It was tropical in its promise. Two old men in flannel shirts smoked on the stoop.

Up until this moment, she hadn't really allowed herself to contemplate the reason Marcus Berger had contacted her; or perhaps more precisely, she hadn't let herself imagine the identity of his client. But now Myla realized that all along she'd assumed the client was Ruth. As far as Myla knew, no one had seen or heard from Ruth Handel in thirteen years. But now, here, it was thrilling to imagine that Ruth had orchestrated this. That she was the "unnamed client" who'd provided the flight coupons and summoned Myla to this meeting. It would mean she was alive. That she'd survived. It would mean Myla would get to see her.

Still, if Ruth were to present herself alive, there'd be all sorts of problems. Things needing to be addressed, conversations. If Ruth were sitting upstairs . . .

Myla opened the car door then and let the Portland of her childhood rush in to greet her. It still seeped. The glorious rain, a permanent wet that thoroughly soaked into hedges and tires and sidewalk cracks, was strangely surreptitious: when she leaned down to press her hand against the sidewalk, her palm came up dry. And yet moss edged every asphalt and concrete crack, tingeing the world with green. This was seepage. It was an old wet, deeper than the surface. It made you moist inside your heart, made your insides warm as rotting, mottled wood.

It started to drizzle, and she looked up and saw tiny bits of wet gleaming down on her. She felt them pattering on her hand, weightless, translucent. It could rain here for days, and you'd never feel the wet as something distinct from the whole vast dampness of the world. You were never that separated from the ground and its constant pull on sky. The sky spilled and made it all—the ground, the city, the people—deeper and greener with each passing day. She felt like a little girl again.

All that wet outside her made her realize she was intensely thirsty, longing for a long draw of water down her throat. She hoped the building would have a drinking fountain. She focused on her thirst—an easy need to meet—to avoid thinking about Ruth.

Marcus Berger's office was on the third floor. He buzzed her in from the street and was waiting outside his office door when she walked up the stairs. She shook his hand and soon realized there was no drinking fountain and no Ruth. Upon Myla's request for something drinkable, Berger brought his guest a cup of lukewarm water from the men's bathroom. This left something to be desired. They settled into chairs side by side and angled toward each other. She'd expected him to be sitting behind a desk, and she was glad she'd spoken to him on the phone; otherwise the shock of his youth might have been laughable. She liked him immediately, though she wasn't about to admit it.

With no sign of Ruth, Myla felt bitter, disappointed. She hadn't let herself admit how much she'd been hoping to see Ruth again. Meanwhile, Berger crossed his legs. "If you wouldn't mind, let me explain myself. My client has hired me to transfer into your hands certain items that are rightfully yours, legally yours. My client wishes to remain anonymous, so I'll be unable to answer any questions about who or where he or she is." Myla felt a stab of sadness; perhaps Ruth simply didn't want to see her. She nodded for Berger to continue.

"In any case, my client has instructed me to transfer one item in person if at all possible—*my* person, I mean," he added with a nervous smile. "Which is why, of course, I asked you to come all this way. I myself am not privy to the contents of the envelope. It's been sealed for just over thirteen years." He stood and walked to a file cabinet, pulled out a file folder with a manila envelope inside, and brought the envelope back to her. He kept the folder for himself. The envelope was heavy with paper, and she could feel the metal spine of a spiral notebook inside.

"Now, before you open it," he continued, "I've been asked to read you this letter. " 'I've been holding this for you. Your father asked me to wait until you were ready. Each day passes more quickly than the last, but that doesn't mean our past gets any further away from us. Which is all to say: I don't know if you're ready, but I do know it's time. Thirteen years have passed. Extend yourself. Perhaps you'll get some answers.' " Berger looked up and smiled. "So. Any questions?"

So many. Did this mean Ruth was alive? The note didn't necessarily sound like Ruth, but what did that mean, anyway? Myla hungered for thousands of answers, but she couldn't frame a single question. Suddenly the immensity of what she faced hit her. She was exhilarated and also exhausted: in one instant she'd left behind everything that had kept her safe for years and had headed straight back into the unknown. Was she ready for this? Obviously Ruth, or whoever was orchestrating this—it could be someone else, she reminded herself—thought she was. "Extend yourself," the letter said. She'd left the East Coast precisely because she needed to learn how to stretch beyond herself, and this letter read her mind. This made her want to touch it. "Can I see that?" Her hand reached for the paper.

"No, I'm afraid not." He drew back. "One of my client's conditions."

Myla could see through the paper that the note had been written by hand, with black ink. Berger noticed her glance and placed the paper quickly back into the file folder in his hand.

"So this is it? Whatever's in this envelope?" She fingered the package, her heart sinking a bit. Not heavy enough. Bound. Not what it could have been.

Berger shook his head. "The client's condition is that I may read you this letter"—he tapped the folder— "and you can draw any conclusions you want from that. But unfortunately, *I* am unable to answer that question."

In the midst of all this frustration, Myla knew the plan had worked. She was here, wasn't she? And she was tantalized. She was itching to know what was in the envelope, even if it wasn't what she'd initially hoped for. Her palms were greedy for it. She asked Berger to read the letter again. He read it twice.

She asked him, "Must I open this now?"

"You can open the envelope whenever you want to. It's just in my charge to make sure you have it in your possession. After that, you can do whatever you'd like with it." He smiled at her, obviously relieved that he could do something she wanted.

"Well, thanks." She stood. "Until we meet again?"

He shook her hand. "Let's be in touch."

The light outside was brighter than she'd remembered. Her hands trembled against the envelope. She was distracted by the world outside, by being swept up into a movement, like a Mozart piano concerto that would guide her, ineffably, toward beauty and completion. It was a feeling she hadn't experienced since walking these streets with Pru on one side and David and Ruth on the other. The envelope made a smooth bundle under her fingers. She was hugging it, she noticed, all the way to the car.

PETER ROCK

Born and reared in Salt Lake City, Utah, Peter Rock (1967–) attended Deep Spring College and graduated with a B.A. in English from Yale. He held a Wallace Stegner Fellowship at Stanford University and is a recipient of a National Endowment for the Arts fellowship. Rock taught fiction writing at the University of Pennsylvania, Yale, Deep Spring College, and San Francisco State University and is an assistant professor of creative writing at Reed College. His novels include This Is the Place *(1997),* Carnival Wolves *(1998), and* The Ambidextrist *(2002). In addition to* The Unsettling: Stories *(2006), his short stories have appeared* Zoetrope, Cross Connect, Stanford Magazine, *and* Tin House Magazine. *In this excerpt from* The Bewildered *(2005), teenaged skateboarders ride the* MAX *blue line to Washington Park for an exhilarating night ride through the zoo.*

From *The Bewildered*

The three rode the MAX, the blue line, the train sliding west out of the city and speeding through the dark buildings. It was just after midnight, and Kayla sat between Leon and Chris, her knees knocking each of theirs. The boys had to lie to be out this late, but not Kayla; she lived with her father, who worked the night shift and slept most of the day. Her freedom was rarely compromised.

On buses, the three always sat in the very back, shoulder to shoulder; on the MAX, they went as far to the rear as they could without having to face backward. They liked to be able to see where they were headed.

"So I heard this story," Kayla said. "No, forget it."

There was only one other passenger on the MAX, five seats ahead of them—a tall, skinny man with his long legs bent out into the aisle, his narrow, black leather shoes stretching to sharp points. His black beard was also pointed, hooking down his jaw, meeting in a sharp V beneath his mouth. He may have been sleeping; he may have been watching them through the slits of his eyes.

"Tell it." Leon said.

"No," Kayla said. "You're not going to like it."

"Whatever," Chris said, "but you can't come halfway like that, you know we have a policy—"

"All right." she said. "Anyway, I heard about this guy, somewhere down in California, whose dick was so long it would drag on the ground when he walked—"

"Who told you this?" Chris said.

"Don't interrupt," Leon said. "Remember, Kayla decided we had to hear this."

"So," Kayla said, "this guy, just to walk down the street, had to wrap his

thing around and around his leg, tie it there. But then one day he saw something that made him get a hard-on, and you know what happened?"

The two boys just stared at her, faces serious, trying to appear bored.

"It broke his leg in three places," she said.

No one said anything; the subject matter of Kayla's story—or joke, or whatever it was—had raised a temporary uneasiness between them. They had a policy about this; they didn't talk about sex. Of course, they had codes about sex itself, any kind of attraction. It was banned, especially between the three of them.

Kayla's jeans had a hole in the knee, the edges frayed; on her smooth, pale skin was the chalky circle of a lost scab, and her name written in red ballpoint, and another word or two that were mostly hidden, that Chris could not make out. He turned away from her, stared at his own reflection in the window. His hair seemed dark, cut this short, and he looked younger, his head smaller. He ran his hand over the smooth bristles. He had gone with Leon to have his head shaved, for solidarity; the accident, just a week before, had left Leon with hair on only one side. He had to even it out. When Chris had asked the barber how much it cost to get a shave, the barber had condescended, as adults liked to do, saying *For you? I could put a little cream on there, under your nose, bring my cat in here to lick it off.*

"I didn't tell you that story because I thought it was interesting," Kayla said. "But because someone else thought so. That's what's interesting about it. Pathetic."

"Still," Chris said, "you see how everyone acts at school—you give yourself over to that, it forces all the thoughts out of your head."

"And as soon as you start copulating," Leon said, "you can have children, of course—and then you might become a *parent.*"

"It's not completely their fault." Kayla said.

"They should have seen it coming."

"And we'll become just like them if we're not careful," Chris said.

"Maybe, maybe not," Leon said.

"Unless," she said, "unless we can figure out another way to be."

"Right, right, right."

Ahead, the skinny, bearded man straightened his long legs, all the way across the aisle. He stretched his neck, twisting his face toward them, then away again.

"It was just a stupid story," Kayla said. "Probably wasn't even true."

"Definitely wasn't," Chris said.

The three sat, silent again, waiting, their skateboards propped against their knees, grip tape scratching rough against their jeans. They all skated Santa Cruz decks, but scraped off the brand name; they wrote in magic marker, and circled the insides of their Kryptonics wheels, covering the words. They all rode Independent trucks; there was no way to disguise that. Now they

checked the bearings, the bolts that held on the trucks, the tension and tightness of the trucks themselves. Chris took out a wrench and loosened his; he wanted to make wide, carving turns, coming back down the hills in the darkness.

"What about Natalie?" he said.

"What about her?"

"She's not the same," he said. "I don't think so. Not like other adults. I mean, the way she talks to us, all business. She doesn't shift the tone of her voice because we're younger, she doesn't condescend, doesn't really care if we like her."

"But we never really hear her talk to other people," Kayla said.

"Still, she's different."

"You just think she's different," she said. "You want her to be."

"You don't?"

"It's not like I have a crush on her or anything."

The MAX stopped and started again, sliding past PG&E Park, all the dark empty seats, the black slant of the baseball diamond far below.

"It's been a week," Chris said. "You think we'll work for her again?"

"You know the deal," Kayla said. "I have to call her every day at the same time, and she tells me yes or no. Lately it's 'no, no, no.'"

"What else does she say?" Chris said.

"I should get the money soon," she said. "The payment for the last time. When are we going to put it away?"

The money was adding up; the three of them kept it, never spent it, stored it in their hiding place. One day they would all move away, and they would live together, somewhere, and they would live in a way that no one had lived before, a way they were still figuring out. The money was an important part of the plan. Crucial.

"Maybe she's worried because of what happened last time," Chris said.

"She doesn't even know," Kayla said. "Even Leon hardly knows."

Leon didn't seem to notice she was talking about him. He was too busy adding some scratchiti to the train's window, using a house key to mark the letters B-E-W-I- and starting on an L. The other two watched him; as he worked, he made a noise with his lips that seemed unintentional. Silver duct tape circled his shoe, holding the sole on—they were the same shoes he'd been wearing when the accident happened. Lately he seemed calmer, quieter, the set of his jaw less antagonistic than usual. He was hardly hungry at lunch, or after school; he seemed disinterested in studying. When they asked him about the accident, what had happened, what it felt like, he acted as if he could not remember it. *It didn't feel bad* was all he'd say, and that was both frustrating and tantalizing. They had difficulty believing there wasn't more he could tell them, something he was keeping back. Secrets were against the code.

"What, Leon?" Kayla said. "What are you thinking?"

"Hey," he said, looking up.

"I don't know," Chris said. "It seems like 'The Bewildered' is a good name for a band of losers, maybe, but more like the opposite of a name for people who are smart."

"And we don't need a name," Kayla said.

"Also," Chris said, "that makes us seem like people who join things."

"Joiners," Kayla said.

"It's not a name," Leon said. "I mean, saying someone is bewildered is always in comparison to what everyone else agrees makes sense, you know. So if everyone else, all the adults think you're bewildered, then you're actually not, you probably actually have a clue."

Chris looked up, out the window, at Highway 26, running parallel. A lone car, a long sedan, kept pace; suddenly, the driver opened his door—to slam it tighter or to spit something on the street—and the inside of the car was illuminated. An old man with tangled white hair, smiling to himself, driving late at night, going home or running away. He slammed his car door and the light went out, he disappeared, and in the same moment the train plunged into the tunnel, underground.

The lights flickered; something was wrong with them. Had the pointy-bearded man moved a row closer? It seemed as if he had, but it was hard to say, because now it was dark. The three sat close together, waiting; the next stop was theirs.

"Anyway," Kayla said, "don't worry, I have a plan. I'm gathering all the information we have about Natalie, in a notebook. I'm figuring how to find out where she lives, moving backward from the phone number I have for her. Then we can find out some more, find out how different she really is."

"Washington Park." said the woman's prerecorded voice from the speaker overhead. The lights returned, and the three stood, braced against each other as the train jerked to a stop.

They exited through the sliding doors. Chris looked behind them, but it didn't seem like the bearded man had followed. He'd stayed on the train, which was already gone, leaving them here, in the white tile of the tunnel.

"Holy crow," Kayla said, spitting down onto the tracks. "I can't wait."

"Listen to you," Chris said. "Look at you. Copying. Maybe you're the one with the crush on Natalie."

"Je nai yo!" she said.

Leon was already waiting, holding the elevator door open. Now they were close, preparing themselves. Only Chris had a helmet, a skull sticker on one side; Kayla took out her leather gloves, the palms and fingers worn down, shiny. She practiced kick-flips, the sharp crack of her board's tail on the metal floor echoing off the walls. The numbers above the buttons counted the elevator's rise, the feet above sea-level. The tunnel was at 450 feet, and

they climbed; the doors opened at 693 feet. They stepped out, surrounded by the zoo parking lot and the signs for the Washington Park shuttle, which didn't run this late. Lamps cast circles of light, here and there, illumination for security—exactly what they hoped to avoid.

They moved silently; they did not skate; not yet. A double thickness of ten-foot chain-link fence, with barbed wire on top, stretched up from the entrance gate a hundred feet away. The three moved closer, up to the right. Tossing their skateboards over, whispering, they went under the first fence, climbed the second—Kayla tapping the metal NO TRESPASSING sign with her fingernails—and slid down a slope of ground cover, tangled bushes. Regrouping, they climbed up through more of the same undergrowth, staying low and quiet, then pulled themselves up through the supports of a long wooden deck, and atop it, helping each other.

Here they stood, on the deck, near the mountain goats—asleep, white and shaggy, raising their bearded, horned heads at the sound of the whispered voices, the dark shapes of the three hurrying past.

"Hey, boys," Chris said, waving. "We're back."

"Quiet," Leon said.

When they reached the asphalt, they gently, quietly set down their boards. They paused for a moment, looking down the slope, the whole zoo below them. They could already smell the animals; low calls and night cries rose here and there.

"We have to remember to time it," Kayla said. Her round watch face flashed at her wrist, moonlight catching there. "How long did it take, last time?"

"Eight minutes through the zoo," Leon said. "Twenty to downtown."

With that, he was gone, out ahead, the sole of his right foot flashing—the straight stripe of duct tape, there—and then both feet on the board, his body down in a tuck, his left arm angled straight out in front and his palm facing down, his hand cutting the air and streaming it over him.

"Go ahead," Chris said to Kayla. "I'll catch up."

"Right," she said. "Try."

She pushed off and Chris followed, keeping her in sight. They went slow at first, the bumps still there, the lighter stones in the asphalt blurring together into straight lines as the warm air shifted cool and the ground went smooth. All three liked the speed, though none so well as Kayla, who could control it best. They shot across the bridge, the dull empty tracks of the miniature zoo train below, the wind in their ears, their eyes going teary. No one else did this; no one would think of it. Here was the first sharp right into an S turn—Kayla ahead leaning into it, dragging her gloved fingertips along the ground—and then the swooping left under a low arch, out past the sea lion pools and the otters, and under another arch, underground—into a cave, Chris holding his breath because it was almost like being underwater, the edges of the dark

glass walls lost and the shadowy fish suspended, hanging, swimming around him and then here was the stretch of carpet under his wheels, slowing him with its friction that had to be anticipated, leaning back, Kayla already off it, and then asphalt again and his wheels loose as he shot past the elephant seals, rising so wise and fluent like huge black ghosts on a flickering white movie screen, watching, waving flippers and tails, huge enough to swallow three of him—and he was out, cool, unfishy air rushing past as he swooped around the penguin house and began to lose speed on the flats (this was a dangerous section, exposed and slow; the second time they'd done this a night watchman, some kind of security person, had run out, emerging near the Bearwalk Cafe, but by the time he got to where Kayla had been she was fifty yards past him, and he was facing the wrong way, watching her go, as Leon and Chris passed on either side, howling as they swept by, toward the gibbons) and had to start pumping hard to maintain momentum. He could hear Leon's foot, and Kayla's, their feet slapping in syncopation as they shot past the gibbons in their tall cages, up all night on manila ropes. The sound of wheels startled, roused the bears, off to the left. The air was thick with the smells of manure and hay and strange animal musks. Bamboo and ferns and cool, broad-leafed plants slipped by, slick against his bare arms. His legs ached, but the next long slope was coming, right after the Asian elephant building, and then gravity again letting loose, just enough—

—swooping down under the tall totem pole with its arms outstretched, all the frightening heads in profile, piled up, and he rocketed past the Alaskan Tundra, the slow musk ox and the hidden grizzly bear and the ragged, halfhearted gaunt wolves howling now. There was no better feeling, no name for it, no better sound, and the best was to be together, the three of them— Chris, Kayla, Leon—the points of a triangle, bending and twisting the sides, the corners and angles; he liked to be last, to keep the other two in sight, and to imagine how at the same time all the snakes were winding themselves tighter, the jaguars and tigers pacing, snapping through liquid turns like his own, and the crocodiles' slitted yellow eyes staring beneath lukewarm water, and the bad-tempered zebra, the blue-tongued giraffe turning its long neck in wonder.

They skated, their twelve wheels roaring. There was only the moon overhead, the animals above them, the city below. No one else did this; no one would think of it. And ahead Chris could see a strange light in the sky. Glaring, shining, dead ahead, calling them in. He watched as Leon, still out in front, stood up from his crouch, his body straight but his trucks wobbling, the board unsteady beneath him at that speed. Leon's head turned and his face flashed sideways in the moonlight—what was he looking at? not where he was going—and his wheels caught something or he simply lost it. His body catapulted and skidded on one side, his board kicked back, spinning so Kayla barely missed it, so Chris had to swerve around it.

Both shot by where Leon lay motionless, dark against the asphalt. Kayla leaned back, put her gloves down and slid sideways, her wheels screeching, her body only inches above the ground. Chris rode off the shoulder, leaning against the bite of the gravel, the friction, but it was too much and he was jerked loose, forward, his board lost behind him and his feet still underneath, trying to catch up before he went down, arms windmilling, feet slapping as he ran up the side of a hill, saved like a runaway truck, helmet rattling on his head, his heart and breath rattling, too, as he turned, searching back toward Leon, toward the light.

Kayla had already reached Leon, who was trying to climb a fence, to get a better view. The left side of his jeans was shredded, the sleeve of his flannel shirt completely gone. Blood there, and in the moonlight the grit visible, dark asphalt in the wound. He didn't seem to notice.

"Are you in some kind of shock?" Kayla was saying. "What is your deal?"

She and Chris tried to climb up, to be at the same level as Leon, to talk to his face, to see what he was seeing. He didn't seem to hear them.

Highway 26, the Sunset Highway, stretched out below, a few car headlights climbing. Closer, fifty feet away from the three, a workman stood in a cherrypicker, bright floodlights fixed on him from below. The man was working on the electrical line. He wore a yellow helmet, and a black, rubber outfit, thick safety gloves. He adjusted the lines with a long-handled pole, assorted pincers and attachments on its end. The crane that held the cherrypicker aloft groaned, moving the man higher and lower when he gave hand signals. A spark kicked out, fell, disappeared. Leon clung to the fence, watching, transfixed.

"Listen," Kayla said. "We can't stay here. We'll be caught. We've got to get through the fence, over there, then down to the streets." She pointed toward the enclosure of the tree kangaroos, where the fence was bent out.

Leon looked over at her, as if awakening. He turned and smiled at Chris, then began to climb down.

"Are you all right?" Chris said. "Can you skate?"

"Of course I can skate," he said.

KEVIN CANTY

*A professor of creative writing at the University of Montana, Kevin Canty (1954–)
graduated from the University of Montana and received an M.A. at the University
of Florida and an M.F.A. from the University of Arizona. He is the author of two
collections of short stories,* A Stranger in This World *(1994) and* Honeymoon
and Other Stories *(2001), and three novels, including* Into the Great Wide
Open *(1996) and* Nine Below Zero *(1999). In this excerpt from the novel* Win-
slow in Love *(2005), the main character meets his girlfriend in Kelly's Olympian,
a Portland bar.*

From *Winslow in Love*

The rain fell on downtown Portland, not in any kind of unusual way. It
was four-thirty on a December afternoon and Winslow, drunk, sat by the
front window of Kelly's Olympian and watched the passersby. The after-
noon was fading fast and the faces were darkening outside, unfurling their
umbrellas against the rain, hurrying toward their buses and cars and taxicabs
and appointments, everybody rushing toward their own deaths, Winslow
thought, and none of them knew it.

He had a pack of Tareytons and a pitcher of draft beer and the daily papers,
the *Oregonian* and the *New York Times* both. He read the local paper carefully
from back to front, from sports to news, and then went back through the
Times to see what he had missed. When an item struck his imagination he
would sometimes write a sentence or two down in his notebook. He kept
the notebook in his overcoat pocket, as he was not the type to write ostenta-
tiously in bars or coffee shops. Just then he felt an image coming up to the
surface, something about the faces outside the window, like a whole school
of fish turning at once, the silvery bodies in three dimensions, something
about the way they didn't recognize themselves as beautiful but just kept on
schooling to their separate ends. Then remembered that Pound had gotten
there first: *petals on a wet, black bough* . . . It was not fair that so many of his
best ideas were someone else's.

The bar was long and high and dim with neon lights high up against an
old tin ceiling. A kitchen at the far back contributed the smell of stale fryer
oil to the general funk of spilled beer, cigarette smoke and Lysol. Toothless-
ness and vomit; he watched a pair of old girls going at it, shoving each other
against the bar, cursing. One of them he recognized as the folding-chair
woman, a tiny short angry woman who had been beating the day bartender
with a metal folding chair the first day he had found Kelly's. The bartender
was at least eighteen inches taller than she was and had an earring and his
head shaved like Mr. Clean. He stood impassively with his arms folded in
front of him while she beat against his arms with the folding chair until she

wore herself out, and then he 86'd her. She had been 86'd by every bartender so far, but the turnover was high on the day shift and so she was back.

Later, when the light outside died completely, Winslow would move back to sit at the bar, where generations of drinkers had worn grooves into the top of the bar by rubbing quarters back and forth on the wood, the knurled metal edges digging deep smooth trenches into the bar, and nobody minded.

In the last months, he had seen youth in the bar, the black T-shirt and black leather crowd, and soon it would be over and the last downtown bar would be gone and Portland would have finished turning into something else and it would be time to move on. Not yet.

So much money in town now, he thought. So much success. A little failure kept him honest.

Winslow stubbed his cigarette out and laid the butt in the ashtray in a parallel line with the rest of the afternoon's dead soldiers. They were each smoked down to half an inch from the filter, each the same length, each lined up neatly with the others. The rain was coming down a little harder now, the pedestrians all walking faster or sleek under dark umbrellas and dark overcoats but still hurrying before their shoes got wet, all hurrying toward drinks or dates or a last appointment, all holding the city in the air between them, Winslow thought, a city made not from bricks and concrete and asphalt but by the intentions and desires of the souls who lived in it. Everybody wanted something. Everybody wanted the same thing, lately: money, success, a mistake-free life, a life without enemies. All these intersecting desires, colluding, colliding, all this assorted *valence,* with some of them missing an electron in the outer shell and some of them with an extra electron . . . Wisdom from the Army: he remembered Solomon Jackson, the look in his red, diseased eyes when he said: You want to live without enemies. You're afraid to make enemies.

Later on they became friends. After that, Solomon died. Winslow slumped back against the well-worn wooden bench, his hands splayed out in front of him, like a priest's hands, open and fat. The light was delicate and gray. Winslow himself was fat and bald and drunk but at least he was clean, he was scrupulous about that. He wore a white shirt and a tweed sport jacket. He sat back waiting for whatever the afternoon would bring him, and after that the evening.

He was watching the sky when June Leaf came in. He didn't see her until she sat down across from him and poured her own clean glass full from what was left of Winslow's beer.

"You fucker," she said. "I thought you were working."

"I was," he said.

He pushed the pack of cigarettes over to her but she shook her head. June Leaf smoked three a day but this wasn't the time.

"What happened?" she said.

"I came to a spot," he said. "It just seemed like a moment to take a break."

"How long have you been here?"

He held the pitcher at an angle so the beer ran down into a corner of it. "Just this," he said.

"Don't you lie to me."

Winslow looked at her: something in her voice, some new aggravation. It was a small lie, one pitcher short of the truth, and, besides, June Leaf was not an innocent herself. She drank the first glass of beer in a hurry and then poured herself another out of the rest of Winslow's beer, leaving him half a glass away from dry. Then she shook the cigarette out of the pack and looked around to see who she knew. Eddie in the plastic pants waved back at her. She regarded Winslow through the haze of her smoke.

"Did you get anything done today?" she asked.

"Enough," he said. "I paid my debt to society."

She knew he was not telling the truth—Winslow could feel it, the way her eyes glanced off his face—but she didn't take him up on it. This was marriage in Winslow's experience: knowing the other well enough to know she was lying but not well enough to know why. June Leaf settled into the opposite chair, a tall thin angular woman all in black, half a head taller than Winslow, people stared when they went out. She craned around to watch the dim afternoon outside.

"Nice light," she said. "Filthy weather, though. You got a call this afternoon."

Winslow waited for the rest of it, watching her hands in the soft enveloping light, as she was watching her hands herself. She stubbed out her cigarette haphazardly in the ashtray, ruining his careful alcoholic symmetry. June Leaf was a painter, though lately she had been supporting both of them as a claims adjuster for Kaiser. Winslow was fifty-five and she was forty-one and they had been married three years. They met in Mexico.

"Who did I get a call from?" he finally asked.

"It was Jack Walrath, over in Athens?" June Leaf said. Winslow felt his heart race inside him, this new call to glory, a voyage to Greece; and June Leaf must have seen it on his face as she quickly added, "Not *that* Athens. The one in Montana."

Winslow remembered Walrath then, a fool, a fixer, a second-rate poet. "What did he want?"

She said, "Apparently a visiting writer canceled out on them and now they want you."

"For what?"

"A semester, is what he said. Twenty-five thousand dollars and an apartment, is what he said."

"Oh, shit," Winslow said.

He looked at her face in the fine soft light of the window, long and lined, dark eyes, dark lips, the beautiful hollow at the base of her throat. She looked tired, he thought.

"What's wrong?" she said. "I thought you'd be happy about it."

Winslow hadn't written anything worth reading for eighteen months. He knew that for a fact, knew that as well as he knew his own name, and the thought of trying to tell anyone anything about poetry made him ill. The idea of standing up in a classroom again, which he had done before, and pretending that he knew anything about it. He should have told her before, should have confirmed what June Leaf suspected: that he spent his working hours in idleness and masturbation. The enterprise of poetry had defeated him entirely.

He should have told her but he had not, and now it was too late. June Leaf had been supporting both of them, with small exceptions. It came down to the money.

June Leaf looked at him warily. "I thought you'd be happy about it," she said again.

"No, it's good," he said. "Its a good thing."

She knew him well enough to disbelieve him.

"Well, I'm celebrating," she said, taking the empty beer pitcher from the table. "I'm drinking gin myself. Do you want anything? Or are you going to keep on drinking beer?"

"Scotch on the rocks," he said automatically, watching her skinny ass recede into the gathering crowd around the bar. It would take her a few minutes to get the bartender's attention, which was good. Winslow would try to compose himself, try to be happy, as she believed he should be. To feel the proper emotions. What one ought to feel.

She had told him before—she was feeling it now—that she felt invisible sometimes, that Winslow was the only living being in Winslow's world, that everybody else including her was just furniture. He didn't know that she was wrong. He hoped she was wrong but he didn't know. Did he love her? Winslow didn't know. He felt some deep stirring inside him but whether it was what other people called love or not was a mystery.

But solvent, Winslow thought. Money in the bank, money in his pocket. Back to being the overdog. He knew it wasn't good for him but still.

Somewhere outside, past the edge of the city and even in the city itself, in the dark dripping passages between buildings and the blackberry brambles along the edges of the railroad cuts, water was dripping over dark leaves, animals were moving through the undergrowth, the steelhead were making their way upstream from the Pacific. *Anadromous,* he thought. Oregon out there in the rain.

"What's the matter with you?" June Leaf said. She set the bar glass down on the table in front of him and Winslow saw that it was a double: happy hour.

"The long illness of my life," he said. and both of them laughed and drank. "When does all this start?" he asked. "When does he want me over there?"

"The semester starts the end of January."

"Dear God," said Winslow. "We're moving to the North Pole."

"*You're* moving," June Leaf said.

DAVID OATES

Reared in California, David Oates (1950–) spent much of his youth exploring the Sierra Nevada Mountains as climbing instructor and back-country guide. He attended Westmont College and earned a Ph.D. from Emory University on a Danforth fellowship. A Portland resident since 1992, Oates teaches English at Clark College in Vancouver, Washington, and environmental studies at Marylhurst University in Portland. One of the nation's most innovative nature writers, Oates explores how the world of thinking, writing, and feeling connects to the larger world of natural wildness. His books include Earth Rising: Ecological Belief in an Age of Science *(1989),* Peace in Exile *(poems, 1992),* Paradise Wild: Reimagining American Nature *(2003), and* Channeling Walt in a Time of War *(poems, 2004). Oates's work has also appeared in* Creative Nonfiction, Isotope, Contemporary Philosophy, *and* Earth Island Journal. *In this excerpt from* City Limits: Walking Portland's Boundary *(2006), the author walks through the Portland suburb of Sherwood, part of the city's 260-mile Urban Growth Boundary.*

Boots on the Ground in Sherwood Forest

I walked in the forests of Sherwood today in a blue funk, despite the pastoral charm of the place.

Sherwood is a suburb on the south edge of Portland's west side, tucked into forested hills within the coiling meanders of the Tualatin River. The UGB loops around Sherwood like another kind of meander, coming close enough to full-circle that after ten miles tracing the boundary, I needed only another half-mile to get back to my car.

Like my whole project, in a way: a circular journey. Normally that would please me, an emblem of containment, self-awareness, contentment.

But today my mind travels inward to doubt and outward to faraway misdeeds. What am I doing here, puttering in Portland while outrages are perpetrated? Photographs of U.S. soldiers humiliating Iraqi prisoners have been in the news for a week. Unspeakable fundamentalists have responded unspeakably, beheading an American (on video, to show off their bravado; yet their faces and heads were hooded). Meanwhile twenty thousand civilians, at least, are dead at our hands. Bland lies and murderous policies rain down on

us all from on high. And I am going walkies, street by street, for . . . what? to notice birdies and nice little houses?

What responsibility do I bear, I wonder?

Or what innocence?

I know that strapping on my boots in the early morning, starting out on the first hopeful mile of sidewalk, riverside trail, or country highway, I feel that fresh elation of a new beginning, as if I had been reborn, as if the day had no history and was nothing but endless possibility. I'm committed to that feeling and its underlying truth. Thoreau, my beloved guide for so many decades now, said it, wringing my heart when I read it for the first time: "Rise free from care before the dawn, and seek adventures . . ."

What does it mean, though, with this shadow across it, the dark flicker of this bird of prey? There are bloodier facts to attend to.

Walking in this wartime has started to feel disconnected. Self-involved. Trivial.

What strikes you immediately about Sherwood is its prettiness. The gentle roll of hill gives vistas of village or green bottomland or fir forest encroaching, edging, reminding. The sameness of these middle-class houses lined up on subdivision drives is offset by all this topography. As I thread along Michael and Highpoint streets, the UGB manifests itself in a now-familiar effect—that wall of fir trees just behind back fences. Views and forests give a pleasant feeling, the quilty this-'n'-that of real life—of nature, even. "Landscapes plotted and pieced" just past the end of the street. I've always been happiest on the edges of things. That's how it feels here. That this street is on its first asphalt, these houses still under their first roofs, is somehow forgiven by the setting. Room for new and old, it says. A peaceable kingdom.

This is noticed with dark irony. I am edgy, hawking for trouble. I don't trust peaceable suburbs, not one inch.

A chat with Michele, caught carrying grass clippings across her driveway, tells me the other side I crave to hear. "Do you like living next to the UGB?" I ask—my lame conversation opener. "Of course! But those politicians keep trying to move it. . . ." she shakes her head. She's a lean and active grey-haired mom, probably my mid-fifties age, has a son home from college. "Excuse me if I'm a little cynical about our leaders!" she adds. I've read about Sherwood's battles with the Metro government. Residents fear being swamped in undiluted suburbia and they noisily resist attempts to extend the Boundary. Like almost everyone I've conversed with, they approve the boundary *right where it is*. Their voices were loud and sustained, so the recent round of Boundary-moving has made only minor adjustments here. Sherwood is safe for another five years. Far off to the east, the less-organized community of Damascus (more rural, more poor) has taken the brunt of the expansion instead. "Oh

but that's not our only fight," says Michele. "We tried to stop the gas pipeline and failed. It's right over there." Somehow managing to convey cheerfulness, anger, and resignation all at once, she dumps the clippings, and points down hill, where I'm headed.

And I continue down Michele's street reassured somehow, knowing that strife is not absent even here.

But I'm also struck by what I begin to think of as the *graininess* of life: its close-up detail. Distracted by it, perhaps. Two little girls of maybe three and five run up to deposit something in the curbside mailbox, then scamper ahead of me, back toward their house. The bigger girl is skipping, la la la, and little sister is running behind, attempting to imitate the puzzling skippy-step. She trots, bounces, *nope*, tries a two-legged hop, *nope still not it*, races to catch up. . . . Yesterday's play is colored chalk underfoot. Overhead the sky blue is warm and serene, the plantings all around are well-grown-in, the next hill over is forested, a scent of something sweet floats on a current of warm air. Of course there are birdies.

The girls find their doorstep and are home.

Life is lived in these ten- and twenty-foot segments, isn't it? Five minutes at a time. Our block, our house, our mom. My day, my moment. Here and now. The fine-grained texture. "Far away" is a thought, a headline. It's not here. It's not the step we're trying to master, the thing that is before us to do next. Gracefully if possible. With love, if possible. Walk, skip, cut the grass, write.

Faraway battles seem further away. Oh but I am watching this mood carefully, from a short, deadly distance. Suburbanization of the mind? Or just plain good sense?

Two steep downhill blocks (which my knees don't like), two turns, and suddenly I am in rural Oregon. View lots and sidewalks disappear, and I am traveling down Brookman Road on asphalt shoulders under heavy forest with full green-fern understory. I pass isolated houses, collapsing tin-roofed sheds, abandoned barns. There must be different stories down here, though suburban prosperity is just blocks away. Down here there's evidence of some time having passed, some life having been endured, enjoyed. Here it's obvious that we *do* see as far only as the next turn—the last catastrophe, the next break. The old truth: Close, immediate, real. Concentrate on the breath. *Here.*

But on this day, my Zen moralizing cannot quite mask the presence of trouble. Bumper-sticker patriotism reminds me that soldiers from this working-class neighborhood, sons and daughters, husbands and wives, are fighting that distant war, somewhere the rest of us experience only in headlines. The next hoped-for-thing is that someone will come home safely. Many more of these folks, poorer by several notches than the hilltop suburbanites, will

have enlisted in the armed forces. They are doing the fighting, bleeding, dying, and killing. They need the money, they need the job, they need the chance at college tuition. That war is close by, after all.

There's the paradox we can't solve. We're bound to get it wrong either way: obsess over politics, and it steals your real life. Stay merely quiescent and private, and you ignore what we must never ignore, things done in our name, things done to us and by us, by a government we purport to control. What's real, the near or the far? What's responsible mean? To whom, for what?

Breathe, I tell myself. I've stopped walking. Down the road I see heavy machinery tearing up the far side, just over the Boundary. They're installing that unwanted natural-gas pipeline. Along the road on small, sometimes unpainted houses, weathered "NO PIPELINE" signs show who lost this battle.

I'm left with a confused sense of general struggle, the muddle of here and there, green forest and class warfare, youngsters sent to bomb foreigners while their homeplace is abused for industrial gain. The pipeline was opposed by the people who live here, yet it was unstoppable. It will carry natural gas southeast from coastal-mountain Mist to Willamette-Valley Molalla, grazing the edge of greater Portland as it goes, introducing (one supposes) some kind of efficiency for the consuming public and (certainly) some kind of profit for someone. Life right here will go on, in the form of apple and pear orchards along the rural side of Brookman, with a soon-invisible stream of explosive gas running underneath.

Chances are, the pipeline will accomplish what those suburban activists wanted after all, freezing the Boundary along a line of hazard that will probably not be crossed. Too risky for new suburbs.

The September 11 attacks had already occurred when I started my UGB project. So had the American response of uprooting the Taliban from Afghanistan, which seemed like a good idea then and still does. But the arrogant adventurism of Iraq had not yet (publicly) begun, nor could I have imagined it . . . except that I'm old enough to remember how Viet Nam was started by a lie; how it was pursued for a vague and unattainable goal; how it ended in a slaughter of innocents (theirs) and innocence (ours). In that perspective what has happened in Iraq is almost predictable. Almost.

Meanwhile I'm walking, pretty literally, in the Sherwood Forest . . . where Robin Hood shows up on an Elks Club billboard, when I turn onto the busy highway. Robin Hood! He, perhaps, would deliver me from these concerns. A wronged innocent, he could shoot arrows with impunity into anyone who opposed him. And he doubled his innocence by giving the proceeds to the poor. Everything is clear to the innocent.

It's not such a remote connection. Of the several rationales our president advanced to justify the Iraq war, the only one that survived the first year was

the *doing-good* one. "Weapons of Mass Destruction" of course were never found; the "imminent threat" evaporated; no plausible connection existed between Saddam Hussein and the 9/11 attacks. That left a generalized mission to overthrow badness and implant goodness. *Our* goodness: American power, used to install upon the Iraqis an American definition of democracy. For their own good. International Robin Hood.

One thing I know clearly from my work as a nature writer is that America believes in its innocence. We live on the continent that Europeans called the New World, as if it had no history, as if it were an untouched Eden. The fifty million people who were already living in this hemisphere in 1492 were somehow overlooked. Anyhow, most of their descendants were dead within a century or two. Now our national parks enshrine the imposed vision of a stupendous, empty land, into which we have poured an empire of youthful virtue. A new land, empty, as innocent as Robin Hood: that's America.

Perpetual innocence is the national self-image that dominates American politics and empowers the Right. Our goodness is unassailable, our motives benevolent. When "old Europe" was publicly scorned by our war leaders, the meaning lay exactly here: that we are new and unsullied. We are America the Innocent. If we act, even with violence, we are entirely just in our innocence.

When President George W. Bush was asked to account for the hatred of those foreigners who committed the 9/11 attacks, his answer was simplicity itself. Anyone who attacks us must simply *not know how good we are.* American goodness is unquestionable and unalloyed. The other half of the President's explanation? That they, these foreign warriors, themselves are "evil."

In the power-politics of innocence, the eternal boy-nation is untroubled by any distressing consciousness of its own capacity for evil. It pretends that we (alone among humans) are not likely to commit cruelties when our power is unchecked, not likely to rationalize self-interest by fine-sounding phrases. It forgets all our national wrongs, preferring a Disney tale of clean, clear-eyed pioneers building a nation by hard work — rather than the tragic, mixed tale of an empire built, yes, by virtue and hard work, but also by murdering the inhabitants, stealing their land, driving off other claimants by force, and settling, in remarkable measure, upon a cushion of real or virtual slave labor extracted from millions of people with black, brown, yellow, and white skin.

This un-innocent tale is the one we cannot quite remember. It keeps slipping from the national awareness. In its place is that fresh American Adam, with an ax in one hand and a Bible in the other and nothing — nothing at all — on his conscience.

America is a state of mind that endures by *not-knowing* whatever it doesn't want to know: a forced and artificial Innocence. Such a boy-nation is of course shocked to find wrongs done to it. A wrong done to an Innocent calls

for fiery retribution, for action without hesitation or doubt—without leniency, compassion, restraint, or any other mitigating human virtue.

Thus the ultimate product of this assumed Innocence is shamelessness. No American misdeed, no matter how awful, can be recognized. Not even the My Lai massacres of Viet Nam, which the entrenched Right, then and now, cannot admit. Not even the torturing of prisoners, by Americans, in Saddam Hussein's own torture-prison. The wronged Innocent—in the form of an Oklahoma senator or a pill-addicted radio host—looks into the camera, leans into the microphone, and, spotless in his outrage, declares there is nothing, nothing, nothing at all to regret.

Without shame or the capacity for shame, Innocence turns, with deadly irony, into its opposite.

Thorough lived in dark times of his own, and had to find his own way between shamelessness and outrage, quitism and righteous action. His years at Walden Pond (1845–46) were times of terrible human suffering and patriotic gore: the naked aggression fo the Mexican War, the brutality of southern slavery. Yet Thorough resisted the demands of his Boston abolitionist and activist friends to join the political battle. He said *only he knew* what his proper work was . . . and holed up in the woods to think and write, to walk and while away the days. "I came into the world, not chiefly to make htis a good place to live in, but to live in it, be it good or bad." If anyone ever cliamed innocence, it was he.

Yet in the midst of this contemplative retreat, one night in 1846, he ventured forth into political resistance and found the basis for *Civil Disobedience* inside the Concord jail, where he was imprisoned for refusing to pay tax to a slave-supporting government that was in the process of invading Mexico on trumped-up pretexts. "Under a government which imprisons any unjustly, the true place for a just man is also in prison," he famously said. This essay echoed far. Gandhi and M.L. King both loved it and built their work on its foundation. Literally millions were mobilized, inspired, and liberated.

Somehow, Thoreau found right action in the heart of withdrawl from action. This is a mystery, a koan, a divine irony—a union of opposites deeper than contemplation or reason can explain.

Caught in my private life, my quiet luxuries of time and body and place. My boots on the ground in the Sherwood Forest, walking in a land of plenty, surrounded by the planet's most fortunate people. Caught in self-doubt and politics and war. American boots-on-the-ground (catch-phrase of the moment) in Iraq, kicking, pursuing, fleeing, laying low. Boots sweltering the feet of soldiers longing for home . . . or being unlaced, alas, from corpses in field morgues.

What is the point of walking in war time? Or of picnicking, or reading something beautiful, or goofing off, or harassing the politicians into doing the right thing? Strife there, strife here, peace everywhere in the gaps and hedgerows and stolen moments and lucky decades.

I can't say which is the realer reality. I appear to be living in both.

Bibliography

Abbott, Carl. *Frontiers Past and Future: Science Fiction and the American West.* Lawrence: University Press of Kansas, 2006.

—. *Greater Portland: Urban Life and Landscape in the Pacific Northwest.* Philadelphia: University of Pennsylvania Press, 2001.

—. *The Great Extravaganza: Portland and the Lewis And Clark Exposition.* 3rd ed. Portland: Oregon Historical Society, 2004.

—. *Portland: Planning, Politics, and Growth in aTwentieth-Century City.* Lincoln: University of Nebraska Press, 1983.

Adams, William Lysander. *Oregon As It Is: Its Present and Future, by a Resident for Twenty-Five Years, Being a Reply to Inquirers.* Portland, Ore.: W.L. Adams, 1873.

Alexander, Shana. *The Astonishing Elephant.* New York: Random House, 2000.

Allen, Eleanor. *Canvas Caravans: Based on the Journal of Esther Belle Mcmillan Hanna, Who with her Husband, Rev. Joseph A. Hanna, Brought the Presbyterian Colony to Oregon in 1852.* Portland, Ore.: Binford & Mort, 1946.

Ames, Kenneth M., and Herbert D.G. Maschner. *Peoples of the Northwest Coast: Their Archaeology Aand Prehistory.* London: Thames & Hudson, 1999.

Anderson, Kent. *Nightdogs.* New York: Bantam, 1998.

Anonymous. "Confessions of a Japanese Servant." *Independent.* September 21, 1905, 661-668.

Anonymous. "The Portland Exposition." *Independent.* September 14, 1905, 630-634.

Applegate, Jesse A. *A Day with the Cow Column in 1843: Recollections of my Boyhood.* Ed. Joseph Schafer. Chicago: Caxton Club, 1934.

—. *Recollections of my Boyhood.* Roseburg, Ore: Press of Review Publishing, 1914.

Applegate, Shannon. *Skookum: An Oregon Pioneer Family's History and Lore.* New York: Beech Tree Books, 1988.

— and Terence O' Donnell, eds. *Talking on Paper: An Anthology of Oregon Letters and Diaries.* Corvallis: Oregon State University Press, 1994.

Atwood, A. *The Conquerers: Historical Sketches of the American Settlement of the Oregon Country, Embracing Facts in the Life and Work of Rev. Jason Lee, the Pioneer and Founder of American Institutions on the Western Coast of North America.* Portland: Jennings and Graham, 1907.

Bailey, Margaret Jewett. *The Grains: Or, Passages in the Life of Ruth Rover, with Occasional Pictures of Oregon, Natural and Moral.* Portland: Carter & Austin, 1854. Reprint, edited by Evelyn Leasher and Robert J. Frank. Corvallis: Oregon State University Press, 1986.

Ball, John. *Autobiography of John Ball.* Comp. Kate Ball Powers, Flora Ball Hopkins, and Lucy Ball. Glendale, Calif.: Arthur H. Clark, 1925.

Bancroft, Hubert H. *History of Oregon.* San Francisco: The History Company, 1890.

Baker, Doug. *River Place: One Man's Search for Serenity.* Forest Grove, Ore: Timber Press, 1980.

Barcott, Bruce, ed. *Northwest Passages: A Literary Anthology of the Pacific Northwest from Coyote Tales to Roadside Attractions.* Seattle: Sasquatch Books, 1994.

Barnard, Mary. *Assault on Mount Helicon: A Literary Memoir.* Berkeley: University of California Press, 1984.

Barnett, Ruth, with Doug Baker. *They Weep on My Doorstep.* Medford, Ore.: Pacific Northwest Books, 1978.

Barker, Neil. "Portland's Works Progress Administration." *Oregon Historical Quarterly* 101:4 (Winter 2000): 414-521.

Balch, Frederic Homer. (1890). *Bridge of the Gods.* Portland, Ore.: Metropolitan Press, 1932.

—. *Genevieve : A Tale of Oregon.* Portland, Ore.: Metropolitan Press, 1932.

Beard, James. *Delights and Prejudices.* Philadelphia: Running Press, 1964.

Beeson, John. *A Plea for the Indians; With Facts and Features of the Late War in Oregon.* New York: J. Beeson, 1857.

Bell, Edward. (Captain Robert William Broughton). "Columbia River Exploration, 1792." Edited and with an introduction by J. Neilson Barry. *Oregon Historical Quarterly.* 33:2 (June 1932): 143-55.

Beverly-Whittemore, Miranda. *The Effects of Light.* New York: Warner, 2005.

Bingham, Edwin, and Tim Barnes, ed. *Wood Works: The Life And Writings Of Charles Erskine Scott Wood.* Corvallis: Oregon State University Press, 1997.

Blankenship, Judy. *Intersections: Trimet Interstate MAX Light Rail Community History Project: Stories from Interstate Avenue Portland, Oregon: Tri-County Metropolitan Transportation District of Oregon, 2003.*

Booth. Brian, ed. *Wildmen Wobblies & Whistlepunks: Stewart Holbrook's Lowbrow Northwest.* Corvallis: Oregon State University Press, 1992.

Bowen, William A. *The Willamette Valley: Migration and Settlement on the Oregon Frontier.* Seattle: University of Washington Press, 1978.

Boas, Franz. Told by Charles Cultee. *Chinook Texts.* Washington, D.C.: Government Printing Office, 1894, 101-106.

—. *Kathlamet Texts.* Washington, D.C.: Government Printing Office, 1901.

Browne, Sheri Bartlett. *Eva Emery Dye: Romance with the West.* Corvallis: Oregon State University Press, 2004.

Bryant, Louise. "Two Judges." *The Masses,* April. 18, 1916.

Buan, Carolyn M., and Richard Lewis, eds. *The First Oregonians: An Illustrated Collection of Essays on Traditional Lifeways, Federal-Indian Relations, and the State's Native People Today.* Portland: Oregon Council for the Humanities, 1991.

Callenbach, Ernest. *Ecotopia.* New York: Bantam Books, 1975.

Canty, Kevin. *Winslow in Love.* New York: Nan A. Talese, 2005.

Carey, Charles. H. *History of Oregon.* Chicago: The Pioneer Historical Publishing Company, 1922.

Carpenter, Don. *The Class of '49: A Novel and Two Stories*. San Francisco: North Point Press, 1985.

Case, Robert Ormond. *The Empire Builders*. Portland, Ore.: Binford & Mort, 1947.

Chacón, Daniel. "Aztlán, Oregon." *Chicano Chicanery*. Houston: Arte Publico Press, 2000.

Cheuse, Alan. *The Bohemians, John Reed and His Friends Who Shook the World*. Cambridge, Mass.: Apple-Wood Books, 1982.

Clark, Malcolm. *Eden Seekers: The Settlement of Oregon, 1818-1862*. Boston: Houghton Mifflin, 1982.

—. *The War on the Webfoot Saloon*. Portland: Oregon Historical Society, 1969.

—, ed. *The Diary of Judge Mattew P. Deady 1871-1892: Pharisee Among Philistines*. Portland: Oregon Historical Society, 1975.

Clawson, Augusta H. *Shipyard Diary of a Woman Welder*. New York: Penguin, 1944.

Cleary, Beverly. *A Girl from Yamhill: A Memoir*. New York: William Morrow, 1988.

Cleaver, J.D. "L. Samuel and the *West Shore*: Images of a Changing Northwest." *Oregon Historical Quarterly*. 94:2/3 (Summer-Fall 1993): 167-224.

Cody, Robin. *Voyage of a Summer Sun: Canoeing the Columbia River*. Seattle: Sasquatch Books, 1996.

Cook, Warren L. *Flood Tide of Empire: Spain and the Pacific Northwest, 1543-1819*. New Haven, Conn.: Yale University Press, 1973.

Corning, Howard McKinley. *Willamette Landings: Ghost Towns of the River*. 3rd ed. Portland: Oregon Historical Society, 2004).

Elliott Coues, ed. *History of the Expedition Under the Command of Lewis and Clark, To the Sources of the Missouri River, Thence across the Rocky Mountains and Down the Columbia River to the Pacific Ocean, performed during the Years 1804-5*. Vol. 3. New York: Francis P. Harper, 1893.

—. *The Manuscript Journals of Alexander Henry. Fur Trader of the Northwest Company. and of David Thompson 1799-1814. Exploration and Adventure Among the Indians on the Red, Saskatchewan, Missouri, and Columbia Rivers*. Vol. 2. New York: Francis P. Harper, 1897

Coupland, Douglas. *Generation X*. New York: St. Martin's Press, 1991.

Curtis, Walt. *Mala Noche & Other "Illegal" Adventures*. Portland, Oregon: BridgeCity Books, 1997.

—. *The Roses of Portland*. Portland, Ore.: Hoodoo Times, 1974

—. *Peckerneck Country*. Portland, Ore.: Mr. Cogito Press, 1978.

—. *Rhymes for Alice Bluelight*. Amherst, Mass.: Lynx House Press, 1984.

—. *Salmon Song, and Other Wet Poems*, Portland, Ore: NYMPH & SATYR, 1995.

—. "Portland-on-Wallamet." *The Overland Monthly* 1 (1868): 34-43.

Dearborn, Mary V. *Queen of Bohemia: The Life of Louise Bryant*. Boston: Houghton Mifflin, 1996.

De Smet, Pierre-Jean. *Oregon Missions and Travels over the Rocky Mountains*. New York: E. Dunigan, 1847.

DeWolfe, Fred, ed. "Portlander John Reed Remembers Lee Sing, His Family's Chinese Servant." *Oregon Historical Society Quarterly* 97:3 (Fall 1996): 356-371.

Dietsche, Robert. *Jumptown: The Golden Years of Portland Jazz, 1942-1957.* Corvallis: Oregon State University Press, 2005.

—. "Where Jump Was a Noun: Jazz in Portland in the 40s." *Open Spaces* 2:1 (1999): 30–35.

Dodds, Gordon B., ed. *Varieties of Hope: An Anthology of Oregon Prose.* Corvallis: Oregon State University Press, 1993.

Douglas, David. "Sketch of a Journey to the Northwestern Parts of the Continent of North America During the Years 1824-25-26-27." *Oregon Historical Quarterly* 5 (1905): 230-71.

Drake, Albert. *Beyond the Pavement.* Adelphi, Md.: White Ewe Press, 1981.

—. *One Summer.* Adelphi, Md.: White Ewe Press, 1981.

Duncan, David James. *The River Why.* New York: Bantam, 1982.

Duniway, Abigail Scott. *Captain Grey's Company; Or, Crossing the Plains and Living in Oregon.* S.J. McCormick, 1859.

—. *From The West To The West : Across The Plains To Oregon.* Chicago: A.C. McClurg, 1905.

—. *Judge Dunson's Secret: An Oregon Story.* Published serially March 15 - September 6, 1883. *The New Northwest.*

—. *My Musings, Or, A Few Fancies in Verse.* Portland, Ore.: A.G. Walling, 1975.

—. *Path Breaking: An Autobiographical History of the Equal Suffrage Movement in Pacific Coast States.* Portland, Ore.: James, Kerns & Abbott, 1914.

Dunn, Katherine. *Truck.* New York: Warner Books, 1990.

Dye, Eva Emery. *The Conquest : The True Story of Lewis and Clark.* Portland, Ore.: Binford & Mort, 1936.

—. *McCloughlin and Old Oregon : A Chronicle.* Chicago: A.C. McClurg, 1900.

—. *Oregon Stories.* San Francisco: Whitaker and Bay, 1900.

—. *The Soul Of America : An Oregon Iliad.* New York: Press of the Pioneers, 1934.

Edmo, Ed. "After Celilo." *Talking Leaves: Contemporary Native American Short Stories.* Ed. Craig Lesley. New York: Delta, 1991.

Edwards, Thomas G., and Carlos A. Schwantes. *Experiences in a Promised Land: Essays in Pacific Northwest History.* Seattle: University of Washington Press, 1986.

Edwards, Margaret Watt Edwards. *Land of the Multnomahs: Sketches and Stories of Early Oregon.* Portland, Ore.: Binford & Mort, 1973.

Eells, Myron. *Father Eells; Or, The Results of Fifty-Five Years of Missionary Labors in Washington and Oregon; A Biography of Rev. Cushing Eells, D.D.* Boston: Congregational Sunday-School and Publishing Society, 1894.

Ermenc, Christine. *Voices of Portland.* Portland, Ore.: Neighborhood History Project, 1976.

Faris, John Thomson. *Winning the Oregon Country.* New York, Missionary Education Movement of the United States and Canada, 1911.

Foster, Ken. "The Circuit." *The Kind I'm Likely To Get*. New York: Quill, 1999.

Federal Works Agency. *Oregon: The End of the Trail*. Portland, Ore.: Binford & Mort, 1940.

—. "History of Portland, Oregon." Writers' Program of the Works Projects Administration in the State of Orego, 1941.

Franchère, Gabriel. (1819). *Narrative of a Voyage to the Northwest Coast of America in the Years 1811, 1812, 1813, and 1814; Or, The first American Settlement of the Pacific*. Trans. and ed. J. V. Huntington. New York, Redfield, 1854.

Friedman, Elaine S. *The Facts of Life In Portland, Oregon*. Portland, Ore.: Portland Possibilities, 1993.

Fulton, Anne. "The Restoration of an iÂkák\mana/A Chief called Multnomah."*American Indian Quarterly* (forthcoming).

Gaston, Joseph. *Portland, Oregon, Its History and Builders in Connection with the Antecedent Explorations, Discoveries and Movements of the Pioneers that Selected the Site for the Great City of the Pacific*. Portland, Ore.: S.J. Clarke, 1911.

Gay, Theressa. *Life And Letters of Mrs. Jason Lee, First Wife of Rev. Jason Lee of the Oregon Mission*. Portland, Ore.: Metropolitan Press, 1936.

Geer, Theodore Thurston. *Fifty Years in Oregon; Experiences, Observations, and Commentaries upon Men, Measures, and Customs in Pioneer Days and Later Times*. New York: Neale Publishing, 1912.

Gibb, Evelyn McDaniel. *Two Wheels North: Bicycling the West Coast in 1909*. Corvallis: Oregon State University Press, 2000.

Gies, Martha. *Up All Night*. Corvallis: Oregon State University Press, 2004.

Gilmore, Mikal. *Shot in the Heart*. New York: Doubleday, 1994.

Greenhow, Robert. *Memoir, Historical and Political, on the Northwest Coast of North America, and the Adjacent Territories; Illustrated by a Map and a Geographical View of Those Countries*. Washington, D.C.: Blair and Rives, 1840.

Goldberg, Ed. *Dead Air*. New York: Berkley Crime, 1998.

—. *Served Cold*. Portland, Ore.: West Coast Crime, 1999.

Goulder, William Armistead. *Reminiscences: Incidents in the Life of a Pioneer in Oregon and Idaho*. Boise, Idaho: Timothy Regan, 1909. Reprint, Moscow, Idaho: University of Idaho Press, 1989.

Gunselman, Cheryl. "Pioneering Free Library Service for the City, 1864-1902." *Oregon Historical Quarterly*. 103:3 (2002): 320-337.

Hart, Alan. *Doctor Mallory*. New York: Norton, 1935.

—. *Sprigs of Rosemary*. Portland, Ore.: National Society of the Colonial Dames of America in Oregon, 1975.

Hartwell, Barbara Bartlett. "The Wood Household." (Address in 1942 to the Portland Art Museum). *Nanny Wood: From Washington Belle to Portland's Grande Dame*. Ed. Philip W. Leon. Heritage Books. 215-224, 2003.

Haycox, Ernest. *The Earthbreakers*. Chicago: Sears Readers Club, 1952.

—. *The Long Storm*. Boston: Little, Brown, 1946.

Henry, April. *Buried Diamonds*. New York: Thomas Dunne Books, 2003.

—. *Shock Point*. New York: Putnam Juvenile, 2006.

Hills, Tim. "Myths and Anarchists: Sorting out the History of Portland's White Eagle Saloon." *Oregon Historical Quarterly* 101:4. (Winter 2000): 520-529.

— and Herbert O. Lang. *History of the Willamette Valley; Being a Description of the Valley and Resources, With an Account of its Discovery and Settlement by White Men, and its Subsequent History; Together with Personal Reminiscences of its Early Pioneers.* Portland, Ore.: G.H. Himes, 1885.

Hines, Gustavus. *Life on the Plains of the Pacific. Oregon: Its History Condition and Prospects: Containing a Description of the Geography, Climate and Productions, with Personal Adventures among the Indians during a Residence of the Author on the Plains Bordering the Pacific While Connected with the Oregon Mission: Embracing Extended Notes of a Voyage Around the World.* Buffalo, N.Y.: G.H. Derby, 1851.

Holbrook, Stewart. *Far Corner: A Personal View of the Pacific Northwest.* New York: Macmillan, 1952.

—, ed. *Promised Land: A Collection of Northwest Writing.* New York: Whittlesey House, McGraw-Hill, 1945.

—. *The Portland Story.* Portland, Ore.: Lipman Wolfe, 1950.

Holt, Hamilton. 1990. "The Life Story of a Japanese Servant." *The Life Stories of Undistinguished Americans, As Told By Themselves.* Introduction by Werner Sollors. New York: Routledge. Reprint. 159-164. First published "The Confessions of a Japanese Servant." *Independent* 59 (Sept. 21, 1905): 661-68.

Houck, Michael, and M.J. Cody, eds.*Wild in the City.* Portland: Oregon Historical Society Press, 2000.

Houle, Marcy Cottrell. *One City's Wilderness: Portland's Forest Park.* Portland: Oregon Historical Society Press, 1988.

Irving, Washington. *Astoria.* New York: G.P. Putnam's, 1836.

Hugo, Richard. *Death and the Good Life: A Mystery.* Boise: University of Idaho Press, 2002.

Jacobs, Melville. *Clackamas Chinook Texts.* Part 1. Ed. C.F. Voegelin. *International Journal of American Linguistics.* Bloomington: Indiana University Research Center in Anthropology, Folklore, and Linguistics, 1958-1959.

—. *The Content and Style of an Oral Literature: Clackamas Chinook Myths and Tales.* Chicago: University of Chicago Press, 1959.

Johansen, Dorothy O., and Charles M. Gates. *Empire of the Columbia: A History of the Pacific Northwest.* New York: Harper & Row, 1967.

Jones, Nard. *Oregon Detour.* New York: Payson & Clarke. 1930. Reprinted wiht an introduction by George Venn. Corvallis: Oregon State University Press, 1990.

—. *Scarlet Petticoat.* New York: Dodd, Mead, 1941.

—. *Swift Flows The River.* New York: Dodd, Mead, 1941.

Jones, Suzi, and Jarold Ramsey, eds. *The Stories We Tell: An Anthology of Oregon Folk Literature.* Corvalis: Oregon State University Press, 1993.

Kendall, Nancy Noon. 1947. *The Wise in Heart.* Thomas Crowell.

Kipling, Rudyard. 1899. *From Sea To Sea: Letters Of Travel*. New York, Doubleday & McClure Co. V2.

Kirkpatrick, Jane. *A Land of Sheltered Promise*. New York: WaterBrook Press, 2005.

Klooster, Karl. *Round The Roses: Portland Past Perspectives*. Portland, Oregon: K. Klooster, 1987.

Knuth, Priscilla and Charles M. Gates, eds. "Oregon Territory in 1849-1850." *The Pacific Northwest Quarterly*. 40:1 January 1949): 3-23.

Labonte, Louis, or La Bonte. "Coyote Builds Willamette Falls and the Magic Fish Trap." 183-184. Ed H.S Lyman. "Reminiscences of Louis Labonte." *Oregon Historical Quarterly* 1 (1900): 169-188.

Lampman, Ben Hur. *At the End of the Car Line*. Portland, Ore.: Binford & Mor, 1942.

—. *How Could I Be Forgetting? Being a Compilation of Some of his Editorial Writings and Poems, Heretofore Published Principally in the Morning Oregonian*. Portland, Ore.: W.W.R. May, 19262.

Lancaster, Samuel Christopher. *The Columbia, America's Great Highway through the Cascade Mountains to the Sea*. Portland, Oregon: J.K. Gill Company, 1926.

Lang, Herbert O. *History of the Willamette Valley; Being a Description of the Valley and Resources, with an Account of its Discovery and Settlement by White Men, and its Subsequent History; Together with Personal Reminiscences of its Early Pioneers*. Portland, Ore.: G.H. Himes, 1885.

Lang, William L., and Carl Abbott. *Two Centuries of Lewis & Clark: Reflections On the Voyage of Discovery*. Portland: Oregon Historical Society Press, 2004.

Lang, William L., and Robert C. Carriker. *Great River of the West: Essays on the Columbia River*. Seattle: University of Washington Press, 1994.

Langer, Elinor. *A Hundred Little Hitlers: The Death of a Black Man, the Trial of a White Racist, and the Rise of the Neo-Nazi Movement in America*. New York: Metropolitan Books, 2003.

Lansing, Jewel Beck. *Deadly Games in City Hall: A Murder Mystery*. Portland: Skylark Press, 1997.

—. *Portland: People, Politics, and Power, 1851-2001*. Corvallis: Oregon State University Press, 2003.

Least Heat-Moon, William. *River-Horse: The Logbook of a Boat Across America*. Boston: Houghton Mifflin, 1999.

Lee, Daniel. *Ten Years in Oregon*. Collard, New York, 1844.

LeGuin, Ursula K. *Blue Moon over Thurman Street*. Portland, Ore.: NewSage Press, 1993.

—. *The Lathe of Heaven*. Cambridge, MA: Robert Bentley, 1971.

Levi-Stauss, Claude. *The Way of the Masks*. Trans. Sylvia Modelski. Seattle: University of Washington Press, 1982.

Lewis, Meriwether. *History of the Expedition under the Command of Captains Lewis and Clark, to the Sources of the Missouri: Thence Across the Rocky Mountains and Down the River Columbia to the Pacific Ocean; Performed During the Years 1804-*

5-6; *By Order of the Government of the United States.* Prepared for the press by Paul Allen, Esquire, 1814.

Lockley, Fred. *Captain Sol. Tetherow, Wagon Train Master: Personal Narrative of his Son, Sam. Tetherow.* Portland, Ore.: Fred Lockley, 1925.

— . *Conversations With Bullwhackers, Muleskinners, Pioneers, Prospectors, '49ers, Indian Fighters, Trappers, Ex-Barkeepers, Authors, Preachers, Poets & Near Poets & All Sorts & Conditions of Men: Voices of the Oregon Territory.* Ed. Mike Helm. Eugene, Ore.: Rainy Day Press 1981.

—. *Conversations with Pioneer Women.* Ed. Mike Helm. Eugene, OR: Rainy Day Press, 1981.

—. *Oregon Folks.* New York: Knickerbocker Press, 1927.

—. *Oregon's Yesterdays.* New York: Knickerbocker Press, 1928.

—. *Visionaries, Mountain Men & Empire Builders.* Ed. Mike Helm. Eugene, OR: Rainy Day Press, 1982.

Love, Glen A., ed. *The World Begins Here: An Anthology of Oregon Short Fiction.* Corvalis: Oregon State University Press, 1993.

Lowenstein, Steven. *The Jews of Oregon, 1850-1950.* Portland: Jewish Historical Society of Oregon, 1987.

Lyman, H.S. "An Oregon Literature." *Oregon Historical Quarterly* 2 (1901): 401-409.

—, ed. "Coyote Builds Willamette Falls and the Magic Fish Trap," 183-184. "Reminiscences of Louis Labonte." *Oregon Historical Quarterly* 1:2 (June 1900): 169-188.

MacColl, E. Kimbark. *The Growth of a City: Power and Politics in Portland, Oregon, 1915-1950.* Portland, Ore.: Georgian Press, 1979.

—. *Money, Merchants and Power: The Portland Establishment, 1843-1913.* Portland, Ore.: Gerogian Press, 1988.

—. *he Shaping of a City: Business and Politics in Portland, Oregon, 1885-1915.* Portland, Ore.: Georgian Press, 1976.

McArthur, Lewis A. *Oregon Geographic Names.* 7th ed. Portland: Oregon Historical Society Press, 2003.

Maddux, Percy. *City on the Willamette: The Story of Portland, Oregon.* Portland, Ore.: Binford & Mort, 1952.

Margolin, Phillip. *Ties That Bind.* New York: HarperTorch, 2003.

Markham, Edwin. *California the Wonderful: Her Romantic History, Her Picturesque People, Her Wild Shores, Her Desert Mystery, Her Valley Loveliness, Her Mountain Glory, Including Her Varied Resources, Her Commercial Greatness, Her Intellectual Achievements, Her Expanding Hopes; With Glimpses of Oregon and Washington, Her Northern Neighbors.* New York: Hearst's International Library, 1914.

Masson, Louis. *Reflections: Essays on Place and Family.* Pullman: Washington State University Press, 1996

Manning, Richard. *Inside Passage: A Journey Beyond Borders.* Washington, D.C.: Island Press, 2001.

Marlitt, Richard. *Nineteenth Street.* Portland: Oregon Historical Society Press, 1968

McAllister, Tom, and David B. Marshall. "Hometown." *Oregon Historical Quarterly* 101:3 (Fall 2000): 376-382.

McLagan, Elizabeth. *A Peculiar Paradise: A History of Blacks in Oregon, 1788-1940*. Portland: Georgian Press, 1980.

Merry, Thomas B. *Portland, the Beautiful Metropolis of the Pacific Northwest*. St. Paul-Minneapolis, Minn.: E.V. Smalley, 1885.

Miller, Donald. *Blue Like Jazz: Nonreligious Thoughts on Christian Spirituality*. Nashville: T. Nelson Books, 2003.

Miller, Joaquin. *Memorie and Rime*. New York: Funk & Wagnalls, 1884.

Miranda, Gary. *Following A River: Portland's Congregation Neveh Shalom, 1869-1989*. Portland: Congregation of Neveh Shalom, 1989.

Moore, Kathleen Dean. *Riverwalking: Reflections on Moving Water*. New York: Harcourt Brace, 1995.

Morris, Jan. "The Other Portland." *Portland Magazine,* Summer 2001, 28-33.

Moseley, Henry Nottidge. *Oregon: Its Resources, Climate, People, and Productions*. London: E. Stanford, 1878.

Moynihan, Ruth Barnes. *Rebel for Rights: Abigail Scott Duniway*. New Haven, Conn.: Yale University Press, 1983.

Munk, Michael. "Inside Portland's Bohemia: The Diaries of Helen Walters." *Oregon Historical Quarterly* 106 (Winter 2005): 594-615.

—. "Portland's 'Silk Stocking Mob': The Citizens Emergency League in the 1934 Maritime Strike." *Pacific Northwest Quarterly* 91:3 (Summer 2000: 150-160.

—. "Oregon Tests Academic Freedom in (Cold)wartime: The Reed College Trustees Vs. Stanley Moore." *Oregon Historical Quarterly* 97 (Fall 1996): 262-354.

—. "The 'Portland Period' of Artist Carl Walters." *Oregon Historical Quarterly* 101 (Summer 2000): 134-161.

—. 2007. *The Red Guide to Portland*. Portland, Ore.: Ooligan Press, forthcoming.

Nash, Wallis. *The Settler's Handbook to Oregon*. Portland, Ore.: J.K. Gill, 1878.

—. (1904). *Oregon: There and Back in 1877*. Corvallis: Oregon State University Press, 1976.

Neal, Steve, ed. *They Never Go Back to Pocatello: The Selected Essays of Richard Neuberger.* Portland: Oregon Historical Society Press, 1988.

Nelson, Blake. *Exile*. New York: Scribner's, 1997.

Nelson, Herbert B. *The Literary Impulse in Pioneer Oregon*. Corvallis: Oregon State University Press, 1948.

Nester, Paul M. *First Half of My Life*. Beaverton, Ore.: Willamette Press, 1983.

Netboy, Anthony. *Memoirs of Anthony Netboy: A Writer's Life in the 20th Century*. Ashland, Ore.: Tree Stump Press, 1990.

Oates, David. "Boots on the Ground in Sherwood Forest." *City Limits: Walking Portland's Boundary*. Corvallis: Oregon State University Press, 2006.

—. *Paradise Wild: Reimagining American Nature*. Corvallis: Oregon State University Press, 2003.

O'Donnell, Terence, and Thomas Vaughan. *Portland: A Historical Sketch and Guide*. Portland: Oregon Historical Society Press, 1976.

Okada, John. *No-No Boy*. Seattle: University of Washington Press, 1976.

Orlean, Susan. *The Bullfighter Checks Her Makeup: My Encounters with Extraordinary People*. New York: Random House, 2002.

—. *My Kind of Place: Travel Stories from a Woman Who's Been Everywhere*. New York: Random House, 2004.

Ozawa, Connie P., ed. *The Portland Edge: Challenges and Successes in Growing Communities*. Washington, D.C.: Island Press, 2004.

Palahniuk, Chuck. *Fugitives and Refugees: A Walk in Portland, Oregon*. New York: Crown, 2003.

Parker, Samuel. *Journal of an Exploring Tour beyond the Rocky Mountains: Under the Direction of the A.B.C.F.M. Performed in the Years 1835, '36, and '37, Containing a Description of the Geography, Geology, Climate, and Productions, and the Number, Manners, and Customs of the Natives; with a Map of Oregon Territory*. Ithaca, N.Y., 1838.

Parsons, John. *Beside the Beautiful Willamette*. Portland, Ore.: Metropolitan, 1924.

Patterson, Alexander. "Terrasquirma." *Oregon Historical Quarterly* 101:2(Summer 2000): 162–191.

Payette, B. C. *The Oregon Country under the Union Jack: A Reference Book of Historical Documents for Scholars Aand Historians*. Montreal: Payette Radio, 1961.

Polishuk, Sandy. *Sticking to Tthe Union: An Oral History of the Life and Times of Julia Ruuttila*. New York: Palgrave Macmillan, 2003.

Portland, The Rose City: Pictorial And Biographical. De luxe supplement. Chicago: S.J. Clarke Pub, 1911.

Portland Parks and Recreation. "Council Crest Park." Retrieved April 23, 2006. http://www.portlandonline.com/parks/finder/index.cfm?action=ViewPark&PropertyID=24&c=38308

Powell, Fred Wilbur, ed. *Hall J. Kelley on Oregon; A Collection of Five of his Published Works and a Number of Hitherto Unpublished Letters*. Princeton, N.J.: Princeton University Press, 1932.

Powers, Alfred. *Early Printing in the Oregon Country*. Portland: Students of Benson Polytechnic School Print Shop, 1955?.

—. *History of Oregon Literature*. Portland, Ore.: Metropolitan Press, 1935.

—. *Long Way to Frisco: A Folk Adventure Novel of California and Oregon in 1852*. Boston: Little, Brown, 1951.

Pratt, Laurence. *I Remember Portland 1899-1915*. Portland, Ore.: Binford & Mort, 1965.

Puter, Stephen A. *Looters of the Public Domain, by S.A.D. Puter, King of the Oregon Land Fraud Ring, in Collaboration With Horace Stevens . . . Embracing a Complete Exposure of the Fraudulent System of Acquiring Titles to the Public Lands Of The United States*. In collaboration with Horace Stevens. Portland, Ore.: Portland Printing, 1908.

Putnam, Robert, and Lewis M. Feldstein. *Better Together: Restoring the American Community*. New York: Simon and Schuster, 2003.

Rice, Clyde. *Nordi's Gift*. Portland, Ore.: Breitenbush Books, 1990.

Ramsey, Jarold, ed. *Coyote Was Going There: Indian Literature of the Oregon Country*. Seattle: University of Washington Press, 1977.

Pilcher, William W. *The Portland Longshoremen; A Dispersed Urban Community*. New York: Holt, Rinehart and Winston, 1972.

Pintarich Paul L. *History By the Glass*. Portland, Ore.: Bianco Publishing, 1996.

Reid, John Phillip. "Restraints of Vengeance: Retaliation-in-kind and the Use of Indian Law in the Old Oregon Country." *Oregon Historical Quarterly* 95:1 (Spring 1994): 48-92.

Redon, Joel. *If Not On Earth, Then In Heaven*. New York: St. Martin's Press, 1991.

—. *The Road to Zena: A Novel*. New York: St. Martin's Press, 1992.

Reed, John. *Adventures of a Young Man: Short Stories from Life*. San Francisco: City Lights Books, 1975.

Rollins, Philip Ashton, ed. *The Discovery of the Oregon Trail; Robert Stuart's Narratives Of His Overland Trip Eastward From Astoria in 1812-13*. New York and London: C. Scribner's, 1935.

Ronda, James P. "Calculating Ouragon." *Oregon Historical Quarterly* 94:2/3 (Summer-Fall): 121-140.

Robbins, William G., ed. *The Great Northwest: The Search for Regional Identity*. Corvallis: Oregon State University Press, 2001.

—. *Colony and Empire: The Capitalist Transformation of the American West*. Lawrence: University Press of Kansas, 1994.

Rock, Peter. *The Bewildered: A Novel*. San Francisco: MacAdam/Cage, 2005.

Ross, Alexander. *Adventures of the First Settlers on the Oregon or Columbia River*. Ed. Milo Milton Quaife. Chicago: Lakeside Press, 1923. Reprint Corvallis: Oregon State University Press, 2000.

Ross, Nancy Wilson. *The Farthest Reach: Oregon and Washington*. New York: Alfred Knopf, 1941.

Rubin, Rick. *Naked Against The Rain: The People of the Lower Columbia River, 1770-1830*. Portland, Ore.: Far Shore Press, 1999.

Rugoff, Ralph. *From Baja to Vancouver: The West Coast and Contemporary Art*. San Francisco: Wattis Institute for Contemporary Arts, 2003.

Salmonson, Jessica Amanda. *The Mysterious Room and Other Ghostly Tales of the Pacific Northwest*. Seattle: Sasquatch, 1992.

Schafer, Joseph. *Documents Relative to Warre and Vavasour's Military Reconnaissance in Oregon, 1845-6*. Portland: Oregon Historical Society, 1909.

Scott, Harvey W. *History of the Oregon Country*. Cambridge, Mass.: Riverside Press, 1924.

—. *History of Portland*. New York: Mason and Co., 1890.

Schwantes, Carlos A. *The Pacific Northwest: An Interpretive History*. Lincoln: University of Nebraska Press, 1989.

Seaman, N.G. *Indian Relics of the Pacific Northwest*. Portland, Ore.: Binford & Mort, 1946.

Shein, Debra. "Not Just the Vote: Abigail Scott Duniway's Serialized Novels and the Struggle for Women's Rights." *Oregon Historical Quarterly* 101: 3 (2000): 302-327.

Simpson, George. *Narrative of a Journey Round the World, During the Years 1841 and 1842*. London: H. Colburn, 1847.

Snyder Eugene E. *Early Portland: Stump-town Triumphant, Rival Townsites on the Willamette, 1831-1854*. Portland, Ore.: Binford & Mort, 1984.

—. *We Claimed This Land: Portland's Pioneer Settlers*. Portland, Ore.: Binford & Mort, 1989.

Snyder, Gary. *The Practice of the Wild*. North Point Press, 1990.

Solinger, Rickie. *The Abortionist: A Woman Against the Law*. Berkeley: University of California Press, 1994

Spencer, Omar C. *The Story of Sauvies Island*. Portland, Ore.: The Metropolitan Press, 1950.

Stadler, Matthew. "Brown at the Edges with a Chewy White Center: Letter From Portland." *The Stranger* 14:14 (December 22, 2004): 25.

—. "Dump Your Tired Suburban Notions." *Portland Oregonian*, April 16, 2006. C1-C2.

Stafford, Kim. *Having Everything Right*. Seattle: Sasquatch Books, 1986.

—. *A Thousand Friends of Rain: New & Selected Poems*. Pittsburgh, Penn.: Carnegie-Mellon University Press, 2005.

—, and William Stafford. *Braided Apart: Poems*. Lewiston, Idaho: Confluence Press, 1976.

—. *Early Morning: Remembering My Father*. Saint Paul, MN: Graywolf Press, 2002.

Stanford, Phil. *Portland Confidential: Sex, Crime, and Corruption in the Rose City*. Portland, Ore.: Westwinds Press, 2004.

Stern, Kenneth S. *Loud Hawk: The United States Versus the American Indian Movement*. Norman: University of Oklahoma Press, 1994.

Stevens, James. *Jim Turner, A Novel*. Garden City, N.Y.: Doubleday, 1948.

Stevens, James, and H. L. Davis. *Status Rerum: A Manifesto, Upon The Present Condition Of Northwestern Literature, Containing Several Near-Libelous Utterances, Upon Persons In The Public Eye*. The Dalles, Ore.: privately printed, 1927.

Stevenson, Janet. *The Ardent Year*. New York: Viking, 1960.

—. *Departure: A Novel*. Hillsboro, Ore.: Blue Heron Publishing, 1985.

—. *Sisters and Brother*. New York: Crown, 1966.

—. *Weep No More*. New York: Viking, 1957.

Strahan, Kay Cleaver. *Footprints*. Garden City, N.Y.: Doubleday, 1929.

Strong, Emory M. *Stone Age on the Columbia River*. Portland, Ore.: Binford & Mort, 1959.

Strong, Thomas Nelson. *Cathlamet on the Columbia*. Portland, Ore.: Metropolitan Press, 1930.

Sturtevant, William C., ed. Handbook of North American Indians. Vol. 7. Washington, D.C.: Smithsonian Institution, 1978.

Thompson, David. *Journals Relating to Montana and Adjacent Regions, 1808-1812.* M. Catherine White, ed. Missoula: Montana State University Press, 1950.

Thorseth, Matthea. *Cradled in Thunder: A Novel.* Seattle: Superior Publishing, 1946.

Thwaites, Ruben Gold, ed.*Early Western Travels, 1748-1846.* Cleveland, Ohio: Clark, 1904.

Tisdale, Sallie. "Portland From the Air." *Portland Magazine* 19:2 (Summer 2000): 28-33.

—. *Stepping Westward: The Long Search for Home in the Pacific Northwest.* New York: Henry Holt, 1991.

Titus, Norman. *A Portland Affair.* New York: Carlton Press, 1977.

Truchot, Teresa. *Charcoal Wagon Boy.* Portland: Binford and Mort, 1952

Vancouver, George. *A Voyage of Discovery to the North Pacific Ocean, and Round the World; In which the Coast of North-West America Has Been Carefully Examined And Accurately Surveyed.* London, Printed for G. G. and J. Robinson, 1798.

—. *The Exploration of the Columbia River By W.R. Broughton, October, 1792, An Extract From The Journal Of Captain George Vancouver.* Longview, Wash.: Longview Daily News Press, 1926.

—. *A Voyage Of Discovery To The North Pacific Ocean And Round The World, 1791-1795: With An Introduction And Appendices.* Ed. W. Kaye Lamb. London: Hakluyt Society, 1984.

Victor, Frances Fuller. "Hall J. Kelley: One of the Fathers of Oregon." *Oregon Historical Quarterly* 2:4 (December 1901): 381–400.

—. *The New Penelope, and Other Stories and Poems.* San Francisco: A.L. Bancroft, 1877.

—. *The Women's War with Whiskey; Or, Crusading in Portland.* Portland, Ore.: G.H. Himes, 1874.

Ward, Jean, and Elaine A. Maveety, eds. *Yours For Liberty": Selections from Abigail Scott Duniway's Suffrage Newspaper.* Corvallis: Oregon State University Press, 2000.

Warre, Henry James. *Overland to Oregon in 1845: Impressions of a Journey across North America.* Ottawa: Information Canada, 1976.

—. *Sketches in North America and the Oregon Territory.* London: Dickinson & Co., 1848.

Williams, Lee. *After Nirvana: A Novel.* New York: W. Morrow, 1997.

White, Richard. *The Organic Machine: The Remaking of the Columbia River.* New York: Hill and Wang, 1995.

Wilson, Joseph R. "The Oregon Question." *Quarterly of the Oregon Historical Society.* 1:2 (1900): 111-131; 1:3 (1900): 213-252.

Wise, Stephen Samuel. *Challenging Years: The Autobiography of Stephen Samuel Wise.* New York: Putnam, 1949.

Wolf, Edward C., and Seth Zuckerman, eds. *Salmon Nation: People and Fish at the Edge.* Portland, Ore.: Ecotrust, 1999.

Wong, Marie Rose. *Sweet Cakes, Long Journey: The Chinatowns of Portland, Oregon.* Seattle: University of Washington Press, 2004.

Wood, Charles Erskine Scott. "Portland's Feast of Roses." *Pacific Monthly* 19:6 (June 1908): 623-633.

Woody, Elizabeth. *Luminaries of the Humble*. Tucson: University of Arizona Press, 1994.

—. *Seven Hands, Seven Hearts*. Portland, Ore.: Eighth Mountain Press, 1994.

Wyeth, Nathaniel. *The Journals of Captian Nathaniel J. Wyeth's Expeditions to the Oregon Country, 1831–1836*. Edited by Don Johnson. Fairfield, Wash.: Ye Galleon Press, 1984.

Citations and Permissions

Early Portland: Muddy Streets and Destiny

1. "Position and Advantages of Portland" and "Settlement and Early Times," by Harvey W. Scott, are from *History of Portland, Oregon: with illustrations and biographical sketches of prominent citizens and pioneers* (Syracuse, N.Y.: D. Mason, 1890), .53, 77–79, 92–97, 468.

2. Selections from *From Sea to Sea: Letters of Travel* by Rudyard Kipling (New York: Charles Scribner's Sons, 1906), 90–95.

3. "The New and the Old," by Joaquin Miller, from *Memorie and Rime* (New York: Funk & Wagnalls, 1884), 118–21.

4. "Interlude" and "Once to Every Warrior," by Robert Ormond Case, from *The Empire Builders* (Garden City, N.Y.: Doubleday, 1947), 233–42. Reprinted by permission of the publisher.

5. Selections from *Long Way to Frisco: A Folk Adventure Novel of California and Oregon in 1852,* by Alfred Powers (Boston: Little, Brown, 1951), 92–96, 124–8. Reprinted by permission of Molly Powers Dusenbery.

6. "Smuggler Catchers," by Theresa Truchot, from *Charcoal Wagon Boy* (Portland, Ore.: Binfords & Mort, 1952), 15–19. Reprinted by permission of the publisher.

7. "Portland-on-Wallamet," by Matthew Deady, *Overland Monthly* 1, 34–43.

8. "The War on the Webfoot Saloon," by Malcolm Clark, from *The War on the Webfoot Saloon & other tales of feminine adventures* (Portland: Oregon Historical Society Press, 1969), 5–23.

9. "History of the Picture that Elected Hermann to Congress," by Stephen A. Douglas Puter, from *Looters of the Public Domain: Embracing a Complete Exposure of the Fraudulent Systems of Acquiring Titles to the Public Lands of the United States* (Portland, Ore.: Portland Printing House, 1907),

10. Selection from *The Road to Zena,* by Joel Redon (New York: St. Martin's Press, 1992), 215-220. Reprinted by permission of V'Anne Didzun.

11. "The Third Month," "The Fourth Month," and "The Fifth Month," from *Departure: A Novel,* by Janet Stevenson (Hillsboro, Ore.: Blue Heron Publishing, 1985), 308–23. Reprinted by permission of the author.

12. Selection from *Long Storm,* by Ernest Haycox (Boston: Little, Brown, 1946), 99–114. Reprinted by permission of Ernest Haycox Jr.

13. "Wide Angle View," from *The Shaping of a City: Business and Politics in Portland, Oregon, 1885-1915,* by E. Kimbark MacColl (Portland, Ore.: The Georgian Press, 1976), 1–16. Reprinted by permission of the author.

14. "The Life Story of a Japanese Servant," in *Independent* 59, September 21, 1905, 661–8, and *The Life Stories of Undistinguished Americans, as told by Themselves,* ed. Hamilton Holt (New York: Routledge, 1990), 159–64.

15. "The Portland Exposition," in *The Independent* 59:2963, September 14, 1905, 630–4.

16. "Three Sirens of Portland," by Stewart Holbrook, from *Wildmen Wobblies & Whistlepunks: Stewart Holbrook's Lowbrow Northwest*, ed. Brian Booth (Corvallis: University of Oregon Press, 1992), 129–36. Reprinted by permission of Sybil Holbrook.

17. "Little Pretty and the Seven Bulls," from *Big Jim Turner,* by James Stevens (Garden City, N.Y.: Doubleday, 1948), 199–214. Copyright 1948 by James Stevens. Used by permission of Doubleday, a division of Random House, Inc.

18. "The Story of Aaron and Jeanette Meier," by Steve Lowenstein, in *The Jews of Oregon, 1850-1950* (Portland: Jewish Historical Society of Oregon, 1987), 22–29. Reprinted by permission of the Oregon Jewish Museum.

Modern Portland: The Rose City

19. "Portland's Feast of Roses," by Charles Erskine Scott Wood, in *Pacific Monthly*, 19:6 (June 1908): 623–33.

20. "Two Judges," by Louise Bryant, in *The Masses* April 18, 1916, 18.

21. Excerpt from *Two Wheels North: Bicycling the West Coast in 1909*, by Evelyn McDaniel Gibb (Corvallis: Oregon State University Press, 2000), 129–34. Reprinted by permission of the author.

22. "The Wood Household," by Barbara Bartlett Hartwell, an appendix in *Nanny Wood: From Washington Belle to Portland's Grande Dame,* by Philip W. Leon (Bowie, Md.: Heritage Books, 2003), 215–24. Reprinted by permission of the Portland Art Museum.

23. "Almost Thirty," by John Reed, in *The New Republic*, 1936. Reprinted in *Adventures of a Young Man: Short Stories from Life,* by Janet Stevenson (San Francisco: City Lights Books, 1975), 125–32.

24. Selection from *The Bohemians, John Reed and his Friends who Shook the World,* by Alan Cheuse (Cambridge: Apple-Wood Books, 1982), 171–90. Reprinted by permission of the author.

25. Excerpt from *Doctor Mallory,* by Alan Hart (New York: W.W. Norton & Company, Inc., 1935), 22–28. Copyright 1935 by W.W. Norton & Company, Inc. Used by permission of W. W. Norton & Company, Inc.

26. "Portland's 'Silk Stocking Mob': The Citizens Emergency League in the 1934 Maritime Strike" by Michael Munk, in *Pacific Northwest Quarterly*, Summer 2000, 150–60. Reprinted by permission of the author.

27. Selections from *Sticking to the Union: An Oral History of The Life and Times of Julia Ruuttila,* by Sandy Polishuk (New York: Palgrave McMillan, 2003), 48–56, 66–69. Reproduced with permission of Palgrave McMillan.

28. "Chinatown and Bicycle," from *I Remember Portland, 1899-1915,* by Laurence Pratt (Portland, Ore.: Binford & Mort, 1965), 16–27. Reprinted by permission of the publisher.

29. Selections from *Delights and Prejudices*, by James Beard (Philadelphia: Running Press, 1964), 17–21, 26–28, 31–36. Reprinted by permission of John Ferrone, © by James Beard, © renewed 1992 by the Executors of the Will of James Beard.

30. Excerpt from *The Wise in Heart,* by Nancy Noon Kendall (New York: Thomas Y. Crowell Company, 1947), 6–18.

31. Selections from *Assault on Mount Helicon: A Literary Memoir,* by Mary Barnard (Berkeley: University of California Press, 1984), 4–6, 19–27, 31–32. Reprinted by permission of Elizabeth Bell, © 1984 Barnardworks.

32. "High School Freshman," "Wise Fools," and "Love and the Spelling Bee," from *A Girl From Yamhill: A Memoir,* by Beverly Cleary (New York: William Morrow and Company, Inc., 1988), 110–9, 181–8, 210–8, 225–6. Copyright © 1988 by Beverly Cleary. Used by permission of HarperCollins Publishers.

33. Excerpt from *Nordi's Gift,* by Clyde Rice (Portland, Ore.: Breitenbush Books, 1990), 66–75. Reprinted by permission of Virginia Rice.

34. "Hometown," by Tom McAllister and David Marshall, in *Oregon Historical Quarterly* 101:3 (Fall 2000): 377–82. Reprinted by permission of the authors.

35. "Sober Industrious and Honest," from *A Peculiar Paradise: A History of Blacks in Oregon, 1788-1940,* by Elizabeth McLagan (Portland, Ore.: The Georgian Press, 1980), 109–10, 119–22, 123–24. Reprinted by permission of the publisher.

36. "An American Negro Speaks of Color," by Kathryn Hall Bogle, originally in the *Oregonian,* February 14, 1937. Republished in *Oregon Historical Quarterly* 89:1 (Spring 1988): 70–3, 78–81. Reprinted by permission of Dick Bogle.

37. Selections from *Shipyard Diary of Woman Welder,* by Augusta Clawson (New York: Penguin Books, 1944), 8–10, 14–15, 54–60, 94–95. Copyright 1944 by Penguin Books Inc. Used by permission of Viking Penguin, a division of Penguin Group (USA) Inc.

38. Selection from *No-No Boy,* by John Okada (Seattle: University of Washington Press, 1976), 145-60. Reprinted by permission of the author.

39. "The Flower Girls," by Lawson Fusao Inada, in *The World Begins Here: An Anthology of Oregon Short Fiction,* ed. Glen A. Love (Corvallis: Oregon State University Press, 1993), 276–86. This selection from "The Flower Girls" is reprinted by permission of the author.

40. Selections from *Sweet Cakes, Long Journey: The Chinatowns of Portland, Oregon,* by Marie Rose Wong (Seattle: University of Washington Press, 2004), 3–4, 6–8, 12–16, 26–28. Reprinted by permission of the author and the University of Washington Press.

Portland Proper: Neighborhoods, Activists, Nature, and Beer

41. "Where Jump Was a Noun: Jazz in Portland in the 1940's," by Robert Dietsche, in *Open* Spaces 2:1 (1999): 30, 32–35. Reprinted by permission of *Open Spaces* and the author.

42. "May Fete Day," by Don Carpenter, from *The Class of '49: A Novel and Two Stories* (San Francisco: North Point Press, 1985), 25–32, 37–42. Reprinted by permission of the publisher.

43. "My Hometown Is Good Enough fFor Me," by Richard L Neuberger, from *They Never Go Back to Pocatello: The Selected Essays of Richard Neuberger,* ed. Steve

Neal (Portland: Oregon Historical Society Press, 1988), 209–16. Used by permission of the Oregon Historical Society Press.

44. "Back to Business as Usual," "The Tantalizing Candy Renee," and "Hot Times at the Desert Room," by Phil Stanford, from *Portland Confidential: Sex, Crime, and Corruption in the Rose City* (Portland, Ore.: West Winds Press, 2004), 49–69.

45. "Same Old Song and Dance," by Gary Snyder, from *Practice of the Wild* (Emeryville, Calif.: Shoemaker & Hoard, 2004), 48-51. Copyright © 1990, 2003 by Gary Snyder from *Practice of the Wild*. Reprinted by permission of Shoemaker & Hoard.

46. Selection from *History by the Glass: Portland's Past and Present Saloons, Bars, & Taverns,* by Paul Pintarich (Portland: Bianco, 1996), 9–20. Reprinted by permission of the author.

47. "Settling Down" and "Strangers," by Mikal Gilmore, from *Shot in the Dark* (New York: Doubleday, 1994), 107–9, 121–31, 136–40, 166–8. Copyright © 1994 by Mikal Gilmore. Used by permission of Doubleday, a division of Random House, Inc.

48. "The Separate Hearth" by Kim Stafford, from *Having Everything Right: Essays of Place* (Seattle: Sasquatch Books, 1997), 81–91. Reprinted by permission of the author.

49. "The Elephant's Child," by Shana Alexander, from *The Astonishing Elephant* (New York: Random House, 2000), 3–5, 15–21. Copyright © 2000 by Shana Alexander. Used by permission of Random House, Inc.

50. Selection from *They Weep on my Doorstep* by Ruth Barnett, as told to Doug Baker (Beaverton, Ore.: Halo Publishers, 1969), 4–19. Reprinted by permission of Sheldon Baker.

51. Selections from *One Summer* by Albert Drake (Adelphi, Md.: White Ewe Press, 1979), 9–17, 29–34. Reprinted by permission of the author.

52. Selection from *The Lathe of Heaven,* by Ursula K. LeGuin (New York: Scribner, 1971), 25-39. Reprinted with permission of Scribner, an imprint of Simon & Schuster Adult Publishing Group. Copyright © 1972 by Ursula K. LeGuin.

53. "A Bullet in a Guy's Head," by Kenneth S. Stern, from *Loud Hawk: The United States Versus the American Indian Movement* (Norman: University of Oklahoma Press, 1994), 81–83, 88–92. Reprinted by permission of the author.

54. "Terrasquirma and the Engines of Social Change in 1970s Portland," by Alexander Patterson, in *Oregon Historical Quarterly* 101:2 (Summer 2000): 163–8, 171–2, 175–85. Reprinted by permission of the author.

55. "After Celilo," by Ed Edmo, from *Talking Leaves: Contemporary Native American Short Stories,* ed. Craig Lesley (New York: Delta, 1991), 70–73. Reprinted by permission of the author.

56. Selections from *Death and the Good Life: A Mystery,* by Richard Hugo and James Welch (Moscow: University of Idaho Press, 2002), 61–64, 101–9, 180–5. Reprinted by permission of the University of Idaho, Moscow.

57. Selection from *Deadly Games in City Hall: A Murder Mystery,* by Jewel Lansing (Portland, Ore.: Skylark Press, 1997), 40–48. Reprinted by permission of the author.

58. "From the Wheelhouse of the Western Couger," by Louis Masson, from *Reflections: Essays on Place and Family* (Pullman: Washington State University Press, 1996), 17–23. Reprinted by permission of the author.

59. "Little, but Strong" and "Closing the Door," by David James Duncan, from *The River Why* (New York: Bantam, 1982), 186–90, 195–8. Reprinted by permission of the author.

60. "Immigrants" and "Notes on the Mexican Kids," by Walt Curtis, from *Mala Noche & Other "Illegal" Adventures* (Portland, Ore.: Bridge City Books, 1997), 21–26, 77–80. Reprinted by permission of the author.

61. "Aztlán, Oregon," by Daniel Chacón, from *Chicano Chicanery: Short Stories* (Houston: Arte Publico Press, 2000), 59–74. Reprinted by permission of the author.

62. "MTV Not Bullets," "Transform," and "Welcome Home from Vietnam, Son," by Douglas Coupland, from *Generation X: Tales for an Accelerated Culture* (New York: St. Martin's Press, 1991), 141–7, 149–51. Reprinted by permission of the author.

63. "The Urban Waterway," by Robin Cody, from *Voyage of a Summer Sun: Canboeing the Columbia River* (New York: Alfred A. Knopf, 1995), 271–81. Reprinted by permission of the author.

64. "Robot of the River," by William Least Heat-Moon, from *River Horse: The Logbook of a Boat Across America* (Boston: Houghton Mifflin, 1999), 489–92. Copyright © 1999 by William Least Heat-Moon. Reprinted by permission of Houghton Mifflin Company. All rights reserved.

Contemporary Portland: Scenes and Reflections

65. "The Death of Mulugeta Seraw" and "Underground," by Elinor Langer, from *A Hundred Little Hitlers: The Death of a Black Man, the Trial of a White Racist, and the Rise of the Neo-Nazi Movement in America* (New York: Metropolitan Books, 2003), 9–14, 28–31, 32–35, 37–44. Selection from *A Hundred Little Hitlers* © 2003 by Elinor Langer. Reprinted by permission of Henry Holt and Company, LLC.

66. "Figures in a Mall," by Susan Orlean, from *The Bullfighter Checks her Makeup* (New York: Random House, 2001), 245-255. Copyright © 2001 by Susan Orlean. Used by permission of Random House, Inc.

67. Excerpt from *Dead Air* by Ed Goldberg (New York: Berkley Crime, 1998), 38–53. Reprinted by permission of the author.

68. Selections from *Truck,* by Katherine Dunn (New York: Warner Books, 1990), 6–7, 12–13, 20–24, 47–48. Reprinted by permission of the author.

69. "City Living," by Lee Williams, from *After Nirvana: A Novel* (New York: W. Morrow, 1997), 50–58. Copyright © 1997 by Lee Williams. Reprinted by permission of HarperCollins Publishers.

70. "Ramona Quimby's Portland: The Nicest City Possible?" by Carl Abbott, from *Greater Portland: Urban Life and Landscape in the Pacific Northwest* (Philadelphia: University of Pennsylvania Press, 2001), 75–87. Reprinted by permission of the author and the University of Pennsylvania Press.

71. Dan Newth, "Chillin'," *Street Roots* 6:3 (February 1, 2004), 8.

72. "The Other Portland," by Jan Morris, in *Portland Magazine,* Summer 2001, 14–15. Reprinted by permission of the author.

73. Selections from *Ties That Bind: A Novel,* by Phillip M. Margolin (New York: HarperCollins, 2003), 221–25, 231–34. Copyright © 2003 by Phillip M. Margolin. Reprinted by permission of HarperCollins Publishers.

74. Selection from *Buried Diamonds,* by April Henry (New York: Thomas Dunne, 2003), 165–83. Copyright © 2003 by the author and reprinted by permission of St. Martin's Press, LLC.

75. "Obdulia at the Rose Garden," by Martha Gies, from *Up All Night* (Corvallis: Oregon State University Press, 2004), 94–99. "Obdulia at the Rose Garden" is reprinted from *Up All Night,* by Martha Gies, published by Oregon State University Press © 2004 Martha Gies, by permission of the publisher.

76. "The Willamette" by Kathleen Dean Moore, from *Riverwalking: Reflections on Moving Water* (New York: Harcourt Brace, 1995), 3–12. Reprinted by permission of the author.

77. "Shifts," by Donald Miller, from *Blue Like Jazz: Nonreligious Thoughts on Christian Spirituality* (Nashville: T. Nelson Books, 2003), 15–21, 37–43, 177–79. Reprinted by permission of the author.

78. "Getting Off: How to Knock Off a Piece in Portland," by Chuck Palahniuk, from *Fugitives & Refugees: A Walk in Portland, Oregon* (New York: Crown Journeys, 2003), 98–105. Copyright © 2003 by Chuck Palahniuk. Used by permission of Crown Journeys, a division of Random House, Inc.

79. "Brown at the Edges with a Chewy White Center: Letter From Portland," by Matthew Stadler, in *The Stranger,* 14:14 (December 22, 2004), 25. Reprinted by permission of the author.

80. "Portland from the Air," by Sallie Tisdale, in *Portland Magazine,* 19:2 (Summer 2000), 28–33. It is also published in *Stepping Forward: The Search for Home in the Pacific Northwest* (New York: Henry Holt, 1992).

81. "Buckskin," by Elizabeth Woody, from *Seven Hands, Seven Hearts* (Portland, Ore.: Eighth Mountain Press, 1994), 21–24. It is also in *The Stories We Tell: An Anthology of Oregon Folk Literature*, ed. Suzi Jones and Jarold Ramsey (Corvallis: Oregon State University Press, 1994), 299–301. © 1994 by Elizabeth Woody. Reprinted by permission of the author and Eighth Mountain Press.

82. Selection from *The Effects of Light,* by Miranda Beverly-Whittemore (New York: Warner Books, 2005), 61–72. Copyright © 2005 by Miranda Beverly-Whittemore. By permission of Warner Books, Inc.

83. Selection from *The Bewildered: A Novel,* by Peter Rock (San Francisco: McAdam/Cage, 2005), 43–55. Reprinted by permission of the author.

84. Selection from *Winslow in Love,* by Kevin Canty (New York: Nan A. Talese,

2005), 1–10. Copyright © 2005 by Kevin Canty. Used by permission of Double-day, a division of Random House, Inc.

85. "Boots on the Ground in Sherwood Forest," by David Oats, from *City Limits: Walking Portland's Boundary* (Corvallis: Oregon State University Press, 2006). Reprinted by permission of the author.

Photographs

Unless otherwise noted, all photographs are from the collections of the Oregon Historical Society Reference Library, Portland.

Frontispiece: Newsstand at Dahl & Penne on Broadway, c. 1945, OHS neg., OrHi 51949

Page xxvii: Unknown Artist, Columbia River Anthropomorphic figure, pre-contact, basalt, H: 55½ in., W: 17 in., D: 6½ in. Portland Art Museum, Oregon. Purchased with proceeds from auction funds 1999.58.

Early Portland: Muddy Streets and Destiny
Page 1: Main Street, c. 1850, OHS neg., OrHi 13137
Page 8: Harvey Scott, OHS neg., OrHi 66115
Page 22: Joe Meek, OHS neg., OrHi 10126
Page 52: Portland waterfront, OHS neg., OrHi 54839
Page 69: Portland grid, OHS neg., OrHi 12517
Page 72: Theodore Roosevelt and Binger Hermann, OHS neg., ba016834
Page 82: Government Island, Lewis and Clark Exposition, 1905, OHS neg., OrHi 097648
Page 86: Log boom on the Willamette, OHS neg., OrHi 21754
Page 101: Meier & Frank building, OHS neg., OrHi 95295

Modern Portland: The Rose City
Page 103: Rose Garden, OHS neg., OrHi 17500
Page 107: First Rose Festival parade, 1908, OHS neg., OrHi 76677
Page 116: Erickson's Bar, OHS neg., OrHi 21750
Page 128: John Reed, OHS neg., OrHi 85530, courtesy of the Failing family archive
Page 136: Louise Bryant, portrait, OHS neg., OrHi 13358
Page 155: Waterfront strikers, OHS neg., OrHi 81706
Page 171: Bicyclists in front of the Fred T. Merrill bicycle shop, OHS neg., OrHi 103592
Page 178: Portland public market, OHS neg., OrHi 49965
Page 198: Downtown Vancouver, Washington, OrHi 13186
Page 206: Beverly Cleary, OHS neg., CN 001274
Page 212: Dodge Park, OHS neg., OrHi 94427